VICTORIAN SCULPTURE

VICTORIAN SCULPTURE

Benedict Read

Published for the Paul Mellon Centre for Studies in British Art
by Yale University Press, New Haven & London

Designed by Caroline Williamson.
Filmset in Monophoto Baskerville
and printed in Great Britain by BAS Printers Ltd, Over Wallop, Hampshire.

Library of Congress Cataloging in Publication Data

Read, Benedict.
 Victorian sculpture.

 Bibliography: p.
 Includes index.
 1. Sculpture, British. 2. Sculpture, Victorian—Great Britain. 3. Sculpture,
Modern—19th century—Great Britain. I. Title.
NB467.R4 730'.941 81-70483
ISBN 0-300-02506-8 (cloth) AACR2
ISBN 0-300-03177-7 (paper)

To my friends at the Courtauld Institute

Preface

The aim of this book is to offer an introduction to a particular, large area of artistic activity, Sculpture in Britain between about 1830 and about 1914. The fact that no such introduction exists in part explains how the book came about and its manner of presentation. Originally I was asked by Alan Bowness to give a brief survey of the subject to his Courtauld Institute students; but it soon became clear to me that with no frame of reference on which to base either my account or their comprehension, it was essential to go right back to the basics; and what follows is really an extended elaboration of my initial efforts. This may help to explain the perhaps rather simple-minded deictic tone of much of the book, as well as the somewhat archaeological approach adopted; for, starting rather in a vacuum, I was prepared to let the facts and the evidence dictate the structure of my interpretation. Such a basis may preclude the expression of personal critical opinion about the works in question; but I would suggest that a superfluity of experience, familiarity and understanding is necessary before one can begin to exercise discrimination and make value judgements. It is possible that nonetheless I have not entirely succeeded in concealing occasional personal sympathies.

One net effect of these background considerations is the way in which the book is structured. Chapters 1 to 6 are very much focussed on the 1830s to the 1870s, the period that has hitherto wholly lacked a conceptual framework of presentation. In an effort to reinforce my account I have often had recourse to a *précis* of contemporary sources, and this may sometimes explain a change in prose style. The period from the 1870s onwards—covered in chapters 8 to 10—has more apparent cohesion to it, thanks to the published accounts of such as Gosse and Spielmann (for which the Bibliography should be consulted). In addition much more work has been done recently on artists active in this latter period, so that my account of it can be less personalised and my presentation of its events more securely based. I am nevertheless very conscious that since this book is not thesis-based, it will inevitably not have been subject to the assistance that formal supervisory discipline can bring.

In this respect I am the more aware of my immeasurable debt to two authorities without whom the problems might have seemed virtually insuperable. First must be the work of Rupert Gunnis, whose *Dictionary of British Sculptors 1660–1851* in fact extends its coverage over a good two-thirds of the period I deal with and has been a constant source of information. In addition Gunnis's collection of photographs, bequeathed to the Courtauld Institute and now incorporated into the Conway Library there, has frequently directed me to the works themselves. Second only in this respect and equal in value as a source of inspiration and as testimony to the value of studying this period has been the work of Sir Nikolaus Pevsner, to which again I am greatly indebted.

As my involvement with sculpture has proceeded over the years, I have received great encouragement from a number of those involved in the field. I cannot forget the kindness shown to me at a very early stage of my studies by Charles and Lavinia Handley-Read,

while the generous cooperation of the descendants of certain of the artists I deal with—particularly Professor John Lough, Mrs Katharine Macdonald (*née* Munro), Mrs Elfrida Manning (*née* Thornycroft), Mrs Catherine Roper (*née* Brock), and Major-General Christopher Woolner—has given a special fillip to what I was seeking to achieve. Their generosity has been equalled by that shown by other scholars in the field, now I am happy to say increasing in number, and I owe a great deal to the spirit of friendly interchange with Dr Nicholas Penny, Susan Beattie, Elisabeth Darby, Richard Dorment, Fiona Pearson and Dr Homan Potterton.

There are many other individuals to whom I am indebted: the staffs of libraries, galleries and other institutions throughout the British Isles who have responded so kindly to my enquiries; of all these I must single out the services (as so many have done before me) of the London Library, the Courtauld Institute Book Library and the R.I.B.A. Drawings Collection. Many vicars and members of the public have been invaluable in drawing works to my attention. There are others I would like to thank individually for their company, help or hospitality, and in particular A.F.C., Geoffrey Fisher, Richard Hopkinson, Peter Howell, Mr and Mrs Ian McClure, Simon Mahon, Lady Mander, Mr and Mrs Alec Parker, Mr and Mrs William Read, Dr Helen Smith, Hugh Stevenson, Christian Thwaites, Rosemary Treble and Raleigh Trevelyan. For their fast and efficient typing I am grateful to Ros Fisher, Sarah Hyde and (in an emergency) my sister Sophie Hare. John Nicoll and Caroline Williamson have as publishers been both generous and patient. The index was most competently compiled by Mrs A. A. Mackrell, of the Society of Indexers.

The dedication of this book is I think self-explanatory. Again though there are some whom I must specify: particular teachers such as Alan Bowness and Peter Kidson, and that anonymous Friend of the Courtauld Institute who, by providing the money to go out and photograph many of the works illustrated here, gave me an exceptional opportunity to inspect a large number of the originals. That the major part of the photographs that appear were taken by the Courtauld Institute should indicate the extent of my debt to the Photographic Services there, including Janet Balmforth and Bridget Klebinder of the Photographic Department. To my successive Departmental superiors Constance Hill (Conway Librarian) and John Sunderland (Witt Librarian) I owe a great deal, and I am most grateful to them for the opportunity both afforded for me to undertake and complete the present work. Two colleagues and friends must occupy a special place in my indebtedness: James Austin who patiently photographed a major proportion of the works illustrated in the pages that follow, and Dr Philip Ward-Jackson for his constant presence and intellectual stimulation, even if often by virtue of a differing standpoint.

There is finally a fundamental debt that I cannot adequately repay: to my parents, not just for my life and education, but for the enhanced value of art in life that they represented. I am quite sure that my awareness of art owes everything to them, and that growing up in an environment where sculpture was valued so highly has helped to produce this work. Just as my father dedicated his Andrew Mellon Lectures of 1954, *The Art of Sculpture*, 'to Naum Gabo, Barbara Hepworth, Henry Moore Sculptors and Friends In Gratitude', so with temerity I would suggest that this book is in its way a fruit of the love and appreciation of these artists and their work with which I have been familiar from my earliest days.

Benedict Read

Contents

Photographic acknowledgements

The following are reproduced by gracious permission of Her Majesty the Queen: plates 24, 62, 66, 77, 94, 155–67, 220, 253–6, 373, 400–5, 426.

Grateful acknowledgement is made to the following for the supply of photographs and for permission to reproduce them: National Museum of Wales, Cardiff: Colour plate III, plates 374, 383, 385. Walker Art Gallery, Liverpool: Colour plate II, plates 265, 371, 382, 387. Department of the Environment, Crown Copyright: plates 40, 57, 79–82, 135, 139, 298. National Monuments Record: plate 154. Tate Gallery, London: plates 352, 355, 378. Janet Balmforth: Colour plates I, IV. A. F. Kersting: plate 92.

I am grateful to other private owners and institutions for permission to reproduce works in their possession or care. Unless otherwise credited, photographs are by courtesy of the Courtauld Institute of Art, University of London.

The Position of Victorian Sculpture

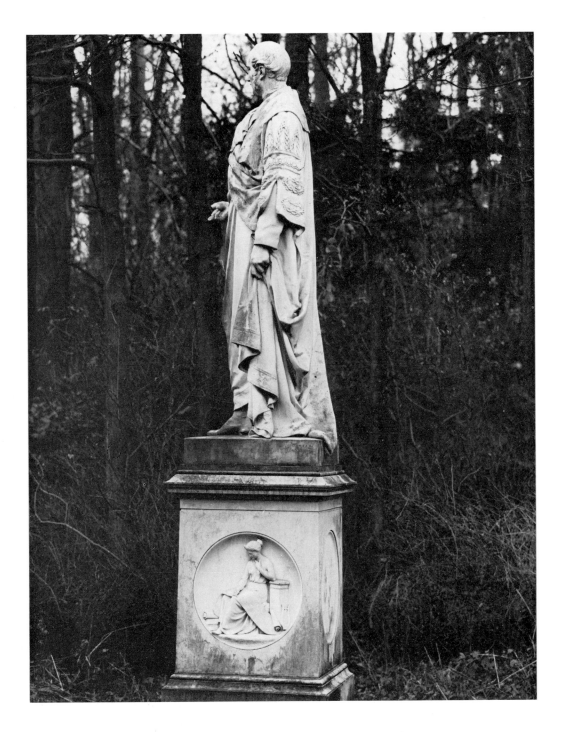

1 (preceding page). John Henry Foley, *Prince Albert*, 1866. Madingley.

'The dulled perception, and uneducated apathetic eye'[1]

Some four miles out of Cambridge, near the village of Madingley and overlooking a lake, stands a statue of Prince Albert by John Henry Foley R.A. (plate 1). Inscribed with the artist's name and dated 1866, it is in certain respects typical of Victorian commemorative sculpture. Members of the Senate of Cambridge University met in 1862 and agreed to ask for subscriptions from members of the University to erect a memorial to their recently deceased Chancellor, to consist of a statue 'to be placed in some conspicuous place in the University'. In 1870 the statue was offered to the University by the New Chancellor on behalf of the subscribers, and it was accepted; in 1878 it was unveiled, positioned in the staircase hall of the Fitzwilliam Museum.[2]

The figure is in court dress, with lace bands, ribbon and star of the Order of the Garter, underneath the robes of the Chancellor of the University. It is set on a pedestal which has three carved reliefs (the fourth side bears an inscription) representing Learning, Literature and Science. Like much Victorian commemorative statuary, the overall ensemble thus offers a not too complex message in sculpture about the figure. Symbolic too is the fact that at a later date this tribute of the University to its Royal Chancellor, executed by an eminent Victorian sculptor, was moved from its original prominent site to an inconspicuous glade.

This is not really surprising in view of present-day coverage and appreciation of Victorian sculpture. Although there has been a revival of interest in Victorian art for many years, its focus has been extremely haphazard. Certain members of the Pre-Raphaelite Brotherhood, particularly William Holman Hunt, John Everett Millais and Dante Gabriel Rossetti, are the subjects of endless articles, books and theses, as is the Brotherhood as a whole and some of its associates. Yet Thomas Woolner, a sculptor and one of the original seven members of the Brotherhood, has received such scant attention in recent years that *The Last of England*, Ford Madox Brown's painting of departing emigrants which was directly inspired by Woolner's departure for Australia in 1852, might also be called *The Last of Woolner* as far as most Pre-Raphaelite authors are concerned—even though Woolner soon returned from Australia to establish a position for himself as one of the most prominent and successful Victorian sculptors (Royal Academician, Professor of Sculpture at the Academy). This success was due in part to an element of sincerity and truthfulness in his work that could well be classified as an extension of certain Pre-Raphaelite principles (see below pp. 179–86). Only in the cases of Alfred Stevens (who was as much a painter and interior decorator as a sculptor) and of later Victorian sculpture, particularly the so-called 'New Sculpture' movement, does the present-day coverage improve,[3] though even here a certain imbalance is evident: Stevens was largely untypical of his age, and Alfred Gilbert among the new sculptors receives a measure of attention which though possibly commensurate with his quality leaves little room for the solider achievements of Thomas Brock and Hamo Thornycroft. With neither case, of necessity, can any contextual reference be made by Victorian sculpture overall,

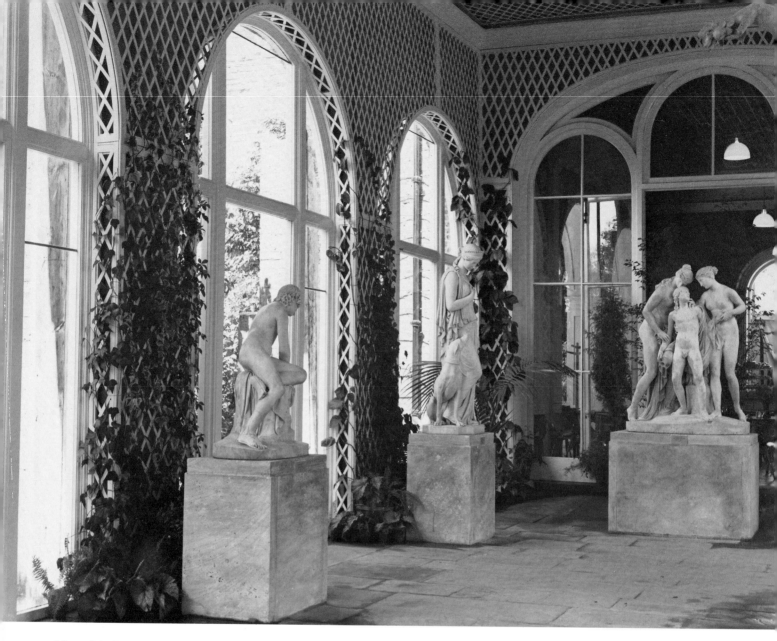

2. View of the Holland Park Sculpture Exhibition, 1957.

and even the very occasional exhibition (plate 2) in which Victorian sculpture has featured to a greater or lesser extent has done little to illuminate the field as a whole.[4]

This general lack of appreciation of Victorian sculpture has complex origins. It may be inevitable that one generation should react against the values of their fathers; there are, furthermore, problems even today over the appreciation of so finite an art as sculpture in romantic aesthetics, which indeed affected the nineteenth century as well as the twentieth. For instance John Ruskin is generally silent in the face of the sculpture of his age, an art that was preponderantly neo-classical even as late as the 1860s and 1870s if in a somewhat watered-down vein, and it was probably this latter aspect that put him off. He made rare comments such as: '. . . the state of sculpture in modern England, as compared with that of the great Ancients, is literally one of corrupt and dishonourable death, as opposed to bright and fameful life.'[5] There were one or two individual exceptions: Marochetti was 'a thoroughly great sculptor'.[6] Other critics less pre-eminent than Ruskin were less inhibited, as we shall see, so possibly it should be set down as a critical lacuna peculiar to him.

Beyond the intellectual issues, so to speak, there is the problem for present-day appreciation that the displaced Foley work from Cambridge typifies: the object itself may have shifted from our physical gaze as much as from our critical focus. It is only by chance

4

that a bust of Queen Victoria by Matthew Noble, originally in the Infirmary at Birmingham,[7] has found a happy home at Wightwick Manor, near Wolverhampton, and that two busts by Joseph Durham A.R.A. of Chaucer and Milton (both dated 1870) are for the time being in an hotel at Bedford. While these are relatively minor works that are simply displaced, the huge extent of contemporary writing on Victorian sculpture should make us wonder what sort of phenomenon it was concerned with. Moving away from Ruskin (a sometimes salutary exercise) to those writers whose principles and livelihoods were more closely in line with what was happening at the time, we begin to become aware that implicit in print is a whole area of art (such status was emphatically claimed for it, even if some thought it bad art), of an extent still unknown, whose masterpieces are only indicated through the written word: the works themselves have moved on either to temporary oblivion or to permanent destruction.

In order to establish a relationship between the sculpture being written about and the critical language being used, we can examine two works that were highly rated in their own time by more than one authority and which have survived, although displaced. Foley's equestrian statue of Viscount Hardinge (plate 3), between its completion in 1858 and its shipment out of the country in 1859, received from the *Art Journal* praise of the highest order:

> To our minds it is the finest work of the kind we know, either here or elsewhere—bold, almost daring, in conception, and masterly in execution . . .[8] The horse is admirable—a noble specimen of an Arab, and the attitude judicious, though novel. It is a really good horse, not cat-hammed or overnecked, but one that would live across country; with a good flank to drive him over timber, and well ribbed-up—fiery, but not peppery. We have seen no equestrian statue of late in England in which we have liked the horse so well. With all this, he is duly subservient to his rider, not only in the riding-school point of view, of being well in hand, but as a matter of Art—a consideration of great importance in equestrian statues, in which, too often, the horse is the more attractive and impressive animal of the two. This rock is thoroughly avoided in the statue in question . . .[9]

This was all written while the statue was still in Foley's studio, within whose comparatively confined limits the fine proportions and the spirit of the general design were half lost, the *Art Journal* writer thought.[10] The statue was then moved to the quadrangle of Burlington House and here the previous verdict of '. . . without any exception the noblest equestrian statue of modern times'[11] was confirmed: 'We consider . . . this great work as a triumph of British Art.'[12] After it had left the country: '. . . the group of Hardinge on his charger is no ordinary, no every-day work—it is a master-piece of Art, one that for grandeur of design, for truth of action, and for power and beauty of execution, has scarcely, if at all, a parallel in the world.'[13]

The work arrived in Calcutta, its original destination, in 1859[14] and was placed west of Red Road and south-east of the grounds of Government House, where it was later to be contrasted with another Foley work, *Earl Canning*, the one thought to be representative of 'Repose', the other of 'Movement'.[15] The *Art Journal* was not alone in its admiration, as it was keen to let its readers know:

> The statue is greatly admired, particularly by the natives, who have never seen anything approaching to it before. The Arab horse-dealers, with whom the love of the horse is a passion, and knowledge of their points of excellence a universal acquirement, are daily to be seen gazing at it. A more impressive admiration than that of these wild children of the desert, it is impossible to witness anywhere.'[16]

This latter comment was sadly true in more than one sense. Great efforts were made by

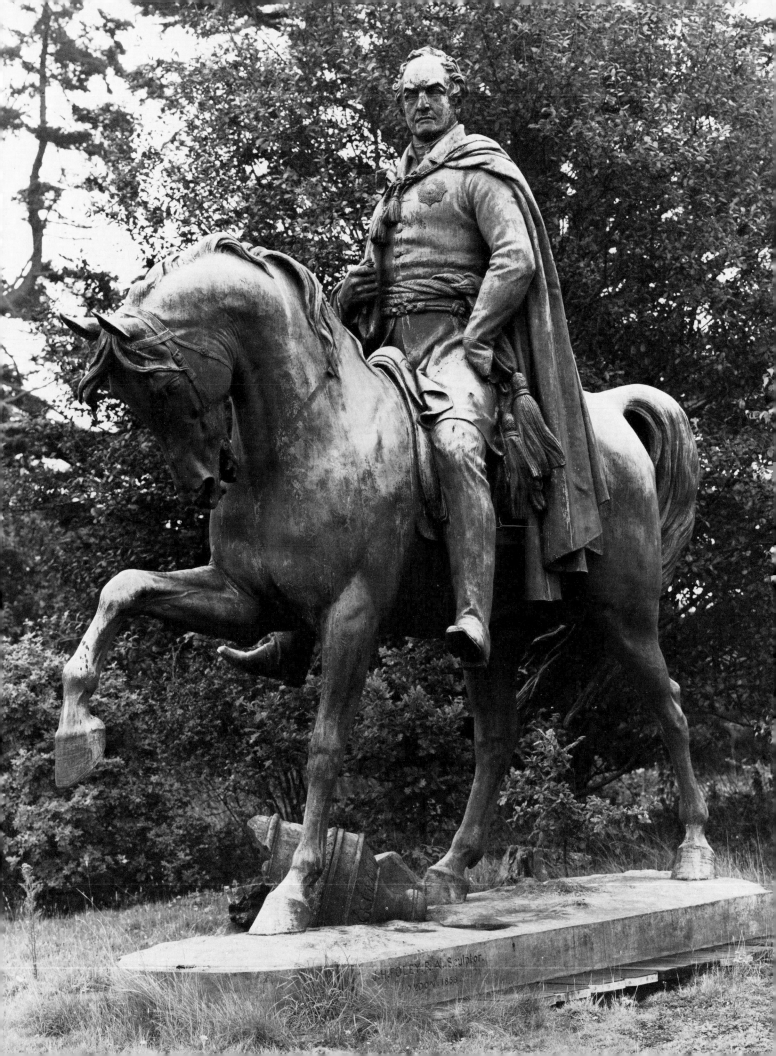

J. H. FOLEY, R.A. Sculptor
LONDON 1860

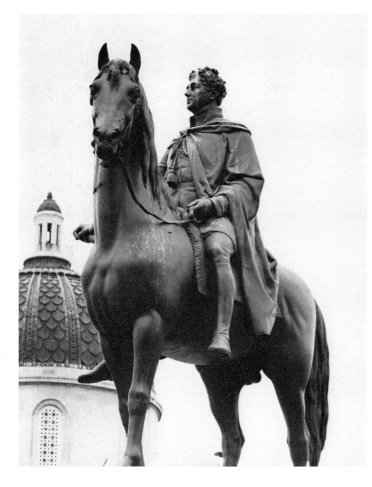
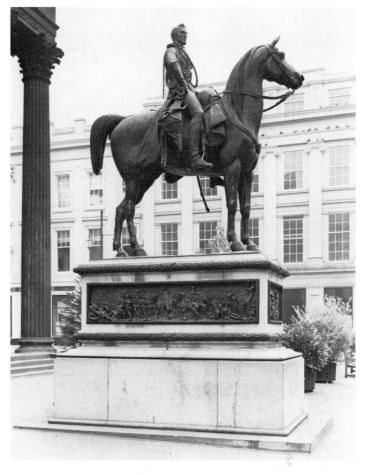

some of Foley's professional colleagues, backed up by the *Art Journal*, to obtain a replica (or rather a near-replica, in deference to the family's wishes) for London. But subscriptions did not come in as fast as they might have done, and the replica never materialised.[17] The work had however left its mark even on those of a different critical standpoint from that of the *Art Journal*. William Michael Rossetti wrote in 1861 that it 'stands markedly at the head of British equestrian statues of any period',[18] and Francis Turner Palgrave, in his *Handbook to the Fine Art Collections in the International Exhibition* (1862), rated very highly[19] the original plaster model (bronzed) which was shown at the Exhibition.

Over a century after its erection in Calcutta, and some years after the work had been carefully dismantled and put into store (for obvious political reasons), a descendant of the sitter heard that it was extant and available for transfer; the necessary arrangements were made and the work now stands in a garden in Kent. It is thus possible to come face to face with the work (in so far as this is possible with a sculpture eight feet high), and try to see why it so excited and impressed contemporary critics. While one may not entirely share the experience of 'one who has written much and well upon the art of sculpture'—'I look at that noble horse, I look—I turn my head aside for a moment, and expect to find that during this brief interval he has dashed forward'[20]—it has undeniably that quality of vitality about it that William Michael Rossetti considered a prerequisite for art,[21] and the pre-eminent position as an equestrian statue that both Rossetti and the *Art Journal* accorded it seems unquestionable when compared with works such as Chantrey's *George IV* (plate 4) in Trafalgar Square, London (1829). In this case the horse does perhaps match up to the *Art Journal*'s stricture as being 'the more attractive and impressive animal of the two'[22] and not without reason: 'The story goes that Chantrey showed His Majesty a number of small sketches of equestrian statues drawn on cards, which the King shuffled

4. Sir Francis Chantrey, *George IV*, 1829. London, Trafalgar Square.

5. Baron Carlo Marochetti, *The Duke of Wellington*, 1844. Glasgow, Royal Exchange Square.

3 (facing page). John Henry Foley, *Viscount Hardinge*, 1858. Private Collection.

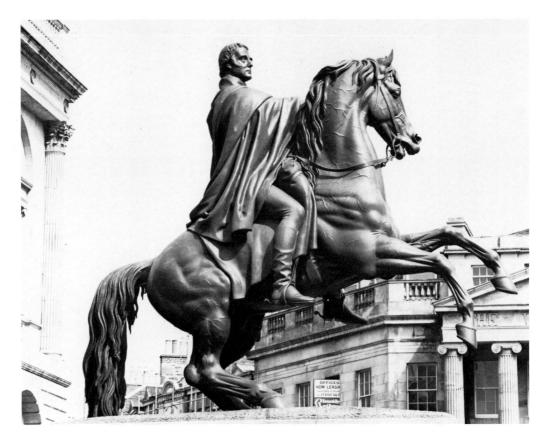

6. Sir John Steell, *The Duke of Wellington*, 1852. Edinburgh, Princes Street.

7 (facing page). Thomas Woolner, *Constance and Arthur/The Fairbairn Group*, 1862. Tunbridge Wells, Borough Cemetery.

about, unable to make up his mind whether he prefered a prancing or a galloping or a trotting charger as a mount. Eventually, prompted it appears by the sculptor, he chose a horse at rest.'[23] Further various representations of the Duke of Wellington on horseback by Chantrey (London, Royal Exchange, erected 1844) (plate 90), Marochetti (Glasgow, Royal Exchange Square, 1844) (plate 5) and Steell (Edinburgh, Princes Street, 1852) (plate 6), similarly confirm the *Hardinge*'s high reputation.

Another major work that we can consider in the same light is Thomas Woolner's *Brother and Sister*, also known as *The Fairbairn Group*, *Constance and Arthur* and *Deaf and Dumb* (plates 7, 8). This was exhibited at the International Exhibition of 1862 and was praised by Palgrave in both his *Handbook*[24] to and *Catalogue* of the Sculpture Section, British Division of the Fine Art Department. In the latter Palgrave speaks generally of Woolner's works as being 'truthful, dignified, and conscientious'; to these qualities the artist adds 'simple earnestness and intensity in expression, inventiveness in arrangement, with a tenderness and finish in execution without which marble never passes into vitality'.[25] He then proceeds to single out for its excellence what he calls *Arthur and Constance*. The group also features in J. B. Waring's compendious selection of choice objects of sculpture and the applied arts from the Exhibition. It is

> very natural and pleasing . . . Nothing can be more life-like and true than the treatment of every portion of the composition, from the excellently studied figures of the children to the diapered cloth or fringed rug on which their feet rest. Nor can too great praise be awarded to the drapery, which is often slurred over by sculptors with anything but artistic feeling, and in a conventional style, which may suit ideal subjects, but is not endurable in works professing to embody and perpetuate Nature itself. We think this work of Mr. Woolner's places him at the head of the Realistic school . . .[26]

The work also inspired a very different type of tribute, a poem by Robert Browning:

8

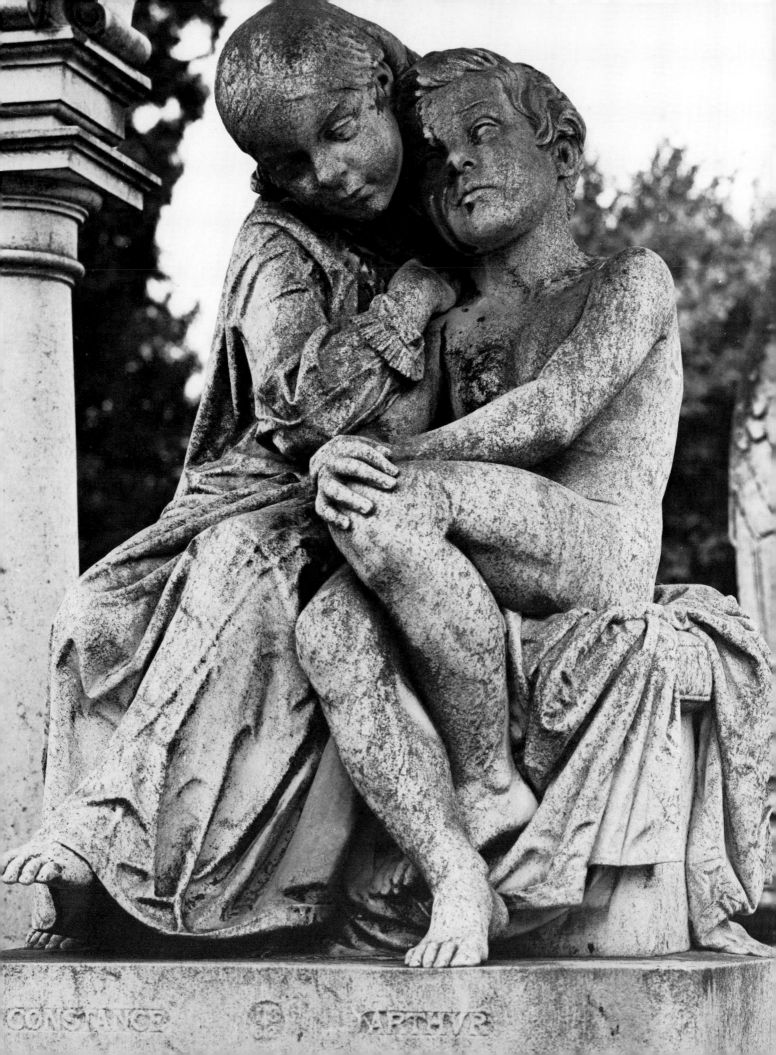

CONSTANCE ARTHVR

8. Thomas Woolner, *Constance and Arthur/The Fairbairn Group*, 1862. Tunbridge Wells, Borough Cemetery.

Deaf and Dumb—A Group by Woolner
Only the prism's obstruction shows aright
The secret of a sunbeam, breaks its light
Into the jewelled bow from blankest white;
　　So may a glory from defect arise:
Only by Deafness may the vexed Love wreak
Its insuppressive sense on brow and cheek,
Only by Dumbness adequately speak
　　As favoured mouth could never, through the eyes.[27]

While this may not be one of Browning's greatest works, and while, indeed, what aroused a response from Browning was the pathos of the work[28] (the nature of the sentiments involved in the Victorian response to sculpture and the other arts is a vital problem but is too complicated to go into here), the fact that he did respond presupposes an effectiveness in the work of art in communicating the pathos which could only have been achieved by artistic means.

The work survives today in the Borough Cemetery at Tunbridge Wells in Kent. Covered by a canopy, but weathering badly, it marks the grave of the two children who form its subject. The comments of the contemporary critics are confirmed, with the truthfulness and realism of the figures evident in the wrinkles in Arthur's stomach, caused by the way he is sitting, in the completeness of all parts that his nudity demands (even if artfully concealed from the casual observer), and in the drapery in such areas as the frills of Constance's wrist ruffs and the incised decorative pattern on the top horizontal surface of the base.

We should not perhaps read too much into two instances where we can confirm that what critics wrote at the time about works can be substantiated on the spot. But it does mean that, if we turn to the substantial contemporary literature on the subject of sculpture, we should be conscious of the fact that some of the authors may have known what they were talking about. I say 'some' with due and deliberate caution, as Palgrave (whom we have already met as a critic of sculpture) wrote of the press coverage of sculpture: '... our journals, in place of the careful criticism which they supply on painting, too often allow each public work in its turn to be announced by what is less a review than an advertisement'.[29] A similar opinion was expressed (slightly earlier) by William Michael Rossetti:

> The newspaper critics, with notable unanimity, announce in neat paragraphs that Mr. A.'s statue of the eminent B. is now completed, and exhibits a fine union of portrait-like truth, artistic treatment, and vital effect. The statue is placed, and is immediately derided, and very soon passed by with entire carelessness and neglect. The newspapers by this time have changed their note; and, if they cite the masterpiece, it is only to class it with the other guys and bugbears of our thoroughfares. Napier succeeds to Wellington, and Jenner to Napier; but it is still the same (plates 9, 10, 11).[30]

These criticisms are to a certain extent borne out if one examines journalistic coverage of sculpture at that time. To take as examples passages that do more than simply state subject, place and artist, from Edinburgh we read:

> A full-length statue in marble of the late Lord Justice-General Boyle has just been completed by Mr. Steell. It is to be placed in the Parliament House, which, it is understood, will be done by the time the Court meets. This, we think, is the best full-length statue which Mr. Steell has yet produced. There were fewer finer looking men than the late Justice-General, and his intrepid spirit found fitting expression in

9. George Gamon Adams, *General Napier*, 1856. London, Trafalgar Square.

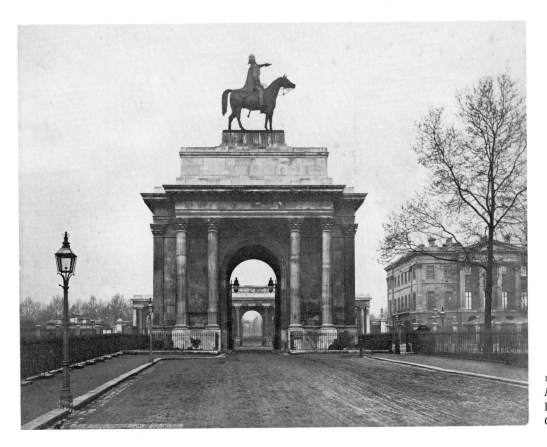

10. Matthew Cotes Wyatt, *The Duke of Wellington*, 1846. Formerly London, Hyde Park Corner.

his gallant bearing and physical energy of deportment. These characteristics the sculptor has seized with no gloved hand, and, as a comparative anatomist can describe an extinct animal from inspection of a single tooth, so were the present statue covered up with the exception of the left limb, anyone acquainted with the energetic *physique* of the late Justice-General would, from inspection of that member alone, be able to form a shrewd guess as to the identity of the statue. His Lordship is represented as seated on the bench in his official robes, with his note-book before him, and a pen in his hand. His head is turned as if looking to a speaker, or, it may be, addressing a jury. His fine countenance and animated expression are admirably rendered, and the whole figure is replete with masculine energy and dignity. In striking individuality and truth of expression, it reminds us of Roubiliac's statue of President Forbes, though in breadth and grandeur of style it much excels that very able, though somewhat finical work.[31]

Then again, back in London:

The statue of Jenner (plate 11) is not a bad one, but it is entirely out of place. Surely a more appropriate site could be found for the commemoration of one of the benefactors of the human race. The statue of Sir Charles Napier (plate 9) is so bad that it ought to be put anywhere but in the prominent position where it is placed on trial. We do not like this system of placing great stone memorials upon trial. It is so difficult to get them removed. The statue of the Duke of Wellington on the arch in Piccadilly (plate 10) was the ugliest thing in London, until the Guards' memorial was erected in Waterloo-place (plate 12). And yet the respect felt for 'the Duke' and for the valiant warriors who defended the flag of England through the military campaigns of the Crimea, will probably keep these two prominent deformities of modern London where they are.[32]

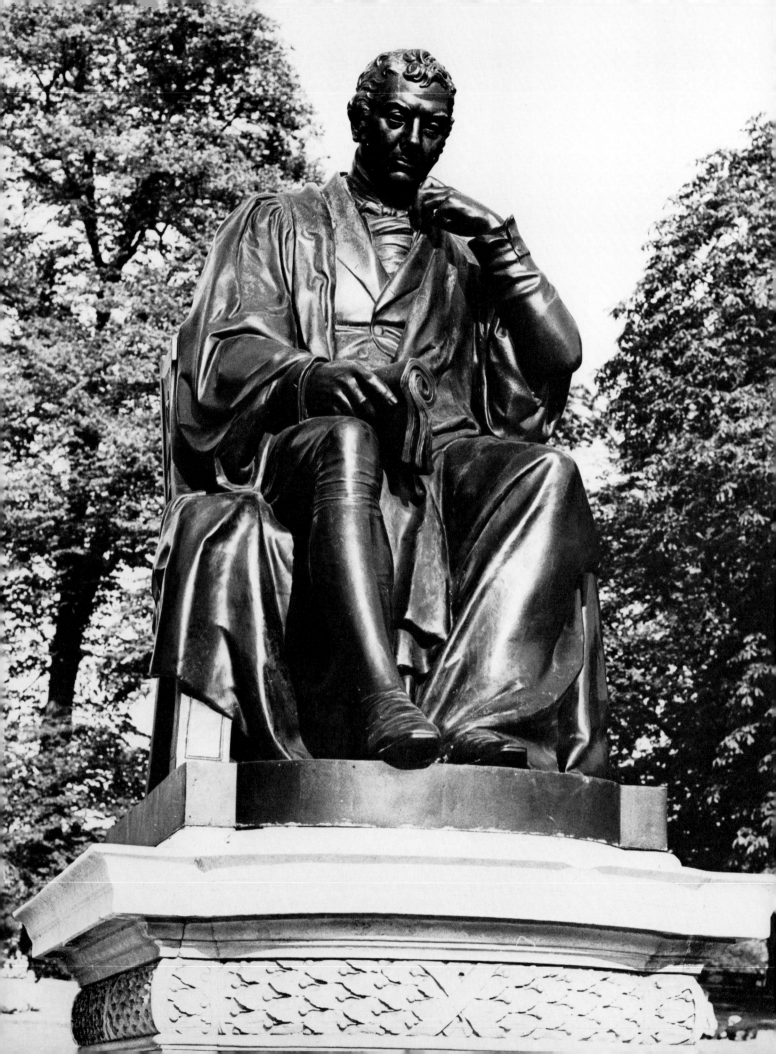

Coverage could be much fuller. The *Dundee Advertiser* for 27 September 1859 devoted some twenty-seven column inches to the inauguration alone of the statue of Joseph Hume M.P. in Montrose, giving details of what the statue was like, what the weather was like, the size of the crowd and seemingly verbatim reports of the speeches made at the occasion. *The Times* in London was pre-eminent among the daily press for its fairly comprehensive coverage of sculpture and related issues. This could sometimes be particular and in depth: it gave thirteen column inches on 2 November 1860 to Marochetti's *Coeur de Lion*, set up in Old Palace Yard by the Houses of Parliament (colour plate I): '. . . another equestrian statue which deserves to take rank with the few great statues of that class in Europe. . . . The designer of this Richard may, without presumption, claim for this work a place by the side of the terrible Bartolommeo Colleoni of Verocchio, or the statelier, if less living, Gattamelata of Donatello.' On a more general level *The Times* commented that: 'Doubtless the low state of the sculptor's art in this country, and the many failures which are conspicuous in our streets, have tended to cause a preference for a school or a hospital over an obelisk, a column or a statue. But surely the world is not so poor in genius that Art cannot be trusted to commemorate one whose life was devoted to its cause?'[33]

This called forth a response from the *Art Journal*:

> It is, indeed, deeply to be lamented, when the most powerful organ in Europe—the most effectual advocate for Right or for Wrong—gives currency to an opinion so utterly opposed to fact. There are no sculptors in 'the world' so truly great as are those of Great Britain. They are so considered abroad—if there be a determination to ignore their merit at home. Who in Italy will compare with Gibson—to say nothing of others there as yet less known to fame? And what artist of France or Germany has produced works more indubitably excellent than the Hardinge (plate 3), the Falkland (plate 80, actually by John Bell), or the 'Boy at a Stream' (plate 20) by John Foley, or the 'Eve', and the 'Pensive Thought' by MacDowell—the list might be largely augmented. Let the *Times* wait until the Exhibition of 1862 opens—provided, that is to say, our sculptors obtain fair play, which, if the arbitrators are pre-resolved, like the writer of the article we have quoted, they will not have—and the folly and cruelty of that article will be apparent to all.[34]

12. John Bell, detail from the Guards' Crimean War Memorial, 1860. London, Waterloo Place.

Now the *Art Journal* was by far the most consistent, regular and serious published commentator on sculptural affairs. It not only published frequent short entries of the subject of statue–artist–location variety but it followed through major schemes (e.g. the City of London Mansion House scheme[35]—see below, p. 206) and above all fitted these references into a wider picture of the British School of Sculpture. The whole question of a memorial to Prince Albert (plate 95) which had initially called forth *The Times*'s gloomy comment produced later from the *Art Journal*: 'This will be the most glorious opportunity for British sculptors to show what they can really do.'[36] Three years earlier it had reported:

> *British Sculpture*—There is a prospect that British sculpture will, at length, obtain the consideration and the position to which it is undoubtedly entitled. His Royal Highness the Prince Consort recently received a number of leading members of the profession, with a view to ascertain the requirements of the art in England: the immediate purpose being, we believe, the placing a series of statues in the grounds of the Horticultural Gardens: but having for its object a means of properly exhibiting the works that are annually produced in Great Britain, but which are rarely seen except by those by whom they are commissioned. We are not as yet in a position to make a more minute report: but it will be our duty to watch future proceedings—with anxiety, but also with confidence in the issue.[37]

11 (facing page). William Calder Marshall, *Dr Jenner*, 1858. London, Kensington Gardens.

13. Thomas Woolner, *George Dawson*, 1880. Birmingham, Municipal Works Store.

This wholesale backing of the British School of Sculpture was clearly very much a personal editorial direction by S. C. Hall;[38] when reflecting on the changed state of sculpture in England over thirty years (this was in 1874), Hall was justly not averse to mentioning the part he and the *Art Journal* played in this; for instance, by publishing engravings of statuary, and by drawing the attention of 'Art-patrons' to particular artists of merit.[39] It should be observed, though, that interest in sculpture was not sufficient to maintain the existence of the *Sculptors Journal and Fine Art Magazine* for longer than three numbers in 1863. And if one were to say that the most sustained periodical coverage of sculpture after the *Art Journal* was that provided by *Punch* and the *Builder*, granted the particular nature of each's viewpoint, this comment speaks for itself.

The effect of what was demonstrably extensive and varied criticism of contemporary sculpture in the press is difficult to judge. It would be tempting to believe that the *Art Journal*'s description of George Gamon Adams's statue of General Napier in Trafalgar Square (plate 9) as 'perhaps the worst piece of sculpture in England'[40] was what persuaded another sculptor, John Adams, to change his name to John Adams-Acton, though this did not happen until 1869. We are told that he did this 'in order more effectually to identify himself and his sculpture';[41] and George Gamon Adams seems generally to have been the recipient of much critical obloquy—the Rossetti passage cited above specifies the Napier statue as one of the 'guys and bugbears of our thoroughfares'. (Perhaps, though, John Wood (1839–86) did add 'Warrington' to his name for this reason: an alternative John Wood (1801–70) is known from works at Nottingham Art Gallery.)

But of the newspapers' 'guys and bugbears of our thoroughfares' that William Michael Rossetti mentions specifically, while G. G. Adams's *Napier* is still in Trafalgar Square, the *Jenner* (by William Calder Marshall) (plate 11) was moved from Trafalgar Square (adjacent to the College of Physicians) to the Water Gardens off Bayswater Road in 1862, and the *Wellington* (by Matthew Cotes Wyatt) (plate 10) was moved from the top of Constitution Hill to Caesar's Camp, near Aldershot, in 1883. Another reference has it that Woolner's *George Dawson* in Birmingham 'was so ludicrously bad that after the deceased's fellow-townsmen had laughed at it for several years they agreed to take it down'.[42] Certainly Woolner's statue was replaced by another by F. J. Williamson which stood under an ornate Gothic canopy in Chamberlain Square, Birmingham until 1951. Of this, only the head and shoulders seem to have survived, and are now in Small Heath Park. The Woolner was set up for a time in the entrance hall of the Central Reference Library, Ratcliffe Place and, ironically in view of what happened to the Williamson replacement, it still survives, intact, in the Public Works Department Store.[43] It is not one of Woolner's successes, but in mitigation it seems that the statue was made from pictures and photographs (plate 13).

All this was, however, coverage of sculpture at a fairly basic and strictly ephemeral level. At another level there was much more seriously thought out consideration in print. Early in the Victorian period, in association with the Royal Commission set up to encourage the Fine Arts during the rebuilding of the Palace of Westminster, a paper on sculpture by the Secretary of the Royal Commission, Sir Charles Eastlake, was published as an appendix to one of the Commissioners' Reports (Third Report, 1844). When some of Eastlake's essays were republished in book form in 1848,[44] the paper on sculpture was included, with another on bas-reliefs which had originally appeared in *The Penny Cyclopaedia*. These essays are somewhat academic in the best and worst senses—best in that they are clearly defined and set out, worst in that their deliberate lack of particular reference makes them a bit dry. They are also theoretical, which is not surprising, as that is the way treatises tend to turn out both by their nature as theoretical excursuses and by the particular conventions of art writing at the time. But it should be noted that Eastlake's experience of sculpture was not wholly theoretical; he provided the design for the

sculpture in the pediment of the Fitzwilliam Museum, Cambridge in 1837 and supervised its execution (by William Grinsell Nicholl) and installation in June 1840.[45]

To paraphrase Eastlake, the more obvious determining factors in sculpture are 'the necessity of beauty in an art which can conceal nothing'; arising from this is 'the necessity of balancing the mere weight, and the degree of symmetry in composition'. That is, the first necessity imposes certain limitations which make the resulting requisites all the more necessary. And then also determining are those 'general principles (applicable to all the arts of design) of proportion, breadth, gradation of quantities, and contrast'.[46] Sculpture is, of its nature as an art, restricted. Because it has, strictly speaking, but one style, the selection and treatment of subjects is limited.[47] All imitation will be relative because its main object is flesh which cannot be reproduced in marble absolutely illusionistically; moreover the use of marble to represent flesh is a convention and this governs the main focus of a work. Therefore the other parts (such as drapery) must be according to convention also, since they are subordinate to the main focus. Accessories must thus be treated in a merely relative manner.[48] But here another limiting but determining factor from which sculpture suffers comes into play—the principle that 'in proportion as the means of representation become circumscribed the imitation of inanimate objects becomes less satisfactory'. Sculpture can imitate the substance and form of objects, but not their colour. This is not because it is impossible but because the end of genuine illusion would be defeated by the attempt.[49] Colour might deceive the spectator for a moment, but he would then discover that life and motion were wanting, that the art has limitations, and his illusions would be destroyed. The question of colour in sculpture affects both animate and inanimate objects, flesh and accessories; and this was a topic regularly aired throughout the century, sometimes with reference to the Ancients and whether they coloured their sculpture, but also with reference to contemporary practice (see below, pp. 25, 174).

Eastlake's constant point of reference in his discussion of sculpture is the art of Antiquity. As far as sculpture is concerned, the practice of the Ancients is equivalent to the High Style in painting as something to look up to. Such respect needs to be qualified—'it is too certain that modern habits and associations may often render it impossible to conform to the example'.[50] There are particular difficulties in some areas of modern sculpture, such as military dress. The whiteness and smoothness of leather belts, the polish, hardness and sharpness of metal come across well in marble, but flesh does not: 'the flesh, however finished, looks petrified and colourless, for objects of very inferior importance, even to the buttons, are much nearer to nature'. And there are problems with London: 'As the details of statues, whether of marble or of bronze, become indistinct at a moderate distance, and especially in the atmosphere of London, it is essential that their general outline should be intelligible.'[51] (This is a point of view that should be remembered in these post-Clean-Air-Act days.) Eastlake seems happy to admit that his posited ideal of excellence in Antiquity for the specific style of sculpture is not a *sine qua non*: 'great excellencies may exist where this style is not rigidly adhered to', and he proceeds to specify Giovanni da Bologna's *Rape of the Sabines* as an example.[52] Elsewhere in his arguments he features Italian Renaissance and seventeenth-century works and artists, French seventeenth- and eighteenth-century artists, and, from times nearer his own, Canova and Flaxman.[53] While these are not all necessarily mentioned 'without prejudice', Eastlake does show a considerable breadth of knowledge and sympathy towards non-Antique sculpture; this accords with Lady Eastlake's more general claim for him: 'With all his peculiar refinement of taste he was too large and sound in his feeling for art to exclude or undervalue *any* form of excellence. And we must remember that this true catholicity was a thing unheard of then. . . .'[54]

The Professors of Sculpture at the Royal Academy during the Victorian period should

have made serious contributions to sculptural thinking: but Sir Richard Westmacott (in office 1827–56) seems to have retired from most professional duties about 1840; and although his son, Richard Westmacott junior, who succeeded him in 1857 and held office until 1869, lectured and wrote extensively on sculpture, his writings are as 'competent, though uninspired' as Gunnis describes his monumental sculpture.[55] It is really only with Henry Weekes (Professor from 1869 to 1877) that a significant corpus was published as *Lectures on Art* in 1880.

A surprising aspect of the *Lectures* is the humour:

> You have in your Antique Academy a cast of a statue alluded to by Pliny which appears to me . . . of exquisite Beauty, yet not wholly devoid in its proportions of individuality. It is supposed to represent, and has been designated as the Runner, from the length of the legs. Our jockeys study after a like fashion their favourite animal. They call what they admire, and what they seek to produce by breeding, the points of a horse; but it is much the same thing, Beauty and Utility combined: and by devoting what little brain they possess to the subject, they manage to obtain a fine animal, with elegance of form and power of action. This again, following the old custom, they perpetuate by a portrait when successful. They seem to be more earnest in their endeavours to obtain perfection on their ground than we sculptors are on ours, for these portraits come so completely up to their standard of excellence that there appears to me no difference between any of them. Individuality seems lost or absorbed in that ideality of which they are such enthusiastic advocates. I have heard of a painter of race-horse portraits, who could give a likeness of a Derby winner without ever seeing the animal at all, and who only required to be informed of his colour and of how many white fetlocks he had, if any; perhaps, too, he had to ascertain whether there was a spot in the middle of his forehead,—of the horse I mean.[56]

Weekes goes on to write of the train—of thought—that is left to proceed over the different points to the end of its journey, by its own impetus, and he continues: 'Mine, however, is a more responsible [task], for though travelling on a loop-line, and on a narrower gauge, Style in sculpture, I have to accompany, if not guide, you, past the different stations, to the terminus from whence you alight, and go each your own road to your final destination.'[57]

Weekes is, however, seriously concerned with the state of sculpture, both generally in that as an art it is limited and can never be popular,[58] and specifically at the Academy itself where he is aware that it receives little encouragement.[59] The first half of his lectures deal with topics such as Composition, Beauty, Taste, Style, Idealism and Realism in Sculpture, Colour in Sculpture, Education and Portraiture. (The second half is mainly an historical survey.) For beauty in sculpture, avoid affectation and keep things simple.[60] Don't enforce artificial rules, yet don't let the imagination run riot.[61] A crucial problem, as Weekes sees it, is the reconciliation of idealism and realism.[62] Idealising is abstracting from Nature: 'the abstract of Nature is, in fact, the essence of the abstract Art, Sculpture'.[63] But reality is necessary for us to 'identify'; moreover the Ideal has changed, or is less poetic than of old, Science has come and shifted people's Ideal focus,[64] Antiquity is to some extent no longer sufficient. On a practical level, Weekes deals with the use of drapery,[65] and the effects and uses of marble and bronze,[66] and he describes the best practical method of carrying out a portrait bust.[67]

Weekes questioned the effectiveness of his lectures as he gave them: 'practical instruction can be carried on in the schools only, with the modelling-tool in hand, and the clay to operate upon';[68] and one certainly wonders how many people read them to any effect. Nevertheless they are the most consistent and intelligent exposition of sculptural

thinking in the Victorian era and, as far as published material goes, exceptional if not unique.

Weekes's successor as Professor of Sculpture was Thomas Woolner, but he held the position for only two years before resigning in 1879. He never gave any lectures, and used to say he was the best professor there ever was, for he only professed and never practised. He did in fact prepare three lectures; we are told they were technical affairs, suitable for students: an Introduction, 'Conception' and 'Finishing'.[69] But they were never delivered and certainly never published, Woolner being unable (or probably unwilling) to give the time to finish the series and compose the required number.

But in his long poem *Pygmalion*, published (in twelve books) in 1881, Woolner writes at one remove and at some length on sculptural themes—inevitably really, as Pygmalion was a sculptor. Sculpture is 'the Gods' own language',[70] a 'High, difficult, and stern, laborious art'.[71] Pygmalion uses clay for modelling and appears to be working in marble directly.[72] But his main concern initially is with modelling a statue of the goddess Hebe, and with the relationship between the image that is formed and its resemblance to its original model Ianthe. As Calliope, one of the beautiful young maidens who surround him, says: 'that's Ianthe the model, why call it Hebe?'[73] It would seem there was a problem here about reconciling Idealism and Realism. In the later books there are problems with the statue makers

> disconcerted by unseemly fears
> Their markets may be broken up and closed
> Should this new art of making statues live
> Kindle the people to demand of them
> Like statues they would dread to undertake.[74]

and with the archaisers:

> . . . for Daedalus
> They hold is far too free; his statues have
> Too much of motion for archaic truth;
> The only truth select ones care to know.[75]

These are in a way artistic problems become social too. The climax comes with the attempted murder of Pygmalion (the new realist) by some Archaic statue-makers, but they are not successful. There are other, non-artistic themes in the poem, and Pygmalion ends up as King of Cyprus. Woolner wrote to Gladstone: 'The subject, "Pygmalion", has not been understood as an artist understands it, and I hope I have succeeded in making the story intelligible.'[76]

After Woolner's resignation, the post of Professor of Sculpture was not filled again until the appointment of Alfred Gilbert in 1900. It is possible that the new President of the Academy, Frederic Leighton, considered he was himself as capable as anyone of talking to the point on the subject. Moreover the teaching of sculpture at the Academy was greatly enhanced by the appointment of Hamo Thornycroft to a teaching position in the Royal Academy Schools in 1882; as both Weekes and Woolner had held that for sculpture practical tuition was the only answer, it may well have been thought this was the best solution.

Between the pronouncements of the press on the one hand and the Professors of Sculpture at the Royal Academy on the other (in whatever form), and passing over the extraordinary and idiosyncratic statements in print of John Bell,[77] there was a body of published sculptural criticism by William Michael Rossetti and Francis Turner Palgrave. This occupies a rather special position: it was journalistic in origin, appearing in, for example, *Fraser's Magazine* and the *Saturday Review*, particularly between 1861 and 1865;

these were however serious, intellectual journals rather than either daily organs or specialist artistic publications. In addition, these few years were a time of heightened sculptural activity, with the memorialisation of Prince Albert, who died in 1861, the founding in 1861 of the professional body the Institute of Sculptors, the inclusion of sculpture at the 1862 International Exhibition, and the prominent featuring of sculpture and its attendant problems in the Evidence given to the Royal Commission of Enquiry into the Royal Academy of 1863.

William Michael Rossetti's contribution was *British Sculpture, its Condition and Prospects*, which originally appeared in 1861 in *Fraser's Magazine* and was reprinted in 1867 in the collection of Rossetti's art criticisms *Fine Art, Chiefly Contemporary: Notices Reprinted with Revisions*.[78] He reports the condition of British sculpture as being poor: its divorce from architecture makes it lose half its power, its audience is limited, the general public indifferent;[79] sculpture, in any case a laborious and expensive art, lacks adequate provision for proper exhibiting and the sculptor is limited in his choice of subject by both the natural and the conventional rules of his art—'he plays a losing game in the teeth of neglect'.[80]

For Rossetti, the right object and end of sculpture is Form: true form invariably and beautiful form as the rule.[81] The human form is at once the noblest and most beautiful, offering the highest range of subject and eliciting the greatest intellect in the sculptor; so the human form must be the staple of sculpture.[82] The sculptural requirements of the modern age must be reconciled with this, if sculpture is to flourish, but there is no real problem here: 'The modern ideal is expression and character',[83] and there is plenty of scope for this in portraiture, national character—'the rendering of whatever is beautiful, suggestive, and sculpturally available, in the character, type, costume, employments, or intellectual purposes, of the various nations of the earth'—and ideal inventions.[84] Rossetti's verdict on living sculptors and their ability to fulfill these requirements is basically 'no comment'. Exceptions are made of John Gibson and John Foley: the latter's portrait-works 'are sometimes of a very high standard'.[85] And then there is Woolner: 'In portraiture, we are not acquainted with any recent works which, for consummate study and art, for life and power, can stand beside his.'[86] And the side groups of Woolner's project for a memorial to Wordsworth are amply sufficient to indicate their sculptor's faculty of ideal invention.[87]

Francis Turner Palgrave's sculptural criticism began in style. He was commissioned to write both the *Introduction* to the Sculpture section, British Division, of the Official Catalogue of the Fine Art Department at the International Exhibition of 1862 and the *Handbook* to the Fine Art Collections at the same. The *Introduction* is a slightly more formal essay: beginning with the words, 'Sculpture, the forlorn hope of modern art'[88] he proceeds to give a careful, historically-determined and reasoned account for this; the principles he expounds are backed, where necessary, in general terms by reference to the history of European sculpture.

No art can less afford to decline from the highest standard than the art which is summed up in this one quality—simple earnestness. Thus, when decoration or falsehood are sought instead, true sculpture, and with this delicacy and refinement, become impossible. Public taste, reacting on the artist, now fulfils the second law of degeneracy. No longer educated by models of excellence, what sculpture can do in her glory is soon forgotten, with hardly less completeness than if she were numbered amongst the arts confessedly lost from the fields of human achievement. Neither energy in the figure or meaning in the group, neither vitality in the surface or truth in the drapery, are longer looked for or missed: the dulled perception, and uneducated apathetic eye, would hardly recognize them if present. The sculptor

follows the fashion by which his labour and his gains are so much facilitated; and soon a barbarous slovenliness, varied from time to time by some new phase of false elaboration, or meretricious pedantry, sets in, and the Athéné of Phidias is succeeded by the Icons of Byzantium.[89]

Palgrave devotes the last part of his *Introduction* to considering sculpture of the last hundred years: this because the collection of works exhibited included a section of fifty works by deceased artists (out of a total in excess of 290 works) starting with Thomas Banks (1735–1805) and Joseph Nollekens (1737–1823). He has muted, qualified praise for Canova and Flaxman, and admits that there is some real excellence in English portrait sculpture in this period. Foley, Watson and Woolner are noted as artists 'who have boldly and consistently renewed the earlier and severer style',[90] and he then goes on to praise Woolner further in the words quoted earlier (p. 8) with reference to *Constance and Arthur*.

The sustained high tone of the *Introduction* was not continued in the section devoted to sculpture in the *Handbook*. Here Palgrave starts with some general theorising about the poor state of sculpture: it has no real hold on people; any popular sympathy is for mechanical trick or mechanical grandeur, for sensual polish or spasmodic distortion, for 'picturesque' sculpture, or the facetious, or 'sweetly pretty' style—everything, in short, which the Art should shun—not for deep or tender feeling, truth to nature, freshness of invention, refinement in handling, loftiness in aim—for those qualities, in a word, without which the block in the mountain side is far more living than the statue.[91]

He then gets down to detailed criticism and the naming of names: the 'empty extravagance' of Marochetti, the 'dead dullness' of Matthew Noble.[92] Then there is what he calls 'Degraded Poetry', the total emptiness of William Brodie's *Highland Mary* and *Dante*, Joseph Durham's *Child and Dog*, John Gibson's *Nymph*, John Lawlor's *Titania* and *Allegra*, Frederick Thrupp's toppling and proportionless *Hamadryads* and *Nymph*.

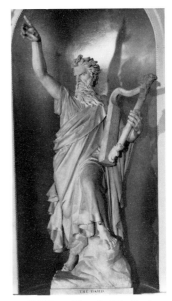

14. William Theed, *The Bard*, 1858. London, Mansion House.

Such poetical counterfeits as Munro's 'Child's Play' and 'Shell', Bell's 'Dorothea', and Theed's 'Bard' (plate 14) must, with regret, be exempted from silence by their positive and prominent failure. . . .[93] If it is unpleasant thus to criticize works that have no redeeming quality, I find it, perhaps, more so when we see traces of a little natural gift, which might have done us service if educated by study and directed by truth. But of what use is a feeling for prettiness, when wasted on such result as Munro's 'Child's Play', 'Maternal Joy', 'Child Asleep' and the like?—in which there is no limb physically possible, no surface rendered with any real modelling, the draperies obstinately untrue, the sentiment that of the Book of Beauty in marble? There is but one standard for Sculpture,—the look of the real thing. Think of a child's lithe limbs,—so delicate and yet so firm,—so mobile and so well balanced,—look at the 'Child's Play' or the 'Sound of the Shell',—and it will not need much examination to feel that these vague writhing forms have not even a good doll's likeness to human children. In the natural history of Sculpture, we must class them under *Mollusca*, not *Vertebrata*. I wish the details redeemed the misfortune of the design; but here again, beside the pretty finery of ornament and foolish parade of flowers, everything has, I know not whether to be learned, or to be unlearned,—so systematically are hands, eyes, lips, and feet slurred and misrepresented. Gaps, scratches, lumps and swellings here stand, alas! for the masterpieces of Nature's modelling; the eyes are squinting cavities, the toes inarticulate knobs; whilst the very dresses of the poor children,—in reality so full of charm and prettiness,—become clinging cerements of no nameable texture, and thrown into no possible folds. We should not have thought it worth while to scrutinize work of an ignorance so grotesque and babyish as all that we have ever seen by Munro with any detail, if it did not appeal in subject to popular interests, or

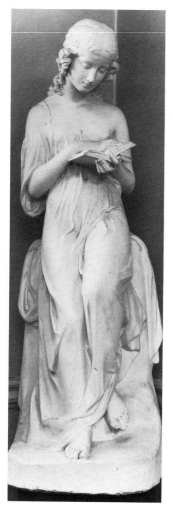

15. Patrick MacDowell, *A Girl Reading*, 1838. Dublin, Dublin Society.

if we had not some faint hope that,—arduous as are the steps from 'Child's Play' in marble to art,—the author of these works may retrieve himself by recommencing his art before it is too late . . .'[94]

Some works did win Palgrave's approval: Foley's *Caractacus*, Patrick MacDowell's *A Girl Reading* (plate 15), E. G. Papworth's *The Young Shrimper*. And Woolner's *Love* 'with a charm and individuality of character rarely given in statues of this class, shows the artist's perfect mastery over truth of surface and sweetness of line. The execution also is uncommonly tender and conscientious.'[95] Portraiture too he found to be, as a branch of sculpture, quite lively, and he praised the work of Foley and Woolner in particular.

Over the next few years Palgrave wrote further on sculpture, both as part of Royal Academy reviews and in separate articles, for the *Saturday Review* and other periodicals. The general situation of sculpture was, he thought, poor: 'Our school has fallen lamentably low, and is the derision of foreigners; most of our sculptors display but little genius of knowledge; we have but one or two men of practised skill and original gift. . . .'[96] He singled out on more than one occasion[97] the ignorance in private patronage as a cause of the failure of British sculpture and the harmful effect this could have: 'Sculpture has . . . been hitherto, in comparison with painting, so little studied or understood by the mass of English spectators and patrons, that, in the most important sense, it may be said that no modern sculptor of ability has had a fair trial.' '. . . a few sculptors, obtaining a run often for no better reason than that they have gained a footing among the *coteries* of Rome, or found their way to some noble or mercantile patron, are literally overwhelmed with more commissions in a year than could be executed in a real style of art in twenty.'[98] Public patronage was no better, the committees making the decisions not being chosen for their artistic judgement.[99] Imperfect training of sculptors did not help,[100] nor the prevalence of conditions that militated against competent or even skilled artists making any headway.[101] The end result was the triumph of the school of Chantrey, 'the founder of that coarse and careless style in modelling and execution which . . . has gone far to destroy the credit of English sculpture on the continent.' Palgrave names Chantrey's followers— Matthew Noble, Henry Weekes, Marshall Wood, the two Messrs Adams (G. G. and J. 'Acton' presumably) and Patrick Macdowell.[102] This corrupt school of Chantrey with its slovenly mode of modelling and carving, was one of the three branches of bad sculpture. The others were the Too Imitative school, whether of Antique or modern dress and subjects, in which all classes of work were marked by clumsiness and immobility; and the Picturesque school, bad copyists of modern French or Italian style, non-sculptural, decadent, and 'characterized by theatrical showiness, spasmodic action, and slovenly pretence'.[103]

In his Royal Academy reviews in particular, Palgrave could get down to details. Of *Mr Marshall* (R.A. 1863) he wrote:

Here, as in M. Marochetti's heads generally, the features are made to tell, not by truth or subtlety of surface, but by suppressing all minor details in favour of those points which first strike the eye, and then by opposing to the flesh a coarse and heavily-handled mass of drapery. The drab-coloured surface, the marking of the eyes, the colour thrown in here and there, are all ingenious tricks of the same kind: expedients for concealing the absence of the ever-recurring necessities of sculpture— mastery over form, insight into character, and power to put them into marble.[104]

On Henry Weekes's *Dr Hunter* (plate 16) (R.A. 1864) he wrote:

A theatrical attitude and scowling expression replace the rapt concentration of the original; whilst (where this aid was less available) the modelling of the legs is inaccurate and tasteless: they are like poor Lord Clive's (plate 17), whom

20

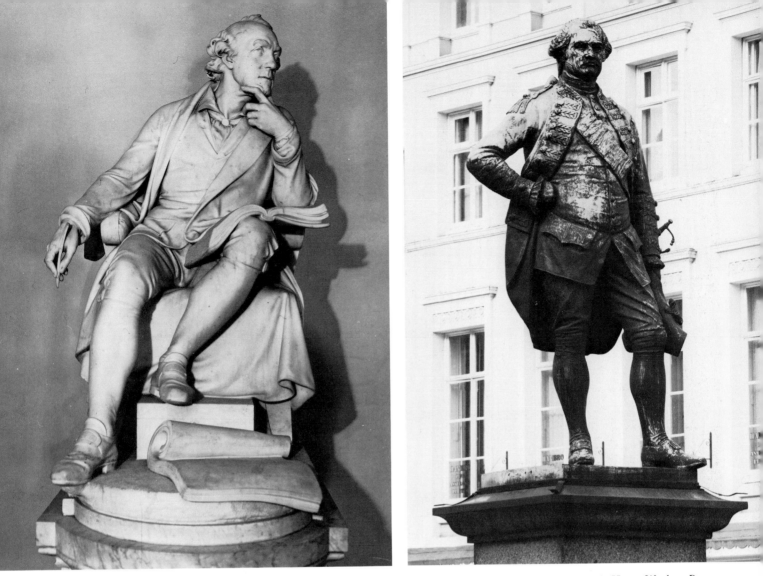

Marochetti has put on his pedestal at Shrewsbury, in the attitude of a gentleman performing an eternal *pas seul* before all the market-women of the city.[105]

And in 1865 he was still on at Alexander Munro, picking on his *Violet and Henry* (R.A. 1865) 'where the limbs and faces are so shapeless and boneless that the group looks as if it were already decomposing, in Tennyson's phrase, "into lower forms". The artist appears bent upon sacrificing the sense of grace which was a redeeming point in his earlier works.'[106] These are only three among the artists whom Palgrave pilloried.

Palgrave did however state what he saw to be the elements necessary for success in sculpture. Firstly there was Imagination, that is, force of intellect and of feeling, and the power of poetical invention. Secondly there was power of Characterization, the former gifts directed into distinctive interest in living human creatures. Thirdly there was Knowledge of Form: mastery of the mysteries of curve and plane, truthfulness in surface, special adaptations and conventions required by sculpture, in addition to a sense of beauty in general outline, light and shade in mass. The fourth necessity was Executive Faculty, that is the technical competence to translate these virtues into marble and bronze.[107] And Palgrave was not averse to naming those whom he counted among the elect, especially William Behnes (though not without some reservations) and some of those who had been through his studio, particularly Musgrave Lewthwaite Watson, Timothy Butler, John Henry Foley and Thomas Woolner.[108]

With these exceptions, the general picture was poor: 'The present time will probably be looked on in future years as the *nadir* of English sculpture. . . .'[109] Not that this was for

want of effort, as Palgrave described in terms of subtle, derisive irony unmatched certainly in criticism of Victorian sculpture and possibly in English nineteenth-century art criticism overall:

> More money than ever, it is credibly stated, is now in course of expenditure upon marble-chipping and smoothing; and artists of the calibre of Mr. Bell and Mr. Philip rival Phidias in the size and importance, at any rate, of the work they are executing for an Albert Memorial (plates 97, 103), being hence unable—witness also Mr. Theed (plate 100) and Baron Marochetti—to contribute their common quota of masterpieces to the Academy. And yet, in fact, we all know, and sadly have to confess it,—nobody believes in or cares for English sculpture, except the prosperous few who fall thus within range of the genial shower which, if it cannot transmute ignorance into artistic skill, performs at least the more tangible metamorphosis by which bronze refines into gold, and bank-notes freely form themselves upon the surface of the marble.[110]

It is interesting to note with regard to the distinctive views on sculpture of both Palgrave and Rossetti their common though dissimilar connexions with the Pre-Raphaelite movement. William Michael Rossetti was of course one of the founding Brothers, while in Palgrave's biography it is claimed of him that 'he had been much connected with the spread of Pre-Raphaelitism, and was an ardent admirer of that school'.[111] This could explain their common views on, say, the necessity of natural expression to effective sculpture, particularly in portraiture reflective of character, an artistic criterion that would not be out of place in Pre-Raphaelite thinking.[112] Both, too, deplore the divorce of sculpture from architecture; and this reflects a concern for an overall decorative function in art that can be found in the second, later phase of Pre-Raphaelitism associated with Dante Gabriel Rossetti, Morris, Burne-Jones and others.

Not only did sculpture feature in the early days of the Pre-Raphaelite Brotherhood proper, as is apparent from the *Journal* kept by William Michael Rossetti, but much was concerned with Thomas Woolner specifically, who was a friend of both Palgrave and William Michael. He was on 'Dear William' terms in his correspondence with William Michael Rossetti in 1857[113] and later William Michael praised Woolner's *Whewell* in uncompromising terms. Palgrave was actually living at Woolner's studio at the time of the publication of the 1862 *Handbook* in which he praised Woolner to the detriment of Munro, an associate of Dante Gabriel Rossetti's, and this not unnaturally caused a rumpus. Strong objections to Palgrave's treatment of Marochetti and Munro were voiced in the correspondence columns of *The Times* on 15 May 1862; on the following day, the news about his sharing a house with Woolner appeared in the same columns, as well as a joint letter from Calder Marshall, Woodington and E. B. Stephens objecting to the sale of the *Handbook* under the Exhibition's Commissioners' sanction. Palgrave and Woolner both replied with letters on 17 May, Palgrave saying that the point at issue was whether he had told the truth, and that the cohabitation issue was irrelevant; Woolner wrote that ever since he had known Palgrave was to do the *Handbook* he had refrained from discussing sculpture with him. Finally, on 19 May, the correspondent who had originally spilled the beans wrote insisting that Palgrave's views on sculpture must be Woolner's; Millais and Watts together wrote that whatever Palgrave's qualifications as a critic, an official catalogue should not contain any individual opinion; this was in effect answered by another letter from Palgrave pointing out that he had resigned the official sanction for the *Handbook*; while Holman Hunt wrote that Palgrave and Woolner had only been sharing a house for two months, that either's knowledge and experience of sculpture was of much longer standing, and that Palgrave's views on sculpture were absolutely right.

The end result was an emended Second Edition of the *Handbook*. And while the

Colour Plate I. Baron Carlo Marochetti, *Richard Coeur de Lion* (bronze), erected 1860. London, Old Palace Yard.

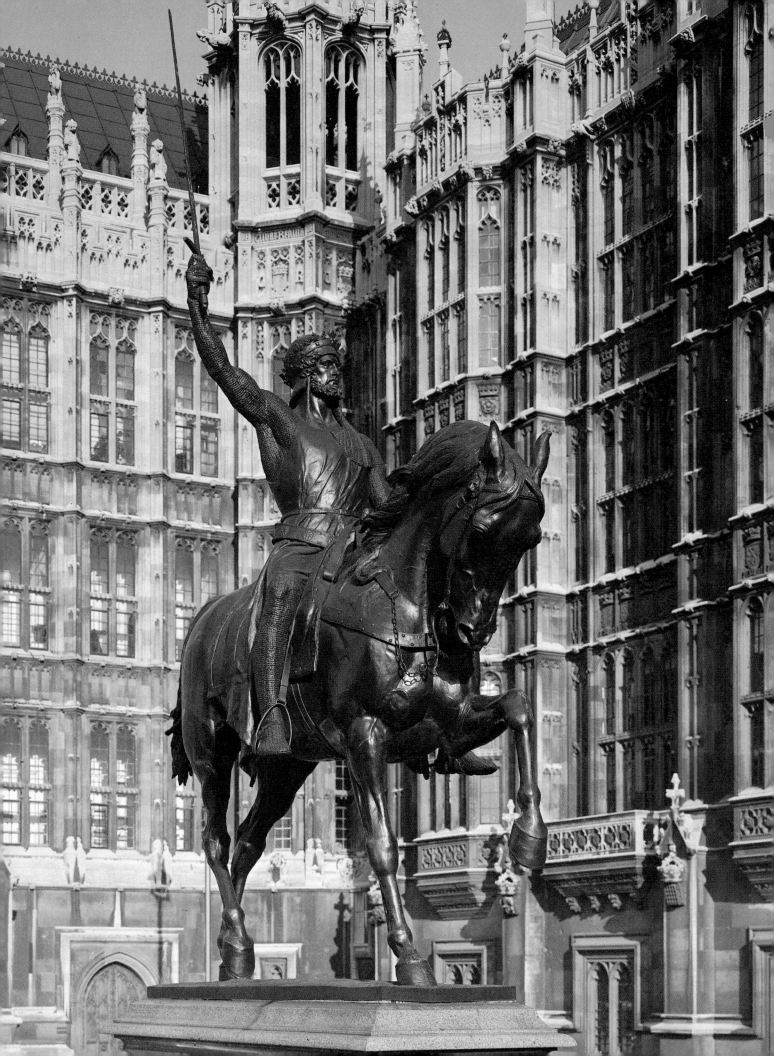

vehemence of Palgrave's views on sculpture was characteristic of the man's opinions overall ('. . . he was never afraid to denounce meanness, selfishness, or lack of truth in any form. His unswerving courage of opinion, often expressed with great fervour and vehemence, led some to fear his righteous indignation, and others to consider him harsh and hypercritical'),[114] this was the expression of a temperament very similar to Woolner's—'In life, as in art, he was the uncompromising foe of shams, of claptrap, and of superficiality.'[115] And when Palgrave denounces a studio practice ('Very few . . . since the system of manufacturing for effect was established by Chantrey, have been thorough masters in finishing the marble. Some well-known artists hardly even attempt it'),[116] it is hard not to catch an echo of Woolner on Matthew Noble: '. . . a person who never touches the work that goes under his name.—This is true, for I know the sculptors who do his work.'[117]

The question of whether there was or indeed could be such a thing as Pre-Raphaelite sculpture will be investigated at some length later (see pp. 179–86), and it would certainly be excessive to claim that the views of William Michael Rossetti and Francis Turner Palgrave on sculpture were specifically Pre-Raphaelite. But it is possible to see in them perhaps some reflexion of that artistic penumbra, conceivably developed in conjunction with the Pre-Raphaelite Brother who was subsequently to become Professor of Sculpture at the Royal Academy.

CHAPTER TWO

'Here today, gone tomorrow'

Palgrave's writings should warn us that there may be more to Victorian sculpture than meets the (present-day) eye. The strength of his views both for and against the work he considered implies some variety, and the fact that his criticism is the cynosure of an extensive literature should lead us to infer the existence of an extensive, active industry. It then becomes reasonable to ask what has actually happened to the works that Palgrave and the other critics and reporters had before their eyes, let alone what were the fuller circumstances from which the works sprang, to which these writings refer.

The International Exhibition of 1862, which first occasioned Palgrave's sculptural criticism, included a major international display of the British School of Sculpture. Yet of the over 290 works exhibited, only a few are at all accessible now. This must obviously have a bearing on how we regard them; moreover, the circumstances under which they were then shown and the subsequent history of such works as can still be traced are extremely revealing as to the whole nature of the present day relation to Victorian sculpture.

Woolner's *Constance and Arthur*, as we have seen, is today located above the grave of its subjects in a municipal cemetery. Another survival is the *Tinted Venus* by John Gibson (colour plate II). This was a major work by a major artist, a formal demonstration by the period's leading neo-classical sculptor of his belief that the Greeks painted their statuary, and it was shown at the Exhibition in a setting specially designed by Owen Jones for it and other tinted statues by Gibson: 'a beautiful Greek temple, simple, chaste, in consonance with the statuary and to set them off'.[1] Some difference of opinion was aroused. In its obituary of Gibson less than four years after this major manifestation of the work, the *Athenaeum* wrote of it as: '. . . the most fortunate of our subject's productions . . . the figure is the best of those he made, not only as regards execution, but in being most sincerely conceived. As representing a naked, impudent English woman, it is excellent in its way, but in no respect a Venus, simply because, although almost as meretricious as the 'Venus de Medicis', there is enough vulgarity in it to destroy all alluring power, and every sign of the goddess.'[2] Gibson's position was: 'The statue must be coloured with delicacy and taste—a conventional effect—not that of a living being. So done it has a new charm, but the beholder must have feeling for the beautiful to enjoy it.'[3] One may object to the waxy texture given to the flesh, one may have reservations about the effect of the colouring which may in any case have been tampered with since the work left Gibson's hands; but then one should remember with respect the strength and sincerity of Gibson's views, and pay perhaps particular attention to his caution that 'the beholder must have feeling for the beautiful to enjoy it', since so often in Victorian art the novelty of the effect the work produces on sensibilities otherwise trained may not be as reliable a basis for judgement as prolonged familiarity.

Whether the work is as effective as that eponymous tribute by Frank Anstey would

require, readers of *The Tinted Venus* (1885) must decide for themselves. Subtitled *A Farcical Romance*, this is the myth of Pygmalion retold with a vengeance: a statue of Venus brought to life and pursuing Leander Tweddle, a young hairdresser in London, who had jokingly placed a ring on the statue. She tells him his suit is accepted, to his considerable dismay; for he had seen the operas of *Don Giovanni* and *Zampa* and knew that any familiarity with statuary was likely to have unpleasant consequences.[4] Various escapades follow, and a temporary compromise is arrived at whereby she only comes to life after dark. But this is all to Tweddle's immense discomfort:

> 'If she was only a little more like other people, I shouldn't mind so much; but it's more than I can bear to have to go about with a tablow vivant or a pose plastique on my arm!'
>
> All at once he started to his feet. 'I've got it!' he cried, and went downstairs to his laboratory, to reappear with some camel-hair brushes, grease-paints, and a selection from his less important discoveries in the science of cosmetics; namely, an 'eyebrow accentuator', a vase of 'Tweddle's Cream of Carnations' and 'Blondinelle Bloom', a china box of 'Conserve of Coral' for the lips, and one of his most expensive *chevelures*.
>
> He was trembling as he arranged them upon his table; not that he was aware of the enormity of the act he contemplated, but he was afraid the goddess might revisit the marble while he was engaged upon it.
>
> He furnished the blank eye-sockets with a pair of eyes, which, if not exactly artistic, at least supplied a want; he pencilled the eyebrows, laid on several coats of the 'Bloom', which he suffused cunningly with a tinge of carnation, and stained the pouting lips with his 'Conserve of Coral'.
>
> So far, perhaps, he had not violated the canons of art, and may even have restored to the image something of its pristine hues . . .'[5]

The resolution comes only when Tweddle persuades the goddess to let him have the vital gold ring, to have it assayed in a chemist's shop in the Gray's Inn Road.[6]

While the statue in its original condition was clearly not a simulacrum of Gibson's work, the last sentence of the passage quoted above could well refer to the controversy of which it was a part. And a similarity in effect between what the hairdresser's means and methods of tinting and the artist's techniques achieved cannot be wholly denied.

Though the work can be said to have been somewhere behind Anstey's entertaining fantasy, and though it was for some time *de rigueur* to discuss it in the literature of sculpture, after the 1862 exhibition it returned to its private owners and then, to all intents and purposes, disappeared. It changed hands in 1890 and 1916, and was only with some difficulty resurrected in 1962 after a public appeal over the radio.[7] When it came on the market again in 1971, the Walker Art Gallery at Liverpool, conscious of a responsibility to local artists (Gibson began his career in Liverpool), was able by good fortune to buy it, and the work is now installed at the branch gallery at Sudley, on the outskirts of the city. In this instance, a major work has returned to view, though only through the conscientiousness of a particular public collection.

As it happens, the *Tinted Venus* was one of the works reproduced photographically by the London Stereoscopic Company, 'sole photographers to The International Exhibition 1862', and this was the first exhibition in England in which sculpture was so recorded. Another of the works reproduced by the London Stereoscopic Company was *Lady Godiva* by John Thomas. This, an original model (a term more fully explained later—see pp. 55–6) and thus unique in its plaster form, is today in the Museum and Art Gallery at Maidstone in Kent, to which it was presented by the artist's widow.[8] It is a major work in the ideal, poetic class by an artist reputed to be Prince Albert's favourite sculptor, and an over-life-size statement of mid-Victorian nudity. Yet its survival in an inherently fragile

medium was haphazard: by chance it devolved directly from the immediate family of the artist to a public collection and even more fortuitously, as we shall see, it has there survived.

John Bell's *The Eagleslayer* (plate 19) in marble was another 1862 exhibit. It belonged then to the collection of Earl Fitzwilliam and is today still *in situ* in the former Fitzwilliam residence, Wentworth Woodhouse in the West Riding of Yorkshire.[9] In the context of exhibited works and their survival, this work must hold the record for the sheer persistence with which the artist sent it in one form or another to every sculptural *vernissage* of any significance over twenty-five years. If only for this reason it deserves to survive.

It had first appeared in plaster (presumably) at the Royal Academy of 1837, exhibit no. 1176 with the title of *The Eagleshooter* and part of an 'Ode, Anonymous', attached in explanation:

> A moment more the shaft is sped,
> With lightening speed and steady aim:
> A moment more the feathers red
> In the best blood the wretch can claim.

When first exhibited, works were nearly always in plaster or clay. The reasons for this relate to the whole career structure of a sculptor, which will be described in the next chapter, but the basic reason was financial: the cost of plaster or clay was much less than that of bronze or marble, and the artist would not normally be in a position to underwrite the greater expense of the more permanent materials. Indeed one of the functions of exhibiting an artistic idea in plaster was precisely to attract the patron who could afford a more durable version. Now if the Victorian art world had been full of rich patrons prepared to sink their wealth into marble or bronze, this would have been fine not only from the point of view of the artist's prosperity, but also from ours with regard to the work's survival in a more permanent medium. But in fact the Victorian art world was not in such a happy state, and one of the most persistent, plangent laments throughout the first fifty years of Victoria's reign was the lack of such enlightened patronage. We must therefore bear in mind when scanning, say, the lists of Royal Academy exhibits by sculptors, the extent to which their sketches and ideas may not have survived their first statements in plaster or clay.

In fact, Bell's *Eagleslayer* was eventually transferred to marble, bronze and iron, though in what medium it was presented at its next appearance in 1844 is not clear. The occasion was the major exhibition, held in Westminster Hall, to select artists for various statues in bronze and marble of British sovereigns and illustrious personages for the decoration of the New Palace at Westminster, otherwise known as the Houses of Parliament. The specifications for this exhibition, issued by the Royal Fine Arts Commission who sponsored it, lay down that a specimen or specimens not exceeding two in number may be either prepared for the occasion or selected from works executed within the previous five years (this would in effect exclude the Bell plaster, unless it were executed in some other material between 1837 and 1843 when the specifications were issued). The works could be ideal or portrait statues, or groups, but not *relievi*. The subjects were left to the choice of the artist, and materials were to be such as were commonly used for models and casts[10] (which would rather presuppose plaster for the Bell). Bell at any rate submitted the work as *The Archer*, describing it as 'for' Lord Fitzwilliam, which implies the commission was under way. The *Literary Gazette* thought it 'a performance so striking and masterly that it at once fixes the attention, not only by the novelty of the subject, but by the ability of the treatment'.[11] The Royal Fine Art Commissioners probably thought well of it too, as Bell is one of the three artists listed as having especially distinguished themselves in the exhibition,[12] but he had also shown *Jane Shore* at the same time, which has disappeared.

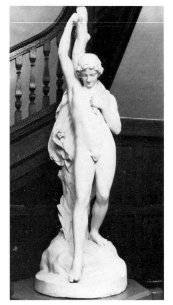

18. John Henry Foley, *Youth at the Stream* (original plaster model), 1844. Dublin, Royal Dublin Society.

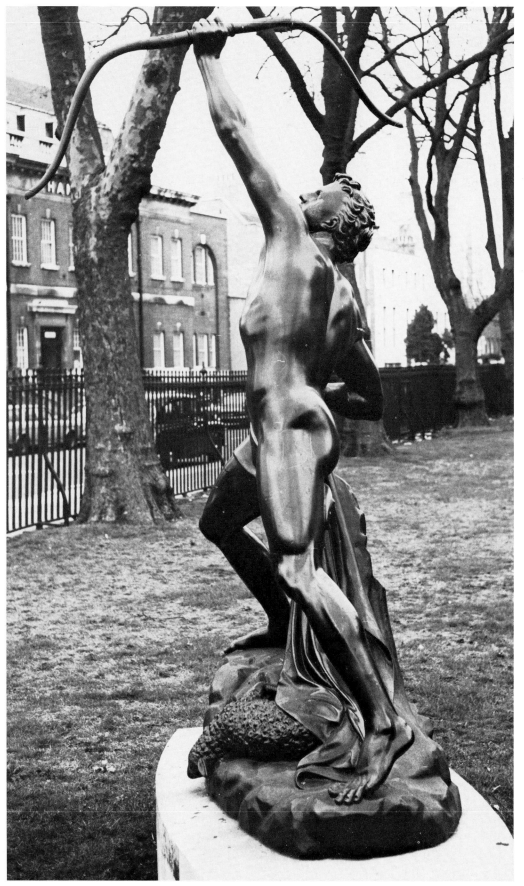

19. John Bell, *The Eagleslayer* (iron, version of 1851). London, Bethnal Green Museum.

The other two artists to be singled out were William Calder Marshall and John Henry Foley. And in Foley's case, what is most unusual is that the original models he submitted have survived. One is *A Youth at the Stream* (plate 18), still in the collection of the Royal Dublin Society, to whom it devolved after the artist's death in 1874. This was no. 155 in the 1844 exhibition, and it had affixed to it the lines:

> Playful and wanton to the stream he trips,
> And dips his foot.[13]

The *Art Union* (immediate predecessor of the *Art Journal*) wrote: 'The head is modelled in fine taste, and had such a figure been dug up in Rome, or near Naples, somewhat mutilated, it would have been pronounced a valuable specimen of classic Art.'[14] The fact that this work survives in other versions cannot diminish the importance of the Royal Dublin Society example as a surviving plaster model, as submitted to a competitive exhibition. This is another entire class of work which has all but disappeared. As with the Royal Academy and private commissions, so with works due for public commission: the artist would submit either to an exhibition or to a committee a plaster model, at a scale variously determined. For the national memorial to the Duke of Wellington in St Paul's Cathedral, London, eighty-three models were sent in to an exhibition in 1857.[15] Of these, only that by the artist who eventually obtained the commission, Alfred Stevens, appears to have survived and is in the Victoria and Albert Museum (plate 20). Out of all the rest, we only know the general appearance of the other premiated designs from engravings in the *Illustrated London News*,[16] and the entry of John Thomas from a drawing and two photographs, preserved in an album in the R.I.B.A. Drawings Collection. In one or two other cases of public monuments, what was probably the original model submitted survives: in the Museum and Art Gallery at Bury there is the model in plaster (plates 22, 23, 24) for the statue of Robert Peel in bronze which stands in the town's Market Place (plate 182); it is by E. H. Baily, inscribed and dated 1852. And the Thoresby Society in Leeds has a plaster model for the statue of Sir Peter Fairbairn of 1869 by Matthew Noble, destined for Woodhouse Square, Leeds.[17]

20. Alfred Stevens, Competition Model for the Wellington Monument, 1856–7. London, Victoria and Albert Museum.

The last major appearance of Bell's *Eagleslayer* that we should note was at the Great Exhibition of 1851, and this was conceivably its greatest triumph. Cast in both bronze and iron by the Coalbrookdale Company, one version appeared inside a cast-iron canopy. This had its vertical supports in the shape of slender oak-trunks with leaves and acorns and right at the top the object of the archer's attention, namely the eagle, transfixed by an arrow.[18] Because it was exhibited by the Coalbrookdale Company (who incidentally were also responsible for casting the version of *The Eagleslayer* in iron which is now outside the Bethnal Green Museum, London), Bell's statue qualified as 'Industry' rather than as 'Art', though the extent of the latter at the Great Exhibition was always a matter of some doubt. There was a separate Class for Sculpture (Section III, Class 30), with eighty-six entries and considerably more items (the Art Union of London Corporation entry, for instance, contains twenty-four items). But then there were further items of statuary separately catalogued in the main circulation areas of the building, as can be seen in a number of the engraved views of the interior. And there were other examples in the Industrial section, as indeed was another surviving John Bell work, *Andromeda*, which was bought by Queen Victoria and is now in the gardens at Osborne House in the Isle of Wight (plate 21). The exhibition also contained a sizeable foreign contingent, with examples of such contemporary classics as August Kiss's *Amazon on Horseback Attacked by a Tiger* (see plate 197), in zinc and bronze, after the original of 1839 in front of the Royal Museum, Berlin (plate 25), and Eugene Simonis's colossal equestrian statue, in plaster, *Godefroy de Bouillon*, the bronze prime exemplar of which was erected in the Place Royale, Brussels, in 1848 (plate 26); still another exhibit was *The Greek Slave*, in marble, by the American sculptor Hiram Powers (plate 27).

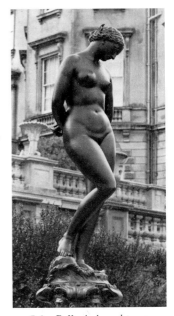

21. John Bell, *Andromeda*, c. 1851. Royal Collection, Osborne.

29

22 & 23 (above). Edward Hodges Baily, detail of base, plaster model for *Sir Robert Peel*, 1852. Bury, Art Gallery.

24 (right). Edward Hodges Baily, *Sir Robert Peel*, (plaster model), 1852. Bury, Art Gallery.

25. August Kiss, *Amazon on Horseback Attacked by a Tiger* (bronze), 1839. Berlin, Altes Museum.

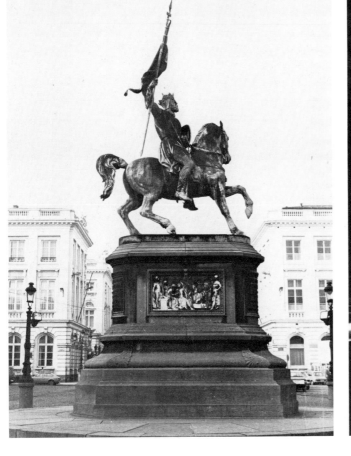

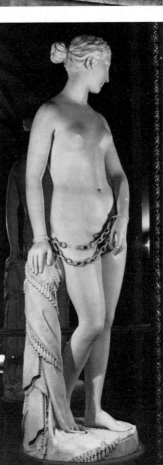

26 (far left), Eugène Simonis, *Godefroy de Bouillon*, 1848. Brussels, Place Royale.

27 (left). Hiram Powers, *The Greek Slave*, 1844. Private Collection.

28. John Henry Foley, *Youth at the Stream* (bronze, version of 1851). Stratford-upon-Avon, Bancroft Gardens.

That a few works do survive in some form should not obscure the fact that many others shown do not. Some were illustrated by individual engravings, so that not all have disappeared without leaving any trace of how they may have looked. But even here a certain caution may be necessary: an engraving of one work with which we are otherwise familiar, Foley's *Youth at a Stream*, bears no resemblance to it at all.[19] Another problem with this work at the Great Exhibition is in what material it was exhibited—Tallis's *History and Description of the Crystal Palace* gives it as both marble and bronze, the latter 'executed . . . by Hatfield'.[20] While a J. A. Hatfield bronze version is still to be found (appropriately placed by the water's edge) in the Bancroft Gardens near the Royal Shakespeare Theatre at Stratford-upon-Avon (plate 28),[21] a marble version does not appear to have materialised until later, when it was commissioned as part of the scheme initiated by Prince Albert for placing works of sculpture in the gardens of the Royal Horticultural Society;[22] this was not completed until 1869.[23] It has disappeared; the gardens have been built over and the work was presumably returned to the Royal Commission for the 1851 Exhibition, who had taken possession of it in any case when the R.H.S. Council would not pay for it.[24] Prince Albert, the first President, had presumably channelled the scheme through the Commission as part of its Supplemental Charter to apply the surplus funds from the Exhibition to promote the knowledge of science and art and their applications in productive industry.[25] But the trail stops there.

In a way, of course, there is no reason why the various types of work in plaster should survive. It was obviously much less permanent than bronze or marble, and it could in any case (as with clay) be broken up and reused. Sometimes, though, special provision was made for the preservation of the artist's original plaster models, that is, the version of a particular work that he would have executed early on in the executive procedure of the work, to serve as a base for further transfer into other materials and as a record of work done (for a more detailed account of this, see pp. 55–6). One sculptor, Musgrave Lewthwaite Watson, is known to have had his models brought into the sickroom where he lay dying 'as a final review of their worth and fitness to live as memorials of their master' and to have had nearly all of them smashed up before he died[26] (in 1847) but this deliberate destruction seems to have been exceptional.

In England the prime example of assembling a sculptor's models for preservation was the case of John Flaxman, and this actually happened early on in Queen Victoria's reign. Henry Crabb Robinson, a friend of Flaxman and also a Founder of University College, London, gave generous financial help to Maria Denman, Flaxman's sister-in-law and adopted daughter, to save the models from dispersion after Flaxman's death in 1826; and it was largely through his good offices that Miss Denman presented these, in 1848, to University College. A committee under the chairmanship of the poet Samuel Rogers (also a friend and patron of Flaxman) was formed to raise the necessary funds for repairing the models and installing them on the premises of University College, and this was completed in 1857[27]—thus the whole business was in the air for at least nine years in mid-century. Meanwhile, Sir Francis Chantrey's widow had presented all his original models of busts, statues and other portraits to the University of Oxford in 1842.[28]

Of course, those whose cultural horizons extended over Europe could know of similar, slightly earlier cases involving the works of Canova (Italy), Thorwaldsen (Denmark) and Ludwig Schwanthaler (Bavaria). It was certainly exemplars such as these that led John Gibson to bequeath the models and statues in his studio, as well as most of his fortune, to the Royal Academy in London. In a letter of 1864 to Sir Charles Eastlake, then President of the Academy, he wrote:

My renowned master Canova left in his will the models of some of his works to the Academy of his own country. Thorwaldsen left all his models to his sovereign and

32

29. Alfred Stevens, *Valour and Cowardice* (original plaster model), *c.* 1858–67. London, Victoria and Albert Museum.

country, with the principal amount of his money. They are arranged and seen by the public of his own country. It is this fact that has induced me to venture to make an offer to leave in my will all the models of my works executed in marble, with the chief part of my fortune, to the Royal Academy . . . I will also express without fear of being considered presumptuous that these works of mine—the labour of forty-six years of study and practice under the instruction for five years of Canova, and, after his death, of Thorwaldsen, and at the same time surrounded by able rivals from different nations—yes—I do feel that the collection of my models seen together would be of use to the young sculptors as to style.

Lady Eastlake tells us that, needless to say, this offer, upon the conditions stated, was joyfully accepted at a general meeting of the Academy.[29]

After Alfred Stevens's death in 1875, a few friends, admirers and pupils took special care to preserve as much as they could of his work;[30] when John Graham Lough died in 1876, his widow presented his models to the Corporation of Newcastle-upon-Tyne, his home town, and they were displayed in Elswick Hall. There they were joined by a

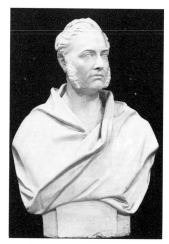

30. John Graham Lough, *John Graham Lough* (original plaster model). Newcastle-upon-Tyne, Museum of Science and Engineering.

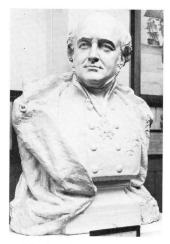

31. Matthew Noble, *Sir John Franklin* (original plaster model). Newcastle-upon-Tyne, Museum of Science and Engineering.

32. Matthew Noble, *Cotton-spinning* (original plaster model), Newcastle-upon-Tyne, Museum of Science and Engineering.

collection of models by Matthew Noble (who also died in 1876), again presented by the sculptor's widow, and at one time this combined collection amounted to over 364 items.[31] After Henry Stormouth Leifchild died in 1884, his widow presented the models of his more important works to Nottingham Museum,[32] and in 1894, the year before he died, Frederick Thrupp gave the works in marble and plaster in his studio to the City of Winchester; these were returned to the sculptor's family in 1911, who then presented them to Torquay Corporation.[33] After Boehm's death (1890) the South Kensington Museum acquired a collection of works in plaster from his executors.

The Stevens works in sculpture are now largely in the Victoria and Albert Museum, London (plate 29); the Thrupps remain in the care of the Borough of Torbay, the marbles on display at Torre Abbey, the plasters in store there;[34] some Boehms survive in store at the Victoria and Albert Museum.[35] But of the Lough/Noble collection (over 360 works), only nine survive today in the Museum of Science and Engineering at Newcastle: three plaster models of busts by Lough (plate 30), and models of three busts (plate 31) and three bas-reliefs (plate 32) (one in five sections) by Noble. The remainder are rumoured to form part of the ballast of the urban motorway in which contemporary Newcastle takes some pride.[36] Of Leifchild's models, one survives today (*Jacob and the Angel*); the rest were destroyed by a curator before 1929.[37] One cannot help agreeing with Sterne that 'they order . . . this matter better in France',[38] where museum after museum still preserves substantial collections of sculptors' original models: for example, of David 'd'Angers' at Angers, of Chapu at Le Mée, and of Carpeaux at Valenciennes. Italy too has such collections: of Bartolini in Florence, and of Vincenzo Vela at Ligornetto.

Collections left to private institutions have fared slightly better. The Gibson bequest, which consisted of casts from all his works, models in plaster of various designs not executed in marble, a group of *Theseus and the Robber* left in clay and cast after his death, the original statue of Bacchus in marble, several replicas in marble from other statues and his book of original designs, has survived to a fair extent (plate 33).[39] A number of John Henry Foley's models went to the Royal Dublin Society at his death, and while two busts, one statuette and six full-size statues (plates 20, 34, 35, 36, 56, 212) may not seem a particularly large proportion of the collection to survive, considering that fourteen statues are known to have been surviving at the time of the Society's bicentenary in 1931,[40] the exact number of the original collection is not known, and the works that are available for inspection (including the Goldsmith model which has appropriately come to rest at the site of 'The Deserted Village') offer an important selection of the artist's work.

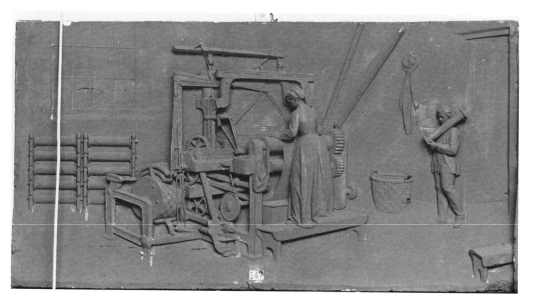

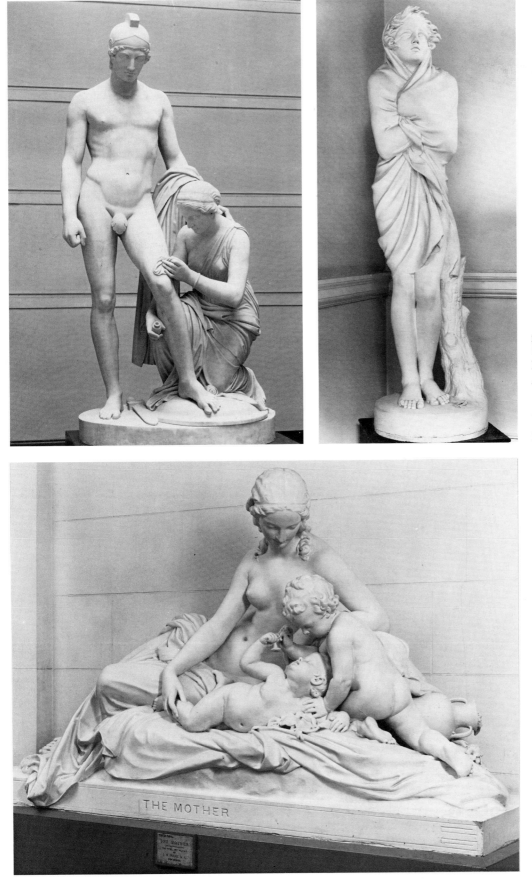

33 (far left). John Gibson, *The Wounded Warrior, c.* 1860. London, Royal Academy of Arts.

34 (left). John Henry Foley, *Winter* (original plaster model). Dublin, Royal Dublin Society.

35. John Henry Foley, *The Mother* (original plaster model), R.A. 1851. Dublin, Royal Dublin Society.

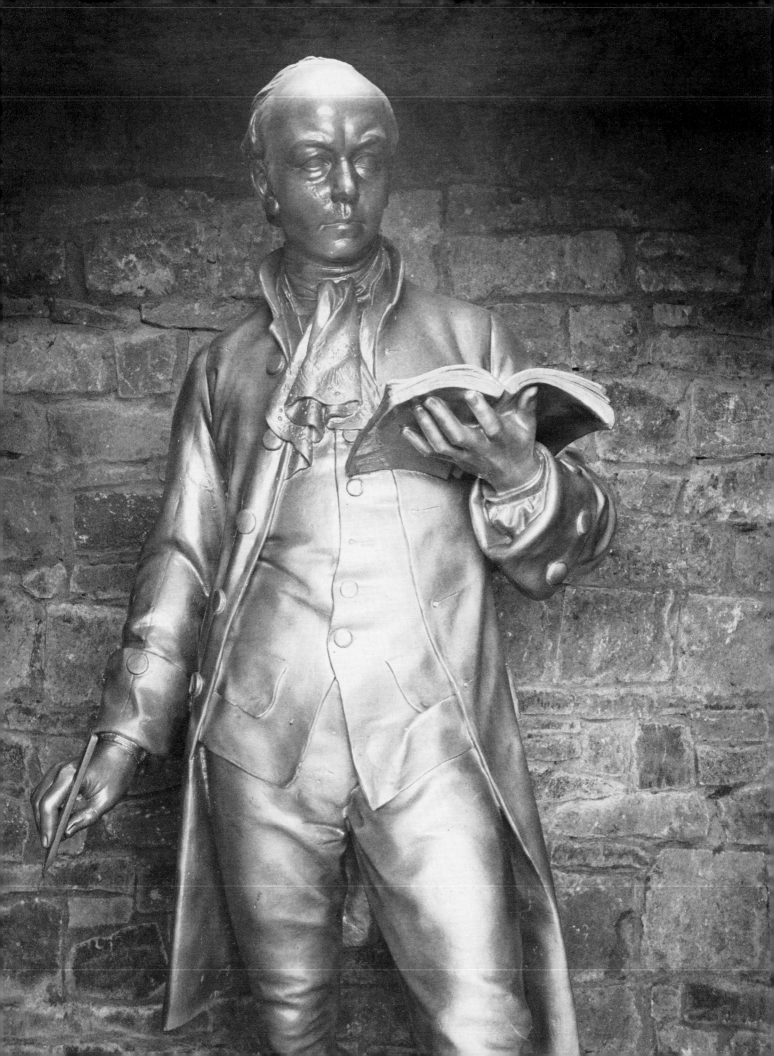

There are also instances of individual, isolated bequests and survivals of original plaster models, like the *Lady Godiva* of John Thomas at Maidstone. John Birnie Philip gave the plaster model of his statue of King Alfred in the Royal Gallery at the Houses of Parliament to Bradford Corporation;[41] what must be the original model for the statue of Henry, first Duke of Lancaster (†1362) by Farmer and Brindley on the facade of Manchester Town Hall survives in the Statuary Hall inside the building (plate 37), and a plaster *Puck* by Thomas Woolner still in the possession of his grandson (plate 39) is probably the original model. The contents of Woolner's studio indeed survived for over twenty years after his death and were exhibited to the public (11 to 4.30, Sundays included, Admission by visiting card) in February 1913;[42] one can get some idea of how it all looked from photographs that survive (plate 52). But what has happened to the 218 works listed in the catalogue is not known. Most were for sale, and it was noted in the catalogue that any works not disposed of during the Exhibition would be sold in the studio by auction, on a date to be announced later. Still more recently, after the death of Hamo Thornycroft in 1925, his widow distributed some of the studio contents; the original plaster model for his *Artemis* (1880) went to Macclesfield Town Hall (where it survives) (plate 38) while a large collection of models in plaster, wax and plasticine went to the Tate Gallery, Leighton House and the University of Reading,[43] and these survive in part (see below, p. 54).

Sometimes provision was made for the preservation of special series of original models. Those used for the architectural statuary on and in the Houses of Parliament went to the Crystal Palace Company[44]—these were clearly the best examples, as the remaining models for the various sculptures and carvings were inspected in 1859 by John Thomas, the chief carver (and no mean artist in his own right) with a view to their disposal, and he found 'a great portion is in a mutilated state so much so that they would not be worth restoring' and others were large and unwieldy.[45] A selection was in fact made, submitted to the South Kensington Museum and later transferred to the Royal Scottish Museum, Edinburgh, where they were subsequently destroyed.[46] These were models for architectural decorative details (cusps, pinnacles etc.) and not strictly of the same class as those under discussion, but their fate was very much the same. The statuary models were set up in a screen in the Sydenham Crystal Palace, and survived until 1936 (plate 40).

The Crystal Palace at Sydenham burnt down in 1936, and with it went not only the John Thomas models, but a substantial collection of plaster casts of what had been contemporary works. These had been exhibited in the Courts of Modern Sculpture, and had a *Handbook* by the redoubtable Mrs Jameson. This was a very practical introduction to the subject, starting with a definition of the art and its various constituent types, and a sensible theoretical discussion. There are sections dealing with material, size and locality, and then an extended discussion of subject matter in sculpture, with references to some of the examples displayed: these were objects of modern sculpture, defined as dating from the close of the seventeenth century to the present. The examples and the discussion concentrate on works from the middle of the eighteenth century onwards. Mrs Jameson apologises for the absence of work by, for example, Flaxman, Chantrey, Banks and Foley, but hopes that amends will be made: those in fact most numerously represented were Gibson (eighteen works), R. J. Wyatt (ten), John Bell (nine), R. Westmacott junior (eight), J. G. Lough (eight) and E. H. Baily (eight); a number of other artists had from one to five works on show. Mrs Jameson also spent time describing national characteristics in modern sculpture, and this was backed up by an impressive collection of European works: thirty-seven Thorwaldsens, twenty-three Rauchs at least, nineteen Canovas, fourteen Schwanthalers and ten W. Geefs. All these, and the twenty-six statues representing different countries on the Upper Garden Terrace (by Bell, Monti and others) must have been, even in the form of plaster reproductions, an emphatic display of the art's capacities at that time.

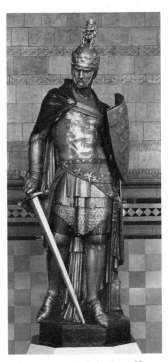

37. Farmer and Brindley, *Henry, first Duke of Lancaster* (plaster), *c.* 1868–77.

38. Sir William Hamo Thornycroft, *Artemis* (original plaster model), 1880. Macclesfield, Town Hall.

36 (facing page). John Henry Foley, *Oliver Goldsmith* (original plaster model), 1863. Pallas.

37

The purpose of it was educational:

> In none of the fine arts does such an amount of ignorance prevail as in sculpture. It is a universal complaint with sculptors, that they are forced to deviate from their own convictions of the true and the beautiful, to please the unrefined taste of patrons. Let those who wish to learn, come here: such materials for comparison and delightful contemplation were never before brought together to educate the mind and eye of the public.[47]

But these works were fragile, and thus prey to the ravages of war, fire and acts of God, and it was the second of these three that eventually put paid to them.

War has also taken its toll. Casualties indirectly of the Second World War were three of the four panels by Thomas Woolner set into the pulpit at Llandaff Cathedral. Although the pulpit itself survived the wartime bombing, the protective covering it was given until the post-war restoration got under way was in some way defective, the rain got in, and when the covering was removed, much of the stonework had largely disintegrated beyond repair.[48] One of the panels survived (the *Moses*) (plate 324) but our only record of the remaining figures is a series of photographs of the original plaster models, at one time in Woolner's own possession. In London, certain statues were also destroyed by bombing—Birnie Philip's *Reynolds* (c. 1875), once in Chelsea Town Hall, and the *Poets' Fountain* by Thomas, Mary and Hamo Thornycroft (erected 1875) once in Park Lane. A fragment survives at Renishaw Hall, Derbyshire.

39 (facing page). Thomas Woolner, *Puck* (plaster), 1847. Private Collection.

40. John Thomas, original models for statues at the Houses of Parliament. Formerly London, Crystal Palace.

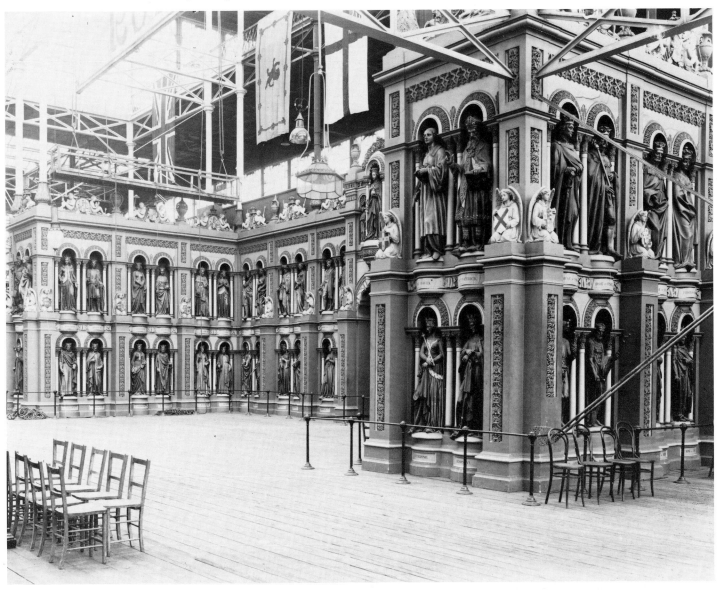

41. John Henry Foley, head of *Viscount Gough*, 1874. Dublin, Works Depot.

42. John Thomas, *Thomas Attwood*, 1859. Birmingham, Calthorpe Park.

Bombing has displaced and damaged, if not destroyed, certain works in Ireland. Foley's statues of Lord Carlisle, a nineteenth-century Lord Lieutenant of Ireland, and of Viscount Gough, a nineteenth-century Irish-born military hero, used to be in Phoenix Park, Dublin. These figures were considered by the I.R.A. to be politically unacceptable, so they brought in experts in plastic bombing from France who, by carefully placing explosives at critical points of the structure of the statues, managed to bring them down without completely destroying them. The statues were removed to a Works Depot on the outskirts of Dublin where they are now stored in a small yard (plate 44)—except for Viscount Gough's head, which is kept separately in a cupboard (plate 41). The Irish national monument to Queen Victoria was carefully dismantled before the I.R.A. could get to it, and now surveys a courtyard in a somewhat disjointed manner (plate 43). The Indians, too, found the commemorative relics of the Imperial Raj politically distasteful, but dismantled most of the monuments before any serious damage was done. Many of those in Calcutta were removed to the police barracks at Barrackpore, some miles out of the city, and are still stored in the courtyard there. It was from such a predicament that *Viscount Hardinge* (plate 3) was repatriated.

The effect of changing political taste on our current judgement of Victorian sculpture is paralleled in the much more fundamentally affective shift of aesthetic taste which is really the leit-motif of this whole chapter: the position of Victorian sculpture in the tastes of today can be governed by the position in which the work finds itself, often relegated by the tastes of yesterday. This chain of cause and effect was already at work in the nineteenth century, as we can see with the case of Matthew Cotes Wyatt's equestrian statue of Wellington.[49] Opinion was divided as to its merit even as it was being erected at its original site on top of the arch at the top of Constitution Hill in 1846 (plate 10). The designer of the arch, Decimus Burton, wanted some statuary on top, but certainly not Wyatt's figure, which he thought too big. He did not manage to stop it being put there, so he set aside £2,000 in his will to have it removed. This was finally done in 1883, but only because of the reconstruction of Hyde Park Corner. At that date, opinion was still divided. Some simply wanted to resite it somewhere else in London, while others wanted to melt it down and use some of the metal for a new, smaller statue. But this latter proposal did not go down well with the army, who had largely paid for it. The Prince of Wales agreed with them and suggested it should be re-erected at Aldershot, this suggestion was taken up and the statue is there to this day. Such a removal was not just the prerogative of the metropolitan cognoscenti of London. A statue of Thomas Attwood (plate 42), founder of the Birmingham Political Union and a local hero, was set up in Birmingham in 1859, in Stephenson Place in the city centre. 'The site selected for the statue is the most conspicuous position in the town' one contemporary report read; it was in the centre of New Street, and at the head of the outlet from the London and North-Western Railway. It was removed to Calthorpe Park in the suburbs of the city in 1925.[50]

The whole problem is perhaps at its worst with private collections, particularly as these were the main repositories of ideal, 'poetic' or subject pieces, the class of work in which it seems to have been generally accepted that artists could best express their highest ideals and talents (see below, pp. 129, 199). Alexander Munro's *Paolo and Francesca*, which originally belonged to Mr Gladstone, was spotted by chance in a junk shop and is now in Birmingham City Art Gallery. In general the provincial municipal ambience seems to have been the most effective safety net for works from private collections, and in Town Halls, municipal conservatories and public galleries all over the country one can begin to reconstruct this crucial lacuna in our awareness. The Town Hall at Blackburn in Lancashire has on its main staircase two ideal works, provenance unknown, by relatively major artists: *The Octoroon* by John Bell (plate 45), exhibited at the Royal Academy in 1868, and a figure of a maiden with a pail by Joseph Durham, A.R.A. (plate 46), signed

43. John Hughes, *Queen Victoria*, unveiled 1908. Dublin, Works Depot.

44. John Henry Foley, remains of *Earl of Carlisle*, 1870; and *Viscount Gough*, 1874. Dublin, Works Depot.

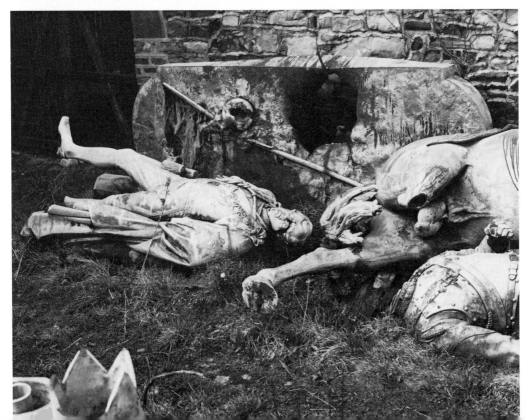

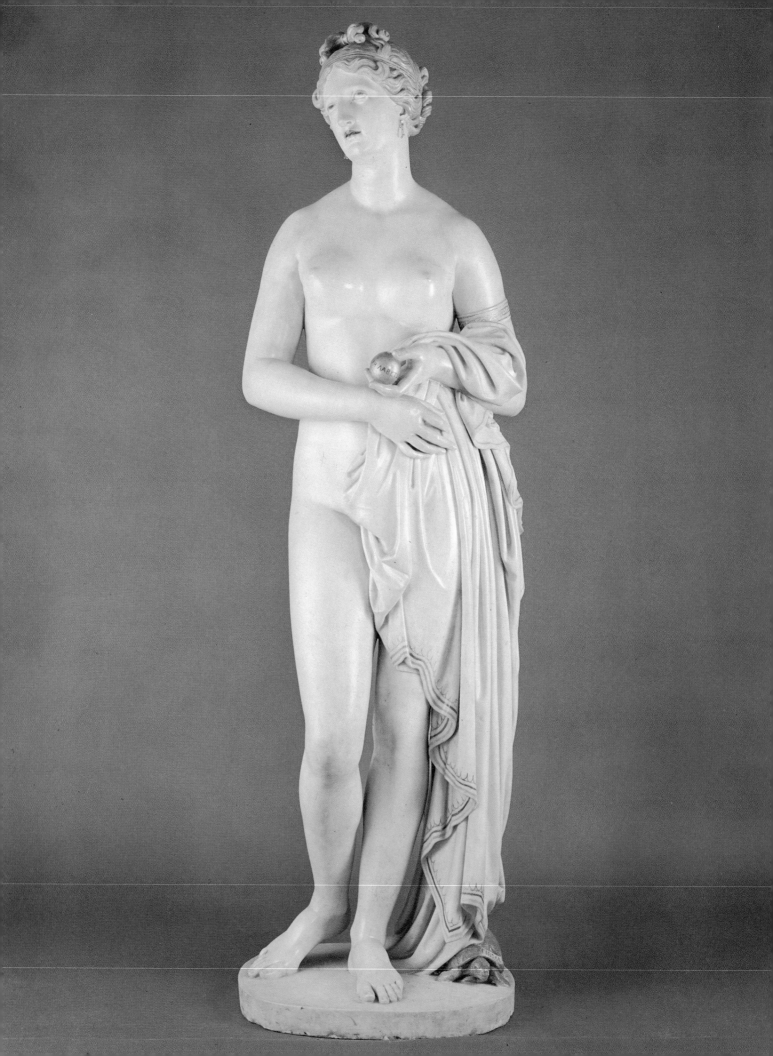

and dated 1867 (this could be identified as either *At the Spring* or *Early Morn*). Liverpool has in its municipal conservatories in Stanley Park and Prince's Park works such as Benjamin Spence's *Highland Mary* (1854) (plate 269), *The Angel's Whisper* (1863) (plate 267), and Patric Park's *A Child in the Bath* of 1840 (plate 47); some are there under the care of the Walker Art Gallery, which has other works at its main premises. The City Art Gallery at York has five subject works bequeathed to it from a local collection, that of the Atkinson family, in 1896: four by Joseph Gott, *Ruth*, *Rebecca*, *Crossing the Brook Cedron* and *Jephtha's Daughter*, and one by Frederick Thrupp, *The Boy and Butterfly*.[51] Present-day private collections specialising in Victorian sculpture are very rare: there is one at Gawsworth Hall, Cheshire, that specialises in works by artists with local connexions, such as Alfred Gatley (1816–63, from Cheshire), John Warrington Wood (1839–86, from Warrington) and the Thornycrofts (a Cheshire family).

Of the four principal classes of Victorian sculpture work—busts, funerary monuments,

45. John Bell, *The Octoroon*, R.A. 1868. Blackburn, Town Hall.

46. Joseph Durham, *At the Spring/Early Morn*, 1867. Blackburn, Town Hall.

Colour plate II. John Gibson, *The Tinted Venus*, 1851–6. Liverpool, Walker Art Gallery.

ideal works and public statuary—busts and ideal works have largely disappeared from view, busts in particular having been a massive preoccupation of private patronage. Funerary monuments are usually still *in situ*, but can often be remote, and are the least considered furnishings in churches which are probably locked anyway.

> Inconvenient though it is, it does make for the excitement of the pilgrimage, rare now that great art tends to be concentrated in great collections. More important, it means that we see this sculpture in its original context, and it should therefore be less easy to forget its intended function and meaning than is the case with an altarpiece or a family portrait elevated to the status of national 'treasure' in a public gallery.[52]

How then can there be anything but 'the dulled perception, and uneducated apathetic eye'? The only works that have on the whole survived, even if unregarded, are the public monuments. They may not be the best objects for our attention, as we have seen from some of their contemporary critics. But they are at least there for our consideration, even if we do no more than repeat what is perhaps still the most effective and evocative response to nineteenth-century sculpture, that of Baudelaire, notwithstanding its different national context:

> You are proceeding across a large town grown old in civilisation, one of those that contain the most important archives of human existence, and your eyes are drawn upwards, *sursum, ad sidera*; for in the public squares, at the corners of crossroads, motionless figures, taller than those who pass at their feet, recount to you in a soundless language the pompous legends of glory, of war, of science and of martyrdom.
>
> Some point to heaven whereto they ceaselessly aspired; others point to the ground from which they have sprung up. They brandish or contemplate whatever was the passion of their life, which has become its emblem; a tool, a sword, a book, a torch, *vitai lampada*! Were you the most indifferent of men, the most unhappy or the most vile, beggar or banker, this phantom of stone seizes you for several minutes and orders you, in the name of the past, to think about those things that are not of this earth.
>
> Such is the divine role of sculpture.[53]

The Life and the Works

48 (preceding page). Interior of the studio of Alexander Munro.

CHAPTER THREE

The Making of Sculpture

There is a poem in Robert Browning's *Dramatis Personae* (1864) called 'Youth and Art',[1] about a youthful couple (probably in Rome), he a sculptor and she a singer. She is addressing the sculptor in later life and regretting that their acquaintance had not developed further. In addition to the main theme, which gives the work its poignancy, the poem contains a certain amount of incidental detail reflecting on the life of a sculptor:

> II Your trade was with sticks and clay,
> You thumbed, thrust, patted and polished,
> Then laughed 'They will see some day
> Smith made, and Gibson demolished.'
>
> IV I earned no more by a warble
> Than you by a sketch in plaster;
> You wanted a piece of marble,
> I needed a music-master.
>
> XIV No, no: you would not be rash,
> Nor I rasher and something over:
> You've to settle yet Gibson's hash,
> And Grisi yet lives in clover.
>
> XV But you meet the Prince at the Board,
> I'm queen myself at *bals-paré*,
> I've married a rich old lord
> And you're dubbed knight and an R.A.
>
> XVI Each life unfulfilled, you see;
> It hangs still, patchy and scrappy:
> We have not sighed deep, laughed free,
> Starved, feasted, despaired,—been happy.
>
> XVII And nobody calls you a dunce,
> And people suppose me clever:
> This could but have happened once,
> And we missed it, lost it for ever.

Here, succinctly expressed in verse, are some of the ups and downs of a Victorian sculptor's life: ambition, lack of proper materials to work with, acquaintance with Royalty, professional recognition and a title, and a hint that for all these latter, the sculptor has still to realise his youthful ideals.

Of the honours mentioned, knighthood was very rare for sculptors in the Victorian period until towards the end of the century. Earlier both Chantrey and Westmacott received this accolade, the latter in 1837; later Boehm, Gilbert, Hamo Thornycroft and

Brock were so honoured. But of the generation that flourished between 1840 and 1870, only the Scotsman John Steell was knighted, and this was specifically for his work on the Scottish memorial to Prince Albert in Edinburgh (plate 195); he received the honour on the occasion of the inauguration of the monument in 1876.[2] In England the chief figure involved in the National Prince Consort Memorial was knighted, but he was the architect, Gilbert Scott, and it is legitimate to wonder whether Foley might not have been knighted also had he lived to see the inauguration of his figure of Albert at the centre of the London memorial (plates 95, 68), especially as he was otherwise so widely respected; but he died two years before the figure was finally ready in 1876.

No full-time sculptor became President of the Academy, though Sir Richard Westmacott was pressed to stand for election to this position in 1850, but he declined in favour of Eastlake.[3] And while George Rennie (1802–60) did become Governor of the Falkland Islands, where he was an unqualified success,[4] there is no reason to suppose this was due to his being a sculptor. But friendship with the great was not impossible: W. E. Gladstone was on good terms with Alexander Munro and John Adams-Acton,[5] and Gibson was treated by the Royal Family with respect, even being allowed to indulge in playful banter with Queen Victoria in his old age.[6] Of John Evan Thomas (1810–73), who incidentally became a Deputy Lieutenant, a Justice of the Peace, and who served a term as High Sheriff of Brecknockshire in 1868, we are told that his social qualities endeared him to a large circle of friends, and his conversational powers and fund of anecdote, as well as his mature judgement of all matters concerning art, made him 'an honoured guest in all the houses of the great in rank, literature and opulence'[7] (my italics).

On the other hand, misfortune was equally, if not more characteristic. When Musgrave Lewthwaite Watson died in 1847, aged forty-three, the common refrain was: 'he was a lost man—what he might have been if encouraged'.[8] Although generally accepted at the time as an artist of some talent, he was forced to spend many years working in the studios of other artists. As a young man, patrons had not materialised and his goods and chattels were distrained for rent—a 'colossal figure which had cost him months of work, if not years of thought, was treated as a piece of clay, it being knocked to pieces and sold as earth'.[9] It was admitted that his independent, self-willed nature may not have helped him; as the years went on his health too broke down, and for some time he lived on cups of coffee, bread and butter,[10] and alcohol.[11] The time and exertion required in the design and execution of his major work, the colossal double-figure group of Lords Eldon and Stowell at University College, Oxford, on which Watson was working when he died, gave the last blow to an already debilitated frame, we are told, the rheumatism he contracted being largely attributed to the long time he had to spend modelling damp clay for this group.[12] Indeed, John Henry Foley, according to one account,[13] contracted the pleurisy that eventually killed him while working on the *Asia* group for the London Albert Memorial (plate 49): this had entailed his sitting for hours at a time on the wet clay of the limbs of the main female figure while modelling her bust. No wonder Ruskin wrote to Norton in 1860: 'Munro the sculptor, like all sculptors, lives in a nasty wood house full of clay and water-tubs (plate 48), so I can't go without catching cold.'[14]

William Behnes got into difficulties through moving into premises unsuited for a sculpture studio. The expense incurred in trying to adapt these new premises, particularly the building on of a modelling room high enough to admit statues of heroic proportions, crippled him financially. His extravagant habits caused him to fall into the hands of money-lenders, and eventually in 1861 he went bankrupt. Later he was found one night literally in the gutter with threepence in his pocket, and he died in the Middlesex Hospital nearby.[15] Neville Northey Burnard (1818–78) was a Cornish sculptor who achieved some standing in London, but when his wife died he took to drink, returned to Cornwall and spent his latter days wandering about Bodmin Moor dressed like a tramp, reciting verses

49. John Henry Foley, *Asia*. London, Albert Memorial.

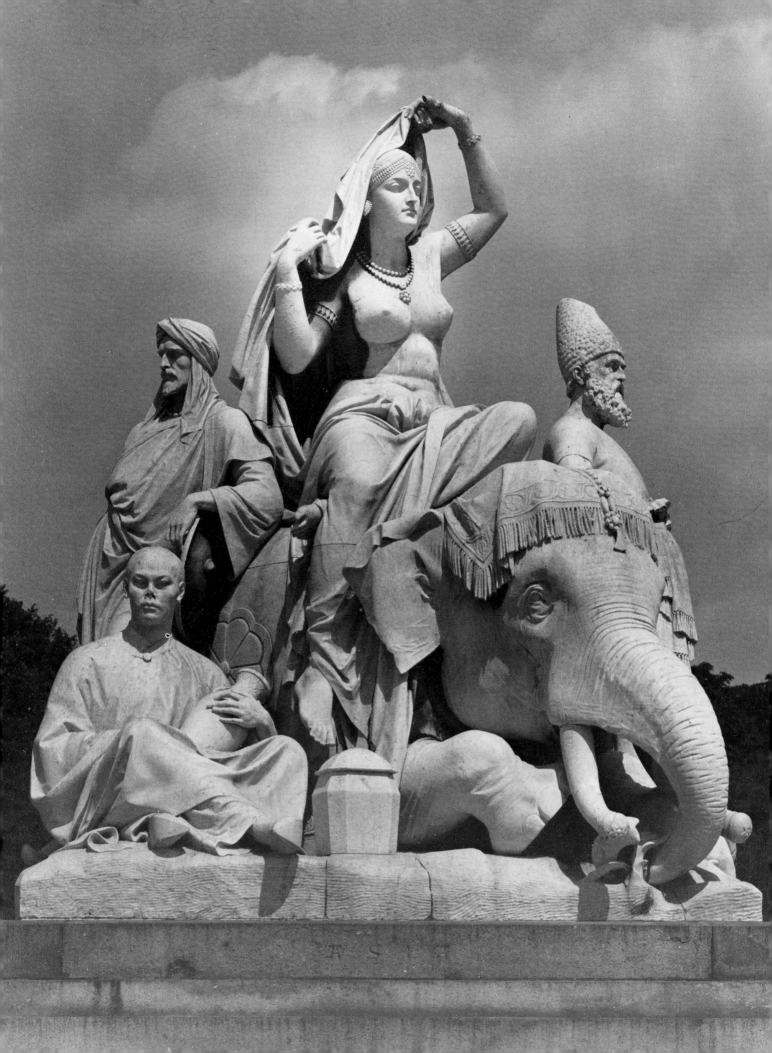

and earning a pittance drawing portraits and sketches at farms and public houses.[16] Alfred Stevens suffered throughout his career from the seeming incompatibility of market conditions with his artistic ideals, particularly with his monument to the Duke of Wellington (though admittedly a tendency to procrastination on his part did not help). John Thomas is rumoured to have died of disappointment as a result of his Shakespeare Memorial not being positioned as he would have liked it at the 1862 International Exhibition.[17] And Thomas Earle (1810–76) is said to have died of a broken heart on hearing that his *Alexander the Great*, which had taken him three years to execute, had not been accepted for exhibition at the Royal Academy.[18]

Now it is true that in the case of Burnard, the conditions of the art world can scarcely be blamed, so far as we know, for his change of life style, and that in the cases of Watson, Behnes and Stevens, their personal dispositions clearly exacerbated their difficulties. But both Foley and Thomas were, so far as all records go, personally equable, yet they too suffered for their art. Thomas is an excellent case in point. He came from a humble background, began his career in the lowest class of craftsmanship, then rose to become Prince Albert's favourite sculptor, patronised by nobility, banks and nouveaux-riches alike, but in the end it is said that he died as the result of an artistic slight.[19]

These problems were very much personal misfortunes, arising from matters of judgement or character. They were in addition to (and may well have arisen from) the difficulties that were held to be inherent to the art of sculpture. The *Art Journal* mentions some of these[20] in its comment in 1849 on:

> ... this, the noblest department of Art, the most difficult and costly of execution, and the most uncertain of other reward than fame, when complete. The sculptor labours at a disadvantage beyond all other artists; the cost of his material for a work of any magnitude involves a moderate capital; for instance, a block of the purest marble, suitable for a life-size figure, cannot be had for less than a hundred pounds. His casts and his clay, and the paraphernalia of his studio also add largely to his first outlay; and perhaps when all is done, he finds no purchaser for his work. There is genius enough in this country to produce sculptures of the greatest eminence...

It is essential for an understanding of the subject to realise how widespread the problems could be, particularly in the whole structure of the procedures of execution, in the structure and mechanics of the professional career, and even, indeed most of all, in the very nature of the art and its formal realisation; and this can only be confirmed if we examine in detail the sculptor's working life.

The first stage in the execution of a work could be a drawing. E. Roscoe Mullins specifies it in his *Primer of Sculpture* (1890), not just as a general element in education, but as a means of recording fleeting observations.[21] In his instructions for executing a portrait bust or statue, Weekes recommends starting with a drawing on paper of the profile, attaching to it such measurements as will secure its being correct in size. The sculptor should then get on paper each feature in its place in respect to this view, with the facial angle as it should be, and then proceed in the same manner with the drawing of the full face, and measurements of the width of the head in various parts, of ears and as far as possible of other features.[22] Gibson used to measure the features of his sitter with compasses. He got a bit worried only when Queen Victoria commanded him to execute a statue of herself, so he suggested to Prince Albert that he do the measuring. But he was told that 'the Queen would permit everything he might think necessary'.[23] Gibson it would seem worked in this case modelling directly in clay, but portrait drawings by Chantrey relating to busts are known (for instance, in the Huntington Museum, California) and there is an example by William Behnes—a study of the head for the statue of Sir Robert Peel in Leeds (plate 50).[24] As a general practice this may well have been widespread and

50. William Behnes, *Sir Robert Peel* (drawing), *c.* 1852. Leeds, City Art Gallery.

51. Dante Gabriel Rossetti, *Thomas Woolner* (drawing), 1850. Birmingham, City Art Gallery.

drawings relating to sculpture survive by Richard Westmacott junior; drawings are mentioned in Lonsdale's biography of Watson; and there is a fair corpus of drawings by John Thomas,[25] most of which are sketches or early realisations of subsequent three-dimensional plastic forms. However the survival or availability of such material is so limited that one cannot say for certain how far the practice was general.

The next stage in the execution of a work (in some cases the first stage) would be the execution of a sketch model, usually on a small scale, in clay, plaster or occasionally wax. The latter was regarded as 'a useful and cleaner material' than clay, but expensive, prohibitively so for large-scale work.[26] Gibson for one certainly worked directly in clay to produce a small model: a girl watching her flock, observed on a walk one day, 'ripened into a small clay model of the shepherdess Enone, deserted by Paris'.[27] And it was almost certainly a first-stage model of this type that Woolner is contemplating in the drawing of him by Dante Gabriel Rossetti at Birmingham (plate 51). (The work cannot be identified. About the date of the drawing (1850) Woolner was working on a figure of *Little Red Ridinghood*, which the seemingly nude figure with arms uplifted is scarcely likely to be; he had been working on a figure of *Grace Dancing* in July 1849,[28] and was certainly at work on something when visited by the Rossettis in January 1850,[29] but this work, judging from earlier references, was by then already life-size.[30])

Roscoe Mullins states: 'It is very essential to the student to learn to sketch easily and use his clay freely for sketching.'[31] Clay should be kept moist in a tank or tub, with a damp cloth over it, unless shut up entirely from the outside air. Sculptors sometimes had a tin-lined air-tight box with a tap at the bottom to draw off superfluous moisture, but any simple expedient answered, as the only object was to keep the clay soft. Once modelled,

52. Interior of the studio of Thomas Woolner.

53. Interior of the studio of Alexander Munro.

the clay had to be kept moist, otherwise it cracked as it dried. 'For small works there is no better method than using glass shades, such as one sees sometimes placed over clocks and vases.'[32] For any degree of permanency, either the clay had to be fired or a plaster cast had to be made; in this form it could be shown specifically at exhibitions such as the Royal Academy or those held to settle public commissions.

Clay could be used again and again, improving rather than otherwise with use; all you needed to do was break it up and remoisten it if dry, or simply rework it if still moist.[33] One consequence of this is that these small-scale models rarely survive. They could easily be destroyed if a plaster cast were made from them, while even this version of an artist's original conception rarely survives due to the fragility in its turn of plaster. E. H. Baily's figure of *Eve* at Bristol City Art Gallery, which I take to be one such example, is exceptional, and while a photograph of the inside of Woolner's studio (plate 52) shows what must be a collection of these plaster casts of the initial, very small-scale sketch models of certain of his works such as *John Stuart Mill* (final large-scale version on the Thames Embankment, London) and *William Whewell* (final version in Trinity College, Cambridge, plate 145), only a version of the small-scale *Mill* survives (William Morris Gallery, Walthamstow). A very exceptional instance of the survival in bulk of such models consists of the Hamo Thornycroft models at Reading and elsewhere (see above, p. 37), but even here the number extant today is only a proportion of what was in his studio at his death in 1925. Certain factors help explain the relative survival of these works, for instance the more recent date of their distribution to public collections, the fact that many are in wax which is more durable than plaster, and the continued interest of the artist's family in their fate.

The Woolner figure in the Rossetti drawing is on a standard piece of studio equipment, the three-legged modelling stool or stand, with a revolving top: this was so that the work could be continually moved round, giving different points of view and changes of light, thus helping the eye to detect faults.[34] On top of the stand is a modelling tool, and both these pieces of equipment are visible in another photograph taken inside Munro's studio (plate 53). The best tools (again according to Roscoe Mullins) were the fingers and the hand generally. Of mechanical tools, some were made of twisted or straight wire, but most were of boxwood. 'The shapes will depend greatly on fancy, and each sculptor is apt to recommend his own: . . . preference should be given to rounded rather than to sharp ends.'[35]

54

The next step in producing a work was the construction of the full-scale model. This was really the key stage in the effective realisation of a work; who knows how many sketch models in clay sprang in deserts where no patrons abided and must have uncommended died from sheer fragility and ephemerality of both material and concept. But full-scale models, cast in plaster, had a certain degree of permanence and significance about them. They were important for attracting attention at exhibitions, whether at the Royal Academy or for competitions, and, where the patron had declared his interest at the sketch model stage, they were essential to the process of transference to the final material of marble or bronze.

A preliminary full-scale model would be constructed in clay or plaster: it was possible for an experienced artist to work directly in the latter but it was difficult and clay was more common. For this full-scale version a framework was essential: even for a bust, but most of all for a figure or group, due to the sheer weight of material that would be involved. When Gibson went to Rome as a young man, without any formal training, and was taken in as a pupil in the studio of Canova, he was allowed to start by copying Canova's own *Pugilist*. He tells us:

> I began to model my copy from the cast at the studio. After I had worked at the clay a few days down it all fell. It seems that my Master had observed to his foreman, Signor Desti, that my figure must fall, 'for', said he, 'you see that he does not know anything about the skeleton-work; but let him proceed, and when his figure comes down show him how the mechanical part is done.' So when my model fell, a Blacksmith was called, and the iron work made, and numerous crosses of wood and wire. Such a thing I had never yet seen. One of his pupils then put up the clay upon the iron skeleton and roughed out the model before me, so that the figure was as firm as a rock. I was enchanted. . .[36]

Mullins illustrates such a framework and explains it in some detail.[37] Ideally modelling should proceed with the material of the final version in mind; this could affect the treatment, with effects that would look well sketchily treated in clay turning out coarse and unfinished in marble. Bronze tended to require even blander handling of surfaces and details, at any rate until the finer technique of 'lost wax' casting was introduced later in the century. Clay, as already pointed out, needed to be kept moist. When Thomas Woolner was absent from his studio where he had been at work on the full-size clay model of the Trevelyan group *Mother and Child* (plate 63), through injudicious wetting (presumably by a studio assistant) the lady's head fell off and had to be redone.[38]

From this full-size clay model, a plaster model would be cast.[39] This was because clay would not last: about the same group Woolner wrote to Sir Walter Trevelyan: 'a work in clay will not remain for an indefinite period: after a certain time the wooden framework which supports it gives way from decay and the clay falls to pieces. . .'[40] The plaster model would be cast by using a 'waste mould', and because this involved the destruction of the mould, and usually of the clay original, the resultant plaster cast which would be an unique cast formed what was regularly called the 'original plaster model'; we have come across these before (see pp. 26, 32).

The 'waste mould' process of casting was like this: around the clay model coatings of plaster were applied, the nearest coating to the original being tinted. These were allowed to dry, thus forming a mould, which was then removed. It could simply be split in two; a more elaborate method was to insert thin projecting pieces of zinc (say) into the clay model and form the mould in two independent sections anyway, with the necessary adjustments (e.g. making small holes at the edge of one piece of plaster in section to form joints with projections from the other half). The clay core could fall to pieces either at this stage or later, or it would subsequently be reused.

What was left in plaster were the two halves of a mould, the innermost surface of which would be tinted. The two halves were tied together, and liquid plaster poured in. You could either fill the mould entirely or swish it about as it dried to form an even internal coating, ideally about half an inch thick. When this was dry, you would start chipping off the outside of the mould, and when you got to the tinted coating you would stop, as you had now reached virtually the beginning of the casting. What you were now left with was your 'original' plaster model. The waste mould was so called, obviously enough, because in chipping it away it went to waste. An alternative to this was the piece mould, which was so constructed and used that it took to pieces after the casting had taken place and so allowed of multiple reproduction. It was possible, but not usual, to cast the original plaster model from a piece mould. Possibly a cast from a waste mould would, if the proper care had been taken to ensure precise jointing of the two halves, be more absolutely precise for the formal archetype, shall we say, and it would be from the original plaster model that the piece mould would be formed.

The casting of the original plaster model could be done in the studio, by the sculptor himself or by his assistants, but for more complex works (full-scale figures or groups) professional specialists would be used. Woolner writes of 'the plasterman' with reference to the Trevelyan group—he 'was filled with consternation when he looked at and saw the immense amount of work he had before him'.[41] Adams-Acton, having laboured at one work for three days and two nights without even a moment's rest and having been literally dragged from the statuary which in all other eyes but his own was perfected long before he would acknowledge this, reluctantly gave it up

> into the hands of the moulders who, with every implement ready for its cutting, were waiting in groups to 'fall on'. He cast one look at his achievement, then turned away with a tottering step and crawled to his bed, where he lay without stirring all that night and all the next day in deepest slumber. On waking, his first impulse was to rush back to resume work; but in place of the clay group he had left, there was now a dazzling white plaster group gleaming in the Roman sunshine, while all the labour of the past months in clay lay piled up in broken fragments ready to be beaten together again as material for some fresh undertaking.[42]

It is clear from this passage that large works were cast in sections.

It was possible to work directly on the plaster model, touching it up as and when required, though this could have unfortunate consequences. Woolner wrote to Lady Trevelyan with whom he had just been staying:

> . . . Soon after my return I worked at the plaster model of your Group, intending alterations in the drapery so as to give more prominence to the Child and greater neatness and grace to the Lady, and in doing this I used a great heavy iron chisel which after working more than a week produced a blister on the thumb of my right hand: a mortal with even an undersized share of commonsense would have left off till his thumb was well: but I was so impressed with the desirability of these improvements and absorbed in my work that despite the pain I used the thumb fully a week longer, and the consequence was that I was forced to undergo an ordeal of poultices-lancing and having my arm in a sling almost burning myself up with disgust at my compulsory idleness.[43]

The full-scale plaster model had two main functions, first as a semi-permanent record of the artist's work, and then as the medium of transfer of the work to other materials. Because of its relative fixity in plaster (which made it ideal for record purposes) the transfer did not need to happen immediately, and a work such as Sir John Steell's *Alexander and Bucephalus* (plate 54), in the forecourt of City Chambers, Edinburgh, was

54. Sir John Steell, *Alexander and Bucephalus*, 1832; 1883. Edinburgh, City Chambers.

55. Thomas Thornycroft, *Boadicea*, 1856; 1897. London, Westminster Bridge.

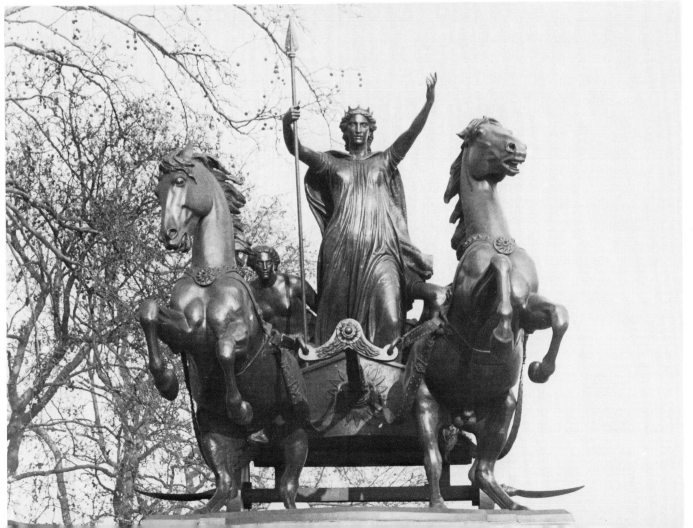

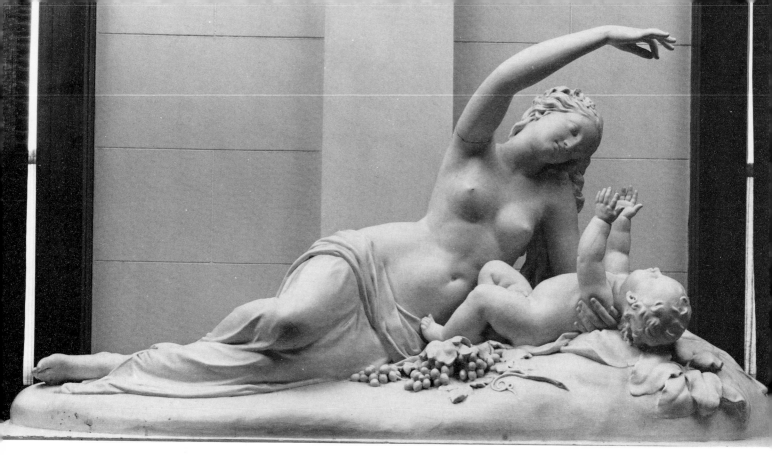

56. John Henry Foley, *Ino and Bacchus* (original plaster model), 1840. Dublin, Royal Dublin Society.

57. John Henry Foley, *Sir Charles Barry*, 1865. London, Houses of Parliament.

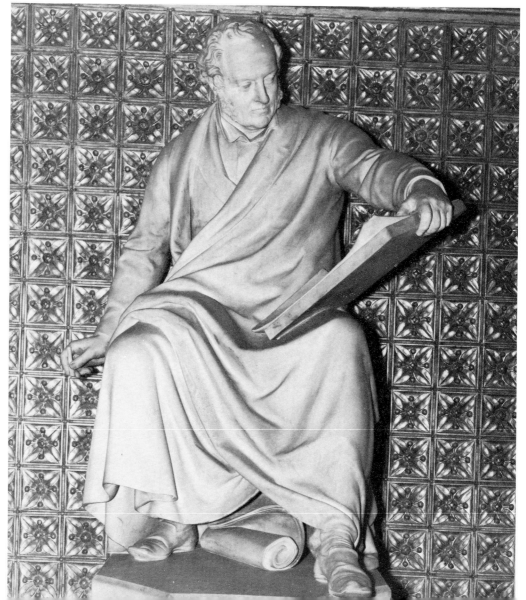

modelled in 1832 and cast in bronze only in 1883, fifty-one years later. Thomas Thornycroft's *Boadicea* (plate 55), which was begun in 1856 and was modelled over some fifteen years, in part during the lifetime of Prince Albert, who thought very highly of it and lent horses as models, was not actually cast in bronze until the sculptor's son Sir John Thornycroft presented the plaster model to the nation in 1895 and the London County Council organised a subscription to have it cast in 1897 and finally erected in 1902.[44]

The final version of a work would be executed in a permanent material such as marble or bronze. It was essential to have a patron for this, simply to pay for the expenses involved, and the normal system was that with ordinary commissions the sculptor would receive half the sum agreed upon when the sketch or design was approved, and the other half when the whole work was completed. With larger works it was more common for the sculptor to receive one third of the sum when the sketch was approved, another third when the full-size model was done and the rest when the work was finished.[45] Foley had problems about systems of payment early in his career. He exhibited *Ino and Bacchus* in plaster in 1840 (plate 56), and it attracted considerable attention. Lord Charles Townshend expressed interest in a marble version (at a cost of 550 guineas), paid some of the money but then changed his mind. Foley thought he should keep the money, which he considered he was entitled to as an advance: 'it was usual in such cases for the party giving a commission to pay one-half of the whole amount if he did not take the statue'. Lord Charles had been given to understand (by the artist's brother) that he was putting money down for the right of first refusal; he considered he was commissioning the work only on approval, and having decided against it, he wanted his money back, entering a suit against Foley to achieve this end. The case was settled by a compromise; Foley having already sold the work in question to Lord Ellesmere (for 750 guineas), he agreed to execute a single figure for Lord Charles in settlement (more or less) of the money paid.[46]

For his memorial statue in marble to Sir Charles Barry in the Houses of Parliament (of 1865) (plate 57) Foley received £908 15s which was paid for by subscribers. But there were further expenses involved: £169 10s to Mr W. Field for the marble plinth etc., £46 9s to Mr J. G. Crace for gilding the arch etc., £29 1s to Mr J. Mabey, for two plaster models of the statue and the adjoining portion of the building, and £44 12s for printing etc. Total expenditure: £1,198 7s. In fact only £1,030 had been subscribed, and the balance was subscribed (in addition to a previous contribution) by Barry's partner, J. L. Wolfe.[47] Further random examples of costs are: £1,950 voted by Parliament for the bronze statue of Sir John Franklin by Matthew Noble in Waterloo Place, London (plate 58) unveiled in 1856;[48] and over £3,000 for the statue in bronze of Richard Coeur de Lion, by Baron Marochetti, erected in Old Palace Yard, Westminster in 1860 (colour plate I). The latter was met by public subscription, with the pedestal, paid for by Parliament, costing in addition £1,650.[49]

Busts obviously cost much less than statues or groups, simply because of the greatly reduced scale of operations, material costs and so on. Of a series of marble busts by Henry Weekes at the Royal College of Surgeons, London, one (*Sir A. P. Cooper*) cost £113 8s in 1845, pedestal included, another (*J. M. Arnott*) cost £110 in 1853, and another (*J. H. Green*) cost £126 in 1866.[50] The price of around £100 must have been standard about this time, because when the *Art Journal* came to hear that the committee behind the bust of Thackeray for Westminster Abbey (plate 59) was asking for £600, they declared that the most it could come to was £200, a figure they broke down to £50 for the Dean and Chapter, £50 for the pedestal and £100 for the bust itself.[51] The fact that the sculptor involved in the commission was the flashy Baron Marochetti may have added to the outrage.*

*For further examples of Marochetti's supposed iniquities, see pp. 79, 84, 90.

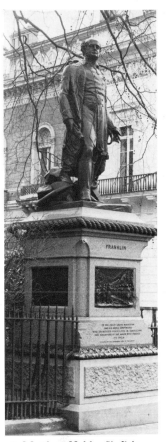

58. Matthew Noble, *Sir John Franklin*, 1856. London, Waterloo Place.

59. Baron Carlo Marochetti, Monument to William Makepeace Thackeray, *c.* 1865. London, Westminster Abbey.

Apart from the expense simply of the material (bronze or marble) for the final version, a major contribution to the total cost of a work was the laborious procedure of execution, whatever the material. For instance, the casting of a work in bronze (an alloy of copper, tin and zinc) was an elaborate and highly technical process, requiring considerable specialist expertise. (It was done almost entirely by professional firms, and even when a sculptor such as Sir John Steell set up his own foundry, it was still a matter of employing specialist technicians rather than the artist doing it himself.) The standard method of casting bronze throughout most of the nineteenth century was 'sand casting';[52] the principal alternative method, known as 'cire perdue' or 'lost wax', was almost certainly not introduced into Britain until Alfred Gilbert's *Perseus* of 1882 (plate 356) which was so cast in Italy (see below, p. 313). The basic idea in sand casting was to have an outer mould and an inner core, both formally derived from the plaster model, made from a sand rich in loam which, when ground, was made sufficiently moist to make it cling together without breaking apart. Mould and core when formed would be baked dry in an oven; a layer would then be taken off the core, as thick as the bronze was required to be. Two iron rods would then be inserted in the core at right angles to each other which would in turn project into the mould; these would keep the pared-down core in position within the mould, otherwise obviously it would rattle about. Further smaller iron rods known as 'Gets' were put inside the core to serve as feeders for the molten metal to circulate more freely; Toft informs us that the workmen called these the 'Gits'.[53]

When mould and core were in position within a frame, the molten metal was poured in through a hole which led to the empty spaces between the two; the metal cooled and solidified, mould and core were removed, and you were left with your bronze form, though not in its final state; for where the 'Gets' formed channels for the bronze to flow there would be metal projections. Furthermore, it nearly always happened that a work would be cast in sections, simply for ease of handling: the moulding would be done from the plaster model in parts. As a result, once the casting had been done, there was still considerable work involved before the final product emerged. The various sections had to be riveted together, joints closed up, and projections removed; but the best founders would do this so skilfully and effectively that it is nearly always impossible to spot the joints. However done, it was invariably a lengthy, complicated and expensive operation.

The other principal final medium was marble, which in turn was expensive and difficult to handle in many respects. It had to be almost entirely imported, and as it was heavy, this inevitably cost money. There could be delays in shipment, due to general logistical problems[54] or strikes, and even without such problems there could be a monopoly in marble shipping which would limit the artist's freedom of action.[55] When an individual block had finally arrived in this country, its progress to the artist's studio was not necessarily easy, as can be seen from the account of an Adams-Acton adventure:

When the great block of marble which he had selected in Carrara at length arrived in the London docks, it was found impossible to land it there, so it was taken down to Sheppey where it smashed up the launching gear and caused infinite trouble. Then Messrs. Pickford sent a conveyance with eight horses to deal with it, but as the great slow-moving lorry made its way through London, with its following of vehicles which could not get past it, confusion reigned. Traffic was blocked, omnibus routes had to be diverted, drivers and pedestrians alike became enraged, cries, lashing of horses and Cockney sarcasm all added to the commotion. Even after it reached Sunnyside, it was not till dusk when, before an ever-increasing crowd, it was at last successfully heaved inside the great gates, and it was not till 2 a.m. the following morning that by the aid of the indefatigable sculptor, the weary men finally succeeded in getting it safely into the vestibule. But there at last it stood—the great eight-ton block which was to be fashioned into a semblance of Queen Victoria. . .'[56]

60. Interior of the studio of Alexander Munro.

61. Nelson being executed (drawing). London, R.I.B.A. Drawings Collection.

62. Eduard Müller, detail from *Venus and Cupid/Innocence in Danger*, 1862. Royal Collection, Osborne.

Even a marble bust presented problems and Adams-Acton nearly had to postpone his wedding after injuring himself lifting one single-handed on to a pedestal, having watched three men trying to lift it in vain. 'Only sheer force of will enabled him to struggle to his wedding with one side of his body strapped up.'[57] It is possible to speculate that such exertions weakened Patric Park's constitution; he died aged forty-four at Warrington railway station where he had burst a blood vessel in trying to help a porter to lift a heavy trunk.[58] And when all else had been accomplished, it was possible for there to be a flaw in the marble undetected until work started on it; though infrequent this would cause additional expense which the patron could be asked to guarantee.[59]

Once the block of marble was installed in the studio, the design was transferred in three dimensions from model to final material. This was usually done with a pointing machine, a device consisting of a steel needle calibrated to a fixed axis which would transfer measured three-dimensional points set out on the plaster model on to—or rather into—the marble block. That is, you would drill a series of measured holes into the marble block. Depending on which type of pointing machine you had, this could be done either on a one to one basis, or from a small model to a large block, or from large to small. A photograph of Alexander Munro's studio shows *Another Reading* in plaster and marble side by side, with a pointing machine dimly visible behind (plate 60). Another illustration, a drawing, shows E. H. Baily's *Nelson* (for Trafalgar Square) in a studio at an advanced state of execution (plate 61). The final version, in two halves, stands adjacent to a small model, similarly divided; there is though no sign of a pointing machine. The transfer of a design to a small scale was required in the reproduction of a work in Parian Ware or ivory and this was done by various Reducing Machines. An example of one of these, Cheverton's Patent Reducing Machine, is in the collection of the Science Museum, London and its illustration[60] shows what it was designed to achieve.

To return to the work being executed: once the measurements in three dimensions had been transferred to the block, workmen, either professional stone carvers or aspirant

63. Thomas Woolner, *Mother and Child/The Lord's Prayer*, 1856–67. Wallington Hall.

62

64. Thomas Woolner, *Lord Tennyson*, 1857. Cambridge, Trinity College.

65. Thomas Woolner, *Lord Tennyson*. London, Westminster Abbey.

sculptors employed as studio assistants, would then cut away the marble until the measured points were reached; carried out all round, this would result in a rough-hewn version of the original form. Then either a higher grade of carver or the master sculptor himself (the initial hewing-out stage could presumably be carried out by a single skilled craftsman to a point of greater refinement, and a less prosperous artist would presumably be prepared to do more of the actual cutting of the later stages) would begin to carve the finer details; until, at the end, the sculptor himself applied the finishing touches, particularly the final surface treatment. With reference to the Trevelyan group, Woolner wrote: '. . . there have been until lately two carvers constantly employed from early till late at night; but of late the fine part has come on so that only the fine hand is allowed to touch it.'[61] Obviously the sculptor would remove at this stage all traces of the mechanics of pointing and so on, so that their survival is most exceptional. Eduard Müller's *Venus and Cupid* or *Innocence in Danger* (plate 164), in the Royal Collection at Osborne, does seem still to bear marks at certain crucial contour points, for instance, along Venus's arm (plate 62). One might hazard an explanation for this in the lamentable circumstances of the work's commission—Queen Victoria intended it for Prince Albert's birthday present in 1862, but the Prince Consort died before the work was completed, having seen only a photograph of it. So there may have been some hurry to finish it, especially as it was to go on show at the International Exhibition of 1862 in London, a fitting tribute to the Prince's patronage of sculpture in the midst of what had become in itself his massive Memorial.[62]

The Woolner work referred to (plate 63) is in fact a case in point where we have a detailed cost analysis, by the artist, taking into account the whole range of factors involved. For the group, Woolner claimed he should properly charge £2000, that is, twice the standard professional charge (he claimed) for an ordinary life-size portrait statue. Simply in terms of cost to himself he reckoned the group at £600—expense of marble

£150, preliminary work £350, and charges for models and casting £100—and this was without charging for his own time. This latter was problematic with a large work of some formal complexity: it took a long time to execute in all its stages, particularly if there were delays (as there sometimes were) in getting suitable marble; the money, even if paid in stages as and when it should be, would not come in soon enough to maintain the artist. Thus to mitigate the added financial problems a work of this size inevitably gave rise to, the artist was obliged to take in smaller commissions (such as busts) which he could execute fairly promptly and get paid for; but this in turn set back the completion of the larger work still further. The Trevelyan group in fact took eleven years from commission to final delivery, and although he stated, as mentioned, that he should properly charge £2000, Woolner informed Sir Walter he was prepared to settle for £1500—which is what he got.[63]

66. John Henry Foley, *Innocence* (Copeland ware, 1847). Royal Collection, Osborne.

The existence of phenomena essential to the process of sculpture making such as original models and pointing machines meant that replicas were always possible and these could obviously be a means of earning extra money. The straight replica, size for size, is known for all types of work. John Warrington Wood's biblical figure of the Israelite Maid who waited upon Naaman's Wife[64] occurs in the church of Sts Peter and Paul, Ormskirk, signed and dated 1873, and in a monumental mason's showroom in Carlisle, this latter version having come from the vicinity of Warrington, Lancashire in the later 1930s. The original marble version of Woolner's bust of Tennyson of 1857 is at Trinity College, Cambridge (plate 64); one marble replica originally executed for Charles Buxton is now in the Museum and Art Gallery at Ipswich, and another, originally executed for Charles Jenner, is now in Westminster Abbey, London (plate 65). These were all executed by Woolner himself (a further replica, in the National Portrait Gallery, London, was executed in 1893 by Mary Grant from the plaster then belonging to a Tennyson son),[65] and there is no reason for casting aspersions on their status as original works of art, particularly once some understanding of the Victorian sculptural world, with the degree of mechanisation and industry that was an essential part of its character, has been acquired.

A further field of replication, and indeed another means of income for the sculptor, lay in multiple reproduction at a reduced scale in bronze or ceramics. A specific type of pointing machine was used such as the Cheverton Reducing Machine mentioned earlier, by which the original figures and busts could be reproduced at a reduced scale to form the model from which moulds would be made for mass production. This was a particular concern of the Art Unions, particularly the London institution, who would distribute these objects as prizes among their subscribers. What they did was to acquire reproduction rights of specific works from the artist, rather like publishers of engravings with paintings: thus for *Innocence*, first shown at the Academy in 1839, Foley was paid 100 guineas by the Art Union of London, and they produced this in 1847, manufactured by Copeland (plate 66).[66] At the Great Exhibition of 1851 the London Art Union exhibited twenty-four works in this form,[67] and it produced others in bronze, Foley's *Youth at the Stream*, first exhibited in 1844, being produced as an Art Union bronze in 1860 (plate 67). This was clearly a flourishing industry for some sculptors; the principal ceramic firms such as Doulton, Minton and Wedgwood in turn all produced ranges of Parian and other reproductions,[68] and among the sculptors represented were Cumberworth, Joseph Durham, Alfred Gatley, John Macbride, William Calder Marshall, Matthew Noble, John Thomas[69] and many more. John Bell produced extensively in this medium, and at one point he was even commissioned to work directly for it—this by Summerly's Art Manufactures under Henry Cole.[70] The whole industry was clearly geared to a market which could not afford or could not fit in to domestic premises of limited-scale original works by the sculptors.

67. John Henry Foley, *Youth at the Stream* (Art Union bronze, 1860). Private Collection.

CHAPTER FOUR

Practice and Ideology

This account of the sculptor's working life has so far related mainly to its practical aspects, and particularly to procedures of execution. But certain features already mentioned have further practical and ideological ramifications that affect the whole nature of the art, the way we relate to it and, more importantly, the way it was seen and considered at the time. This is particularly the case with the question of the structure of the studio, and how far the extensive use of assistants qualified considerations of originality, assuming that this is a concept applicable to sculpture in the somewhat purified, individualised interpretation of a single individual being solely responsible for the execution of a work of art in all its stages.

The evolution of the work could be seen in poetic terms. Mrs Adams-Acton described the Italian view of the three stages of sculpture as Life, Death and Resurrection: the clay is the artist's creation; the plaster-work is purely mechanical; then comes the marble, first measured by instruments from the plaster on to the rough block until the Creator's work reappears, and the sculptor again takes it in hand to breathe life into it and turn it into a finished work.[1] This basic idea has been attributed to both Canova and Thorwaldsen[2] but if English sculptors thought like that, they did not record it.

Some were certainly much more concerned with the question of how far the finished work was the work of the artist himself rather than his assistants. Woolner when feeling he had been unjustly treated would cast aspersions on Noble's works: 'a person who never touches the work that goes under his name.—This is true, for I know the sculptors who do his work'[3]; whereas he himself, so his daughter assures us, carved every work finally himself—'the surfaces of all his marble sculptures show the work of his own hand'.[4] The question of the role of the studio assistant and how far he contributed to the final work was the fundamental issue in the libel case of *Belt* v. *Lawes* that lasted with intermissions and an appeal from June 1882 to March 1884.[5] The original libel claimed that all works supposedly by the sculptor R. C. Belt and executed between 1876 and 1881 (including among these was the statue of Lord Byron in Park Lane, London (plate 218)) were in fact either by Thomas Brock or Pierre François Verhyden who had been Belt's assistants during these years, and that Belt, in claiming these as his own, was actively practising deception. To which Belt not unnaturally took exception.

Questions that arose during the case included whether Verhyden used to hide in Belt's studio while sitters were there, observing them unobserved so that he could come out at night and work on their busts, and whether, when visitors arrived unexpectedly at the studio, Belt forced Verhyden to leave the studio through a trapdoor. And what about the money Belt allegedly handed over to Verhyden on a bench in Hyde Park at night? What was it for? At one stage a messenger brought in a bust which was supposed to be of Miss Nelly Plimsoll; but when the work was uncovered it turned out to be a melancholy bronze bust of Lord Beaconsfield—'some merriment was here produced'.[6] Belt in the end won the case, and a factor that would seem to have carried some weight was that there was no

legally prescribable limit to the extent of the assistance that a studio assistant could contribute before being able to call a work his own. This was obviously hard for the aspirant artist (as opposed to the contented craftsman), particularly in a case such as Watson's where a combination of personal 'heterodoxy' (as his biographer puts it politely, to cover self-will and rudeness)[7] in conflict with market ignorance and apathy, forced on an undoubtedly gifted artist years of artisan subservience. It was perhaps an ironic justice when Palgrave singled out Behnes's statue of Dr Babington in St Paul's Cathedral, London, for praise. 'The head has that impressive air of truth above spoken of, and the modelling (although much has here been lost by unskilful carving) is at once grand and delicate' which is not surprising since portrait features were what Palgrave and others considered to be Behnes's particular gifts. But Palgrave also praises the drapery which, unusually for Behnes, 'though not carried far in realization, is beautifully and, on the whole, truthfully treated'.[8] And it was just for this that Watson was taken on by Behnes, his biographer detailling the statue of Dr Babington as one on which Behnes worked on the head, and Watson on the remainder.[9]

The general situation in which studio assistance became not just a natural, technical necessity, of potential advantage to a trainee, but a positive limitation to the art of sculpture generally, was blamed, for instance by Palgrave, on the scale and nature of the studio operations of Chantrey: though unable either to mould the human form or to carve his marble (and so, of necessity, having to employ assistants), it was Chantrey who, Palgrave held, established a system of manufacturing for effect which brought him the enjoyment of a thousand fashionable patrons.[10] This is perhaps a little unfair on Chantrey, one of whose virtues was held to be the technical ability to finish the marble in such a way, with his own hands, as to render the flesh at least several stages nearer vitality than was common in the predominant neo-classical school of his time. And if we are practically minded, as undoubtedly Chantrey was, it is easy to see how this would appeal to a patron. And if we were to be, for a moment, even less idealistic and tender-minded, and appreciate that a sculptor must, after all, earn a living, and if for a moment we were, without actually becoming Marxists, to allow that the economic conditions of an expanding market in sculptured likenesses would enable an artist such as Chantrey with his particular gift to do extremely well professionally—he was a hard-headed Northerner and made a large fortune which he left to the nation which still enjoys its benefits—after all this, we might see that there were forces of taste, patronage and personnel scarcity at work on the market that brought about the apparently unsatisfactory situation regarding studio structure.

The issue of personnel scarcity is not introduced lightly and ties in with the qualification 'apparently'. If we grant that there was a sudden upsurge in demand for portrait sculpture for a number of reasons: for instance, because taste was conditioned by the neo-classical movement increasingly to favour busts (of which there were a lot of ideal antique prototypes); or because of an increase in the number of memorable heroes from the Napoleonic Wars; or again because of the extension of political awareness and power to a relatively larger section of society—if we grant these factors, how could the relatively meagre number of sculptors that the eighteenth century had found adequate for their much more limited purposes possibly cope with this sudden increase in demand, other than by taking in large numbers of assistants and setting up what was virtually a production line? Moreover, in doing this, they were doing sculpture a great service, for they provided, by the training that assistants could receive in the studio, the next generations of sculptors who were to bulk so largely in the Victorian era. For there is little doubt, as we have seen, that in spite of the reservations of some critics, which were in any case largely aesthetic, in the mid-Victorian period sculpture could be said to have ranked virtually as an industry.

The role that working as an assistant in a studio fulfilled in the practical education of the aspirant sculptor far outweighed any injustices that the system, possibly inevitably, produced. The function of the Royal Academy in this respect was almost universally acknowledged to be inadequate. In evidence given to the 1863 Royal Commission of Enquiry into the State of the Royal Academy, all sides were critical. Morton Edwards, Honorary Secretary to the Society of Sculptors, which was founded specifically because sculpture was not represented in the Academy as it ought to be, held that there was little accommodation for students in sculpture at the Academy and that it attached too much importance to the annual exhibition and too little to teaching;[11] and he made various suggestions for improvement in this respect. Thomas Woolner, at this date still unrecognised as an establishment sculptor, but a former student at the Academy, stated in his evidence that there were not sufficient opportunities for study: the schools were only open about half the year, the living model ought to be more easily accessible, and sit all day as well as every night.[12]

Within the Academy too there was some criticism. Foley, an Academician, but also an independent figure, respected by all sides, was generally satisfied with the system, as such, of teaching at the Academy, but he thought there had not been enough sculptor visitors hitherto, resulting in insufficient instruction,[13] and he thought the closing of the schools during the annual Exhibition a serious drawback, perhaps more so to sculptor students even than painters.[14] He also made a number of suggestions for improvement in sculpture instruction.[15] Richard Westmacott, by then Professor of Sculpture at the Academy, even so had some reservations. He thought the small number of sculpture students was attributable to the defective system of teaching in the Academy[16] and that, though sculptors were beginning to derive greater advantage from the antique school, the life school, which was even more essential to the study of sculpture than of painting, was badly attended.[17] Woolner's testimony gives one reason why this was so—the limited access to and availability of the living model.[18] Westmacott thought the system of visitors in the life school was what needed improvement;[19] Foley thought this was already under way, with a new arrangement having been adopted, with one-third of the visitors being sculptors.[20]

The effect of this, if beneficial, would not necessarily be apparent immediately nor would it necessarily be enough. Westmacott's successor as Professor of Sculpture, Henry Weekes, in his seventh lecture is still concerned:

> I am aware that the encouragement given to the Art is small; that there is but little Sculpture-teaching during the year; that the rooms, owing to the seats for the painter-students being fixed, and so preventing that close access to the model necessary for the worker in clay, are inconvenient; and that gaslight is less suitable for the proper carrying out of Form than daylight.[21]

Moreover this discouragement of practical tuition, which could only be carried on in the schools 'with the modelling-tool in hand, and the clay to operate upon' made his task of theoretical exposition even less effective.[22]

To all intents and purposes, therefore, it was in the studio of an established sculptor that the most effective method of training was to be found: there was no adequate alternative for the acquisition of technical experience, and there were added advantages and benefits both immediate and long-term by which, notwithstanding the taint of subservience which could be read into the initial situation, the industrious apprentice could profit as a professional.

Some artists had a succession of pupils whose subsequent success and sheer number must imply a certain *je ne sais quoi* about their studio training. Edward Hodges Baily, himself a favoured pupil of Flaxman (the major figure in British sculpture in the decades either side of 1800) had a succession of assistants who later did well, including Musgrave

Lewthwaite Watson (1804–47), William Theed junior (1804–91), William Calder Marshall (1813–94), Joseph Durham (1814–77), Edward Bowring Stephens (1815–82) and Alfred Gatley (1816–63).[23] William Behnes had through his studio such subsequent stars as Musgrave Lewthwaite Watson, Alfred Gatley, John Carew, John Graham Lough, Henry Burlowe, Henry Weekes, Henry Timbrell, Neville Northey Burnard, Edward and John Henry Foley, Timothy Butler and Thomas Woolner. Some died young, and the merits of the others might vary, but all featured prominently in the sculptural history of the time. Palgrave wrote of Behnes: 'Those who knew him speak strongly as to the openness with which he gave instruction to others, and describe his studio as the last in which the old system of frank tuition was practised.'[24] While we should view the latter statement with some reservation, granted Palgrave's total antipathy to what one might call the increase in industrial sculpture making, and while indeed his tribute is hearsay and unattributed; while too the status of such lists of pupils is obviously dependent on what knowledge has survived to be available today; and while the historical situation whereby an expanding market required an increase in artists clearly required such an assembly of pupils, the evidence simply of number and professional success gives leave for some such assumption of studio pre-eminence. Other artists took in pupils that we know of without success being guaranteed: John Henry Foley had Thomas Brock, Mary Grant, G. F. Teniswood, Samuel Ferris Lynn, George Mossman, F. J. Williamson, Albert Bruce-Joy, C. B. Birch and others[25] (not least both plaintiff and defendant in the *Belt* v. *Lawes* case!) but among these Brock is exceptional for later (professional) prominence. Some artists simply did not take pupils, so the absence of lists of eminent pupils cannot be taken to reflect necessarily any studio inadequacy. Adams-Acton would never take them, considering it would be too great a bore and a waste of valuable time. The painter Millais counselled him otherwise: 'just put your pupils in a corner in one of those downstairs studios, give them a lump of clay, and then every time you pass them give them a kick!'[26]

Even if there was nothing special about the training received in a studio, it did at least provide a living for a beginner in what as we have seen was a financially difficult not to say perilous profession, and this was why most aspirants underwent such an experience. Weekes acknowledges as much in his lectures: 'I am aware that many, perhaps most of our young men, are obliged to earn their bread during the daytime by working in the *ateliers* of others';[27] and R. C. Belt, when Foley's pupil (briefly), had received £1 per week.[28] Sometimes, of course, the system even at this basic level did not work satisfactorily. When Musgrave Lewthwaite Watson first arrived in London, he was repeatedly urged by his brother artists to join a studio 'where work was to be had' and where his services could be appreciated.[29] At first he was fiercely independent, saying he was his own master and meant to be so; but soon his financial situation became so desperate that he called at Chantrey's studio with some drawings, asking for work. Cunningham, Chantrey's chief assistant, examined these and the following day engaged him as a modeller. While with Chantrey, Watson received an offer, which he accepted, to work for Sir Richard Westmacott, and for a time he worked for both, giving he claimed eight hours each day to each studio. Though Chantrey paid him tolerably well, Watson did not think it was enough, and put in for a rise. Cunningham supported him in this, but Chantrey refused, so Watson quarrelled with Chantrey, calling him mean, and as he left the studio he said to Cunningham: 'Nobody but a Scotchman would work for so parsimonious a fellow as Chantrey.' For a time after this he worked on his own in a friend's studio, then he came to the attention of Behnes, who asked him to come and be his assistant, which Watson did. But although Watson made his mark on the work of the studio while he was there, and Behnes rested much on his counsel (we are told), Behnes did not actually say anything about more money, so once again Watson felt he had to leave. He did rather better this time, working for E. H. Baily, for better pay, and

eventually he managed to set up on his own. But the effect of his having to spend the first ten years of his life in London hawking his talents around as a studio assistant contributed to the generally rather inequable nature of his temperament.[30]

This, in turn, would not have helped his professional advancement. For another advantage of working in a studio was the opportunity to make the social contacts that were almost essential for a satisfactory career in that they could be the means of attracting patronage. The important sources of social contact were visitors to the studio, and visiting studios seems to have been a regular social event. It had been common in Rome at the time of Thorwaldsen and certainly featured at the Adams-Acton studios: 'Society people, knowing nothing about Art, would come crowding to the studio in constant succession, making ridiculous remarks. . . "Do you know how many studios I have visited today? And yesterday I did sixteen!"'[31] The more serious visitor was of course the potential patron; he did not necessarily commission at once—Joseph Neeld only expressed a wish to possess a statue by Gibson 'at length', after he had often visited his studio.[32] Here once again the role and function of the sketch or more particularly the original model comes into play, with the physical presence of these objects conditioning the wary but interested patron. But from the social point of view Watson's touchy nature and tendency to rudeness would not have helped; we are told of the lengths to which he would go in order to avoid unwelcome visitors, and one final laconic letter to someone who pestered him ran: 'Sir, I hate you.'[33] In contrast, a most spectacular instance of professional advancement through social contacts at work was the case of John Thomas,[34] engaged by the architect Sir Charles Barry to be chief stone carver for the architectural sculpture at the Houses of Parliament in London. Thomas, who was basically a glorified stone-mason, here attracted the attention of such patrons as Prince Albert (Chairman of the Royal Commission to encourage the Fine Arts during the rebuilding of the Houses of Parliament) and Sir Morton Peto (for a time the chief contractor for the rebuilding works) and for them he subsequently executed works of architecture, architectural sculpture and 'art' sculpture.

With this social emphasis a general education, quite distinct from a professional training, was considered important for a sculptor, though it was clearly not essential. We are told of John Henry Foley: 'Even if he had been illiterate he would not have been altogether an exception among sculptors; for some, even of eminence in the art, were uneducated, and one of the very greatest in our own day could hardly write or spell.'[35] Weekes told his students: 'I wish you to be thinking men' and held out Flaxman to them as exemplar, as one who studied Plato in the original language.[36] He did not insist on this, but made the point that translations of the classics and of treatises on other subjects made a lot of material available to non-specialists. This wider education to which the students should aim was not directed just to a knowledge of the higher ideals and philosophy of art, but should be of a more general application, of practical advantage in particular to portrait sculptors. They must converse with their sitter, draw him out, get him to show himself in his natural habit and manner.[37] 'He comes, you must recollect, to your studio generally with a prejudice against sitting as a tedious process, and if you can while away the hour so as to make him forget what he is about, he will be agreeably surprised, and be more likely to recommend others to undergo the same.'[38] Variations were of course possible: Adams-Acton got his wife to entertain his sitters so that he could obtain a natural, animated expression when modelling their faces.[39]

In addition to the practical and social benefits that could arise from working as a studio assistant, and which were to a certain extent available to whoever was inclined to take advantage of them, outstanding pupils or assistants stood a good chance of inheriting specific commissions at the master's death, in addition to any general mantle of artistic endeavour. In practical, business terms, if a sculptor died with commissions in hand, they

68. John Henry Foley, *Prince Albert*, 1868–74. London, Albert Memorial.

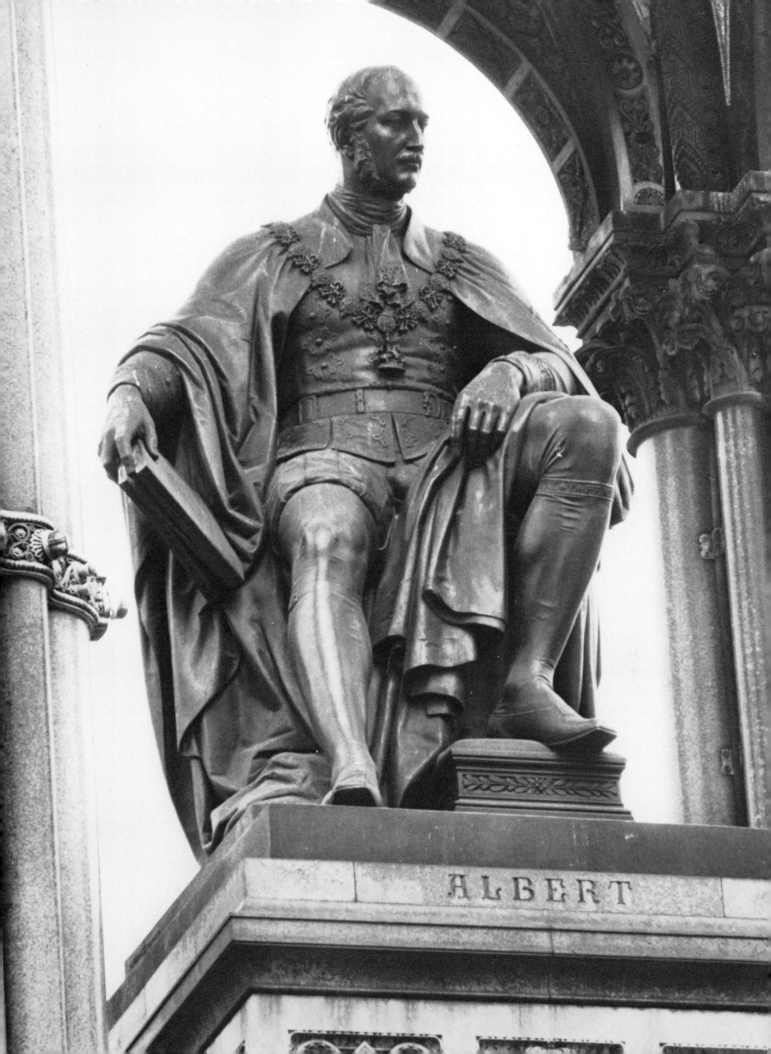

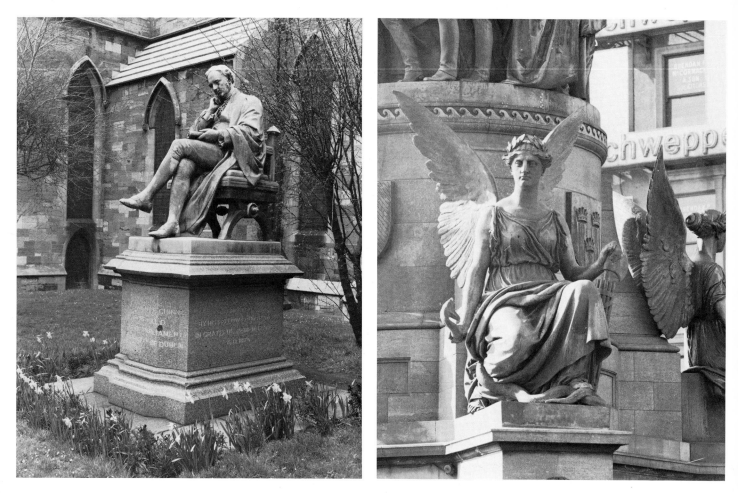

69. John Henry Foley, *Sir Benjamin Guinness*, 1873. Dublin, St Patrick's Cathedral.

70. John Henry Foley and Sir Thomas Brock, detail from the O'Connell Monument, 1866–83. Dublin, O'Connell Street.

71. John Henry Foley and Sir Thomas Brock, The O'Connell Monument, 1866–83. Dublin, O'Connell Street.

needed to be completed and this would be a source of income and prestige to the lucky inheritor. When Foley died, he had a large number of works awaiting completion; these had built up over the last years of his life when in spite of his poor health his reputation was such that work continued to come in. His technical executors were G. F. Teniswood and Thomas Brock, both pupils of his. Teniswood supervised the completion of the figure of Prince Albert for the London Albert Memorial (plate 68): the model for this was completed at the time of Foley's death, and the head and hands cast in bronze and chased under the sculptor's supervision. Teniswood was responsible for overseeing the casting and chasing of the remaining parts of the work.[40] It was Brock though who inherited responsibility for the majority of the uncompleted commissions. For the statue of William Rathbone (Sefton Park, Liverpool), for which Foley had completed the model, Brock supplied the base reliefs and supervised completion;[41] he oversaw the completion and installation of the statue of Sir Benjamin Guinness (plate 69) (now outside St Patrick's Cathedral, Dublin).[42] Foley had worked on the full-size model for the equestrian *Viscount Canning* (destined for Calcutta), had completed a small model for *Viscount Gough* (Dublin) (plates 41, 44) and started the full-size model; Brock finished off both works, replicating for the equine part of *Vicount Gough* the horse of *Viscount Hardinge* (plate 3).[43] The major work that Brock took over was the O'Connell monument for Dublin (plate 71) and then only after some deliberation and delay on the part of the Memorial Committee. At Foley's death the Committee sought Counsel's opinion as to their legal position over the uncompleted monument. Counsel advised that if all the artistic part of the monument was completed by the hand of the sculptor and all that remained to be done was purely mechanical, the contract had in fact been fulfilled. Representatives of the Committee visited Foley's studio to determine whether that part of the monument left uncompleted was artistic or mechanical. The statue of O'Connell standing thirteen feet high was

72

finished apart from the boots; and Foley had put the finishing touches to the head a few weeks before he died. (These references are obviously to the full-size model.) The drum with its fifty figures (plate 189) was also complete with the exception of the 'underclothing' of some of the figures; but of the four winged Victories (plate 70) only the heads had been executed by Foley. In the best interests of both Art and Mechanics the Committee decided the contract should stand, and a contract was signed with Brock in June 1878. The figure of O'Connell was installed on 4 August 1882, and the fourth and final Victory figure on 21 May 1883. Foley had been paid £2,000 for his work, and Brock was paid £10,500 for his contribution, which presumably included the cost of casting.[44] There can, I think, be little doubt that such extensive experience with public monumental work stood Brock in good stead in his subsequent career; though commissions originally intended for Foley went initially elsewhere—Woolner, for instance, obtained *John Stuart Mill* (London, Thomas Embankment)[45] and *Queen Victoria* (Birmingham) (plate 72),[46] both in default of Foley, Brock's own career in this area of work began shortly after he finished most of the Foley *nachlass*: *Robert Raikes* (London, Victoria Embankment Gardens) was unveiled in 1880, *Bartle Frere* (London, Victoria Embankment Gardens) (plates 73, 409) in 1888, and these are only early examples in a whole series between the 1880s and the 1920s of which the climax was the London Victoria Memorial (plates 459–64), for the execution of the sculpture of which Brock was knighted on the spot in 1911.

What was probably an unofficial single instance of inheritance involved another pupil of Foley's, Albert Bruce-Joy (1842–1924), a native Irishman. Before his death Foley had completed three statues of eminent physicians for the Royal College of Physicians,

73 (left). Sir Thomas Brock, *Bartle Frere*, 1887. London, Victoria Embankment.

74 (centre). John Henry Foley, *William Stokes*, 1874. Dublin, Royal College of Physicians.

75 (right). Albert Bruce Joy, *Robert James Graves*, 1877. Dublin, Royal College of Physicians.

72 (facing page). Thomas Woolner, *Queen Victoria*, 1883. Birmingham, Council House.

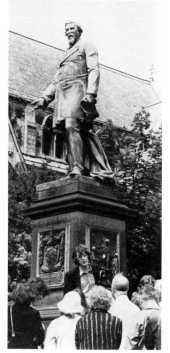

76. John Birnie Philip, *Edward Akroyd*, 1875. Halifax, Akroydon.

Dublin: *Sir Henry Marsh* (signed and dated 1866), *Sir Dominic Corrigan* (signed and dated 1869) and *William Stokes* (signed and dated 1874) (plate 74). A fourth, *Robert James Graves* (plate 75), was executed by Bruce-Joy (signed and dated 1877), but this may also be due to his having some family connection with the college, which has a bust by A. Bruce-Joy of one William Bruce Joy.

A transparent attempt by a chief assistant to inherit not only the jobs but the mantle of a sculptor took place at the death of John Birnie Philip in 1875. His widow, the proprietor of his studio, issued a leaflet[47] in October 1875 stating:

> Mrs. J. B. Philip has arranged to carry on the Studio of her late Husband, Mr. John Birnie Philip, under the management of Signor Fucigna, for many years Mr. J. B. Philip's Chief Assistant Modeller. In proof of the ability of Signor Fucigna, attention is directed to the annexed testimony of Mr. W. Calder Marshall, R.A., Sir G. Gilbert Scott, R.A., Mr. John R. Clayton.

Works begun by Philip, left unfinished at his death and since completed at the Studio are listed: the 'Model of a Colossal Statue of Colonel Akroyd, Halifax, now being Cast in Bronze' (still at Halifax (plate 76));[48] nineteen 'Colossal Heads' for the Home Office; an 'Angel in Statuary Marble' for a Mortuary Chapel, Dumfries and others. Works wholly executed since Philip's death are also listed—a reredos and pulpit for Lightcliffe Church, a font for St Augustine's, Halifax, and a statuette of St Cecilia and a figure of St James. Then follows the testimonial:

> We have inspected, at Merton Villa, King's Road, Chelsea, several original Models executed by Signor Fucigna, comprising colossal Heads, a sketch for a Bas-relief for the Reredos of Lightcliffe Church, Halifax, and a Classical Figure; and we are of the opinion that he is an able Modeller and Sculptor, and fully qualified to complete the commissions left unfinished by the late Mr. J. Birnie Philip at the time of his death, and to carry out the work of the Studio.

This is signed by Calder Marshall, a prominent Academician sculptor, Gilbert Scott, a foremost architect, and John Clayton, a leading Art Manufacturer. And while it was clearly of some concern to Philip's widow that his works should be completed, the main aim of the operation was to set up Fucigna in a similar line of business beyond the completion of his master's works.

These examples of studio assistants are very much instances of those who subsequently made the grade. But the hierarchy of studio assistance was more elaborate. Birnie Philip's address book,[49] also part of his *nachlass*, lists among a wide variety of names and occupations people content to remain at a lower level and specialise there: stone carvers, plasterers, figure carvers, carvers in wood and stone, and plain carvers. They were at least established at this level, but it is clear that class distinctions were in operation, and were particularly strong at the mechanical end of the business. When Watson declared his wish, aged sixteen or seventeen, to be an artist or sculptor rather than a lawyer as his family planned: '. . . his mother and aunt were indignant at the idea of his becoming a poor artist, and a disgrace to his family name. The Lewthwaites had as high a bearing and quite as much pride as the Watsons, so that artisanship and masonic-like work could not be reconciled with their self-dignity as money and land possessors.'[50] Watson of course managed eventually to transcend this class barrier and his family in any case were identifying the profession as a whole with its more menial manifestations. But the sense of the artisan (which is what in effect many studio assistants would have been) as the proletariat of the profession is what lies behind the troubles retailed in Woolner's *Pygmalion*, where the 'statue men' are troubled by the excellence of what an 'artist' can do.[51] There is evidence elsewhere of resentment at class discrimination within the

77. Robert Glassby, *Sir Joseph Edgar Boehm*. Royal Collection, Windsor Castle.

profession. This was certainly true in an area such as architectural sculpture which the 'finer' sculptors usually considered the preserve of mechanical carvers, employed by firms who provided ornamentation for buildings at so much a square yard. Baldry, writing in 1902 of 'quite recent times', says such work was classed as stonemason's work, and an artist working in this area was treated as altogether outside the pale of respectability.[52]

Some would seem however to have been quite content with these distinctions. Woolner was not afraid to be photographed sitting with 'his men',[53] and some quite competent artists were prepared to stay on in the status of assistant. Robert Glassby (1835–92) began as an apprentice mason at Doncaster, then moved to Hadfield's marble works in Sheffield where he also attended evening classes at the School of Art under Young Mitchell and Godfrey Sykes (both associates of Alfred Stevens). In 1860 he went to study in Paris, then

became assistant to Birnie Philip, whom he helped to carve the marble reliefs on the Albert Memorial. He then moved on to be assistant to Henry Weekes, then later to Baron Marochetti, at whose death in 1867 he was commissioned to complete unfinished works such as the recumbent effigy of the Prince Consort for the Royal Mausoleum at Frogmore. In 1870 he entered the studio of Boehm and continued as his principal assistant until Boehm died in 1890 (plate 77); Glassby succeeded Boehm as Sculptor to the Queen. He certainly executed works independently (*Cupid* and *Satan* were once in the collection of the Mappin Art Gallery, Sheffield); nevertheless for nearly thirty years he was prepared to occupy a subservient position in other sculptors' studios, and perhaps only his proximity for twenty-five years to the social heights of the Royal Circle offers any convincing explanation for such sustained lowliness.[54]

Whether such class discrimination applied to women as sculptors is hard to determine. There were certainly very few women sculptors that are known of, but then the physical problems of sculpture were considerable, and Roscoe Mullins pinpoints this as a problem for women. In the field of the art of carving, he thought women, from their slighter physique, were placed rather at a disadvantage, because the practice required a firm grip of the tool, and strength of arm and wrist, to ensure good execution.[55] He reckoned the problem could be overcome by women getting the marble work done for them by workmen or assistants. But the problem here, of course, as we have seen, was that it was usually only by training as such an assistant, i.e. by doing the hard labour and the donkey work in the studio, that a sculptor could receive the technical training and develop into an independent figure. And it is perhaps significant in this context that of the few women who did make the grade as sculptors, one, Mary Thornycroft (1814–95) was the daughter of a sculptor, John Francis, and married a sculptor, Thomas Thornycroft (1815–85), who was studying in Francis's studio; and another, Mary Grant (1831–1908) was the niece of a President of the Royal Academy, Sir Francis Grant: both therefore would have started out in a professional artistic milieu which could ameliorate any natural disadvantages. Perhaps the ease with which these two did slip into an otherwise virtually all-male preserve explains the absence of a distinctively feminine character to their work; certainly neither was a match for the much more spectacular eminent American women sculptors, such as Harriet Hosmer or Edmonia Lewis; the latter, half Indian and half Negro, only took to sculpture after a varied career that included being tried and acquitted for the murder of two of her closest friends, fellow students with her at Oberlin College, who had been mysteriously poisoned.[56] Mid-Victorian England had nothing to offer like that.

CHAPTER FIVE
Patronage

OPPORTUNITIES

The preceding description of the sculptor's life—how he set about his career and executed his works—should have demonstrated, if nothing else, that to overcome the practical, material and conceptual limitations of the art, it helped to have a patron. Patronage was the pivot of the sculptor's profession, and the means of attracting it were various. We have seen that visits to studios could be productive, and private lobbying was possible, though if successful it would invariably seem to the unsuccessful like 'fixing', or 'jobbing'. Woolner wrote to Lady (Walter) Trevelyan in March 1862, asking if she would do him a good turn with Lady (Charles) Trevelyan: what Woolner wanted was for Lady Walter to ask Lady Charles, if she liked Woolner's style of art (as he thought she did from a visit she paid to his studio), to express herself emphatically in his favour to the committee that was to choose the sculptor for Lord Macaulay's statue at Cambridge; they would, many of them, Woolner had heard, be decided by the wishes of Sir Charles Trevelyan and his wife, who were Macaulay's brother-in-law and sister and, in turn, related to Sir Walter[1] (Sir Walter and Sir Charles were cousins). Woolner did get the commission (plate 78), though by what means is unrecorded; he had also clearly been lobbying Sedgwick to the same purpose.[2] In another letter to Lady Trevelyan (date uncertain) Woolner wrote:

> I enclose a list of Gods of Judgement, so far as Government Art dispensation is concerned, and if by any means Sir Walter or you can give me a push forward in the matter of Cromwell's statue, why it will be a gigantic service to me, and perhaps some little use to art in its present public state. What I want is, that if ever the Government determines on having a statue of the Protector in the Palace of Westminster that I may obtain the promise of its execution. . .[3]

Woolner was not alone in this type of lobbying. Another instance can be found a generation later: in 1894 James Nesfield Forsyth wrote to a Mrs Fraser angling for the job of doing a monument to the Bishop of Bath and Wells, lately deceased; she could achieve this for him via her contacts with church people. Miss Elliot had seen a model of his and was much pleased with it; so too had other Bristol friends. This probably refers to Forsyth's effigy of Dean Elliot (†1891) in Bristol Cathedral; Bishop Harvey (†1894) was in fact commemorated by a monument by Thomas Brock.[4]

These three certifiable examples are simply the tip of a vast iceberg of rumour and suspicion extending throughout the period. Marochetti was frequently suspected of this type of behaviour, as was Noble (often by Woolner!)[5] and the public suspicions of jobbery surrounding the commission for the Wellington monument may have contributed to the Government's decision (eventually) to submit it to competition (see below, p. 84). This, of course, was no guarantee of purity. In 1846 a competition was held to choose the sculptor for a memorial statue to Sir Fowell Buxton in Westminster Abbey. One of the five

judges was the painter George Richmond, a personal friend of the sculptor Frederick Thrupp (1812–95), and when the latter received the commission it was rumoured in artistic circles that undue influence had been brought to bear to get his model chosen. These suspicions were not controverted by what was felt to be the low quality of the work. The *Art-Union* called it 'the worst statue of all' and added that 'it is such proceedings as these which disgust our best artists with competitions'.[6]

The other means, probably the principal one, whereby the artist attracted attention to his work and to himself was exhibiting, and there were various types of exhibition. There were a number of individual prestige occasions which, even if they had no specific market potential, were certainly good opportunities for advertisement and publicity. The series of mammoth exhibitions such as the Great Exhibition in London of 1851, the Manchester Art Treasures Exhibition of 1857, the London International Exhibition of 1862, the Leeds Exhibition of 1868, and others like them all over the country, generally included sculpture to some extent, though the variation in its significance was considerable. We have already examined the presence (and relevance) of sculpture at the London International Exhibitions of 1851 and 1865 (see Chapter 1, pp. 25, 29–31); at Manchester in 1857 160 sculptures are listed in the catalogue, of which sixty-two were by foreigners or were pre-nineteenth-century. This compares with over 1,800 paintings by Old and Modern Masters, over 1,200 drawings and watercolours, and nearly 1,500 engravings. At Leeds in 1868 there were only nineteen works by contemporary British sculptors amongst the thousands of paintings, drawings and engravings; these were categorised as part of the Museum of Ornamental Art. Some market transactions could take place on these occasions—Queen Victoria and Prince Albert acquired works at the 1851 Exhibition, for example John Bell's statue *Andromeda* (plate 21), now in the gardens at Osborne House— but on the whole they were rather more formal demonstrations of the art.

The more practically aimed type of exhibition consisted primarily of the annual exhibition at the Royal Academy, London, where in theory at least sculpture was an accepted branch of art. But in practice there was, certainly in mid-century, as much and as widespread criticism of the manner and surroundings in which sculpture was exhibited at the Academy as there was of the Academy's educational practice towards sculptors. From the 1863 Commission it is evident that sculpture was shown for some time in a separate room, and while the number of works sent in was small, they were still too many for the space; they were huddled together rather than exhibited, and although a sculptor undertook the actual physical arrangement, it was difficult to effect anything adequate where the space was unsuitable.[7] In 1856 sculptors both within and without the Academy submitted a petition for permission to exhibit poetical sculpture in the painting rooms; many painters thought it would be very desirable and all the sculptors wished it, but it was turned down.[8] Occasional attempts to improve the space for exhibiting the sculpture were made, but not to any great satisfaction.[9] A consequence of this was that by 1863 sculptors of such eminence as Gibson and Foley, though Academicians and thus automatically entitled to send eight works for exhibition, did not do so. Foley said he never cared to send a work there which he set very much value upon; owing to the situation of the room, the works exhibited were but little seen by visitors, and when seen were seen to a disadvantage. Gibson had by then not exhibited at the Academy for many years, and Foley understood he would never again exhibit there until proper exhibition space should have been provided for sculpture.[10] In fact it would appear that Foley exhibited nothing at the Academy after 1861, owing to a difference of opinion with the Committee concerning the arrangement of his sculpture at that year's exhibition.[11]

Other art societies and institutions exhibited sculpture both nationally and locally; very occasionally one-man exhibitions are recorded but these were probably of no more than two or three works shown in some room hired for the purpose; this was certainly the

78. Thomas Woolner, *Lord Macaulay*, 1866. Cambridge, Trinity College.

THOMAE BABINGTON BARONI MACAULAY
HISTORICO DOCTRINA FIDE VIVIDIS INGENII LUMINIBUS PRAECLARO
QUI PRIMUS ANNALES ITA SCRIPSIT
UT VERA FICTIS LIBENTIUS LEGERENTUR
ORATORI REBUS COPIOSO SENTENTIIS PRESSO ANIMI MOTIBUS ELATO
QUI CUM OTII STUDIIS UNICE GAUDERET
NUNQUAM REIPUBLICAE DEFUIT
SIVE INDIA LITTERIS ET LEGIBUS EMENDANDA
SIVE DOMI CONTRA LICENTIAM TUENDA LIBERTAS VOCARET
POETAE NIHIL HUMILE SPIRANTI
VIRO CUI OMNIUM ADMIRATIO MINORIS FUIT QUAM SUORUM AMOR
HUIUS COLLEGII OLIM SOCIO
QUOD SUMMA DUM VIXIT PIETATE COLUIT
AMICI MAERENTES S.S.F.C.

79. John Henry Foley, *John Hampden*, 1850. London, Houses of Parliament.

80. John Bell, *Lucius Cary, Viscount Falkland*, 1848. London, Houses of Parliament.

case with Lough's first exhibitions: that of 1827 consisted of two statues (*Milo* and *Samson*) in the Hanover Square Rooms, that of 1828 comprised four works—*Milo, Samson, Musidora*, and *Iris waking Somnus*.[12] The case of Robert Forrest (1790–1852) in Edinburgh seems to have involved a one-man show becoming a permanent fixture and tourist attraction: starting with four groups in 1830, by the time he died he had executed thirty groups and statues for his exhibition. But this was in essence little different from a well-organised sculptor's studio available for visiting (see pp. 66, 70, 141), which is what most successful sculptors would rely on, rather than on one-man exhibitions *per se*.[13]

NATIONAL AND LOCAL GOVERNMENT

Competitive exhibitions were the other occasions in which sculptors could profitably participate; these would be held to select designs to fulfil specific projects, often national or local memorials. The 1844 exhibition, held in Westminster Hall, has already been mentioned (see p. 27). This was held under the auspices of the Royal Fine Arts Commission set up to encourage the Fine Arts in association with the rebuilding of the Houses of Parliament in London, burnt down in 1836. In an appendix to their *Second Report* of 1843, the Commissioners gave notice that various statues in bronze and marble of British Sovereigns and illustrious personages would be required for the decoration of the New Palace at Westminster, and artists were invited to send models to be exhibited for the purpose of assisting the commissioners in the selection of sculptors to be employed. Models should be sent in during the first week in June 1844—the specimen or specimens not exceeding two in number might be either prepared for the occasion or selected from works executed within 'five years previous'. Works might be ideal or portrait statues, or groups,

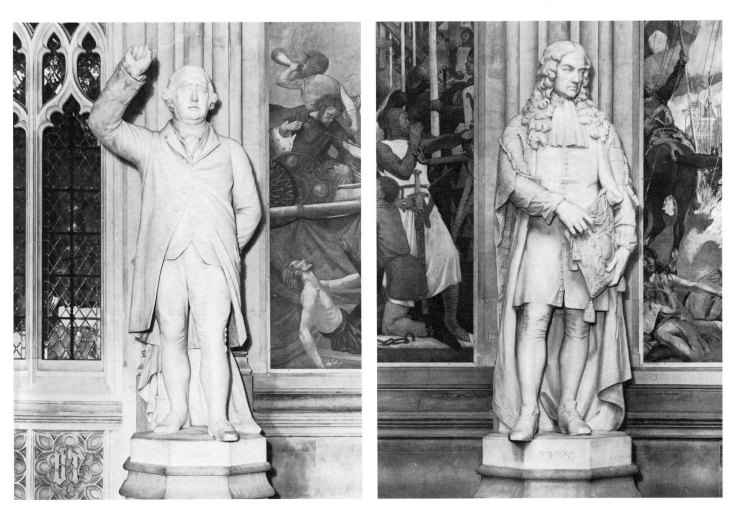

but not *relievi*. Subjects were left to the choice of the artist, materials to be such as were commonly used for models and casts. The competition was confined to British artists and foreigners resident in the country ten years and more. Intending artists should signify the secretary on or before March 15th 1844.[14]

The Commissioners reported on this exhibition in their *Third Report* of 1844. They were satisfied with the evidence of ability displayed by many of the exhibitors, and were prepared to recommend the artists whose names were contained in a subjoined *Report* as worthy to be employed on such works, to be placed in the Palace of Westminster, and for remuneration. The selection did not imply, though, exclusion of other sculptors.[15] In an appendix, the Commissioners stated that they had inspected the models and that the exhibition was highly creditable to the country. But they were not at present in possession of sufficient information, as to the extent to which decorations in Sculpture may be considered desirable in the Palace at Westminster, or as to the time when such decorations might be required. (The Commissioners were in fact having a demarcation dispute with the architect, Barry, who was anxious to have as much of the decoration of the building under his own supervision as was possible.) So the Commissioners for the time being only listed those who had especially distinguished themselves in the exhibition—namely William Calder Marshall, John Bell and John Henry Foley.[16] (Foley's entries had been *Youth at the Stream* (plate 20) and *Ino and the Infant Bacchus* (plate 56), the only works actually submitted that have survived; the form of Bell's *Eagleslayer* (plate 19) at the exhibition is not certain, but judging by the Commissioners' specifications was probably plaster.)

In their next *Report* (1845), the Commissioners were finally able to be more concrete about the end results of the exhibition. They were being forced to concede defeat to Barry

81. Edward Hodges Baily, *Charles James Fox*, 1856. London, Houses of Parliament.

82. William Calder Marshall, *John Somers*, 1855. London, Houses of Parliament.

over the extent of their domain, but could at least take charge of the decoration with sculpture of St Stephen's Porch and Hall; they listed some of the eminent to be commemorated there in twenty-two statues, and proposed to commission the first three—*Hampden*, *Falkland* and *Clarendon* (all three parliamentary heroes of the seventeenth century) from those whose 1844 exhibits had stood out.[17] They finally did so in 1846: Foley got *Hampden* (plate 79),[18] Bell got *Falkland* (plate 80)[19] and Calder Marshall got *Clarendon*;[20] all three were in position by 1852. Further commissions followed: *Selden* went to Foley,[21] *Walpole* (as *Earl of Orford*) to Bell,[22] *Mansfield*[23] and *Fox* (plate 81)[24] to Baily, *Chatham*[25] and his son the younger *Pitt*[26] to MacDowell, *Grattan* to Carew,[27] *Somers* (plate 82) to Calder Marshall[28] and *Burke* to Theed;[29] the latter was in position by 1858, the last of the series to be installed. Whatever the merits of these works (they have been referred to as 'petrified lobbyists'[30]) they are, if nothing else, testimonies to the substantial prestige and achievement that could arise from a competitive exhibition. (For further examples arising from the 1844 Exhibition, see below, p. 90.)

Another major competitive exhibition was that held for designs for the national memorial to the Duke of Wellington, who had died in 1852.[31] Parliament had voted £100,000 for his funeral, and when the expenses of this had been paid, there was some £23,000 left, which it was decided to devote to a national memorial. In the first instance, four sculptors were approached by the First Commissioner of Works (the Government Minister responsible) to submit designs. Of these four, Gibson and Marochetti declined—the latter, it was later rumoured, was hoping he would get the job come what may, via his friends in high places. The other two, Baily and Foley, agreed, and sent in designs. But after some delay, Foley asked to withdraw, inferring from the delay that his design was not suitable. There was no answer from the First Commissioner. Both sculptors then said they would make any modifications suggested. Finally the answer came that the government would be advised not to proceed with the matter; the two sculptors protested, only to be told that the matter was closed, though they could claim for expenses.

This was in May 1855. A year later, the Government announced its intention to erect a monument and that several sculptors would be invited to compete. This brought a strong protest from a group of English sculptors in a letter to the *Daily News*. They objected to a campaign of disparagement going on about the ability of British sculptors, to the possibility that foreigners (i.e. Marochetti) might get the job, and to the overall dearth of opportunity hitherto, the neglect of immense talents and so on. Among the signatories were Baily, MacDowell, Calder Marshall, Foley, Weekes, Woodington and Behnes, all men of some distinction and experience. When the Government issued the terms of the competition a couple of months later, its attitude had modified and opened out somewhat. Artists of all nations were invited to submit designs (not just a limited number of sculptors, as in May); quarter-size models should be constructed and sent to Westminster Hall by June 1857 for an exhibition to be held in July. Nine prizes would be awarded.

Eighty-three models were submitted from England and abroad and the nine prizes were awarded: first to Calder Marshall, second to Woodington, third to E. G. Papworth, fourth to Giovanni Dupré (of Florence), then five equal fifth prizes to Messrs Folcini and Cambi (of Florence), Alfred Stevens, Matthew Noble, Herr Hähnel (of Dresden) and Thomas Thornycroft. Though only Stevens's model (plate 18) has survived, we know the appearance of some of the others—the prize-winners were all illustrated in the *Illustrated London News*, and others appear elsewhere. But the winning of this competition was not so simply advantageous as might be expected. For although Calder Marshall had won the competition, the government had never guaranteed it would put up the winning entry—as the Secretary of the Sculptors' Institute had pointed out in the *Morning Post* when the government's terms had been published. Of the judges who had made the decisions, only

C. R. Cockerell, the architect, could be claimed as professionally qualified to make a competent aesthetic judgement—and he dissented from the final decision. The other judges were Lord Lansdowne, a Member of the Cabinet, Dean Milman, Dean of St Paul's, Lord Overstone, a peer and financier, General Cust representing the military, and W. E. Gladstone, Member of Parliament and Privy Councillor. And they claimed only to have indicated what they liked best, saying they had not taken into consideration the suitability of their preferences for the actual site in St Paul's. It was not wholly surprising therefore that in 1858, after discussions between the First Commissioner and the new cathedral architect, F. C. Penrose, it was announced that these two had decided that Alfred Stevens's design was the most suitable for St Paul's and would be proceeded with.

This was far from being the end of the story; that came over half a century later with the completion of the Stevens work (plate 92) in 1912. But the full story up to the 1858 decision is worth detailing as an illustration of the trials and tribulations that could attend the competitive situation. The principle of committee decision in competitions was held in disrepute over a wide spectrum—from Richard Westmacott junior in his evidence to the 1863 Royal Academy Commission[32] to Palgrave in his journalism,[33] Palgrave indeed giving many reasons for distrusting committee decisions whether in competitive circumstances or not. The fact that such opinions were expressed so short a time after the Wellington hoo-ha (within ten years at the most) must make it at least a possibility that this coloured and confirmed their views. And in any case they were only confirming the opinion expressed by the *Art Union* and attributed by it to 'our best artists' at the time of the Buxton commission of 1846.

Sculptors nonetheless persisted in this field, and it is not difficult to see why. As a form of patronage, the public memorial could bring consistently to the sculptor both prestige and success, and this to the professional artist must have made the race, even if the prize were for but one, very much worth the running. The field of public memorials, seen within a patronage context, was extensive, and formed the main type of public patronage of sculpture. The tradition was certainly established in the eighteenth century, with national monuments set up in Westminster Abbey to political and military leaders, and was expanded about 1790 first by the proposals to erect in St Paul's Cathedral, London, monuments to benefactors of the nation. The first of these were by John Bacon, senior (1740–99) and commemorated John Howard the philanthropist, Dr Johnson (these two unveiled in 1796), and Sir William Jones (completed 1799),[34] 'the first European to open the treasures of Oriental learning, the poetry and wisdom of our Indian Empire';[35] a fourth to Sir Joshua Reynolds, by Flaxman, was installed in 1813. These represented very much an extension of the coverage and subjects of commemoration and, above all, a new location for national monuments. And they were followed very shortly afterwards by the Napoleonic Wars which provided for the grateful nation a veritable host of heroes to be commemorated, mostly dead.

In the Victorian period the phenomenon built up to staggering proportions, and established patterns of commemoration both national and local. All types of figure were commemorated—political, military, literary, industrial, and generally beneficial, quite apart from royalty. The pattern included national commemoration of national heroes, local commemoration of national heroes, local commemoration of local heroes, of specific local ties or achievements; parallel with this was a pattern of choice of sculptors—national artists doing national and local heroes, local artists doing national and local figures, let alone locally-born national artists executing local commemorations of national figures; in Scotland and Ireland there was a further distinction in the choice between major national artists who had stayed at home and those who had been lured away, for instance, to the 'wealth and blandishments of Babylon',[36] as was said of Foley, who had gone to London to pursue his career.

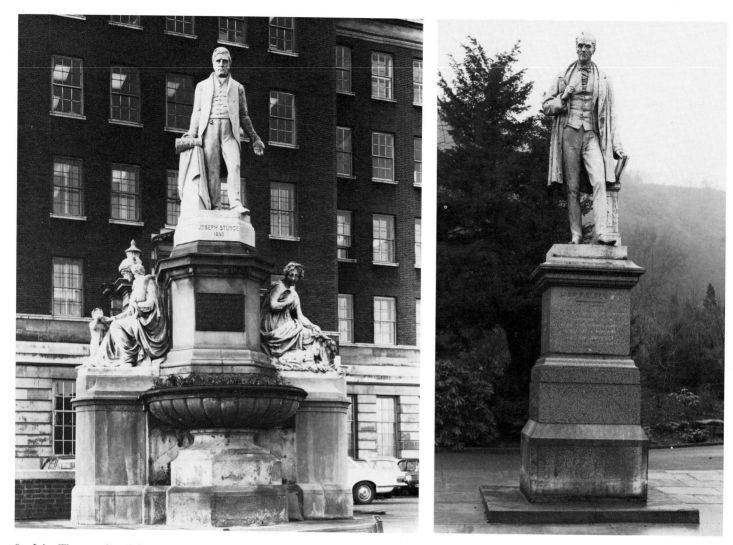

83. John Thomas, *Joseph Sturge*, 1859–62. Birmingham, Five Ways.

84. John Henry Foley, *John Fielden*, 1863. Todmorden, Centre Vale Park.

In vain did Coventry Patmore write a short, wry article entitled *Shall Smith have a Statue?*[37] His answer was, briefly, no, or at least not yet; let things die down and let the genuinely worthy candidates for commemoration emerge. But this point was not generally taken, and from the sculptors' point of view most fortunately. Matthew Arnold, in the Preface to his selection of *Poems by Wordsworth* of 1879 wrote: 'I remember hearing Lord Macaulay say, after Wordsworth's death, when subscriptions were being collected to found a memorial of him, that ten years earlier more money could have been raised in Cambridge alone, to do honour to Wordsworth, than was now raised all through the country.'[38] If (notwithstanding Arnold's warning that Macaulay had his own heightened and telling way of putting things) one applies this comment of Macaulay's to the field of sculptural commemoration generally, no doubt the sculptors were very glad not to have too much delay in setting monuments up, as otherwise the decline in interest might do them out of a staple job.

So to their delight (one may generally assume) and profit Birmingham[39] got its *Thomas Attwood* (already mentioned) by John Thomas (plate 42), the town's testimony, paid for by subscribers, to 'sledge-hammer Attwood', the people's champion, whom Thackeray called 'at best but a Birmingham barbarian', unveiled in 1859. It also got its *Joseph Sturge*, again by Thomas (plate 83), unveiled in 1862; Sturge was a Quaker philanthropist, alderman in 1838 in the first Borough Council of Birmingham, and a worker for the abolition of slavery. Further statues were put up to commemorate Sir Robert Peel, Prime Minister and Corn Law Repealer (by Peter Hollins, a Birmingham-born sculptor: unveiled in 1855); Prince Albert (by Foley: unveiled in 1868); Queen Victoria (by

Woolner: unveiled in 1884) (plate 72); and others. Todmorden got *John Fielden* (1784–1849), local land owner and Member of Parliament (plate 84). By Foley, and signed and dated 1863, it was raised by Public Subscription in Gratitude to him whose Persevering Efforts succeeded in obtaining the Ten Hours Act (Royal Assent 8 June 1847). Patmore wrote: 'It should be remembered that, in our haste, we may be placing an awful and easy vengeance in the hands of posterity; which might choose, not to pull down such monuments, but—to let them stand.'[40] Posterity has sometimes moved the statues— *Fielden* used to be in Fielden Square, whereas he is now in a public park, and *Attwood* and *Peel* have also been replaced. But it has not eradicated (yet) these testimonies of grateful people to the heroes of their time. Unfortunately the same cannot be said of Salford, where the Peel Park collection has all but disappeared.*

From around 1800 onwards, it was the Napoleonic Wars that provided the major momentum behind public commemoration, and this persisted into mid century since not all the great heroes died in action. Though Nelson had done so at the Battle of Trafalgar (1805), with a monument in St Paul's Cathedral, London, by Flaxman being erected quite speedily (1808–18), the national memorial took a considerable time to get established and set up.[42] The question was discussed in Parliament in 1818, but it was not till 1838 that a Nelson Memorial Committee was formed and a competition held for designs. The first prize went to the architect William Railton for a project consisting mainly of a Corinthian column; the second prize went to the sculptor E. H. Baily for a statue of Nelson in front of an obelisk, with various allegorical accompaniments. As we have seen, though, the course of Government competitions did not always run true, and these first results were set aside as being somewhat unsuitable. A second competition was held the following year, 1839, to which competitors of the first one could resubmit their projects. Some of them clearly did so, as Railton was again the winner with the same design. Though not popular with, say, the *Art-Union* (see below), Railton's design at least had the merit of a relative simplicity. Amongst all the other entries, rather varied, the oddest, it was generally agreed, was by Benedetto Pistrucci, a Roman who had settled in London and whose design of St George and the Dragon used to figure on gold sovereigns. Undeterred by the miniature work of his general practice, Pistrucci proposed a colossal trident, eighty-nine feet high, rising from a segment of the globe on which three reclining Victories were carving memorials of the hero. The *Art-Union* said it would be nothing more nor less than a large toasting fork.[43] Other proposals included a lighthouse, a circular open temple and a figure of Britannia 120 feet high—this latter refers back to a scheme first proposed by Flaxman on another occasion.

Eventually it was decided by way of compromise that Baily's statue should be added to Railton's column. There was a problem with money, in that only £17,000 had been suscribed at this stage, but it was decided to proceed without for the moment extras like the bas-reliefs at the base and lions at the corners. By the end of 1843 the column and the statue (plate 85) were finished. (The original model for the statue still exists in the Admiralty.) The column was not at first very popular. The *Art-Union* expressed the hope that a strong wind would come and blow it down on top of the National Gallery which it also did not like.[44] Its hopes were not entirely without foundation: the Office of Works had called in experts who recommended a reduction in its height, that the column should be of solid stone, and that the diameter at its base should be increased. Sir Robert Peel warned the Commons that it would be extremely inconvenient should the monument fall in that crowded part of the metropolis.

*If it is any consolation, though, the borough is the setting of the 'Hero of the North' Garden in the comic strip *The Fosdyke Saga*, where are assembled a superb collection of statues of 'Tyrants, Despots, Scoundrels, Millionaires and Gentlemen.'[41]

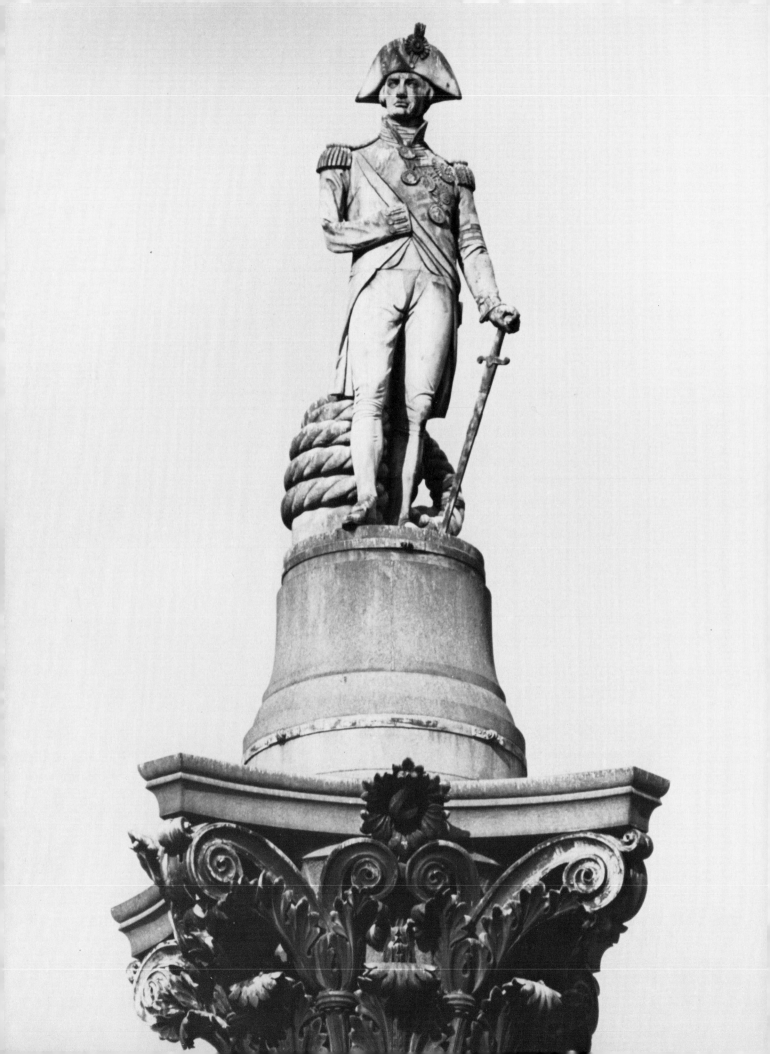

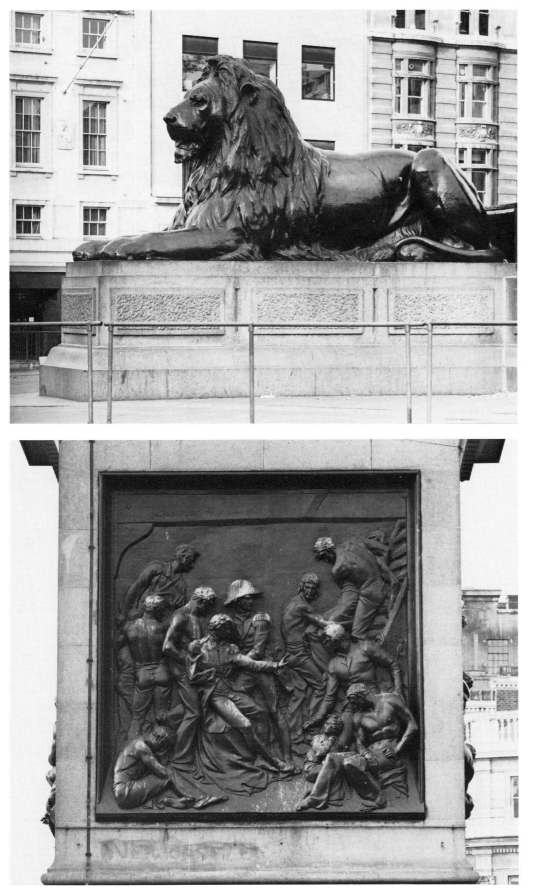

86. Sir Edwin Landseer, *Lion*, unveiled 1867. London, Trafalgar Square.

87. William Frederick Woodington, *The Battle of the Nile*, 1850. London, Trafalgar Square.

85 (facing page). Edward Hodges Baily, *Viscount Nelson*, 1839–43. London, Trafalgar Square.

The question of the bas-reliefs was complicated because the Memorial Committee had run out of money. The Government eventually agreed to complete the job, but on the condition that while Railton continued to supervise generally, the Government selected the sculptors and laid down the conditions of work. For the choice of sculptors, the Government turned to Eastlake for advice, and on his recommendation selected John Carew and W. F. Woodington for the reliefs and J. G. Lough for the lions. Sir Robert Peel added Watson and John Ternouth for the other two bas-reliefs. According to the Government official dealing with the matter, the choice of sculptors was very much influenced by the results of the 1844 Westminster Hall exhibition (for which, see p. 83). The Government also, on Eastlake's advice, laid down formal considerations for the reliefs: there had to be an eight-inch border to the top and sides of each relief, to Railton's design; the composition as a mass was to occupy only the lower two-thirds of the panel; the costume of the period was to be observed; and smoke was to be avoided even though battle scenes were to be portrayed.

The Government provided bronze and equipment for casting, but individual artists had to make the arrangements for the execution. In December 1849 the first relief was fixed in position—this was Carew's *Battle of Trafalgar*. The name of the founders is inscribed: Christy, Adams and Hill. It was however reported to the Office of Works that the relief had not been cast to the specified bronze content. This was found to be true; they had cheated, and they were prosecuted and imprisoned. The remaining reliefs were installed between 1850 and 1852. Woodington's *Battle of the Nile* (plate 87) has the new founders inscribed: Moore, Fressance and Moore. The other two reliefs are *The Battle of Copenhagen* by Ternouth and *The Battle of St Vincent* by Watson.

The lions were originally assigned to Lough, but in fact the first ones were done by Thomas Milnes (1813–88). These, though, were rejected and now adorn the school at Saltaire in the West Riding of Yorkshire. In 1858, Sir Edwin Landseer was commissioned to do the lions, which caused protests from the sculptural fraternity—not surprisingly, as he was, after all, a painter. The Zoo provided a lion as a model, but unfortunately while Landseer was out of London it became seriously ill and died. (It is not recorded whether or not the sculptors had anything to do with this.) Landseer hurried back to work for as long as he could from the carcase, of which plaster casts were being made. He wrote to a friend:

> ... anything as fearful as the gasses from the royal remains it is difficult to conceive ... We have shut our eyes to nasty inconvenience and opened them to the importance of the opportunity of handling the dangerous subject whilst in a state of safety. With the experience of the Animal photographs, Casts in Plaster and Studies you may believe that I shall neither disappoint you, my Country or the brave Nelson in my treatment of these symbols of our National defences.[45]

The business of casting the lions in bronze was entrusted to Baron Marochetti, which again must have infuriated the sculptural fraternity; he was a foreigner and used his friends in high places (indeed, almost the highest: Prince Albert) to obtain commissions for which he had not competed.* The lions (plate 86) were unveiled in January 1867 (sixty-two years after Nelson's death), and on the day of Landseer's funeral in St Paul's in 1873 they were adorned with black wreaths.

Another naval hero who fell in the line of duty was Admiral Lord Collingwood (†1810) and two of the memorials to him were by sculptors of the immediately pre-Victorian

*There is a painting by John Ballantyne in the National Portrait Gallery purporting to show Landseer modelling his lions in Marochetti's studio, but it is not entirely clear what exactly he is doing: he is holding his sculptor's tool in the wrong position; thus held it would give the minimum power.

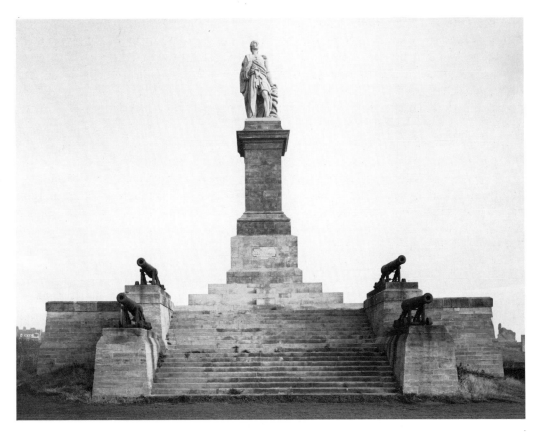

88. John Graham Lough, *Lord Collingwood*, 1847. Tynemouth.

generation. That in St Paul's was executed by Sir Richard Westmacott between 1813 and 1817[46] and that in Newcastle Cathedral, his local church monument so to speak, has a bust of 1819 by J. C. F. Rossi, R.A. (1762–1839), part of an overall monument designed by the architect C. R. Cockerell. Another local monument, at Tynemouth, Northumberland (plate 88) was by a local sculptor, J. G. Lough. This takes the form of a twenty-three-foot statue on top of a fifty-foot pedestal designed by the architect John Dobson. The statue is dated 1847 and though so high is signed clearly enough for the artist's name to be easily legible from below.

The other major military hero of the Napoleonic Wars was the Duke of Wellington,[47] who did not die on the field; thus any commemoration in the immediate aftermath of his military achievements would have to be while he was still alive. This possibly explains why the first national memorial to him took the form of a symbolic figure of Achilles (plate 89), one of the supreme warriors of classical antiquity, rather than a portrait statue. It was first adumbrated in 1814 and unveiled in 1822; by Sir Richard Westmacott, it was cast from twelve twenty-four-pounder French guns taken at Wellington's victories at Vittoria, Salamanca, Toulouse and Waterloo. It was organised, subscribed for (£10,000) and erected to Wellington and his brave companions-in-arms by their countrywomen, which caused a certain amount of laughter, as it is an eighteen-foot-high naked man. Other heroes of the war had appeared in a similar state of undress: *Nelson*, at Liverpool, by Matthew Cotes Wyatt, in which Westmacott had had a hand, let alone the colossal figure of Napoleon by Canova at Apsley House.[48]

The City of London put up at least two monuments to Wellington. After his death in 1851 they set up one in the Guildhall by John Bell, but their first commemoration (by Chantrey) was erected in front of the Royal Exchange while Wellington was still alive (plate 90). This was not in recognition of his victories in the field but for his assistance in getting a Bill passed in Parliament for the rebuilding of London Bridge, which took place

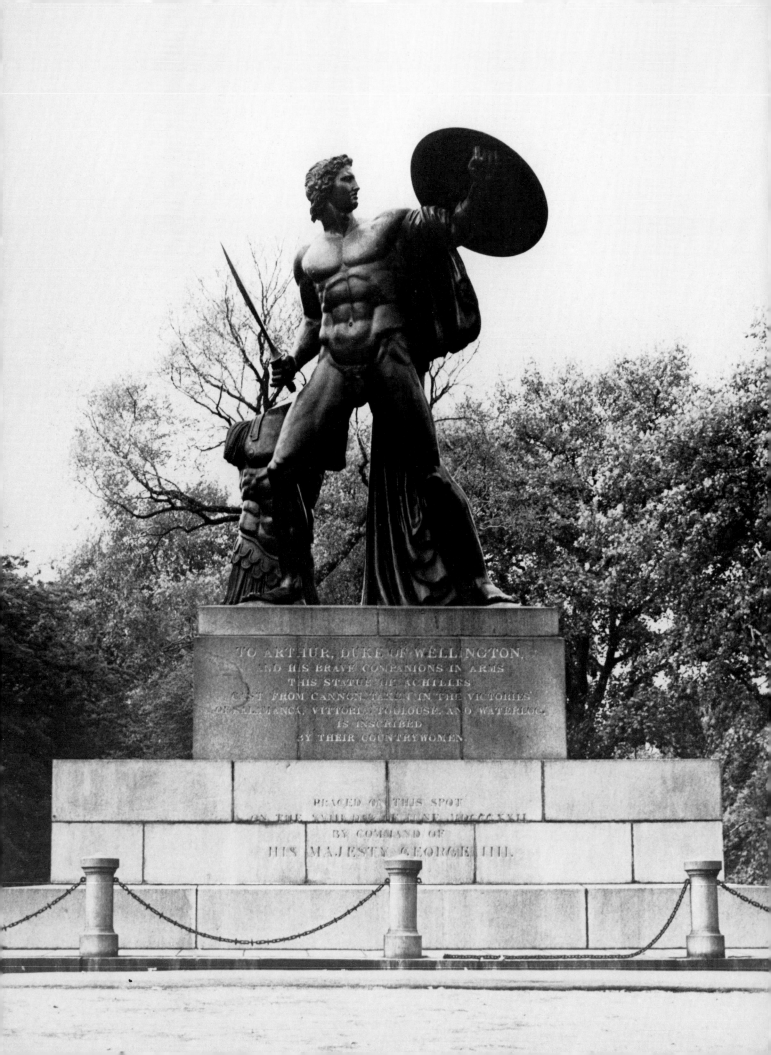

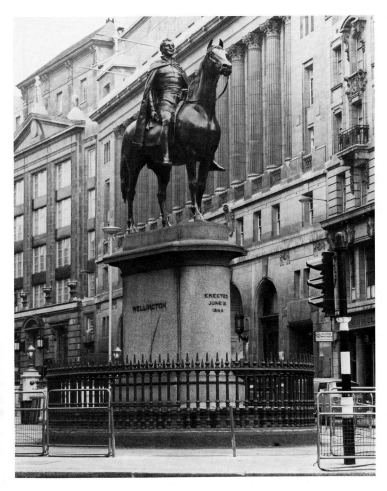

between 1823 and 1831. Chantrey, at his death in 1841, had completed only a quarter-sized model, a full-sized head, and the horse. The impending death of the sculptor may explain the similarity of the horse to that of George IV in Trafalgar Square by the same artist (plate 4): while there are differences in the disposition of the reins and the direction of the horse's head, the general stance of horse and rider is very close. The monument was completed by Henry Weekes.

Chantrey had only received this commission by the casting vote of the Lord Mayor at a committee meeting held to consider the matter. The original proposer of the scheme, Mr T. B. Simpson of the Court of Common Council, had wanted the job to go to Matthew Cotes Wyatt; so when he was thwarted in this, he proposed another statue of the Duke to go up in West London, and Wyatt eventually obtained this new commission. He worked on the statue with his son James from 1840 to 1843: it was cast in eight pieces and hoisted into position in 1846 (plate 10) and weighed about forty tons. There were delays and difficulties surrounding the whole project: shortage of bronze, the need to strengthen the arch to take the weight of the figure, and difficulties experienced by Wyatt in getting the full amount of money he was owed. As we have seen already, the statue was displaced in 1883 and nearly melted down, but ended up near Aldershot. At this time a competition was held for a replacement, the statue by Boehm that is still at Hyde Park Corner (plate 91); it was unveiled in 1888. But meanwhile London was not finished with statues of the Duke. In 1848 another was erected near Traitors' Gate in the Tower of London; by Thomas Milnes (who did the first Nelson lions), it was to commemorate Wellington's Master-Generalship of the Ordnance from 1818 to 1827. Its position within the Tower changed in 1861, and it was moved again in 1863 to the Royal Arsenal, Woolwich.

The final, national monument to the Duke of Wellington is that in St Paul's Cathedral, set up after he had died in 1852 (plate 92).[49] We have already seen how tortuous were the

90. Sir Francis Chantrey, *The Duke of Wellington*, erected 1844. London, Royal Exchange.

91. Sir Joseph Edgar Boehm, *The Duke of Wellington*, unveiled 1888. London, Hyde Park Corner.

89. Sir Richard Westmacott, *Achilles*, unveiled 1822. London, Hyde Park.

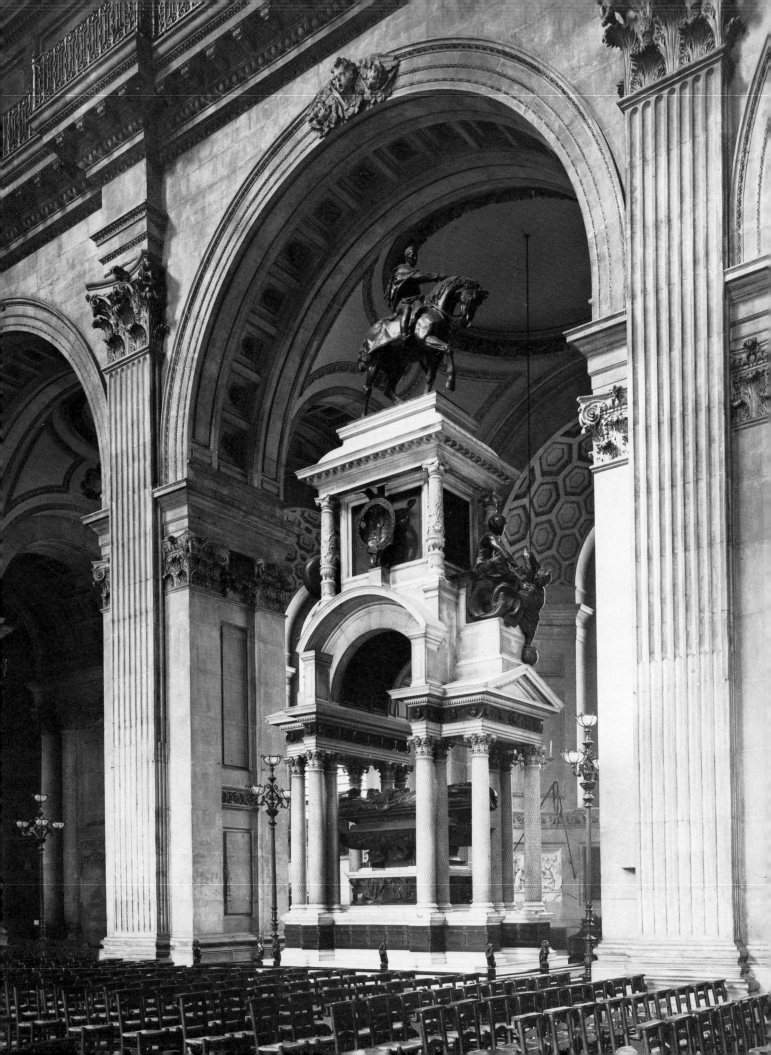

arrangements for choosing a sculptor for it, but this was nothing compared to the difficulties in actually getting it up. Through Government shilly-shallying and, later on, active interference, through misunderstanding between the Government and Stevens, and not least through a certain amount of the procrastination that was a feature of Stevens's make-up, the monument was still not up when Stevens died in 1875. Stevens had failed to understand how much money he was getting from the Government and for what; this problem cropped up continually as time went on and expenses increased. Both the Government and the Cathedral authorities changed their minds (which were not in any case one) as to the location and appearance of the monument. And the Government had insisted on having, somewhat unusually, a full-scale model constructed, subsequently to be moved to St Paul's just to see how it looked.* In the end the Government had had to call in Leonard Collmann, an old friend of Stevens's who alone seemed able to act as a catalyst to Stevens's effective artistic productivity, and had acted in this capacity before with the artist. The architectural elements of the monument were in the most advanced state of preparedness; the effigy was sent for casting in the year before Stevens's death, at which time the full-scale plaster models of the symbolic groups, *Truth Plucking Out the Tongue of Falsehood* (plate 259) and *Courage Spurning Cowardice* (plate 29) were ready for casting. The monument was provisionally erected in 1877, out of position and lacking the equestrian figure (which is what the St Paul's authorities objected to). The story of the rectification of these injustices comes later.

But perhaps the greatest recipient of public memorials in the Victorian era was Prince Albert.[51] At his death in 1861, statues and monuments were set up all over the country, to a scale and extent that was unprecedented. Royal memorials were certainly known, but they had usually been modest and infrequent. The *George IV* in Trafalgar Square (plate 4) was originally ordered by the king himself to go on top of Marble Arch, which was then in front of Buckingham Palace; it was put up in the square as a temporary measure in 1843 and it has stayed there ever since.[52] The statue of William IV by Samuel Nixon, set up in 1844 in the street named after him in the City of London, has subsequently been moved to Greenwich.

With Albert it was different, and Dickens wrote to John Leech in 1864 in words which could well be applied to his commemoration in sculpture: 'If you should meet with an inaccessible cave anywhere in that neighbourhood, to which a hermit could retire from the memory of Prince Albert and testimonials to the same, pray let me know of it. We having nothing solitary and deep enough in this part of England.' And the requirements of such a programme of sculptural commemoration illustrate in all its complexity the elaborate pattern of patronage in national and local contexts. Exeter's statue was by Exeter-born E. B. Stephens (1815–82); it is in the Albert Memorial Museum. Salford's statue (plate 93), erected by public subscription in 1864, is by Matthew Noble. Though Yorkshire born and working in London, Noble's career was established by the extensive patronage he received early on from Manchester and its immediate surroundings: Palgrave refers in his review of the Royal Academy Exhibition of 1863 to 'Mr. Noble's work, which has done so much to disfigure Manchester. . .'.[53] Wolverhampton's statue, of 1866, is by Thomas Thornycroft, who had previously executed a statue of Wolverhampton's first mayor, G. B. Thorneycroft, in 1857; he had also done a statue of the Prince Consort for Halifax in 1864.[54] Manchester, Edinburgh, Glasgow and Dublin all had theirs, as we shall see, and as late as 1874 the City of London received the

93. Matthew Noble, *Prince Albert*, erected 1864. Salford.

*Other instances of this are known: in Manchester a full-size timber framework of Worthington's Albert Memorial was set up in front of the Infirmary in Piccadilly, the original site for the Memorial. It was feared that the Gothic of the Memorial would clash with the classical character of the Infirmary and indeed after this operation the site for the Albert Memorial was changed to its present position.[50]

92. Alfred Stevens, Monument to the Duke of Wellington, 1856–1912. London, St Paul's Cathedral.

equestrian figure by Charles Bacon at Holborn Circus, presented by Mr Charles Oppenheim; the City Corporation presented the pedestal.[55]

Queen Victoria erected her own memorials. These included a recumbent effigy by Henri de Triqueti for the cenotaph that is part of the Albert Memorial Chapel at Windsor Castle (plate 94), and another effigy, by Marochetti, surmounting Prince Albert's place of burial at the centre of the Royal Mausoleum at Frogmore. She also set up a cairn near Balmoral, which Swinburne noted in a letter:

> . . . The Tummil is very pretty but much defiled by memories and memorials of the royal family. At the waterfalls, significant of who shall say what other effusions? Her Majesty has set up—I should say erected—a phallic emblem in stone; a genuine Priapic erection like a small obelisk, engraved with her name and the date of the event commemorated, whatever that may have been. . . As I presume it stands there for ever in honourable record of the late Prince Consort's virility, it should have borne (instead of the hackneyed 'sic sedebat') the inscription 'sic Arrigebat Albertus Bonus.'[56]

The Queen was also closely involved with the national Memorial in Hyde Park, London (plate 95). A month after Albert's death (14 December 1861) a public meeting was called by the Lord Mayor of London and subscriptions were invited. An advisory committee was set up by Queen Victoria to investigate the various ideas that were being put forward on what would be the most suitable form of memorial. Thinking at first seemed to go along very much architectural lines—a memorial building or institution— and architects such as Scott, Smirke, Pennethorne and Hardwicke were asked to furnish designs. But by July 1862, when the advisory committee issued its instructions, sculpture, which had featured to some extent in the preliminary ideas, had come much more to the forefront. Eastlake was one of the committee and drew up the instructions: these insisted that 'the design for the architectural portion of the Memorial should be regarded chiefly as a means of ensuring the most effective arrangement of the sculpture which is to complete it.'[57] Entries were to be in by 1 December that year.

The committee reported in March 1863, and indicated a preference for the design of Hardwicke. But they recommended the adoption of Scott's design, not least because they were reverting (they thought) in some measure to the Queen's original intention in proposing the erection of a monument 'in the usual acceptance of the word', with groups of statuary round the base. The report that Scott submitted with his design was also (and perfectly reasonably) framed with the patron in mind.[58]

> From the time of the very first proposal of the memorial my thoughts were almost constantly directed to the subject. The claims of that great and Good Prince who was to be commemorated; the magnificence of the scale on which the public had,— from the first and most justly,—framed their ideas as to what the Memorial to such a personage should be; and Her Majesty's first choice of a monolith greater than any that the world had seen surrounded by magnificent groups of sculpture in due proportion to its colossal magnitude, rendered it impossible for me deliberately [this word inserted] to strike out a thought on an unworthy scale. . .

He claimed that his design represented what he had first 'struck out' in the heat of the moment, so to speak, under a strong impulse to do what he could to make it worthy of its object: this before he had even been invited to submit a design. Scott then went on to emphasise the contacts he had had with the Prince Consort, and how His Royal Highness had personally told him he had no objections in principle to the Gothic style. Indeed:

> When I made some few years back a Gothic design for the Guards' Crimean

94. Windsor Castle, view of the interior of the Albert Memorial Chapel.

97

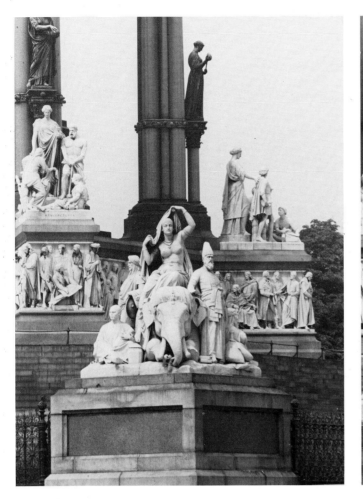

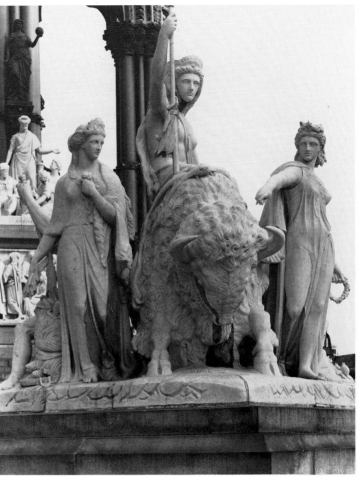

96. London, detail from the
Albert Memorial.

97. John Bell, *America*. London,
Albert Memorial.

Memorial, I am informed on the best authority that my design was honoured by the approval of the Prince Consort to such an extent that though he had previously objected to the memorial being erected in Hyde Park,—on seeing this design he at once withdrew the objection and offered every facility for its erection in the Park facilities which were withdrawn when another design was adopted. I would lay the more stress upon this circumstance as being an emphatic approval by the Prince Consort himself of the erection of a Memorial in the Gothic Style in Hyde Park and that a design which though, of course, infinitely inferior to that which I have now the honour of submitting, agreed with it sufficiently in general idea to shew that the approval of the one would of involve a still stronger approval of the other.

Scott emphasised the most touching of Consort Memorials—the Eleanor Crosses (in Gothic)—and how the centrepiece of his design would be a colossal statue of the Prince, surrounded by sculpted illustrations of those arts and sciences which he fostered and the great (this word inserted) undertakings which he originated.

In April 1863 the committee were notified of the Queen's acceptance of Scott's design. (Henry Cole alleged later that the choice was virtually made by the Princess Royal.) Later that year discussions were held with Scott to settle the exact design, working drawings were prepared and a large model built so that the Queen and her family could keep a careful check over what it was to be like, a supervisory role extended to many of the constituent parts by the different sculptors involved. The sculpture sections of the model were drawn out in a general way on the first elevation drawings by Clayton and by Scott's eldest son; they were then executed for the model by Henry Hugh Armstead entirely.[59] In April 1864, Scott and his contractor produced their estimate (£85,508) and in May the first shovelful of earth was moved. In 1865 the granite for the plinth arrived, the first block

95 (facing page). London,
general view of the Albert
Memorial.

99

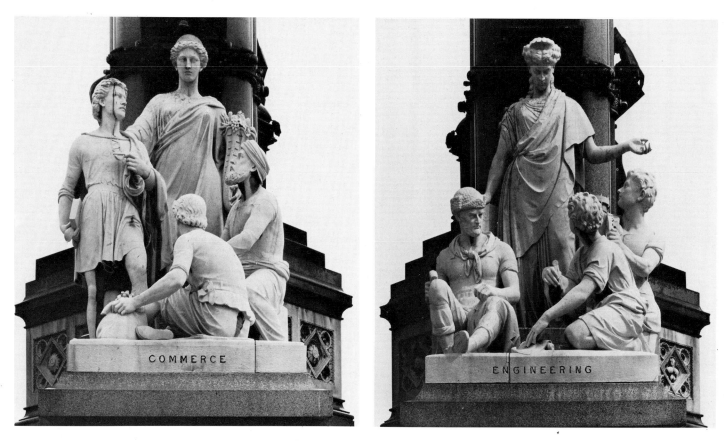

98. Thomas Thornycroft,
Commerce. London, Albert
Memorial.

99. John Lawlor, *Engineering*.
London, Albert Memorial.

was fixed in its place in November, and by December some of the sculptors had started work. Construction of the monument was completed to the top of the arches by May 1867, the cross on the top of the spire was fixed in June 1868 and the scaffolding was removed at the end of March 1871. In Spring 1872 the podium sculpture was finished and on 1 July the Queen inspected the monument, two days before the general public were admitted. At this time the central figure was still in the process of execution; it was not installed finally until 1876.

The extent of the sculpture on the monument is considerable (plate 96) and offers good grounds for the *Art Journal*'s enthusiastic comment: 'This will be the most glorious opportunity for British sculptors to show what they can really do.'[60] It was, above all, a multi-artist affair, with eleven sculptors involved in the figure work, many of them leaders of the profession. At the four corners of the perimeter are groups representing the Continents: *America* by John Bell (plate 97), *Africa* by William Theed (plate 100), *Asia* by Foley (plate 49) and *Europe* by MacDowell (plate 199). At the inner corners are groups of *Commerce* by Thomas Thornycroft (plate 98), *Engineering* by John Lawlor (plate 99), *Manufactures* by Weekes and *Agriculture* by Calder Marshall. At the centre is the figure of Prince Albert (plate 68): this was originally assigned by the Queen to Marochetti, but his first project was found unsatisfactory and he died before he could do anything further. Foley was then chosen, again, apparently, by the Queen. The delay in completion of this figure was due to Foley's illness in the last few years of his life and it had to be completed by his executor and pupil G. F. Teniswood.

The base on which the Foley figure stands is surrounded by a relief by two artists, Armstead and Birnie Philip; it illustrates the edifying arts. The sciences feature on the way up the corner pillars: *Astronomy*, *Chemistry* (plate 101), *Rhetoric* and *Medicine* by Armstead; *Geometry*, *Geology*, *Physiology* and *Philosophy* (plate 103) by Birnie Philip. Further up still are statues of the Virtues (plate 102) by James Redfern and at the summit the mourning and exultant angels are by Birnie Philip. As at the Houses of Parliament there was a clear demarcation between the areas under the direct supervision of the architect—

100

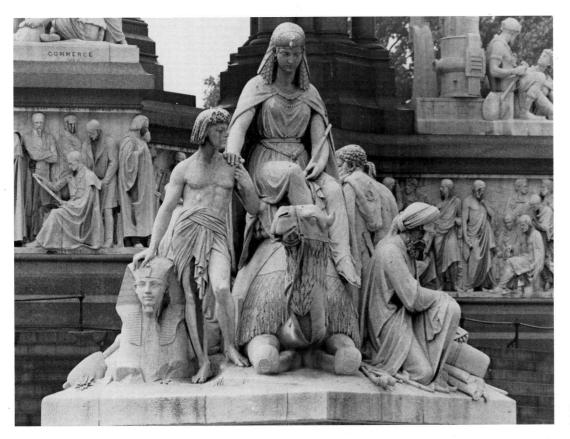

100. William Theed, *Africa*. London, Albert Memorial.

101 (far left). Henry Hugh Armstead, *Chemistry*. London, Albert Memorial.

102 (left). James Redfern, *Prudence, Humility* and *Temperance*. London, Albert Memorial.

Birnie Philip, Armstead and Redfern worked closely with Scott—and those open to a wider critical access. These latter groups, though not necessarily financially profitable for the sculptors involved, were professionally speaking of great prestige.

One idea that was mentioned in the very earliest discussions about the most appropriate form of memorial to the Prince Consort was a Walhalla, a Germanic concept for hero commemoration that found concrete expression at Regensburg and Kelheim in the 1840s and 1850s. The British never really got round to one of these and one very good reason was that the basic idea of a building containing sculptured representations of national heroes already existed to all intents and purposes at Westminster Abbey and to a lesser extent at St Paul's Cathedral. For many figures, political, military or literary, a national memorial took the form of statue or bust in Westminster Abbey, though they could also be commemorated elsewhere, nationally and locally. John Laird Mair Lawrence, First Baron (1811–79), Governor of the Punjab during the Indian Mutiny and subsequently Viceroy of India, is commemorated in Westminster Abbey by a bust by Thomas Woolner of 1881 (plate 104) and in Waterloo Place, London, by a statue by Boehm (plate 105) erected in 1884. Robert Southey (1774–1843), Poet Laureate from 1813, is commemorated by a bust by Weekes in Poets' Corner, Westminster Abbey (1843), by a bust by Baily in the Cathedral at Bristol, his birthplace (1845), and by a full-scale reclining effigy by Lough (dated 1846) in the church at Crosthwaite, near Keswick in Cumberland, where he is buried. (The figure is wide awake (plate 106), not sleeping as both Boase and Pevsner claim.)[61] Wordsworth (1770–1850) by contrast received a full-length statue in Westminster Abbey (plate 107). This was executed by Frederick Thrupp

104. Thomas Woolner, Monument to Lord Lawrence, 1881. London, Westminster Abbey.

105. Sir Joseph Edgar Boehm, *Lord Lawrence*, erected 1884. London, Waterloo Place.

103 (facing page). John Birnie Philip, *Philosophy*. London, Albert Memorial.

106. John Graham Lough,
detail from the Monument to
Robert Southey, 1846.
Crosthwaite, St Kentigern.

and aroused almost as much ill-feeling as his Buxton statue and for the same reason: favouritism in securing the commission.[62] Thomas Woolner had also competed for this, and his failure to secure the commission is sometimes given as a reason for his emigrating to Australia. He had previously been commissioned to execute the head in relief that forms part of the memorial to Wordsworth in Grasmere church (plate 231), in the graveyard of which the poet is buried.

Parallel to this pattern of commemoration of national figures was another commemorating local heroes and events. At Chelmsford in Essex there is a statue of Chief Justice Tindall, a one-time Member of Parliament and Chief Justice of the Common Pleas. Born near Chelmsford, he was thus a local lad made good. The work, exhibited at the Royal Academy in 1847, was by a major national sculptor, E. H. Baily, though there was at the time some doubt as to how much he was responsible for; artistic circles alleged that he had patched up an old model by John Bacon, R.A. (1740–99).[63] We have already seen Todmorden's commemoration of John Fielden by Foley (plate 84), and there are numerous other examples of this type throughout the British Isles. Foley's *William, third Earl of Rosse* (plate 110) (signed and dated 1875) at Birr, a small town some eighty-eight miles due west of Dublin, commemorates the local lord who was President of the Royal Society and who had built at his castle in Birr what was then the world's greatest telescope. A statue at Prestonpans east of Edinburgh (plate 109) commemorates Thomas Alexander (1812–60), a native of Prestonpans. From the pedestal we learn that

the improved sanitary conditions of the British Army as well as the elevation in rank and consideration of its medical officers are mainly due to his exertions. His high professional attainments and his great administrative powers were wholly devoted to the service of his country and to the cause of humanity. Throughout a long military career he laboured incessantly to elevate the condition of the soldier, and during the Crimean War his indefatigable efforts as principal medical officer of the light division to alleviate the sufferings of the troops were of inestimable value in stimulating others to follow his example.

107 (facing page). Frederick
Thrupp, Monument to William
Wordsworth, 1854. London,
Westminster Abbey.

104

108. Matthew Noble, *Queen Victoria*, erected 1857. Salford.

109. William Brodie, *Thomas Alexander*, 1862. Prestonpans.

110 (right). John Henry Foley, *William, third Earl of Rosse*, 1875. Birr.

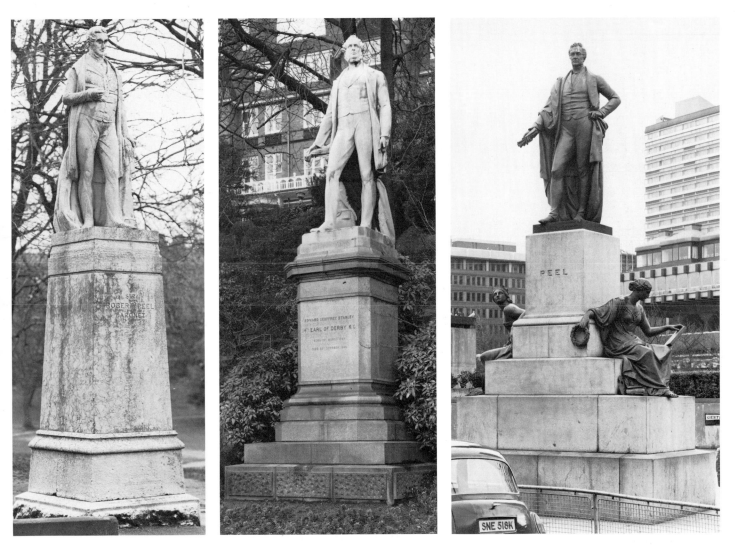

By William Brodie, the work is dated 1862. Salford in Lancashire set up a statue of Queen Victoria by Matthew Noble in 1857 (plate 108); this was to commemorate her visit in 1851 and reception by more than eighty thousand Sunday School teachers and scholars.

South Lancashire, in fact, as a region provides an illuminating and excellent microcosm of municipal patronage in its heyday. During the nineteenth century it was an area of major industrial activity with significant political awareness and power arising from this, and the various localities were quite prepared to commemorate the important events and personalities in sculpture. Samuel Crompton invented the spinning mule at Bolton, and is commemorated by a statue in Nelson Square there. Dating from 1862 it is by Calder Marshall and has a principal seated figure in bronze with two reliefs below on the base; one showing Hall i' t' Wood where the invention took place, the other showing Crompton contemplating his invention. At Bury a statue by Baily (of 1852) (plate 182) commemorates Sir Robert Peel, the first Prime Minister to come from a commercial family—his father had helped establish the leading firm of calico printers in Bury in 1773. Peel is also commemorated at Preston (plate 111) with a monument, erected by public subscription, in Winckley Square; unlike the *Peel* at Bury and Bolton's *Crompton*, which are by major national sculptors, Preston's *Peel* is by Thomas Duckett, a local artist.* Also

111 (left). Thomas Duckett, *Sir Robert Peel*, 1852. Preston.

112 (centre). Matthew Noble, *The Fourteenth Earl of Derby*, 1873. Preston.

113 (right). William Calder Marshall, *Sir Robert Peel*, 1853. Manchester, Piccadilly.

*It is possible that Peel was the (unwitting) means whereby public statuary commemoration began to approach the prolific. In the 1830s there seem to have been some 18 public statues of a dozen or so subjects, and some 11 public statues in the 1840s of 10 subjects. But following Peel's death in 1850 over 20 public statues to him alone were set up, mainly in the industrial north, and this may well have been the newly-enfranchised and politically established middle classes honouring the first hero from their own background.

115 (above left). Matthew Noble, The Wellington Monument, 1856. Manchester, Piccadilly.

116 (above right). General view of the Albert Memorial, Manchester.

117 (left). The Sculpture Hall, Manchester Town Hall.

114 (facing page). William Theed, Monument to Humphrey Chetham, 1853. Manchester, Cathedral.

118. Henry Stormonth
Leifchild, *George Wilson*, R.A.
1871. Manchester, Town Hall.

119. William Theed, *John
Bright*, 1878. Manchester, Town
Hall.

121. Matthew Noble, *Sir Thomas Potter*, 1864. Manchester, Town Hall.

120. William Theed, *W. E. Gladstone*, 1879. Manchester, Town Hall.

122. Matthew Noble, *Oliver Cromwell*, 1875. Manchester, Wythenshawe Park.

at Preston, in Avenham Park, is a statue of the Fourteenth Earl of Derby (1799–1869) (plate 112),[64] a prominent government minister under Peel and later himself Prime Minister, but also head of one of the oldest aristocratic families of Lancashire. The work is by Noble.

The major centre of this powerful industrial and political complex was Manchester. Throughout the nineteenth century it proclaimed its historical, industrial and political identity in sculpture in a series of statues and busts of national heroes, national heroes of local significance, and local heroes, by a wide variety of artists. The patronage specifically of Theed and Noble led Palgrave to call Manchester 'a city full of diverting commentaries on the taste of the patronizing British man of business'.[65] From 1837 dates the statue by Chantrey of John Dalton, the Manchester schoolmaster whose experiments with marsh gas led to his invention of Atomic Theory, thus earning him a claim to being the father of modern chemistry. The statue is now in Manchester Town Hall. Manchester's memorial to Robert Peel (plate 113) is by Calder Marshall, signed and dated 1853. Of the same year is the memorial in Manchester Cathedral to Humphrey Chetham (plate 114), the seventeenth-century founder of the Grammar School and Free Library. This is by William Theed, and was presented by an anonymous donor.[66] A copy of Chantrey's statue of Dalton, again by William Theed, was made in 1855, and is now outside the Dalton College of Technology. From 1856 dates Manchester's Wellington Monument (plate 115), erected by public subscription. It is a substantial work, incorporating a statue of the Duke, four supporting figures and four reliefs on the base, and is by Matthew Noble. Another work by William Theed, a monument to James Watt, dates from 1857. Following Prince Albert's death in 1861, Manchester set up its own memorial (plate 116);[67] as with the national memorial in London, there was at first some variety in the ideas put forward about what form the memorial should take—a Museum of Arts and Sciences, public baths combined with a Walhalla, new botanical gardens, and even a fairy palace. In the end the committee responsible for making the decision ordained that the memorial should include the statue that the Mayor of Manchester had already commissioned from Noble and which he was offering as his own contribution. (The Mayor just happened to be chairman of the committee.) As set up, the memorial consists of a statue by Noble set in a Gothic canopy by the architect Thomas Worthington. Later in the 1860s came a statue of Richard Cobden (1804–65), the radical Member of Parliament, champion of Free Trade and a leader of the Anti-Corn Law League, both major political concerns of the district. This was by Marshall Wood, a less well-known artist; dated 1867, it is in St Anne's Square.

After *Cobden*, exterior commemorative statuary in Manchester came to a virtual standstill for some twenty years, especially when compared to the burst of activity of the 1850s and 1860s. This is simply explained by a change of venue. In 1868 construction began of the Town Hall, symbol of Manchester's municipal pride—and explicit provision was made inside the building for commemorative sculpture, the first main area after the Entrance Hall being designated the Waiting or Sculpture Hall (plate 117).[68] Here are assembled in the form (mainly) of busts, the men who made nineteenth-century Manchester magnificent—John Benjamin Smith (1794–1879), first President of the Anti-Corn Law League (bust, unsigned); George Wilson, Chairman of the Anti-Corn Law League (plate 118) (bust by Henry Stormonth Leifchild, exhibited at the Royal Academy, London in 1871); Sir John Potter, Mayor from 1848 to 1850 (bust, unsigned); Thomas Goadsby, Mayor 1861–2 (bust by Noble, signed and dated 1862); and John Knowles, who built and managed the Theatre Royal in Manchester from 1845 to 1875 (bust, unsigned). Also appearing in bust form are Gladstone (unsigned) and Cobden (unsigned), the latter featuring as Alderman from 1838 to 1844, and many others. On the main stairs up to the Great Hall, there is a statue by Theed (dated 1878) of John Bright

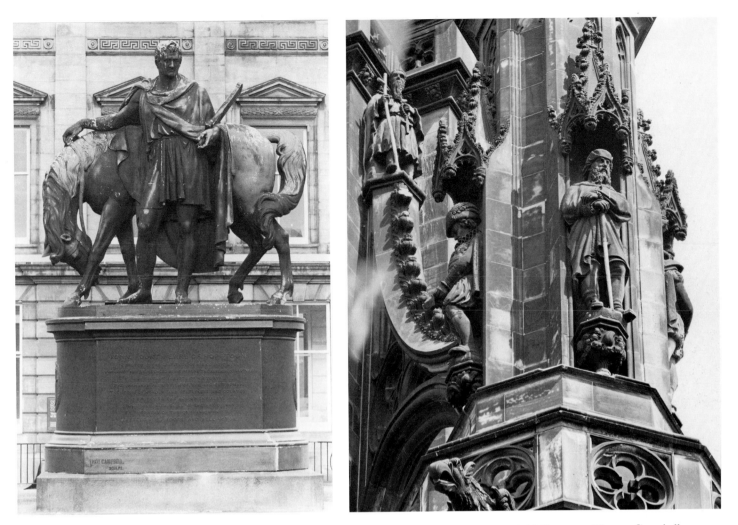

(1811–89) (plate 119), associated with Cobden in the Anti-Corn Law League and M.P. for Manchester from 1847 to 1857. On the landing outside the Great Hall are more busts, including one of Sir Thomas Potter, Mayor of Manchester 1838–9 (plate 121); this by Matthew Noble, dated 1864. Finally, within the Great Hall, there are busts of Queen Victoria, Prince Albert, the Prince and Princess of Wales, plus statues by Theed of C. P. Villiers (1876) and W. E. Gladstone (1879) (plate 120). The only instance of an exterior monument in Manchester between the later 1860s and the later 1880s is Matthew Noble's statue of Oliver Cromwell, now in Wythenshawe Park (plate 122). This was presented to the citizens of Manchester by Elizabeth S. Heywood in 1875; it was originally erected near the Cathedral, on the spot where the first man was killed during the English Civil War.[69] A bust of Cromwell, again by Noble, and dated 1861, is in the Town Hall. Of course other major municipalities such as Liverpool and Leeds were also leading patrons of sculpture, with a similar pattern of representation by major national sculptors in the work executed.* But none gained quite the position as a power base for a sculptor's national reputation and practice as Manchester seems to have done for Noble.

123. Thomas Campbell, *John, fourth Earl of Hopetoun*, 1833. Edinburgh, St Andrew's Square.

124. Detail from the Scott Monument, Edinburgh.

*Leeds has for example *Peel* by Behnes (1852) and *Wellington* by Marochetti (1855), both formerly in Victoria Square, now on Woodhouse Moor; *Queen Victoria* (1858) and *Prince Albert* (1865), both by Noble, in the Town Hall, itself of 1853–8. Liverpool has a fine collection inside St George's Hall, for instance *George Stephenson* by Gibson (1851); *Peel* by Noble (1852); *Archdeacon Brooks* by Benjamin Spence (1856); *Sir W. Brown* by MacDowell (1858); and others. Immediately outside are G. A. Lawson's *Wellington* (completed 1863), and Thomas Thornycroft's *Prince Albert* (1866) and *Queen Victoria* (1870). At the top of Prince's Avenue there is Gibson's *Huskisson* of 1847, originally for the Customs House, Canning Place; in Sefton Park is Foley and Brock's *William Rathbone* of 1874–7.

113

125. General view of the Scott
Monument, Edinburgh.

126 (facing page). Sir John
Steell, *Allan Ramsay*, 1865.
Edinburgh, Princes Street.

127. John Hutchison, *Adam Black*, 1877. Edinburgh, Princes Street.

128. John Greenshields and Andrew Handyside Ritchie, *Sir Walter Scott*, 1838. Glasgow, George Square.

It is rather to alternative national centres, Edinburgh and Dublin, that one must look for variations in the pattern of patronage and a clear definition of national identity in the field of sculpture rivalling what London could achieve. The *Illustrated London News* wrote in 1854: 'Scotland has been extremely barren of sculptors: indeed, we cannot call to mind any sculptor of great eminence born north of the Tweed, who can be named in the same breath with Flaxman or Chantrey, with Banks or Bacon.'[70] Certainly in Edinburgh[71] in the 1830s it was to London that they looked for memorial sculpture, with Chantrey responsible for the statues of George IV (1831) and William Pitt (1833) in George Street, as he had been ultimately for the statue of Viscount Melville (1828) in St Andrew's Square, which was executed from a design of his by Robert Forrest. Only the Hopetoun Monument (1833) (plate 123), also in St Andrew's Square, was by a Scottish-born sculptor, Thomas Campbell (1790–1858), and he was firmly based in London.

Sir John Steell[72] (1804–91) however set up in Edinburgh, and, though urged by Chantrey to come to London, he remained there all his life, with positive results. His statue of Sir Walter Scott, which is the centrepiece of the Scott Memorial in Princes Street, was probably the first marble statue ever commissioned in Scotland from a native artist, and Steell was the first to introduce artistic bronze casting into Scotland, building at his own expense a foundry where not only his own works but those of other artists could be satisfactorily cast. The Scott monument (plate 125)[73] was the first major national memorial in Scotland: it was, it should be noted, to a literary figure. Discussions had started immediately after Scott's death in 1832 as to how he would best be commemorated, and by 1835 it was decided that while an architectural monument was the obvious answer, a statue must form part of it. The selection of a design went through the

116

customary rigmarole of competitions, prizes, settings aside of results and so on. Finally a design by the architect George Kemp was adopted and eventually erected (by which time Kemp had been drowned in a canal). The monument was inaugurated with the unveiling of Steell's statue in 1846.

In addition to the main figure, provision was made in the design for some sixty-four further statues, representing characters from Scott's novels and poems (plate 124). These took much longer to complete: at the time of the inauguration only eight had been completed, by three sculptors, Peter Slater (1809–c. 1870), John Ritchie (1809–50) and his brother Andrew Handyside Ritchie (1804–70). Twenty more statues were commissioned in that year from Patric Park (1811–55); they were paid for, but never received, as Park went bankrupt when he had done only seven. These were not even set up for their original purpose, but were sold to a man who put them in his garden at Clapham Common. Nothing more was done about the statues until the centenary of Scott's birth, 1871, when twenty-four by a variety of artists were exhibited and installed—'a most interesting series, it must be admitted'.[74] By William Brodie (1815–81) were *Jeannie Deans*, *The Laird of Dumbiedykes*, *Amy Robsart*, *The Earl of Leicester*, and *Edith of Lorne*; by John Hutchison *Flora McIver*, *Baron Bradwardine*, *The Glee Maiden* and *Hal o' the Wind*; by Clark Stanton *Rebecca*, *Friar Tuck* and *Saladin*; by Mrs D. O. Hill *Magnus Troil*, *Minna* and *Richard Coeur de Lion*; by D. W. Stevenson *Queen Mary*, *Halbert Glendinning* and *James VI*; by G. A. Lawson *Diana Veron*, *Baillie Nicol Jarvie* and *Robert the Bruce*; and by A. Currie *Old Mortality* and *Eddie Ochiltree*. The remaining thirty-two figures were installed in 1882.

The *Scott* established Steell in a near-monopoly of public monuments in Edinburgh, including the major examples commemorating Wellington (1852—'The Iron Duke in Bronze by Steell') (plate 6) and Prince Albert (1870–6) (plate 195). He also executed the memorials to Allan Ramsay (1865) (plate 126) and Professor Wilson (1865) in Princes Street and to Dr Chalmers (1878) in George Street. Other monuments in Princes Street were executed by A. R. Paton (*Dr Livingstone*, 1876), J. Hutchison (*Adam Black*, 1877) (plate 127) and William Brodie (*Sir James Simpson*, 1877), and it can be no coincidence that these were all executed by sculptors who stayed in Scotland, rather than by a possibly superior artist such as Calder Marshall who settled in London.

Glasgow was rather more cosmopolitan in its choice of artists for public monuments,[75] and the traveller who emerges from Queen Street Station into George Square and responds like Baudelaire (see p. 45) will get a wider choice of artistic vibrations than he would going along Princes Street in Edinburgh. The monument to Sir John Moore, erected in 1819, is by John Flaxman, and that to James Watt of 1830 is by Chantrey. The figure of Walter Scott (plate 128) on top of the column (plate 129) was designed by John Greenshields and executed by A. H. Ritchie; it dates from 1838. The equestrian figures of Queen Victoria and Prince Albert, set up to commemorate their visit of 1849, are by Baron Marochetti; the *James Oswald* of 1855 is also by Marochetti while the *Robert Peel* of 1859 (plate 130) is by the Glasgow sculptor John Mossman. The statue of Lord Clyde (1867) is by Foley, that of Thomas Graham (1871) by William Brodie, *Robert Burns* (1876) is by the Scottish sculptor George Ewing (1828–84) with reliefs by his brother James (1843–1900), while *Thomas Campbell* (1877) is by John Mossman again. A short distance away is the equestrian statue of Wellington (1844), by Marochetti (plate 5).

In Dublin[76] the situation seems to have been that, while certain public monuments were executed by London-based Irish sculptors, there was business enough for those who stayed behind. The statue of the poet Thomas Moore, in College Street, Dublin, is by Christopher Moore, who based himself in London, though he was a frequent visitor back to Ireland. Foley went to London at the age of sixteen: nonetheless he executed for Dublin the monuments to Henry Grattan (who had been commemorated earlier by a statue by Chantrey of 1827, now in City Hall) (plate 132), the Earl of Carlisle, Viscount Gough

129. General view of the Scott Monument, Glasgow.

130. John Mossman, *Sir Robert Peel*, 1859. Glasgow, George Square.

131. John Hogan, *Thomas Drummond*, 1843. Dublin, City Hall.

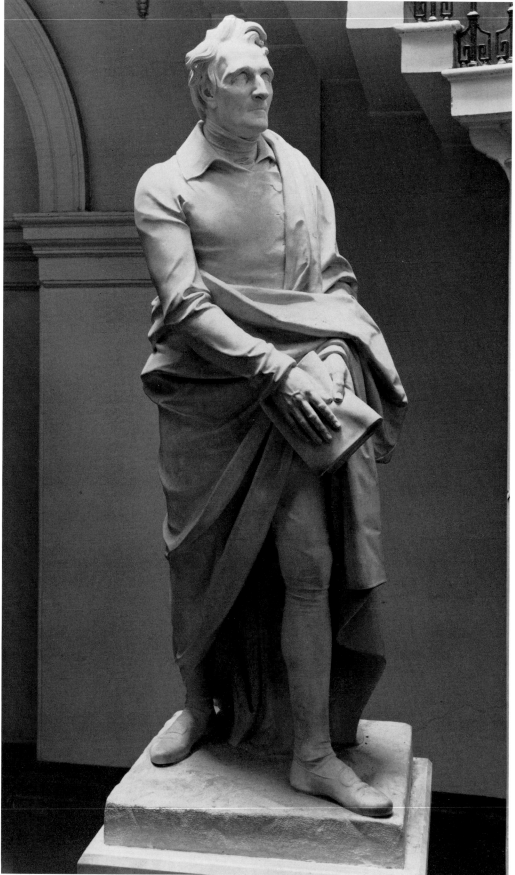

132. Sir Francis Chantrey, *Henry Grattan*, 1827. Dublin, City Hall.

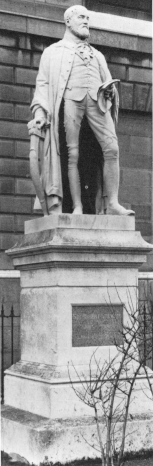

134. Sir Thomas Farrell, *Sir Robert Stewart*, erected 1898. Dublin, Leinster Lawn.

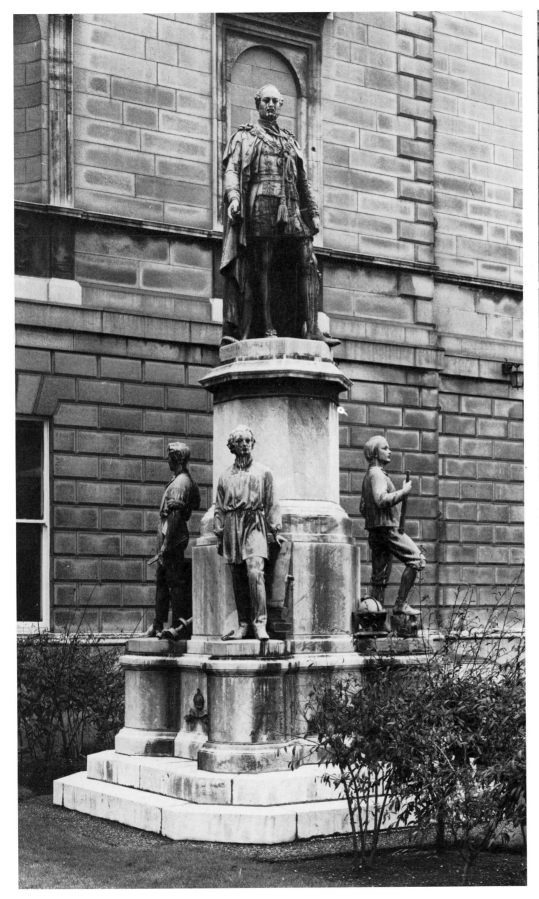

133. John Henry Foley, *Prince Albert*, 1871. Dublin.

135. Andrew Handyside Ritchie, *William de Mowbray*, 1851. London, Houses of Parliament.

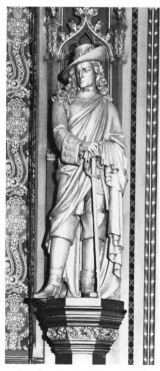

136. John Birnie Philip, *William III*, 1869. London, Houses of Parliament.

(plates 41, 44) and Sir Benjamin Guinness (plate 69); he also executed the two principal national monuments to Prince Albert (dated 1871) (plate 133) and to Daniel O'Connell 'the Liberator' (plates 70, 71, 189). He did not obtain this latter without criticism on the home front: 'he has been so absorbed by the wealth and blandishments of Babylon that his native land seems to be to him as a thing of nought'.[77] On the other hand, John Hogan (1800–58) who after spending some years in Italy had in the end returned to Dublin, executed statues of O'Connell, Drummond (plate 131) and Thomas Davis which are now in City Hall, Dublin, while Sir Thomas Farrell remained in Ireland and executed the public monuments in Dublin to Sir Robert Stewart (plate 134), Dargan (1863) and Sir Alexander McDonnell (1878).

The pattern of nationally-based patronage providing the foundation for a sculptor's prosperity can be extended even further within the (then) British penumbra. Charles Summers (1825–78), like Woolner the previous year, went to Australia in 1853 to prospect for gold. He was not successful in this, so resumed work as a sculptor; unlike Woolner, who returned to England, Summers stayed on and established himself as the leading sculptor in Australia of his time, executing a series of busts of the City Fathers of Melbourne and other worthies. He also won the competition for the monument to the explorers Burke and Wills, the first major national memorial in Australia; the thirteen-foot-high bronze group, with reliefs below, was unveiled in 1865. Summers's position and esteem were such that even though he returned to England in 1866 and settled in Rome in 1867 (where he remained until his death), he continued to produce work for Australia as well as England. In the year of his death, 1878, he completed four colossal statues, of Queen Victoria, Prince Albert, the Prince of Wales and Princess Alexandra, for Melbourne. His hold on the market in Australia was such that he was held to have stunted the work of other sculptors there, and his career was sufficiently prosperous for his studio to be considered one of the finest in Rome.[78]

INSTITUTIONS

Institutional patronage also played an important part in the sculptor's livelihood, and, as with public monuments, was not confined to London. We have already seen Parliament patronising sculpture via the Royal Fine Arts Commission, the rebuilding of the Houses of Parliament and the 1844 Exhibition and so on, and it is important to register Parliament as such an institution distinct from Government or for that matter from the public. During the 1840s and 1850s Parliament was, by the means described, a major commissioner of sculpture, of which the St Stephen's Hall 'petrified lobbyists' were only part.[79] The Chamber of the House of Lords was designated for statues of the Barons and Prelates who signed Magna Carta, and sculptors for the eighteen figures were selected in 1847. Among these were some we have already come across: John Thomas, Thrupp, A. H. Ritchie, Thomas Thornycroft, W. F. Woodington, Patrick MacDowell; the others were John Evan Thomas (1810–73), Henry Timbrell (1806–49) and James Sherwood Westmacott (1823–1900). Woodington's model of the Earl of Arundel was completed by December 1848, and the last model, that of William de Mowbray by A. H. Ritchie (plate 135), was completed by May 1851. The statues were cast in zinc, coated with copper by the electro process and chemically tinted as required (which apparently was a great saving on the cost), and the series was installed by 1858.[80]

In the Prince's Chamber, the Commissioners installed a series of bronze reliefs by William Theed, representing scenes from Tudor history; they date from 1853 to 1856.[81] In the same room, the Commissioners installed one of their major commissions, the group of *Queen Victoria flanked by Justice and Clemency*.[82] When the Commissioners under their chairman, Prince Albert, had met to decide on who should do it, a note was passed

round saying: 'His Royal Highness thinks Mr Gibson should have it', and so he did. The
original scheme was for an equestrian statue, but this was altered to a single enthroned
figure and later still, at the suggestion of Prince Albert, two allegorical figures were
added; Gibson was prepared to offer a range of allegorical sets. The group was executed
by the sculptor in Rome, and arrived in England and was installed in 1856. 101 years later
the figures of Justice and Clemency were removed and put in store; still more recently
they have been restored.

The Commissioners also set in motion a series of statues of monarchs for the Royal
Gallery.[83] Though first adumbrated in the 1840s, the scheme did not get going until 1860:
the sculptors selected were by now familiar figures—Weekes, Thornycroft, Theed,
Woolner and Munro. Unfortunately, when the first two were ready (Thornycroft's *James
I* and *Charles I*) they were found to be too large for the designated niches, and the series,
after some years in Westminster Hall, was transferred to the Old Bailey. Theed executed
George IV and *William IV*, Munro *Mary II* (plate 137), Weekes *Charles II* (plate 138) and
Woolner *William III* (plate 139). A replacement series was executed by John Birnie Philip
(plate 136), under the supervision of E. M. Barry, who had succeeded his father as
architect in charge; these were no longer strictly the results of the patronage of the Fine
Art Commission, which was by then defunct.

More typical, perhaps, of national institutions and their patronage of sculpture was the
Royal College of Surgeons in London. Between 1845 and 1867, the Council of the College
acquired six busts by Henry Weekes of officials of the College: that of Sir Astley Paston
Cooper, Bart. (1768–1841), President of the College in 1826 and 1837, was bought by the
Council on 17 October 1845 for £113 8s. including pedestal;[84] that of Joseph Henry

137 (left). Alexander Munro,
Mary II, 1868. London, Old
Bailey.

138 (centre). Henry Weekes,
Charles II, 1870. London, Old
Bailey.

139 (right). Thomas Woolner,
William III, 1867. London, Old
Bailey.

140. John Graham Lough, *James Losh*, 1836. Newcastle-upon-Tyne, Literary and Philosophical Institute.

141. Alexander Munro, *Lord Armstrong*, 1860. Newcastle-upon-Tyne, Literary and Philosophical Institute.

142 (right). Thomas Woolner, *Prince Albert*, 1864. Oxford, University Museum.

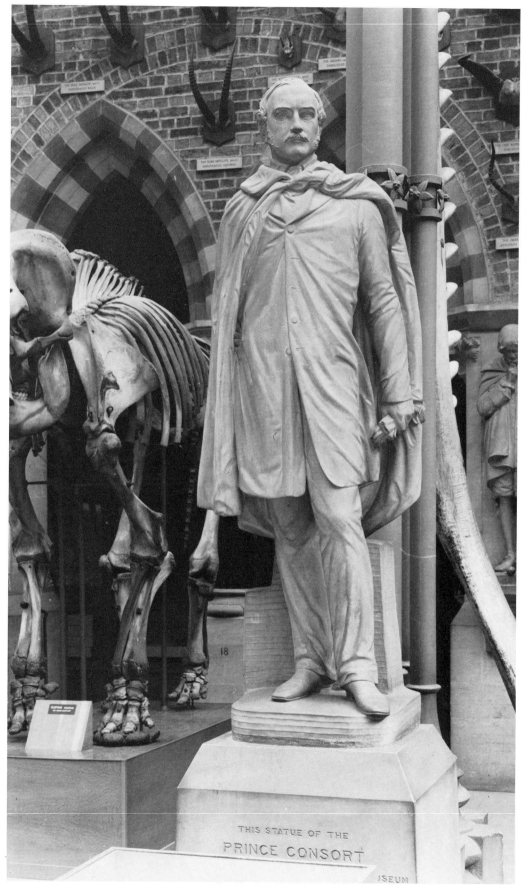

Green (1791–1863), President of the College in 1849 and 1858, was ordered from Weekes by the Council in 1865 and bought in 1866 for £126 (this was a replica of Weekes's Diploma Work for the Royal Academy);[85] that of James Moncrieff Arnott (1794–1885), President of the College in 1850 and 1859, was ordered by the Council in April 1853 and received on 10 November that year, price £110.[86] But the College also acted as recipient for subscribed memorials: the marble bust by Timothy Butler of Samuel Cooper (1781–1848), President of the College in 1845, was presented by the subscribers of the *Samuel Cooper Testimonial Fund* on 15 March 1851.[87] The major work of this type was undoubtedly the full-length marble statue by Weekes of the eminent surgeon John Hunter (1728–93) (plate 16), which was erected in the Hunterian Museum of the College in 1864, by public subscription.[88] By singular good fortune and provision, this major work survived war-time bombing of the Museum and is still to be seen at its new site in the inner Hall of the College.

This type of patronage was not confined to national institutions in London. Between 1825 and 1860 at least, a number of works were commissioned for the Literary and Philosophical Society in Newcastle-upon-Tyne.[89] Subscribers presented to the Society a bust of Thomas Bewick, the engraver, by E. H. Baily of 1825. James Losh, a great leader in the North of the movement for the abolition of slavery, who died in 1833, had a bust presented to the Society by subscribers: it is by David Dunbar, a Carlisle artist then working in Newcastle, and is dated 1832. Subscribers also presented to the Society a full-length statue of Losh (plate 140), by the then up-and-coming young Northumberland artist J. G. Lough; it is signed and dated 1836. Members of the Society subscribed to a bust of the first Lord Armstrong, by Alexander Munro (plate 141), and in 1860 the Society commissioned a bust of Robert Stephenson by Edward Wyon (1811–85), a London sculptor. Thus local celebrities were recorded by artists from varying backgrounds.

The universities were also prominent institutions in the patronage of sculpture. This could be simply a matter of placing a professor on record with a bust, or it could be a more substantial simulacrum of a noted alumnus or official. This book started with an account of Cambridge University's memorial to Prince Albert (plate 1); Oxford's consisted of a statue by Woolner (plate 142), which was placed in the University Museum in April 1864, presented by the citizens of Oxford. Also in the Museum, and an intrinsic part of it, is a series of full-length statues of famous scientists; these form part of the overall University project, though it would seem that individual donors paid for particular statues—Queen Victoria, for instance, presented Woolner's *Bacon* (plate 143) and (later) *Hunter* by H. R. Pinker (1849–1927). Other artists involved in this project were Munro, who did six figures (plates 302, 303), Joseph Durham, who did two (plate 301), E. B. Stephens, Weekes, Armstead and J. L. Tupper (plate 228), who each did one.[90] Woolner, again, was called on for the University's Memorial to Gladstone (plate 144), which was presented to the University by subscribers in 1866. It consists of a bust of Gladstone, surmounting a plinth on which are three reliefs of scenes from Homer. Originally in the Bodleian Library, the work has since been moved to the Ashmolean Museum.[91]

Within the Universities of Oxford and Cambridge were the colleges, separate institutions with considerable financial resources, and some of these were extensive recipients of sculpture. Trinity College, Cambridge 'graciously condescended' to accept Woolner's bust of Tennyson (plate 64) (these are the words of Vernon Lushington, who was one of the main forces behind this attempt to commemorate Tennyson at Cambridge), though they would not have it in the Library itself, only in the Vestibule.[92] The bust of Archdeacon Hare, brother-in-law of F. D. Maurice and for a long time a resident fellow of Trinity, was commissioned from Woolner by the Rev. H. Montague Butler, for presentation to Trinity, but conditional on the assent of the Master of Trinity

143. Thomas Woolner, *Francis Bacon*, 1857. Oxford, University Museum.

144. Thomas Woolner, *W. E. Gladstone*, 1866. Oxford, Ashmolean Museum.

145. Thomas Woolner, *William Whewell*, 1873. Cambridge, Trinity College.

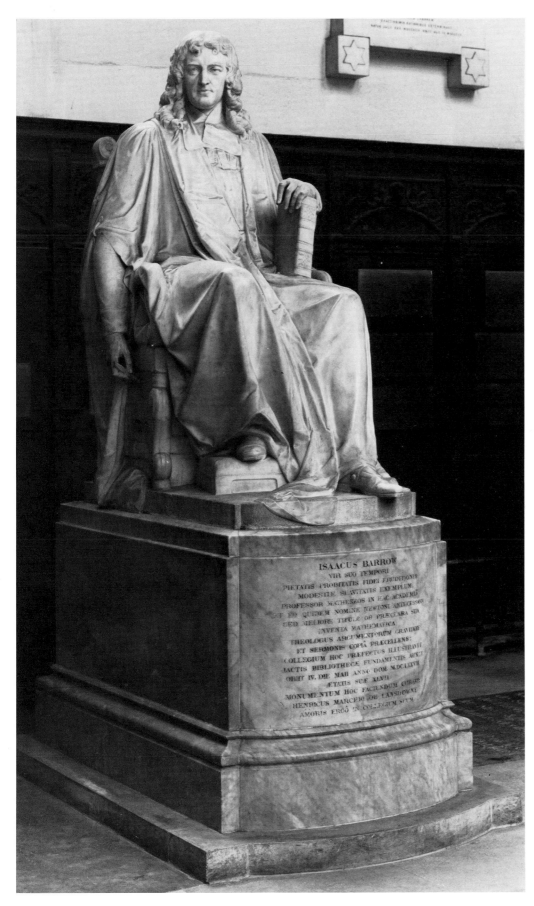

147. Christopher Moore, *The Rt. Hon. Thomas Lefroy*, 1859. Dublin, Trinity College.

148. Joseph Watkins, *W. C. Magee*, 1869. Dublin, Trinity College.

146 (left). Matthew Noble, *Isaac Barrow*, 1858. Cambridge, Trinity College.

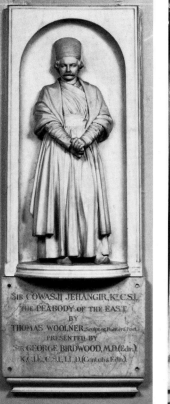

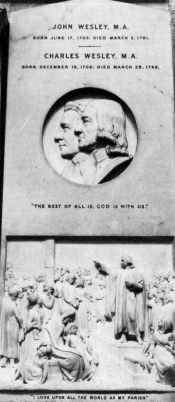

149 (above left). William Brodie, *Sir James Young Simpson*, 1872. Edinburgh, University.

150 (above centre). Thomas Woolner, *Sir Cowasji Jehangir*, 1875. Edinburgh, University.

151 (above right). John Adams-Acton, Monument to the Wesley brothers, 1875. London, Westminster Abbey.

152 (right). John Adams-Acton, Monument to Bishop Waldegrave (†1869). Carlisle, Cathedral.

153 (facing page). Sir Francis Chantrey, Monument to Bishop Ryder, 1841. Lichfield, Cathedral.

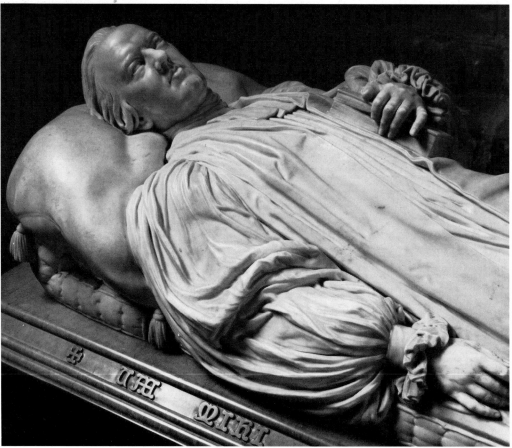

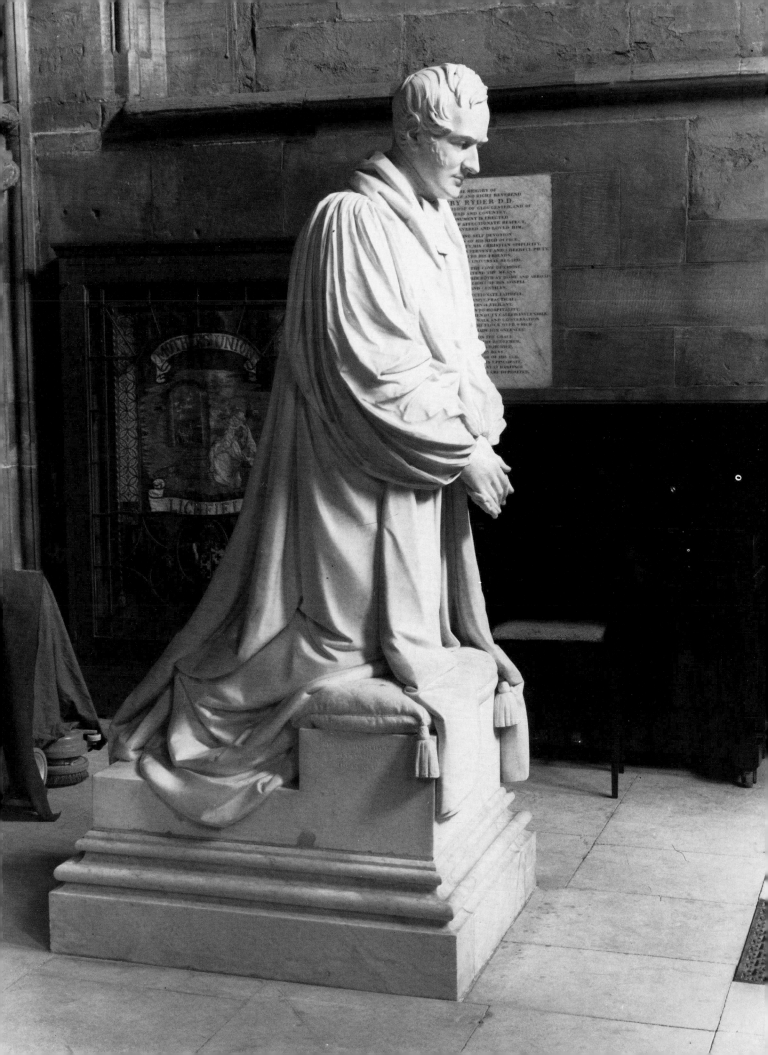

to accept the bust, which he did. This Master was William Whewell, who is in turn commemorated at Trinity by a full-length seated statue by Woolner of 1873 (plate 145), one of a notable series of major works of a similar type belonging to the College: the others are *Francis Bacon* by Weekes (1845), *Isaac Barrow* by Noble (1858) (plate 146), *Macaulay* by Woolner (1866) (plate 78) and *Tennyson* by Hamo Thornycroft (1909).

Trinity College, Dublin also patronised sculpture in this way.[93] The series of commemorative busts in the Long Room, begun in the eighteenth century, continued in the nineteenth, with examples such as *The Rt. Hon. Thomas Lefroy* by Christopher Moore (plate 147), signed and dated 1859 and *W. C. Magee* by Joseph Watkins, R. H. A. (plate 148), signed and dated 1869. And on the lawns outside the main entrance of the College are two statues of prominent late-eighteenth-century alumni, *Oliver Goldsmith* (unveiled 1864) (plate 206) and *Edmund Burke* (unveiled 1868). Both are by Foley. Edinburgh University's collection of busts, most now in the Library Hall of the Old University Building, are almost entirely Victorian, and predominantly by Scottish sculptors, such as that of Thomas Charles Hope (Professor of Chemistry, 1795–1844) by John Steell, signed and dated 1844; and that of Sir James Young Simpson (plate 149) by William Brodie, signed and dated 1872. Other commemorative works within the University include a relief to Sir Cowasji Jehangir by Woolner (signed and dated 1875) (plate 150), and a statue to D. Brewster by William Brodie.

To a certain extent it could be said that the concept of institutional patronage should be extended to cover monuments of the Established Church to their officers in cathedrals—bishops and deans particularly being there commemorated *ex officio*, with effigies often excelling in scale any other monument in the building. Thus at Lichfield Cathedral between 1840 and 1880 five monuments to dignitaries were erected: to Bishop Ryder (†1836), a kneeling figure by Chantrey (plate 153), signed and dated 1841; to Archdeacon Hodson (†1855), a predominantly architectural monument designed by G. E. Street without a figure; to Bishop Lonsdale (†1867), a reclining effigy by G. F. Watts (plate 346); to Dean Howard (†1868) (plate 328), and to Archdeacon Moore (†1876), the latter two monuments being designed by Sir G. G. Scott with effigies by Henry Hugh Armstead, dated respectively 1872 and 1879. This pattern of official commemoration is repeated in other cathedrals, for instance, Adams-Acton's monument to Bishop Waldegrave (†1869) (plate 152) at Carlisle.

The pattern was not confined to the Church of England: Adams-Acton became known as 'the Wesleyan sculptor'[94] from the extensive use made of him by that religious body. It started with the commission he received for the Wesley memorial in Westminster Abbey (of 1875) (plate 151) and he went on to execute a number of busts of prominent Wesleyan ministers to adorn the Chapel in City Road. 'And when it was decided to place a statue of Wesley himself over the entrance of the Chapel, to be erected on an anniversary of the birth of the great divine, Adams-Acton was unanimously nominated as the only sculptor qualified to undertake this important work.'[95] It was unveiled in 1891.

PRIVATE PATRONS

In dealing so far and so thoroughly with works commissioned for public or institutional consumption, one is dealing with a work area that is (if it survives at all) by its nature available. This, though, should not be allowed to mislead one into thinking that this area represents the whole, or even the most vital part, of the patronage that was available to sculptors; it was, figuratively speaking, the icing on the cake, both financially and in terms of prestige. For it was largely by private patronage that the sculptor survived (if he did). The demand for busts and funerary monuments was the staple of his livelihood, as everyone recognised: S. C. Hall said so in the 1840s,[96] Woolner did so in effect when, while

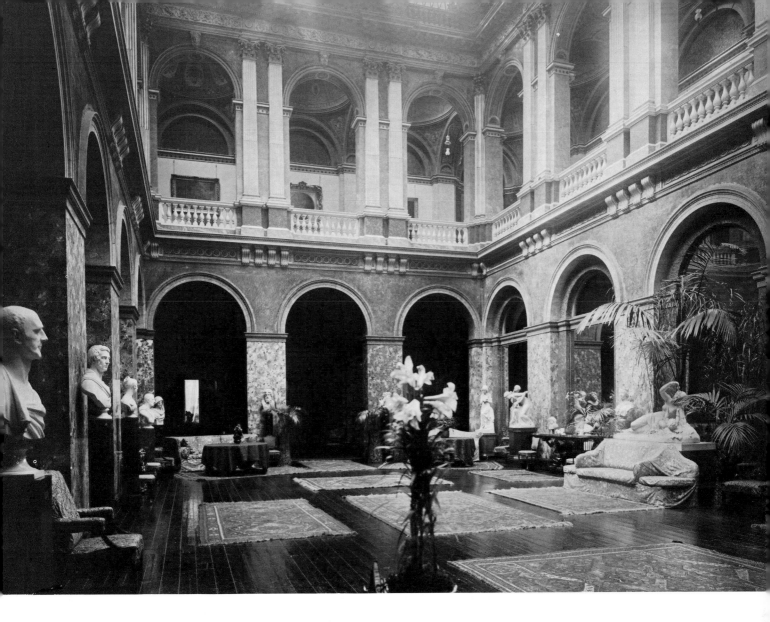

154. View of the Main Hall, Bridgewater House, London.

working on the Trevelyan Group, he had to break off to earn his living by doing busts.[97] And it was to private patronage that the sculptor had to turn for the wherewithal to realise and express, in durable form, his higher ideals—those figures and groups, based on mythology and literature, by which he thought he could best express the poetry of art that he considered was within him. Our picture, therefore, of the Victorian sculptural world, if it is to be at all representative, must take private patronage into account.

But this is as yet the most obscure corner of that world, and any account of this work area must be taken for the moment as idiosyncratic in the extreme, being dependent wholly on such stray evidence as has turned up. Few private collections have survived intact, and none so far as I know is catalogued. Apart from one or two isolated instances, most available information only casts a faint, fitful light on a vanished world.

Among the ghost collections that fleetingly appear is that of the Dukes of Sutherland and Earls of Ellesmere (whose titles merged during the nineteenth century): this included a seven-foot statue of *Erin* by Marochetti (sold at the Duke of Sutherland sale, Knight, Frank and Rutley, 14 July 1913), Foley's *Ino and Bacchus* (plate 56) and MacDowell's *A Girl Reading* (plate 15) (both of these are visible in an old photograph of the interior of Bridgewater House (plate 154)), J. G. Lough's *Ariel* (at Messrs Crowther in 1956) and busts of the Duke and Duchess of Sutherland by Matthew Noble. The Fitzwilliams of Wentworth Woodhouse in Yorkshire had statues by MacDowell; two at least by John

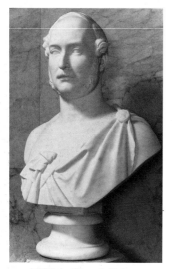

155. William Theed, *Prince Albert*, 1862. Royal Collection, Osborne.

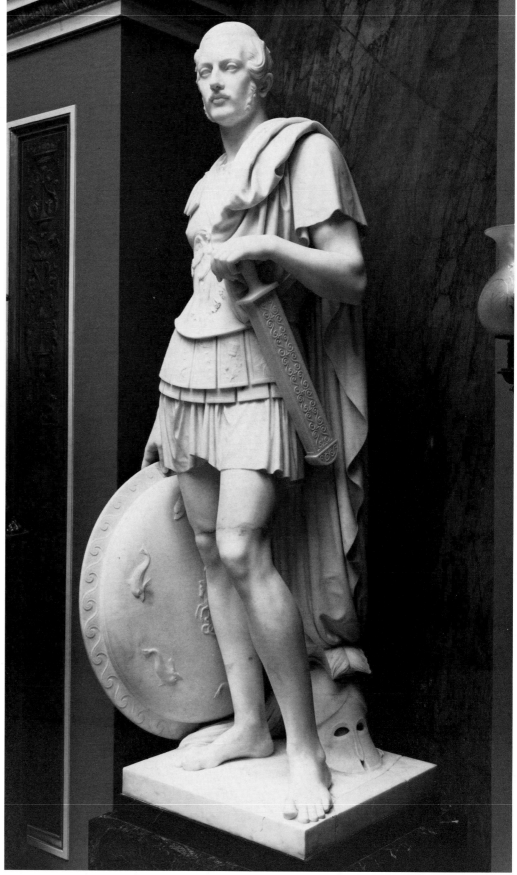

156 (right). Emil Wolff, *Prince Albert*, 1844. Royal Collection, Osborne.

157 (facing page). John Gibson, *Queen Victoria*, 1849. Royal Collection, Osborne.

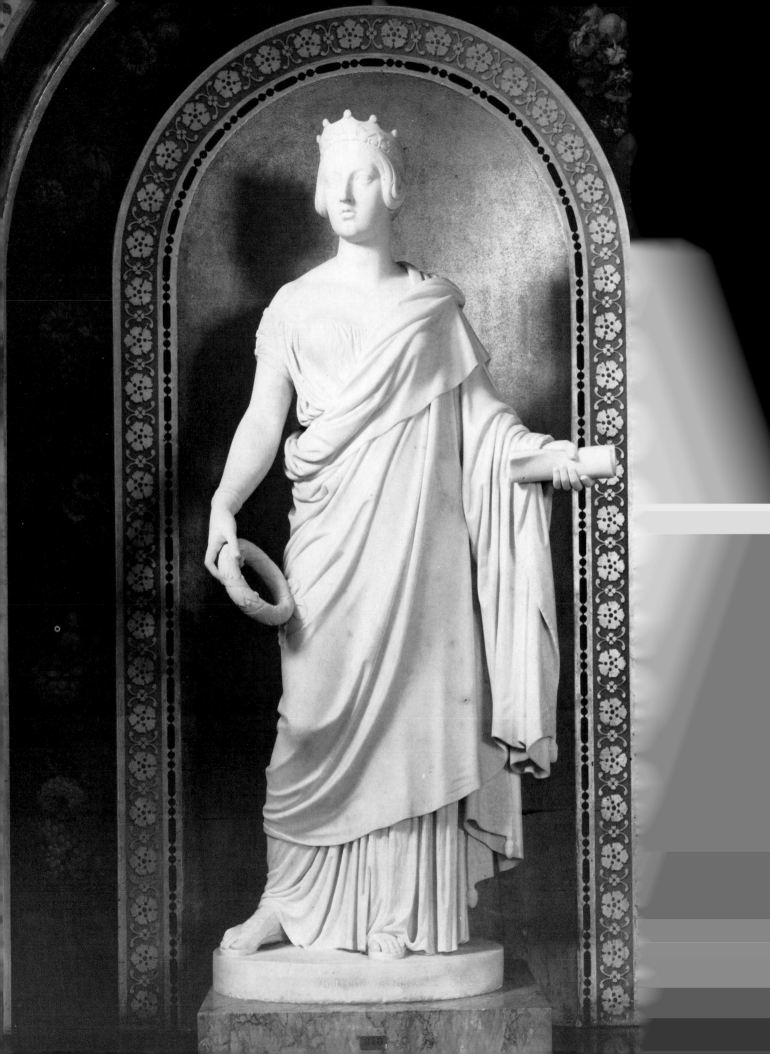

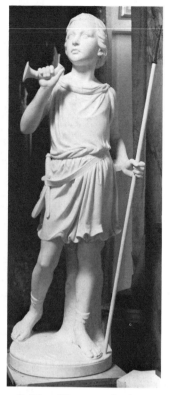

158. Mary Thornycroft, *A Hunter*, 1859. Royal Collection, Osborne.

Bell, *The Archer* and *Lalage*; *The Young Fisherman* (1877) by Lawrence Macdonald; *The Huntress* by R. J. Wyatt; and a model of Jerusalem on a scale of eighteen inches to the mile, dated 1846, by the sculptor Edwin Smith (1810–89) of Sheffield.[98] The picture gallery at Cragside, Northumberland, the Armstrong residence, contained at one time busts and a couple of figures; among the bronze figures lining the staircase can be seen what is sometimes called *The Norseman* by Foley, though this would seem to be a version of his *Caractacus* at the Mansion House, London.[99] The Armstrong collection was sold shortly before the First World War. Again, it is related that Sir Isaac Holden, Baronet and M.P., had a marvellous garden at his house, Oakfield, near Bradford, where he introduced fine statuary, whilst George Moore, the Carlisle philanthropist, had a fine sculpture gallery at his house in Palace Gardens, London:[100] neither collection would seem to have survived. The collection at Brodsworth Hall, in Yorkshire, does survive, but is untypical; most of it comes from the continent having been sent over by Casentini, the architect of the house, in 1866.

One major private collection does survive and, to some extent, in its original setting. This is the collection formed by Prince Albert and Queen Victoria and in its range and variety it must have been the most substantial in the country as well as an important and prestigious source of patronage.[101] It included a number of busts of members of the Royal Family, such as that of Prince Albert by William Theed (plate 155), commissioned by the Queen at her husband's death; this is still in its originally designated position in the Main Staircase Hall at Osborne. Full-length portrait statues in the collection sometimes assume a somewhat ideal guise: both *Prince Albert* (by Wolff, 1844, at Osborne) (plate 156) and *Queen Victoria* (by Gibson, at Osborne (plate 157), given to the Prince Consort by the Queen as a birthday present in 1849; it is a replica of one at Buckingham Palace) are in classical gear, they are represented together as Anglo-Saxons by Theed, while the Royal Children were portrayed in a series by Mary Thornycroft between 1845 and 1860 as *The Seasons*, *Peace and Plenty*, *A Fisher Boy* and *A Hunter* (plate 158)—the latter being for instance a portrait of Prince Arthur aged nine.

There was a large collection of Ideal Works drawn from mythology and literature, for example R. J. Wyatt's *Penelope with the Bow of Ulysses* (plate 159), now at Windsor but originally at Osborne. This was one of a series of mainly classical subject pieces commissioned from young sculptors in Rome through the agency of John Gibson; another is Macdonald's *Hyacinthus* (plate 160) of 1852. These in fact formed, together with some genuine antique works and a large collection of small-scale bronze reproductions of famous classical works, what was virtually a Classical Sculpture Gallery at Osborne, an equivalent from the 1840s and 1850s of the traditional collection of this kind known in princely and noble homes all over Europe. Osborne's collection led off with Josef Engel's *The Amazons and the Argonaut* (plate 161), a group of heroic proportions sited in the Main Staircase Hall of Osborne, which no visitor could possibly miss.

The collection included though many works drawing on other sources. Troschel's *La Filatrice Addormentata* (plate 162) was originally in the Billiard Room at Osborne; it is now at Windsor. William Geefs's *Paul et Virginie* (plate 163), bought at the Great Exhibition of 1851 and given by Prince Albert to the Queen as a Christmas present that year, took its place in the Principal Corridor at Osborne along with its classical counterparts (and is still there). Eduard Müller's *Venus and Cupid* (plate 164) seems in place there too, and the fact that it has an alternative title—*Innocence in Danger*—of a more sentimental character is symbolic of two polarities of taste that lie behind the collection.

Other aspects of sculpture that were patronised include Prince Albert's extensive employment of John Thomas for architectural sculpture such as reliefs of *War* and *Peace* for Buckingham Palace, and a frieze of kings' heads for the Private Audience Chamber at Windsor Castle. Also at Windsor are two schemes in which Thomas was able to exercise

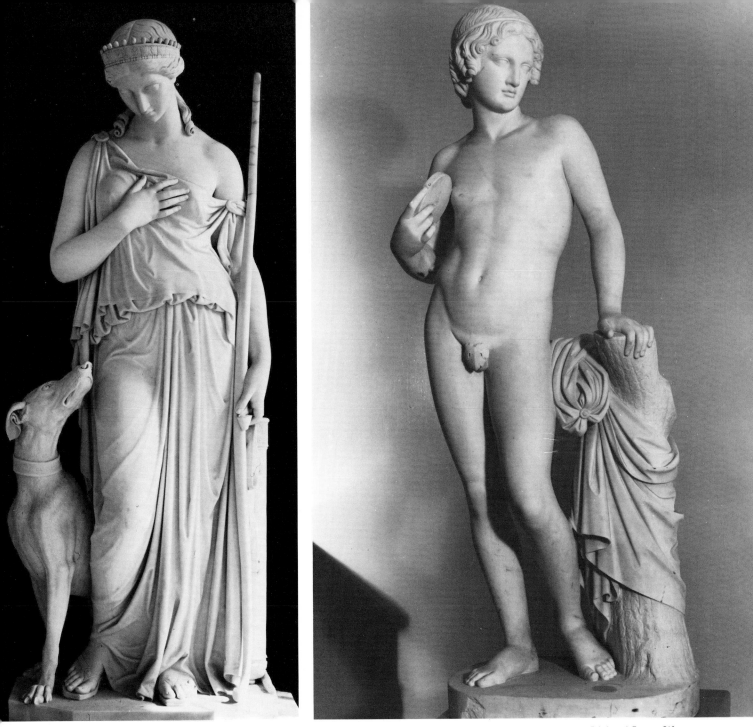

his twin capacities as sculptor and architect, the Dairy on the Home Farm,[102] and the remodelling of the Royal Print Room (plate 165).

The Royal Collection was not averse to replicas: *Highland Mary* by B. E. Spence is one, Theed's *Narcissus* is almost another (there is no fig leaf on the original at Anglesey Abbey), and this also applied to busts of notable contemporaries, such as one by Foley of Viscount Hardinge. One can in fact read something quite positive into this, especially with the number of ceramic and Art-Union bronze reproductions that the collection contains, such as Foley's *Innocence* (plate 66), in an edition by Copeland; these would reflect Prince Albert's support and concern for Art made available to a wider public via industrial means. The Prince's direct concern with sculpture is frequently evident; we have seen how he channelled work directly to Gibson on the Fine Art Commission, he lent Thomas Thornycroft horses as models for the *Boadicea* group (plate 55), and his favour of Marochetti was yet another reason for the latter's unpopularity with the native sculptural

159. Richard James Wyatt, *Penelope with the Bow of Ulysses*, c. 1841–2. Royal Collection, Windsor Castle.

160. Lawrence Macdonald, *Hyacinthus*, 1852. Royal Collection, Buckingham Palace.

133

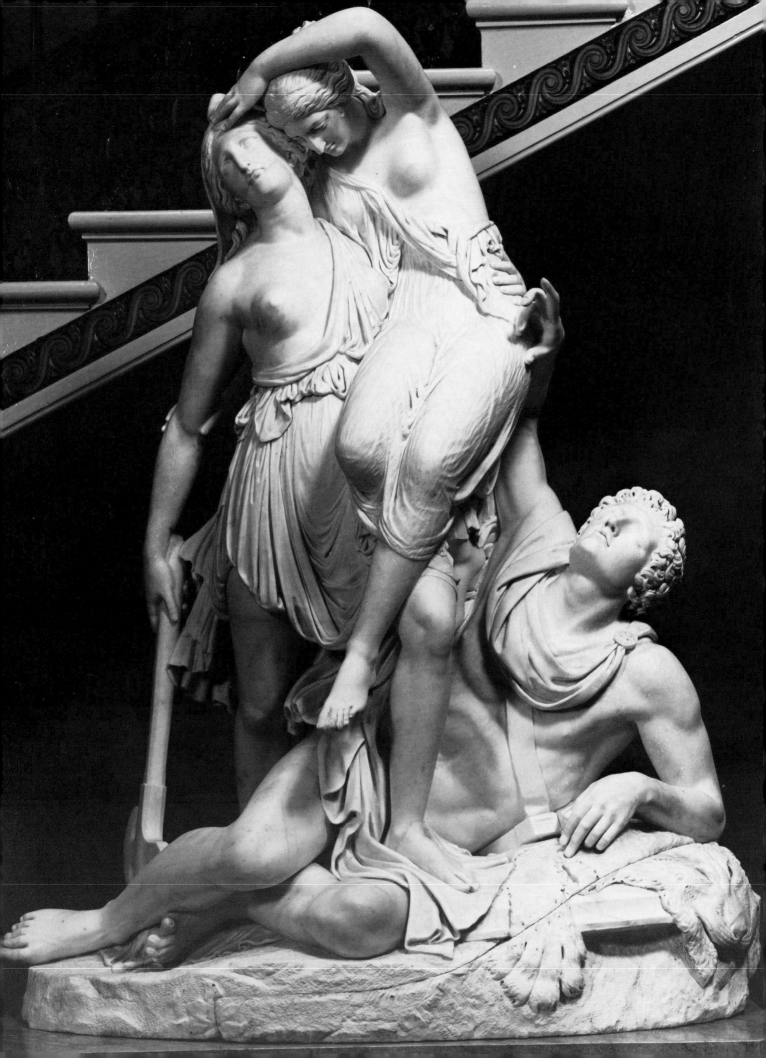

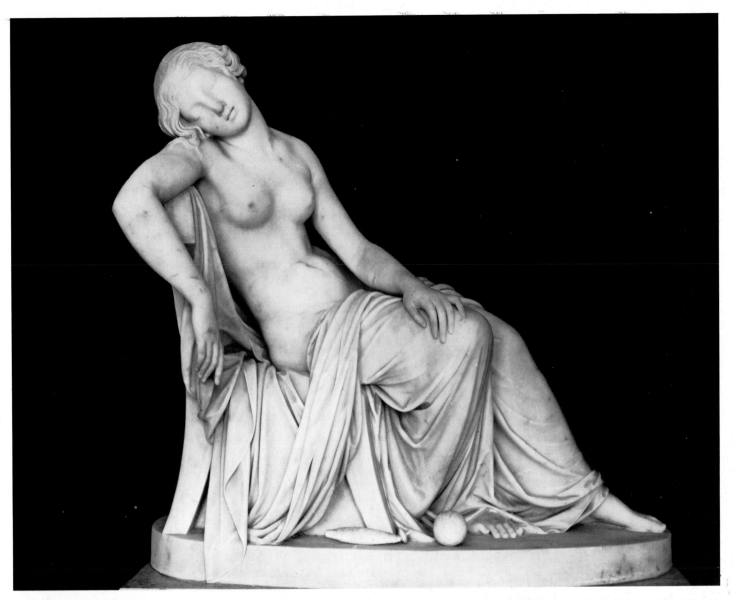

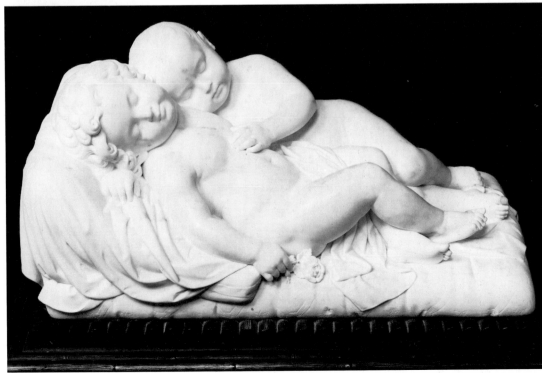

162. Julius Troschel, *La Filatrice Addormentata*, 1845. Royal Collection, Windsor Castle.

163. William Geefs, *Paul et Virginie*, 1851. Royal Collection, Osborne.

161 (facing page). Josef Engel, *The Amazons and the Argonaut*, *c.* 1851. Royal Collection, Osborne.

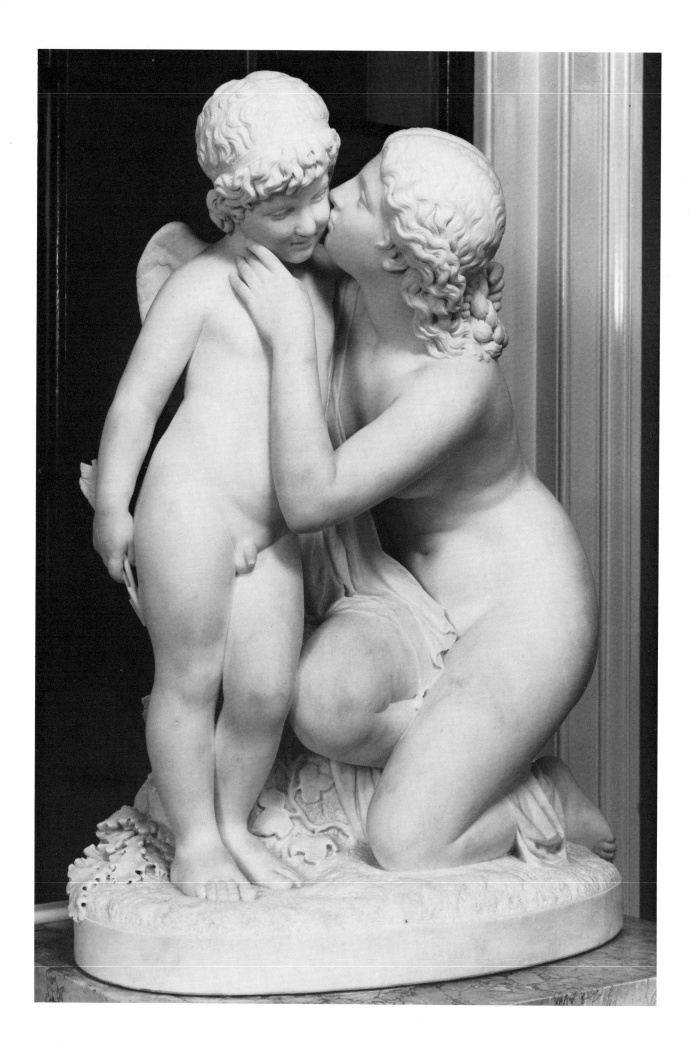

165. Detail from the interior of
the Print Room at Windsor
Castle.

166. Prince Albert, *Greyhound*,
c. 1845. Royal Collection,
Osborne.

164 (facing page). Eduard
Müller, *Venus and Cupid/Innocence
in Danger*, 1862. Royal
Collection, Osborne.

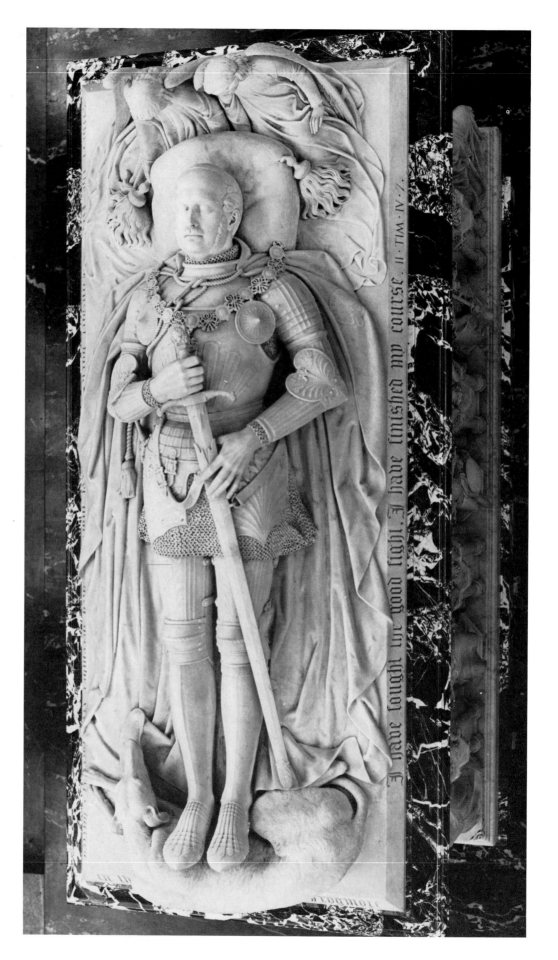

167. Baron Henri de Triqueti,
Prince Albert (†1861). Royal
Collection, Windsor Castle,
Albert Memorial Chapel.

168. John Graham Lough,
Somnus, 1850. Blagdon.

169. John Graham Lough, *Milo*
(bronze of 1863). Blagdon.

fraternity. It should come as no surprise then that Prince Albert turned his hand even to sculpting: the *Greyhound* (plate 166) on the Terrace at Osborne is a portrait of Eos, the Prince's favourite greyhound, and, though cast by John Francis, it was modelled by the Prince Consort himself.

The names of Wolff, Engel, Troschel, Geefs, Müller and Marochetti are indicative of another exceptional aspect of the Royal Collection, its cosmopolitan scope—Wolff, Troschel and Müller were German, Engel was Hungarian, Geefs was Belgian and Marochetti Italo-French. After Prince Albert's death, at the Queen's request it was Marochetti who was first asked to execute the figure of the Prince for the National Memorial, and he certainly executed the effigy of Albert (and that of Victoria) for the Royal Mausoleum at Frogmore. Meanwhile it was a French sculptor, Henri de Triqueti, who was responsible for the cenotaphic effigy of Albert and the painted marble scenes for the Albert Memorial Chapel at Windsor Castle (plates 94, 167).

Of the landed families, we know something of the patronage by the Ridleys in Northumberland of J. G. Lough, from his early years.[103] The very first Ridley commission in 1832 was for an ideal work, but thereafter for some considerable time Lough produced just busts: one of Sir Matthew White Ridley, third Baronet, in 1833; one of the fourth Baronet in 1841 (with a replica in 1863); one of Lady Ridley in 1842; with a replica executed in 1846 after her death, when he also executed one of her son, the future fifth Baronet. Lough also executed a bust of the second Baronet, from a portrait, and one of Lady Ridley's sister. In 1843 the Ridleys began to order more substantial works from Lough, quite possibly in order to help him out during a time of financial difficulties. Lady Ridley wrote to her father that year:

> We had a most melancholy letter from the Loughs yesterday. I do not know whether they wish the state of their affairs to be a secret or not, but I cannot help thinking that some of the great and rich people of the world would be very likely to give him orders if they knew what a state he is in. They said yesterday they were positively so reduced that he had to go out and see if he could borrow a few pounds to pay his men, and that he had only eighteen shillings in the world. Literally now he lives upon what he gets from Matt, who pays him every now and then as much

as he can, and Lough hurries on his things much more than we wish really because he has no other hope. It is very sad.

The first of a series of statues of Shakespearean characters for the Ridleys was *Ophelia* of 1843; after this *Iago* and *Lady Macbeth* (1844), and by 1847 *Hamlet, Macbeth, Edgar, Puck, Oberon, Titania, Ariel* and *Portia*. From 1850 dates *Somnus* (plate 168), in 1851 Lough was paid £2,000 for a six-ton group of *St Michael and Satan*; subsequently he executed a large bronze plaque of the *Fall of Phaeton* and a bronze version (1863) of the *Milo* (plate 169) he had first executed in plaster in 1827. In 1863 Lough was paid another £2,000 by the Ridleys for a final Shakespearean commission, a marble frieze for the staircase of their town house. This represented Shakespeare sitting at the top with raised arm; on his right hand is the opening storm scene from *The Tempest*, on his left Macbeth and Banquo hailed by the witches; the story of Macbeth then continues with the murder, the sleepwalking, Birnam Wood, and the death of the Tyrant with Victory crowning Malcolm and concludes with a triumphant dance of the witches. Similarly *The Tempest* continues the narrative of the play and ends with the masque—a work, therefore, of some complexity.

Finally, between 1869 and 1871, Lough executed four statues for the bridge on the drive leading to the Ridley's Northumberland home, Blagdon. These were a *Deer Slayer*, a *Boar Hunter*, a *Shepherd* and an *Eagle Slayer*. Thus consistently, over nearly forty years, one family had commissioned works from a single sculptor, some of which survive at Blagdon, though not necessarily as originally sited. The *Fall of Phaeton* survives in the porch of their London house in Carlton House Terrace. In addition, Lough had received two public commissions in the North East almost certainly through the support of so substantial a local family—the Collingwood monument at Tynemouth (plate 88), and the Stephenson memorial in Newcastle-upon-Tyne. As a record of patronage of a single sculptor, this has no equal.

A more obviously *nouveau-riche* collection was that formed by Joseph Neeld at Grittleton

170. View of the Main Hall, Grittleton House.

171. Robert William Sievier, *Sleeping Bacchante*, 1824. Formerly Grittleton House.

House, in Wiltshire.[104] Neeld was the great-nephew of the silversmith Philip Rundell of Rundell and Bridge, who at his death left Neeld nearly a million pounds. Neeld acquired Grittleton in 1826; in 1848 he began to have it rebuilt and this was still going on when he died in 1856. Inside the house he installed his collection of sculpture, at various focal points of the decorative schema (plate 170), and though it included some busts the works were on the whole ideal, subject pieces. Some were bought from other collections, but others were commissioned directly. From E. H. Baily Neeld commissioned a pair of statues, *Nymph preparing for the Bath* (1845) and *The Tired Hunter* (1851) (plate 172), as well as groups such as *Adam and Eve* (1853) and *The Three Graces* (executed in marble in 1849 from the model Baily had executed as a young man in Flaxman's studio nearly forty years earlier). Neeld commissioned a *Venus Verticordia* from Gibson, whose studio in Rome he had visited. The work was completed in 1833, and several versions were executed later, one of which became the *Tinted Venus*. And from E. G. Papworth he commissioned *The Nymph Surprised*, which is dated 1856.

The works he bought from other collections included *Sleeping Bacchante* (1824) (plate 171) and *Musidora* (1830) (plate 173) by R. W. Sievier (1794–1865), *Innocence Mourning the Loss of her Dove* (1826) by Angelo Bienaimé (*fl.* 1829–51), *Diana* (1826) by Joseph Gott (1786–1860) and *Ino and Bacchus* by R. J. Wyatt (1795–1850), the original version of which is dated 1837. Neeld also bought works by contemporary Italian sculptors, such as *Venus and Cupid* (1845) and *Pescatrice* by Scipione Tadolini and *Eve after the Fall* (1848) by Rafaello Monti (plate 174), though the latter had such extensive business in England as to be semi-naturalised. Neeld's works form a coherent collection, showing what in the first half of the century the sculptor's ideal could express, should the patron's taste and pocket allow. The collection survived intact until 1966, when it was split up and sold at auction.

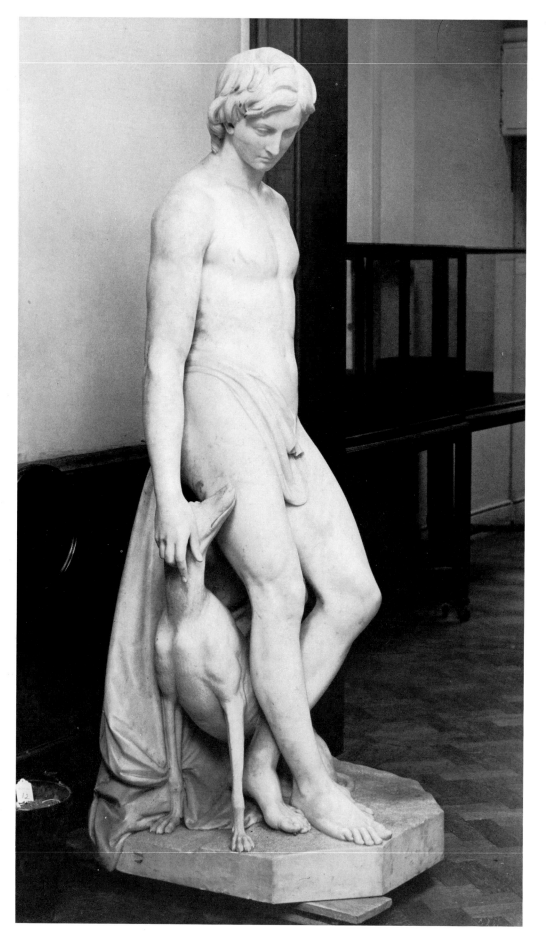

172. Edward Hodges Baily, *The Tired Hunter*, 1851. Formerly Grittleton House.

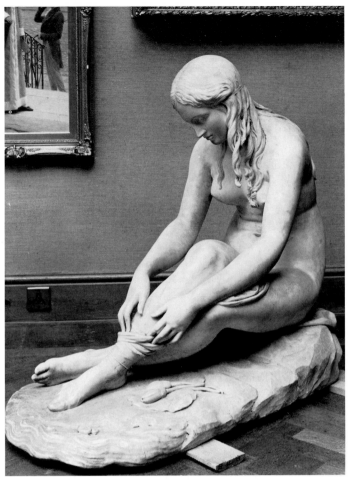

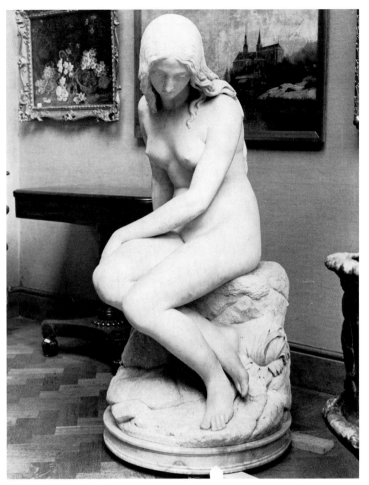

173. Robert William Sievier, *Musidora*, 1830. Formerly Grittleton House.

174. Raffaelle Monti, *Eve after the Fall*, 1848. Formerly Grittleton House.

Perhaps more typical of the Victorian big business man was Sir Samuel Morton Peto (1809–89).[105] After being apprenticed to his uncle, a builder, he inherited the business with a cousin of his, Thomas Grissell, with whom he built up a very successful contracting business in London; among the works they undertook were the Hungerford Market, some London clubs and theatres, Nelson's Column, railway works and the Houses of Parliament. Grissell and Peto dissolved their partnership in 1846, Grissell retaining the building contracts, Peto taking the railway jobs and setting up in partnership with Betts, another railway man. Peto was a Member of Parliament from 1847 to 1854, offering a guarantee of £50,000 for the Great Exhibition of 1851, but in 1854 he won a contract with the Government for a railway in the Crimea, and so was obliged to resign his seat. In compensation he was made a Baronet in 1855, and he returned as an M.P. from 1859 to 1868. Meanwhile, though, there was a financial panic in 1866, and Peto and Betts had to suspend payments; their liabilities were £4 million, their assets £5 million. This disaster obliged Peto eventually to resign his seat again, and tributes were paid to him by both Gladstone and Disraeli.

He was therefore a characteristic Victorian business man, and he was a patron of sculpture. Through, no doubt, his work at the Houses of Parliament, Peto would have become acquainted with John Thomas[106] and Peto employed him extensively as architect and sculptor at his country house, Somerleyton Hall, in Suffolk (plate 175),[107] which he rebuilt between 1844 and 1857. We have here therefore an example of what is virtually a sculptural *Gesamtkunstwerk*: that is, a patron commissioning a complete programme from a single sculptor, who was also responsible for the general architectural setting. The main gates to the east of the house had deer by Thomas (recently cleaned and recarved) surmounting the gateposts, the bottom of the garden has two groups of a *Huntsman with Hounds* and a *Huntsman with a Stag*; both signed by Thomas. On the terrace are reclining

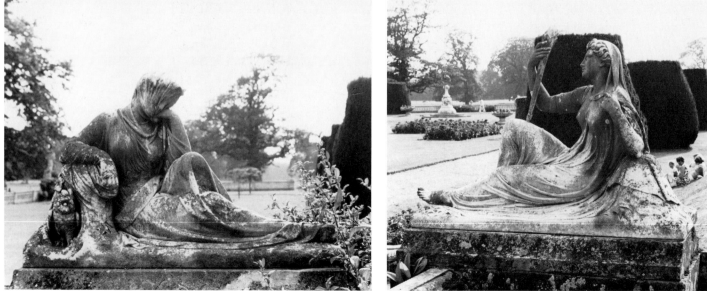

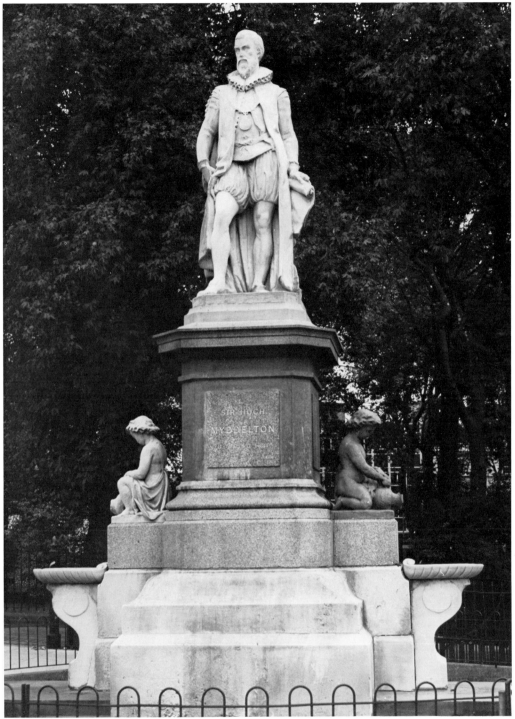

175 (facing page, above).
General view of Somerleyton
Hall.

176 (facing page, below left).
John Thomas, *Night*, 1851.
Somerleyton Hall.

177 (facing page, below right).
John Thomas, *Day*, 1851.
Somerleyton Hall.

178. John Thomas, *Sir Hugh Myddelton*, unveiled 1862. London, Islington Green.

figures representing Night (plate 176) and Day (plate 177). Inside the house, in the Drawing Room, are two fireplaces with inset medallions of Raphael, James Watt, Beethoven and Shakespeare, and standing figures of Art, Science, Music and Poetry: these are wholly characteristic of Thomas's fireplace style, as is that in the Tea Room.[108] Attached to the house used to be the magnificent Winter Garden, designed by Thomas, but all that now survives is the Loggia: this, though, still contains statuary from the old garden, with works by Thomas and by A. Hautman, of Florence.

Peto's patronage of Thomas did not stop here. He owned at least one fine art group, the *Boadicea* by Thomas, in marble (a bronze of which survives at Birmingham City Art

Gallery),[109] and it was Peto who largely paid for the Myddelton memorial fountain, by Islington Green in London (plate 178).[110] This was one of Thomas's last works, and features a full-length statue of the seventeenth-century provider of London's water supply, with accompanying putti with vases lower down. It is possible to view this work as in some ways archetypal, testifying to the sculptural patronage of one of the most spectacular self-made business men of Victorian England, and the art of the 'unassuming self taught genius in his way'[111] that was its sculptor (this description of Thomas is by Sir Charles Barry, who can be presumed to have known what he was talking about—see later, pp. 232–4). Amidst the tangle of London's traffic the work still stands in testimony to the sculpture of its age.

CHAPTER SIX

Formal Options

PORTRAIT STATUES

If the answer to the question 'Shall Smith have a Statue?' was 'yes', this settled the basic premise for the work. But there were further considerations involved in the commemorative idea, not least that of the design and scale of the monument, ranging from the simplest statue to one adorned with allegories and reliefs set in a most elaborate architectural framework.

Sir Robert Peel, in Winckley Square, Preston (plate 111), by Thomas Duckett is described simply as 'Baronet' on the plain pedestal on which his single figure stands. In Avenham Park, Preston, *Edward Geoffrey Stanley, Fourteenth Earl of Derby, K.G.* (plate 112), by Matthew Noble, also stands alone and without further description, though the dates of his birth and death are inscribed. The fact that both these subjects were Prime Ministers presumably needed no notice in the region from which they came. In both, the bulk of drapery and other miscellaneous props behind the standing figure has no meaningful symbolic function: it is a device to give practical physical support to the material mass. *Prince Albert* at Salford (plate 93), again by Noble, has a bit more going for him: the inscription has, in addition to his name, titles and dates, the description 'Chancellor of the University of Cambridge, &c.' and the physical support behind includes some books, presumably referring to his Cambridge position. *John Fielden*, at Todmorden (plates 84, 179), by Foley, has, as we have seen, a more extensive inscription on the pedestal, giving the particular claim to fame for which he was commemorated, viz. his Persevering Efforts which succeeded in obtaining the Ten Hours Act (Royal Assent 8 June 1847). One hand holds a booklet or pamphlet, picking it up from a pile of some other papers, probably of Parliamentary reference and origin.

The next level of complexity as far as props are concerned involves the utilization of the pedestal or base. The statue of Peel by Baily, at Bury (plate 182), which stands above sheaves of corn symbolic of Peel's major Parliamentary achievement, the Repeal of the Corn Laws in 1846, has on its pedestal, in addition to an escutcheon (presumably Peel's own), two reliefs, one representing Commerce (plate 180), the other Navigation (plate 181). (One should perhaps note that the design illustrating Commerce changes between model stage (plate 23) and final version.) This is a fairly simple formal idea—the illustration of the achievements or properties of the person commemorated—and it could take a number of forms. In Scotland one finds relief heads, in silhouette, as in the monument to Allan Ramsay *père*, the poet (plate 126), in Princes Street, Edinburgh, where characters from the subject's writings are commemorated. This form of sculpture may even be a local speciality, harking back to the Age of Elegance, during which Edinburgh was supreme as the Athens of the North, and the silhouette portrait (in two dimensions) was a familiar form of domestic portraiture: it is a common form of commemoration in the Dean Cemetery, Edinburgh.

179. John Henry Foley, *John Fielden*, 1863. Todmorden, Centre Vale Park.

147

180. Edward Hodges Baily,
detail, *Commerce*, from *Sir Robert
Peel*, 1852. Bury, Market Place.

181. Edward Hodges Baily,
detail, *Navigation*, from *Sir
Robert Peel*, 1852. Bury, Market
Place.

182 (right). Edward Hodges
Baily, *Sir Robert Peel*, 1852.
Bury, Market Place.

More usual, though, as a means of adorning a figure at its base, were reliefs and allegorical figures. Manchester's *Peel* (plate 113) (by Calder Marshall) has three-dimensional allegorical figures, symbolising Art, Learning, Science and Industry for the one part (plate 183), and Trade, Commerce, Agriculture etc. (plate 184) for the other. These three-dimensional figure representations were fine for allegories, but for more specific, narrative reference, reliefs had no rival. Noble's *Franklin* (plate 58), in Waterloo Place, London, who is portrayed in the act of telling his crew that the object of their voyage, the North-West Passage, is discovered, has two reliefs: one representing the deceased explorer's body being committed to the ice (plate 185), the other on the back representing a chart of the Arctic regions, showing the position of the ships at the time of their commander's death. This is not normally visible, being now behind railings. Foley's *Sidney, Viscount Herbert of Lea*, also in Waterloo Place, London, has three reliefs, illustrating important events in the career of a politician who was Secretary at War for three periods between 1845 and 1860, which included involvement in the Crimean War and the transfer of the Army in India to the Crown. Represented in these reliefs are the Volunteer Force, which Herbert encouraged, Florence Nightingale visiting the Herbert Hospital at Woolwich (Herbert was one of the honorary secretaries of 'The Nightingale Fund') and *The Forging an Armstrong Gun* (plate 186); the *Art Journal* commented about the latter: 'a better theme might perhaps have been chosen, but to the foresight of Mr. Herbert England is mainly indebted for improvements in the terrible weapons of war'.[1]

For the Wellington Monument in Manchester (plate 115), Matthew Noble employed both supporting figures and reliefs. Below the statue of the Duke, at the front of the monument, two martial figures, probably Ares/Mars and Pallas Athena/Minerva, indulge in a *sacra conversazione*; behind are two more peaceful figures (plate 188), not wholly identifiable, one with a wreath on her head and another in her hand (possibly Fame), the other holding a young plant, with corn and fruit at her feet (possibly Peace and her Fruits). In spite of obvious differences (in that the allegorical figures are seated

183 & 184. William Calder Marshall, details from *Sir Robert Peel*, 1853. Manchester, Piccadilly.

185. Matthew Noble, detail from *Sir John Franklin*, 1856. London, Waterloo Place.

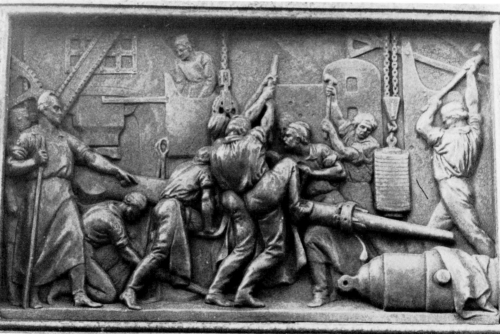

186. John Henry Foley, detail, *The Forging an Armstrong Gun*, from *Sidney, Viscount Herbert of Lea*, 1867. London, Waterloo Place.

187. Matthew Noble, detail, *Council of War*, from *The Duke of Wellington*, 1856. Manchester, Piccadilly.

rather than standing, and in some of the particular symbols displayed), there is a close similarity in the general disposition of these figures to Noble's national Wellington Memorial Competition entry, of the year before, 1856,[2] which confirms the general impression that such attributes were used without much originality; but then, as we have seen, it would be wrong to stress too much ideas of 'art' in what was at times more akin to an industry. The Manchester *Wellington* was finished off with four reliefs, representing the Duke campaigning in Egypt, the Battle of Waterloo, A Council of War (plate 187) and the House of Lords—the Duke receiving the thanks of the House. These, and the allegories, thus pay tribute to the Duke's outstanding achievements in war and in peace.

The scale of monuments increased still further with certain national commemorations of national heroes. The O'Connell Monument in Dublin, by Foley and Brock (plate 71), has four large allegorical figures at the base (plate 70); an intermediate drum stage with, instead of the small reliefs more usually found, a continuous frieze with figures in deep relief, some seven feet high (plate 189); then finally the statue of the hero of heroic proportions, twelve feet in height. The four figures at the base represent winged Victories—Victory by Patriotism, grasping a sword in her right hand and holding a shield in her left; Victory by Courage, strangling with one hand a serpent, while she crushes its writhing body under her feet, and with the other hand grasping a bound bundle of reeds, symbolising strength of weak materials effected by union; Victory by Fidelity, holding the mariner's compass and caressing the head of a hound; and Victory by Eloquence, holding in one hand the roll of documents from which she draws the arguments of her cause, while the other hand is gracefully outstretched in the classic attitude of oratory. The drum relief has in the centre at the front a figure of Erin, trampling underfoot her discarded fetters, her left hand grasping the Act of Emancipation, and her right pointing aloft to the statue of the Liberator. To her right is a Catholic bishop, leading a youth by the hand and pointing to the charter of freedom in Erin's hand; and in a knot around the bishop,

188. Matthew Noble, detail from *The Duke of Wellington*, 1856. Manchester, Piccadilly.

listening to his words, are a number of priests, forming a group representative of the Church. Following these (going round to the right as you face the monument from the front) are the historian with his book; the painter with the implements of his art; and the musician, holding a scroll, on which are legible the words and score of the air of Moore's spirited melody, so frequently quoted by O'Connell—'Oh! where's the slave so lowly . . .'. Next in the group come the artisan, with his kit of tools, the soldier and sailor side by side, the Peer and the Commoner (discussing the Act and its effects), the Doctors of Law and Medicine in their academic robes, the man of science, the architect, the merchant, the representative of civic authority in municipal robes, and the peasantry of various types—by which time we are back with Erin again, pointing aloft to the statue of the Liberator.[3]

A similar range of scale can be observed in the various commemorations of a single figure, Prince Albert. Foley's statue in Birmingham has no supporting features, though it should be noted that it was originally intended to be placed under a Gothic canopy. This was deferred owing to the failure to find a suitable site and it was placed in the Art Gallery and unveiled there (in 1868) before being removed to its present position in the Council House.[4] Nonetheless it was considered adequate on its own in its time. The Cambridge University statue (plate 1), originally on an indoor site, has, as we have seen, three relief roundels on its base, representing Learning between Literature and Science. The Albert Memorial at Manchester (plate 116) may represent what the Birmingham version might have been, viz. a full-length statue in a Gothic frame, the statue being by Noble, the architectural framework by the local architect Thomas Worthington. The architectural element is here substantial, and the elaborate programme of decorative carving (plate 190) relieves the sculptural element of any narrative necessity. On the base of the monument there are a number of crests and coats of arms of His Royal Highness's dominions in Saxony. Moving on up, the first series of statuettes consists of figures illustrative of Painting, Architecture, Sculpture, Music, Astronomy, Chemistry, Geometry, Mechanics and Literature. Above are four pinnacled canopies with figures of Art, Science, Commerce and Agriculture. Set around the star in the centre of each of the four gables are three portrait medallions, portraying Michelangelo, Beethoven, Mendelssohn, Wren, Goethe, Schiller, Inigo Jones, Milton, Shakespeare, Raphael, Tasso and Dante. On the tops of the gables are angels blowing trumpets. The general idea was to represent in some form what the Prince Consort had considered Good Things.[5] The national Memorial at Dublin (plate 133), again by Foley, reverts to the predominantly sculptural type and is quite substantial: the main statue is on a high base, around which stand four youthful symbolic figures representing Science (plate 191), the Arts (plate 192), Industry (plate 193) and Agriculture (plate 194). The Edinburgh Memorial (plate 195), by Steell and others, is still more elaborate: an equestrian figure of the Prince surmounts a high base, in which are set reliefs of scenes from the Prince's life, including a family group of himself, Queen Victoria and nine of their children in an educational context (plate 196); this is repeated in a scene of a public prize-giving and expanded in the scene of the Prince at the 1851 Great Exhibition (plate 197). Around the base stand life-size groups of classes of the populace (plate 198)—a Peer and his Lady, a Farmer with his son, the Military and so on—paying homage.[6]

But it was of course the London National Memorial (plate 95) which for sheer size, scale, elaboration and complexity (plate 96), stood at the head of all commemorative monuments in Victorian England.[7] The work's programme has been described as reflecting, symbolically but accurately, the Prince's sincere belief, under Providence, in the edifying role of the arts, the promise of advances through science and the benefits of material progress, and his adopted country's mission to spread these benefits to the four corners of the earth.[8]

These four corners are represented on the monument by four groups at its outermost

189. John Henry Foley, detail from the O'Connell Monument, 1866–83. Dublin, O'Connell Street.

153

corners portraying the Continents of America (plate 97), Africa (plate 100), Asia (plate 49), and Europe. Each is by a different sculptor and each has its separate signification. In *Europe* (plate 199), by MacDowell, 'France, as a military power, is shown holding a sword in the one hand and in the other a wreath of laurel. Germany, the great home of literature and science, is represented in a thoughtful attitude, with an open volume on her knee. Italy is shown as awakening from a dream in allusion to her recent union into one Kingdom.'[9] The bull alludes to the mythical Europa.

At the inner corners of the monument, above the frieze, stand four groups representing Commerce (plate 98), Engineering (plate 99), Manufacturers and Agriculture. The frieze that runs around the base portrays the edifying arts, through significant representatives of each : architects, builders, sculptors, musicians, writers and painters. At the centre point of the monument, above the podium, sits Prince Albert (plate 68), regarding the world with a copy of the catalogue of the Great Exhibition of 1851 in one hand. On the main piers of the canopy are statues representing the physical and natural sciences (plates 101, 103); at the lower stages of the main spire stand eight figures of Virtues (plate 102) (Justice, Hope, Fortitude and so on) with, further up, two groupings of mourning and triumphant angels.

With regard to its form and type, the London Albert Memorial has had a number of sources assigned to it. The School of Manchester insist on the priority of their monument (plate 116) by Worthington and Noble and claim London's version as a borrowing. This is unfortunately in defiance of close chronology, especially if Scott's own version of how early he arrived at the basis of the design subsequently erected is allowed; it does not take into account the priority of Scott's design for a Crimean Guards Memorial of *c.* 1856–9 which was Gothic; and it assumes an unique origin with respect to a statue enclosed in a Gothic canopy which only a world view with Manchester at its centre could reasonably maintain. One general source sometimes cited for the London monument applies indeed to both—the Scott Monument in Edinburgh (plate 125) dating from the 1830s and 1840s.

191. John Henry Foley, detail, *Science*, from the Albert Memorial, 1871. Dublin.

192. John Henry Foley, detail, *Art*, from the Albert Memorial, 1871. Dublin.

193. John Henry Foley, detail, *Industry*, from the Albert Memorial, 1871. Dublin.

194. John Henry Foley, detail, *Agriculture*, from the Albert Memorial, 1871. Dublin.

190 (facing page). Detail from the Albert Memorial, Manchester.

155

196. Sir John Steell, detail, *Prince Albert and Queen Victoria at home*, from the Albert Memorial, 1876. Edinburgh, Charlotte Square.

197. Sir John Steell, detail, *The Opening of the Great Exhibition*, from the Albert Memorial, 1876. Edinburgh, Charlotte Square.

195 (facing page). Sir John Steell (and others), the Albert Memorial, unveiled 1876. Edinburgh, Charlotte Square.

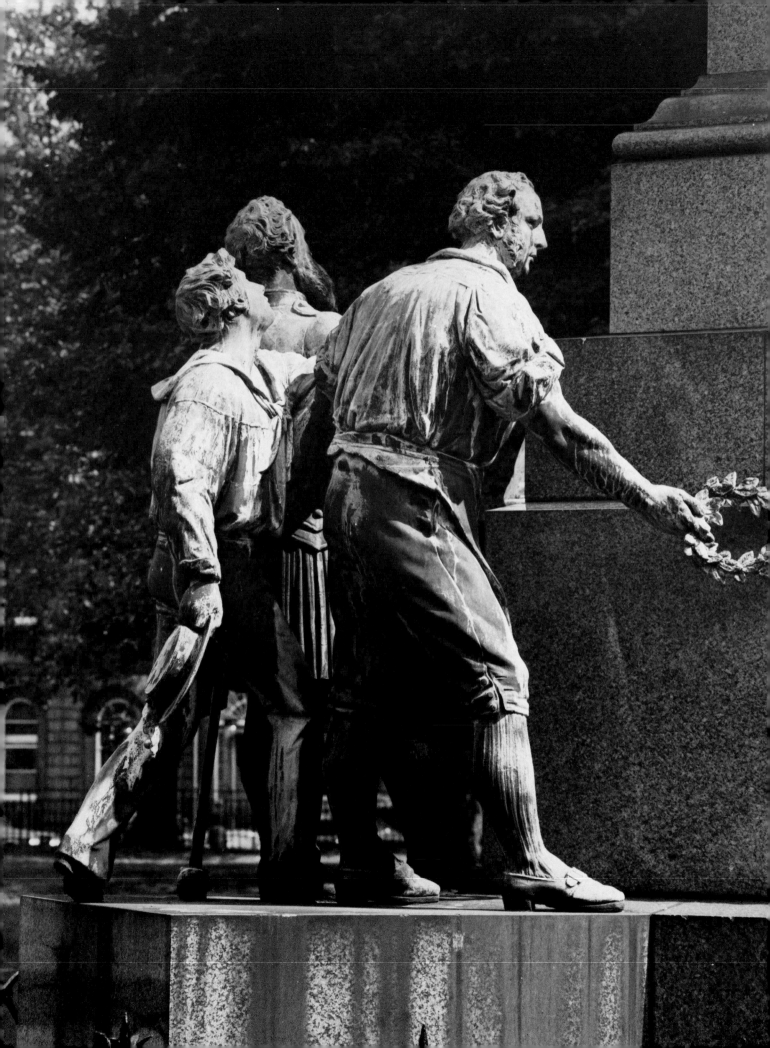

But this is an unspecific source at best, and would feature more satisfactorily as an analogue: one might just as well cite Henning's monument to the Earl of Leicester at Holkham, in which the plan of relief-bearing podium and arrangement of sculptural features (plate 200) could, if viewed rather strangely, be seen as very close to the central area of Scott's monument; this dates from 1845.

This is all without regard to the debts that Scott himself admitted, which it would be perverse to ignore and unreasonable to discount. For the idea of the gabled canopy to protect the statue Scott acknowledged some debt to Early Christian *ciboria*, though he insisted this was initially an unconscious derivation.[10] Scott mentions also a more general debt to the metalwork shrines of the Middle Ages, notably examples at Aachen,[11] and if one were to fuse in the imagination Orcagna's tabernacle in Or San Michele, Florence and elements from two particular metalwork shrines at Aachen, one would begin to see what Scott meant. Elements from the Orcagna are emphatic triangular gable and pinnacles; general ornamental incrustations, especially those going up the gable; and the position of corner statuary at the springer level of the main arch. From the Three Towers Shrine at Aachen comes the polygonal base to an open Gothic structure containing a figure; this latter feature obviously can claim a more general derivation, but the polygonal base is more exceptional. Finally from the Charlemagne Reliquary, the composition of its upper register pinnacles can be seen as bearing a close though varied resemblance to those at the top of Scott's monument: those at the gable corners (though blind) use the same elements of arcade, roundel, gables, mini-pinnacles plus central spire; while the open structure of the Charlemagne pinnacles is echoed in the structure of Scott's principal spire, where the gesticulating figures, virtuous and angelic, closely resemble the overall style of the angels at the corners of the Charlemagne Reliquary's base. A further important source has been pointed out by Nicola Smith: the Ciborium by Arnolfo di Cambio at S. Paolo fuori le mura, Rome, which would confirm Scott's own acknowledgement to Early Christian *ciboria*.[12]

Furthermore, in the draft report on his design for the Prince Consort Memorial that Scott prepared for submission with the design, he emphasised another prototype:

> . . . I have not hesitated to adopt in my design the style at once most congenial with my own feelings and that of the most touching monuments ever erected in this country to a Royal Consort—the exquisite 'Eleanor Crosses' of which King Edward I erected no less than fourteen to commemorate his beloved queen. I would further suggest that this style has a peculiar appropriateness in the present instance that its perfect revival has been up to the present time the one great characteristic of the history of architecture during the reign of Queen Victoria. Though adopting, however, the style of a Gothic Cross, I have not followed any existing type, but have struck out one suited, to the best of my judgement, especially to this individual object.[13]

The significance of this reference to the Eleanor Crosses—beyond the obvious sentimental effect it might have on the Queen—is confirmed by the presence of one, almost in vignette, sculpted on the frieze. There too we find illustrated another major consort memorial, the Mausoleum at Halicarnassus (plate 201). The classical origin of this makes it obviously of no comparison from a stylistic point of view; but it might be noted that in scale it formed an apt and worthy exemplar, and in general points of arrangement, as actually being published in the 1850s, there are some specific analogies: four massive corner groups of sculpture and a continuous sculpted frieze around the podium, on which, in addition, a sculpted simulacrum of the commemorated consort is positioned. This makes much less surprising the appointment of Charles Newton, of the British Museum, who was excavating and publishing the Mausoleum in the 1850s, as

198. Clark Stanton, *Servicemen Paying Homage*, from the Albert Memorial, 1876. Edinburgh, Charlotte Square.

159

sculptural overseer of the Albert Memorial in succession to Eastlake and A. H. Layard in 1869.[14] On the point of scale, Scott had thought that his realisation of jewellers' architecture in a structure of full size (the Three Towers shrine writ large) was something that had never actually happened in the Middle Ages. But recent architectural historians[15] do claim exactly this realisation on behalf of the builders of the Court Style and later High Gothic in France towards the middle of the thirteenth century. This is not to prove Scott wrong, but rather to show that in this respect he was being as true and archaeological a Goth as any architect in the nineteenth century.

The overall form of the Memorial has thus a number of possible sources. It has not yet been determined who was responsible for laying down the disposition of the elaborate sculptural programme, and although some study of the extensive documentation in the Royal Collection has been made, it is not really possible to come to any conclusions until fuller research has been done in other archives and in other relevant related material. The position of the three successive sculptural advisers—Eastlake, Layard and Newton—must be borne in mind, particularly Eastlake, who drew up the instructions for the preparation of designs to be submitted to the advisory committee. Thus, an attempt has been made to ascribe to Armstead, one of the sculptors of the podium frieze, the choice of artists to be represented there:[16] an ascription strongly qualified as largely supported by negative evidence, but emphatic nonetheless. In the light of the lack of study of other documentary sources that may affect the ascription, the value of the negative evidence presented wanes, quite apart from any general reservations one might have concerning such evidence. The positive evidence adduced for Armstead is a preliminary plan of a section of the frieze showing rather fewer names than were actually adopted, with innumerable drawings and studies for the individual figures chosen.[17] Now if this is enough for Armstead, it must be enough too for Birnie Philip, among whose papers similar documents survive for his section of the frieze.[18] On the other hand it was Armstead who executed not only the entire frieze but the whole programme of sculpture on the architect's model of late 1863.[19] But according to Scott the design of the sculpture for this was drawn out in a general way on the first elevation drawings by Clayton and by Scott's eldest son,[20] who were assistants

200. John Henning, junior, detail from the Leicester Monument, 1845. Holkham Hall.

199 (facing page). Patrick MacDowell, *Europe*. London, Albert Memorial.

UPÆLUS PHIDIAS.

in his office, and in this instance Armstead must simply have been an executant. In any case the programme as indicated on the model is not exactly that as executed on the monument, though it is often very similar. But it is clear at any rate that the programme was not finalised at the model stage, nor even later: in a letter to the Memorial Committee prepared jointly by Armstead and Philip to explain the increase in the costs of the podium over their estimates,[21] one reason they give is that the programme was not fixed when the estimates were drawn up (model prepared late 1863; estimates submitted April 1864). It would thus seem that a certain fluidity existed with regard to the sculpture programme, and this would make Armstead's (and Philip's) 'lists' less crucial: they could simply be records they had made at some indeterminate stage of the work they were having assigned to them. And the drawings and studies for the individual figures finally chosen need be no more than testimonies to both artists' desire to get the portraits as historically accurate as possible; this must be what the *Art Journal* was referring to when it commented: 'it must have cost the sculptor no little research into the annals of music . . . to *trace out* [my italics] the men most worthy of being commemorated in his work'.[22] In the context of an artist, 'trace out' would more obviously be a graphic exercise than an intellectual one. The absence of any documentary instructions to Armstead as to whom he should represent on the podium could be because the instructions passed between, say, Eastlake and Scott. This is obviously equally hypothetical, but is much more likely even in that state than that Armstead (and Philip and all the other artists too?) was given free rein.

The Albert Memorial in London is not alone as an example of the blending of architectural and sculptural elements in public memorials, though it must certainly be the largest and most significant. A more modest class consisted of the 'fountain' type. Joseph Chamberlain (1836–1914), the Birmingham-based politician, was commemorated there by a fountain structure, designed by John Henry Chamberlain and erected in 1880. It incorporates a medallion portrait by Woolner.[23] The wife of George Moore (1806–76), the Cumbrian philanthropist, was commemorated by a fountain in the Market Place at Wigton, Cumberland (plate 202). The architectural structure was designed by J. T.

201 (facing page). John Birnie Philip, detail from frieze. London, Albert Memorial.

202. John T. Knowles and Thomas Woolner, Moore Memorial Fountain. Wigton, Market Place.

203. Thomas Woolner, detail, *Teaching the Ignorant*, R.A. 1872, from the Moore Memorial Fountain. Wigton, Market Place.

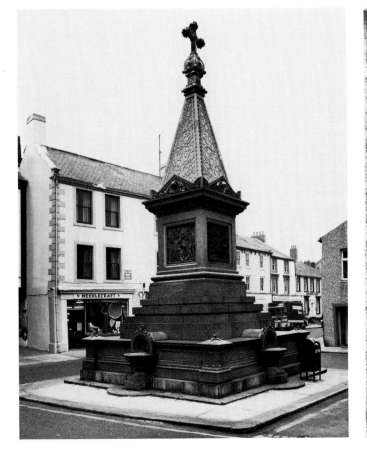

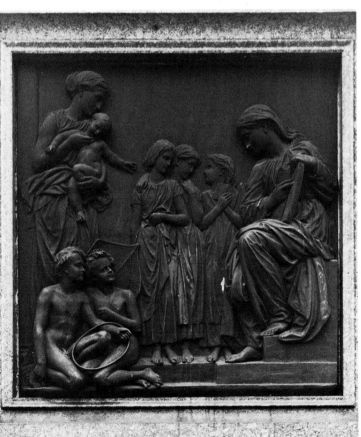

204. John Thomas, *Queen Victoria (The Randall Fountain)*, 1862. Maidstone.

205 (facing page). William Theed, detail from *Humphrey Chetham*, 1853. Manchester, Cathedral.

Knowles; the sculptural element, rather more predominant than in, say, the Chamberlain memorial, was again by Woolner, and consists of four large bronze reliefs portraying Acts of Mercy—Feeding the Hungry, Clothing the Naked, Visiting the Afflicted and Teaching the Ignorant (plate 203). The monument dates from 1871. George Moore was evidently a patron of sculpture, as already mentioned (p. 132), with a fine sculpture gallery at his beautiful house in Palace Gardens, Kensington; and he was instrumental in getting work for Adams-Acton.[24] This would explain the presence in Wigton of a substantial work by a major sculptor like Woolner.

Other commemorative fountains were more straightforward in their blending of structure and statuary. The Randall Fountain (1862) at Maidstone in Kent (plate 204) consists of a marble statue of Queen Victoria inside a Gothic canopy; both statue and structure were by John Thomas. Another Thomas example that we have already come across is the Myddelton Memorial at Islington Green, London (plate 178); here the statue is sited on a tall pedestal, on the sides of which, half way down, are positioned putti with urns, from which water should issue into bowls. Thomas was in fact an extensive executant of sculptured fountains at various scales: from the massive work now facing the South Front of Castle Howard, in Yorkshire (a fine confrontation), which was acquired from the 1862 International Exhibition, to the more intimate majolica fountain in the Home Farm Dairy at Windsor.[25]

Whatever the supporting features involved in public monuments in the form of allegories or architectural settings, and for all that these could at times come to preponderate or even virtually take over, the central element in most of the works we are considering was the statue of the commemorated. In other words, we are back to Smith. But even granted that Smith was to have a statue, and once the type of monument had been considered, there was one aspect that exercised considerable concern throughout the period, and that was his clothing. For historical figures there was little argument; the operative conditions were the depth of archaeological knowledge of costume of the past, and the sculptor's capacity to render this in, say, marble. The various commemorative statues associated with Parliament and its history offered a wide scope to sculptors, particularly with the seventeenth-century figures whose costume to be accurate might have to be quite ornate. Foley's *Hampden* (plate 79) and Bell's *Falkland* (plate 80), while more sober (and historically rightly so) still offer the challenge of a large lace collar, a billowing shirt and floppy boots; while Thornycroft's *Charles I* and Weekes's *Charles II* (plate 138)—the latter especially—offer a more florid range of costume ornament with the ribbons and rosettes of the Cavalier party. Birnie Philip's Royal Gallery figures (plate 136), from a wide historical range, are less adventurous in the ornamental expressiveness of their clothing. This is not due to any material limitation or deficient subject matter; the sculptor must simply have been cutting the cloth to suit his capacity. Similar historical scope could be offered elsewhere: Theed's figure of Chetham at Manchester (plate 205) is fully worked out in respect of its seventeenth-century costume; Weekes's *Hunter* (plate 16) at the Royal College of Surgeons is closely based on the portrait by Reynolds of 1786, and Foley's *Goldsmith* (Trinity College, Dublin) (plate 206) was held at the time to reflect the subject's own fondness for fine clothing:[26] quite a material challenge, considering the statue is in bronze. In Watson's series of statuettes of literary figures (*Chaucer, Spenser, Jonson, Shakespeare, Beaumont* and *Fletcher*) we are told the sculptor laboured hard to get the true costume of the period; with *Chaucer* this had to be generally estimated, but with the later figures there was a 'larger freedom'. While occupied on these Watson made extensive drawing studies of costume 'from the time of the Edwards of England' to the eighteenth century.[27]

With contemporary figures, there was, it seemed to some, a problem, arising from what William Michael Rossetti called 'the especial untractableness of our costume,'[28] a point of

206 (left). John Henry Foley, *Oliver Goldsmith*, 1864. Dublin, Trinity College.

207 (centre). John Gibson, Monument to Sir Robert Peel, 1852. London, Westminster Abbey.

208 (right). Musgrave Lewthwaite Watson, *Major Aglionby*, 1843. Carlisle, Assize Courts.

view confirmed by the usually practical Roscoe Mullins, who considered modern male dress always difficult.[29] The end result was that 'tight trousers' became a term of critical abuse. Eastlake had made some qualified allowance for modern dress in his theories, based on antique practice. Parts other than flesh, such as drapery and accessories, would in any case follow the convention by which marble represents reality, and they were subordinate to the main focus of the work. But while certain difficulties could arise within this convention from, say, modern military dress, nevertheless some features such as the whiteness and smoothness of leather belts and the polish, hardness and sharpness of metal would come across well in marble.[30]

One extreme answer was that provided by Gibson and others. Gibson considered that 'The human figure concealed under a frock coat and trousers is not a fit subject for sculpture'[31] and his statue of Peel in Westminster Abbey, of 1852 (plate 207), is dressed as a classical orator. This was a fairly widespread practice, with honourable precedents in other centuries in which such an appeal to the Glory that was Greece and the Grandeur that was Rome could be an aspect of state propaganda. The Prince Consort appears in classical dress in a statue by Emil Wolff of 1844 (Osborne) (plate 156), made in Rome and so consciously part of a neo-classical statement, though for a private context; Lough's statue of James Losh (1836) (plate 140), the anti-slave politician, at the Newcastle Literary and Philosophical Society is also conceived and executed in an Antique-derived convention—again perhaps not surprisingly, as it also was executed in Rome.

The riposte to this came from such as Watson, in the latter's case with specific reference to Gibson when both were in the running for a statue at Liverpool. 'I will make it a bold vigorous statue', claimed Watson, 'but, at the same time, an Englishman from head to foot; not Mark Aurelius with the head of George the Third; nor Lord Erskine in Cicero's night-shirt.'[32] Watson's practical answers to the problem can be seen in his statue of Major

166

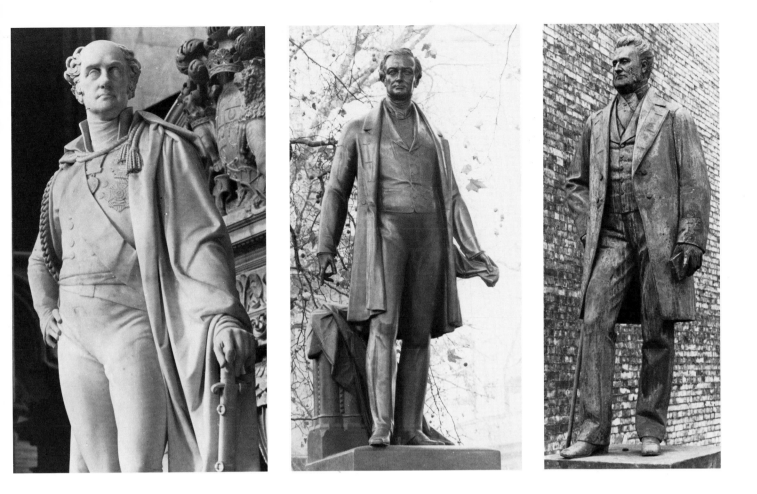

Aglionby (plate 208), for instance, Member of Parliament and Chairman of the Quarter Sessions at Carlisle, who expired at the door of the Court on his way to the Bench, and is commemorated by the gentlemen of the county with a seven-foot portrait statue (the likeness being therefore heroic rather than literal) which still stands near the spot where he died. He is represented in a standing attitude, firm, commanding, yet not severe, in the dress of a country gentleman. Lonsdale states he has an outer toga elegantly tied across his breast;[33] this would seem to be a case of neo-classical *gestalt*, since it appears to be a simple, everyday cloak. The work is signed and dated 1843.

Outside the courts is another work by Watson, a statue of the Earl of Lonsdale, and this represents another answer to the sartorial problem. Lonsdale is clad in the costume and insignia of a Knight of the Garter—'as an English garb, deviating materially from modern conceptions of dress, it has a striking effect'.[34] Weekes, in his *Lectures*, was rather against Garter Robes, on account of their difficulty; the eye is distracted by the intricacy of the details, and forgets the man within.[35] But formal dress was a consistent solution throughout the Victorian period, indeed almost a necessary one, with many subjects of commemoration being men of degree or military distinction. Chantrey's *Sir John Malcolm* in Westminster Abbey (†1833) (plate 209) could be taken as a practical demonstration of Eastlake's views on military dress in marble; Marochetti's *Duke of Wellington* in Glasgow (in bronze, 1844) (plate 5) affords in its full military regalia an excellent opportunity for the sculptor to display his trickery and 'effectism'. Foley's *Earl Canning* (†1862) in Westminster Abbey is dressed in his peer's robes, which are sufficiently enveloping to avoid most reference to whatever else he is wearing; the same sculptor's *Prince Albert* at Birmingham in his Garter get-up, while giving some support to Weekes's reservations, in that one does marvel at the intricacy of ornament that has been rendered, demonstrates at the same time the sculptor's developed proficiency in doing this so well, which the artist

should not be obliged to conceal; furthermore the image presented would be intentionally formal, with little room for 'the man within' except insofar as this persona is externalised in just such a formal icon.

For the rest, it was a matter of varying degrees of modern dress to varying degrees of success; in one sculptor, Weekes declared, 'the insight into costume hardly extends beyond the last most fashionable make of a pair of trousers'.[36] Noble seems to have been regarded as the principal purveyor of tight trousers: his statue of Peel in Parliament Square, London (plate 210), would seem to bear this out, though the iconographic pattern in this respect is found also in Calder Marshall's statue of Peel in Manchester (plate 113) of over twenty years earlier, so this is possibly a fashion attached to the man; certainly his not being a peer will have emphasised the problem, since there would therefore be no robes to hide it under. In a case such as that of *Franklin* (Waterloo Place, London) (plate 58) Noble would seem to be reducing the area of dispute by means of a knee-length military frock-coat and on top of that a fur-lined surcoat. But Noble was not the only offender: Marochetti's *Jonas Webb* at Cambridge (plate 211) has tight trousers and waistcoat, judging by the creases, while Theed's *Bright* (plate 119) and *Gladstone* (plate 120) in Manchester Town Hall are only marginally less closely fitted in their nether regions.

That successful modern dress was possible in sculpture was admitted by some. Holman Hunt considered that Woolner's treatment of Prince Albert in the Oxford statue (plate 142) settled the question of the adaptability of modern costume for the purposes of sculpture,[37] though he was admittedly at that time a friendly source of judgement. But in Foley, too, one can find a handling of contemporary costume that defies the normal criticism. In his statue of William, third Earl of Rosse at Birr, County Offaly, in Ireland (plate 110), the formal cloak of office, probably of the Chancellor of Trinity College, Dublin, is set back on the figure, revealing a frontage of frock-coat, trousers, waistcoat, shirt and tie. These are formulated with a crispness of handling that compared with, say, Marochetti's *Jonas Webb* (plate 211), begins to assume a character of positive virtue. Indeed this crisp handling of clothing detail can be found in all of Foley's mature work: in the *Earl Canning* at Westminster Abbey, where the formal robes of a peer and informal modern details commingle; in the tassels, cords and folds of *Viscount Hardinge*'s military equipage (plate 3); and if one compares the overall drapery treatment of Foley's *The Mother* (plate 35), a subject piece (R.A. 1851) in which a mass of drapery is disposed along conventional lines, with the intricacies of folds and variations in drapery disposition in his *Manockjee Nesserwanjee* of 1865 (plate 212), one begins to appreciate what he has achieved in the handling of this normally conventional element in sculpture.

It is perhaps hard to see, at first, what is a fine distinction of degree. But when one begins to analyse in what this distinction lies, in the cases of both Foley and Woolner, the matter becomes more straightforward. In both, the quality they bring to this element in their work is a more varied formal disposition. In, say, Woolner's *Prince Albert* (plate 142), in Foley's *Canning*, *Rosse* (plate 110) or *Hardinge* (plate 3), the sculptors are manipulating their materials to do more, to describe a form more subtly, and it is inescapable that this is a point of technical excellence, where both artists are getting their materials to display properties that other sculptors, using the same materials, could not or would not achieve. In the rare instances (such as the work of Marochetti) where they did do so, they did so only on the external knick-knackeries of trivial decoration (or so Palgrave *et al* would have us believe). Among the writings on sculpture of the period, Palgrave writes on Behnes that the draperies in his grand portrait figures are, to use the painter's phrase, rather too much 'cut up' into brief lines, lacking the flow and continuity that are observed even in the common fourth-rate antiques;[38] Weekes writes that a stout, heavy figure will bear heavy drapery, and a thin, light figure calls for smaller, more

212. John Henry Foley, detail from *Manockjee Nesserwanjee*, (original plaster model), 1865. Dublin, Royal Dublin Society.

delicate folds;[39] Mullins writes that drapery should explain, not hide the form beneath, and that its lines should flow so as to help the movement and intensify the action of the figure:[40] these are all statements in which drapery is simply an adjunct, not an element in the overall work which has a life and above all a form that is its own. It is only in the work of Woolner and Foley that one can find any attempt to break away from this dead hand of convention, in thinking and in practice, to give this element in sculpture the first signs of life and nature.

BUSTS

The commemorative statues that we have been considering so far had certain conventions and areas of variety proper to them as a genre. Busts, which share certain properties with statues (which will be considered later), had also their particular conventions, though these were often related. As with historic portrait statues, so there was a small subsection of the bust genre devoted to figures from the past. London's Leicester Square Gardens contains four examples, by prominent sculptors, erected to commemorate local worthies: *Sir Isaac Newton* by William Calder Marshall (1874); *Dr John Hunter* by Thomas Woolner (1874); *Sir Joshua Reynolds* by Henry Weekes (1874); and *William Hogarth* by Joseph Durham (1875) (plate 213). There could be busts also of ideal subjects, such as *Summer* and *A Dancing Girl* (both in Bury Art Gallery, date and artist unknown); or they could be drawn from literature, such as *Ophelia* by Thomas Woolner (1874, Christchurch Museum and Art Gallery, Ipswich).

It was however the contemporary portrait bust that, as a genre, was a staple source of income for the profession; both private and public commemoration could frequently take this form. Here the issue of dress was not such a key topic, for obvious reasons; the range of options was rather which of a number of formal types of bust might be chosen, and even this was not a matter of much concern. Weekes spends some time in his *Lectures* on busts, but concerns himself in the main with practical suggestions—how actually to set about executing a bust[41]—and only Roscoe Mullins expresses opinions as to form.[42]

The bust as an art form was very much tied up with its classical origins, not just because the Romans specifically invented the type as a cheap and easy way of reproducing an original Greek portrait in statue form, but also because, of the relics of Antiquity, it seemed to have survived in greater numbers and, because of its easier transportability, was more readily accessible. The classical form of bust was, therefore, frequent. It might have specific drapery, as in that of Prince Albert by Theed of 1862–3, of which various versions are known (including several in the Royal Collection (plate 155) and London, Royal Society of Arts). Lawrence Macdonald's bust of the fifth Marquess of Londonderry of 1856 represents the classical herm type: square base as if from the top of a full herm, without clothing, and cut off before the shoulder. This bust was made in Rome, where Macdonald lived and worked as one of the neo-classical expatriates, along with Gibson, Spence and others, so for him to execute this type is not surprising. But Weekes too could use it, as in his bust of W. H. Whitbread (1864) (plate 214), and it also features in the work of other usually non-classical sculptors—see Noble's monument to Sir James Outram (†1863) in Westminster Abbey (plate 215) where the bust of this type is set, somewhat incongruously, on a base containing an inset relief within a Florence-Baptistry-Door-type quatrefoil, with supporters on either side representing quite realistically Indian figures. Marochetti's bust of Thackeray in Westminster Abbey (plate 59) and Leifchild's bust of George Wilson, Chairman of the Anti-Corn Law League (R.A. 1871) in Manchester Town Hall (plate 118) are further variations of this classical type, but with the form rounded off below the neck rather than squared up. Mullins believed this type was used specifically to avoid any dress reference:

214. Henry Weekes, *Henry William Whitbread*, 1864. Whitbread Collection.

213 (facing page). Joseph Durham, *William Hogarth*, 1875. London, Leicester Square.

171

215. Matthew Noble, Monument to Sir James Outram (†1863). London, Westminster Abbey.

216. Matthew Noble, Monument to George Gordon, fourth Earl of Aberdeen (†1860). London, Westminster Abbey.

. . . it is a dire offence nowadays, and revolting to our realistic proclivities, to allow such a bust to be robed as would best become it, independent of fashion—for the days of Dr. Johnson in a Roman toga, as seen in St. Paul's, are over—so, as we are not allowed to do this, we do the next best thing, that is we do not allow room for a shirt-collar and coat and buttons at all.

He adds a warning: 'But this treatment would look strange if applied to a head with long side whiskers, or a nose and lip of strong Celtic origin.'[43]

Of classical derivation was another type of bust, that in which non-specific drapery is randomly disposed over a wider area that now includes the shoulders, to give a general, vaguely classical appearance. 'This form', wrote Mullins, 'disfigures and hides the body, and so is unnatural, especially in the case of portraits.'[44] The type was used by E. H. Baily for his bust of Rundell (1838) from the Grittleton collection, by Behnes for a bust of Robert Vernon (Tate Gallery), by Behnes again, as late as 1858, for the bust of Benjamin Travers, one-time President of the College, at the Royal College of Surgeons, London; Weekes used it for his bust of Robert Southey in Westminster Abbey (1843), Noble for two busts of University worthies in the University Museum, Oxford—*William Smith* (1848) and *John Phillips* (1849)—and for *Sir Thomas Potter* (1864) in Manchester Town Hall (plate 121); there we also find a bust of Sir Joseph Heron by Warrington Wood (signed and dated 1878) and an unsigned bust of Gladstone of this type: all of which demonstrate the prevalence and wide distribution among a variety of artists of this particular style of portrait-bust.

But modern dress was also widely used. It could be of a more formal character, as with portrait statues, as in Baily's bust of Prince Albert (1841) in the Victoria and Albert Museum (Garter robes), or Sievier's bust of John Silvester in the Central Criminal Court, Old Bailey, London (legal professional robes—Silvester was Recorder of London). Straightforward contemporary costume could also be used, as with Noble's bust of Sir Joseph Heron (signed and dated 1858) or the anonymous, undated bust of Richard Cobden, both in Manchester Town Hall; other examples are the memorial to George

172

Gordon, Fourth Earl of Aberdeen (†1860) by Noble in Westminster Abbey (plate 216), the Oxford memorial to Gladstone by Woolner (1866), now in the Ashmolean Museum (plate 144), and the memorial to George Cruikshank by Adams-Acton in St Paul's Cathedral, London (possibly R.A. 1871).

There are certain issues involved in the field of portrait sculpture, whether in statue or bust form, that are tangential to the question of dress and which have already and inevitably begun to arise. These issues revolve around the fundamental question as to what exactly was being attempted in portrait sculpture: was it Art or was it Reality? Du Maurier published a cartoon in *Punch* in 1879 entitled 'At the R.A.—Triumph of Realistic Art' (plate 217). One Blenkinsop is complacently gazing at a Bust of himself by a fashionable sculptor, and is commenting: 'It's not so much as a *Work of Art* that I value it, Brown, but the *Likeness* is so wonderful, you know!'[45] And it is true: in a remarkable way the bust manages to be like enough Blenkinsop, who is represented as being extremely ugly, and yet at the same time it is an idealisation. On the other hand, we are told that when Trelawny, 'that sturdy old berserk, who had been intimate with Byron', went to see the statue by Belt now in Park Lane (plate 218), 'he was disgusted with it—"It does not in the remotest degree resemble Byron either in face or figure".'[46] We can perhaps grant that Belt was not the most skilful of sculptors and that working on a portrait over fifty years after the sitter's death might have caused problems with verisimilitude. Yet again, when Peel commented to Gibson about his statue of Huskisson (plate 219): 'It is very like Huskisson, but you have given a grandeur of look to the figure which did not belong to him', Gibson's answer was: 'I fancy 150 years hence people will not complain of that.'[47] Indeed with Gibson this was a quite positive emphasis, part and parcel of his neo-classical aesthetic, and aimed at presenting an image worthy virtually of eternity. He declared:

> The fault of the portraits of the present age is that every man is expected to look pleasant in his picture. The old masters represented men thinking, and women

217. George du Maurier, *At the R.A.—Triumph of Realistic Art. Punch*, 17 May 1879.

218. Richard Charles Belt, *Lord Byron*, unveiled 1880. London, Park Lane.

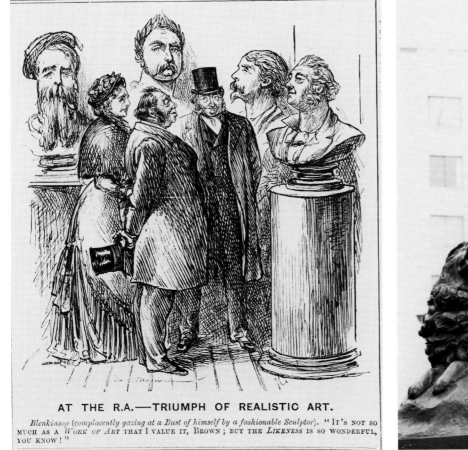

AT THE R.A.—TRIUMPH OF REALISTIC ART.

Blenkinsop (complacently gazing at a Bust of himself by a fashionable Sculptor). "IT'S NOT SO MUCH AS A *WORK OF ART* THAT I VALUE IT, BROWN ; BUT THE *LIKENESS* IS SO WONDERFUL, YOU KNOW !"

219. John Gibson, *William Huskisson*, 1836. London, Pimlico Gardens.

220 (facing page). Baron Carlo Marochetti, *Princess Gouramma of Coorg*, c. 1856. Royal Collection, Osborne.

tranquil—the Greeks the same. Therefore the past race of portraits in paint and in marble look more like a superior class of beings. How often have I heard the remark, 'Oh! he looks too serious',—but the expression that is meant to be permanent should be serious and calm.[48]

This idea of images to go down in history was certainly current. Adams-Acton claimed that a bust by him of Gladstone was the sitter's favourite, and that when Lord Aberdeen wanted to select the most satisfactory likeness of the deceased leader wherewith to perpetuate his memory, an early bust by Adams-Acton was the one chosen.[49] With regard to Woolner's bust of Gladstone at the Guildhall in London, we are told that Gladstone himself insisted on the character of the bust being severely classical, with no drapery whatever. Gladstone gave Woolner many sittings for it, '. . . and when the model was finished he literally danced round it in delight and satisfaction. It was just as he desired to go down in posterity, he said.'[50] That the images presented by nineteenth-century sculptors of the leading figures of their time can indeed affect our reading of history has been noted, and we might bear this in mind as we review the Noble heroes who populate our public places. Whether we have gone so far as to make our lawgivers look like gods, an idea expressed in Plato's *Republic*, and referred to by Weekes in his *Lectures*,[51] is a moot point; perhaps we should remember, with regard to Adams-Acton's likenesses of Gladstone, the comment on one in a review by Palgrave:

Mr. J. Adams, by a sort of inversion of Mr. Darwin's theory, appears to lie under the impression that the human species is rapidly returning to the gorilla type. He has selected Mr. Gladstone, of all people in the world, as a leading instance of this process, and has in turn been selected by the patrons of art in Liverpool to perpetuate his idea in a colossal figure of the Chancellor![52]

There were other options available to sculptors to aim at in portraiture. There was the horrific 'effectism' practised by the foreigners Marochetti and Boehm, particularly in their busts where (according to Palgrave) the suppression of every natural detail except the leading features was a brilliant device to gain spurious effect.[53] Marochetti was even known to tint some of his busts, according to Weekes (an example exists in the Royal Collection at Osborne: *Princess Gouramma of Coorg*) (plate 220), an effective exercise, he admitted, but an exception that proved the rule.[54] Weekes, who like William Michael Rossetti believed that portraiture only could be the main field for sculpture in the future, was chary of too much realism; sculpture simply did not have within itself the means for its satisfactory portrayal. The lack of colour, *pace* Marochetti, was an important shortcoming, and in his practical way Weekes describes various devices to compensate for this want: the eyelids should be thickened, the projection of the brow sharpened, the eyes sunk deep; the edge of the lips should be given more decidedly, the hair cut deeply, more or less according to its natural colour. These were all, he believed, legitimate exaggerations,[55] though they do seem to approach the brilliant devices for spurious effect condemned by Palgrave in Boehm and Marochetti.

Another aim in portraiture could be, of course, character. Behnes was considered to have had a penetrating appreciation of this which, allied with a really thorough mastery of form, gave him two of the powers most obviously requisite for the art of portraiture—see certain of his busts, for example *Sir Jonathan Pollock*, Inner Temple, London (signed and dated 1842), or *Richard Porson*, Eton College (signed and dated 1845), where the representation of the physiognomies at least lifts the works well out of the ordinary. Similar powers are evident in Samuel Joseph's *William Wilberforce* (1838) at Westminster Abbey. Of Foley's *Sidney, Viscount Herbert of Lea* (London, Waterloo Place, 1867) the *Art Journal* commented: '. . . to all acquainted with the unobtrusive bearing and high

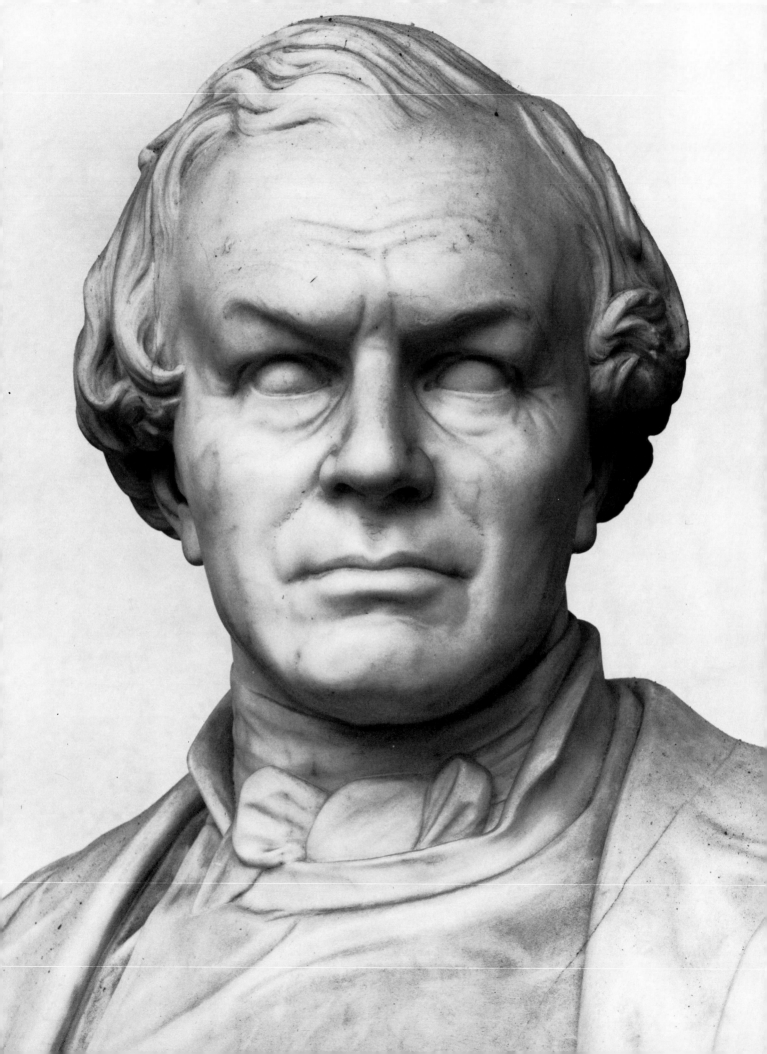

intellectual refinement characterising the physique of the lamented nobleman, it will be a matter of gratification to know how thoroughly such characterics have been rendered by the artist.'[56] And we can relate directly to Woolner's portrait statue of William Whewell (Trinity College, Cambridge, 1873) (plate 145) the accounts of the sitter in the *Dictionary of National Biography*: 'A man of splendid physical development. A Cambridge legend told of a prize-fighter who had exclaimed, "What a man was lost when they made you a parson!" His face (plate 221) showed power rather than delicacy, and a massive brow gave special dignity to his appearance.'[57]

The portrayal of character, particularly if it is reflected in the subject's physical delineaments, can involve concepts such as likeness, realism, verisimilitude and naturalism, all of them in their finer distinctnesses, admissable up to a point in sculpture, though with some contemporary reservation. Palgrave castigated 'the "naturalistic" school of modern Italy, in which the sculptor's aim is to do in marble what Madame Tussaud does in wax'.[58] We have already noted Weekes's cautious attitude to realism, though he was keen to instruct aspirant portrait sculptors in the necessity of keeping their sitters happy—whether with intelligent conversation or 'with not prolonging the modelling sessions too long'—in order to keep them looking natural.[59] Both these means were used by other sculptors, Adams-Acton employing his wife to talk to sitters while he worked,[60] and Roscoe Mullins advising sculptors not to work on portraits for longer than two hours, which he considered long enough for both artist and sitter.[61] William Brodie's *Greyfriars Bobby* (plate 222) was modelled from the life just before the dog's death. How the sculptor kept his sitter occupied is not recorded, though the dog's patience was exemplary and renowned; whatever the case, the portrait is very natural.

There comes a stage when it is hard to define what is natural or realistic in an art which has such strict (and self-admitted) limitations: Roscoe Mullins remarked that 'someone has likened Nature for artist's purposes to a cabbage, of no use until it is cooked',[62] that is, raw Nature *versus* the limits imposed by Artifice. There is the case of Foley, whose fineness of naturalistic detailing we have already commented on. Other works by him of various types were held in their time to express a certain truth. Of his *Hampden* (St Stephen's Hall, Palace of Westminster, 1850) (plate 79) it was said: 'The face, which was modelled from

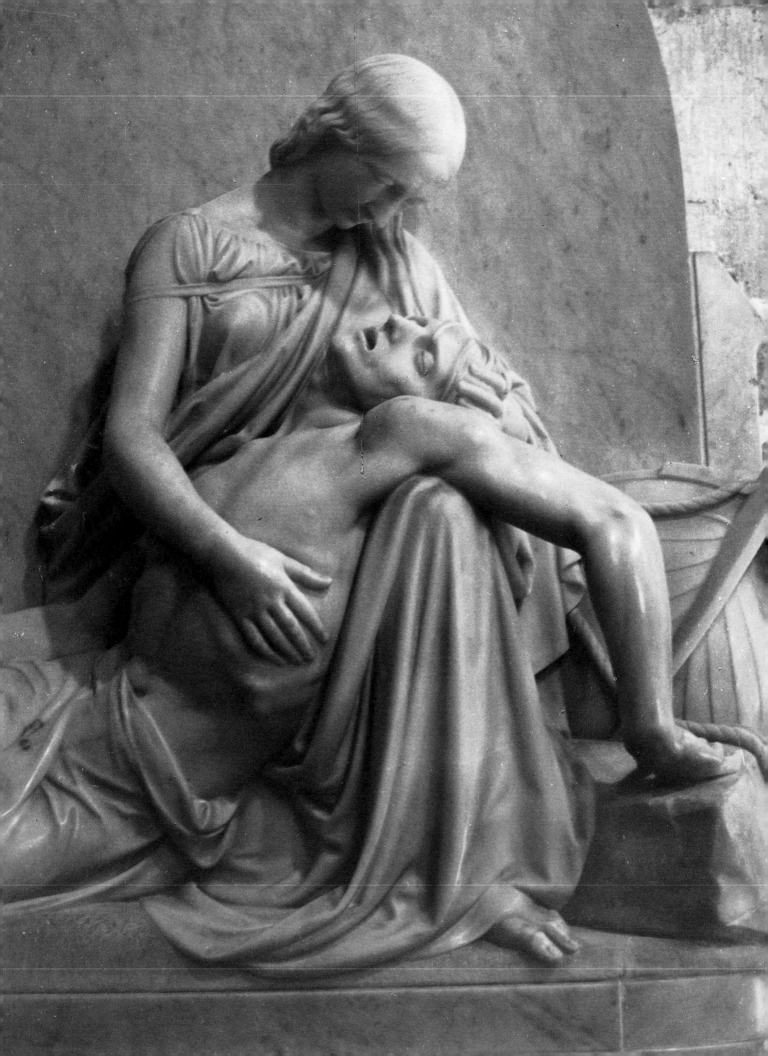

the best authenticated portraits, well expresses the character of the man, bold, energetic, loving, and just.'[63] In the *Asia* group for the Albert Memorial in London (plates 49, 223), the presence of the elephant apparently deterred every other sculptor;[64] Foley's beast, with its wealth of wrinkles closely observed, shows the sculptor could match the challenge of Nature. And in his portrait statues, such as that of the Earl of Rosse (plate 110), and the many of Prince Albert (plates 1, 68), it is not impossible for us to allow that the skill that renders every detail of drapery so true extends as well to the representation of the physiognomies. Then there is Weekes's memorial to the poet Shelley (Christ Church Priory, Hampshire, 1854), in which the marble of the central feature, the corpse of the drowned poet, just brought out of the sea, glistens in such a way as to convey a bloodless cadaver that is still wet (plate 224). William Michael Rossetti writes of Woolner's busts: 'His modelling of flesh in all its delicate niceties may well be termed perfect. . .',[65] and this only re-echoes what the sculptor thought himself, for instance, of his *Tennyson* bust (Cambridge, Trinity College, 1857) (plate 64):

225. Bernhard Smith, *M. E. Gray*, 1849. Location unknown.

> I have striven to show that vitality can be expressed in subtlest detail on the surface
> of marble as it can by means of color etc. and likewise what I hoped was to do such
> a likeness of a remarkable man that admirers of his centuries hence may feel it to be
> *true* and thankful to have a record which they can believe in.[66]

His *Brother and Sister* (plates 7, 8), shown at the International Exhibition of 1862, called forth comments such as '. . . very natural and pleasing . . . Nothing can be more life-like and true than the treatment of every portion of the composition . . . We think this work of Mr. Woolner's places him at the head of the Realistic school. . .'[67]

Woolner's excellence in this respect has however a further particular point of reference. He was an original founder-member of the Pre-Raphaelite Brotherhood, though his work in sculpture has never really been viewed as Pre-Raphaelite as such. Whether such a dimension to Pre-Raphaelitism is possible depends on one's definitions of what constituted that movement, though there seems to have been little doubt at the time that it was possible: there was not only Woolner's consistent presence as a Pre-Raphaelite Brother, but there were a number of other sculptors within the Pre-Raphaelite penumbra—Alexander Munro, who was closely associated with Dante Gabriel Rossetti, John Lucas Tupper and John Hancock whose names flit through the official Pre-Raphaelite *Journal*, and finally Bernhard Smith, who actually signs a portrait medallion of Mrs (or Miss) M. E. Gray of 1849 'Bernhard Smith PRB' (plate 225).[68]

Smith was never formally elected or appointed a Pre-Raphaelite Brother, nor were Munro, Tupper or Hancock: only Woolner could claim that distinction. It is perhaps more germane to ask whether the works of these sculptors in any way partake of qualities in style or subject matter that could be described as Pre-Raphaelite. It would not be unreasonable to posit, say, 'truth to nature' as an ideal to which the Pre-Raphaelites at various times and to varying degrees could subscribe, nor to single out anguished, intense expressions, portraying possibly exaggerated emotional states as a feature detectable in the work of Hunt, Millais and Rossetti, particularly when they were closely associated in the early days of the Brotherhood. Add to these concern with medieval, early Italian, literary and religious subject matter—none admittedly unique to the Brotherhood—and you have a fairly wide catchment for Pre-Raphaelite sculpture.

226. Thomas Woolner, *Robert Browning* (plaster), 1856. Wallington Hall.

224 (facing page). Henry Weekes, detail from the Monument to Percy Bysshe Shelley (†1822). Christchurch, Priory.

Smith's medallion portrait, signed PRB, might perhaps tip one off to a possible field—portraiture through truth to Nature, in the form of medallions such as were common in Italy at least from the fourteenth century; certainly Woolner had an extensive practice in this field in his earlier years, and his medallion portraits of Tennyson, Browning (plate 226), Carlyle and others were highly regarded in Pre-Raphaelite and related circles.

229 (facing page). Alexander Munro (after Dante Gabriel Rossetti), *King Arthur and the Knights of the Round Table*, 1857–8. Oxford, Union Society.

Munro too executed medallion portraits, of a formal purism that harks back to Italian Early Renaissance medals. Then again Munro's *Paolo and Francesca* (plate 227) represents two intense-looking sharp-featured lovers from Dante; and if this were not enough to make it an aspirant Pre-Raphaelite work, it was formulated in close association with Dante Gabriel Rossetti.[69] In the rest of Munro's *oeuvre*, so far as it is known, there is about, say, some of his portrait busts (e.g. plate 141) a formal simplicity and purism that relates to the theory of Pre-Raphaelitism, taking as models works of art from periods before a more developed maturity has pushed out that breath of juvenile springtime.

A quite specific area of Pre-Raphaelite concern for and involvement in sculpture is to be found in architectural sculpture. William Michael Rossetti, an indisputable Pre-Raphaelite Brother, wrote firmly about this context: 'Foremost among the causes of depression of the sculptural art may be named the divorce which has taken place of sculpture from architecture.'[70] And it is possible to identify in the Ruskin-inspired Oxford Museum project[71] (of which more later, see pp. 235–7) to some extent a scenario for this Pre-Raphaelite concern. The building contains a series of statues of eminent scientists; and while some of these are by sculptors who by no stretch of the defining imagination could be called Pre-Raphaelite (Durham (plate 301), Weekes, Stephens), no less than six of the statues are by Munro (plates 302, 303), one is by Woolner (plate 143), and another by Tupper. The latter's *Linnaeus* (plate 228) is a rare instance of his work and it is possible to see in the faithful representation of the furry coat worn by the botanist a demonstration of Pre-Raphaelite principle. Dante Gabriel Rossetti may well have been instrumental in obtaining the commission for Tupper,[72] and at one stage he entertained the possibility that his own goatskin jacket had served as model for that of Linnaeus.[73] The more strictly decorative architectural sculpture on the building, like the capitals on the west side which portray animal and plant forms with much truth and sincerity, certainly conform to the Ruskinian back-to-nature call that features as part of Pre-Raphaelitism.

Elsewhere in Oxford there is Munro's tympanum at the Oxford Union (plate 229),

227. Alexander Munro, *Paolo and Francesca*, 1851. Wallington Hall.

228. John Lucas Tupper, *Linnaeus*, c. 1856. Oxford, University Museum.

"*Quel giorno più non vi leggemmo avante.*"

PAOLO AND FRANCESCA

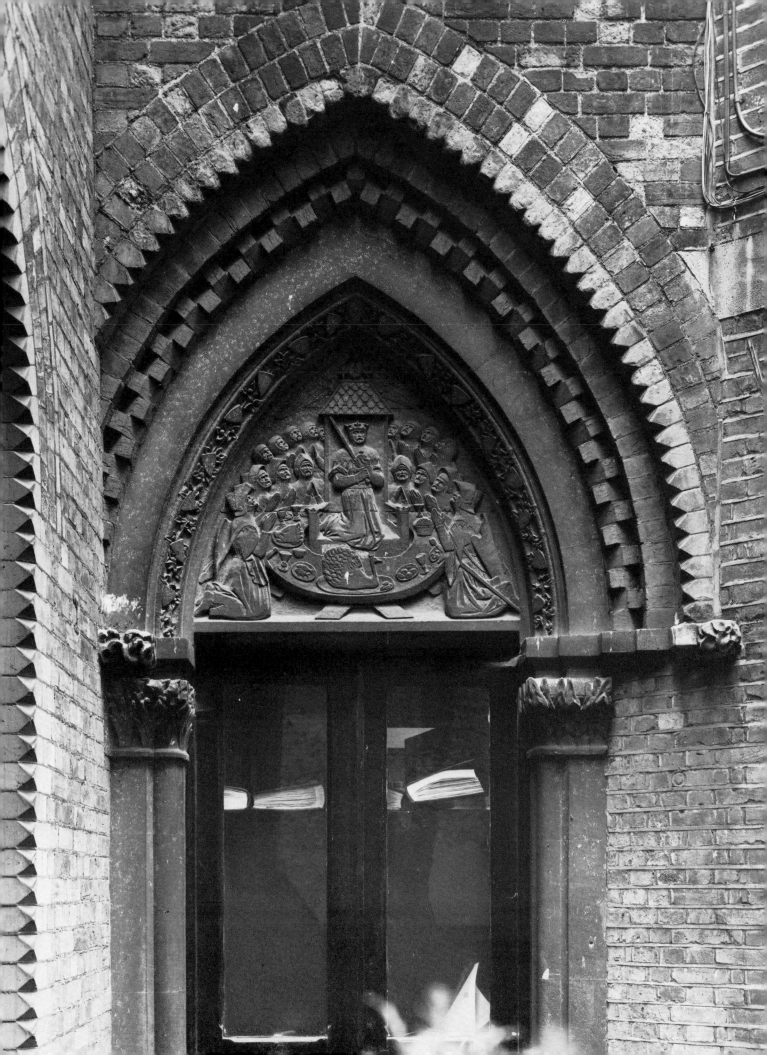

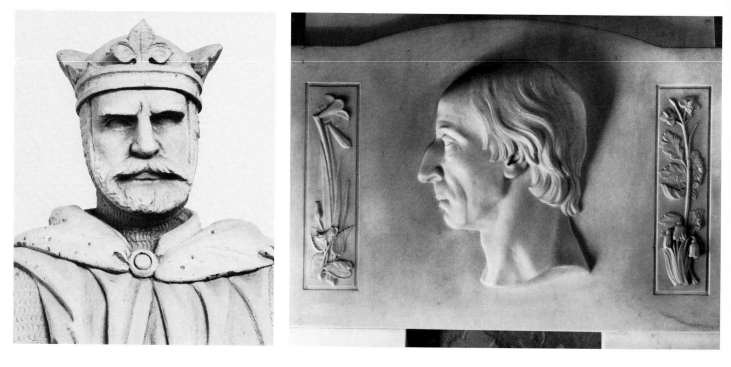

230. Thomas Woolner, detail from the statue of a king, 1863–7. Formerly Assize Courts, Manchester.

231. Thomas Woolner, detail from the Monument to William Wordsworth, erected 1851. Grasmere, St Oswald.

executed from a design by Dante Gabriel Rossetti and representing King Arthur and the Knights of the Round Table. This can certainly be seen as part of the decoration of that building by second-phase Pre-Raphaelites (Rossetti, Morris, Burne-Jones). But it is perhaps more in the contributions of Woolner to architectural sculpture that this feature of Pre-Raphaelitism is evident. These contributions were quite substantial: at the Oxford Museum, the Manchester Assize Courts (plate 307) and Llandaff Cathedral (plate 324) (for detailed consideration of which see below pp. 237–8, 258). Quite apart from the way this work fits in to the specific context just defined, there are further individual qualities about it that can also be seen as Pre-Raphaelite. Thus Woolner's figures for the pulpit at Llandaff (largely destroyed) and the statues of Lawgivers at Manchester (preserved) both belong to Gothic, that is deliberately pre-Renaissance contexts (which is what the term Pre-Raphaelite in essence implies). Both sets of figures express physiognomic intensity (plate 230) in their features, which is what we have previously put forward as a Pre-Raphaelite concern. Indeed Woolner's figure of St Paul at Llandaff was considered by J. P. Seddon, one of the architects in charge of the cathedral's restoration (and himself a Pre-Raphaelite associate through his brother the painter Thomas Seddon) to be a most admirable attempt to realise the character of the Apostle as he described himself in II Corinthians x 10: 'for his letters, say they, are weighty and powerful, but his bodily presence is weak and contemptible'[74]—that is, the work embodies realism and truth to nature.

These are in fact characteristics that we come across constantly with reference to Woolner's oeuvre, and there is a quite substantial case for defining it as Pre-Raphaelite. His formal membership of the original Brotherhood is indisputable, and his participation in its activities considerable. He gets 110 mentions in *The P.R.B. Journal*, compared to 234 for William Michael Rossetti, 200 for Dante Gabriel Rossetti, 89 for Holman Hunt, and 71 for Millais[75] and so on; in other words he comes third. Meetings in the early years of the Brotherhood were frequently held at Woolner's studio, including that, for instance, at which the first discussion about *The Germ* took place, on 14 August 1849. As far as Woolner's works are concerned, we have already seen his portrait medallions featuring as part of a general Pre-Raphaelite concern. It is not, I believe, unreasonable to look more closely at these, and at the extension of their idiom into relief portraiture generally that Woolner first effected at about this time, to see how far they can

be claimed to embody those qualities of 'excelling truthfulness' and 'devotion to Nature' that Holman Hunt had specified as Pre-Raphaelite.[76] Thus if one takes Woolner's Wordsworth memorial in the church of St Oswald, Grasmere (plate 231), one can (in the mind's eye) impose a circle round the head, and you have another typical Woolner portrait medallion: the principle is the same. It was in fact while Woolner had been modelling his 1850 Tennyson medallion, staying with the Tennysons in the Lake District, that he had met a Mr Fletcher, who in turn proposed Woolner for the Wordsworth Memorial to a brother of Sir Humphrey Davy who was in charge of the matter.[77] Woolner's memorial was placed in position in August 1851, and the *Spectator*'s comments on it confirm, I believe, its Pre-Raphaelite qualities, as previously defined:

> The likeness to the man has received decisive praise from persons whose verdict is final; the intellectual likeness to the poet will be more widely appreciated and recognized with as cordial an admiration. The meditative lines of the face, the thoughtful forehead and eye, the compressed sensitive mouth are rendered with refined intelligence.[78]

In other words, this is a truthful representation not just of the details of the physiognomy and the total physical image (i.e. Nature), but the artist has managed to portray the intellectual character also. On either side of the head there is a crocus, a celandine, a snowdrop and a violet, treated, as the *Spectator* again says, 'with a rare union of natural beauty and sculpturesque method'. This almost relentlessly truthful representation of details from Nature can be posited as another characteristic of the Pre-Raphaelite Movement; it can be found, at different times and in different ways, in the work of both Hunt and Millais. Woolner certainly maintained his application to and skill in this field; his memorial to the botanist Daniel Hanbury of 1876, at La Mortola, near Mentone, bears on either side of the relief portrait medallion examples of natural specimens (such as morning glory) rendered with a truthful accuracy appropriate to the commemoration of a professional scientist.

Following on from his Grasmere *Wordsworth*, Woolner put in for the national memorial, to be set up in Westminster Abbey. His design for this was shown at the Royal Academy in 1852, and the sculptor's own description of the work is as follows:

> In the present design, the aim kept in view has been to embody the 'Individual Mind' of Wordsworth. In the centre is the Poet himself: on the pedestal which supports him is an illustration in *rilievo* from 'Peter Bell'.—as being the poem wherein he has most distinctly enunciated his doctrine *that common things can be made equally suggestive and instructive with the most exalted subjects*; whence arose his direct influence on modern literature. The Groups are symbols of the two great principles he strove to inculcate.
>
> 1. Control of Passion (being the basis of Law.) This is represented by a father admonishing his sullen boy.
>
> 2. Nature contemplated to the glory of God. (Being the basis of Religion) Here a Mother, while discovering to her daughter the works of creation, becomes lost in her own sense of their mystery.

This is obviously a work of moral symbolism, commemorating one of the Pre-Raphaelite Immortals, and simply as such could be put forward as a quintessential work of Pre-Raphaelite sculpture. To my mind, confirmation of this interpretation comes from the manuscript of Woolner's description, given above, which is signed at the end: 'Thomas Woolner PRB'.[79]

These same principles, of realism, of truth to nature, can be seen to feature prominently through the rest of Woolner's career, not just in the series of striking, characterful portrait

busts, but in his portrait statues too. We have already seen *Constance and Arthur* (alias *The Fairbairn Group*) (plates 7, 8) heralded as 'truthful, dignified and conscientious', 'very natural and pleasing . . .' Nothing can be more life-like and true than the treatment of every portion of the composition. . .' (see earlier, p. 8); and such tributes to Woolner's truthfulness to nature are echoed (if in a rather different way) by the comments on his statue of John Robert Godley, erected in New Zealand in 1867. For while one Pre-Raphaelite—William Michael Rossetti—might write: 'Legs and feet have not much to do with the portraiture of the man; trousers and boots still less',[80] it is reported that when some of Godley's friends came to see Woolner's statue of him they said that 'if they had only seen his legs they would have known them for Godley's'.[81] Ultimately one must begin to wonder whether such truth to nature on Woolner's part, allied to an unrelenting moral earnestness and to occasional sallies into distinctive architectural sculpture, do not make of him as true and as life-long an adherent to the principles of Pre-Raphaelitism as only Holman Hunt is usually credited with having been.

Be that as it may, the position of sculpture within Pre-Raphaelitism is unquestionable. As final proof, one need only turn to a location where the work of both Woolner and Munro functions within an overall Pre-Raphaelite decorative schema—the main hall at Wallington Hall in Northumberland (plate 232).[82] Originally an open courtyard, it was covered over for Sir Walter and Lady Trevelyan, and the arcades were filled with large historical narrative paintings by William Bell Scott. The pilasters were decorated with painted flowers etc. by Ruskin, Lady Trevelyan and other amateurs, and for this setting a Woolner group, *Mother and Child* or *The Lord's Prayer* (plate 63) was commissioned. This is a modern life subject, an area of concern to the strict Pre-Raphaelites, and represents a religious idea—again not unknown in Pre-Raphaelitism. And however unlikely its

233. Thomas Woolner, detail from *Mother and Child/The Lord's Prayer*, 1856–67. Wallington Hall.

234. Alexander Munro, *Pauline Lady Trevelyan*, 1857. Wallington Hall.

232 (facing page). View of the Main Hall, Wallington Hall.

treatment may seem in a Pre-Raphaelite context, the truth and strength that Woolner attempted to express in the work should suggest that such a reading is not so easily discounted. Woolner was most concerned that the modelling of the features, figures and drapery in the group (plate 233) should be natural and truthful, and the effectiveness of this was demonstrated while the work was still in Woolner's studio:

> One of the best compliments ever paid me was by Mrs. Hollands little boy anent your Group. She came the other day with her pretty sister and child to bring me a message from the Indian Lady Trevelyan, and while they were standing before the group I said to the child 'He's a good boy to want to kiss his Mama, is'nt he?' 'No!' 'Why not?' 'Because he's saying his prayers!' I can fairly say that out of the mouths of babes and sucklings cometh forth praise. I told Mrs. Holland that the child's remark spoke to the value of her discipline: and she retorted that it equally proved the naturalness of my idea, as the boy had never heard the group talked of at all.[83]

At the other end of the hallway is positioned Munro's *Paolo and Francesca* (plate 227), a work whose Pre-Raphaelitism has by now been established. Nearby is Munro's moving, purist portrait of Lady Trevelyan (plate 234); at the other end of the hall are casts of two of Woolner's medallion portraits (plate 226). There would thus seem to be no question of the validity of sculpture in a Pre-Raphaelite decorative context.

FUNERARY MONUMENTS

The other major area of work for sculptors, besides portraiture, was funerary monuments. Due to the more fixed nature of their proper setting, these tend to survive *in situ*, though this depends on the building around them (if they are, as most are, church or chapel monuments). The memorial to John Whitaker I (†1840) by Foley, originally in the New Connexion Methodist Church, Queen's Road, Hurst in Lancashire, would seem to have vanished along with the building it was in, which is a pity as the group, consisting of figures, some or all portraits, and called *Charity*, was described by Pevsner as 'an uncommonly fine, tender piece'.[84] Sometimes a dismantled work will find refuge in a museum store, as with the monument to William Stevenson (*c.* 1854) by John Alexander Patterson Macbride (1819–90), a Liverpool sculptor; originally in St Mary's Church, Birkenhead, this is now in the basement of the Walker Art Gallery, to whom credit should be due for the work's survival.

The range of scale offered in church monuments is similar to that offered by secular commemorations. At the one extreme there could be whole buildings erected as memorials, as with the church of Christ the Consoler at Newby Park, near Skelton in the West Riding of Yorkshire. Designed by William Burges and consecrated in 1876, this church was set up as a memorial to Frederick Vyner, her third son, by Lady Mary Vyner; he had been killed by brigands in Greece in 1870. This church memorial was in addition to two stained glass windows, a brass and a church monument also set up as memorials in various other places. Another of this type was the Crimea Memorial Church by G. E. Street in Constantinople (1864–8), an ecclesiastical equivalent, in a way, to Bell's sculpted monument in Waterloo Place, London (plate 12).

For the rest, monuments ranged from simple tablets through to recumbent effigies on elaborately sculpted tomb chests and independent mausolea. These latter represent the final state in which sculpture is in partnership with architecture and still predominant; beyond a certain scale the building takes over, although in an example such as that at Frogmore, near Windsor, from the sculptor's point of view it is what is inside the building (a double tomb with effigies of Prince Albert and Queen Victoria, two more tombs with

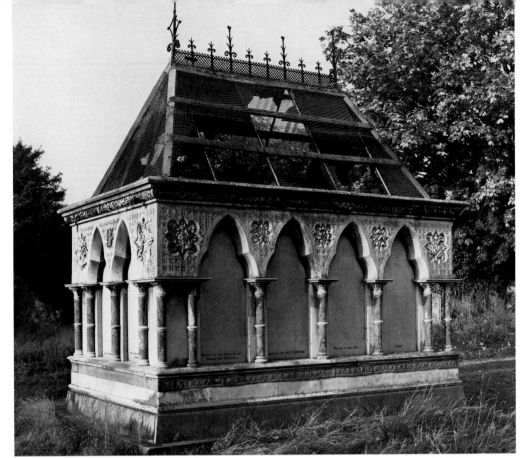

235. Henry Stormonth Leifchild, Robertson Mausoleum, *c.* 1867. Edinburgh, Warriston Cemetery.

236. Henry Stormonth Leifchild, interior view of the Robertson Mausoleum, *c.* 1867. Edinburgh, Warriston Cemetery.

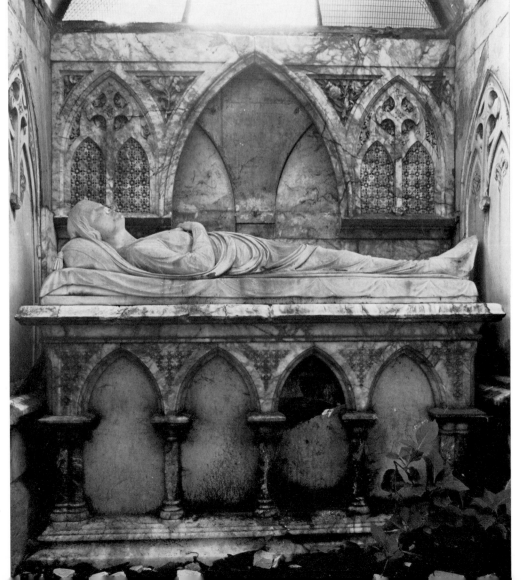

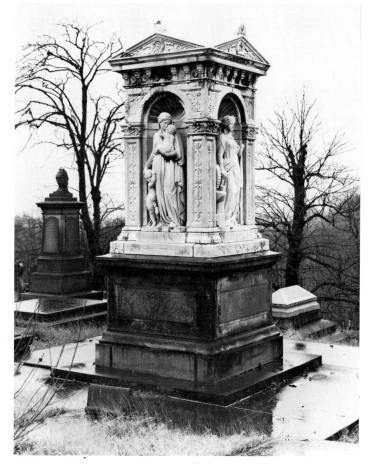

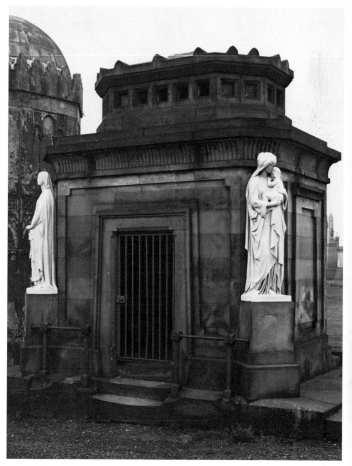

237. John Thomas, Brooks
Mausoleum, 1851. Prestwich,
St Mary.

238. John Thomas,
Houldsworth Mausoleum,
1854. Glasgow, Necropolis.

239 (facing page). John
Thomas, interior view of the
Houldsworth Mausoleum,
1854. Glasgow, Necropolis.

effigies by Boehm, and commemorative figures by Theed and Boehm) that is significant, rather than the isolated pieces of sculpture around the exterior.

The more modest type of mausoleum could be Gothic, as in the Robertson Mausoleum (plate 235) in Warriston Cemetery, Edinburgh. On the exterior beneath a short Gothic arcade, itself ornamentally carved to a high degree, is a series of incised scenes representing the Lord's Prayer, by Henry Stormonth Leifchild. Inside there is an effigy of Mrs Robertson (plate 236), also by Leifchild, lit from a roof of red glass that is perhaps trying to cast a roseate hue over the unpalatable fact of death. The Brooks Mausoleum, by John Thomas, at Prestwich in Lancashire (plate 237), is more classico-Renaissance in style. It has no interior sculpture display but rather four-square Allegories within niches on the exterior, representing Charity, Truth and possibly Industry and Trade. Open-type mausolea by Thomas are known—the Houldsworth mausoleum in the principal Eastern Necropolis at Glasgow (plate 238) has Faith and Charity on the outside and inside a figure (plate 239) representing either Hope or a deceased female looking heavenwards with a kneeling angel on either side.

The main range of funerary monuments, designed for dependent siting, so to speak, within a building, starts at its simplest with the tablet. As with most of the types of church monument there was nothing specially new about them in the Victorian period, and they were often simply continuing a tradition. Certain firms still practised in the mid nineteenth century what they had been providing at the end of the eighteenth; a particular local example of this can be seen in the monument to Lawrence Rawstorne (†1850) (plate 240), in the church of St Mary at Penwortham, Lancashire, by Websters of Kendal, prominent in the north-west from about 1790 to 1850 in the provision of simple, excellent tablets. Slightly more elaboration could come in with the addition of, say, a Gothic frame—see the monument to Charlotte Palmer (†1868) in St Peter's Church, East Carlton, Northamptonshire—and still more if a coat of arms were added—see the

188

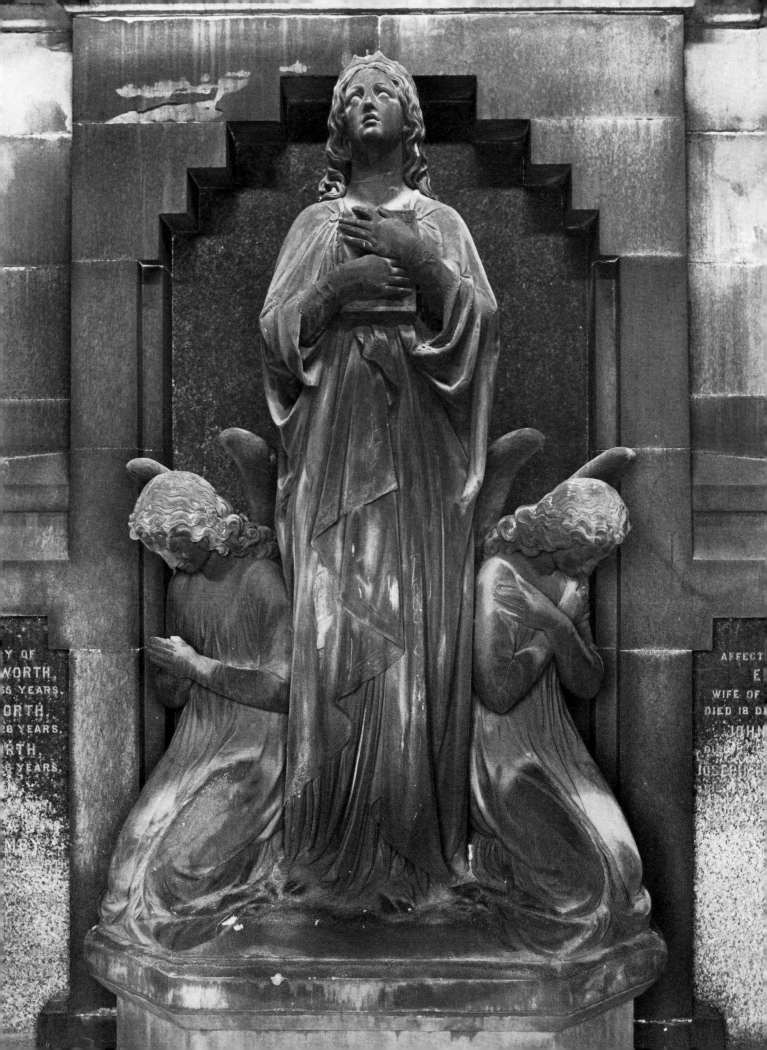

monument to John Crichton Stuart, second Marquess of Bute (†1848) (plate 241) at All Saints Church, Kirtling, Cambridgeshire, by John Evan Thomas. Alternatively the tablet could be adorned with elementary symbolic props such as funerary drapes or wilting foliage: see the monument to Skynner George Woodroffe (†1848) at St Michael's Church, Farthinghoe, Northamptonshire or that to John Jackson Blencowe (†1857) (plate 242) at St Lawrence's Church, Marston St Lawrence, Northamptonshire. These are both by Matthew Wharton Johnson, 'a prolific but dull statuary'[85] (Gunnis) based in London and active between 1820 and 1860; his work may be found all over England and also in Ireland.

The introduction of props begins to add a more sculptural dimension to funerary monuments. Moreover the tablet element in the Johnson monuments on which the message is inscribed has already begun to assume a formal life of its own, and as the scale of monument increases so too can the variety of forms it takes. The monument to Francis Aglionby (†1840) by Musgrave Lewthwaite Watson (in the church of St Michael, Ainstable, Cumbria: signed and dated 1843) (plate 243) has, in addition to the inscription, a winged soul and a funerary urn, all in an elaborate setting. Watson, it may be recalled, was also responsible for the commemorative statue of Aglionby at the Law Courts in Carlisle (plate 208). Watson's monument to the Reverend Walter Fletcher (†1846: St Michael, Dalston, Cumbria) (plate 244) has a general setting of similar design to the Aglionby monument, only the position of the significant parts is altered, with the inscription going above, and a representation of the deceased below. This represents a major variation in the general pattern of monuments: instead of conventional symbols of general applicability you can get a direct, individual reference, though these were not necessarily mutually exclusive. The type of portrait incorporated into the monument could vary: in Scotland the medallion portrait seems to have been quite common, at any rate in the Dean Cemetery, Edinburgh. The half-bust features in the monument to Lord Chewton (†1859: Navestock, Essex) by Noble, the full bust in a splendid niche setting in the monument to General Sir James Yorke Scarlett (†1871: St Peter's, Burnley, Lancashire) (plate 246), also by Noble (signed and dated 1874).

With the incorporation of a larger scenario into the general plan, more scope was available for the sculptor. The monument to Thomas Sheffield (†1853) by George Nelson (signed and dated 1856) (plate 245) in Carlisle Cathedral has a full-length relief portrayal

240 (left). F. Webster (of Kendal), Monument to Lawrence Rawstorne (†1850). Penwortham, St Mary.

241 (centre). John Evan Thomas, Monument to John, Marquess of Bute (†1848). Kirtling, All Saints.

242 (right). Matthew Wharton Johnson, Monument to John Jackson Blencowe (†1857). Marston St Lawrence, St Lawrence.

of the subject within a medallion. The monument to Robert Cary Elwes (†1852) in St Andrew's Church, Great Billing, Northamptonshire, by Weekes, has a full-figure conventional mourning female plus urn plus drapes, and the monument to Stapleton Cotton, Viscount Combermere (†1865) at Wrenbury in Cheshire, by Theed, has, in addition to a portrait medallion, three conventional figures in the main scene, remarkable at that date for the still strict neo-classicism of the convention observed. Convention could be varied: Clara Thursby (Burnley, St Peter) (plate 248) is being borne aloft by angels, which is reasonable enough, but below is sculpted a landscape from which she is rising, which does not usually feature in such scenes. The monument to Brigadier-General Nicholson (†1857) at Lisburn Cathedral, Co. Antrim, by Foley, has a relief portraying the incident during the storming of Delhi on 14 September 1857 when the general was mortally wounded; only, in compliance with the expressed wish of some of Nicholson's relatives, all representation of the general's appearance on the scene has been excluded.[86] The monument to Edward Brown (†1857) by Matthew Noble, in the church of St Michael, Ashton-under-Lyne, Lancashire (plate 247) is a remarkable compendium. The deceased is represented by a bust at the top of the monument; the deceased's wife by a medallion portrait relief at the bottom of the monument; at either side are figures of Benevolence/Charity and Piety/Religion offering comfort, with, in the background in shallow relief, what one must take for aged parents mourning. Floating in the middle above the inscription is a rather disembodied, sub-Baroque putto's head. It is noticeable that the portrait elements in the work are the most effective, in their strength of expression; the rest of the composition is somewhat characterless.

Full-length portrait figures could be incorporated in a number of ways. *Lady Scudamore Stanhope* (†1859; Holme Lacy, Herefordshire), by Matthew Noble, stands looking up expectantly to Heaven; *Bishop Ryder* in Lichfield Cathedral (by Chantrey, 1841) (plate 153) is kneeling. But probably the most common attitude was that of reclining, sometimes dead (*Mrs Farington*, †1863, signed and dated 1867, by John Hutchison at St James's, Lostock Stream, Leyland, Lancashire) (plate 249), sometimes alive (*Robert Southey*, 1846, St Kentigern's, Crosthwaite, Cumbria, by Lough) (plate 106), and sometimes possibly only sleeping (see the Cardigan Monument, Deene, St Peter) (plate 251). Optional extras were symbolic props and/or figures. *Robert Otway Cave* (†1844, in St Nicholas's Church, Stanford, Northamptonshire, by Richard Westmacott the Younger)

243 (left). Musgrave Lewthwaite Watson, Monument to Francis Aglionby, 1843. Ainstable, St Michael.

244 (centre). Musgrave Lewthwaite Watson, Monument to Walter Fletcher (†1846). Dalston, St Michael.

245 (right). George Nelson, Monument to Thomas Sheffield, 1856. Carlisle, Cathedral.

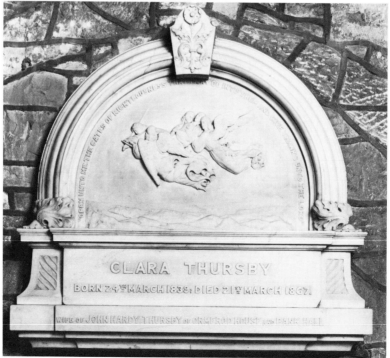

246 (above left). Matthew Noble, Monument to Sir James Yorke Scarlett, 1874. Burnley, St Peter.

247 (above right). Matthew Noble, Monument to Edward Brown (†1857) and his wife. Ashton-under-Lyne, St Michael.

248 (right). Monument to Clara Thursby (†1867). Burnley, St Peter.

249 (facing page, above). John Hutchison, Monument to Mrs Farrington, 1867. Leyland, St James, Lostock Stream.

250 (facing page, below). John Graham Lough, Monument to Charles, Lord Sudeley and his wife, 1872. Toddington, St Andrew.

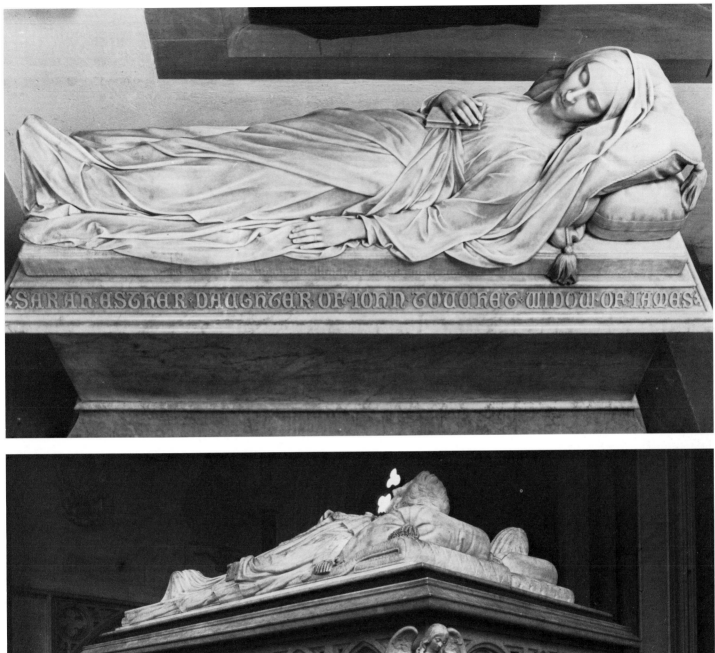

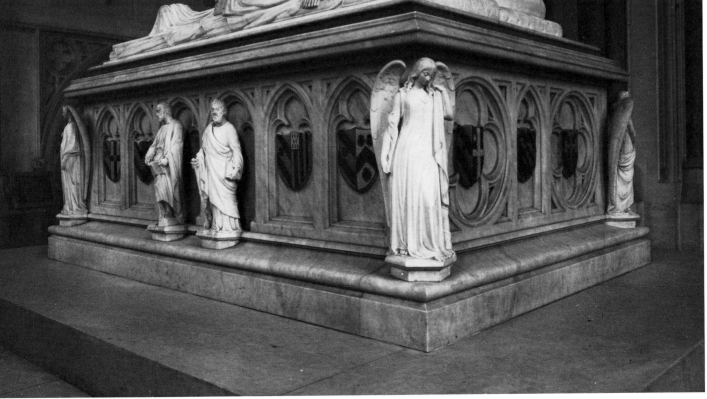

reclines asleep on his tomb chest within a capacious Gothic niche. At the foot of the tomb to the left a mourning female lowers her head in grief having just inscribed his record on the tomb; in a corresponding position at the top of the tomb are piled books, papers and more wilting foliage: one book labelled 'Scriptores Graec. et Rom.', one paper rolled up reading 'Reform Bill'.

In contrast to the demure classical vibrations of Otway Cave's tomb, that of Charles Hanbury Tracy, Lord Sudeley (†1858, in St Andrew's, Toddington, Gloucestershire) (plate 250) is a full-blown Gothic recreation. Effigies of the Lord and his Lady by Lough surmount a Gothic tomb chest with full complement of mourners, as in the grandest fourteenth-century originals. Such supporting angels and saints, in cusped niches, were part of a stylistic statement wholly appropriate for one who was a prominent supporter of the neo-Gothic style in architecture—both in his own home, Toddington, and in the Houses of Parliament, where he had been chairman of the Royal Commission that judged the designs for the rebuilding. The tomb style was fitting too for the new church in which it was set, designed by G. E. Street.

Another double effigy is that of the seventh Earl of Cardigan (†1868) and his wife, by Boehm, in the church of St Peter, Deene, Northamptonshire. Replete with decorations and side whiskers, the earl is asleep beside his wife, whose head is turned towards him, the eyes half open and watching (plate 251) (appropriately, no doubt, as he was well known for his philandering). The tomb chest, decorated with coats of arms, has four gryphons at its corners, and set in at either end are bronze reliefs representing such prominent events in the earl's life as the Charge of the Light Brigade (plate 252).

The ultimate in funerary monuments perhaps were those of Prince Albert and Queen Victoria. As a memorial to Albert, a whole chapel attached to St George's Chapel, Windsor, was restored (by Sir Gilbert Scott, the architect) and richly adorned, the main feature being a series of incised and coloured marble pictures of Biblical scenes (plate 94). These are by a French sculptor, Baron Henri de Triqueti, who was also responsible for the centrepiece of the Chapel, a cenotaph to Prince Albert (plate 253). On top of a tomb chest, most excellently designed in Gothic by Scott, lies an effigy of the Prince by Triqueti (plate 167), accompanied by hounds (plate 254). Around the tomb in niches are mourning angels, and allegorical figures: Truth is about to bare her bosom (plate 255); a regal figure mourns (plate 256), who can only be Queen Victoria. At the actual spot where Victoria and Albert are buried, the Royal Mausoleum, a double effigy tomb was erected. Less ornate than Triqueti's cenotaph, it has a massive, simple grandeur. Four bronze angels kneel at the corners, beneath Albert and Victoria, sculpted together by another foreigner, Baron Marochetti. The figures were executed at the same time, after Albert's death in 1861, but only that of Albert was immediately installed. What happened to the effigy of the Queen for the remaining forty years of life granted to her is not recorded.

Two examples of monuments on a grand scale remain for consideration to indicate substantial variations in type. The tomb of Cardinal Cullen (†1878) in the Roman Catholic Pro-Cathedral in Dublin (plate 257) exceeds all other episcopal monuments of the nineteenth century in the British Isles. Its close overall formal derivation from Italian church monuments of, say, the seventeenth century is a clear statement of ecclesiastical loyalty. By Sir Thomas Farrell, the monument is dated 1882. The other example of a major monument that is almost unique in style for its time is Alfred Stevens's Wellington Memorial in St Paul's (plate 92).[87] Though a national monument as such, it belongs also to the church monument class. Although it has many of the parts and props we have met with before (an effigy, allegorical figures, a representation of the subject commemorated), in style and form Stevens makes use of seemingly heterogeneous sources: the overall form of 'four poster' monument owing much to a type found in England in the seventeenth

251 (facing page, above). Sir Joseph Edgar Boehm, detail from the Monument to the seventh Earl of Cardigan (†1868) and his wife. Deene, St Peter.

252 (facing page, below). Sir Joseph Edgar Boehm, detail from *The Charge of the Light Brigade*, from the Cardigan Monument. Deene, St Peter.

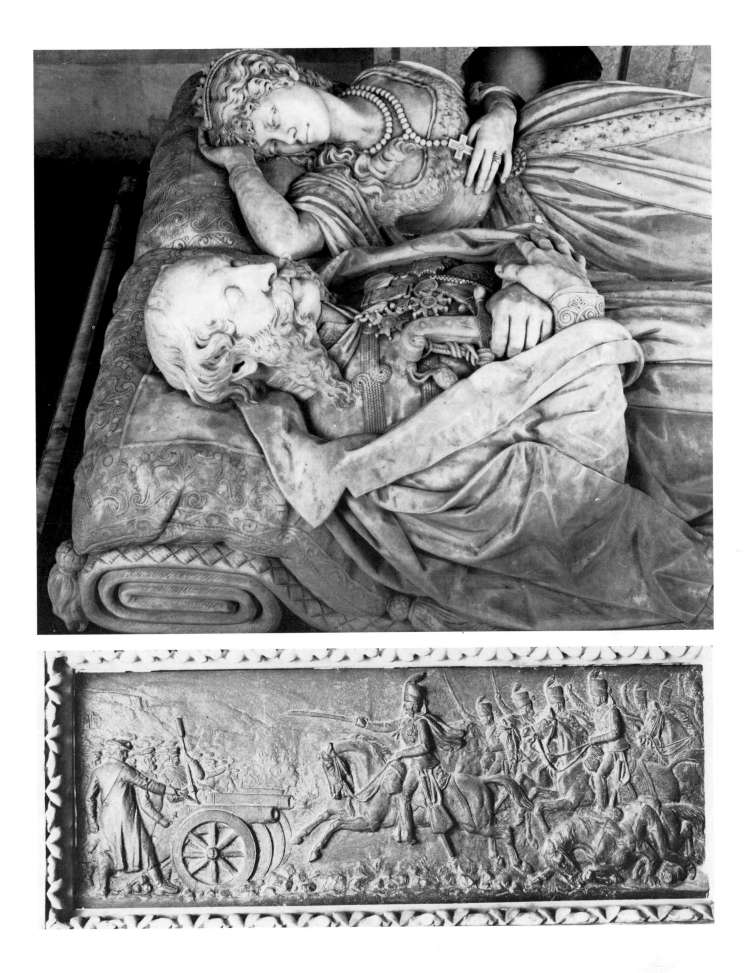

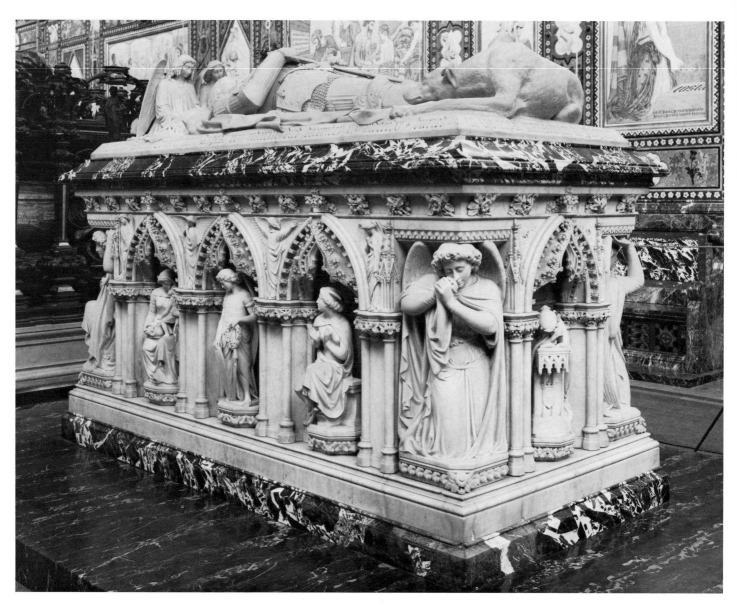

253. Baron Henri de Triqueti
and Sir George Gilbert Scott,
Cenotaph of Prince Albert
(†1861). Royal Collection,
Windsor Castle, Albert
Memorial Chapel.

254. Baron Henri de Triqueti,
detail from the effigy, Cenotaph
of Prince Albert (†1861). Royal
Collection, Windsor Castle,
Albert Memorial Chapel.

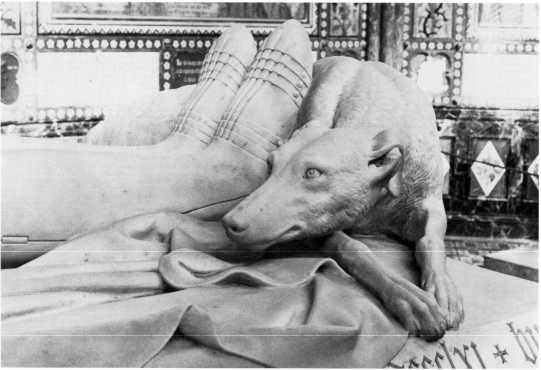

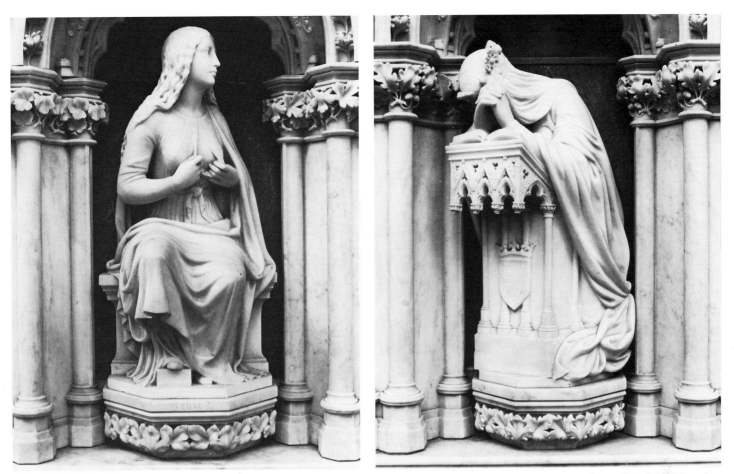

255. Baron Henri de Triqueti, detail, *Truth*, from the Cenotaph of Prince Albert (†1861). Royal Collection, Windsor Castle, Albert Memorial Chapel.

256. Baron Henri de Triqueti, detail, *Mourning Queen*, from the Cenotaph of Prince Albert (†1861). Royal Collection, Windsor Castle, Albert Memorial Chapel.

century, such as the monuments to Mary Queen of Scots in Westminster Abbey, London and to Sir John and Lady Pole at Colyton in Devon (plate 258). On the other hand, there would seem to be recollections of certain Italian Renaissance monuments: those to the Scaligers in Verona, or the painted monument to Sir John Hawkswood in Florence (by Uccello) are sometimes mentioned, the latter particularly for the motif of the surmounting rider. The allegorical group *Truth Overcoming Falsehood* (plate 259) is generally considered to have Michelangelesque affinities in form and style; yet the 'vocabulary' is medieval. Truth is pulling out the tongue of Falsehood in one of the figure groups in the archivolt in the entrance to the Chapter House at Salisbury Cathedral, and Stevens had drawn this group in 1848–9 (plate 260) (before the figures were restored) as part of a series done for the architect C. R. Cockerell to illustrate some lectures.[88] However, the nature of the alembic of Stevens's creative genius cannot be pinpointed further.

The meaning of all these monuments, particularly those at a greater scale, is often at least implicit in the representations that support them—mourning figures, wilting flora and so on. There are of course explicit messages to be read: 'Search the Scriptures', we are told, on the tablet to Agnes Carr in the Church of St Aidan, Billinge, Lancashire. 'The Paths of Glory Lead But To The Grave', we are told at the top of the Combermere monument by Theed; immediately below, one figure has inscribed the names of the campaigns and battles in which the Field-Marshal had fought. The two daughters of Edward Brown and his wife set down literally what the allegorical figures should also convey (plate 247): that their affectionate commemoration is of the piety and benevolence which adorned the parents' lives and the steadfast faith in a Saviour's merits which gave them peace in death. Nowhere, alas, do we find the hint of asperity implicit in the possible ambiguity of Mr Pontifex's memorial: 'He now lies awaiting a joyful resurrection at the last day What manner of man he was that day will discover.'[89]

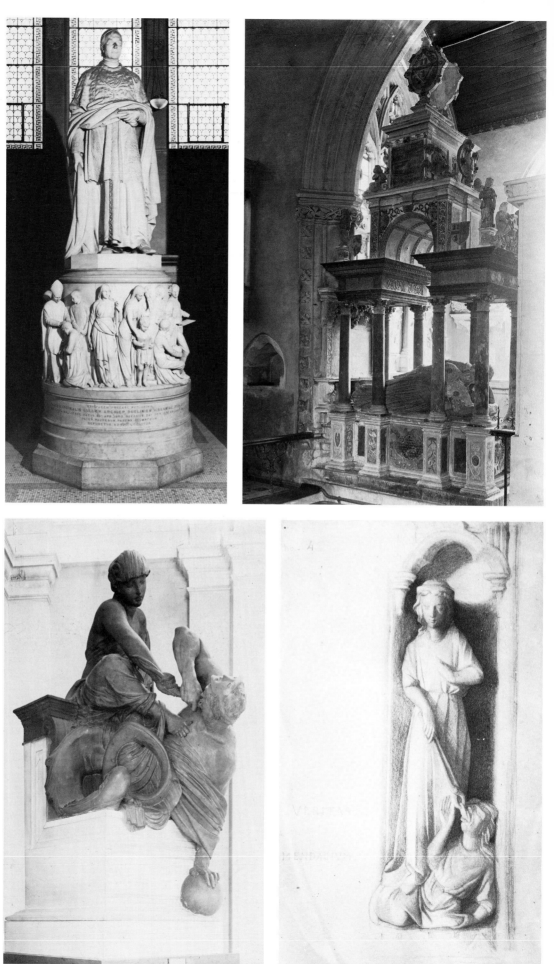

257 (right). Sir Thomas Farrell,
Monument to Cardinal Cullen,
1882. Dublin, Pro-Cathedral.

258 (far right). Monument to
Sir John and Lady Pole,
c. 1630. Colyton, St Andrew.

259 (right). Alfred Stevens,
Truth Overcoming Falsehood
(original plaster model),
c. 1858–67. London, Victoria
and Albert Museum.

260 (far right). Alfred Stevens,
drawing of figure on arch,
Salisbury Cathedral, Chapter
House Vestibule, 1848–9.
London, R.I.B.A. Drawings
Collection.

There is also, we can be sure, a further overall message implicit in the scale of the funerary monument, especially in those cases where the landed family is asserting itself in its local parish church. Perhaps they had not read their Thomas Browne: 'To subsist in lasting Monuments, to live in their productions, to exist in their names, and praedicament of Chymera's, was large satisfaction unto old expectations and made one part of their Elyziums. But all this is nothing in the Metaphysicks of true belief.'[90]

IDEAL WORKS

Meanwhile, though portrait sculpture (especially busts) and funerary monuments were the bread and butter of the sculptor's livelihood, the higher reaches of his art beckoned him to Ideal Works. Like any other class of work, these required a patron to pay for their plastic realisation. But unfortunately the market for this class was more limited than any other. When Christie's sold works from the studio of Benjamin Spence (1822–66), who had died in Rome, the *Art Journal* commented:

> . . . the sale only confirms what we have frequently had occasion to remark, that there is little or no taste for, and less desire to acquire, ideal sculpture on the part of our patrons in art. Portraits, statues and busts are as plentiful as blackberries, they gratify one's vanity, or may proclaim our good deeds, and English sculptors manage to live by them, but imaginative works are but little more than drugs in the market.'[91]

The result could be the fate that, we are told, Watson suffered: he had a large imaginative faculty, but the lack of opportunity for expressing it created a nervous impatience and embittered his feelings.[92]

Notwithstanding this limitation, Ideal Works were still regarded as '. . . the highest attempts to which the sculptor can gird himself, and not to be meddled with at all save by the fewest.' This latter reservation was clearly aimed by William Michael Rossetti at the tradesman sculptor—'Saint, king, or hero, Eve, Venus, nymph, shepherd, baby, or allegory, he is ready enough.' But for the few, wrote Rossetti, such subjects should embody an abstract principle, a moral or intellectual conception, either in a directly symbolic personation, or by example invented by the sculptor. In such subjects, moreover, there was opportunity for using the nude form 'of perfect beauty'.[93] This point was made also by Weekes, stating that the principal study of the sculptor is the human figure, though he too had certain reservations; he was against a too literal rendering of Nature because it rendered a work of sculpture commonplace, if not still more offensive, and it destroyed the purity of the Nude, with which sculpture had mostly to deal.[94]

For most sculptors, the invention of examples was not required; literature and mythology provided an inextinguishable supply of subjects, which would furthermore appeal to the patron, conditioned by cultural circumstances to require an identifiable subject. In the aftermath of the neo-classical revival of the late eighteenth and early nineteenth centuries, it is not surprising to find that up till mid century at least, classical subjects seem to have predominated in Ideal Sculpture. Nymphs and goddesses supplied excellent opportunities for demonstration of the nude or near nude form. Sievier's *Sleeping Bacchante* (plate 171), though dating from 1824, was one of Joseph Neeld's acquisitions at second hand at a later date, setting the tone for what a collector might require; the fact that the Bacchante sleeps after her sexual rampage may have added a suggestive piquancy to the apparent calm. *Andromeda* of 1842 (plate 261) is by Lawrence Macdonald, one of the Victorian neo-classical sculptors who resided for most of their lives in Rome; the heroine is not only mostly naked, but helplessly chained to a rock as well. Andromeda was the subject of a statue (plate 21) by John Bell, who was no particular neo-classicist; his treatment of the subject also has her to all intents and purposes nude and with much more

261. Lawrence Macdonald, *Andromeda*, 1842. Location unknown.

262. John Gibson, detail from *Narcissus*, 1838. London, Royal Academy.

chainage about. It was shown at the Great Exhibition of 1851 and bought by Queen Victoria; it was exhibited not as a statue as such but as an example of bronze casting, which may be why the Queen could buy such a work with impunity. But the classic case of the mid-century Antique-inspired near nude was Gibson's *Tinted Venus* (colour plate II), which has already featured. In its presence we might recall Weekes's remark: 'Absence of colour from statue removes it so entirely from common Nature that the most vulgarly constituted mind may contemplate it without its causing any feeling of a sensuous kind.'[95]

Nudity in classical figures was not confined to the female form. Gibson's *Narcissus* of 1838 (plate 262) was presented by him to the Royal Academy as his Diploma Work, so we

can with some justice examine it closely as a work to which he attached some importance. We are told that

> even in the fable of Narcissus Gibson repudiated the common story, and dwelt upon the deeper sentiment related by Pausanias, viz.: that Narcissus had a twin sister very like himself, and who was habited in the same garments adapted to the chase, to which she accompanied him. This sister died, and accidentally seeing himself in the fountain he took his own image for that of his dead sister and pined away in love and grief.[96]

In a similar way, Gibson's ostensible subservience to the Antique was not as straightforwardly slavish as might at first be thought. Though he granted pre-eminence to the Greeks, Gibson was most emphatic that nature was his true teacher;[97] he had casts from nature,[98] and he believed that the best art was an abstract of beauties observed from nature.[99] So with the *Narcissus*: not only is it not based on the simple classical story, but it is also not a simple classical form, being taken from an incident observed in nature:

> One morning early I was taking my usual walk on the Monte Pinciano, and there was a fountain under the wall of the French Academy. I saw a boy sitting on the edge of the fountain with one leg tucked under him looking into the water; his weight was principally sustained by his left arm and leg, the latter being brought under his right thigh. The action was perfect for a statue of Narcissus. I looked well at him and impressed him upon my memory, immediately went to my studio and modelled a small sketch in clay of the action which I admired. Afterwards I modelled the figure life-size.[100]

263. John Edward Carew, *The Falconer*, 1829. Petworth House.

So that when Weekes advises sculptors in his *Lectures*, 'the Beauty of your work must be in the representing all the organs of the living being you are endeavouring to portray in the state most suited to the use they are intended for',[101] the Beauty that he is talking about, for all his reservations about classicism, is not incompatible with Gibson's beauty, since despite appearances to the contrary, the latter is basing his on the living being too.

By the middle of the nineteenth century, though, objections to classicism were being strongly expressed. One of the problems of course was, to use Weekes's words, 'the representing *all* the organs of the living being' (whether in the state most suited to the use they are intended for or not). This had always been a matter of a certain reservation; Gibson was advised by one patron in 1826: 'Let Paris remain nude—Mrs. Taylor has no false delicacy',[102] and it has already been observed that of the two versions of Theed's *Narcissus*, the one in the Royal Collection at Buckingham Palace (signed and dated 1847) has a fig leaf where that at Anglesey Abbey, Cambridgeshire has not, though when it was affixed is not established. There are still other works in which modesty has been preserved in an almost laughable manner—see J. E. Carew's *The Falconer* at Petworth House (1829) (plate 263) or Benjamin Spence's *Hippolytus* in the Art Gallery of New South Wales, Sydney (1862). Matters came to a head at the Great Exhibition of 1851 when, we are told, 'the . . . bishops of England, afraid that man should be seen in all his proportions, in the marble, . . . wishing for what Milton described as—"shows instead, mere shows of seeming pure",—carried the fig-leaf ornament against Art—the only laurel, as far as history records, gained by the prelacy in that year of grace!'[103] It should be noted, though, with regard to what is often considered typical Victorian prudery, that the circumstances presupposed that there were others who did not consider the statues immodest. Dr Lonsdale's opinion of the whole matter was published in 1866, and Gibson's *Tinted Venus* (colour plate II) was apparently shown with approval in 1862, though whether the nudity being female lessened the anxiety of the prelacy or whether the effect of the tinting was not as Weekes would have it should perhaps be taken into consideration. They may anyway

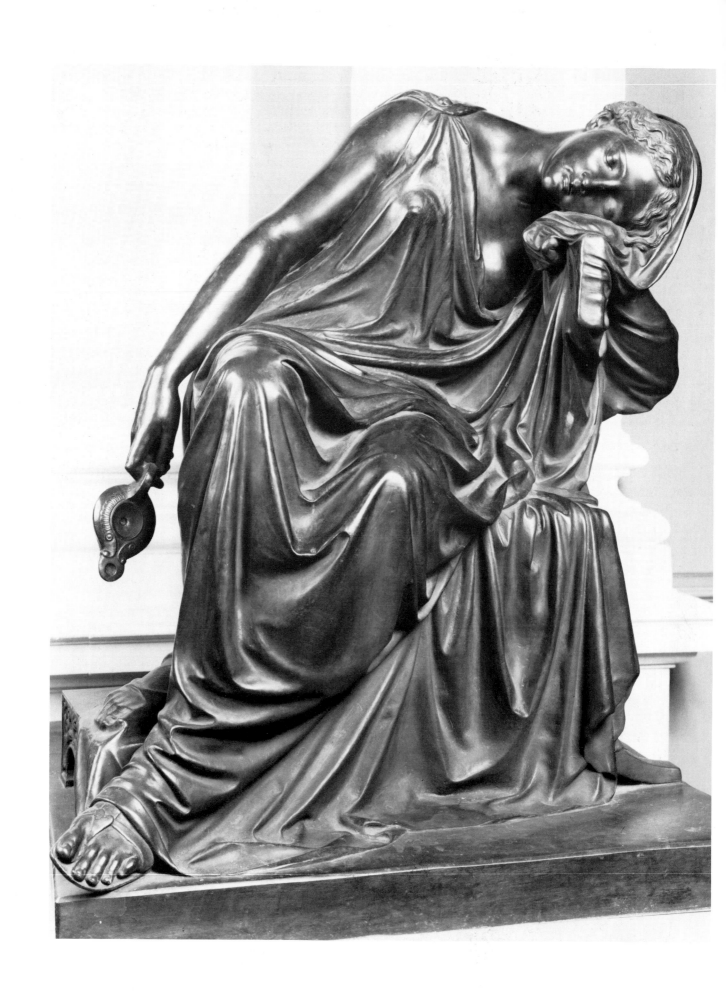

have tried a reaction of Palgrave's: 'I confess it is difficult to think of Nollekens' Venus, Canova's Venus, Gibson's Venus, everybody's Venus with due decorum—one fancies one healthy modern laugh would clear the air of these idle images.'[104]

Another objection to classical subjects was their paganism. Palgrave quotes with approval a passage from Sterne's *Tristram Shandy*: '"There are two Loves:" said Mr. Shandy, "the first, without mother, where Venus had nothing to do; the second, begotten of Jupiter and Dione."—*"Pray, brother"*, quoth my Uncle Toby, *"what has a man who believes in God to do with this?"*'[105] How widespread this attitude was is not certain, but the combination of outraged purity and piety could have devastating results, even if only in fiction:

> Among the 'Saints' in our village there lived a shoemaker and his wife, who had one daughter, Susan Flood. She was a flighty, excited young creature, and lately, during the passage of some itinerary revivalists, she had been 'converted' in the noisiest way, with sobs, gasps and gurglings . . . about the time I speak of, Susan Flood went up to London to pay a visit to an unconverted uncle and aunt. It was first whispered amongst us, and then openly stated, that these relatives had taken her to the Crystal Palace, where, in passing through the Sculpture Gallery, Susan's sense of decency had been so grievously affronted, that she had smashed the naked figures with the handle of her parasol, before her horrified companions could stop her. She had, in fact, run amok among the statuary, . . . Susan Flood's return to us . . . was a triumph; she was ready to recount to every one, in vague and veiled language, how she had been able to testify for the Lord 'in the very temple of Belial'. . .

The narrator subsequently elicits the information that these were statues of the Greek gods.[106]

Not all classical subjects in sculpture were nude or nearly so—see J. S. Westmacott's *Chryseis* (Laing Art Gallery, Newcastle-upon-Tyne, signed and dated 1867) (plate 264). Nor for that matter were religious subjects necessarily clothed; among the Grittleton collection was Baily's *Adam and Eve*, commissioned in 1853, in which the couple are clearly not sufficiently distant from the Fall to require cover. Another Baily biblical work was *Eve listening to the Voice* of 1842, clearly a pre-Fall representation and so entirely nude; an earlier Baily work on the Eve theme, *Eve at the Fountain* of 1822 (now at Bristol City Art Gallery) was not only nude, but naturally so, a cast having been taken for it of the entire body of the model.[107] Some of these works, although their subjects derive from the Bible, are not strictly religious: the source for Eve sitting on Adam's knee, while he kisses her tears away after she has told him of her disturbing dream, is Milton's *Paradise Lost*. Though an extensive market certainly existed for religious sculpture in churches, its architectural context meant it was often the concern of the specialised architectural sculpture field. One obviously cannot exclude the possibility of a market existing in religious sculpture for the home, particularly that of the pious minded: and Warrington Wood's *Israelite Maid* of 1873 may well fit into this category. On the other hand Benjamin Spence's *Rebecca at the Well* (Walker Art Gallery, Liverpool, 1860) (plate 265), well over half nude, again deriving ultimately from the Bible, may again be meant to be seen from the standpoint of literature rather than religion. A *Mary Magdalene* by Joseph Gott (1786–1860) was one of a number of ostensibly biblical subject works commissioned by the Banks family of Leeds for their house, St Catherine's, from 1827 to about 1850. When this *Mary Magdalene* was shown at the Royal Academy in 1848, the *Athenaeum* critic wrote that it

> . . . wants, to our thinking, all the character which the name suggests. It is a piece of sentimentalism—but the sentiment is not that of the Magdalene . . . We have

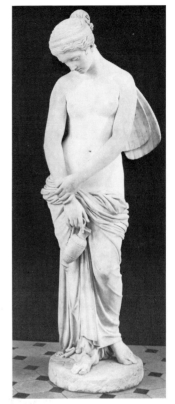

265. Benjamin Edward Spence, *Rebecca at the Well*, 1860. Liverpool, Walker Art Gallery.

264 (facing page). James Sherwood Westmacott, *Chryseis*, 1867. Newcastle-upon-Tyne, Laing Art Gallery.

203

267. Benjamin Edward Spence,
The Angel's Whisper, 1863.
Liverpool, Sefton Park Palm
House.

268. William Calder Marshall,
Sabrina, 1847. Dublin, Royal
Dublin Society.

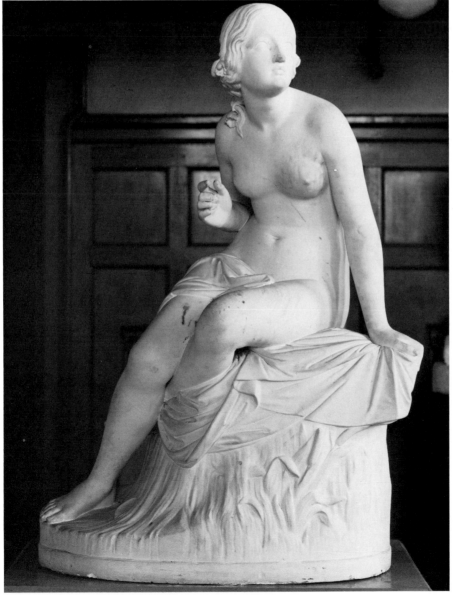

266 (facing page). Thomas
Woolner, detail from *The Lord's
Prayer*, 1856–67. Wallington
Hall.

neither the former passion nor present penitence of the Magdalene. There is not shame, nor anxiety, nor remorse—but a smile of very deliberate sweetness that speaks of a mind on easy terms with itself, and speaks it—we are obliged to use the word—mawkishly. This is no portrait of the Magdalene.[108]

The work is now lost but it is feasible to appreciate what the same critic singled out as 'its defective spiritualities' from other works in the series which have survived, such as *Hagar and Ishmael* (private collection), and to see that their specifically biblical connotations in subject-matter bore little relation to religious sentiment; indeed there is little or no distinction between these and the classically-derived subjects executed by Gott that also adorned the Banks residence. Gott's *Ruth* (City of York Art Gallery, date uncertain, various versions of the subject by Gott having been exhibited in the nineteenth century, including one at the Royal Academy of 1841), like Spence's *Rebecca*, is partially draped (different parts though) and demonstrates again the use of subjects from the Bible as excuses for the portrayal of nude or partly nude women, little different from the classical subjects current at the same time. Indeed virtually the only largely clothed religious sculpture designed for the home that one can find is Woolner's *The Lord's Prayer* at Wallington (plate 63); but the circumstances of this were fairly exceptional anyway, and there is a fair amount of nudity in the very strange relief scenes that adorn the base (plate 266), representing basically society before Civilisation has been bestowed upon it by Religion.

Less ideal perhaps than subjects from ancient mythology and literature, with their conventional superiority, were those taken from more recent literature. These would certainly appeal to an audience that liked a good story, especially if they could appreciate it directly in their own language, and the range of current literature that sculptors could refer to without endangering their livelihoods seems from the sparse surviving examples to have been quite wide. Marshall Wood's *The Song of the Shirt* comes from Thomas Hood, Spence's *The Angel's Whisper* (Palm House, Sefton Park, Liverpool, 1863) (plate 267) from Thomas Moore's *Lalla Rookh*, his *Highland Mary* (Palm House, Sefton Park, Liverpool, 1854) (plate 269) and *Flora Macdonald* (Palm House, Stanley Park, Liverpool, signed and dated 1865) from Robert Burns. A little more obscure from the present-day point of view perhaps would be Lough's *The Lost Pleiad*, based on a poem by Letitia E. Landon.[109]

English Literature from Chaucer onwards was the quite specific subject area of a major piece of municipal patronage of sculpture in Victorian England, the sixteen figures commissioned between 1853 and 1861 by the Corporation of the City of London to go in the Egyptian Hall at Mansion House.[110] Fourteen sculptors worked on these: E. H. Baily, Susan Durant, Joseph Durham, John Henry Foley, John Hancock, J. G. Lough, Patrick MacDowell, Calder Marshall, E. B. Stephens, Theed, Thrupp, J. S. Westmacott, E. W. Wyon and Henry Weekes; some of these are familiar names. Theed's *The Bard* (signed and dated 1858) (plate 14) comes from the poem of the same name by Thomas Gray of 1757, which had been a popular subject with painters and illustrators in the latter half of the eighteenth and the early nineteenth centuries. The essential story was that Edward I, the conquerer of Wales, attempted to prevent the Welsh from keeping alive the spirit of popular resistance and condemned all the bards to death. Only one escaped the slaughter and, as champion of liberty and independence, stood on a rock high above Conway River confronting the King.

There were also the classics of literature to draw from. Woolner's *Puck* (plate 39) derives one must assume from Shakespeare. First exhibited in 1847 at the British Institution in plaster, it was not cast in bronze for some time: a version for Lady Ashburton was shown at the Royal Academy in 1866, and a second cast was made as late as 1908 for Sir John Bland-Sutton; this was later bequeathed to the Royal College of Surgeons, London.

Woolner's *Ophelia* of 1868, again from Shakespeare, takes the form of a half-life-size statuette—a version is currently on loan to the Royal Shakespeare Memorial Art Gallery, Stratford-upon-Avon (signed and dated 1868, exhibited R.A. 1869). Another treatment of the subject by Woolner, dating from 1874, we have already noted (p. 171); it takes the form simply of a bust and is now in the Christchurch Museum and Art Gallery, Ipswich. Woolner also executed a number of Arthurian subjects, such as *Guinevere* (1872) and *Enid* (1881), in the form of half life-size statuettes—these must be derived from Tennyson, who was a close friend of the sculptor's. It is tempting to connect the adoption of this smaller format for such subject pieces with a need to make them suitable for a more modest domestic setting (than, say, the central hall at Wallington) and at a lower price, particularly after the financial crash of 1866; it was only after this date that this format was adopted by Woolner. Finally, Munro's *Paolo and Francesca* (plate 227) comes from Dante, thus demonstrating that European literature was not excluded.

There was still some room in the treatment of literary subjects for the nude, if an appropriate literary subject were chosen. Musidora, from Thomson's *The Seasons*, in preparing to plunge into the water must remove her clothes. In Sievier's treatment (signed and dated 1830, acquired subsequently for the Grittleton House Collection), she is removing her last stocking; in Gott's treatment of the subject (Chatsworth, 1827) the drapery is all cast off behind her. John Thomas also executed a version. Sabrina comes

269. Benjamin Edward Spence, *Highland Mary*, 1854. Liverpool, Sefton Park Palm House.

270. John Henry Foley, *Egeria*, 1855. Bury, Art Gallery.

271. John Evan Thomas, *The Death of Tewdric, King of Gwent, at the moment of Victory over the Saxons*, 1849. Cardiff, National Museum of Wales.

272. William Calder Marshall, *The First Whisper of Love*, 1846. Dublin, Royal Dublin Society.

from Milton and was treated by Calder Marshall in 1847 (a cast of this exists in the collection of the Royal Dublin Society) (plate 268). Egeria features in Byron's *Childe Harold*, a nymph with a fountain in the valley between the old Appian Way and the modern road to Naples. She is represented in one of the statues that Foley executed for the Mansion House scheme, dating from 1855; a small-scale marble version exists at Bury Art Gallery, Lancashire (plate 270). European literature was again the source of further examples of this type: Undine, from de la Motte Fouqué's fable first published in 1811, features, for instance, as a fountain centrepiece by John Thomas (see sketch, coll. R.I.B.A. Drawings) which was appropriate as she was held to typify the Spirit of the Waters. John Bell's *Eagleslayer* (1837ff.) (plate 19) had a poem attached when first exhibited, which provides it with a literary context; complete nudity is tastefully avoided, perhaps because the figure was male.

History as a subject area for ideal sculpture was specified as such for the 1844 Westminster Hall exhibition (see pp. 27, 82–3). Unfortunately works in this area have all but disappeared, and traces of their appearance are few. Lough's *The Mourners* was reproduced at the time of the Great Exhibition of 1851 where it was exhibited; the story behind it was given by the *Athenaeum* when it had been shown in 1844: it represented a 'Wife, who, during the Civil Wars of York and Lancaster, has followed her husband to the field of battle and discovers his lifeless body among the slain, his charger standing over him'. This suggests that history was being used for its sentimental appeal, very much as literature was. Lough's other 1844 history piece was *The Battle of the Standard*, which represented 'Edward I creating a Knight Banneret. The dying man still retains the

208

Banner in his grasp, and is being supported by a Trooper, while the King, who comes up at the moment, is in the act of conferring on him the honour of Knighthood; the Horse of the dying man is also mortally wounded by a spear in his throat.'[111] It was felt though that the story of Edward was not conveyed by the sculpture, and that the king appeared to be striking down the knight rather than giving him the accolade.

John Thomas's *Boadicea* can claim a historical context, however emotive the treatment (a marble version was in the collection of Sir Morton Peto, as already noted; a bronze was once in the City Museum and Art Gallery, Birmingham). The College of Domestic Science, Edinburgh once had a *James V at Cramond Brig* of *c.* 1836 by Robert Forrest,[112] while another *Boadicea* does survive (plate 55), Thomas Thornycroft's, by Westminster Bridge, London (see p. 59). However, these all tend to verge on the historical portrait type, which is not so rare. Virtually the only unqualified example of the genre to be in evidence must be John Evan Thomas's *The Death of Tewdric, King of Gwent, at the Moment of Victory over the Saxons* (bronze; plaster exhibited at the Royal Academy 1849) (plate 271).

Finally, there was an area for ideal sculpture which it is hard to describe strictly as literary or historical, though this may be due at times to simple ignorance of works' sources. One could describe this area, perhaps, as genre, and it would be taken to include such works as Foley's *The Mother* (plate 35), MacDowell's *Girl Reading* (plate 15) and possibly even Calder Marshall's *The First Whisper of Love* of 1846 (plate 272), though one suspects for this latter a literary source. These are all rather generalised in treatment, and there is nothing really to indicate them as modern life subjects. On the other hand, Munro's *Lover's Walk* (shown in plaster at the Royal Academy of 1855, in marble, 1858) and *Another Reading* appear to be specifically contemporary sentimental genre works. There would seem to have been room even here for nudity—see for example John Bell's *The Octoroon* (R. A. 1868) (plate 45); this represents a slave, one-eighth negro.

Watson also executed a number of real-life genre works. His *The Jolly or Crutched Friars*

273. Joseph Durham, *Waiting His Innings*, 1866. London, City of London School.

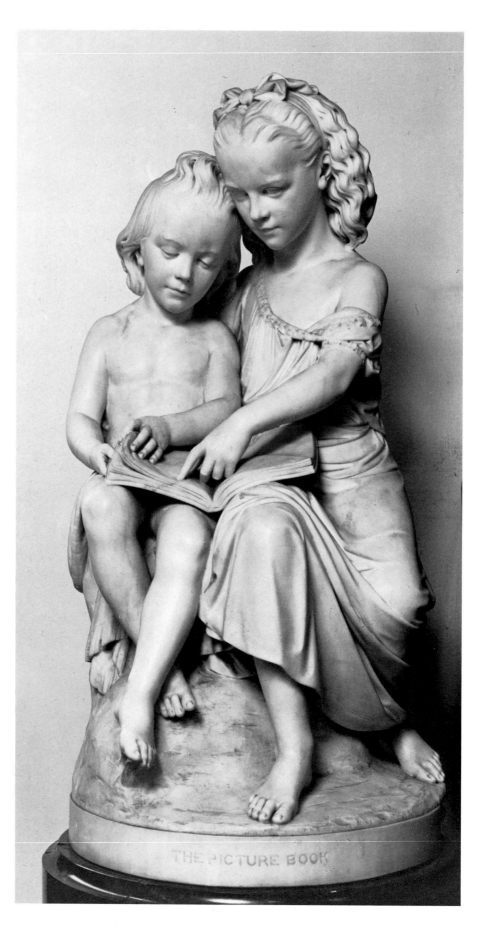

274. Joseph Durham, *The Picture Book*, R.A. 1867. Macclesfield, Town Hall.

275 (facing page). Thomas Woolner, *The Housemaid*, R.A. 1893. London, The Salters' Company.

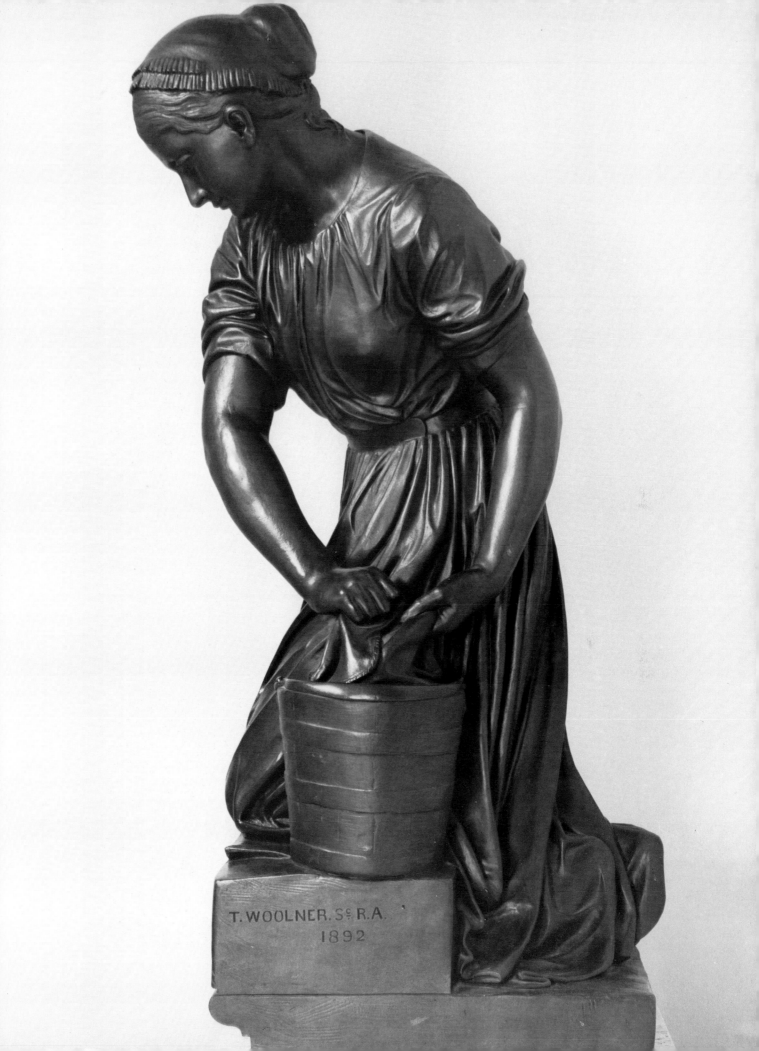

T. WOOLNER. Sc. R.A.
1892

was described by his biographer as a delineation of a type of clerical genus met with in Italy. It is animated with reality, bold, uncompromising, sarcastic; there is life and soul in the group, as well as well-contrasted individualism. Lonsdale adds an interesting comment that has a bearing on the range of ideal sculpture possible in England:

> Partly owing to the fear of being considered non-academical, and still more to the want of the natural gift, the grotesque is not commonly pursued by English sculptors, yet this form of Art has done good in its time, and might do more if properly cultivated—avoiding the grotesque that merges into the coarse and indelicate, or that might wound the susceptibilities of a class not morbidly affected by sickly sentiment, or sicklier puritanism.[113]

Watson's *The Chimney Sweep* is even more an example of real-life genre. Taken from life in the streets (in which Watson was liable to submerge himself when under pressure), Lonsdale tells us: 'No words are necessary to explain the nature of the work, as it is nature throughout.'[114] Apparently several of the same class of models came from Watson's hand, but only this remained as an example available for illustration. Both *The Chimney Sweep* and *The Crutched or Jolly Friars* indeed survive only in the 1866 photographs, and there seems no evidence to suggest they ever proceeded beyond the model stage, though whether this reflects Watson's personal difficulty in attracting patrons, or the lack of appeal of the genre, it is impossible to say. A number of works by Joseph Durham seemingly in this genre are more clearly multifunctional, so to speak: *On the Sea Shore* of 1865 (Somerleyton Hall, Suffolk) is a portrait of Sir Savile Crossley when a boy, while *Waiting his Innings* of 1866 (plate 273) is a portrait of Basil Lawrence; the group of two children called *The Picture Book* (R.A. 1867) (plate 274) comprises portraits of Mary Georgiana and Richard Henry, children of R. Milne Redhead, Esq.

A rare surviving work of real-life genre in Victorian Sculpture is also a very late example—indeed its sculptor's last work: *The Housemaid* by Thomas Woolner, executed in plaster in the year of his death, 1892, and shown in bronze at the Royal Academy in 1893 (plate 275). Though completed at so late a date, when tastes, as we shall see, had changed radically, and a new order of real-life genre works were part and parcel of the New Sculpture credo, it is still reasonable to take *The Housemaid* as a definite statement of the earlier sculpture's potential in this genre; it was a subject Woolner had long wished to do and can even be seen perhaps as done in response to the challenge of the New Sculpture. The work is a life-size figure of a servant girl wringing out the cloth with which she washes the doorstep, a sight which in those days could be seen any morning early in the London streets. The sculptor had noticed the graceful action involved; in addition he used to say the servant girls in their plain print frocks and caps were the best dressed women in London on week-days (and the worst dressed on Sundays).[115] The work is therefore very much an observation of real, everyday life: it is also, in its way, a last statement of Pre-Raphaelite principle, in its dedicated presentation of Truth and Work and Beauty. Its survival to this day, through the decades of neglect and the destruction of war—at one time it was to be seen standing in the middle of the rubble of the Salters' Hall, after the building had been bombed—bears witness to the work of an age that has by and large vanished from view.

PART III
Classes Apart

276 (preceding page). John Thomas, Tympanum, *c.* 1858. Leeds, Town Hall.

CHAPTER SEVEN

Architectural Sculpture

Above the hub of the City of London, where the Bank of England faces Mansion House, watched over by the Royal Exchange, above indeed the massive portico of this latter building, the symbolic entrepôt of the City's commercial prowess, an early Victorian sculptured pediment (plate 277) spells out a suitable message: 'The Earth is the Lord's And the Fulness thereof' (Psalm 24:1). This is no doubt intended to demonstrate the divine sanction behind the fact that, at the time the pediment was executed (1842–4), the Lord's agents on earth in this respect were the merchants and bankers of the City of London. A figure of Commerce holds the Charter of the Exchange, while on either side are portrayed merchants, tally clerks, stevedores and the foreigners with whom trade is conducted.

In August 1853 the foundation stone was laid of Leeds Town Hall, and a choir sang for the occasion:

> May the Hall whose foundations thus broadly are laid
> Stand a trophy to Freedom—to Peace and to Trade.[1]

The completed building, opened by Queen Victoria in September 1858, has a sculpted tympanum above the main entrance (plate 276), portraying a mainly similar message in allegory—the City of Leeds encouraging Commerce and Industry and fostering the arts and sciences.

Both these instances of architectural sculpture feature on quintessential Victorian buildings: the one on a focus of the Victorian business world, the other on the assertion by one of the great nineteenth-century municipalities of its significant identity, its Town Hall. Yet the two works are by sculptors of radically different origin, background and status. The Royal Exchange pediment is by the younger Richard Westmacott, son and grandson of successful fine-art sculptors, himself to be Royal Academician and Professor of Sculpture at the Academy. The Leeds Town Hall tympanum is by John Thomas, apprenticed as a stone-mason, employed early on simply as an executant of ornamental detail on buildings, and rising only gradually by dint of industry and application to a position of supremacy in the field of architectural sculpture (he also became successful at fine art sculpture and architecture, but in this respect he was fairly exceptional). This distinction between the two artists is a crucial one in Victorian architectural sculpture. It not only applies to the status of the executant: between the fine art sculptor, whose ideals would be more in the world of subject pieces, and the glorified stone-mason, steeped in building and its context; the distinction also underlies the nature of the work on the building: between what is basically applied sculpture with its sources in free-standing work, and what is much more decorative sculpture blended with the character of the building on which it is fixed.

277. Richard Westmacott (junior), Pediment group, 1842–4. London, Royal Exchange.

A further examination of the sculpture on the London Royal Exchange illustrates this well. On the Threadneedle Street facade of the building are full-length portrait statues of two of the City's historic heroes: Sir Hugh Myddelton (plate 278), who ensured a decent water supply to the City in the early seventeenth century, and Dick Whittington (plate 279), four times Lord Mayor of the City in the fourteenth century. On the east side of the building there is a statue of Sir Thomas Gresham (plate 280), founder and builder of the original exchange in 1564–70. Commissioned in 1844, these statues are by prominent early Victorian sculptors: *Myddelton* by Samuel Joseph, *Whittington* by John Carew and *Gresham* by William Behnes, artists who all achieved distinction in the areas of work familiar from earlier chapters of this book: Joseph, for instance, for his monument to William Wilberforce in Westminster Abbey, Carew for a series of ideal works at Petworth House in Sussex, and Behnes for his characterful portrait busts and statues. Their statues

216

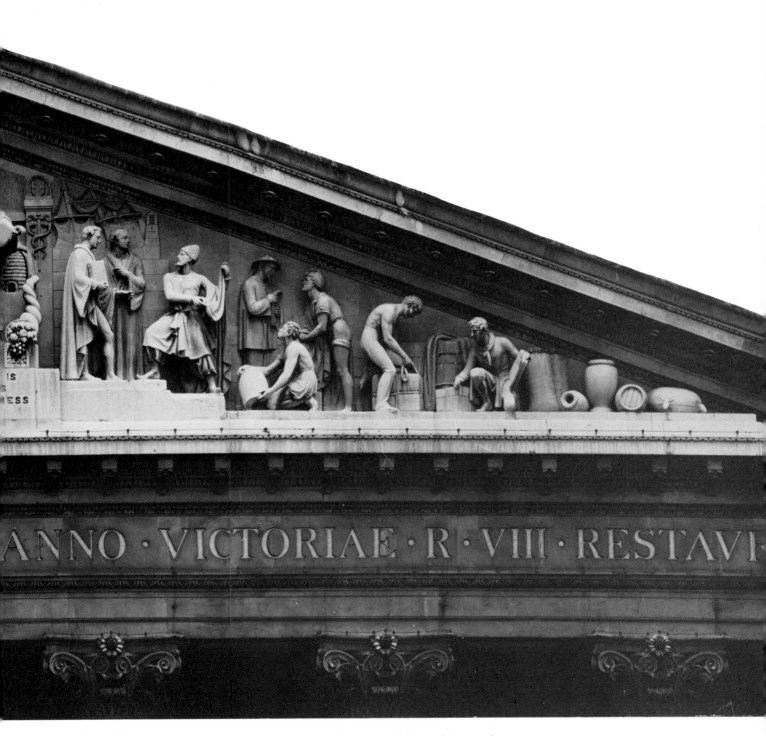

ANNO · VICTORIAE · R · VIII · RESTAV[R]

on the Royal Exchange are simply typical portrait figures stuck into niches and put up on a building; it is difficult indeed to say very much about the Gresham as it is virtually invisible at the height it is on the building—'nothing can be seen from the street except his knees' is Gleichen's remark,[2] which is adequate comment on its success as part of the architecture. So little do the three statues have any specifically architectonic character that they could as well be separate monuments placed on pedestals in some open public place. An element of interchangeability was truly a part of their character, in that the architect, Tite, originally proposed statues of Queens Elizabeth and Victoria for the Threadneedle Street facade; the Joint Gresham Committee (responsible for the building) agreed in principle, but substituted Myddelton and Whittington for the facade and set up the statues of the queens (by J. G. Lough and M. L. Watson respectively) as free-standing figures in the interior quadrangle of the building. *Queen Elizabeth* is still there; *Queen*

278 (left). Samuel Joseph, *Sir Hugh Myddelton*, 1844. London, Royal Exchange.

279 (centre). John Carew, *Sir Richard Whittington*, 1844. London, Royal Exchange.

280 (right). William Behnes, *Sir Thomas Gresham*, 1844. London, Royal Exchange.

281 (facing page, above). Sir Richard Westmacott, Pediment group, 1841–7. London, British Museum.

282 (facing page, below). Musgrave Lewthwaite Watson, Pediment group, *c.* 1840. Bristol, Victoria Rooms.

Victoria was disintegrating by 1890 and was replaced with a statue by Hamo Thornycroft.[3]

The Royal Exchange displays an important type of architectural sculpture, which was fairly widespread. It harked back to the classical and the classico-Renaissance traditions, and for as long as a broadly neo-classical style of architecture was considered apt for, say, town halls and banks, there would be opportunity for sculptural adornment along classically-derived lines, along with a predisposition towards certain forms and types of disposal of sculpture on a building, via, for example, the pediment or the metope. Excellent original classical prototypes for these were to be found among recent arrivals at the British Museum: two sets of pediment figures and a series of metopes from the Parthenon in Athens were among the Elgin Marbles acquired for the nation in 1816 and placed in the British Museum, and there were others.

The sculpted pediment over the main entrance portico of the British Museum (plate 281), of the same decade as the younger Westmacott's Royal Exchange work, is (intriguingly enough) his father's work. Completed in 1847,[4] it represents essentially the Progress of Civilisation: a central figure of Astronomy with on one side Painting, Sculpture, Architecture and Agriculture, and on the other side figures representing Drama, Music, Natural History and so on; in other words intellectual excellencies to parallel the glorification of Trade at the Royal Exchange. The work is slightly tinted: the background in blue and some of the ornaments in gold. This was perhaps suitable in that certain works in the British Museum were at that time under scrutiny in the debate as to whether the ancients coloured their sculpture, particularly in an architectural context; but in architectural sculpture in nineteenth-century England the practice was rare.

In the context of museum buildings, a slightly earlier example of pediment sculpture can be found at the Fitzwilliam Museum, Cambridge. The building's architect, Basevi, seems to have intended having sculpture commemorating Viscount Fitzwilliam; the University, however, authorised *The Nine Muses* from a design by Eastlake, to be executed by William Grinsell Nicholl, who earlier the same year (1837) had been contracted to execute decorative sculpture on the building such as capitals, friezes, panels, vases and chimaeras[5]. Among a range of other public buildings conceived in neo-classical style which incorporated sculpted pediments are examples such as the Victoria Rooms, Bristol

(now part of the University), built by the architect Dyer between 1839 and 1841. Above the main portico the pediment (plate 282) contains sculpture representing Dawn in a chariot, with floating genii in attendance. This is normally attributed to the Bristol sculptor Jabez Tyley,[6] member of a local family firm of sculptors that flourished from 1792 to 1864.[7] In fact, there is reason to believe this is a rare surviving relief by Musgrave Lewthwaite Watson. According to Watson's biographer, Lonsdale, who extracted the information, he claims, under pressure, from Tyley in 1864, Dyer the architect had originally commissioned a group in plaster from Watson, the model for which at the time of the biography was actually at the Victoria Rooms. Thomas Tyley had offered a model for the pediment sculpture, but this was not accepted; instead he was asked to copy, in stone, Watson's model, and this was what was put up. Whatever the truth of the matter, Lonsdale's description of the work is quite detailed: it is the Goddess of Wisdom in the car, drawn by horses. Music, Poesy and Light guide her, with the Graces, strewing flowers, following. Two flying figures precede the car, Night clasping an owl to her bosom and holding drooping poppies, and Morning with an hour-glass, opening flowers.[8] The work is very much in the style of Watson's reliefs, such as *Sleep and Death bearing off the Body of Sarpedon*, and the quality of the design is perhaps rather beyond the capacities of a Bristol statuary family (Jabez or Thomas) more accustomed to busts and funerary monuments.

Another important public building that had pediment sculpture was St George's Hall, Liverpool, by Harvey Lonsdale Elmes and C. R. Cockerell. Cockerell had taken on the building after Elmes's death in 1847 while it was still incomplete, and about 1849 he called in Alfred Stevens to prepare a drawing of the proposed pediment for lithography.[9] Cockerell was employing Stevens in a similar graphic capacity about this time for drawings of the angel choir sculptures at Lincoln Cathedral; the drawings were initially to illustrate a lecture Cockerell gave on the medieval sculpture at Lincoln in 1848, but later in the same year Cockerell asked Stevens to prepare lithographs after the drawings to accompany the lecture's publication. In 1849 Stevens prepared drawings of the chapter house portal sculptures at Salisbury Cathedral, a series of Virtues and Vices in containing niches to illustrate another Cockerell lecture (plate 260).[10] As far as the St George's Hall tympanum is concerned, it is clear that Stevens made considerable modifications to the design of the sculpture, eliminating seven out of twenty-five proposed human figures, pruning drastically and redisposing other details, and generally tightening the composition (according to Towndrow)[11] so as to revolutionise the ultimate effect of the finished work; Stevens also resolved the particular problem of what to put in the acute angles at either end, something that often defeated even quite competent sculptors. The subject of the Liverpool tympanum was Britannia with Commerce and the Arts; executed by William Grinsell Nicholl (whom Cockerell had no doubt met when he performed a similar architectural finishing-off job at the Fitzwilliam Museum) the work unfortunately weathered badly, and was dismantled and destroyed in 1952.[12]

The neo-classical tradition in architecture continued through the nineteenth century for rather longer and perhaps more widely than is sometimes admitted. Banks and town halls, for example, continued to display columnar or pilastered porticoes, with pediments on top requiring sculpture—though it should be noted they did not always get it: the particular poignancy of 'The Empty Pediment' of St George's Hall is fairly exceptional. Among buildings that did receive their complement of pedimental sculpture are two bearing illustrations of a single theme, the Standard Life Assurance building in George Street, Edinburgh, and the Northern Bank (originally the Standard Assurance Office) in O'Connell Street, Dublin. The common subject is most apposite, *The Wise and Foolish Virgins*. The Dublin example (plate 283) is by the Scotsman Sir John Steell and dates from 1868; the Edinburgh example is sometimes given to Steell but this is stylistically improbable. In Edinburgh, still, the National Commercial Bank of Scotland in George

283. Sir John Steell, Pediment group, 1868. Dublin, (former) Standard Assurance Office, O'Connell Street.

284. Samuel Ferris Lynn, Pediment group, 1864. Dublin, (former) Provincial Bank, College Street.

285. William Calder Marshall, Pediment group, c. 1870. Bolton, Town Hall.

Street (of 1847) has pediment sculpture by Andrew Handyside Ritchie representing Fruitfulness accompanied by Trade and Navigation, while back in Dublin again the Allied Irish (originally the Provincial) Bank in College Street contains in its pediment (plate 284) a sculpted grouping featuring Commerce and Agriculture. This is signed and dated 1864, the artist being Samuel Ferris Lynn (1834–76), who later entered Foley's studio in London and assisted in the modelling of the Prince Consort statue for the Memorial in Kensington Gardens.[13]

The Town Hall at Bolton in Lancashire, designed by William Hill of Leeds, was built in classical style between 1866 and 1873. Its pediment contains sculpture by William Calder Marshall R.A. (plate 285), whom we have already met with in earlier chapters as a fine art sculptor of some distinction. The composition of the pediment[14] is traditional to a degree; a lady with castellated crown (at the Royal Exchange, London, considered to represent Commerce—Ein Feste Burg ist Unser Gelt, no doubt) is enthroned at the centre; at one side are figures representing Industry and Agriculture, the sheep and sickle of the latter overcoming with some skill the problem of the acute angle and how to fill it in successfully; on the other side are featured a lady with a caduceus, probably representing Trade, a boy pulling ashore a boat, and an old man reclining with a paddle, presumably representing that Navigation without which world trade was impossible, particularly for Bolton and its cotton spinning, bleaching, dyeing and printing, for which the raw material had to be brought in, and the end product taken away.

Another classical Northern town hall (plate 287) is that at Todmorden in the West Riding of Yorkshire, by John Gibson (the architect) and dating from 1870. Its pediment contains sculpture that is quite magnificent (for all that the angle composition to the left may be a bit strained). The sculpture represents Lancashire and Yorkshire sitting together (plate 286), combining in a perhaps uneasy relationship, illustrating Todmorden's physical siting in a section of Yorkshire that sticks out into Lancashire. On one side is featured Cotton: in bale, being registered in a ledger, on spindle and in thread, with rolls of spun material below. The Yorkshire side represents the iron and steel industry and a double spread for Agriculture: wheat being harvested, and a shepherd with his sheep (fitting neatly into the angle); the latter illustrates in addition an early stage in the production of the wool in which Yorkshire excelled. This fine work is by Mabey of London,[15] probably Charles Mabey who also did, for instance, part of the Temple Bar Memorial in the Strand, London.

Another fine series of architectural sculptures on a Gibson building occurs at what is now the National Westminster Bank in Bishopsgate in the City of London, of 1864–5. Here we meet another type of classical architectural sculpture involving rectangular relief panels, also known as metopes; the building as well has figures along the top of the cornice, again a classical motif. In each of the panels, a central angel holds symbols relating to the subject of the panel, while further illustrative activities continue on either side; thus for Agriculture (plate 288) the angel, standing by a cornucopia, holds a sickle and a sheaf of corn; behind is a ploughing scene with on one side a ploughman with plough and a labourer with a hoe, and on the other side a ploughboy, a team of oxen and a tree. For Navigation (plate 289) the angel holds a rudder; behind is a boat with sailors punting, dropping anchor, hoisting a sail and taking soundings. And so the series goes on, with Science and Engineering, Cottage Industries, Commerce, the Arts and so on. These panels are by John Hancock[16] (of Pre-Raphaelite association—see p. 179).

There was nothing novel about this use of the metope type in architectural sculpture. An earlier series can be found on the walls of the one-time Royal Institution, now the City Art Gallery, in Mosley Street, Manchester. These are by John Henning junior (1802–57) and represent Architecture, Painting, Sculpture (plate 290), Wisdom, Astronomy (plate 291) and Mathematics. Designed in 1836 and executed in 1837, these are relatively

LANCASHIRE · YORKSHIRE

286. Charles (?) Mabey, detail
of Pediment group, *c.* 1870.
Todmorden, Town Hall.

287. Todmorden Town Hall,
1870.

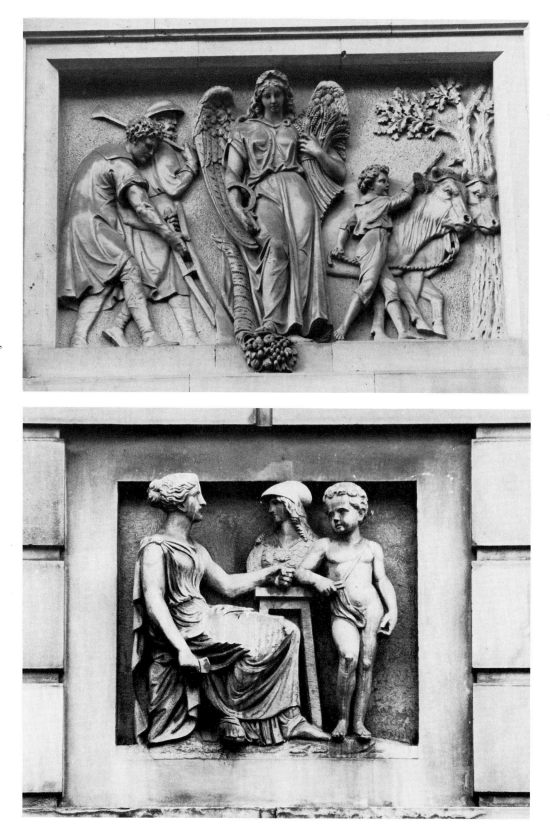

288. John Hancock, *Agriculture*, 1865. London, (former) National Provincial Bank, Bishopgate.

289. John Henning (junior), *Sculpture*, 1836. Manchester, City Art Gallery.

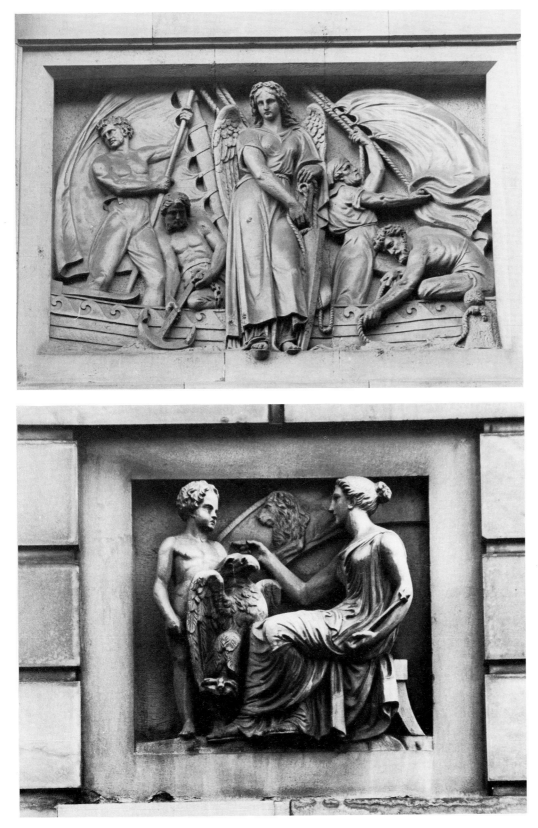

290. John Hancock, *Navigation*, 1865. London, (former) National Provincial Bank, Bishopgate.

291. John Henning (junior), *Astronomy*, 1836. Manchester, City Art Gallery.

292. William Theed, *Adam Smith*, 1869. London, (former) University Headquarters, Burlington Gardens.

simple compositions, usually a single allegorical female figure with attributes and in most cases an accompanying putto. One might note the lengths to which the total nudity of the putti figures is avoided—in one case, that of *Astronomy*, by an eagle's wing—and this in panels which are some twenty or thirty feet above eye level. The correspondence concerning these works that survives in the City Archives, Manchester has been published and gives some useful insight into how such an undertaking was managed. Designs by both Henning and a certain Charles Smith were submitted to the Council of the Royal Manchester Institution by Barry the architect, with a definite preference stated by him for Henning's designs. Henning was obliged to send half-size models of each subject 'for the appreciation of the council', which he did; he also agreed to execute them 'under the direction of Mrs. Barry' on the front of the building for £30 each, the scaffolding to be put up at the expense of the Institution. In April and May 1837 Henning was arranging for a carver, Mr Affleck, to go up before him to get the blocks in a just state for Henning to complete them; Affleck got one pound per week in payment for this. In July and September 1837 Henning was at work on the panels, and there was some discussion about coating them with wax to prevent the stone from decay; the work seems to have been finished by sometime in October that year. Further correspondence took place about money, including two pounds to be paid on Henning's account to Mrs Nabs, housekeeper of the Institution; about the sale back to Henning of his half-size models which the Council declined to transact; and about the return of other models that had been sent by Henning to an exhibition at the Royal Institution, the means of transport envisaged being in packing cases by canal—a practical point of some interest.[17]

A substantial programme of architectural sculpture on a classico-Renaissance building is to be found in London at the Burlington House complex, this under Central Government patronage. The site had been acquired in 1854, and at the rear, in 1866–9, a headquarters for the University of London was built to the designs of Sir James Pennethorne. This building was adorned with a series of statues of celebrities: *Newton*, *Bentham*, *Milton* and *Harvey*, seated over the central portico, by Joseph Durham; *Leibniz*, *Cuvier* and *Linnaeus* by Patrick MacDowell, *Adam Smith* (plate 292), *Locke* and *Bacon* by William Theed (these all standing in niches on the facade); with *Galileo*, *Goethe* and *Laplace* by E. W. Wyon, *Galen*, *Cicero* and *Aristotle* by J. S. Westmacott, *Plato*, *Archimedes* and *Justinian* by W. F. Woodington, *Hunter*, *Hume* and *Davy* by Matthew Noble comprising the figures standing at the level of the balustrade on the building. Further statues of artists by Henry Weekes, William Calder Marshall, E. B. Stephens and Joseph Durham were set up on the facade of the Royal Academy building (to the front of the site, towards Piccadilly) as part of its conversion by Sidney Smirke from 1872 to 1874.[18] These are all conventional portrait statues by regular, typical fine art sculptors, most of whom may be familiar by now from earlier chapters. The programme of architectural sculpture derives from the classico—Renaissance tradition, wholly appropriate for buildings in that style: the motif of the standing figures along the level of the balustrade deriving even more immediately from the classical eighteenth-century Burlington House (at least as engraved in *Vitruvius Britannicus*) that was being converted and rebuilt. All told, whatever the individual merits or otherwise of the figures, there has been no change in basic idea from the Royal Exchange statues of Whittington, Gresham and Myddelton of a generation earlier; it was one of applied sculpture rather than of integral sculpture as architectural adornment, and it was only in the last quarter of the century that a more substantial general aesthetic of integral architectural sculpture evolved, from rather different sources.

Ironically enough, it was from within a context of Government-backed architectural sculpture in a quite distinct classico-Renaissance style (as so far broadly defined) that one of these sources can be traced, namely, the work of Alfred Stevens's pupils and followers at South Kensington. Strictly speaking, one of the very few completed works in sculpture by

Stevens, the Dorchester House Dining Room fireplace, should really be viewed as a piece of architectural sculpture. It was simply one part of an elaborate decorative scheme for the entire room that involved painting, panelling, fixed furnishings carved in wood and so on: only the fate of the fireplace as a distinct piece within an ultimately unrealised full scheme, and its survival and rehabilitation as a separate object have concealed its true identity as a subsidiary part of an overall multi-media decor. The Italian Renaissance determination of this cannot be seriously doubted, with the caryatid figures harking back to Michelangelo, and the putto on top of the fireplace to a general Quattrocento character; this was all a subsidiary part of a house by Lewis Vulliamy that sought to imitate a Genoese Renaissance palazzo as appropriate to a prosperous merchant.[89]

It was while Stevens was at work at Dorchester House (amongst other projects) that certain of his former pupils at Sheffield School of Art became involved in the new building works at South Kensington at the Royal Horticultural Society Gardens and the South Kensington (later the Victoria and Albert) Museum. The Royal Horticultural Society Gardens[20] were designed and set up between 1858 and 1862. They incorporated a series of arcades by Sidney Smirke and Francis Fowke which were in Renaissance style, based on various original Italian arcades studied specifically as prototypes. These were seen in part as the architectural background to the display of the Royal Horticultural Society's more exotic botanical exhibits, but also, particularly as a result of Prince Albert's involvement, as suitable receptacles for 'busts, inscriptions, silicated paintings and statues', this in turn being part of a general policy stemming from Prince Albert that envisaged sculpture occupying an important place in the gardens overall, both figuratively and literally. In 1859 Godfrey Sykes, one of Stevens's principal pupils from Sheffield, was called in to provide sculpture for the arcades, and he produced series of columns, capitals, spandrels and friezes in terracotta. So far as one can tell (the Gardens were successively demolished between 1888 and 1892 to make way for Imperial College and other buildings, but some photographs and drawings survive) Sykes's work was entirely ornamental and non-figurative, no doubt in part because statuary and busts were to be incorporated by other means. Its character, also, was integrally decorative, part of a wider scheme involving Minton tiles, coloured brickwork and so on; but while this obviously led to a diminution of the role of emphatic sculpture such as we have seen on other Italo-Renaissance architectural schemes, it nevertheless fitted in to an overall decorative aesthetic such as Stevens could (in theory) produce and which need not exclude *per se* a more pronounced emphasis on sculpture.

This can be seen in the other official South Kensington scheme in operation at the same time, with Sykes much involved, with his fellow-pupils James Gamble and Reuben Townroe as his assistants. The particular areas of the new museum buildings where they were involved in providing decorative detail were the North Side of the Quadrangle, the South Court and the Refreshment Room.[21] In these last two the work was more purely decorative, in mosaic, majolica etc.; on the exterior of the North Front of the Quadrangle, though, much more emphasis was given to sculpture, with ornate terracotta columns consisting of drums with friezes of putti encircling them (these designed by Sykes and erected about the end of 1865 or early 1866); on the balconies are roundels containing putti; further up, the pediment tympanum and figure panels on the flanking attic stories are by Townroe; at ground level the door, with majolica figure panels above it, contains six bronze panels by Gamble and Townroe with figure scenes after Sykes's designs; the latter panels were exhibited in Paris in 1867.

Now although this South Kensington work can be seen as fitting, in theory, into a tradition of classico-Renaissance architectural decoration, it is wholly dissimilar to what we have examined so far, even at the simplest level of ornamental sculpture. Sykes's work, particularly for Fowke's Royal Horticultural Society arcades, was regarded very

differently from what some considered the artistically worthless stone-carving of the capitals on Smirke's arcades. Cole in particular among the South Kensington authorities thought that the best stone cutters in London emasculated and utterly destroyed an artist's design by the very thoroughness of their craftsmanship, whereas the precise mould of terracotta protected the original conception, in that you could have the exact work of the artist upon it.[22] The extensive use of terracotta for the three-dimensional decoration at South Kensington, whether purely ornamental or figurative, testifies to a new aesthetic: it was not just that it was cheap, kept its bright colour, and that its moulds could be reused as a precise visual discipline (these reasons have been cited in its favour); but that the whole nature of its manufacture and its hesitancy between the status of fine and applied art fitted it more naturally (even when figurative) into a subsidiary role along with other media (such as mosaic and majolica) in a total, integrated decorative philosophy, inspired in this instance by the work and teaching of Alfred Stevens. This sort of approach to sculpture decoration on buildings could certainly not be claimed to underlie the relief and statuary work on the London Royal Exchange with which this chapter started—this was by most distinctively fine art sculptors and the works have an independence about them that makes them potential divorcees from their surrounding structures. This also applies to much of the work featured on the other buildings of neo-classical or neo-renaissance style that we have seen, and this arises without any doubt from the essential conventions of the traditions that both the buildings and the sculpture on them are imitating. On the other hand it could be claimed that work of the Stevens school, being modelled and cast, by the notions of the time was verging on not being sculpture at all, and however much later concepts of the true nature of sculpture may owe to the change of approach, historically speaking we should not ignore such work's questionable validity as sculpture.

A contrast was made initially between Westmacott's work and that by John Thomas at Leeds Town Hall; and while this latter is certainly a building that belongs to the broad classico-Renaissance tradition, the contrast was made rather to pick out the entirely different status that Thomas embodied and, by inference, the different nature of the work he did. Notwithstanding his subsequent eminence, in part in fine art sculpture work, Thomas had an equally eminent career as an architectural sculptor, and in this there can be little doubt that his strength lay in his remaining party to the attitudes and standpoints of a man of his background—trained in the stonemason, craftsman tradition of Gothic ornament, prepared to let his art subserve the buildings on which it featured.

Arising most immediately from this we should note that his work knew no particular stylistic barriers. The Leeds tympanum is one of a number of Thomas sculptures on classical buildings: in 1848 he was commissioned to execute reliefs of Peace and War for the late-Regency main staircase hall at Buckingham Palace;[23] for the Great Hallway of Philip Charles Hardwick's Euston Station of 1847–48 Thomas executed eight metope-type panels at clerestory level; these consisted of allegorical groups representing the cities and towns served by the railway—London, Liverpool, Manchester, Birmingham, Carlisle, Chester, Lancaster and Northampton. These (presumably) came down with the rest of the station in 1962. Retained, though, and now sited in the Buffet on the main concourse of the present station, is another Thomas work, a pedimental group showing Britannia accompanied by a lion, a ship, the Arts, Sciences and Mercury (plate 293). Signed and dated 1849 this was originally placed over the Doric portal that framed the entrance to the Shareholders' Room at the north end of Hardwick's Great Hall.[24] Also for a Hardwick Station at this time was the Thomas pediment sculpture for the Great Western Hotel, Paddington (1851–3): this illustrates Peace, Plenty, Industry and Science, 'a crushingly Victorian programme for a sculptor' (Pevsner).[25]

For classico-Renaissance banks Thomas could produce a relatively modest

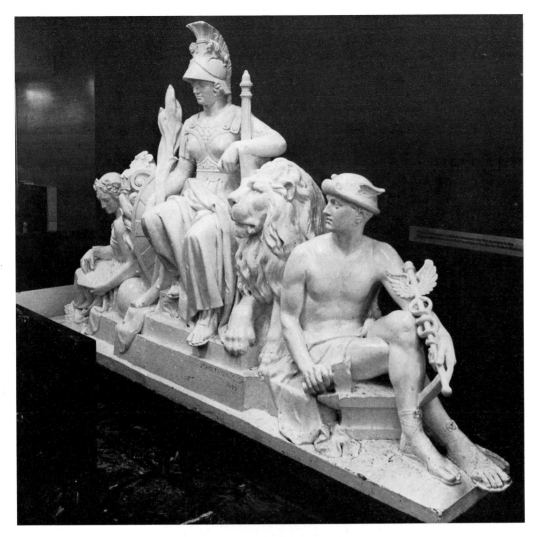

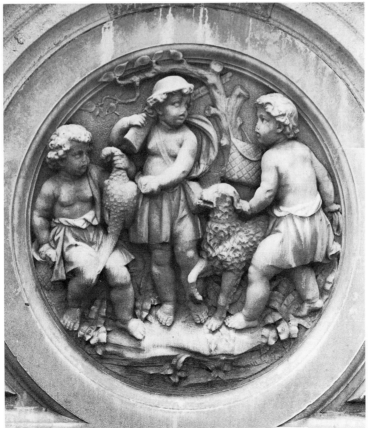

293. John Thomas, Pediment group, 1849. London, Euston Station.

294. John Thomas, *Autumn*. London, Kensington Gardens.

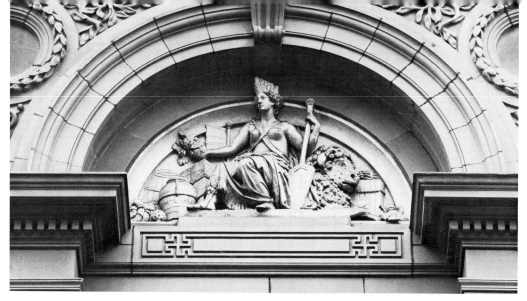

295. John Thomas, *America*, c. 1853–6. Manchester, Free Trade Hall.

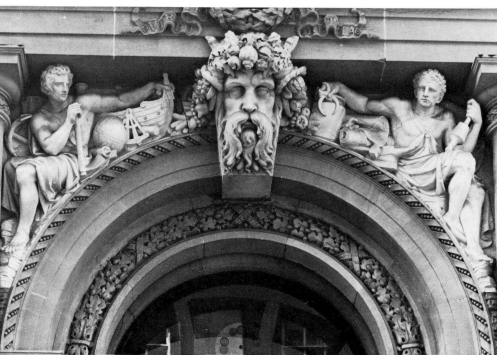

296. John Thomas, detail of sculpture on (former) West of England and South Wales District Bank, Corn Street, Bristol, c. 1854–8.

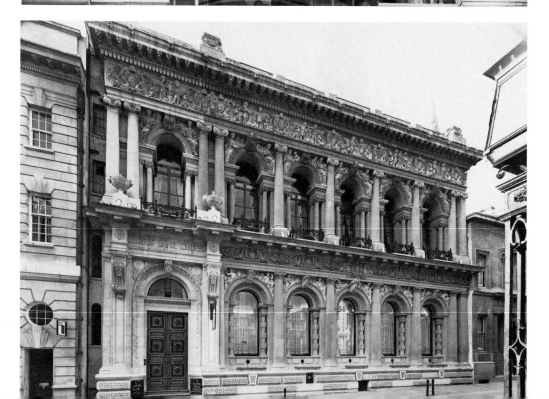

297. Bristol, (former) West of England and South Wales District Bank, Corn Street, 1854–8.

grouping, such as *Commerce* and *Plenty* for the National Bank, Queen Street, Glasgow, a building originally of 1847 by John Gibson and Macdougal, which was later dismantled and reerected in 1902–3 as Langside Public Hall, off Pollokshaws Road in Glasgow, still with its sculpture.[26] On a more substantial scale is the work he executed for the former West of England and South Wales District Bank (now Lloyds) in Corn Street, Bristol (plate 297). This was built to the designs of W. B. Gingell and T. R. Lysaght between 1854 and 1858 'in a glorious Venetian Cinquecento' (Pevsner). The building is encrusted with decorative sculpture by Thomas (plate 296): two stories of large, round-headed windows with spandrel figures, with above a frieze 'bulging with putti in various pursuits, and coats of arms'.[27] The overall message of the figures is quite standard: spandrel ladies with a cornucopia and a sheaf of corn represent Agriculture, two putti exchanging a bag of money and a tied-up box (perhaps containing beads) for an elephant's tusk: these would represent Commerce and Trade and so on. For all the stereotyped imagery, it must be admitted that this is a highly successful exercise in covering a building with integrated sculptural ornament.

For that great symbol of nineteenth-century commercial enterprise, Manchester's Free Trade Hall, designed by Edward Walters and built between 1853 and 1856, Thomas executed a series of sculpted tympana above the windows of the *piano nobile*:[28] these represent the Continents with which Trade was involved (Asia, Australia, America (plate 295), Europe and Africa) and the principal components of a Free Market (Trade, Industry, Commerce and the Arts/Learning). Each tympanum consists of a seated lady surrounded by appropriate accoutrements—America for instance, wearing an Indian-style feathered headdress, has on either side a bison or buffalo, a jar labelled 'Molasses', a bale labelled 'Cotton'; Industry holds a spindle with yarn on it; on either side are a steam-locomotive, an anvil, a boiler, a press etc. Thomas's classico-Renaissance manner could extend to overall schemes—he had after all some practice as an architect—and among these mention can be made of his Dairy at the Royal Home Farm, Frogmore, in Windsor Great Park, an exercise in sculpture and ceramic totality;[29] there are also the Water Gardens for which he was responsible at the head of the Serpentine in London's Hyde Park, with Italianate loggia, sculpted urns and fountain figures, with four roundels set in the wall portraying the Four Seasons: in these putti skate and sledge (Winter), sing and play among the blossoms and lambs (Spring), boat and swim (Summer), and hunt and shoot (Autumn) (plate 294); the latter bears Thomas's signature.

Gothic: secular

But Thomas's origins as a sculptor were Gothic.[30] Brought up in one of the cradles of English Perpendicular architecture (between Gloucester and Bristol), his first employment locally, as an apprentice mason sculptor, was on the restoration of lettering and sometimes of sculptural detail on gravestones in this area, which would have given him invaluable experience of original Gothic. A visit to Oxford focussed his attention more specifically on drawing architectural details correctly and developing skill and knowledge as a carver. For a time he lived in the Cheltenham/Birmingham area where his brother William was working as an architect and it is possible that John Thomas may have executed what little carved ornament there is at the neo-Gothic church of St Matthew, Duddeston, Birmingham of 1839–40, which his brother designed.[31] He certainly obtained employment on many large buildings going up in the Midland Counties at the time (due, we are told, to his success at skilful and knowledgeable architectural carving) and among these buildings was Barry's King Edward VI Grammar School at Birmingham. One account states:

He was employed here carving some ornamental bosses from wax models when,

being delayed by the want of an original to work from, he designed one himself. This was shown to the architect, who saw at once that the designer was a man of very superior abilities. Having had a conversation with him and inspected some drawings he had made, the architect was so satisfied of his capabilities that he at once entered into an engagement with him to superintend the whole of the ornamental decorations at the New Houses of Parliament.[32]

The Grammar School was finished in 1837 and Barry won the Houses of Parliament competition in 1836, so his engagement of Thomas was fairly prompt; and before building actually began in London, Barry sent Thomas on a tour through Belgium where he made numberless sketches of architectural details of all kinds. Although Thomas's appointment as Superintendent of stone-carving at Westminster was not made official until 1846, the Office of Woods had approved Barry's arrangement with him in May 1841. In consequence of his great talent and ability in executing the sculptural effigies and other decorations confided to his directions, his salary was increased from £200 per annum to £300 in 1846, and £400 in 1847–50.[33]

The programme of architectural sculpture at the Houses of Parliament was both extensive and elaborate. Series of figures of monarchs of the kingdom from the Saxon Heptarchy onwards, the patronal saints of the United Kingdoms and London's two principal churches, plus Queen Victoria's uncles and aunts, are variously disposed over the North, South and West Fronts of the building as well as inside in St Stephen's Hall (plate 298) and the Central Lobby. Along the River (East) Front runs a series of royal coats of arms with conventional supporters; where these had not been used authentically before the time of Richard the Second, the shields are held by human figures relating to important contemporary events. In addition to these main features, all over the building, outside and in, there are carved sceptres, labels, badges, shields, inscriptions, bosses both historiated and vegetal, angels, lions, griffins, elaborate ornamental crockets and so on.

Obviously the execution and installation of such work would be of necessity tied in with the erection of the basic structure of the building, rather than being part of the interior fitting out later on. And though precise dates for the various parts of the sculptural programme are hard to come by, we learn from Barry's progress reports on the building submitted to the Office of Works that, for instance, in March 1842 and April 1843 large quantities of masonry *and carving* were by then prepared for setting along the North, South and River Fronts. This would explain the approval by the Office of Woods of Barry's arrangement with Thomas in May 1841. By February 1843 Barry had made his own arrangements with Thomas for external architectonic sculpture; at the Royal Academy of the same year (1843) Thomas exhibited a *View of the Workshops at the New Houses of Parliament*; and *The Book of Art* of 1846 contains an illustration of *The Statuary Room, New Houses of Parliament, in January 1844*, in which the figures may be identified as belonging to the series of Saxon kings on the North and South Fronts. In other parts of the building, the carving of the stone groin in the Royal Porch in the Victoria Tower was completed by 30 June 1847; the bosses in the vault of the Central Hall were being carved at Christmas 1847 (the *Illustrated London News* for 18 March 1848 shows men actually at work on them); by November 1852 bosses, niches and canopies were all there, but no figures; by September 1853 most of the statues had arrived and the remainder were nearly completed.

The procedure for the design and execution of some of the stone carving is described by Thomas Garland in Alfred Barry's *The Architect of the New Palace at Westminster* of 1868. Garland was an Architectural Modeller, who was ten years with John Thomas, for seven of which he was more or less constantly employed for the Houses of Parliament:

> . . . my work was principally to prepare the full-size models for the carvers to work from. The method generally adopted in carrying out the heraldic models for the

298. John Thomas, *Queen Eleanor*. London, Houses of Parliament.

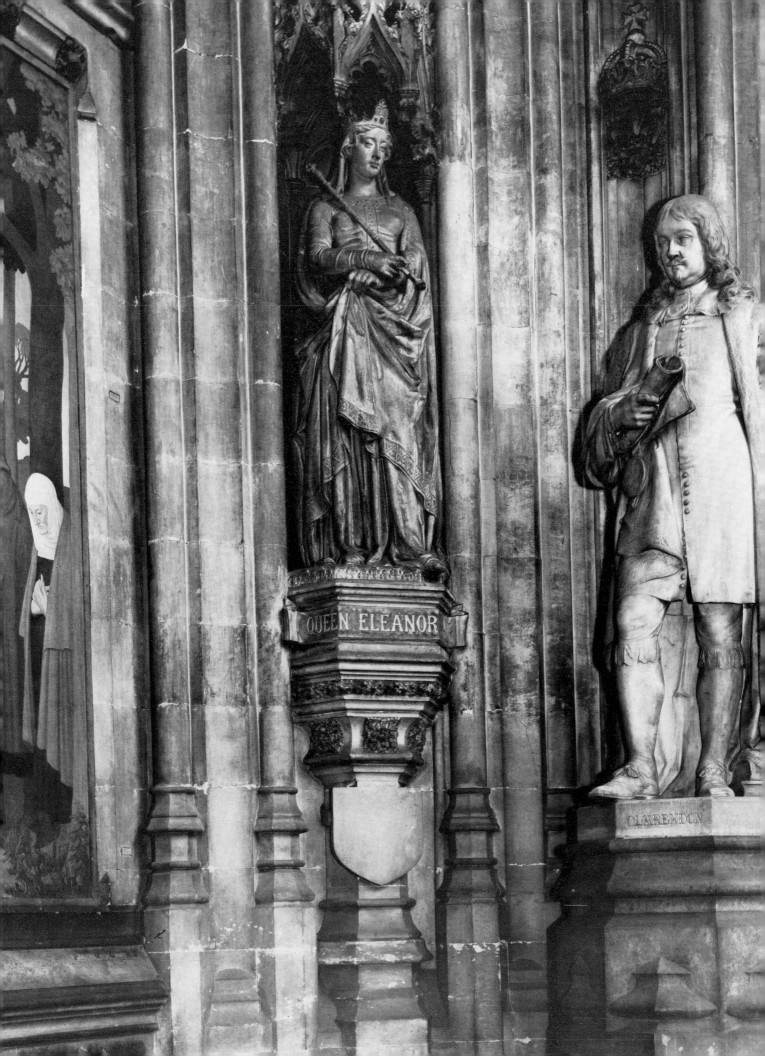

QUEEN ELEANOR

CLARENDON

exterior of the river front and parts of Victoria Tower and other portions of the building of the New Houses of Parliament (many of which I modelled under the late Mr. Thomas), was this: there was generally a small drawing made in Mr. Barry's office showing the general design, which was enlarged by Mr. Thomas and others, and the models were then made in the shops full size, Mr. Barry invariably giving his personal attention to them before they were carved; and I . . . certainly never received any instructions from anyone except from Mr. Barry and Mr. Thomas, the foreman never allowing anything to be cast for the carver until he had given his final approval.[34]

The foreman of the modelling was James Mabey, who testified that he was engaged by Thomas in the year 1842[35] and there are many other printed testimonies to Thomas's overall responsibility for this area, one indeed claiming that Thomas designed all the figure sculpture (as well as personally executing much of it).[36] Certainly a number of drawings survive for figures, bosses and coats of arms firmly attributed to Thomas; and in the working drawings at various scales which indicate the positioning of representational sculpture in the architectural scheme the formal detail of the sculpture is either sketchy or absent. It would seem therefore (as Garland indicates) that this area was left to Thomas and his department who would evolve the designs from small-scale (but complete) drawings through the final full-scale plaster models (some of which survived at the Crystal Palace at Sydenham until 1936), to the finished stonework. A similar procedure may have been followed with the non-narrative ornamental carving; for here again in the smaller-scale elevation drawings details such as cusping and crocketing are rather sketchy, though the overall composition is indicated. As the scale of the drawings increases to the full-size working drawings, the cusping and tracery becomes precisely delineated, while the indication of the crocketing remains fluid. This would seem to fit in with the division of labour, the former being the responsibility of the masons, the latter of the carvers. For the precise form of their work in crocketing, the latter would probably depend on models, as with statuary; mention is made of these, and there may have been casts of genuine medieval examples available similar to those collected by Pugin for the work (e.g. wood carving) under his supervision. Certainly in the field of stone ornamental carving the workmen could depend on Thomas for guidance (if not for the precise forms used) since it was for original excellence in this type of work that, as we have seen, he first came to Barry's attention.*

In the context of Victorian architectural sculpture, the Houses of Parliament can be regarded as a prime exemplar for a succession of public buildings in Britain where the Gothic style, adopted for sound historic, associational values, was reinforced by architectural sculpture. While few of these buildings could quite match the New Palace of

*One should also note in this respect the non-involvement of Pugin in this department. Garland is specific about this in his evidence about his work—'I conscientiously state that I never to my knowledge ever saw Mr. Pugin'.[37] All the other evidence indicates the separate functioning and identity of the stone carving workings: in addition to the attributions cited above, Thomas's position was parallel to and equivalent to Pugin's in their respective Superintendencies; Pugin was quite clearly re-engaged by Barry in 1844 to work on the interior fittings which were then and only then urgently required, and it was precisely in the period of Pugin's absence from assisting Barry—that is, up to 1844—that the stone carving got substantially under way, as the earliest dates cited above demonstrate.

Indeed to predicate Pugin's participation—somehow—in the design of the stone carving at the Houses of Parliament requires not just a disregard for such basic historical data as dates and attributions, but also the phenomenon of substantial perjury on the part of a wide cross-section of others actually involved in the building (for all that they do appear in an essentially combative pamphlet such as Bishop Barry's Apology); also requisite, in the extreme, is an entire dependence for this design on Pugin's strictly partial share in the Competition and Specification Drawings, over and above any major modifications and developments (Barry's continual effective contribution to the designing processes is frequently attested) that may have come about through such practically relevant exercises as working drawings, models and so on.

Westminster for the extent of its integral, essential sculpture—few had quite the same resources or such a determined architect behind them—they certainly maintained a similar character in the type of work and workman employed. Because the character of Gothic (even when Revived) required the craftsman rather than the artist, prepared to subserve himself to and be assimilated into the style, this was on the whole the type of work and sculptor that came to be used, although Thomas at the Houses of Parliament transcended this background and developed in a way a dual personality as a sculptor, but he was fairly exceptional.

It is with Thomas that we are next concerned, in the case of a Gothic public building being erected at the same time as the Houses of Parliament. The Guildhall at Bristol by R. S. Pope, of 1843–6,[38] was built in Gothic style no doubt to reflect the City's historic status during the Middle Ages as one of the most important and prosperous cities of England. On the building's Broad Street facade, in addition to conventional coats of arms and floreate wall bosses, there are six statues set in Gothic niches of figures prominent in Bristol's history. These feature Edward III, who granted the city county status in 1373, Alderman Whitson, Member of Parliament for Bristol and Lord Mayor about 1600 (plate 299), Edward Colston, a prominent merchant who founded Almshouses in 1691, the Right Honourable John Dunning, Recorder of Bristol and Member of Parliament, Sir Michael Foster (another Recorder), and ending with Queen Victoria. For the execution of these, Bristol turned to John Thomas, a prominent architectural sculptor who was also a local-lad-made-good (the Colston is signed, and drawings for the figures exist in the RIBA Drawings Collection). Certainly the style of all these, if in any way distinctive, corresponds to the anodyne historical correctness of Thomas's contemporary Westminster work, and it could be said that they are suitable for a Gothic building only really through the cusping of the canopies beneath which they stand—except for Edward III, who was Gothic anyway.

The University Museum at Oxford[39] (1855–68) by Deane and Woodward is emphatically Gothic, with the influence of Ruskin and *The Stones of Venice* (1851–3) somewhere behind it. There is a considerable display of sculpture about the building—a series of statues of famous scientists (in keeping with the museum's scientific orientation) set against the ground floor arcade, carved capitals (plate 300) on the ground and first floor arcades and in the entrance hall, and carving about the main entrance and some of the windows of the West Front. There is perhaps a certain distinction to be observed in the Museum between the statuary and the rest of the sculpture; for though in form and function the statues fit in to an architectural context, they are very much by fine artists such as Henry Weekes (*Harvey*), Joseph Durham (*Euclid* (plate 301) and *Stephenson*) and Edward Bowring Stephens (*Priestley*). On the other hand, a significant number (six (plate 303): *Hippocrates*, *Galileo*, *Leibniz*, *Watt*, (plate 302) *Davy* and *Newton*) are by Alexander Munro, another (*Francis Bacon*) (plate 143) is by Thomas Woolner, yet another (*Linnaeus*) (plate 228) by John Tupper, and these three were all Pre-Raphaelites to a greater or lesser extent (see pp. 179–86) for a discussion on Pre-Raphaelite sculptors); and one must remember in the context of these the strong emphasis expressed by William Michael Rossetti in his essay on sculpture of 1861 (more or less contemporary with these Oxford statues) specifically on the essential and natural position (as he saw it) of sculpture in architecture (see pp. 18, 180). Woolner was also involved in the more ornamental sculpture, executing the work surrounding the main entrance of the building from designs by James Hungerford Pollen; this depicts Adam and Eve, plus an angel holding a nucleating cell. The remaining work of this type on the west side of the building was done by the O'Shea brothers. The capitals of the inside arcades are strictly realistic representations of various types of plant and tree foliage, often with birds and animals incorporated; these were based on actual specimens provided by the University's Botanic Gardens and represent that same demonstration of scientific

299. John Thomas, *Alderman Whitson*, c. 1843–6. Bristol, Guildhall.

300. Oxford, University Museum, capital.

235

301 (above left). Joseph Durham, *Euclid*, 1867. Oxford, University Museum.

302 (above right). Alexander Munro, *Watt*, c. 1863. Oxford, University Museum.

303. View of the studio of Alexander Munro, showing statues for the Oxford Museum.

instruction as the polished stone columns of the arcades, which are each made from a different British rock. There are further animal-cum-vegetable capitals in the entrance hall, while on the outside of the building the O'Sheas executed some carving around the windows of the West Front; unfortunately the too lively rendering of monkeys and cats led to dismissal; a parting gift of Members of Convocation carved as parrots and owls over the main entrance was hastily excised.

The nature of the work done by the O'Sheas at the Oxford Museum is clearly rather more than straightforward natural ornamentation, and while certainly some credit for this must be assigned to their natural talents,[40] credit too must be given to the architects for whom they worked. Deane and Woodward had employed them previously for the Museum Building at Trinity College, Dublin (1853), where their work has been described as 'in a very free and yet boldly naturalistic vein',[41] and they were to be employed again in Dublin at the Kildare Street Club of 1861 where their work includes bases decorated with monkeys playing billiards (plate 304)—sometimes taken as a comment on Darwin's *Origin of Species* (published 1859),[42] though it might also conceivably be a reflexion on the members of the club. That Deane and Woodward, for their part, had a special predisposition towards sculpture as part of their buildings, which would have been the principal reason why the O'Sheas were thus able so freely to express themselves, can be seen from a published detail of their unexecuted project for the Government Offices in London, which shows their intention to have covered much of the exterior with historical reliefs in an archaic style, confirming their adherence to an ideal of integrating architecture and sculpture.[43]

The combined forces of Woolner and the O'Sheas were to be found again in architectural sculpture in the Assize Courts at Manchester of 1859–64 (plate 305). Though Alfred Waterhouse's unimpeachably neo-Gothic public building has gone, some of the sculpture that adorned it survives: forty-four carved head stops, representing kings and queens of England together with Oliver Cromwell, two large carved capitals, each bearing four scenes of medieval punishment such as 'Torture by Pouring Water down ye

304. The O'Shea brothers, detail of sculpture, *c*. 1861. Dublin, Kildare Street Club.

throat', 'Ye Pillory' (plate 306) (the gentleman in the latter labelled additionally 'Knave'), and eight standing figures of kings (plate 307) and lawgivers (four of which remain in packing cases in a tunnel). The statues were by Woolner: having received the commission in 1861, between 1863 and 1867 he modelled eleven statues of Alfred, Henry II, Edward I, Randolph de Granville, Judge Gascoigne, Sir Edward Coke, Sir Thomas More, Sir Matthew Hale, Mercy, Justice and Moses;[44] these were evidently executed by one Imhof, a Pole by birth.[45] Woolner was also responsible ultimately for a relief five feet in diameter of the Judgement of Solomon, with figures of 'Good Woman' and 'Drunken Woman' on either side; writing about these in 1863, Waterhouse commented: 'The Solomon Women have come to hand. We are all delighted with your virtuous woman, and disgusted as we ought to be with the awful example.'[46] These, with two other reliefs of Historical subjects by Woolner, do not seem to have survived.

The more decorative carving, described as 'rich', with bold treatment outside and even more elaborate carving inside, was by the O'Sheas,[47] and one must presumably include within this part of the programme the Punishment Capitals, with their immense and entertaining vitality. The standing figures may seem by contrast rather over-heavy and crude, at the scale that they are; but one should remember that they were designed to be seen some way up on the building, at a point where this almost exaggeratedly simplified handling could be quite acceptable and effective. Woolner may not have been over-enthusiastic about the work, not expecting it to pay well, but he admitted: '. . . it is considered a most important commission on account of the interest attached to the building and the fame which I shall be supposed to get from the execution of the works'.[48] Furthermore, such work had reputable Pre-Raphaelite qualities attributable to it, and the stern expression on the face of one of the kings could be said to parallel that slightly exaggerated facial expressiveness to be found in some Pre-Raphaelite paintings.

As a footnote to the Woolner/O'Shea combination, one might note in passing that one of the O'Sheas carved the corbels in Woolner's studio (plate 52), behind no. 29 Welbeck Street. In a letter to Palgrave, dated 31 December 1861 during the construction of the studios, Woolner wrote:

> O'Shea is doing his work like a man, and the corbels are bursting forth into violets, roses, thistles, ivies, geraniums & other things lovelier than their names. He does not complain of the stone having been cut away, he says it does very well for his purpose: . . . so fast is his progress that unless your brother come early O'Shea will have done and fled, for such rapidity of workmanship I never saw, he does 3 corbels a day! I thought he would take a day each . . .[49]

Although, as we have seen earlier, the style of town halls could be basically classical, with historical associations with Greek democracy and so on, around the middle of the nineteenth century others went up which were unequivocally Gothic; after all, there were equally justifiable historical prototypes in the town halls of the burghers of medieval Flanders and Germany. One nineteenth-century example in England was that of Northampton, of 1861–4, by E. W. Godwin.[50] At the time, Godwin was full of Ruskinian enthusiasm and for that reason included sculpture in his designs. He had slight problems with this—when submitting his working drawings, one of the town councillors, himself an architect, requested that all the details of the carving and statuary be drawn to full scale; 'the critical councillor was evidently anxious to impress his fellow members by his knowledge at the expense of an anxious young man'.

This Godwin agreed to do. He had his own sculptor, for whom he was going to have to make such full-scale drawings, in any case, though in the event the committee and the obstreperous councillor settled for the drawing-up to be done for just a single figure. That there was a particular sculptor with whom the architect worked was extremely

305. Alfred Waterhouse, drawing of the Assize Courts, Great Ducie Street, Manchester. Collection of Courts of Justice, Crown Square, Manchester.

306 (below left). The O'Shea brothers, *Ye Pillory*, *c.* 1859–64. From the former Assize Courts, Manchester.

307 (below). Thomas Woolner, *King Edward I*, 1863–7. From the former Assize Courts, Manchester.

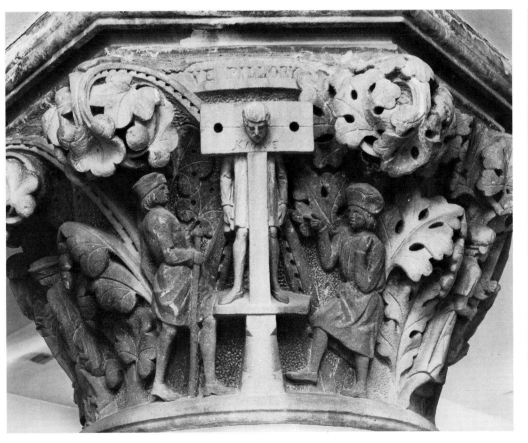

significant, both from the point of view of the nature of architectural sculpture and of the relationship between architect and sculptor. When an alderman objected to Godwin nominating his own man to do the work rather than a local man, Godwin expressed himself most strongly: he would not give up his carving man, he had educated him, he had worked for Godwin in the West of England, he knew what Godwin required and could be relied on to interpret his drawings. The carver moreover had studied Ruskin, which was an important matter with regard to Northampton Town Hall, as it was, Godwin claimed, entirely founded upon *The Stones of Venice*.

Godwin was allowed to keep his sculptor, and it is to Richard Lockwood Boulton (*c.* 1832–1905) that we can assign the execution of Godwin's designs. Along the main facade of the town hall is a series of statues of St George, St Michael, Richard Coeur de Lion (plate 308), Henry III, Edward I, Edward IV, Henry VII and Queen Victoria— King Richard, for instance, identifiable by the figure of Blondel, his minstrel friend, in the capital that supports the base on which the statue stands. In addition, outside and in, there are tympana with relief sculptures of scenes and persons connected with the history of Northampton as well as a mass of rich ornamental foliate sculpture in borders and capitals, often enlivened with scenes such as a man making boots and shoes (plate 309), the predominant local craft; all told, a most convincing demonstration of this type of work, usually described as 'Ruskinian'.

Compared to either his own earlier Assize Courts at Manchester or to Godwin's Northampton Town Hall, Waterhouse's Manchester Town Hall of 1868–77 appears to carry rather sparse sculptural decoration. In addition to a programme of restrained ornament (capitals etc.), the exterior facades contain some fifteen or twenty statues, starting (from the top) with an angel on the clock tower, perhaps symbolising that Divine Providence which according to the beliefs of the time must surely underlie all earthly prosperity—the Town Hall certainly was for the men of Manchester a symbol of all they had achieved in terms of commercial and political prowess during the nineteenth century. Further down come statues of St George, patron saint of England, and a Roman soldier: the latter commemorates Manchester's Roman foundation and represents the earliest of the historic figures important in Manchester's development that are commemorated here. These include royalty such as Henry III, Edward III, Henry, first Duke of Lancaster (who died in 1362) (plate 310), and Queen Elizabeth. Then there are more local worthies from medieval to Civil War times: Roger de Gresley, Thomas de la Warre (Rector of Manchester in 1421 when a licence was granted to refound the parish church as a collegiate establishment), Chetham (plate 310) and others—in essence little different from the programme of the Bristol Guildhall thirty years earlier. In addition there were two relief roundels representing Weaving (plate 311) and Spinning, Old Style, that is, important industries of the Manchester area. The relief of Spinning was removed from the outside wall presumably at the time the Town Hall was connected up by a bridge across Lloyd Street to its extension, and is now in the Sculpture Hall inside the main building.

The entire programme of historiated sculpture on Manchester Town Hall was provided by Messrs Farmer and Brindley. They were a London firm who specialised in providing architectural sculpture under contract to varying degrees and as such represent a significant phenomenon in the development of architectural sculpture during the nineteenth century. For all that they were a firm, the quality of their work could be extremely high, as we see here. Within the firm William Brindley would appear to have been executant under the direction of William Farmer, who also handled the contracts, but this is not always specified: they always feature as a team together.[51]

They were certainly used again by Waterhouse for the decoration of another of his major public buildings in medieval style, the Natural History Museum in London of 1873–81.[52] Here again the decorative function of the sculpture is very much reduced to

308. Richard Lockwood
Boulton, *Richard Coeur de Lion*,
c. 1861–4. Northampton, Town
Hall.

309. Richard Lockwood
Boulton, capital, *c.* 1861–4.
Northampton, Town Hall.

310 (facing page). Farmer and
Brindley, *Humphrey Chetham* and
Henry, first Duke of Lancaster,
c. 1868–77. Manchester, Town
Hall.

311. Farmer and Brindley,
Weaving, Old Style, c. 1868–77.
Manchester, Town Hall.

the level of small-scale illustrative detailing, for all that there is a lot of it, particularly
inside the building. On the outside there is a series of animals perched along the cornice
level, akin to the 'whimsical storks' on the apexes of each dormer window of Waterhouse's
earlier Royal Insurance Building, King Street, Manchester of 1861.[53] Above the main
entrance to the Museum there is a frieze of foliage and animals, with above this five panels
of animal specimens. This is in fact the theme of the more plentiful decoration inside the
museum—the east and west wings are adorned with relief plaques of extinct and living
species respectively, corresponding to the original distribution of the geological and
zoological collections. Elsewhere in the Museum can be found a dodo tympanum, and
there are monkeys on the arches of the entrance hall. The examples were suggested to
Waterhouse by Sir Richard Owen, Superintendent of the natural history collections:
Waterhouse prepared very careful, precise drawings which he then submitted to Farmer
and Brindley; plaster models were made by Monsieur Dujardin of the firm for ultimate
execution of the work in terracotta.[54]

This use of a material such as terracotta for sculptural decoration is, like the
development of a firm such as Farmer and Brindley, a significant feature in the history of
architectural decoration during the nineteenth century, with ramifications that will be
examined later. Its use by Waterhouse is interesting in the context of his approach to
sculpture, as exemplified by the three buildings of his under examination. In the Assize
Courts the approach was to a certain extent conventional, along orthodox Gothic

243

Revival lines at a grand scale, both in the extent of the sculpture (both decorative and figurative) and in the type of artist or craftsman used. In Manchester Town Hall though, and even more in the Natural History Museum, we see a downgrading in the position and disposition of sculpture (whether carved or cast) as a decorative medium. This is clearly part of Waterhouse's developing architectural aesthetics and practice, whereby he articulates for his detailing the more strictly architectural components (fenestration, arcading, colonnettes, mullions etc.) so as to preclude the use of sculpture as a significant element in the decoration of the facades.[55] This is paralleled by his concern at the same time for picturesque and elaborate outlines in elevations;[56] just as his going to a firm for sculpture, to provide simply modelled and moulded wall tiles, paralleled his architectural desire for manufactured, standardised components for the detailing in the overall design.[57] To a certain extent the same principle could be said to have applied to the work on the Houses of Parliament, with which this section on architectural sculpture on Gothic public buildings began. But there, though the detailing both architectural and sculptural is to some extent mass-produced, the role of sculpture and of the sculptor who provided it is crucial, whereas by the late 1870s and 1880s, as the Waterhouse buildings show, this was no longer so. This would have been an ironic fate for the pattern set up by Barry and Thomas, had there not originated from within the later phases of this development some of the sources of the efflorescence of sculpture towards the end of the century.

GOTHIC: RELIGIOUS

Notwithstanding any inferences that may have been drawn from the previous section concerning the role of architectural sculpture in Gothic public buildings, it was nevertheless in the field of church building, in the full vigour of the Gothic Revival, that the prime scope for Gothic architectural sculpture was to be found. Outside and in, with new buildings and old ones revived, it was possible to adorn a church with a wide range of sculpture: statues and other figure work on facades, towers, and porches outside, on reredoses, pulpits, fonts, even label stops and bosses inside; and all this over and above the simpler foliage or abstract ornament that could also serve as sculpted decoration inside and out. There were of course also a wide range of circumstantial factors involved, which could affect the degree of sculpture present, or indeed its presence at all, and it must be admitted that in the selection of slightly random examples that follow, chosen to illustrate the variety of work involved, it is not always possible to determine which of many factors are operative.

Thus, to begin with, it is clear that the presence of sculpture in a church at all could depend on financial considerations. For instance the series of churches by James Brooks in Hackney of the 1860s[58] were intended to be monumental and impressive (to proclaim the presence of the church in the poor parishes where they were built); but also cheap, especially in relation to their size. This latter aim was achieved with the simple use of ordinary materials, particularly brick, and the effect of stark austerity thus achieved at this scale is almost entirely unrelieved by any carved decoration even at the most elementary level. At St Columba's, Kingsland Road (begun 1868) a certain provision is made for capitals of small dimension (e.g. along the aisles), but even here the majority have been left uncut, which must be part of the extreme economy of the building. Similarly, in the provision of such church furnishings as fonts, pulpits and reredoses, economy could exclude the use of examples in stone with figurework included. Both series of *Instrumenta Ecclesiastica* (i.e. 1847 and 1856), which aimed to provide for churches working drawings of those details and fittings most generally wanted, directed the selected designs to cheap and convenient forms. This resulted in specified Pulpits (series i,

312. James Sherwood Westmacott, Reredos, 1857. Newcastle-upon-Tyne, Cathedral.

313. James Sherwood Westmacott, *Alexander the Great*, 1863. London, Mansion House.

plates 38–40; series ii, plate 13) and Sedilia (series ii, plate 63) being wooden; Tombs and Head Stones (series ii, plate 57) and a Font (series i, plate 44) are of stone, but devoid of any carving, the latter being cited in particular as 'a simple and cheap design' for which we are told there is often a want. A Stone Screen (series ii, plate 9) and a Cemetery Cross (series ii, plate 58) are illustrated with rudimentary ornament, and only one Churchyard Cross (series i, plate 27) has two very small instances of figure work attached, and this in any case is quoted as an ancient example. It was not as if ornamental detailing or even figure work were precluded in principle, as a certain amount features in the illustrated examples of woodwork, metalwork and plate. It appears rather that stonework as such was to be sparing in church fittings, and that carved stonework was minimally admissible, and the inescapable inference is that this restriction was for reasons of economy.

On the other hand, this stinginess was far from being universal, and specific acts of piety and patronage could ensure individual items of church furnishing that included sculpture. Thus a font designed by J. P. Seddon for All Saints, Rotherham— 'a complex structure of octagonal plan, with richly carved ornament in a free Decorated style'—was intended as a memorial to the Reverend William Newton;[59] as part of the restoration of the church at Frampton, in Dorset, the Duchess of Somerset gave 'an exceedingly rich carved font of Caen Stone'.[60] At the Cathedral of St Nicholas, Newcastle-upon-Tyne, itself a building of the fourteenth and fifteenth centuries, there is a substantial reredos of 1857 (plate 312); this is work on a much grander scale, containing thirty-five figures of varying sizes, representing for example the Four Evangelists, saints of local interest, (St Aidan, first Bishop of Lindisfarne, holding the head of his friend St Oswald, King of Northumbria), angels, and so on, set within ornate Gothic framing and canopy work.

The figures at Newcastle are the work of James Sherwood Westmacott (1823–*c.* 1900), nephew of Sir Richard Westmacott and in many ways a main-line, fine art sculptor. He took part in the 1844 Houses of Parliament/Westminster Hall exhibition, executed two statues in the House of Lords Chamber (Geoffrey, Earl of Gloucester and Saher, Earl of Winchester) and the figure of Alexander (plate 313) for the Egyptian Hall, Mansion House, London, and featured in other typical schemes. But he seems also to have had a line in religious subjects and church sculpture: he executed a statue of *Satan Overthrown* about 1850 and one of *The Guardian Angel* in 1870, as well as a font for St Mary's Church, Stoke Newington, London in 1858, and a reredos for the church at Little Walston, Buckinghamshire in 1868.[61] Nevertheless his substantial fine art background and practice is in marked contrast to the executants of the fonts etc. previously mentioned. These and much of the widespread ornamental carving to be found in churches were by men such as Harry Hems of Exeter who executed the Seddon font for Rotherham, or Thomas Earp who carved the Frampton font. The latter was a London-based carver whose work can be found nationwide—for instance, at the church of St John the Baptist, France Lynch (by G. F. Bodley, consecrated 1857) where he carved *in situ* corbels and figurative bosses from the architect's drawings.[62] He executed the carving on the Eleanor Cross at Charing Cross, London, of 1863 (plate 314) for which the architect in charge was E. M. Barry; he sculpted the substantial reredos at Exeter Cathedral, designed by Scott as part of his restoration work there between 1870 and 1877;[63] and examples of his employment by the architect Street will be mentioned later (see p. 250). Earp's career as carver, as well as the flourishing of a contractual sculpture firm such as Farmer and Brindley (see p. 240) can only have been sustained at such a level by a substantial demand. Indeed an artist-cum-carver such as Benjamin Grassby, who started his professional life as apprentice to George Myers, Pugin's carving firm (see p. 256) in London, was able to settle in Dorset and establish a sculpting and carving business there, providing a great deal of ecclesiastical sculpture simply on a local basis.[64]

Notwithstanding the Newcastle reredos there were nonetheless still other potentially

314. Thomas Earp, carving on Eleanor Cross, 1863. London, Charing Cross.

315. Reredos, 1877. Wigan, St
James, Poolstock.

restrictive factors bearing on sculpture in churches. While the provision of ornamental
work—bosses, crockets, finials, corbels, and so on, particularly of naturalistic or abstract
character—may have flourished and laid the foundation of the career of someone like
Earp, there was possibly still in the Church of England a residual doctrinal reservation
about figure sculpture, based on the Second Commandment of the Old Testament. Thus
we read in the *Art Journal* for 1865: 'With the revival of Gothic came a fashion for stone
reredoses; which at first consisted of Gothic panelling or tabernacle work, with rows of
canopied niches. When a piece of sculpture was first introduced in the centre panel of one
of these reredoses, people were disposed to take alarm at the novelty.'[65] Certainly in the
church at Highnam, Gloucestershire (architect Henry Clutton, consecrated 1851), while
there is elaborate decorative carving on the font, pulpit, capitals and reredos, with the
latter, which is extremely ornate, sculptured figures were omitted, as it was feared people
might consider that 'going too far'.[66]

The *Art Journal* article continues: 'But that has all gone by'; and certainly one can find
other substantial examples of narrative and figurative reredoses in the middle decades of
the century. The church of St James, Poolstock, near Wigan, by E. G. Paley (1866), had a
reredos incorporated as part of the chancel decoration in 1877 (plate 315):[67] set within an

248

ornamented arcade are scenes of the Annunciation and the Epiphany on either side of a central standing figure of Christ, all these directly behind the altar. In addition, on either side of the main window above the altar are figures of the Twelve Apostles, set in niches. The sculptor is unknown.

It is possible, furthermore, that any slight doctrinal doubts could be securely quieted by thinking of any figurative sculpture as part of ritually required church furnishings rather than as idols to be venerated: the *Art Journal* article is discussing sculpture in the context of Ecclesiastical Art-Manufactures and deals entirely with Fonts and Reredoses, and certainly much Anglican church figurative sculpture of the period can be safely fitted into a 'furnishings' classification. On the other hand, a churchman as eminent as Dean Stanley could preach a sermon (on Easter Day 1871, in Westminster Abbey) on the subject of 'The Religious Aspect of Sculpture',[68] in which he advances a number of quite positive religious justifications for sculpture in churches. He virtually calls God the Great Sculptor in the Sky: sculpture is 'a type and likeness of the transforming changes wrought in our outward frame and inward character by the Great Artificer whose workmanship we are'; he quotes Canova on the analogy between the procedures of sculpture (clay—plaster—marble) and birth, death and resurrection (see above p. 66), this same glorious art thus illustrating that great truth of Life and Immortality that Easter Day (when he was giving the sermon) commemorates. (He did not mention that Canova, as an Italian, was probably a Roman Catholic.) The bright, ideal face emerging from the marble is, he claims, like to the corruptible putting on incorruption, the mortal putting on immortality; the marble figure is a pledge of the undying force of the human spirit, the human mind triumphant over matter; even on earth a victory is stolen from the grave, a sting from death; the sculpted ideal form is a reflection of the spiritual ideal body, the new form and existence that God will give.

All this had been preceded by an eloquent and reasoned defusing by Stanley of the full force of the Second Commandment, and one might legitimately question whether his overall argument would gain much adherence from all sections of the Established Church; he was regarded with some suspicion as a latitudinarian, though in this case, presumably, his tolerance would be verging on the other extreme in belief. Also one should remember that, as Stanley openly admitted, the sermon was occasioned by the erection of four statues as part of the reredos at the Abbey; by Henry Hugh Armstead, these represented Moses, David, St Peter and St Paul.

There were however still other factors to help inhibit the development of figure sculpture within the area of neo-Gothic Church architecture. Simply from an historical standpoint, the combination of previous stylistic preferences (Jacobean, Palladian, neo-classical) with stricter doctrinal and ritual observance had effectively blotted out the very thought of a continuing tradition of church sculpture—quite apart from that even earlier officially sanctioned vandalism that effectively removed from this country much of the sculptural riches of the Middle Ages. These negative circumstances lie behind George Edmund Street's deploring, even in 1855, the lack of any fair attempt made to recover the style, or work upon the principles, of the best mediaeval sculptors,[69] and the Reverend Edward L. Cutts's article on sculpture in the *Art Journal* of 1865, previously referred to, talks of the remarkable progress made in creating new schools of Gothic sculpture and painting quite specifically 'during the last few years'.[70] It is perhaps not surprising therefore that in a relatively earlier instance of figure sculpture being incorporated in a church's decoration (at All Saints, Wigan, in Lancashire, rebuilt by Sharpe and Paley, 1845–50) the very limited amount of figurework, an angel on the pulpit and two standing angels on the reredos, should be by John Thomas.[71] Much of the carving on these is Gothic ornament in which Thomas had of course extensive experience from the secular context of the Houses of Parliament; it would not have been difficult for him, in

view of his immersion in somewhat mass-produced, anodyne neo-Gothic figure sculpture, to turn a king or queen into an angel—and even these latter he had half-realised as label stops on the building at Westminster.

Interwoven with all these affective considerations (financial, doctrinal, historical) was inevitably a wider issue, that of overall aesthetic considerations in the adornment of a church, particularly with regard to alternative modes of decoration. In two examples already cited other means of decoration were employed; at All Saints, Wigan, in addition to Thomas's stone-carving, which consisted of sparing figurework and more plentiful ornament, there is stained glass, woodwork and tiles; the in-fill of the reredos on which Thomas's figures stand is of mosaic, though this is later work.[72] At Highnam, in addition to the rich ornamental carving there is extensive polychromatic painted decoration by Thomas Gambier-Parry (1859–60). And amidst all the variables that could determine not just the extent of church decoration but its very nature, there may well have been at times a definite attitude on the part of the architect as to what if any sculpture should be used.

To the detriment of sculpture one might cite the case of Butterfield. He was all for decorative effect in his churches, using constructional polychromy and applied, diverse brightly-coloured materials, but almost entirely to the exclusion of sculpture. He rarely allowed rich naturalistic ornament—his capitals and corbels are generally absolutely plain or very occasionally boldly fluted.[73] We may already have met with Butterfield's rather strict views on sculpture in the *Instrumenta Ecclesiastica* which he played a considerable part in helping to draw up: his attitude to figure work was commented on in a later number of the *Ecclesiologist*: 'Mr. Butterfield . . . with that severity which forms so conspicuous an element in his artistic character, has always been shy of the sculptured human figure.'[74] And according to the most authoritative recent account of Butterfield's work, the relief panel of the Annunciation on the exterior of All Saints, Margaret Street, and the canopied saints at Keble College, Oxford are unique examples of figure sculpture in his work. The All Saints, Margaret Street work was executed by the Myers firm.[75]

A more encouraging attitude to sculpture can be seen in the work of George Edmund Street. His approach can be seen in such churches as St James the Less, Thorndike Street, Westminster, of 1860–1 (plate 316). The overall decoration of the building is in a wide range of materials: polychome brick and tile work, ornate metalwork, stained glass—even a fresco over the chancel arch by G. F. Watts. In addition there are capitals carved with narrative scenes and stiff-leaf ornament and an elaborately carved pulpit with figures and reliefs; the capitals were carved by one Pearce, the pulpit by Thomas Earp. We have already come across Street's earlier regret (in 1855) that there seemed to be no attempt made to recover the style or principles of the best medieval sculptors, but he seems nevertheless to have built up a satisfactory relationship with Thomas Earp, whom he employed regularly, particularly in the 1860s and 1870s. While detailed drawings for the St James Thorndike Street pulpit do exist, at other times, seemingly, when working with Earp, Street would draw up a general design and discuss composition with him, and then leave him alone to fashion and arrange the figures.[76] At St James, Milnrow, Lancashire, of 1868–69, Street again employed Earp for the fine foliate capitals (plate 317).[77] The church also contains a carved pulpit with three narrative scenes of Christ Teaching, with St John the Baptist and St Paul doing likewise on either side; these are relief panels set within cusped and ornamented Gothic frames (plate 318) and though their authorship is not generally recorded, they could well be by Earp as well. In 1880, the year of consecration of his church at Kingston, Dorset, Street was employing other carvers, for at this church the execution of the elaborate capitals was by Milburn, of York: '. . . Mr. Milburn has had a long training under Mr. Street on the works at York Minster, and has certainly executed all his elaborate work here with great skill. The capitals were all

316. Interior of St James the Less, Thorndyke Street, London.

250

317. Thomas Earp, capital, *c.* 1868–9. Milnrow, St James.

executed from models in clay made by Mr. Street, and are consequently carefully suited to their position.'[78] On the other hand, at York, where he was architect in charge of the fabric from 1871 onwards, with the choir reredos he left the sculpture areas blank in his drawings,[79] this being no doubt a reflection of his confidence in the executant sculptor, George Tinworth—but then Tinworth's talents were out of the ordinary in many ways (see later pp. 311–13). The reredos (of 1879) is now in the north aisle of the presbytery.

So far we have dealt only with the circumstances, attitudes, approaches etc. of the Established Church of England and the architects it employed. With the Roman Catholic Church in nineteenth-century England there were entirely other sets of issues and preconditions at work. The demand for churches was certainly as great if not greater, for not only did the Roman Catholic Church only acquire complete legislative freedom to practise its faith (and so build churches) in the wake of the Catholic Emancipation Act of 1829, but the preponderant social background of its congregations seems to have favoured a relatively greater increase and multiplication of the faithful. But as far as sculptural decoration was concerned, the Roman Catholic Church, while it had no doctrinal reservations, had even less money to spend on so essentially dispensable an art, unless, exceptionally, a rich private patron were involved. It was by no means widely committed to Gothic as the only fitting style for church building, having a strong predisposition towards the Italianate for obvious historical and liturgical reasons arising from the Counter-Reformation, and from the mainly Roman missionary basis of the church organisation over three hundred years. This does not necessarily exclude sculpture but certainly lessens the scope for the integrated all-over-Gothic type. Indeed, following on from this, the Church's lack of any reservations about the use of images, should in principle have encouraged the place of sculpture in churches. However, this could as easily be answered by moveable cult objects such as statues of favourite saints and the Madonna, which could be made more easily and cheaply available: an important factor, in view of the Catholic Church's greater financial stringency. Notwithstanding, there were certain striking exceptions to the general conditions and attitudes that prevailed. As early as 1816–19, the church of St Mary and St John the Baptist was erected in Gothic style at Pleasington in Lancashire; it was paid for by John Francis Butler, later Butler-

318. Detail of pulpit, *c.* 1868–9. Milnrow, St James.

319. Thomas Owen, *The Resurrection*, c. 1816–19. Pleasington, St Mary and St John the Baptist.

320. Thomas Owen, *St Mary Magdalene*, c. 1816–19. Pleasington, St Mary and St John the Baptist.

321. Thomas Owen, *The Decollation of St John the Baptist*, c. 1816–29. Pleasington, St Mary and St John the Baptist.

Bowden, member of a local, old-established Catholic family, and the architect was John Palmer, of Manchester.[80] The church incorporates a substantial programme of sculpture, outside and in. On the west front of the building, in addition to a portal with carved dogtooth ornament and small figures on the archivolts, there are three statues standing on bust brackets—the central figure with the lamb possibly representing Christ the Good Shepherd—and elsewhere on the facade are figures of priests standing on pinnacles and the architect standing in a niche. Inside the church the main sculpture features are a series of roof-bosses, with relief scenes from the Life of Christ such as *The Flight into Egypt*, *The Baptism of Christ*, *The Entombment* and *The Resurrection* (plate 319); at the end of the church, on either side of the altar, two large reliefs portray the penitent St Mary Magdalene (plate 320) and the Decollation of St John the Baptist (plate 321), both principal scenes of the dedicatory saints.

The name of the sculptor of these works is known: Thomas Owen, who is possibly to be identified with the T. Owen who exhibited sculpture works at the Liverpool Academy in 1812 and 1813 (*Cupid Sleeping*, 1812, *Pan* and *Music*, 1813),[81] thus probably a local artist. It would be rash perhaps to judge too harshly the almost unbelievable crudity of the Pleasington work; it was relatively early days in the development of the Gothic Revival, and as we have seen there was virtually no background of architectural sculpture appropriate to nineteenth-century Gothic. There is in addition a possibility that at Pleasington a conscious effort was being made to be crude, to be primitive and Gothic in sculpture, in accordance with views perfectly acceptable even then of the somewhat barbaric nature of Gothic as a style of architecture.

Within a generation or so this view was under strong revision from Augustus Welby Northmore Pugin. His defence of Gothic architecture for churches included sculpture quite emphatically, which is not surprising given Pugin's Roman Catholic standpoint. In *An Apology for the Revival of Christian Architecture* of 1843, he wrote:

> Another great mistake of modern times is the supposition that Christian architecture will not afford sufficient scope for the art of sculpture. So far from this, while a Greek temple admits only of such decoration in the pediment and round the frieze, every portion of a Christian church may and should be covered with sculpture of the most varied kind. . .[82]

Pugin did not insist on a specifically Gothic style of figure sculpture; it was the principle that counted, and the form should not have any specific historical similarity.

> Surely all the improvements that are consequent on the study of anatomy and the proportions of the human figure can be engrafted on ancient excellence; and an image, in correct costume, and treated in accordance with Catholic traditions, would afford equal scope for the display of the sculptor's art as a half-naked figure in a distorted attitude, more resembling a maniac who had hastily snatched a blanket for a covering than a canonized saint.[83]

In practice, Pugin was unfortunately subject to circumstances that denied him full scope for sculpture in his architecture, as well as for the architecture itself, and the particular indigence of the main religious community he wished to provide for was only occasionally overcome sufficiently for us to observe the manner in which he would have treated sculpture in his buildings. At St Mary's College, Oscott, near Birmingham,[84] where he worked from 1837 onwards, Pugin was responsible for the decoration of the Chapel; here as part of an overall scheme involving several of the arts Pugin designed a wooden reredos to incorporate works of art of earlier periods—Flemish fifteenth-century retables, free-standing figures and sixteenth-century Limoges enamels. Similarly at St Chad's Cathedral, Birmingham (1839–41) Pugin had executed similar ornamental carving in wood, setting work that incorporated earlier sculpture as required—a

322. Boss-head and capital, *c.* 1867–8. Barton-upon-Irwell, the City of St Mary the Immaculate.

fifteenth-century German statue of the Virgin Mary, other fifteenth-century German carvings on the Bishop's throne and the chancel stalls, and other works, original 'real things' (Pugin's description) bought and presented to the cathedral by the Earl of Shrewsbury as part of an intentionally rich interior fitting out. On the exterior where, funds being inadequate, it was considered more suitable to the dignity of religion to curtail external ornament (and concentrate resources on the interior decoration) there is nonetheless a limited amount of figure and ornamental carving in stone: the Virgin under a canopy between censing angels in the tympanum of the west portal, with six further figures of saints in canopied niches along the west front.

In his description of the building Pugin claimed: 'the caps, corbels, foliage and other details have been faithfully reproduced from original authorities, and may be considered as the most successful revivals of ancient ornaments that have yet been achieved',[85] and it is this type of non-narrative, decorative stone carving, designed by Pugin, that is found most frequently in his buildings: it was a relatively elementary and less costly way of creating a correct Gothic spirit for a building than statuary. At St Giles, Cheadle, in addition to decorative carving there is some figure work, due no doubt to the greater financial resources available; here we know who actually executed Pugin's designs, for, as Mrs Stanton tells us:

> George Myers . . . was called in . . . for the carving of the most intricate stonework, such as the figures of St. Peter and St. Paul on the west front, the sculptures of the spire, and the complex finials of the Easter Sepulchre . . . A sculptor named Roddis, working at the site, surrounded by casts of medieval carving supplied by Pugin, did the interior details such as the capitals of the nave.[86]

A final example of Pugin's handling of sculpture is the tomb of Lord Rolle, in the Rolle Chantry, Bicton, Devon, a splendid example of ornate decorative tracery and ornament, with figures of angels and a coat of arms with its animal supporters; dating from 1850, this was again executed by Myers (though whether by Myers himself or by sculptors from his works[87] is not clear).

Pugin's attitude to and application of sculpture to a church building, when circumstances permitted, was clearly carried on by at least one of his sons. The Church of the City of Mary Immaculate (1867–8), better known as All Saints, at Barton-upon-Irwell, near Manchester, paid for by a rich and prominent Roman Catholic family—the de Traffords—has been described as the masterwork of its architect, E. W. Pugin.[88] The interior is richly endowed with sculpture: the nave capitals are sumptuously carved with naturalistic foliage (plate 322); the label stops of the arcade are carved with heads of a king, a cardinal, and other (presumably) saints; still further up the wooden roof springs from projecting angels. In the chancel, the clerestory arcade springs from more projecting angels, above the richly sculpted high altar: below, in roundels, is represented the Annunciation; above, in reredos position, are two scenes on each side of the tabernacle— the Nativity, the Epiphany, the Carrying of the Cross and the Crucifixion; along the top of the ornate sculpted screen stand figures of angels, and a small representation of the pelican feeding her young. The north chapel of the church, like the chancel, is rib-vaulted in stone and has sculpted foliage capitals and historiated bosses; it has in addition a substantial sculpted altar-cum-reredos (plate 323). Beneath the altar lies the body of Christ, as if in the sepulchre; behind it is the Virgin with Child surrounded by angels and adoring shepherds and kings, in three main sections, the ensemble topped up by an elaborate fretwork of Gothic canopies, encrusted with ornamental detail. The name of the sculptor is, as yet, unknown. But it does show what could be achieved by a union of adequate financial resources and uninhibited faith to back up the architect and the sculptor.

323. Altarpiece, *c.* 1867–8. Barton-upon-Irwell, Church of the City of St Mary the Immaculate.

Parallel to church building in the nineteenth century there was an equally extensive campaign of church restoration with, equally, intermittent opportunity for work in sculpture. We have already seen examples of newly sculpted fonts (e.g. Frampton, Dorset) and reredoses (Newcastle Cathedral, p. 246, Westminster Abbey, p. 249) taking their places in the refurbishing of extant buildings, and the same could happen with statues. Thus when P. C. Hardwick restored the tower of the church of St Martin in the Bullring, Birmingham (1853–5; he restored only the tower as money was short but made provision for the rest of the building with drawings), two statues of saints were included as part of the work, and a further number of niches on the tower would suggest others were envisaged; these remained empty, presumably for the same reasons of financial restraint that restricted Hardwick's overall plans. The statues that were set up are by John Thomas,[89] by now familiar as provider of architectural sculpture for Hardwick (see earlier p. 228).

Where finance allowed and status demanded, sculpture of various sorts could play a prominent role in church restoration, and a notable instance can be found at Llandaff Cathedral.[90] Here the architects in charge were John Prichard and John Pollard Seddon and the latter, whose painter brother Thomas was a fairly close associate of some of the Pre-Raphaelites, seems to have been in charge mainly of the decorative side of the restoration work. The programme of this was substantial; as well as sculpture, it included stained glass and painting and for such work Seddon turned to his brother's friends and acquaintances—indeed his principal aim was to get something from Dante Gabriel Rossetti, of whom he wrote: 'I looked upon him as the most promising of the fraternity to develop a high class of Ecclesiastical decorative art.' The first Pre-Raphaelite work that Seddon set in motion for Llandaff was the pulpit: into his own design for this he incorporated four relief panels by Thomas Woolner, whose subjects were *Moses with the stone tablets of the Law, veiling his face on the Mount, David Harping, St John the Baptist in a camel's hair robe,* and *St Paul.* Woolner exhibited two of the original models for these (*Moses* and *St John the Baptist*) at the 1858 Royal Academy; he then sent them down to Llandaff where they were executed in stone by Edward Clarke, a professional carver working there in this capacity. The models have disappeared and the pulpit itself was indirectly a casualty of wartime bombing (see above p. 39), so that only the *Moses* (plate 324) survives.

There was a considerable amount of sculpture at Llandaff in addition to the pulpit, though mostly of the type executed by carvers from the architects' designs. A design by Seddon for the font is in the RIBA Drawings Collection; this had carved scenes showing the story of the Flood and a boldly moulded base bearing a representation of the miraculous draught of fishes; dating from 1863, it was destroyed during the Second World War.[91] There was ornamental carving—finials and crocketing—on the reredos and sedilia, with some figurative scenes as well. The centre tympanum of the reredos (of which the main feature was Dante Gabriel Rossetti's *Seed of David* painted triptych) contained a representation of the Lamb and Flag, the Lamb treading the wine press; then there were figures of the Evangelists in the tympana of the sedilia and angels in the spandrels. Nearly all of this work was designed by Prichard and Seddon, and executed by Edward Clarke, under the architects' supervision. But one panel of the sedilia (plate 325), representing the Pelican feeding her young, was designed by Dante Gabriel Rossetti, who went off specially to London Zoo to make preparatory sketches from the live model.[92] The Rossetti panel survived the war, with one other panel, and is now incorporated in the south aisle of the Cathedral.

More sculpture work featured on the Bishop's Throne and the choir stalls. The canopies of the Throne contained statuettes of Prophets and Christian Virtues; at the sides there were panels with reliefs of Our Saviour's command 'Feed my sheep' (west side) and St Paul preaching to the Athenians (east side); and in front of the reading desk there was a

324. Thomas Woolner, *Moses*, 1858. Llandaff Cathedral.

258

large carved panel of Our Lord commanding His Apostles 'Go preach to all nations.' These were all set in an ensemble of rich carving and inlaid woods. The choir stalls, similarly rich in their total effect, had seated statuettes of Old Testament worthies in canopied niches above the prebendal stalls; along the other choir stalls, under the canopies, were statuettes of Apostles and Martyrs with their insignia with, on the first set of choir seats, statuettes of angels holding musical instruments. Much of this work was severely damaged in the war, but a fair number of statues were incorporated in the post-war Majestas structure and parts of the new Bishop's Throne. The execution of the work was principally by Milo Griffith and William Clarke, the son of Edward, though some participation in the programme must be credited to Henry Hugh Armstead.[93] Armstead also provided designs for the statues on the exterior of the south-west tower at Llandaff (drawings for these (one dated 1869) exist in the Clarke workshop at Llandaff, itself still continuing), and he was also involved much later (1889) in the design of the Bishop's pastoral staff for Llandaff.[94]

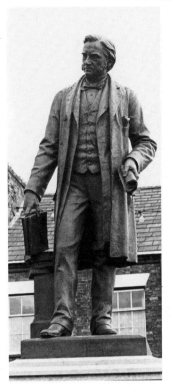

326. James Milo ap Griffith, *Hugh Owen*, unveiled 1888. Caernarvon.

A programme such as this is worth describing in some detail because it shows just how much sculpture, what types and what subjects, could be involved along with the other arts and crafts in a single decorative undertaking. But Llandaff has in addition certain implications and ramifications of particular significance. Thus the sculpture certainly features as part of a specifically Pre-Raphaelite context—we have already noted (p. 180) William Michael Rossetti's concern for sculpture and its essential position (as he saw it) in architecture both Greek and Gothic;[95] there were unmistakable 'Gothic' associations in the early years of Pre-Raphaelitism; and the work by two members of the Brotherhood, Dante Gabriel Rossetti and Woolner (however grudging the latter's participation was: 'I have just been doing a wretched little figure of "Moses" for a pulpit and have to do 3 others, most perfectly uninteresting to me,' he wrote to Lady Trevelyan)[96] is at Llandaff part of a Gothic enterprise, in the same way that Woolner's work was at Manchester and Oxford.

There are further points of interest at Llandaff concerning the types of artist or craftsman who could be involved, from Woolner at one extreme to the Clarkes at the other. Thus Milo Griffith, or more properly James Milo ap Griffith, as a direct result of his experiences and connexions with the Llandaff work, where he was employed as a craftsman–sculptor, moved on to transcend such a 'proletarian' origin to build up a career in genre sculpture, portrait busts and statues (such as *Hugh Owen* in Castle Square, Caernarvon, unveiled 1888) (plate 326). Not only that, but the principal workforce of masons and stoneworkers, when the work at Llandaff was completed, went on to form part of the workforce at Cardiff Castle during its restoration under the architect William Burges,[97] in which crucible of art and craft (to be considered shortly) the prominent late-Victorian sculptor Sir William Goscombe John received his initial training.

Finally, the association at Llandaff of Prichard and Seddon with Armstead is of note, for it was only at about this time that Armstead was turning from a considerable career in metalwork (particularly modelling for silver, such as the Packington Shield, R.A. 1860, the Outram Shield, R.A. 1862, now in the Victoria and Albert Museum, or the Chesterfield Cup for Goodwood Races of 1864) and began to devote himself more exclusively to sculpture; and it would seem that the development of his eminently successful career as both architectural and fine art sculptor was based in part on the work he executed for Prichard and Seddon. Prior to his work at Llandaff, Armstead had produced for them the series of reliefs at Ettington Park in Warwickshire, a notable instance of a Gothic domestic building with substantial figurative architectural sculpture. This series consisted of some twenty large reliefs relating the history of the Shirley family (who lived at Ettington) from the time of the family's Saxon founder up until the time of Cromwell.[98] Armstead worked on the designs between 1861 and 1863;[99] the reliefs were

325. Dante Gabriel Rossetti, *The Pelican Feeding her Young*, c. 1860. Llandaff Cathedral.

327. Henry Hugh Armstead, Monument to Mrs Craik, 1890. Tewkesbury Abbey.

328. Henry Hugh Armstead, Monument to Dean Howard (†1868). Lichfield Cathedral.

carved in stone by Edward Clarke,[100] presumably the Llandaff man, and placed above the building's ground floor windows. It is said that it was this work by Armstead that drew him to the attention of Gilbert Scott,[101] for whom he was to do much fine work (see pp. 269–72); certainly by 1863 he was at work for Scott on the Albert Memorial model.[102] In addition, by the second half of the 1860s he was working for the younger Barry at the Houses of Parliament; his series of eighteen carved wooden relief panels of Arthurian subjects in the Royal Robing Room date from 1866–70;[103] at the same time he executed the statues for E. M. Barry's New Palace Yard arcade of 1866–9.[104] (The statuettes of two of the kings involved, Alfred and William the Conqueror, shown by Armstead at the Royal Academy in 1857 and 1859 are distinct works: they were specified as for or of bronze, and the younger Barry's arcade was only designed in 1864.) At other stages in his career Armstead was to execute works throughout the conventional range of the fine art sculptor: busts, ideal works, public statues such as *Lieutenant Waghorn* at Chatham, and funerary monuments both modest, such as that to Mrs Craik at Tewkesbury Abbey, Gloucestershire (R.A. 1889) (plate 327), and more substantial, for example effigies of Dean Howard (†1868) of Lichfield (plate 328), Dean Close at Carlisle (signed and dated 1885), Bishop Ollivant of Llandaff (R.A. 1887) or the Right Honourable John Wilson Patten, Lord Winmarleigh in the church of St Elphin at Warrington, Lancashire (R.A. 1894).[105]

262

By now it should go without saying that one of the most fundamental aspects underlying the practice of architectural sculpture was the attitude of the architect; for all that the examples so far selected have been random, to illustrate the many other affective factors, the architect has often and inevitably intruded. To demonstrate this major point conclusively, as a finale to the manifold scenario of Victorian architectural sculpture, one can turn to examine the distinctive performances in this field of two exceptional architects.

The first of these architects, whose contribution to architectural sculpture was quite exceptional, was William Burges. His approach to architecture was highly individual, with a strong decorative credo in which sculpture featured, with this like all the other constituent parts of the credo under his close personal control. Burges took on the job of restoring Waltham Abbey, in Essex, about 1860, and part of the decorative adjuncts of this work (in addition to a ceiling painted by Poynter and stained glass by Burne-Jones) was a carved and coloured reredos. This was designed by Burges and the constituent sculpted groups were carved by Thomas Nicholls, the executant craftsman whom Burges was to use almost exclusively for the sculpture in or on his buildings. Parts of the Waltham Abbey reredos were exhibited (under Nicholls's name) at the International Exhibition of 1862, but final payment for the work was not made to Nicholls until 1875 when he received £599.[106]

In 1863 Burges was commissioned to redecorate the chapel at Worcester College, Oxford, an essentially late-eighteenth-century interior by James Wyatt. The scheme executed under Burges included paintings, wall decoration and stained glass; it also featured statues of the Four Evangelists in the corner niches. These were executed by Nicholls, again, but while Burges included small sketches for them in his studies, he apparently stated that while he supervised their execution, he did not design them; in certain kinds of work the sculptor should be left to himself. Similarly, with the marble lectern for the chapel, where small figures encircle the central drum, Burges produced full-size drawings which while sufficiently informative in essentials were not so detailed as to inhibit the sculptor.[107] On the other hand, turning to a case of sculpture in a domestic setting, Burges's drawings for the chimney-pieces in his own Tower House, Melbury Road, London (of 1875–81) are minutely instructive to Nicholls; further sculpture for this type of context occurs with a bronze door for Tower House, cast in 1876 from models by Nicholls.[108]

With two buildings in particular it is possible to gauge Burges's approach to sculpture on a more substantial scale. His Cathedral of St Finn Barr, at Cork, in Ireland, was begun in 1865, consecrated in 1870 and largely completed by 1876.[109] It contains a mass of sculpture both figurative and ornamental; the principal west facade (plate 329) has three portals with serried ranks of statues of saints on either side, sculpted tympana above and in the middle portal a trumeau figure of *Christ as Bridegroom*: this all in the best true Gothic tradition. There are carved symbolic representations of the Four Evangelists around the rose window on the west facade and an angel above; inside the building there are carved foliate capitals at all stages of the elevations—over a thousand sculpted details, one account states—plus carved figures in relief on the pulpit (plate 330), animal, vegetable and human carved detailing on, for instance, the turret door in the south ambulatory. For the figure work Burges made a large number of precise drawings from which Nicholls made full-size plaster models; these were then transferred to Cork where they were carved in stone by one MacLeod and his staff. Nicholls also made models in London, for the ornamental detailing, under Burges's supervision.[110]

Burges's rebuilding of the Marquess of Bute's Cardiff Castle took place between 1868

329. Cork Cathedral, detail of west front, 1865–76.

330. Pulpit, *c.* 1865–76. Cork Cathedral.

and 1881.[111] As in Burges's other buildings sculpture formed an integral part of the overall decoration. On the exterior of the Clock Tower (built 1868–74) are statues, six foot nine inches high, of the planets resting on pedestals carved with the appropriate signs of the Zodiac; inside, in the Summer Smoking Room there is a carved chimneypiece, corbels carved with representations of constellations and the four elements, plus carved foliage ornament; the Banqueting Hall has another carved chimneypiece, linked thematically with the room's fresco decoration (by H. W. Lonsdale) depicting episodes from the life of Robert The Consul, a twelfth-century Earl of Gloucester; in the Library, the five statues over the chimneypiece represent symbols of the four alphabets with which Lord Bute was familiar, namely Greek, Assyrian, Hebrew and Egyptian plus a representation of the Marquess himself. The Chapel of the Castle contains an Entombment scene, the outside walls of the Castle feature sculpted animals along the top.

An account of the design and execution of this work was given by Sir William Goscombe John,[112] the prominent late-Victorian Welsh sculptor who was involved in the Cardiff work as a young man. While, as we have seen, a number of workmen transferred to Cardiff Castle from Llandaff Cathedral when the work there was finished, these were mostly masons and ordinary stoneworkers. For the more skilled work, men were sent down from London, especially decorative painters and stone carvers.

> The Sculptor responsible for practically all the sculpture in the Castle was Thomas Nicholls, of Lambeth. . . The studio and carving shop of Nicholls was in Lambeth, where all the models for the sculpture at the Castle were made and afterwards sent down to Cardiff to be carried out in situ by skilled carvers sent down from London. Amongst these carvers were several men of talent, e.g. Nathaniel Hitch, Charles Bursill and Henry Gunthorp.

Much of the work was therefore designed in detail by Nicholls, though usually from rough drawings by Burges himself; but to Nicholls at any rate one should credit much of the figurework (on for example the fireplaces) plus the animals outside. Another man involved was Fucigna, who was responsible for the *Entombment* in the chapel. Fucigna has featured previously as the heir aspirant to Birnie Philip's studio and practice (see p. 76); he was therefore an architectural sculptor of respectable professional origin. Work by both Nicholls and Fucigna featured also at Castell Coch, near Cardiff,[113] for whose restoration Burges was again to some extent responsible, though when he died in 1881, work on the interior (where the sculpture mainly features) had hardly begun. To Nicholls one should probably assign the chimney pieces in the Drawing Room and Lady Bute's Bedroom, and the statue of St Lucius in the Great Hall. Fucigna was responsible for the statue of the Virgin at the Portal.

Though Burges's architectural sculpture is certainly individual and distinctive, it is very much the expression of his own artistry, extended into three dimensions through a fundamentally subservient executant craftsmanship. For the record of an architect who managed both to feature sculpture (both ornamental and figurative) extensively on his buildings and yet also to employ considerable individual talents as the sculptors involved, with the result that his architectural sculpture is almost certainly the most outstanding of the mid-Victorian period, one must turn to the work of Sir George Gilbert Scott.

For the more strictly ornamental carving on and in his buildings, Scott made extensive use of craftsmen like Harry Hems and the firm of Farmer and Brindley: Scott considered Brindley 'the best carver I have met with and the one who best understands my views',[114] and he executed, under Scott's very careful and anxious personal guidance, the ornamental work on the Albert Memorial.[115] The firm indeed were responsible for executing the Memorial's model,[116] the capitals etc. on Scott's Government Offices in Whitehall,[117] and the ornamental carving in the series of major ecclesiastical restorations

undertaken by Scott—for instance at Exeter,[118] Worcester,[119] and Gloucester.[120] Scott certainly controlled the work they executed, achieving this, he said, 'by influence',[121] that is, by the expression of those views which, as we have just seen, Scott considered Brindley to understand so well. This approach applied to other craftsmen as well; we are told that for the richly carved capitals in Scott's church at Trefnant in Wales (1853–5), the executant craftsman, J. Blundstone, a native of Denbigh, 'studied for some days, under Mr. Scott's direction, the specimens of French carving of the thirteenth century, collected in the Architectural Museum in London, and on his return successfully applied the same principles to his own work, arranging every group of leaves from natural specimens gathered as they were needed from the woods and hedges around';[122] how far this latter development was directed by Scott is not recorded.

Scott clearly saw figure sculpture also as at times an integral part of his architecture; this we can see from both sketches and drawings for major buildings whether executed or not.[123] Sketch projects of 1867 for the London Law Courts competition include much sculpture;[124] both Design 'B' for the War Office (1856)[125] and the 'Byzantine' design for the India Office (c. 1859–60)[126] include substantial amounts of figure sculpture on certain perspective drawings of the Parliament Street fronts. And while it might be claimed that this could be simply window dressing to impress the client, it is clear that when circumstances allowed, Scott would carry such ideas about sculpture through to the buildings as executed. Certainly the Government Offices in Whitehall, as eventually set up, are covered with sculpture (see below, pp. 269–72). Even when a design by Scott (such as that for the south elevation of the Midland Hotel at St Pancras[127]) includes statuary which is not present on the finished building, the empty niches on the building still provide for it, and suggest that the exclusion of figure sculpture could have been for other reasons, such as economy.

The quality of the artists Scott employed for figure sculpture when it was feasible would seem to confirm his serious regard for it. In John Birnie Philip, whom as we shall see Scott employed frequently on important projects, he chose a sculptor whose qualities and skill can be attested by the wide range of work he did for others besides Scott. After initial training at the Government School of Design at Somerset House, Birnie Philip went first to work at the Houses of Parliament in Pugin's Wood Carving Department;[128] he subsequently executed work such as a reredos at Tamworth Parish Church, Staffordshire (1853), and decorative sculpture at Crewe Hall, Blackfriars Bridge and the General Post Office at St Martins-le-Grand, London. In addition he was recalled (so to speak) to the Houses of Parliament to execute the statues in the Royal Gallery for E. M. Barry (plate 139), when those originally designated were found not to fit (see above, p. 121). And this was all in addition to building up a seemingly successful practice in straightforward portrait sculpture: Philip was responsible for the statues of Richard Oastler at Bradford (1866), Lord Elgin (1869) and Colonel Baird (1870) at Calcutta, the Rev. Robert Hall at Leicester (1870) and Colonel Akroyd at Halifax (1875) (plate 76). He ran, in addition, a good line in funerary monuments, such as that to Queen Katherine Parr, Sudeley, Gloucestershire.[129]

Another sculptor employed by Scott was James Redfern (1838–76), who did much work for the important series of cathedral restorations that Scott undertook—sixty statues for the west front of Salisbury (where Birnie Philip was also employed on the chapter house, as was the Belgian sculptor Theodore Phyffers (fl. 1840–72)), statues of the Apostles for Ely, reredos figures for Gloucester, the Christ in Majesty in the chapter house at Westminster Abbey, London and statuary on the North Transept portals there. In contrast to say, Birnie Philip, Redfern was initially a fine art sculptor: a *Warrior and Dead Horse* brought him first to the notice of Beresford Hope who sent him to study in Paris for six months. His first works shown at the Royal Academy were admittedly of a mainly

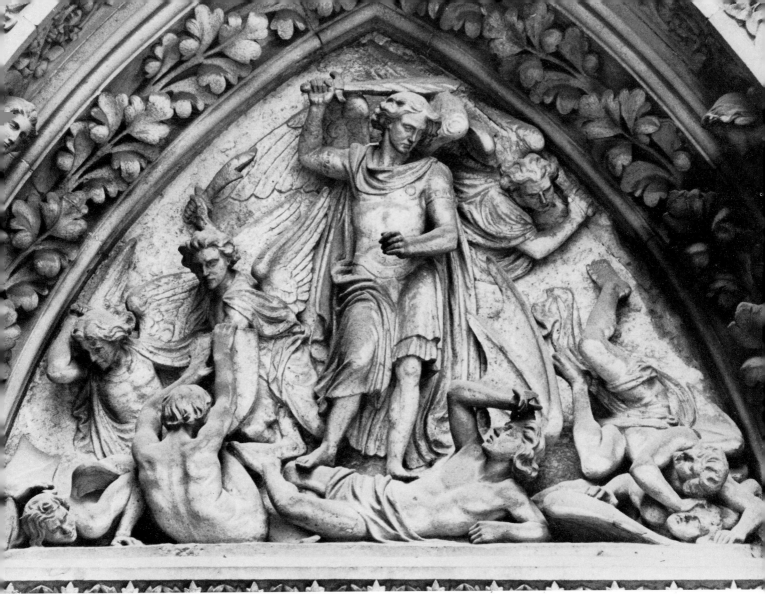

religious nature—*Cain and Abel* (1859), *The Holy Family* (1861) and *The Good Samaritan* (1863)—which may have helped him to produce works fit for sacred buildings. Notwithstanding his work for Scott, he later produced some portrait statues, such as one of the Duke of Devonshire at Cambridge.[130]

331. John Birnie Philip, Tympanum, *c.* 1856–7. London, St Michael, Cornhill.

The way Scott could employ a variety of executants to do work over a wide range can be seen in many of the buildings with which he was associated. Sometimes the work by Farmer and Brindley exceeded the purely ornamental and included the figurative, such as the reredos at Worcester, which included five statues.[131] At other times the work of Birnie Philip could be predominantly ornamental, as in St George's, Doncaster (1854–8),[132] or All Souls, Haley Hill, Halifax (1856–9).[133] At this latter, built for the Akroyd family (later also to be commemorated by a statue by him—see p. 76), Birnie Philip was assisted by his studio assistant Fucigna (see above, *ibid.*). Even when Scott's contribution to a building was limited, he could still bring in sculpture. At the church of St Michael, Cornhill, London, originally by Sir Christopher Wren, Scott added, as part of his restoration campaign of 1856–7,[134] a Gothic porch. This incorporates, as well as much carved vegetal ornament, and holy heads projecting from medallions, a fine tympanum by Birnie Philip portraying St Michael in action (plate 331).

In his work on the restoration of Lichfield Cathedral which began in 1857, Scott employed several sculpture hands. Philip worked on the reredos and choir screen (plate 332), delicate, ornate arcading enclosing statues of saints such as St Blandina; statues in

267

the choir and Lady Chapel are by Farmer and Brindley; and there are figures of angels by Redfern.[135] The statuary on the west front at Lichfield (plate 333) was organised on a different basis, with the Dean and Chapter selling off space to individual private donors, though reserving to themselves the selection of the sculptor, and the arrangement of all the details of the work, for the sake of securing general uniformity of plan; among those selected was Miss Mary Grant, related to the President of the Royal Academy Sir Francis Grant, and a pupil of Foley. In 1884 the Dean and Chapter announced the completion of 'perhaps the most beautiful and elaborate West Front to be seen in this country'.[136] While one must admit there was not much competition (apart, say, from Wells or Salisbury), the Lichfield statues do stand out in their class, particularly the series of apostles in the lowest register; immediately above there is a frieze of seated medieval kings, on either side of St Chad, the patron saint of the Cathedral. The whole programme, indeed, is as impressive in its way and for its date, as the west fronts of Chartres or Wells, and it needs to be asked whether a failure to recognise this is not simply a matter of the attitude of a beholder conditioned by historical prejudice.

The sculpture on Scott's secular structures follows a similar pattern. He was responsible for the memorial to the Scholars of Westminster School killed in the Crimean War, in Broad Sanctuary, London, dating from 1859–61. Its basic form is a polished granite column, with a group of statues at the top (plate 334): Edward the Confessor and Henry III, the builders of Westminster Abbey; Queen Elizabeth, the second founder of Westminster School; and Queen Victoria. These were executed by Birnie Philip. At the summit is a group of St George and the Dragon, executed by Philip, but designed by J. R. Clayton, of Clayton and Bell, more famous for the stained glass of which Scott, along with many other architects, made good use.[137]

Scott's Albert Memorial in London we have already considered in some detail, though it is worth bearing in mind briefly once again as an instance of the work of Scott and his sculptors. Farmer and Brindley built the model,* with the sculptural sections executed by Armstead; the model, Scott later claimed, represented best how he would have liked the sculpture.[138] For those sections of the executed structure over which he had close control, Scott chose Armstead, Philip and Redfern as sculptors; he thus used overall both distinctive artists and the more craftsman type on the one project.

For his Government Offices building in Whitehall, Scott was compelled to adopt a Renaissance-based style, but this does not seem to have affected his incorporation of sculpture.[140] Parts of the building, such as the former India Office Courtyard, were under the supervision of Sir Matthew Digby Wyatt, and to him might be assigned the responsibility for the sculptors employed there—certain rather obscure figures such as Hugues Protat (plate 337), W. Nicholls and Theodore Phyffers. Where Scott was concerned, though, he used once more the well tried and trustworthy Armstead and Philip. By them are a series of spandrel sculptures on the exterior of the building— *Education* (signed and dated 1873), *Prudence*, *Valour*, *Government* and The Continents (plate 338) by Armstead; *Law*, *Art* (plate 339), *Manufacture*, *Commerce*, *Science*, *Agriculture* (plate 340) and *Literature* by Birnie Philip. Also given to Armstead are the reliefs of *Justice*,

334. John Birnie Philip and John Richard Clayton, figures on the Memorial to the Westminster Scholars killed in the Crimean War, 1859–61. London, Broad Sanctuary.

*Farmer and Brindley at about the same time were being employed at Holborn Viaduct, in London, built in 1863–9 by William Heywood, Surveyor to the City.[139] For this they supplied statues of *Science* and *Fine Art* (plate 335) which in some way echo the statues of the Virtues and Sciences in the Albert Memorial by other members of Scott sculpture team; certainly more so than the figures opposite them on Holborn Viaduct, *Agriculture* and *Commerce*. These are by Henry Bursill (*fl.* 1855–70) who also executed the niche figures of *Sir Thomas Gresham* (plate 336), and *Sir Hugh FitzEylwin* (still there), *Sir Hugh Myddelton* and *Sir William Walworth* (gone), originally on the stair buildings at either end of the bridge; these are all much more in the classico-Renaissance tradition, as befits the structures.

332. John Birnie Philip, statues on choir screen. Lichfield Cathedral.

333. Lichfield Cathedral, detail of west front.

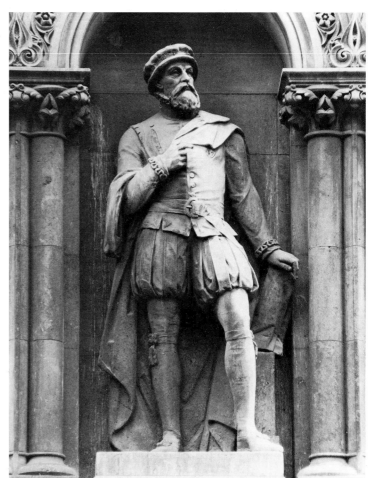

335 (above left). Farmer and
Brindley, *Fine Art*, 1867–9.
London, Holborn Viaduct.

336 (above right). Henry
Bursill, *Sir Thomas Gresham*,
1867–9. London, Holborn
Viaduct.

337. Hugues Protat, figure
sculpture, 1866. London,
Government Offices, Whitehall.

338. Henry Hugh Armstead,
Africa, 1875. London,
Government Offices, Whitehall.

339. John Birnie Philip, *Art*,
London, Government Offices,
Whitehall.

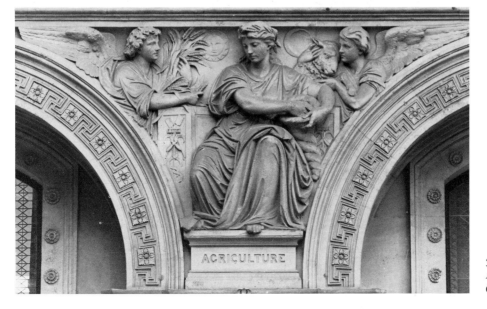

340. John Birnie Philip,
Agriculture. London,
Government Offices, Whitehall.

Fortitude, *Truth* and *Obedience* over the principal doorway, statues of the colonial secretaries, in niches on the upper storeys, plus the medallion portraits of Queen Elizabeth, Drake, Livingstone, Wilberforce, Cooke and Franklin; one source indeed claims that Armstead designed the entire sculpturesque treatment of the facade for Scott.[141] However that may be, and however one might seek to credit Philip, in his sections, with a perhaps more competent fitting of the spaces available—within the severe artistic limitations of their function—these sculptures could well serve as a final testimony to the artistic skills in which Scott had so often trusted.

Victorian architectural sculpture may not perhaps on the whole stand out for its quality. Its overall context was possibly antipathetic, with so much of the sculpture being produced considered as mere ornament; often it was actually so, but even when not, it was probably mostly considered as such. On the other hand, there were certain positive achievements within the field: some architects and sculptors formulated at times a degree of integration between the two arts (such as Scott for the architects, Thomas for the sculptors); furthermore it was in this area of activity that the barriers of class distinction within the sculpture profession—something noticed and felt adversely by some of those concerned—first began to break down. This was the achievement of such talents as John Thomas, Birnie Philip and Henry Hugh Armstead, who rose from their humble craftsman origins to become established masters.

That the quality of their work made architectural sculpture so acceptable may have had an ironic twist to it. When planning the White House, Chelsea, neither Godwin the architect nor Whistler the prospective owner wanted any exterior decoration in the form of bas-relief sculpture. However, the Metropolitan Board of Works, unsympathetic to their unadorned aesthetic purism, demanded that some token of sculpted decoration should appear;[142] the Board of Works obviously considered such adornment was necessary.

CHAPTER EIGHT
The Painter–Sculptors

Architectural sculpture, as may by now be apparent, had very much its own sets of conventions and contexts, and the effect of these was not unnaturally largely limited to that area of activity to which they were strictly relevant: it is, for instance, difficult to see the formal and practical criteria of architectural sculpture having any influence on the plethora of busts, statues and ideal works that make up the bulk of Victorian sculpture in its mid-century heyday. It was rather in another heterodox field of sculpture that more strictly spectacular effects were achieved which were finally to alter radically the sculptural aesthetic in England in the last quarter of the nineteenth century. The artists concerned were painter–sculptors, people whose principal area of artistic activity was painting; and though they did relatively little sculpture, some of it, by some of them, had an influence out of all proportion to its extent.

A fair number of Victorian painters were involved in sculpture, though the work produced varied very much in purpose and significance. There is a marble bust by William Dyce in the City Art Gallery, Aberdeen; we have already come across Landseer's lions in Trafalgar Square, London (plate 86); and William Blake Richmond was responsible for the *Greek Runner* of 1879[1] (plate 341) (bronze, St Peter's Square, Hammersmith) and a memorial to Edward King, Bishop of Lincoln, in the cathedral there of 1913. There are a number of Dante Gabriel Rossetti works transferred into three dimensions—*King Arthur and the Knights of the Round Table* at the Oxford Union (plate 229), *The Pelican feeding her Young* at Llandaff (plate 325) and, from much later, there is a bronze version of *How They Met Themselves* by John Singer Sargent. The memorial to Rossetti in Chelsea Embankment Gardens incorporates, for its part, a half-length, deep-relief bronze portrait of him by the painter Ford Madox Brown. Cloverley Hall in Shropshire (1864–70) by William Nesfield originally had reliefs of The Seasons from designs by Nesfield's friend the painter Albert Moore,[2] whilst two scenes by Burne-Jones were translated into three dimensions and bronze by Sir Joseph Edgar Boehm as part of the monument to Charles Howard (died 1879) and his wife at Lanercost Priory in Cumbria (plate 342).

Other painters made studies in sculpture to assist with the composition of their works. Manchester City Art Gallery has a painted plaster relief by William Holman Hunt, dated 1887, representing the Garden of the Hesperides, which Hunt made to incorporate in the background of the large version of his painting *The Lady of Shalott*, in the Wadsworth Athenaeum, Hartford, Connecticut; also featuring in the painting is a relief of dancing figures, for which again Hunt executed a plaster relief study.[3] G. F. Watts seems to have modelled figures for his paintings extensively throughout his career. There is a clay model for the figure in *Love Steering the Boat of Humanity* in the collection at the Watts Gallery, Compton (which also has the painting);[4] *The Genius of Greek Poetry*, also there, is a bronze cast from the wax figure modelled as a study for the principal figure in the painting of that name (various versions at various places);[5] there are nude giants in plaster, $3\frac{1}{4}$ and $3\frac{3}{4}$

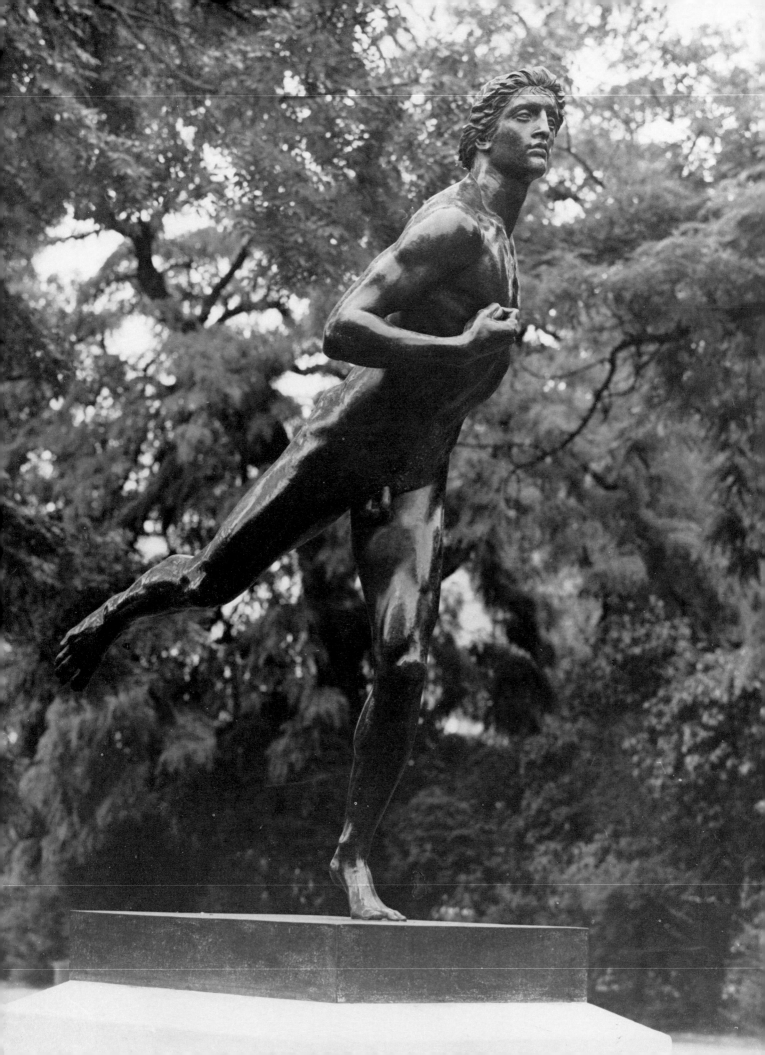

342. Sir Joseph Edgar Boehm, Monument to Charles Howard (†1879) and his wife. Lanercost Priory.

inches in size, for a figure in the painting *Chaos* of 1882;[6] and others. Then there was Lord Leighton: bronze casts of figures modelled initially on a small scale to help determine the composition of large-scale paintings such as *The Daphnephoria* are in the collection of the Royal Academy,[7] which also has a bronze cast of a figure study for the late version of *Perseus and Andromeda*.[8]

But in addition to such study works, Watts and Leighton produced sculpture for its own sake, and it was these works that had some influence and importance. They were joined in this position by another painter–sculptor, Alfred Stevens; and while it may seem a little perverse to place Stevens in this category, especially to those for whom Stevens is the only Victorian Sculptor they know about, a serious study of the full range of his work shows that sculpture was only a very partial manifestation of his artistic achievement.

It was in order to study painting that Stevens went to Italy in 1833, aged sixteen,[9] and there are many early works, copies of Old Masters, that testify to this. He must though, during his years in Italy, have studied and presumably acquired some experience in sculpture, as from 1841–2 he worked as an assistant in the Rome studio of the Danish neo-classical sculptor Bertel Thorwaldsen (1770–1843). On his return to England in 1842, Stevens began two major paintings, entered for the Houses of Parliament fresco competition, made illustrations to Homer, painted portraits—and as far as sculpture was concerned, assisted his father, a decorator, with a job at Chettle House in Dorset. Here he executed four bas-reliefs to go above the doorways in the Main Hall: representing classical scenes (such as *Cupid received by Anacreon*) they are copies of works by Thorwaldsen.

Stevens received his first major sculpture commission in 1846, to design some doors for the Geological Museum; they were never executed, but drawings survive. He had received this commission in consequence of his appointment the previous year to an official position at the Government School of Design, Somerset House, to teach architecture, perspective and modelling. It was about this time (i.e. 1847–9) that

341 (facing page). Sir William Blake Richmond, *Greek Runner*, 1879. London, St Peter's Square.

Cockerell employed Stevens in various capacities, as previously noted. But the major project in which Stevens was involved at this time was the decoration of rooms at Deysbrook House, near Liverpool, done in collaboration with his friend Leonard Collmann, an architect and interior decoration contractor. Though there was some architectural wood carving involved in the Deysbrook scheme, Stevens's contribution in the main consisted of painted figures and narrative scenes. This was true also, at least in theory, of his scheme for the Dining Room at Dorchester House, London, the commission for which he received sometime in the mid 1850s, and of many other schemes, actual and projected, in which Stevens was involved throughout his life—the British Museum Reading Room, St Paul's Cathedral, 11 Kensington Palace Gardens, and so on. The Dorchester House Dining Room admittedly incorporated some sculpture, in particular the fireplace, but the fact that this was the only section to even verge on completion, and that it alone survives should not obscure the fact that it was but a part of a much larger scheme in which painting played a major role, and that similar painted schemes played such a large part in Stevens's artistic outlook.

He was of course involved in a number of purely sculptural projects, the most famous of which was the Wellington Memorial (plate 92), previously considered. In 1857 he submitted an entry to the competition for a Memorial to the 1851 Exhibition; his model for this survives, though the commission went to Joseph Durham. He executed some routine bread-and-butter sculpture work, such as busts (e.g. *Herbert Collmann*, Tate Gallery, 1860) though on closer examination it turns out that these were done, not for a living, but for friends. Other sculpture work by Stevens was very much in an applied art context. He became associated with some Sheffield metal firms, designing for them, for instance a *Rape of Proserpine* fireback, fire-dogs, and hunting knives for the South American market. Now it was in this field, perhaps, that Stevens had most direct influence; certain pupils such as Godfrey Sykes and James Gamble followed his particular idiom and ideology to a quite considerable extent, and this came into some public prominence with the work they did decorating the South Kensington complex (see previously, pp. 226–8). Nevertheless, this was all very much outside the mainstream of Victorian sculpture. Stevens was not a typical figure himself: he clearly did not think of himself as primarily a sculptor, and it is really more by means of a devoted band of pupils and admirers who cultivated his reputation and preserved every scrap of work they could lay their hands on, that Stevens came to assume any position in the history of Victorian sculpture.

The exception of course, is the Wellington Monument, or rather the extended tribulations that surrounded its execution, both in Stevens's lifetime and afterwards until its completion in 1912. Both the monument and its artist became a major artistic *cause célèbre* for the latter part of the century. Stevens, particularly after his death in 1875, became for a younger generation dissatisfied with general convention, a symbol of something 'different' in art (as indeed his style most certainly was), something moreover that had been opposed, not to say thwarted by officialdom and the establishment. The constant struggle to achieve for the monument both its correct siting and its completion was a saga that featured in every decade until the equestrian group (plate 343) was finally positioned in 1912 and even thereafter as controversy continued. All this was meanwhile supplemented by the constant propaganda of a small but extremely partisan group of admirers, which meant that Stevens assumed in the public mind an unique stature, as a sculptor, that is still pervasive and, more important perhaps, was of significant effect on the generation of sculptors coming to maturity in the last quarter of the century.

The painter George Frederick Watts[10] had experience of the sculpture world at an early stage in his career, when he spent some time in the studio of William Behnes. Although he apparently never received formal instruction in sculpture, he certainly drew

343. Alfred Stevens (and John Tweed), detail from the Monument to the Duke of Wellington, completed 1912. London, St Paul's Cathedral.

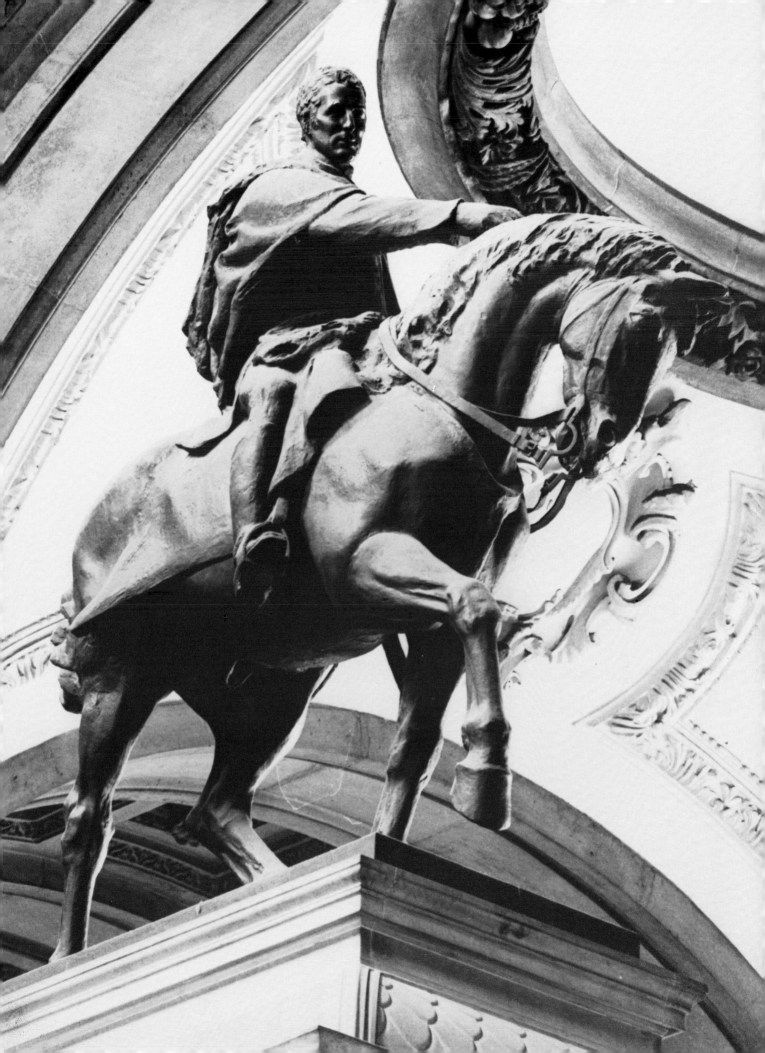

344 & 345. George Frederick Watts, Monument to Sir Thomas Cholmondeley, 1867. Condover, St Mary and St Andrew.

from casts, and had watched Behnes at work. Watts's professional life was very much affected by the personal protection given to him by various individuals; and while this obviously will have lessened his experience of the hurlyburly of the marketplace of professional artistic livelihood, it also meant that he could to a certain extent indulge himself artistically by following his own inclinations. As far as sculpture was concerned, this autonomy meant first that he could take it up at all (a basic but rather important point), then that he could, once into it, express himself with a freedom possibly denied to the professional who was dependent on the general outlook of the market from which his livelihood came. The other side of this same coin was, though, that the work thus conceived in such freedom was, in that condition, somewhat isolated.

At the Royal Academy of 1864, Watts showed *Time and Oblivion*, a design for sculpture to be executed in diverse materials after the manner of Phidias. This was never proceeded with; it sounds rather like a development of Gibson's thinking—the *Tinted Venus* had been on show at the International Exhibition in 1862. In the next ten years, though, Watts did realise a number of sculpture works. At the Royal Academy of 1868, he exhibited—in an incomplete state—an ideal work in bust form called *Clytie*. His intentions he explained in a letter to Gladstone, dated 3 May 1868:

. . . my aim in this my first essay has been to get flexibility, impression of colour,

278

and largeness of character, rather than purity and gravity—qualities I own to be extremely necessary to sculpture, but which, being made, as it seems to me, exclusively the objects of the modern sculptor, have deadened his senses to some other qualities making part—often glories—of ancient art, and this has resulted in bare and cold work.

The latter qualities could certainly not be said to apply to *Clytie*. The studied *contrapposto*, giving a taut but vigorous pose, while it might have unimpeachable precedents in Michelangelo, was not something that Victorian sculpture with its other concerns was familiar with. Moreover Watts was very anxious to give the work a kind of variety of texture, carving the marble himself, the effect of light on the different planes of the surface being what he was anxious to capture.[11] We are told that it was the dramatic feeling of Ellen Terry (to whom Watts was briefly married) that gave value to the conception and inspired the working of the marble.[12]

Watts did not complete *Clytie* until 1878, and in the years between he executed a number of other works, some very much within the sculptural framework of the time, in which he was nevertheless able to develop his ideas considerably—to more effect, possibly, than in *Clytie*. In 1864, the elder brother of Reginald Cholmondeley, a friend of Watts, died, and Watts was commissioned by his friend to execute a life-size figure as a memorial (plates 344, 345);[13] this he completed in 1867 for the church at Condover in Shropshire. In a Victorian context, it is unusual in conception, being a free-standing kneeling figure. Other nineteenth-century examples of such a type are known, such as Chantrey's *Bishop Ryder* of 1841 (plate 153) at nearby Lichfield Cathedral. But in this case one must assume an intentional reversion to the type common in English seventeenth-century monuments; indeed viewed from a certain angle one looks past *Sir Thomas Cholmondeley called Owen* to a set of seventeenth-century kneeling figures, constituting a monument to earlier members of the Owen family with which the Cholmondeleys were claiming continuity: hence 'called Owen'.

Watts received the commission for his next church monument, one of some substance, in 1869; this was to Doctor Lonsdale, Bishop of Lichfield, in the cathedral there, and the work was completed in 1871.[14] It consists of a full-length effigy of the bishop, in alabaster. Watts admitted the likeness was not good, but (he wrote) 'the kind of likeness required should be in accordance rather with an abstract idea than of a realistic character'. Moreover, to concentrate on the head and limbs (however abstract and ideal the intention might be), Watts cut the drapery up into innumerable folds (plate 346), a treatment he thought at that time unique, as indeed it was. In the treatment of the whorling draperies, Watts cut in to his material, producing an effect of extreme variegation and formal vitality of surface handling, unparalleled in the sculpture of the time; closely akin, indeed, only to what Watts was featuring in certain of his paintings of about this time and after, such as *Endymion* (under way by early 1869 and apparently completed in 1873) and *Paolo and Francesca* (e.g. the Watts Gallery version of 1872–5), where a similar whorling linear treatment of drapery is to be found.

This type of treatment would only be possible in a material softer than marble, such as alabaster. In the *Cholmondeley* figure, Watts is certainly beginning to formulate the drapery in a crinkled, *mouvementé* fashion, but only in alabaster could he achieve still greater depth and freedom. While working on the *Lonsdale* he wrote: 'I am so charmed with the colour and texture of alabaster as in my bishop that I think of doing Clytie in that material';[15] this has been construed[16] as a slip of the pen for his *Medusa* of *c.* 1870–3, of which an alabaster version is extant. However, as already mentioned, *Clytie* was as yet incomplete, and it is quite possible that prior to finishing it, Watts considered alternative media suited to the work's achieving the effect that the artist had defined.

279

346. George Frederick Watts, Monument to Bishop Lonsdale, 1871. Lichfield Cathedral.

The source of this style of drapery treatment is sometimes given as classical; Mrs Watts certainly makes a connection with Pheidias.[17] Watts obviously knew Greek prototypes that would serve—he had casts from the Elgin Marbles, both frieze and pediment figures, quite apart from knowledge of them at first hand. He also had (at any rate after 1876)[18] casts of sections of the Balustrade of the Temple of Nike at Athens, in which a particular closely whorling drapery style is evident, and these were certainly on view in Athens at the time of his 1856–7 visit.[19] But it is possible that he may have drawn as much on English seventeenth-century work, particularly in the medium specifically of alabaster. The style of the Cholmondeley-Owen figure has been credited as 'developed, it seems, from that of Nicholas Stone',[20] and later, certainly, Watts's neighbour and friend Hamo Thornycroft was called in by Edmund Gosse to give a professional, sculptor's opinion about Stone's monument to John Donne,[21] and Watts was to transfer to Thornycroft the commission for the Stanley memorial in Holyhead.[22] What one can surely infer from this is an awareness on Watts's part of English seventeenth-century sculpture; one may even posit a source there for a particular phase in Watts's drapery style in both sculpture and painting.

Watts worked on other sculptures at this time. His portrait statue of Lord Holland, in Holland Park, London (plate 347), dates from 1869–70. Though ostensibly a public monument, this was also a commemoration of one of Watts's earliest patrons and protectors. Watts modelled the statue in clay, for casting in bronze, but because of his lack of experience of this later stage, Boehm was brought in to help.[23] Another church monument was that to his friend, Lord Lothian, at Blickling Church, in Norfolk (1871– c. 1874); in this Watts continued his exploration of surface intricacies even more variously in the treatment of the beard and hair.[24]

347 (facing page). George Frederick Watts, *Lord Holland*, 1869–70. London, Holland Park.

280

LORD
HOLLAND
BORN
MDCCLXXIII
DIED

348. George Frederick Watts,
Hugh Lupus, 1876–83. Eaton
Hall.

349. George Frederick Watts,
Physical Energy, c. 1883–1906.
London, Kensington Gardens.

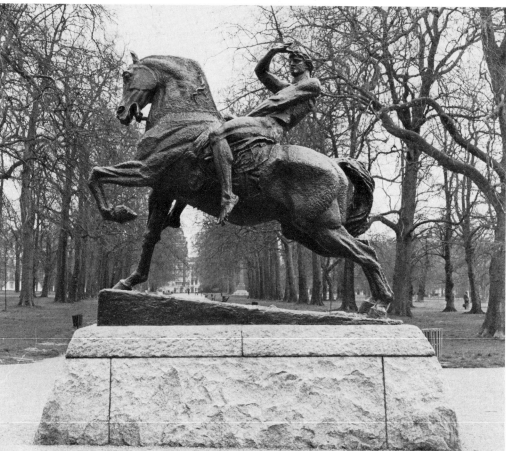

350 (facing page). George
Frederick Watts, detail from
Physical Energy, c. 1883–1906.
London, Kensington Gardens.

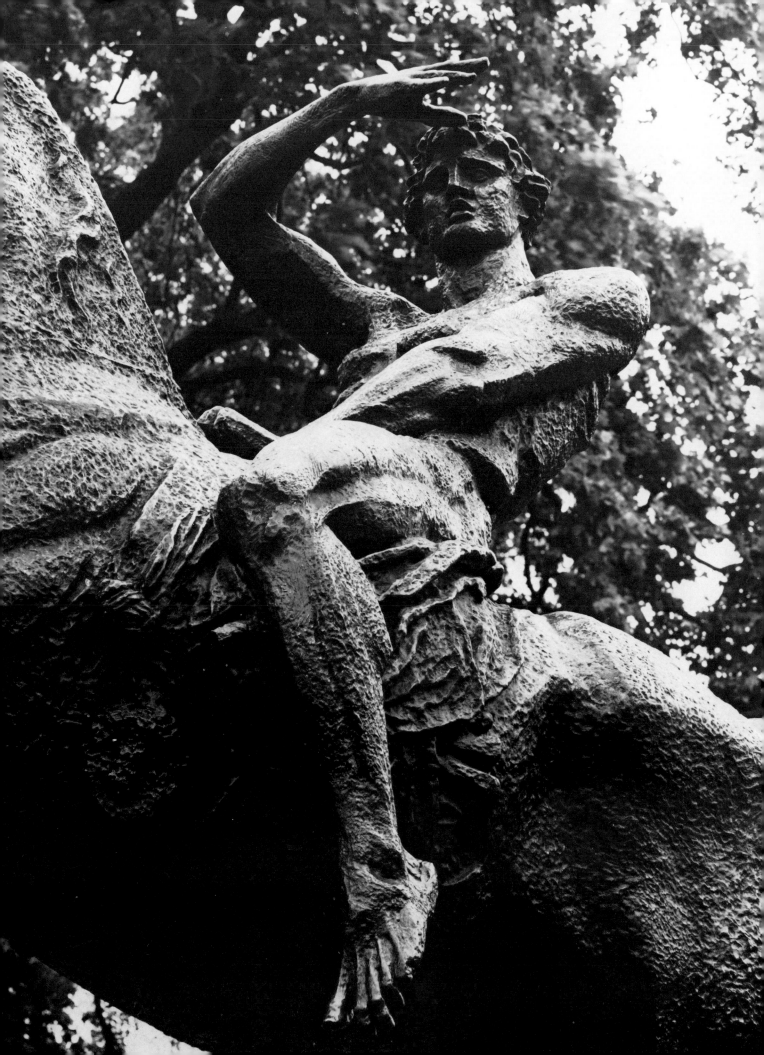

Most of these works, whatever their position, were private commissions from a very select, exalted social milieu. So too was Watts's next commission, from the Marquis of Westminster, who wanted a memorial to his family's founder, Hugh Lupus, the first Gros Venor (plate 348).[25] This was to be executed in bronze: that is, it would normally have required casting from clay, then plaster models—and for assistance in this technical aspect, Watts called again on the services of Boehm. But Watts had found (presumably when working on Lord Holland) that contact with wet clay gave him rheumatism (as Foley also experienced, with ultimately fatal consequences—see pp. 50, 51). However in the 1870s Watts met an Italian sculptor called Fabruzzi, who introduced him to the technique of 'gesso grosso':[26] that is, a mixture of size and plaster powder in which pieces of tow were soaked. This dried very quickly which meant it did not aggravate the rheumatism; although it dried too quickly for extensive modelling by hand, it could be carved once dry, and it produced a varied surface texture, which would appeal to someone like Watts who was very much concerned with producing a variegated effect to catch the light.

The form of *Hugh Lupus* was very much of concern to the Marquis of Westminster and Watts was not really able to give full expression in it to his developing ideas on sculpture. These he saved up and set out in *Physical Energy* (plate 349), his major work in sculpture which he started about 1883.[27] It was not a public or private commission of any sort, so much as simply an embodiment of his ideals. The finished work has a long and complex history. In 1886 Millais begged Watts to have it cast, in 1890 other friends tried; in 1898 Lord Salisbury's government offered to cast and erect it, in 1902 Lord Grey suggested it should be used as a memorial to Cecil Rhodes, as Rhodes had admired it; and this finally persuaded Watts to go through with it. The first casting of 1902–3 was set up as the Rhodes Memorial in Cape Town, South Africa; a second casting of 1906 was set up in Kensington Gardens, London; a third cast of uncertain date was apparently installed at Lusaka, then Northern Rhodesia, in 1960.

The basic concept of the work was the image of a man on horseback symbolizing the energy and progress which for Watts were the essential qualities of the age. Watts claimed that this was man as he ought to be, a part of creation, of cosmos in fact, his great limbs to be akin to the rocks and to the roots, and his head to be as the sun.[28] The work was symbolic of that activity which is impelling man to undertake a new enterprise. The horse is restrained by the hand, which as if on the tiller of a rudder, is not reining it back. This is a symbol of something done for the time, while the rider looks out for the next thing to do. The incline of the plinth is slightly symbolic of a rising wave.[29]

This density of symbolic meaning is matched by a heaviness of formal exaggeration and distortion. There is a heavy accentuation of certain muscles in the legs, arms, stomach and back of the rider, and the length of the rider's back is distorted to strengthen the forward thrust of his head and right arm. All this, paradoxically enough, is applied to a composition for which basic sources of inspiration have been claimed in the Elgin Marbles, casts of which, as we have seen, Watts had in his studio. The formal exaggeration is paralleled in the rugged surface of the bronze, which Watts was able to effect and achieve via his newly adopted 'gesso grosso' technique (plate 350).

Watts used the same surface effect for his last work in sculpture, the statue of Tennyson outside Lincoln Cathedral (plate 351).[30] This was commissioned in 1898, and Watts offered his services free if the county of Lincolnshire, who were responsible for the memorial, would undertake the cost of the casting. There were some problems with the work as it was built up in gesso, and the first figure was broken up; it is possible that the dog was added as a mechanical necessity rather than an aesthetic one. The statue was cast in 1903 and unveiled in 1905.

This was of course a public commission and available to the public, as was *Physical*

351. George Frederick Watts, *Lord Tennyson*, cast 1903. Lincoln, Cathedral Precinct.

Energy. But unfortunately by the time they came to be available, in 1905 and 1906, the revolution that had come over British sculpture in the latter part of the nineteenth century was well-nigh a generation old, so that Watts's sculpture, conceived and executed over the years in relatively hermetic circumstances (only *Clytie* being exhibited, in a transitional state, at the Royal Academy during Watts's lifetime), could not act as the roughage it might have been—particularly with its emphasis on surface texture—for the new generation. For them the Morning Star was to be Frederic, Lord Leighton.

The End of the Century

352 (preceding page). Lord Leighton, *Athlete Wrestling with a Python*, R.A. 1877. London, Tate Gallery.

CHAPTER NINE
The New Sculpture

In 1876 the figure of Prince Albert by John Henry Foley (plate 68) was finally uncovered at the centre of the Albert Memorial in London. This completion of one of the major sculptural monuments of the Victorian era with a work by one of the nation's leading sculptors, lately deceased, brought one phase of Victorian sculpture to a close. Conveniently enough, a new phase can be said to have begun the following year, 1877, when Leighton's *Athlete Wrestling with a Python* (plate 352) was shown at the Royal Academy.[1] (It has been known since also as *Athlete Strangling a Python*[2] or *Athlete Struggling with a Python*[3].) This work was taken in its own time, and has been ever since, as a breakthrough in British sculpture, and in particular as the harbinger of a movement called 'The New Sculpture' which was to assume a dominant position in British Sculpture in the last two decades of the nineteenth century and up to the First World War.[4]

What was significant about the work was the way in which it treated the human form, rendering in a naturalistic and fairly detailed way the musculature of a figure in action, achieving this by careful and detailed modelling, and reflecting this modelling directly in the variegated surface of the bronze. The revelation this must have been for a contemporary audience is immediately apparent if one compares it with a typical Victorian work we have come across often enough before—John Bell's *Eagleslayer* (plate 19) of 1837, 1844, 1851 and so on. This is a similar figure type, a man of muscular action; yet in the Bell work the modelling as reflected in the bronze (plate 354) gives only a most rudimentary and generalised impression of the play of muscles beneath the skin. The Leighton too, unlike the Bell, is wholly naked, although this is not generally appreciated, since the photographs by which it is repeatedly reproduced are all taken from virtually the same angle, so that the writhing python conceals what nature and Leighton would not— an interesting case of concealed censorship. In Bell's defence, one should note what he wrote to Gosse in 1883 about his work: 'Had I the opportunity I could do a better one now, without the drapery.'[5]

The *Athlete* had in fact been under way for three years by the time it was exhibited. The idea had first occurred to Leighton while making the small figures that he used to assist in making up the composition of his painting *The Daphnephoria* (see above, p. 275), and to realise this idea he made a plaster sketch about 9½ inches high. This was seen and much admired by the French sculptor Jules Dalou, then in exile in England (of whom more later, see p. 302). Dalou encouraged Leighton to execute the work full-size, and for technical help in its execution in bronze at this scale Leighton went to Thomas Brock.[6] Brock[7] was at this time a young sculptor, coming up to thirty; after training at his local Government School of Design he had come up to London and had been taken on in Foley's studio. He attended the Royal Academy Schools in 1867, started exhibiting at the Academy in 1868 and won its Gold Medal in 1869. At Foley's death in 1874, Brock inherited a large number of Foley's still incomplete commissions (see above, pp. 72–5), and he was working on these at precisely the same time (1874–7) that he was called in to

assist Leighton. I do not believe that this was fortuitous: Foley, as I have tried to demonstrate, was one of the few Victorian sculptors, if not the only one, who had made more than a gesture towards naturalism and realism in his work, particularly in his treatment of detail in contemporary costume, breaking away to a certain extent from the bland, generalising style that was so prevalent, and attempting—and this above all is important here—to render in bronze a more than superficial acknowledgement of what the substance of nature provided. It was on the completion of works embodying these principles that Brock was engaged at the time, and it was thus wholly appropriate to Leighton's requirements for Brock to complete at full scale in bronze a manifesto of naturalistic rendering.

This commitment of Leighton to a new aesthetic in sculpture would have been considerably enhanced the year following the exhibiting of the *Athlete* when not only did the work receive a Gold Medal at the Paris International Exhibition of 1878, but its author was elected President of the Royal Academy. From this supreme position of influence in the artistic life of the nation, Leighton, in the remaining eighteen years of his life, did a great deal to encourage and sustain sculpture as an art, particularly with regard to the younger, up-and-coming generation of sculptors.* Within the Academy, changes were made in 1881 and 1882 in the arrangement of the exhibiting of sculpture there;[8] this had been a universal cause of dissatisfaction in the 1863 Royal Commission (see p. 80), and the changes brought about early on in Leighton's Presidency led apparently to a great improvement in the effectiveness of the sculpture's display. In 1881 too, within the Academy, Hamo Thornycroft was elected to an Associateship:[9] not only was he quite young for this (thirty-one), but it took place without there being a vacancy to fill. Thornycroft,[10] born in 1850, was the son of sculptor parents, Thomas and Mary Thornycroft. As a young man he studied Greek art at the British Museum; he was admitted to the Royal Academy Schools in 1869 (where he won the Gold Medal in 1875), went to Italy in 1871, returned to help his father with the *Poets' Fountain* (formerly Park Lane, damaged in the Second World War, present state and whereabouts unknown), the same year in which he began to exhibit at the Royal Academy.

At the 1879 Academy he showed *Stepping Stones* (now belonging to Glasgow City Art Gallery, signed and dated 1878), a marble group of two children (approximately life-size), 'pausing with reluctant feet, where the stream and river meet', a pleasant enough genre subject that would not be out of place in the established categories of mid-Victorian sculpture. Only the drapery treatment is perhaps exceptional, showing a fine plastic grasp of certain classical styles that Thornycroft would have found in his British Museum studies, though there may also be here a certain legacy from the drapery style, in drawing, of Lord Leighton, of whom Thornycroft was to write:

> . . . I had the benefit of his teaching at the Academy Schools, where he was most energetic as a visitor, and took the greatest pains to help the students. He was, moreover, an *inspiring* master . . . he started a custom of giving a certain time to the study of drapery on the living model. His knowledge in this department and his excellent method were a new element in the training in the schools, and soon had a salutary effect on the work done by students.[11]

The following year Thornycroft showed two works—a statue of Artemis (plate 38) the Greek divine huntress, a figure whose pose shows some vital expressive tension, with fluttering classical-style draperies, clothing a body that had been modelled substantially in the nude. There are various versions of this: the large scale plaster original model is in

354. John Bell, detail from *The Eagleslayer* (version of 1851). London, Bethnal Green Museum.

353. Sir Alfred Gilbert, detail from *Icarus*, 1884. Cardiff, National Museum of Wales.

*This is notwithstanding two later works of sculpture by Leighton, *The Sluggard* (R.A. 1886) and *Needless Alarms* (also R.A. 1886) but these were much more Leighton keeping his hand in than significant declarations such as *The Athlete* had been.

Macclesfield Town Hall and the principal marble version, commissioned by the Duke of Westminster and shown at the Royal Academy of 1882, was at one time at Eaton Hall, Cheshire. With the plaster *Artemis*, Thornycroft showed *Putting the Stone* (a version is at Leighton House, London), and here the example of Leighton is manifest—another athlete, nude, exerting himself, showing ribs and muscles in bronze in such a way as to give the surface of the work the variegated vitality seen three years previously in the Leighton statue. In 1881, the year of his election to the Associateship of the Royal Academy, Thornycroft exhibited another work of this type, *Teucer*, the classical archer, in plaster, again with ribs and muscles and flesh naturalistically modelled and displayed; this came across particularly well the following year, when Thornycroft showed the full-scale bronze. And it was in this year, 1882, that Thornycroft began teaching sculpture at the Royal Academy Schools, which he continued to do until 1914; the new Sculpture School had only been set up the previous year, 1881, with Horace Montford appointed as first Curator.[12] All this was another important sculptural event within the Academy, with Leighton's Presidency four years old.

Thornycroft's Associateship of the Royal Academy in 1881 was the first for the new generation of sculptors, and they figured prominently in the relatively much larger number of sculptors to achieve official recognition there in Leighton's eighteen-year tenure of the Presidency, or so it seems in comparison with other periods in the Academy's history. Though one should be wary of statistics, nevertheless in the eighteen years that Leighton was President, eight sculptors became Associates of the Royal Academy (Boehm 1878, Birch 1880, Thornycroft 1881, Brock 1883, Gilbert 1887, Ford 1888, Bates 1892 and Frampton 1894) compared to six in the previous eighteen years and ten in the previous thirty-eight years. Similarly with full Academicians, there were six in Leighton's eighteen years (Armstead 1879, Boehm 1882, Thornycroft 1888, Brock 1891, Gilbert 1892, and Ford 1895) compared to three in the previous eighteen years, and seven in the previous thirty-eight years.[13] 'These changes in the composition of the Royal Academy', wrote Gosse in 1896, 'were not a trifling matter.'[14]

Leighton was concerned in other instances of sculptural encouragement outside the immediate context of the Academy. He was one of the judges for the memorial statue to Sir Rowland Hill (1795–1879), introducer of the Penny Post, for which there was an open competition,[15] and this was won by another young New Sculptor, Onslow Ford (1852–1901).[16] The work (plate 355) (unveiled in 1882, originally at the Royal Exchange, London, now outside the General Post Office, in King Edward Street, City of London) is an excellent example of the way in which the by now established form and style of the standing bronze figure is treated in a wholly different way: no longer a flat, bland expanse of bronze with a gesture towards reality in the use of essential details of costume, but a subtler handling of the material, a more variegated treatment of mass in general and in detail, to give a livelier effect of reflected light and texture. The other judges were established sculptors, Calder Marshall and Woolner, and the latter, who had always been to some extent an odd man out in his sensitivity to plastic handling, may well have been sympathetic towards the 'New Man'. But the senior partner of the trio of judges was undoubtedly the President of the Royal Academy, Leighton, and it would be to him in the main that this early triumph of the New Sculpture in the public domain was due. One may note here that Onslow Ford certainly went on to confirm the faith shown in his new-style abilities—from the very next year dates his impressive *Henry Irving as Hamlet* (now in the collection of the Guildhall Art Gallery, City of London). Ford had seen Irving on stage, and was anxious to capture the actor in some characteristic attitude. Having made sketches on the spot, and a rough clay model, he applied to Irving for sittings. He was fobbed off by Irving onto Bram Stoker, to whom Ford showed the model; Stoker was impressed and persuaded Irving to sit. When the statue was finished in marble, Ford

355. Edward Onslow Ford, *Sir Rowland Hill*, 1881. London, King Edward Street.

proposed sending it round to Irving; but he declined the pleasure, saying neither his stairs nor the floor of his room would stand for it, and directed Ford to present it to the Guildhall Gallery, but not from him: 'Hang it all, Ford, a man cannot give his own statue; give it from yourself. I have paid you for it, so give it as a gift from you; I authorise you to.'[17] This took place in 1890. Other prominent works by Ford that followed include *General Gordon on a Camel* (at Chatham, 1890) and the Shelley and Jowett Memorials at Oxford (of 1892 and 1897). Other works, particularly ideal examples, will feature later.

The year Ford's *Hill* was unveiled, 1882, another major figure of the New Sculpture featured for the first time at the Royal Academy. Alfred Gilbert[18] was born in 1854: for a time his career was poised between medicine and art, but having failed to win a scholarship to the Middlesex Hospital he took to art, studying eventually at the Royal Academy Schools and with Boehm. Having failed to win the Academy Gold Medal (in direct competition with Thornycroft, who was successful), Gilbert went abroad, first to the École des Beaux-Arts in Paris where he worked under the sculptor Cavelier, then in 1878 to Rome. It was from here he sent his first Academy exhibit, *The Kiss of Victory*; from here too he sent to the Grosvenor Gallery exhibition of the same year (1882) his *Perseus Arming* (plate 356). This was a statuette-scale (twenty-nine inches high) tautly posed male nude, in which the flesh and muscle is displayed in dappled bronze. This very much impressed Leighton, who commissioned a follow-up from Gilbert: the *Icarus* (colour plate III), shown at the Academy of 1884, which displayed the same qualities and features at a slightly larger scale (height forty-two inches, but still definitely not life-size): superbly fine modelling (plate 353), down to the veins on the hands and feet; intricate natural detailing on the base. Leighton's copy is now in the National Museum of Wales, Cardiff. Leighton also urged Gilbert to return to England on a full time basis, which was in its way a major contribution to the development of the New Sculpture, and he continued during the 1880s and 1890s to put work and credit Gilbert's way.

Leighton's encouragement of sculpture was not confined solely to the new movement. It was he who first led the campaign to have Stevens's Wellington Monument resited in its intended position in the nave of St Paul's, in which he was successful; he then campaigned to have the monument completed by the equestrian figure on the top (plate 343), but he died before this could be effected.[19] It was Leighton, too, who encouraged Henry Fehr (1867–1940) to have his *Rescue of Andromeda* cast in bronze after the plaster had been shown at the Academy of 1893.[20] The bronze was bought from the artist for the nation via the Chantrey Bequest in 1894, and is now outside the Tate Gallery; in this too Leighton as President of the Royal Academy, and thus *ex officio* an administrator of the Bequest, would have had a hand. It would appear, indeed, that Leighton tried during his Royal Academy Presidency to overcome one of the principal stumbling blocks against the application of the Chantrey Funds to encouraging sculpture.[21] A strict interpretation of the terms of Chantrey's will precluded the commissioning of works, and this included paying for the cost of casting in bronze or having executed in marble a work exhibited at the Academy in plaster—an expense as we have seen often enough that even an established artist could not undertake lightly. Although, on appeal, the Master of the Rolls was prepared to overcome this slight difficulty, his colleagues were not, and the case was lost. But this was just one example, among many, of Leighton's efforts to help sculpture, and Hamo Thornycroft was to attest unhesitatingly: 'There can be no doubt whatever that the rapid advance made in the art of sculpture during the last thirty years was to a considerable extent due to the sympathy and the interest which Leighton gave to it.'[22]

The qualities and the treatment of the bronze surface that seemed so outstanding in Leighton's *Athlete* were not, of course, unique to that work, though they were fairly exceptional at the time. Certainly in England at that time only Boehm could be said to have produced an even remotely similar effect in his work, and there is a certain truth in

356. Sir Alfred Gilbert, *Perseus Arming*, 1882. London, Victoria and Albert Museum.

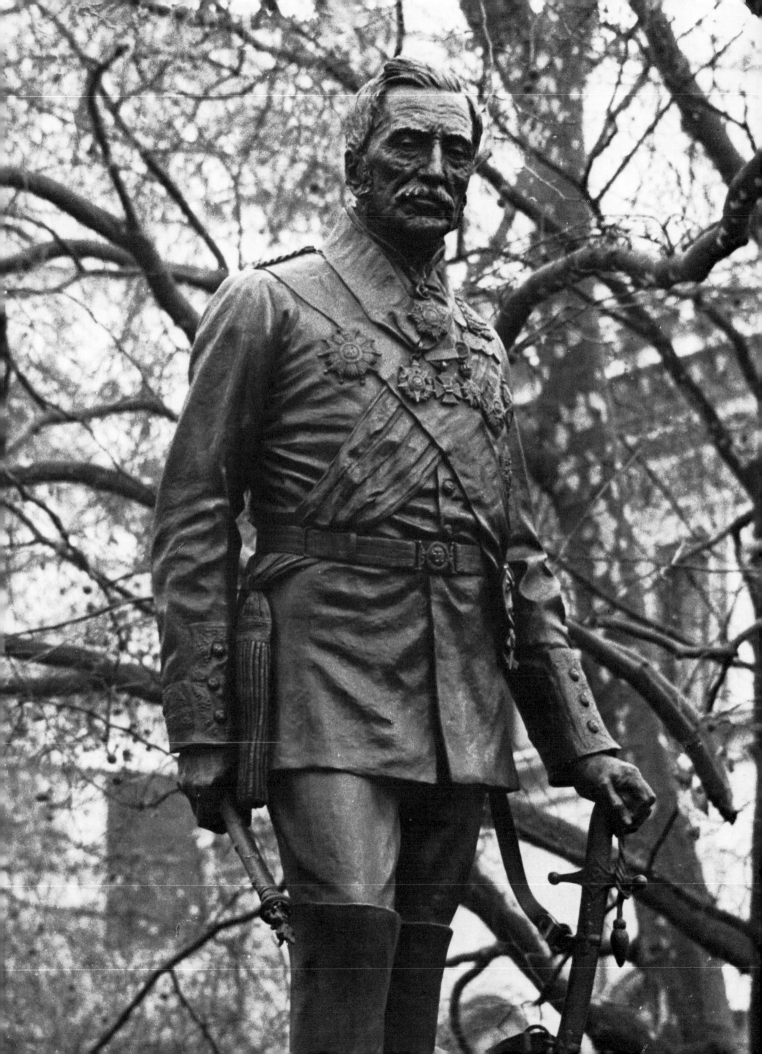

saying that if Leighton was the fairy godfather of the New Sculpture, Boehm was its wicked stepfather. When Marochetti died in 1867, Boehm succeeded him as the *bête noire* of British sculptors, another flashy, tricksy foreigner with friends in high places. Born in Vienna of Hungarian extraction in 1834, Boehm[23] studied in London (mainly at the British Museum), Italy, France and back in Vienna, before settling in London in 1862; he acquired British nationality in 1865. Because he was both willing and able (thanks presumably to his Continental training) to manipulate his materials further than the standard broad anodyne treatment that was the general rule in England, undercutting marble and modelling deeper for bronze, thus producing a much more varied effect of light and shadow, he was identified soon after his settling in England with Marochetti and his 'effectism'.[24] He acquired an entrée to royal circles, executing a number of works for them and becoming Sculptor in Ordinary to the Queen. In the late 1870s and the 1880s his position was almost supreme in the execution of public monuments in London: *Field Marshal Burgoyne*, Waterloo Place (1877) (plate 357), *Viscount Stratford de Redcliffe* (†1880), Westminster Abbey, *Disraeli* (†1881), Westminster Abbey (plate 358), *Thomas Carlyle*, Chelsea Embankment Gardens (unveiled 1882), *Lord Lawrence*, Waterloo Place (plate 105) and *William Tyndale*, Victoria Embankment (plate 359) (both 1884), *The Earl of Shaftesbury*, (†1885), Westminster Abbey, the Wellington replacement (for Wyatt's

358. Sir Joseph Edgar Boehm, *Disraeli* (†1881). London, Westminster Abbey.

359. Sir Joseph Edgar Boehm, *William Tyndale*, 1884. London, Victoria Embankment.

357 (facing page). Sir Joseph Edgar Boehm, *Field Marshal Burgoyne*, 1877. London, Waterloo Place.

statue) at Hyde Park Corner, erected 1888 (plate 91), and the statue of Stafford Henry Northcote, first Earl of Iddesleigh, also of 1888, erected in the Central Hall of the Houses of Parliament—all these in addition to busts and funerary monuments of the noble and the important: such as a bust of Archibald Philip, fifth Earl of Rosebery, dated 1886; the effigy of Dean Stanley, who died in 1887, in Westminster Abbey; and we have already seen his double effigy of the seventh Earl of Cardigan (†1868) and his wife in the church of St Peter, Deene, Northamptonshire (plates 251, 252).

Boehm was, for all his success, sometimes unselfish. He assisted G. F. Watts with his *Lord Holland* (plate 347) and *Hugh Lupus* (plate 348) figures,[25] and he had working in his studio such prominent members of the younger generation as Alfred Gilbert and Alfred Drury; he was moreover instrumental in obtaining for Gilbert perhaps his most famous work, the public memorial to the philanthropic benefactor of the nation, the seventh Earl of Shaftesbury, sited in the middle of Piccadilly Circus, and more commonly known as *Eros* (plate 360).[26] Boehm did the Westminster Abbey monument to Shaftesbury, and received in addition the commission for the Piccadilly Circus one; Gleichen remarks, perhaps rather snidely, that Boehm 'was so busy that he passed it on to Gilbert',[27] but Gilbert's account is perhaps more just:

> I had just returned to England, and was working in a studio in the Fulham Road, adjoining Boehm's, and he gave me many commissions, for he was one of the most large-hearted men I have ever met, ever ready to help his brother artists. In order to do me a service, he told the committee that he would be unable to have the honour of carrying out the tribute to one he so greatly admired; but he was sure that his former pupil would amply justify the liberty he was taking in proposing him to the committee;. . .[28]

Yet this was the man whom Edmund Gosse, the prime interpreter and apostle of the New Sculpture, was to describe as the movement's 'most powerful enemy' whose 'melancholy blindness of prejudice' and 'inability to read the signs of the times' prevented him from recognising the virtues of the younger men. Moreover,

> Boehm saw no necessity for individual studios of sculpture in this country. He thought . . . that the practice of sculpture might very conveniently be centred around one man, who should direct it and preside at it. Boehm would gladly have employed the young men to produce work for him in some such universal emporium of monuments, of which he himself should be president and manager. It is said that at one time he hoped, with the help of the Court, to carry through some such scheme.[29]

This might be the other side of the coin of that generosity of which Gilbert spoke, a personally less well-disposed reading of it. In this, as in his art and his position in the art world, Boehm encountered the same hostility as had Marochetti; its potency must be recognised even if it prevents an adequate assessment of the man and his art.

Leighton's 'naturalism' and Boehm's 'effectism' were related phenomena, in both being due to European influences. Leighton's *Athlete* had sources ascribed to it in both Italian Renaissance and contemporary French sculpture. It had been helped into being by Dalou's encouragement; Leighton is known to have been a close follower of what was going on in the Paris Salons, and shortly before the appearance of the *Athlete* there had been a revival in French sculpture of naturalistic tendencies. But this was only one instance of a much more extensive and widespread influence of French sculpture in England, which in itself forms one of the major features of later Victorian sculpture. The availability of significant contemporary French work in London increased in the 1870s and 1880s, initially thanks in part, no doubt, to the disruption caused by the Franco-

Colour plate III. Sir Alfred Gilbert, *Icarus*, 1884. Cardiff, National Museum of Wales.

298

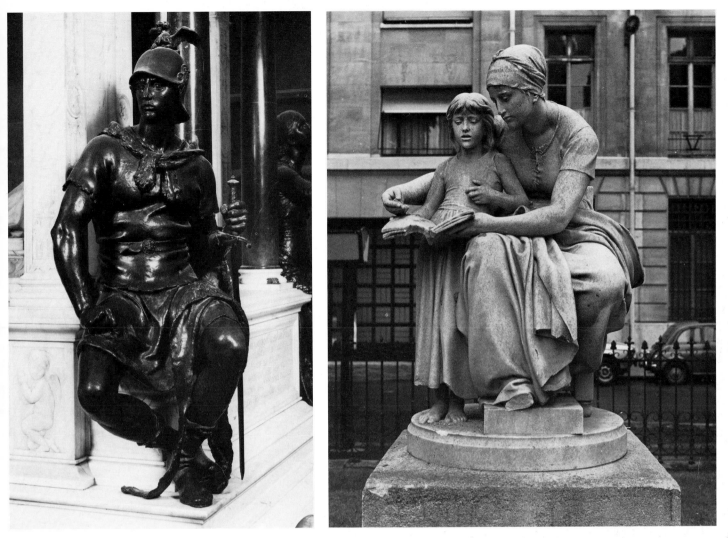

361. Paul Dubois, *Le Courage Militaire*, 1879. Nantes Cathedral.

362. Eugène Delaplanche, *L'Éducation Maternelle*, 1875. Paris, Square Samuel Rousseau.

Prussian War of 1870–1. Carpeaux exhibited first at the London Royal Academy in 1871 and from then on in some quantity; Carrier-Belleuse (who had, incidentally, worked at the Minton factory in Stoke-on-Trent from 1851 to 1855 as director of a design school) exhibited at the Academy of 1873; and Rodin at the Academies of 1882 and 1884: at the latter he showed his *L'âge d'airan* (cat. no. 1667). A work of his was refused at the 1886 Academy. Meanwhile in 1877 the Grosvenor Gallery opened, in conscious rivalry to the Royal Academy. Its first exhibition included three important works by French sculptors:—*Le Courage Militaire*, by Paul Dubois (plate 361), a military figure forming part of the monument to General de Lamoricière in Nantes Cathedral; *L'Éducation Maternelle* (plate 362), by Eugène Delaplanche, a domestic genre group of which a version was eventually set up in the Square Samuel Rousseau, in Paris; and *Jeanne d'Arc à Domremy* by Henri Chapu, a work of historic genre of which the marble is in the Louvre, and the original plaster model is in the Musée Chapu at Le Mée. While these works differ in their particular points of reference (heroic, domestic or historic), all three display that essential quality of French sculpture at that time that was so important for English practitioners: stated simply, this is a degree of fullness in modelling and naturalness in detail that was largely alien to English sculptural conventions still conditioned to the 'purity' (as Watts called it) or blandness of the established plastic tradition.

In later years, the Grosvenor Gallery showed many works by Boehm, Roscoe Mullins and Gleichen, not quite conventional artists but not 'New' either. They did however show the painter William Blake Richmond's *An Athlete* in 1879 (plate 341), occasional works by Onslow Ford (1878 onwards), Alfred Gilbert (*Astronomy* and *Perseus Arming* (plate 356) in

360 (facing page). Sir Alfred Gilbert, *Eros*, 1886–93. London, Piccadilly Circus.

301

1882), and Hamo Thornycroft (*John Belcher*, bust, also 1882); and finally, again in 1882, *Bronze Mask* by Rodin, also known as *Man with a Broken Nose*; the cast shown at the Grosvenor Gallery was apparently bought, interestingly enough, by Leighton.[30]

Still more significant than the availability in England of work of this new sculptural dimension was the presence there of certain individual artists, particularly Aimé-Jules Dalou[31] (1838–1902). Active as a sculptor in France in the late 1850s and 1860s, Dalou was implicated in the Paris Commune of 1871, and was mysteriously allowed to escape to England afterwards. On arrival, he was given particular help by a former fellow-student of his in Paris, Alphonse Legros (1837–1911) who had been in England since 1863. Then one of the first works Dalou exhibited at the Royal Academy—a terracotta statuette, *Jour des Rameaux à Boulogne* (R.A. 1872)—was bought by George Howard (subsequently Earl of Carlisle), and Howard and Legros between them brought Dalou to the attention of the higher echelons of English society, including the Grosvenor family and Princess Louise. The principal works that Dalou executed in England and exhibited at the Royal Academy between 1872 and 1879 were portrait busts in terracotta—for instance, of both Leighton and Alma-Tadema in 1874. A bust of Howard's daughter Mary (later wife of Gilbert Murray) (plate 363), signed and dated 1872, was exhibited at the Royal Academy in 1873 (now in the collection of Lawrence Toynbee, Esq.), and presented by Dalou to George Howard in gratitude for his help; it reveals the immediacy and intimacy that Dalou achieved in this medium. He used it also in the main for the other principal series of works executed during his English stay, charming genre figures with titles such as *Paysanne française allaitante* (R.A. 1873, terracotta version at Bethnal Green Museum (plate 364)) or *Hush-a-Bye* (R.A. 1874, also at Bethnal Green); this latter was executed in marble and shown at the Academy of 1876 under the title *La Berceuse*. Dalou also won a public commission for the fountain group behind the Royal Exchange in the City of London; the original of 1877 was a *Charity* in marble, but this did not weather well, and was replaced by a bronze version in 1897; a reduced replica in marble (plate 365) is in the Bethnal Green Museum, London.

In 1877 Dalou had a particular post created for him as assistant professor of modelling at the National Art Training School at South Kensington (later to become the Royal College of Art) where he taught for three years; later he also taught for some months at the South London School of Technical Art at Kennington. These were the means of Dalou's major contribution to changes in English sculpture; in Gleichen's words, it was 'he who, by instructing our students in the right way, laid the foundations of our modern school of British Sculpture'.[32] Among those who studied under him were Alfred Drury (1856–1944) at the National Art Training School, and Harry Bates (1850–99) and Frederick Pomeroy (1856–1924) at South London. And although Dalou returned to France in 1880—he had been sentenced to death in his absence, but later was pardoned— the French connection continued. Legros had been appointed Slade Professor of Art at University College, London in 1876, and influenced by his friend Dalou began to teach modelling and sculpture there; he continued as Professor until 1892. Another Frenchman, Edouard Lantéri[33] (1848–1917) succeeded Dalou as master of the sculpture classes at the National Art Training School. Lantéri had studied at the École des Beaux-Arts in Paris and had been a pupil of Cavelier, Millet and Guillaume. On coming to England, he became Boehm's studio assistant and remained with him for nearly twenty years up until Boehm's death in 1890; in other words, he was teaching at South Kensington while still working for Boehm.

A colleague of Dalou's during his brief stint at the South London School was W. S. Frith[34] (1850–1924) who had himself trained at Lambeth School of Art and the Royal Academy Schools. Frith had already been selected, in 1879, to carry out at the South London School the scheme set in motion by John Sparkes, Director of the Lambeth School,

363. Aimé-Jules Dalou, *Lady Mary Murray*, 1872. Collection of Lawrence Toynbee, Esq.

364. Aimé-Jules Dalou,
Paysanne française allaitante, R.A.
1873. London, Bethnal Green
Museum.

365. Aimé-Jules Dalou, detail from *La Charité* (marble). London, Bethnal Green Museum.

for the South London School carvers to improve their knowledge. When Dalou departed, Frith took over his life classes as well, and he became there (in Spielmann's words) 'one of the most successful instructors who ever worked in England', with his pupils including Harry Bates, George Frampton, Goscombe John and Pomeroy. His evident prowess as instructor should not obscure his fine executed work: for Aston Webb and Ingress Bell he executed architectural sculpture at the Victoria Law Courts, Birmingham, and at the Metropolitan Assurance Office (now the Bank of California), 13–15 Moorgate, London (plate 366); he was also responsible for the fine group of Edward VI and four famous old boys (Middleton, Lamb, Coleridge and Maine) at the centre of Webb's principal courtyard at Christ's Hospital, Horsham, Sussex (plate 367).

This different attitude and approach to sculptural education[35] was one of the major features of the New Sculpture, compared to normal procedure earlier in the century. The position of schools became much more predominant, with what would seem to be a much lesser dependence for significant influence on working in someone's studio—though this did not disappear entirely. Virtually all sculptors of any subsequent distinction attended either the Royal Academy Schools or the National Art Training School at South Kensington. This was often after a preliminary training at an art school elsewhere: local, as, for example, Havard Thomas[36] at Bristol or Alfred Drury[37] at Oxford, or in London at most particularly the Lambeth Art School, which had Bates,[38] Pomeroy,[39] Frampton,[40] Goscombe John[41] and Tweed[42] among its pupils of distinction between 1879 and 1890. Very distinctive too in the educational background of the New Sculpture was the number of sculptors who received additional training in France—Gilbert, Havard Thomas and Stirling Lee[43] at the École des Beaux-Arts in Paris under Cavelier; Tweed at the same under Falguière; Pomeroy and Frampton worked with Mercié; and Drury in fact followed Dalou back to France and worked as his studio assistant from 1881 to 1885. What this represented in terms of artistic influence can best be seen in Gilbert's *Perseus Arming* (plate 356) (1882) and *Icarus* (plate 353, colour plate III), which, for all their reminiscence

366. William S. Frith, *Prudence, Justice, Truth, Thrift, c.* 1890–3. London, Moorgate.

367 (facing page). William S. Frith, *Samuel Taylor Coleridge,* Horsham, Christ's Hospital.

306

of Italian Renaissance work (Donatello and Giovanni da Bologna, the latter particularly— Gilbert moved on to Italy from Paris in 1878), come closest to Mercié's *David Vainqueur* (plate 368) as small-scale statuettes in which the taut, slightly twisted pose of the figures affords opportunity for the fullest display of modelled musculature and bodywork in rippling, reflective bronze. Further French connections were maintained with Rodin, for whom Bates, Goscombe John and Tweed worked; there were in addition isolated instances of German study, in the cases of Onslow Ford (Munich, 1871–4) and Derwent Wood (Karlsruhe, mid 1880s).

The situation of mason-carver turned artist, familiar from earlier in the century, had by no means disappeared. Harry Bates (1850–99) had first been apprenticed with Farmer and Brindley for ten years (1869–79), and William Goscombe John (1860–1952) was the son of a Cardiff stone-mason whom he assisted at work on Burges's Cardiff Castle; John later went on to work in the studio of Thomas Nicholls, Burges's favourite architectural sculptor.[44] But this class distinction, of which some earlier had certainly been conscious, and sometimes critically so—see R.A. 1863 *Report*—was becoming blurred by this time. Lambeth seems to have regarded itself as a training school of craftsmen, and A.L. Baldry, one of the more discerning and intelligent critics active towards the end of the century, saw in this change of attitude a positive contribution that benefited the new movement:

> . . . in quite recent times, artists were afflicted with a kind of false pride which made them despise architectural sculpture as something beneath their dignity; they had a way of talking of it as an inferior class of Art, which was unfit to be touched by any man who wished to be considered worthy of an honourable rank in his profession. Consequently it fell into the hands of the mechanical carver employed by firms who provided ornamentation for buildings at so much a square yard. It was classed as stonemason's work, and if a younger artist was injudicious enough to break away from the general custom, and to make experiments in the application of sculpture to practical purposes, he was treated as altogether outside the pale of respectability. So long as he contented himself with things which could be stuck on a pedestal, with conventional Venuses and namby-pamby Apollos, or with statues of successful City men and prominent generals, he was regarded as one of the elect; but if he was once discovered doing something which could not stand in solitary grandeur at a street corner, his prospects were certain to suffer.
>
> This ridiculous misapprehension, however, brought its own punishment. A few years ago, when, as it happened, gods and goddesses had gone out of fashion, and there were not quite as many famous moderns as there had been half a century before waiting to be immortalised, sculptors fell on evil days. They found themselves neglected, and they began to suffer from want of support. So they were forced to pocket their pride, and, in the face of all their earlier traditions, they were obliged to enter into competition with the stonemasons whom they had so long looked down upon. Necessity, with its habitual indifference to rules and regulations, taught them to consider professional questions with a breadth of mind that they had not attempted to cultivate before, and the pedantry which had denied to them their best opportunities vanished completely.
>
> The advantage which has come from this change of attitude can scarcely be over-estimated. In the last twenty years there has grown up a development of sculpture which promises to give results such as have not been seen since the great artists of the Italian Renaissance revived many of the glories of classic times. Now we find a host of young sculptors who are extremely well versed in all the details of their craft, and are ready and willing to apply their skill in execution. They do not despise any opportunities, because they know that they can justify themselves by the manner in

308

368. Antoine Mercié, *David Vainqueur, c.* 1872. London, Bethnal Green Museum.

which they turn to account every chance that comes. They value their originality and they see that it can be better displayed in directions that have been only recently opened up than in the conventional ways which satisfied a previous generation.[45]

The way in which established sculptors were willing to try their hands at a wider range of work than convention had previously sanctioned can be seen in their attention to metalwork. There had been to some extent a sculptural 'presence' in such applied art work previously in the century—Foley had designed a Samuel Courtauld Testimonial Plate in about 1855 (*Civil and Religious Liberty triumphant*)[46] and was responsible for the design of the Seal of the Confederate States of America in the 1860s.[47] Armstead, as we have seen, had extensive experience in this type of work, and John Bell, indeed, had exhibited at the Great Exhibition of 1851 an 'Hours' clock made by Elkington's, a matchbox in the form of a Crusader's Altar Tomb (made in Parian by Minton and in ormolu by Dee and Fargues), and a door-stopper in the form of Cerebus with the heads of a bull-dog, a blood-hound and a deer-hound, made by Stuart and Smith of Sheffield, bearing the inscription 'Welcome to come but not to go'.[48] But Bell was, to put it mildly, somewhat unusual in what he got up to. Going still further back, both E. H. Baily and his master Flaxman before him had considerable metalwork experience, but by and large, for trophies and other such work in applied metal to be done by sculptors rather than professional craft designers was fairly exceptional.

Within the New Sculpture movement in this respect things were different. Alfred Gilbert was responsible for the Badge of Office of the President of the Royal Society of Painters in Water Colours (R.A. 1891),[49] and for the Mayor's chain for Preston, Lancashire (R.A. 1892).[50] He executed an Epergne in silver and a Rosewater Ewer and Dish of 1898, also in silver, both done for presentation to Royalty,[51] and the Victoria and Albert Museum has in its collections six spoons with decorative handles by Gilbert.[52] Goscombe John designed the Hirlas Horn for the Gorsedd of Bards (1898),[53] elaborate Regalia for the 1911 Investiture of the Prince of Wales (e.g. Chaplet, Verge, Ring and Sword),[54] plus an ornate set of Trowel, Mallet and Spirit Level used for the laying of the Foundation Stone of the National Museum of Wales by King George V in 1912.[55]

The work of George Frampton in this field—such as the silver casket decorated with ivory, presented to Field Marshal Earl Roberts by the Merchant Taylors' Company, and now in the Victoria and Albert Museum—is probably the most symptomatic of the new close relationship between sculpture and the applied arts. Frampton's career as sculptor[56] started along conventional lines, exhibiting first at the Academy in 1884 and producing from then on portraits, ideal works, and so on. But his sympathies were soon engaged in French Symbolism, he became recognised as a leader of the Arts and Crafts Movement, he became joint head of the London County Council Central School of Arts and Crafts, with W. R. Lethaby, in 1894, and in 1902 he served as Master of the Art-Workers' Guild, for whom he made a Master's Badge. His distinctive and unconventional approach to sculpture is evident even in recognisable, traditional genres: his relief work, whether of ideal subjects or in portraiture, can be exceptionally subtle in its shallowness—see for instance the portrait of Charles Keene, dated 1896, of which a number of versions are recorded (Tate Gallery; Passmore Edwards Library, Shepherd's Bush, London; Bury Art Gallery)—while his extensive use of polychromy, in all sorts of subjects, points to a desire to merge the material boundaries that had been previously held to separate art and craft.

A similar breaking down of traditional craft categorisation seems to have occurred in the field of medalwork.[57] The art and craft of the medallist was traditionally that of the die-engraver, engraving the design of the medal in the steel block that was to form the die. The actual medals are then made by stamping them out between hardened steel dies

under massive pressure. It was only by about the 1880s that it became technically feasible for the design to be first modelled (which enabled the sculptor to participate), and then transferred to the dies by a Reducing Machine. This invited an entirely fresh approach to the design of medals, and from the 1880s onwards what had been hitherto virtually a closed shop admitted a much wider range of artists. Painters played a leading role in this new development, particularly Legros, who brought with him from France knowledge of the earlier revival there of the cast medal: examples by Legros include portrait medallions such as those of Tennyson and Mill of about 1881. Other painters to be involved were Poynter—his Ashantee Medal dates from *c.* 1874, his *Lily Langtry* and *Capri Girl* from 1882, *Clio* from 1889—and Leighton, who designed one side of the Jubilee Medal of 1887. The other side was by Boehm, indicative of the new interest of sculptors in this type of work; Boehm was also responsible for the cast bronze medallion of Carlyle dating from 1875. Examples by New Sculptors include the 1886 Royal Statistical Society—Guy Medal by Bates, the 1887 Art Union Golden Jubilee Medal by Gilbert, and the Winchester College Quincentenary Medal of 1893 by Frampton. Goscombe John's instinctive mastery of the form was, we are told, outstanding;[58] examples exist in the National Museum of Wales, Cardiff, of both official medals (e.g. Seal of Merthyr Tydfil Corporation, *c.* 1907; Prince of Wales Investiture Medals, 1911) and of individual ones (e.g. *Thomas E. Ellis*).[59]

The new sculptural aesthetic, implicit in the changed attitudes described so far, was particularly apparent in the treatment of the materials of sculpture. There was a considerable increase in the use of terracotta: Roscoe Mullins wrote in his *Primer*:

> Many subjects are more adapted to terra-cotta than to marble, because of the ease with which they can be worked in the softer substance, while if the same detail had to be carved it would entail too much labour to be done except mechanically; thus the ease of touch which is often the charm of terra-cotta would be lost in the harder material worked by tools and measurements . . . When I spoke of some subjects being better adapted to terra-cotta than to marble, I referred chiefly to costume figures which entail much elaboration of dress . . . This is . . . the case with woman's modern dress, which treated in detail is apt to have a frivolous look in marble that it does not possess in terra-cotta . . . domestic subjects generally, are most suitably worked in terra-cotta than in either bronze or marble, both of which materials seem to demand a simplicity and severity of style, and in ideal work a nobility of *motif*.[60]

Dalou had used terracotta extensively for his domestic genre and portrait work in England (plate 363), achieving a precision of modelled detail, with in addition a warmth of handling in the portraiture; his principal English follower, Drury, also used it in his *Mother and Child*, now in Birmingham City Art Gallery (undated, but given to *c.* 1885 due to its closeness to Dalou), with again a warmth and confidence in modelling that marble, bronze or even Parian ceramic could not achieve.

The effective use of terracotta, in conditions ready to respond, explains the rise and fame of George Tinworth (1843–1913).[61] Thwarted initially by his father, a wheelwright, he was furtively encouraged in carving and drawing by his mother, and went to the Lambeth School of Art in 1861 and in 1864 to the Royal Academy Schools. In 1867 he joined the firm of Doulton's, in Lambeth, and remained there for the rest of his life. His principal output was of religious scenes in terracotta relief; he was noticed by Ruskin in 1875, and received two important commissions from the architect G. E. Street: one for a reredos in York Minster (now in the north aisle of the presbytery), dated 1876 and 1879, the other for a series of twenty-eight reliefs for the Guards' Chapel, Wellington Barracks in London in 1878, to commemorate Lieutenant-Colonel E. Pakenham. Most of these were destroyed in the wartime bombing of the nave, though one at least survived,

THERE WAS A MAN OF THE PHARISEES NAMED NICODEMUS A RULER OF THE JEWS THE SAME CAME TO JESUS BY NIGHT

LET NOT THEM THAT WAIT ON THEE O LORD GOD OF HOSTS BE ASHAMED

BETTER COME AT NIGHT AND BE TRUE THEN MAKE A PROFESSION IN THE DAY AND BE FALSE

JOB XXV CHAP 6 VER

THE CHURCH MEETING IT IS A GOOD JOB THAT THE MASTER IS AT HOME. ELSE NONE

WAIT ON THE LORD BE OF GOOD COURAGE AND HE SHALL STRENGTHEN THINE HEART WAIT I SAY ON THE LORD

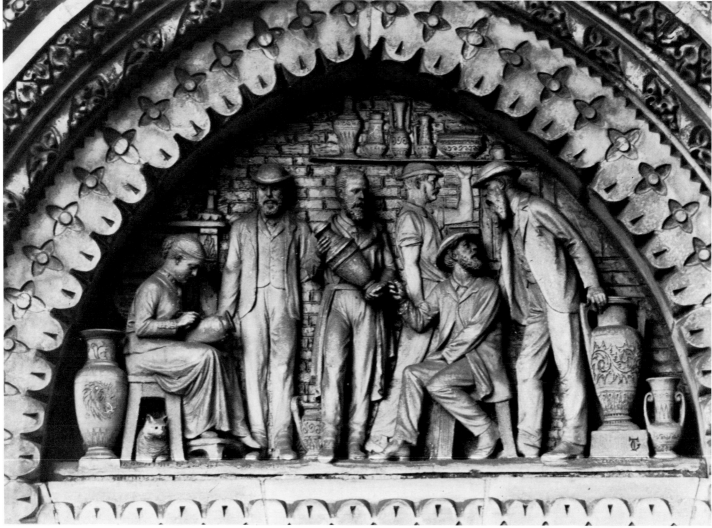

The Raising of Jairus' Daughter. Others feature in Truro Cathedral—*Our Lord on His Way to the Crucifixion*—and at the church of St John the Baptist, Erith in Kent—*The Finding of Moses* and *The Visit of Nicodemus to Our Lord* (plate 369); these were presented to the church by Doulton's. Sir Henry Doulton also presented a monument to Henry Fawcett by Tinworth, once in Vauxhall Park, London, now destroyed.[62] Gleichen describes it as

> A curious production—in terra-cotta throughout. On a very narrow pedestal is seated the revered and blind Postmaster-General, in a decorative and uncomfortable-looking armchair, whilst a large and highly dignified angel stands behind him, holding a laurel wreath over his head. In front of the pedestal squats (there really is no other word for it) Courage, and in rear Justice. But the reliefs on the side are the most precious: on the right are the Post Office (lady at a desk with a flower-pot), Truth, and India (stout lady shading her eyes, palms and pots); whilst on the left, with Sympathy in the centre, are Good News and Bad News, consisting of two solid young women reading letters—with flower-pots and what-nots in the background—in stiff attitudes expressive respectively of joy and despair.[63]

371. Sir George Frampton, *St Christina*, 1889. Liverpool, Walker Art Gallery.

Tinworth was also responsible for the terracotta tympanum, showing Doulton workers (plate 370), on the Doulton Buildings in Lambeth; yet however highly regarded this work may be for representing the proletarian workforce, it is hard not to feel that his work partakes more of a naive charm that was effective only for the moment, and indeed verges on the tricky 'effectism' of a Marochetti in clogs (as Ruskin's backing might lead one to expect), rather than being a significant part of a sculptural mainstream.

The new attitude to materials was perhaps most apparent in the handling of one of the most basic and traditional: bronze. A major factor in Gilbert's striking manipulation of bronze in small-scale figures such as *Perseus Arming* (plate 356) and *Icarus* (plate 353, colour plate III) was the fact that the former was probably the first work by an Englishman to be cast (in fact, in Italy) in the revived 'lost-wax' method. This had historic associations, being the method used for Italian Renaissance statuettes by, for example, Giovanni da Bologna; it had also been revived and extensively practised in Europe for some time during the nineteenth century. Its principal value was as a much more sensitive transmitter of certain subtle surface effects of dappled light and shade, which would in themselves reflect the artist's original modelling. This was all part and parcel of a new aesthetic which called for small-scale art objects, appropriate to a domestic setting, which large-scale heavyweight statements in massive marble or flat, sand-cast bronze could not conceivably fit, being more suited for a conservatory (for more on this, see p. 341). Subtlety and intricacy in bronze handling can be seen in the way certain sculptors used relief-work: Bates's relief *War* (plaster in the Tate Gallery; bronze in Manchester City Art Gallery) has intricacy of detail in shallow relief that would defy execution in marble, while in Frampton's *St Christina* (plate 371) (Walker Art Gallery, Liverpool, dated 1889) the effect of the cast bronze relief is so shallow as to be almost evanescent. In bronze relief roundels such as *Post Equitem Sedet Atra Cura* by Gilbert ($16\frac{1}{2}$ inches in diameter, exhibited in plaster at the Royal Academy in 1887; bronze cast in Birmingham City Art Gallery) or Henry Pegram's *Ignis Fatuus* (plate 384) (dated 1889; just over 20 inches in diameter, an example is at the National Museum of Wales, Cardiff), both artists run to a full repertory of detailing and lighting effects that the bronze in relief is particularly suited to convey.

Material interest is also shown in the use of mixed media. Sometimes this affected only part of a work, as in Gilbert's *Joule* in Manchester Town Hall (plate 372), where the marble mass of the figure is offset by the small metal scientific instrument he holds in his hand; or in Bates's *Pandora* (Tate Gallery, exhibited at the Royal Academy 1891) whose

369 (facing page, above). George Tinworth, *The Visit of Nicodemus to Our Lord*, Erith, St John the Baptist.

370 (facing page, below). George Tinworth, Tympanum. London, Doulton Buildings.

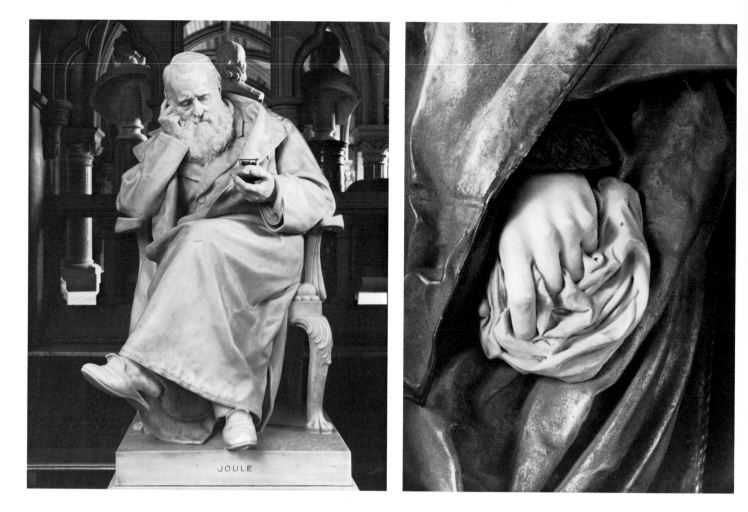

372. Sir Alfred Gilbert, *Joule*, 1893. Manchester, Town Hall.

373. Sir Alfred Gilbert, detail from the Monument to the Duke of Clarence, 1892–9. Royal Collection, Windsor Castle, Albert Memorial Chapel.

box is of ivory and bronze, against the white marble of Pandora herself. More substantial instances include Dame Alice Owen, by Frampton (1897) (colour plate IV), formerly at the Owen School in Finsbury, now at the transferred foundation at Potters Bar. And in the monument to the Duke of Clarence (†1892), in the Albert Memorial Chapel, Windsor Castle,[64] Gilbert uses isolated pieces of white marble to represent the Prince's head, hands and kerchief (plate 373); these are set within a monument which uses polychromy (particularly metallic) to a spectacular degree. The effigy is made of both bronze and aluminium and the screen surrounding the tomb chest carries a series of figures of saints in variegated metalwork and ivory which are justly famous. Gilbert's concern with metals and their artistic use appears to have been lifelong: it was his *Perseus*, as we have seen, that probably inaugurated the use of the lost-wax casting procedure in British late-nineteenth-century sculpture; the principal figure in his Shaftesbury Monument (Piccadilly Circus, London), the *Eros* (plate 360), was almost certainly the first major work of this type to be cast in aluminium*; and both the Clarence Memorial and the earlier Fawcett Memorial (in Westminster Abbey, London, unveiled 1887) make extensive use of coloured metal. Gilbert was friendly with the Professor of Metallurgy at the Royal College of Mines, W. C. Roberts-Austen, who had made discoveries concerning the nature of Japanese laminations, patinas and alloys. Having acquired metallurgic expertise, Gilbert used it in the Fawcett Memorial to achieve a range of

*The use of aluminium for sculpture had been adumbrated as early as 1861. At that date the main feature of the Memorial to the 1851 Exhibition was to be a statue of Queen Victoria of heroic proportions; there were proposals for gilt ornamental work on the statue, possibly coloured enamel, and 'the dove on the sceptre is to be cast in the newly introduced metal, aluminium; and the globe is to be of crystal. These will form very striking innovations.'[65]

314

colours in metal from silver to dark liver-colour, enlivening this with gold and enamel, studded with coral and turquoise.[66]

It should be apparent by now in what ways the New Sculpture was new. Within a decade of Leighton's *Athlete*, new attitudes and concerns, ideas and aesthetic conventions, educational and material principles had manifested themselves on the sculpture scene in England. For the rest of the century, and well on into the following one, the New Sculpture held sway, achieving a position for itself that was virtually supreme—though, as we shall see later, its dominance was not complete.

The new movement was considerably helped by the press it got. Not only did coverage by periodicals continue in, for example, the *Art Journal* (notwithstanding its change of editor and emphases), but new publications such as the *Magazine of Art* and the *Studio* made a point of covering sculpture, and this fitted in with the breaking down of earlier conventions of aesthetic compartmentalisation and the evolution of outlooks applicable to the arts overall. In addition, the New Sculpture was excellently serviced by the quality of the writing; the critical insight and intelligent prose of Edmund Gosse and Marion Spielmann was such that they still inevitably frame our views of the sculptural world of that time.

374. Sir William Goscombe John, *St John the Baptist*, R.A. 1894. Cardiff, National Museum of Wales.

Viewed within a slightly wider temporal context, one sees elements of continuity as well as of change. If one takes for example the field of ideal work, one could see that though there were undoubtedly changes in emphasis, particularly in formal terms, to some extent the same pattern persisted. Subjects drawn from religion still appeared—*St John the Baptist* (plate 374) by Goscombe John (the original version of this, commissioned in block tin by the third Marquess of Bute for his London garden, is now in a private collection; a version in bronze (R.A. 1894) is in the National Museum of Wales, Cardiff), *Eve* by Brock (bronze, 1898, Harris Museum and Art Gallery, Preston), *Eve* by Henry Pegram (bronze, R.A. 1890, Walker Art Gallery, Liverpool), and *Lilith* by Alfred Drury, his diploma work in marble (collection of the Royal Academy, London, signed and dated 1916). In these, as earlier in the century, particularly with the female subjects, the opportunity presented itself for a display of nudity, and with the New Sculpture's new concern for detailed modelling of flesh, the temptation must have been irresistible. The bronzes seem to illustrate the challenge better than Drury's marble.

Literature, past and present, was not ignored. Frampton's *Lamia*, shown at the Royal Academy in 1900, was inspired by Keats's poem of that name; of bronze, ivory and precious stones, the work demonstrates not only the aesthetic principle of polychromy, but also, in the very finely worked incisions (for instance, of flowers) on the surface of the bronze shoulder-pieces, the new application of intricate bronze workmanship. Gilbert Bayes's *Sigurd* (R.A. 1910, now Tate Gallery, London) was exhibited with a quotation from William Morris's *Sigurd the Volsung*, which also features on the base of the statue in Lombardic characters:

> He who would win to the Heavens and be as the Gods on high
> Must tremble nought at the road and the place where men-folk die.

On the lower, larger marble base are two relief scenes along the sides, from the same poem—Brynhilde with the Niblung brothers, Gunnar, Hogin and Guttorm, and their mother Grimhilde, and the body of Sigurd being taken to burial. This is all embodied in a dazzling razzamatazz of bronze, enamel and marble; the work was bought on its being exhibited at the Academy by the Chantrey Bequest for presentation to the nation.[67] In 1912 an anonymous donor presented the London public, the nation and indeed the whole world with another sculptural tribute to literature, *Peter Pan* by Frampton in Kensington Gardens (plate 375), at the spot where Sir James Barrie's boy-hero lands for his nightly visit to the Gardens, as recounted in the author's *Little White Bird*.[68] Piping to the spirits of

315

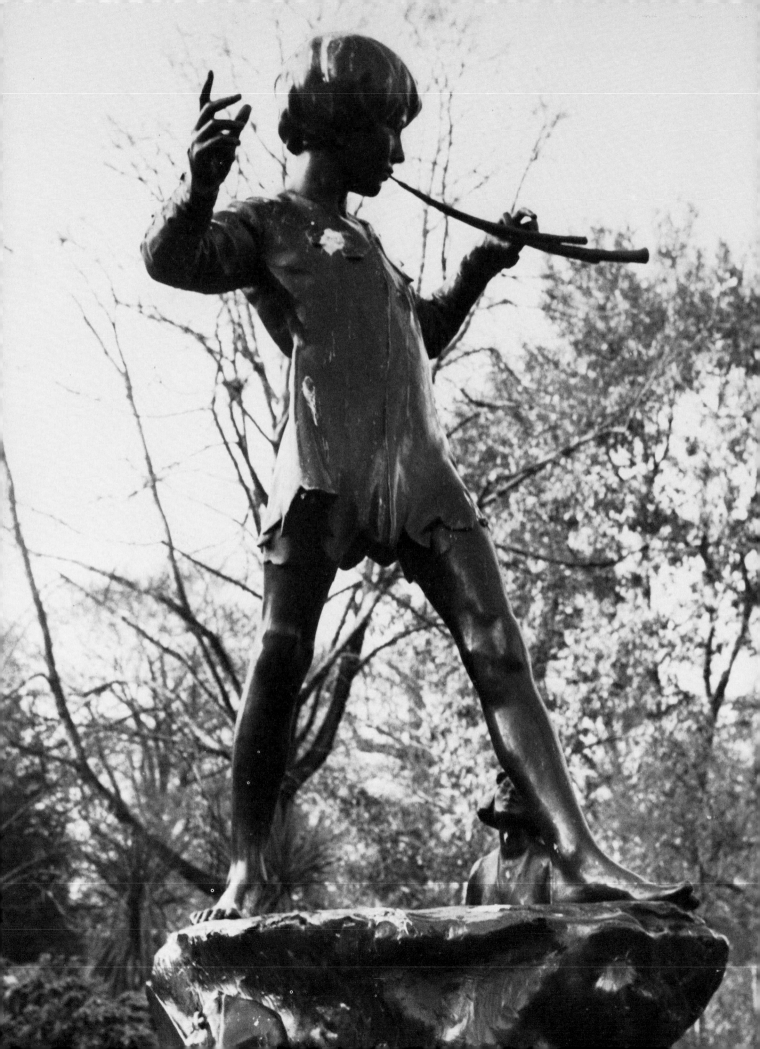

the children who have played there, Peter Pan stands on top of the rock round which cluster, in inquisitive attitudes, fairies, bunnies (plate 376), hares, squirrels, crows, mice and small birds, all offering the sculptor superb opportunity for exploiting to the full the expressive potential of bronze. One should note that notwithstanding the overall literary basis of the work, the figure of Peter himself is to some extent realistic through Sir James Barrie's close relationship with the Llewelyn Davies boys; one in particular (George) was model for the literary character, another (Michael) was to some extent model in the artistic sense for Frampton's statue.[69]

From its very moment of birth, the New Sculpture had had very close ties with classicism, in purer neo-classical form and neo-Renaissance transposition, a dual background prefigured in the loyalties of Lord Leighton, the Movement's midwife, so to speak. Thornycroft's classical works of the 1880s—*Artemis, Teucer* and *Medea* (shown in plaster, R.A. 1888, but not proceeded with due to the commissioner's demise)—represent one classical tradition; while an even closer adherence at this time was that of Harry Bates.[70] In 1883 Bates won the Royal Academy Gold Medal with a relief of *Socrates Teaching the People in the Agora*; this was shown in plaster at the Academy of 1884 and in marble there in 1886; in this latter medium the work was presented to Owen's College, Manchester, by Alfred Waterhouse. At the Academy of 1885, Bates showed three *Aeneas* panels, in 1887 three *Psyche* panels, in 1890 his figure *Pandora* which was bought by the Chantrey Fund and is now in the Tate Gallery. In 1892, when he was elected Associate of the Royal Academy, Bates showed there a relief *The Story of Endymion and Selene*. And even when his subjects did not have a specific classical designation, Bates turned to antique myth for his settings, as with his *War* and *Peace* of 1887 (now Manchester City Art Gallery); the former depicts Hector's Departure from Andromache with, as predella, the Body of Hector Dragged Behind the Chariot of Achilles. Pomeroy's classical subject piece *Dionysus* (various versions known between 1890 and 1909, differing in essentials such as the degree of modesty observed, achieved by means of foliage in the god's hand) is in turn neo-Renaissance in type and in size (2 foot 8½ inches high) as well as in quality of modelling, though in treatment of subject—gesticulative, almost incidental genre— it is more of its own time. James Havard Thomas[71] (1854–1921) was in a way a special case; after training in England and France, he spent seventeen years in Italy (1889–1906)

375 (facing page). Sir George Frampton, *Peter Pan*, 1912. London, Kensington Gardens.

376. Sir George Frampton, detail from *Peter Pan*, 1912. London, Kensington Gardens.

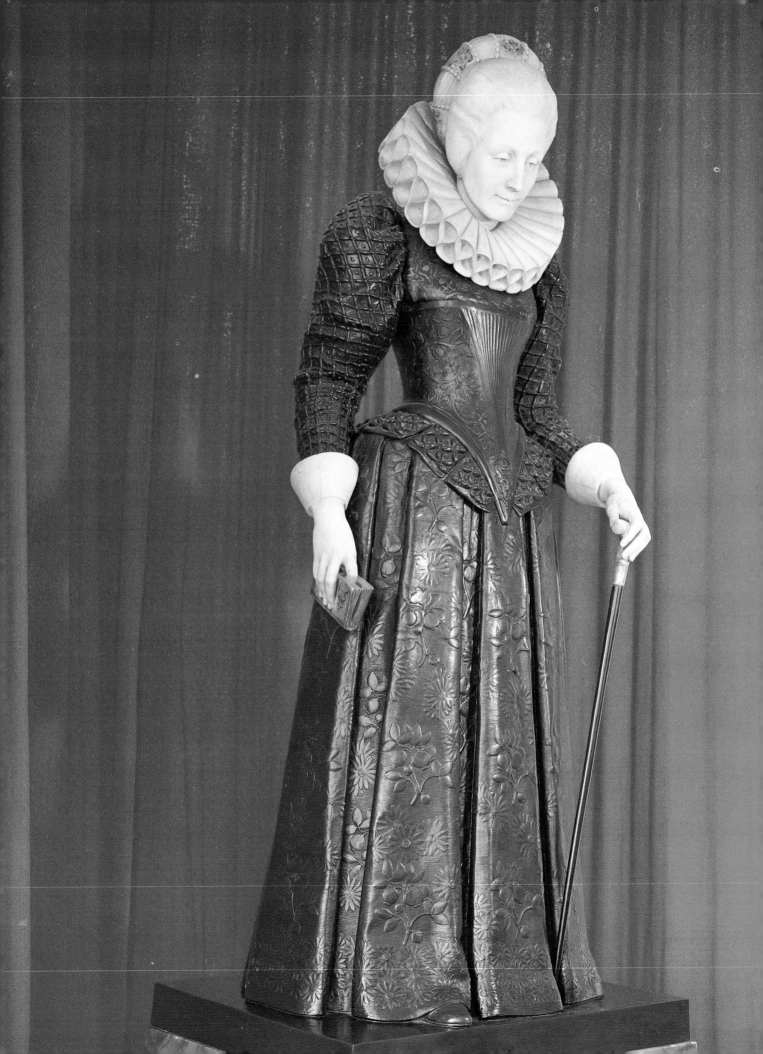

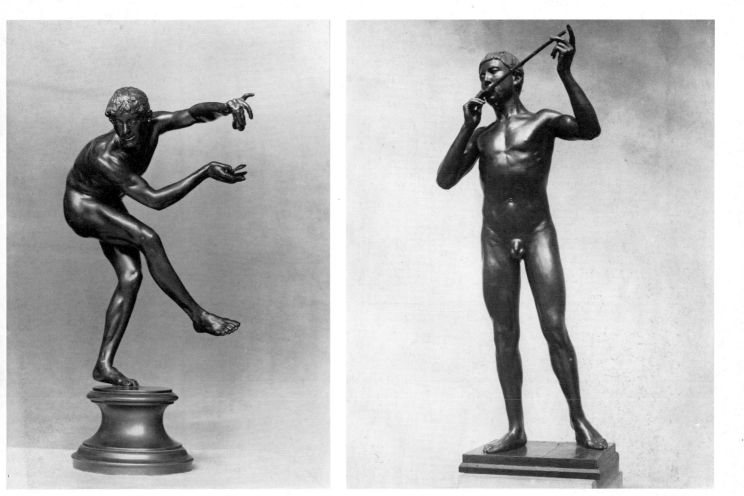

where he worked at a bronze foundry near Naples. While his figures could be gesticulative (for instance *Castagnettes* (plate 337) at the National Gallery of Victoria, Melbourne), others were such as *Lycidas* and *Thyrsis*. The former portrays a young shepherd who catches sight of nymphs in the stream below, and stands tense and eager on its brink. Norman Douglas claimed to have chosen the name of the statue, 'Thomas having asked me to root out a well-sounding and classical one which, however, was to convey no definite suggestion; he wanted some thing vague and yet distinguished. I hit upon Lycidas because it belonged to three or four persons in antiquity, none of any great importance.' The figure is life-size and nude; it is signed and dated 1902–8, various versions exist. The Tate bronze version was apparently finished 'in the ancient Greek manner', that is by working on the surface with files, and also by inlaying where there were imperfections. The result is a close, polished texture that took three months to achieve. *Thyrsis* (plate 378) is also a life-size male nude, playing a flute. The original version of this, of 1912, is of wood and black wax, but a number of bronze versions were executed by the artist (e.g. at Johannesburg Art Gallery, signed and dated 1913; at Manchester City Art Gallery, signed and dated 1914—this version was exhibited at the Royal Academy that year; and one at the National Gallery of Victoria, Melbourne, Australia, also signed and dated 1914. In 1948 the Trustees of the Tate Gallery cast a further version in bronze from their 1912 original).

The two poles of the New Sculpture's classicism are perhaps best represented on the one hand by Pomeroy's *Perseus* of 1898 (plate 379), an eighteen-inch reduction in bronze of a life-size plaster original, magnificent none the less, harking back to Gilbert's statue of sixteen years earlier in its taut pose, flesh and musculature ripplingly rendered in bronze; on the other hand there is Bates's life-size group *Hounds in Leash*, classical by virtue of the snood that ties back the hair of the nude, restraining huntsman (plate 380).

377. James Havard Thomas, *Castagnettes*. Melbourne, National Gallery of Victoria.

378. James Havard Thomas, *Thyrsis*, 1912/1948. London, Tate Gallery.

Colour plate IV. Sir George Frampton, *Dame Alice Owen*, 1897. Potters Bar, Dame Alice Owen School.

319

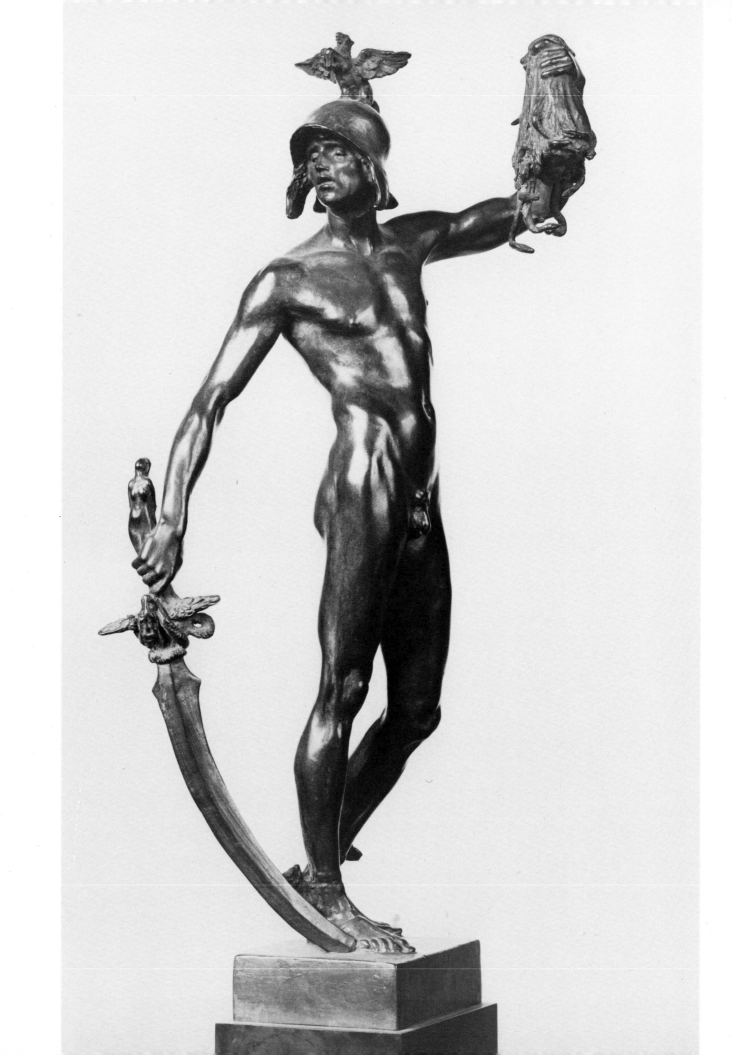

380. Harry Bates, detail from *Hounds in Leash*, 1889. Collection Earl of Wemyss and March.

Commissioned by the Earl of Wemyss and March, exhibited at the Royal Academy of 1891, the group (plate 381) now stands in front of a facade of Gosford House, East Lothian (whose rebuilding in late-nineteenth-century classical style was finished in 1891), where its determined energy is immortalised in bronze, leaping out for the unwary caller.

At the other end of the spectrum from this classicism one might place Frampton's *Mysteriarch* (Walker Art Gallery, Liverpool, signed and dated 1892) (plate 382)[72] a work in polychrome plaster that could be said to illustrate Franpton's considerable interest in French Symbolism. It was shown at the Paris International Exhibition of 1900, where it won a medal of honour; Frampton exhibited elsewhere in Europe, for instance with the Vienna and Munich Secessions and with the Libre Ésthetique, Brussels. There was a certain tendency towards spiritualistic, perhaps slightly ethereal, misty subject matter in some quarters of the New Sculpture: we have already met Gilbert's relief *Post Equitem Sedet Atra Cura*—'Behind the Horseman Sits Dark Care' and Pegram's *Ignis Fatuus* (plate 384). The latter represents a woman sitting on a throne, her right hand supporting her head; she is forsaken, like the broken bow at his feet, by the man to her right in cloak and helmet, who stretches up his arms above her towards human heads with wings of birds and bats, chimeras of his ideal imaginations and desires.[73] This all seems a world away from Calder Marshall's *The First Whisper of Love* (plate 272).

There was, in the New Sculpture's ideal works, a considerable amount of middle-of-the-road domestic genre: Drury's *The Kiss* in bronze, Hamo Thornycroft's *The Kiss* in marble (1916, Tate Gallery), each basically a study of a woman and child in the nude. Goscombe John's *Boy at Play* (London, Tate Gallery) is a life-size bronze nude; it was shown at the Royal Academy in 1896. Onslow Ford decked out his female nude genre pieces with a semblance of reference, historic or symbolic: *Folly* (Tate Gallery, R.A. 1886; sometimes claimed as the first work cast by the revived lost-wax method actually in this country), *The Singer* (ancient Egyptian, Tate Gallery, R.A. 1889), or *Peace* (Preston, Harris Museum and Art Gallery, R.A. 1890) (plate 383). Others gave their varying titles and appearances: for example Pomeroy's *Love the Conquerer* (Walker Art Gallery,

379 (facing page). Frederick William Pomeroy, *Perseus*, 1898. Newcastle-upon-Tyne, Laing Art Gallery.

321

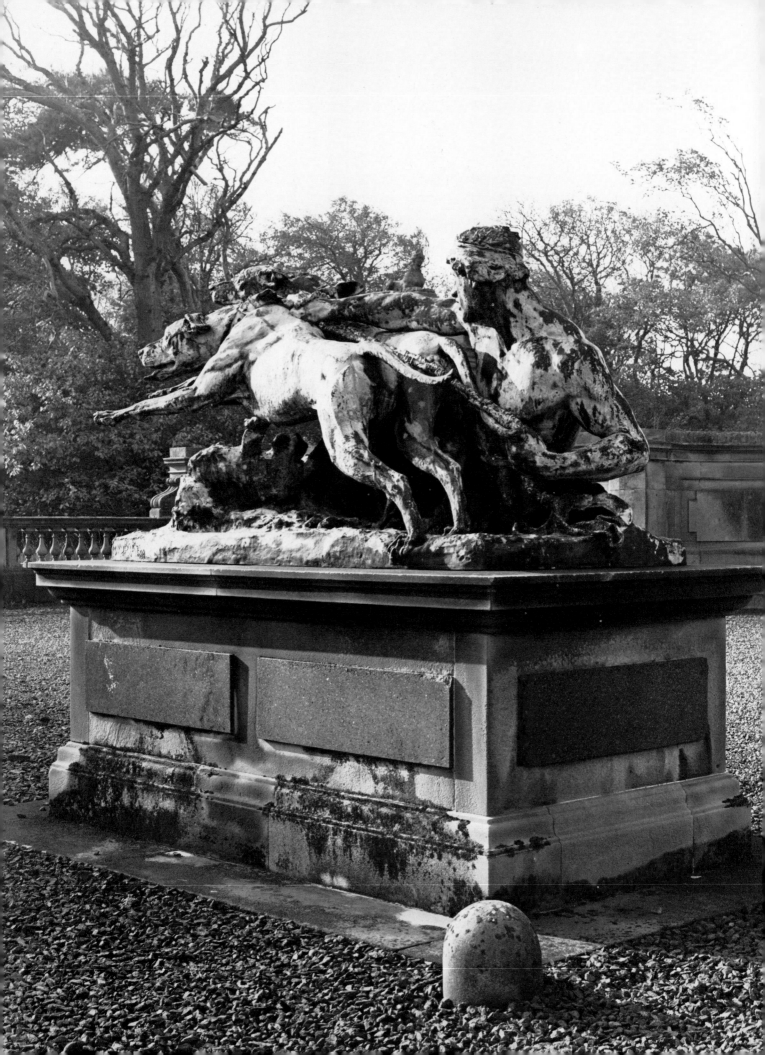

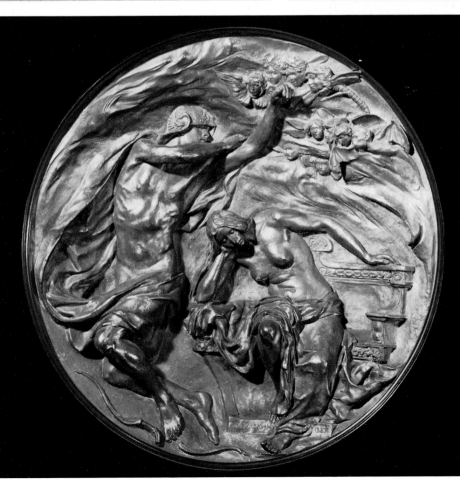

382. Sir George Frampton, *Mysteriarch*, 1892. Liverpool, Walker Art Gallery.

383. Edward Onslow Ford, *Peace*, R.A. 1890. Preston, Harris Museum and Art Gallery.

384 (left). Henry Pegram, *Ignis Fatuus*, 1889. Cardiff, National Museum of Wales.

381 (facing page). Harry Bates, *Hounds in Leash*, 1889. Collection Earl of Wemyss and March.

385. Sir William Goscombe
John, *The Elf*, 1898. Cardiff,
National Museum of Wales.

386. Francis Derwent Wood,
Nude. London, Chelsea
Embankment.

387 (facing page). Sir William
Hamo Thornycroft, *The Mower*,
1884. Liverpool, Walker Art
Gallery.

Liverpool, bronze, R.A. 1893: naked woman), Goscombe John's *The Elf* (plate 385)
(plaster, R.A. 1898; marble, R.A. 1899, now Glasgow City Art Gallery; bronzes in
Diploma Gallery, Royal Academy and the Welsh Folk Museum, St Fagans, on loan from
Cardiff: each of these representing a life-size, crouching, naked woman); Goscombe
John's *Joyance* (plaster, R.A. 1899; bronze replica at St Fagans: life-size figure of naked
boy on tiptoe), and Bertram Pegram's *Serenity* (location unknown; exhibited R.A. 1903:
standing woman, clothed).

The frequent use of the nude is not surprising, considering the movement's
preoccupation with surface effect. It could be used for a memorial—*Glory to the Dead* by
Onslow Ford (1901, formerly Nettlefold Collection); Derwent Wood's Machine Gun
Corps Monument, alias *David* (Hyde Park Corner, London, unveiled in 1925)—or simply
for its own sake, as in Goscombe John's *Boy at Play* already mentioned, or in another
example (plate 386) by Derwent Wood on Chelsea Embankment, London, later to serve
as a memorial to the sculptor, set up by members of the Chelsea Art Club. And the desired
effect was not to be found only in bronze: Onslow Ford's Shelley Memorial of 1892
(Oxford, University College), Pomeroy's *Nymph of Loch Awe* (London, Tate Gallery,
signed and dated 1897) and Onslow Ford's *Snowdrift* (Port Sunlight, Lady Lever Art
Gallery, exhibited at the Royal Academy of 1902) all use the shine of white marble, the
latter work in particular using the contrast between the smooth marble flesh of the body
and the matte marble snow on which it reclines with some skill.

There were apparently some limits to what was acceptable in the 1880s. When
Stirling Lee showed his *Dawn of Womanhood* at the Royal Academy of 1883, never, so Gosse
reported, had anything of the kind been seen in England in which crude realism had been
carried so far. It was like an absolute cast from the flesh (the same point made, at very

324

different times, about E. H. Baily's *Eve* and Rodin's *Age of Bronze*); there was no selection of type, no striving after beauty of line; the figure was a literal copy of an ugly, naked woman.[74] Three years later, at the Academy of 1886, Rodin had a work refused; it is thus clear that, for all the naturalism that Leighton's *Athlete* championed, reality had to be tempered by latent idealism and 'art'. British taste was prepared to accept the Leighton, but it would not go, at any rate in the Academy, so far as to accept Rodin's ruder realism. 'On the whole, the national temperament continued to shrink from the "voluptuousness of the Modern French School", the rolling eye, the bounding bosom and the mature bodies portrayed by the French naturalists.'[75]

When an element of social realism appeared, it too was somewhat tempered. Hamo Thornycroft showed *The Mower* at the Academy of 1884, in plaster. It carried a quotation with it in the catalogue, from Matthew Arnold's *Thyrsis*:

> A Mower, who, as the tiny swell
> Of our boat passing heaved the river grass,
> Stood with suspended scythe to see us pass.

Some detected elements of other moods, of Fred Walker's sentiment (in painting) and of the ideal realism of certain French sculptors such as Coutan and Albert Lefevre.[76] Nevertheless the figure was literally from the life of today, seized from observation, a man seen from a boat and quickly noted in a sketch book.[77] In a way, it is Leighton's *Athlete* in modern dress, a figure posed in slight tension, to allow a full gamut of naturalistic detailing to be displayed in bronze (plate 387). (It was exhibited in that medium at the 1894 Royal Academy, and is now in the Walker Art Gallery, Liverpool.) And it shows that, under the new sculptural aesthetic, the rendering of modern dress in bronze, that had been the bugbear of statuary for so long, need no longer be a problem. Thornycroft followed up *The Mower* with *The Sower* in 1886; an example cast posthumously in bronze is to be found in Kew Gardens.

CHAPTER TEN

'Something new, something old . . .'

For all the distinctive qualities of the New Sculpture that have been traced so far, the basic framework of the profession continued as before, though in certain areas the new formal contribution brought striking changes. Busts continued to be in public and private demand: in the London Law Courts there are busts of Lord Collins (1843–1911), Master of the Rolls, by Derwent Wood and of Sir Samuel Thomas Evans (1859–1904), President of the Probate, Divorce and Admiralty Division by Frampton. The London Royal College of Surgeons commissioned a bust of Lord Lister from Brock in 1912; the sitter's nephew called it 'extraordinarily good'.[1] And St George's Hospital, London, own the magnificent bronze bust of Dr Hunter by Gilbert, which they commissioned in 1893 (plate 388). The Tate Gallery possesses a bust of Mrs Asher Wertheimer by Havard Thomas (signed and dated 1907) which had been commissioned by the sitter's husband, the art dealer. Busts continued in use for ideal subjects: Drury's *Griselda* (example in the Tate Gallery, bronze, signed and dated 1896) comes from a story by Boccaccio, repeated by Chaucer; Drury was also the author of *The Age of Innocence*, the bust of a young girl (plate 389) (various versions, various places, various materials). Even in the bust form, sculptors sometimes excelled themselves in displaying the liberty of formal treatment that their new attitude to materials allowed: Gilbert's *Dr. Hunter* displays an amazing range of planar handling and deep undercutting and variegated surface treatment; while Stirling Lee's bust of Margaret Clausen (London, Tate Gallery, *c.* 1907) uses marble to enhance a quality of evanescence that the sculptor developed to a fine art in his shallow relief work.

Church monuments continued to be put up, though in rather smaller numbers; perhaps space was running out, or stained glass window memorials offered a more dazzling, more immediately apparent and cheaper alternative. National church monuments certainly continued: that to the American poet Longfellow in Westminster Abbey, London (plate 390) takes the form of a bust by Brock (erected 1884); that to the blind Postmaster General, Henry Fawcett, by Gilbert (1885–7) is also at Westminster, as is Goscombe John's elaborate monument to the third Marquess of Salisbury of 1906. A larger proportion were now set up in St Paul's Cathedral, London: to Randolph Caldecott (†1886), Frank Holl (†1887) and the Earl of Lytton (†1891), all by Gilbert; to E. V. Neale (†1892), Sir Walter Besant (†1901), Sir G. Williams (†1905) and R. J. Seddon (†1906), all by Frampton. Church dignitaries continued to get their local dues—for instance the monument to Bishop Goodwin (†1891) in Carlisle Cathedral, by Hamo Thornycroft, signed and dated 1894, a finely and elaborately modelled bronze effigy, supported by two putti. The monument to Bishop Lloyd in the Cathedral of St Nicholas, Newcastle-upon-Tyne (plate 391), incorporates an effigy by Pomeroy, signed and dated 1908. Gilbert's memorial to Lord Arthur Russell, in the Bedford Chapel, St Michael's Church, Chenies in Buckinghamshire takes the form of a bronze candelabrum with halfway up four figures of Truth, Piety, Charity and Courage; the work was commissioned in 1892, and completed in 1900.[2] His memorial to J. B. Thynne (†1887) in

388. Sir Alfred Gilbert, *Dr Hunter*, 1893. London, St George's Hospital.

389. Alfred Drury, *The Age of Innocence*, 1908. Blackburn, Art Gallery.

390. Sir Thomas Brock, Monument to Henry Wadsworth Longfellow, 1884. London, Westminster Abbey.

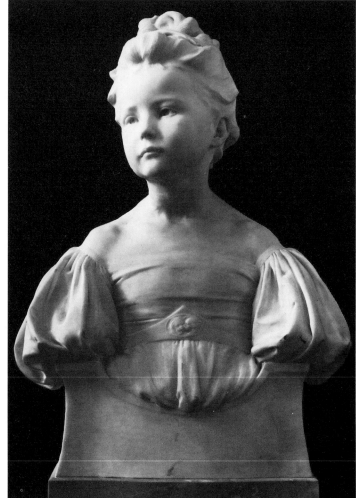

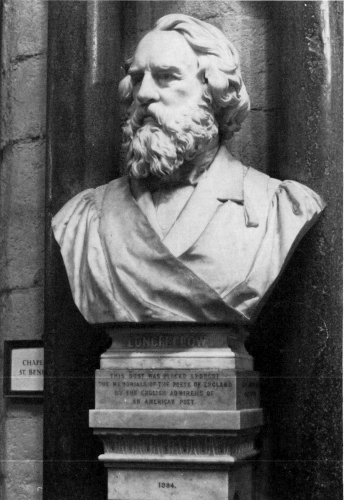

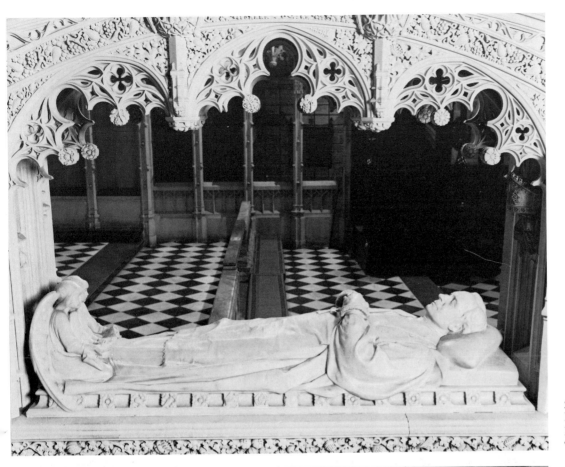

391. Frederick William Pomeroy, Monument to Bishop Lloyd, 1908. Newcastle-upon-Tyne, Cathedral.

392. Sir Thomas Brock, Monument to Lord Leighton, 1902. London, St Paul's Cathedral.

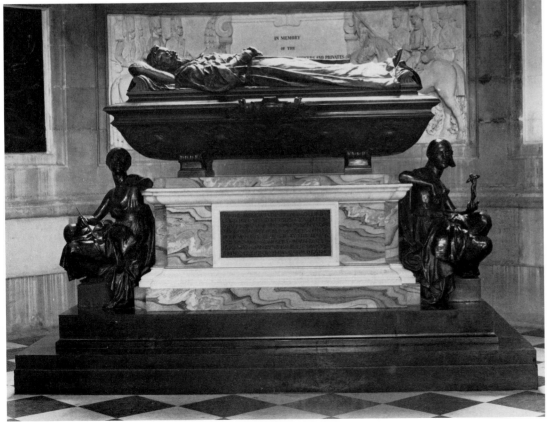

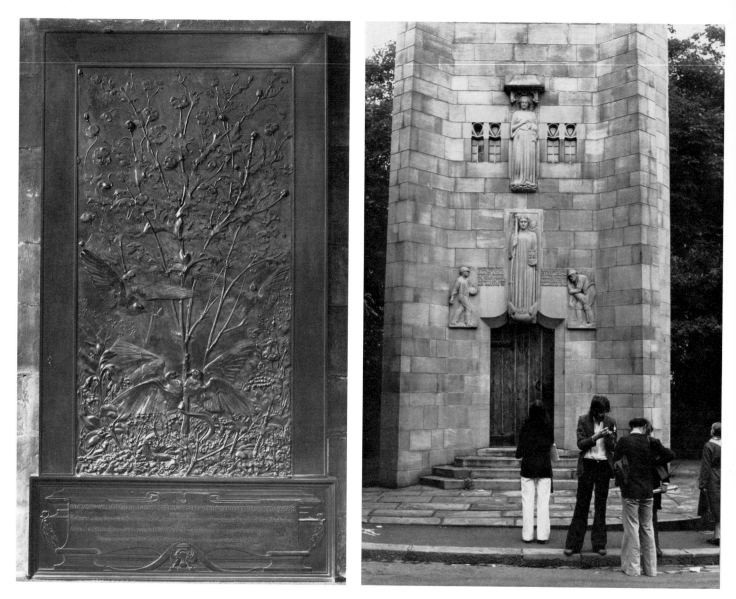

393. Sir Alfred Gilbert,
Monument to William
Graham. Glasgow Cathedral.

394. Thomas Stirling Lee,
decorative sculpture, c. 1902.
Huddersfield, Lindley clock
tower.

the church of Sts Peter and Paul, Longbridge Deverill, Wiltshire, takes the form of a font (exhibited R.A. 1900); but being by Gilbert it is no ordinary piece of church furniture— 'The forms gristly, crustaceous, bossy—how should one describe them' is Pevsner's apt comment.[3] Gilbert's monument to William Graham (†1855) of Burntshields, County Renfrew, in Glasgow Cathedral (plate 393), takes the form of a magnificent shallow relief: it represents Death under happy and hopeful associations. The slight mound at the foot stands for the tomb; the doves are messengers of joy, tokens of purity and love: the bright leaves and flowers, conspicuous among them the poppy, emblem of sleep, tell of the rest and joy of the future awakening. There follows a quotation from Longfellow. The memorial to Isabel, daughter of the seventh Duke of Roxburghe and wife of the Honourable Guy Wilson, who died in 1905, includes a full-length effigy by Frampton; this is at Warter, in the East Riding of Yorkshire. Another monument by Frampton (more modest), to General W. S. A. Lockhart, is in St Giles's Cathedral, Edinburgh; this is signed and dated 1908. The monument to Ellen Webb (†1919) in the Municipal Cemetery, Tunbridge Wells, Kent is by Goscombe John; it portrays a large mourning figure above the inscription 'Mors Janua Vitae'. But perhaps the most poignant of the New Sculpture's funerary monuments is that to Lord Leighton in St Paul's Cathedral, by Brock (plate 392). Here the man to whom the movement owed so much lies in effigy, mourned at one end by an allegorical figure of Painting; at the other by a figure representing Sculpture,

330

395. Sir William Hamo Thornycroft, detail from frieze, 1889–93. London, Institute of Chartered Accountants.

holding in her hand a miniature of Leighton's *Sluggard*, the figure in origin a model caught naturally stretching after a long period fixed in his pose, perhaps symbolising the art of sculpture flexing itself for renewed activity after a long time in the shackles of convention—this being Leighton's particular historic contribution to the art in this country.

The field of architectural sculpture was something the movement's apologists, then and now, consider it made particularly its own. Certainly awareness of the wider, decorative connotations of sculpture would predispose artists to a more satisfactory blending of plastic and structure, and the much more liberal attitude to formal handling would enable them to produce work of a particular suitability. This was not necessarily always the case; the series of busts of eminent watercolourists by Onslow Ford in niches along the facade of Robson's Royal Society of Painters in Water Colours in Piccadilly, London (building of 1881) are as much applied art works as are the statues to the rear of Burlington House nearby, of a decade earlier. The same could be said of Frampton's lions at the entrance to the King Edward VII galleries at the British Museum—Burnet's building was completed in 1914.

On the other hand, Hamo Thornycroft's bronze plaque commemorating Richard Norman Shaw fits snugly but unobtrusively on to the outside of Shaw's Scotland Yard building (it is perhaps too isolated to be particularly effective); and Stirling Lee[4] clearly had something going in his favour in this respect. Having worked in Birnie Philip's studio, Lee won the competition for sets of reliefs to go round the base of St George's Hall, Liverpool; six of these represent *The Story of Justice*: for instance *The Womanhood of Justice*, and *Justice having Attained Maturity Upholds the World Supported by Knowledge and Right*. Six other reliefs tell *The Story of Liverpool*, but Lee only executed two of these, the others being done by two locally based artists, Conrad Dressler and Charles Allen. Lee was also involved with the architect Edgar Wood, carving both font and pulpit for Wood's Long Street Wesleyan Church, Middleton, in Lancashire (of 1899–1901) and the sculptural features for Wood's Lindley Clock Tower, Huddersfield (of 1902) (plate 394).[5]

The New Sculpture's command of this field can be seen well on a series of major buildings in London. Belcher and Pite's Institute of Chartered Accountants in Great Swan Alley (erected 1890–3) bears an extensive programme of sculpture principally by Hamo Thornycroft. The building was intended as a practical demonstration of that unity of the arts in which the Art-Workers' Guild believed very strongly—Belcher, the building's chief architect, was chairman of the Guild on to which Hamo Thornycroft was co-opted as sculptor member (so too was Onslow Ford). Thornycroft's work, in which he

was assisted variously by Harry Bates and Charles John Allen, consists in the main of a frieze representing the Arts, Crafts, and Sciences, Education, Commerce, Manufactures, Agriculture. Mining, the Railways, Shipping and Building (plate 395); in this latter section Thornycroft incorporated portraits of Belcher as the Architect, himself as Sculptor, and George Hardie, his carver, as Carver and others (plate 396).[6] Of the other sculpture on the building some was done by Harry Bates (e.g. the Atlantes group at the corner), and Charles John Allen was acting as Thornycroft's studio assistant while the work was in hand. Superb drawings by Thornycroft exist, studies for the frieze which occupied him from 1889 to the end of 1893. Not so far away, Collcutt's Lloyds Shipping Register, London (1900–1) has exterior sculpture by Frampton and Pomeroy; Mountford's Central Criminal Court, Old Bailey (erected 1900–7) has pedimental figures again by Pomeroy and the famous figure of Justice on top of the dome by the same; inside, the pendentives of the dome above the Great Hall on the upper floor were carved by Pomeroy: excellent groups representing *Mercy*, *Charity* (plate 397), *Justice* and *Temperance*, ably designed to fit well into their allotted spans; *Charity* is signed and dated 1906. The front entrance to the Victoria and Albert Museum (building by Aston Webb, erected 1899–1909) is bedecked with sculpture by three of the New Sculpture movement: statues of Queen Victoria, Prince Albert, Inspiration, Knowledge and nine voussoir figure-panels by Drury, spandrel relief compositions of Truth and Beauty by Frampton, with, above, statues of Edward VII and Queen Alexandra by Goscombe John. In addition there is a series of thirty-six figures of British artists along the southern and western fronts of this part of the building, by a large number of artists, only a few of whom were New Sculptors; but these, and the statues of Architecture and Sculpture up in the tower by Lantéri, are very much traditional niche figures, and do not really fit in to the specific context of well-wrought architectural sculpture that the portal work requires.[7] The choice of artists to be represented is quite interesting nonetheless as a statement of accepted opinion at the time. Two sculptors out of six appear for the Victorian period,

396. Sir William Hamo Thornycroft, detail from frieze, 1889–93. London, Institute of Chartered Accountants.

397. Frederick William Pomeroy, *Charity*, 1906. London, Old Bailey.

398. Aimé-Jules Dalou, Group, 1878. Royal Collection, Windsor Castle.

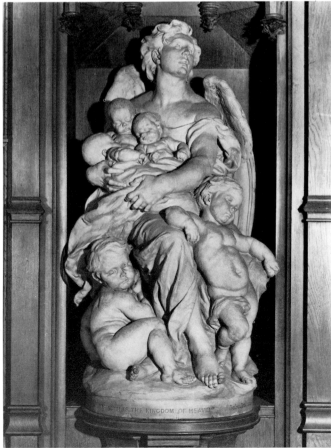

Foley and Stevens, in a way the heroes of the two polarities then current, the 'established' and the 'renegade'. Watts and Leighton also feature, but are placed firmly amongst the painters.

The use of sculpture in churches continued, with a particular conjunction of interests with, say, the Arts and Crafts Movement when sculpture could join in a general, overall scheme of interior decoration. Sedding's Holy Trinity, Sloane Street, in London[8] (consecrated 1890) certainly envisaged extensive figure sculpture: large carved roundels in the spandrels of the arcades to be by Armstead (only two were executed), and figures of the Apostles along the piers, to be by Hamo Thornycroft. Figures in relief along the choir stalls were done by Pomeroy; the cherubim round the shaft of the font were worked by F. Boucher under Onslow Ford; the lectern is by Armstead, while beneath the High Altar is a relief of *The Entombment* by Bates. Intrinsic to these fittings is the bronze memorial to the architect Sedding, who died in 1891 before much work had been done; this is by Pomeroy again. Isolated examples of ecclesiastical New Sculpture include a reredos by Frampton of 1890 in the church of St Mary, Edith Weston, Leicestershire (plate 399): a central panel of *Christ Enthroned in Glory* with the Annunciation going on on either side; this forms also a memorial to the church's rector. Another reredos is that by Gilbert behind the High Altar of St Alban's Cathedral, of 1890–1903 (plate 400). It is no ordinary work; the angels' wings for instance are made of shells that Gilbert 'coloured with all the hues of the sea—pinky, pearly, greeny grey-blues merging into green, soft umbers, and silvery shades'.[9]

To take another aspect of this continuity, the traditional pattern of sculpture continued within the field of patronage, as well as that of formal options and determinants. The Royal Family continued to be substantial patrons of sculpture, carrying on in substance what Prince Albert had established; though obviously, after his death, with the Queen acting on her own or with her children, different principles were involved and other preferences came more to the fore. The Royal family were prominent in their patronage of certain of the New Sculpture movement's precursors—commissioning not least a memorial group from Dalou (plate 398), initially to commemorate Harold, son of Princess Helen Augusta Victoria and Prince Christian of Schleswig-Holstein, who died in 1876; this was to consist of an angel holding a dead child. Later the group was elevated to a more allegorical status, and expanded to include five children; this was possibly to incorporate in addition the memory of Mary, daughter of Princess Alice and Prince Louis of Hesse, who died in 1878. The group in terracotta, signed and dated 1878, is in the Private Royal Chapel at Windsor; the children concerned were Queen Victoria's grandchildren.[10]

However the main mantle of royal favour fell on Sir Joseph Edgar Boehm, whose position in the life of the nation's sculpture we have already examined, not least his relationship to the New Sculpture Movement (see above, pp. 297–8). Boehm was to become Sculptor in Ordinary to the Queen, and the range of works he produced for the Royal Family was considerable. Among these was a series of funerary monuments and effigies, including one to Queen Victoria's father, Edward, Duke of Kent, who died in 1820 and was commemorated by the Queen in 1874 with a monument originally in St George's Chapel, Windsor but transferred to the Royal Mausoleum at Frogmore in 1950; the work is signed and dated 1874.[11] Another monument by Boehm at Frogmore commemorates the Queen's daughter Princess Alice, Grand Duchess of Hesse, who died in 1878 of diphtheria shortly after her daughter Mary (the second child possibly commemorated in the Dalou monument). The Queen wrote in her diary: '. . . I decided with Bertie [the Prince of Wales] as we left the Mausoleum . . . to have a reclining statue of our beloved Alice placed there, and he at once suggested Boehm in which I quite agree . . . Told Bertie I should like to add sweet little May to Alice's statue, which he equally

399 (above). Sir George Frampton, Reredos, 1890. Edith Weston, St Mary.

400 (below). Sir Alfred Gilbert, detail from Reredos, 1890–1903. St Alban's, Cathedral.

335

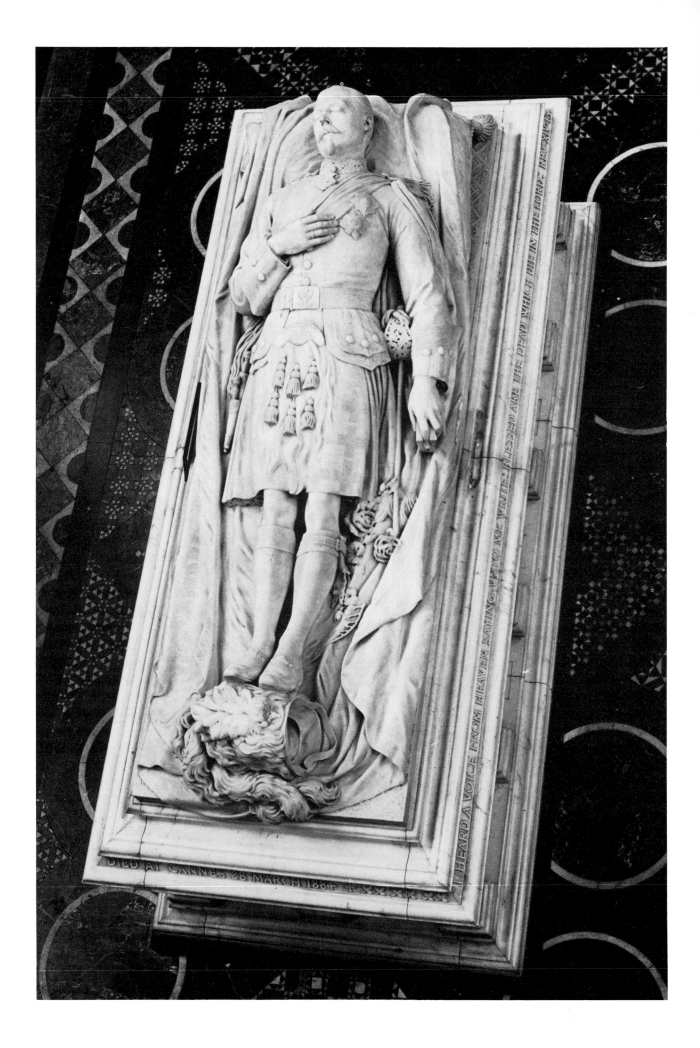

I HEARD A VOICE FROM HEAVEN SAYING UNTO ME WRITE BLESSED ARE THE DEAD WHICH DIE IN THE LORD · RAE VI B·

DIED AT CANNES 28 MARCH 1881·

thought would be very appropriate and beautiful . . . He had seen Boehm who would at once set about a model.'[12] When the Duke of Albany died in 1884 he was commemorated with an effigy by Boehm (plate 401) in the Albert Memorial Chapel at Windsor; the Emperor Frederick of Germany, husband of the Princess Royal, was commemorated with a statue by Boehm in the Frogmore Mausoleum, after his premature death in 1888.[13]

Boehm was very much concerned with the living also, as can be seen in the statue of the Queen herself in front of Windsor Castle, as well as a more domestic representation of her at a spinning wheel (plate 402) (examples at Windsor and Osborne). He also executed likenesses of Royal favourites, human and animal—*Sanjah Ahmad Husain* of 1890, at Osborne, as well as *Prince Leopold, A Herefordshire Bull* (signed and dated 1872), *Noble*, the Queen's favourite collie, aged fourteen (plate 403) (signed and dated 1884) and *Jessie*, Queen Victoria's favourite mare (signed and dated 1887). These are all currently at Osborne.

After Boehm's death, the principal patronage of the Royal Family went to a New Sculptor, Alfred Gilbert. The Prince of Wales commissioned from him one of his major works, the Memorial to the Duke of Clarence,[14] 1892–9 (and 1926–8) in the Albert Memorial Chapel at Windsor (plates 404, 405) (see above p. 314). In 1896 Gilbert was commissioned by Queen Victoria to set up a metal screen or grille in the parish church at Whippingham in the Isle of Wight, near Osborne, to commemorate her son-in-law Prince Henry of Battenberg, who had been Governor of the island. A further figure of St George by Gilbert (a version of one of the statuettes on the Clarence Memorial) was installed by the Royal Family above the royal pew in the parish church at Sandringham in 1910.[15] Other New Sculptors employed by the Royal Family included Onslow Ford: his bust of Leopold of Battenberg at Osborne is signed and dated 1898; his

402. Sir Joseph Edgar Boehm, *Queen Victoria at the Spinning Wheel* (plaster), 1869. Royal Collection, Osborne.

403. Sir Joseph Edgar Boehm, *Noble*, 1884. Royal Collection, Osborne.

401 (facing page). Sir Joseph Edgar Boehm, Monument to the Duke of Albany (†1884). Royal Collection, Windsor Castle, Albert Memorial Chapel.

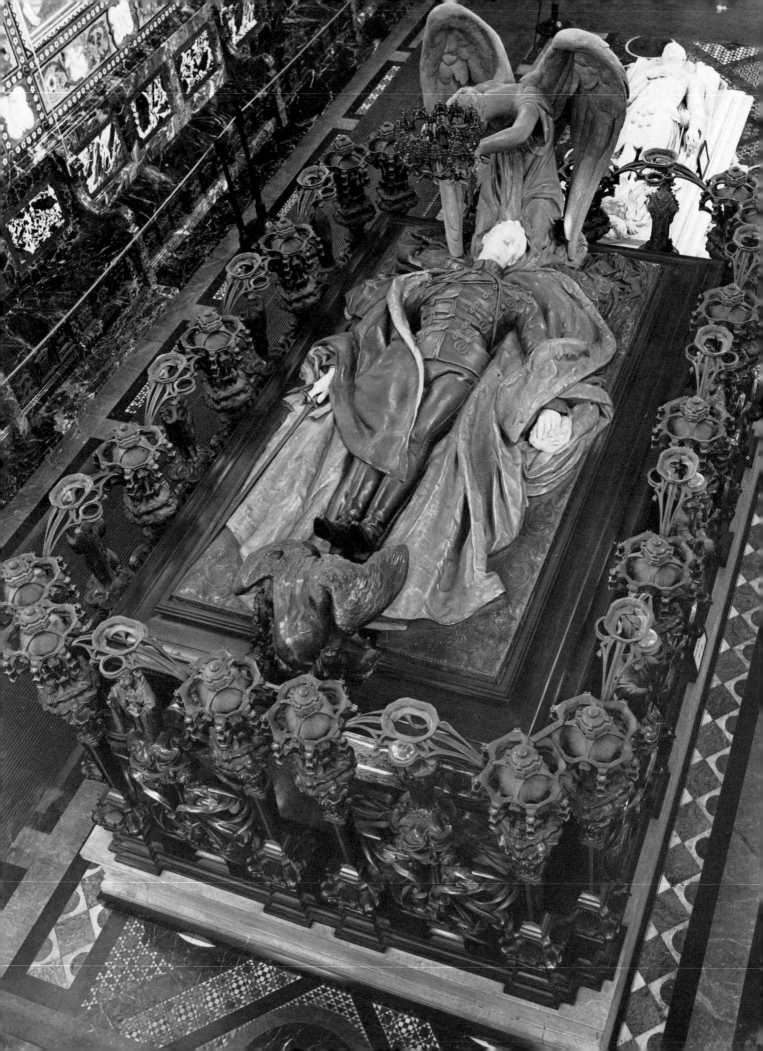

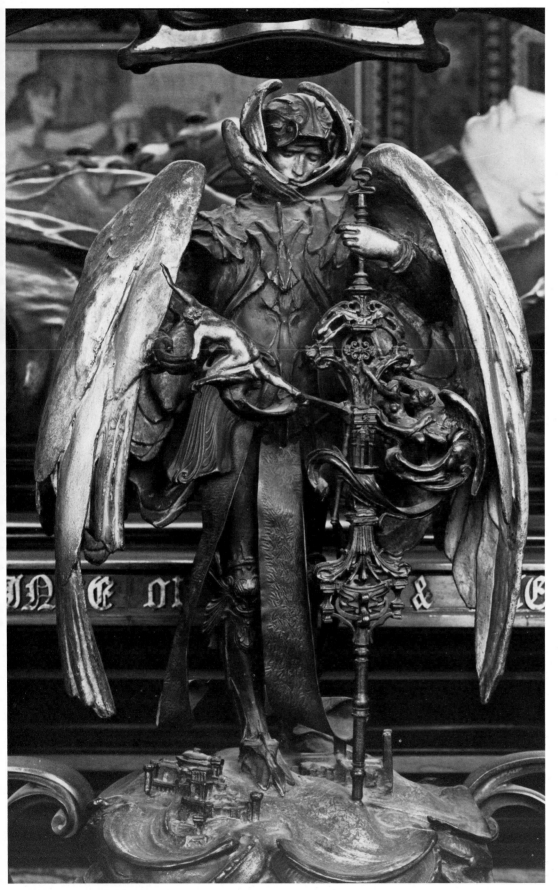

404 (facing page). Sir Alfred
Gilbert, Monument to the
Duke of Clarence, 1892–9.
Royal Collection, Windsor
Castle, Albert Memorial
Chapel.

405. Sir Alfred Gilbert, detail
from the Monument to the
Duke of Clarence, 1892–9.
Royal Collection, Windsor
Castle, Albert Memorial
Chapel.

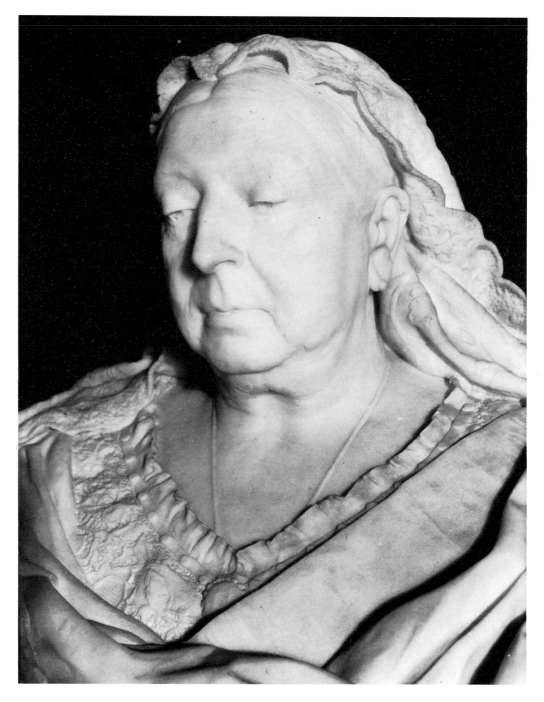

406. Edward Onslow Ford,
Queen Victoria, 1899. London,
Mansion House.

bust of the Queen herself, for which she gave sittings, was begun at Osborne in 1898, then continued and completed at Windsor.[16] The latter originated as a study for his Manchester statue of the Queen (see later pp. 360–3). But it exists also as an independent bust work in various versions, the Queen being so pleased with it she gave several replicas in marble and bronze to members of the Royal Family, while still more were made for civic buildings and institutions all over the country—including a marble version at the Mansion House, London, presented in 1900 by G. P. Ernst (plate 406).[17] Goscombe John was responsible for the memorial statue of Prince Christian Victor of Schleswig Holstein (R.A. 1904) on the approaches to the Castle at Windsor; he also executed for George V the marble medallion of Queen Alexandra placed in Sandringham Church, of 1933 or 1935.[18]

Private, individual patronage continued, as before, over a wide social (if not financial) spectrum. The Duke of Westminster, as already noted, acquired a version in marble of Thornycroft's *Artemis* (R.A. 1882) for Eaton Hall, and another half-size version, in marble, in 1911. A Mr E. Howley Palmer presented St Paul's School, London, with a bronze group by Hamo Thornycroft commemorating the school's founder, Dean Colet (plate 407); dated 1900, the work was unveiled in 1902.[19] A Leeds manufacturer, Sam Wilson, became Gilbert's chief patron between the years 1909 and 1913; for him Gilbert executed an elaborate bronze chimneypiece and replicas of *Perseus Arming*, *Victory* and *Comedy and Tragedy: 'Sic Vita'*;[20] these with a *Bacchante* by Derwent Wood were bequeathed to Leeds City Art Gallery by Wilson in 1925.

It was private patronage, indeed, that could be said to have formed a basis for a new idea of sculpture works as objects suitable for the domestic interior; this was a point virtually of aesthetic principle for apostles of the New Sculpture Movement such as Gosse and Spielmann, though it would appear from what they wrote that the idea did not catch on as much as was hoped.[21] What was involved was an important shift in emphasis and scale—from say the life-size marble for the hallway or conservatory, to the statuette destined for a more intimate new style of domestic interior. In consequence many ideal works were formulated at a reduced scale; furthermore there grew up a practice not really established previously—the production, under the artist's supervision, of multiple reductions at various scales, often in bronze (say by the 'lost wax' method of casting), in which there was no question of reduction in artistic originality through multiple replication, a problem that did apply to the Art Union multiples and others, in bronze and ceramic, earlier in the century. This certainly helps to explain the relative proliferation of small-scale work by both Gilbert and Hamo Thornycroft—the Wilson *Perseus Arming* at Leeds was cast by Gilbert in 1910, the original version was of 1882, and numerous other casts exist from during Gilbert's lifetime.[22]

Institutional patronage continued as before. The Houses of Parliament contain statues of George Leveson Gower, Second Earl Granville by Hamo Thornycroft (1895),[23] W. E. Gladstone by Pomeroy (1900)[24] and William Pitt, first Earl of Chatham by Derwent Wood (installed 1929, being a bronze replica of a marble original, R.A. 1918, now in Washington, U.S.A.).[25] In addition there are busts of George Douglas, eighth Duke of Argyll, by Frampton (1905),[26] John Wodehouse, first Earl of Kimberley, by Hamo Thornycroft (1907),[27] and (very suitably) of Gosse by Goscombe John (1920);[28] in addition to writing about the New Sculpture, Gosse had served as Librarian to the House of Lords. The London Royal College of Surgeons commissioned a bust of Sir William James Erasmus Wilson (1809–84), President of the College and a munificent benefactor to it by his will, from Brock in 1885; in marble, it is signed and dated 1888; it cost 200 guineas.[29] Also by Brock is a marble bust of John Marshall (1818–91), President of the College in 1883; dated 1891, this was ordered by the council in 1892 and purchased for £150.[30] Having voted £210 in 1893 for a bust of Sir Richard Owen (1804–92: Fellow of the College and Conservator of the Hunterian Museum 1842–56), the Council gave the commission to Gilbert in May that year; in 1895 they accepted his request to make it bronze instead of marble, and the work was exhibited at the Royal Academy in 1896.[31] Another work by Gilbert was presented to the College in 1909 by the wife of a member of the college, Edward Percy Plantagenet Macloghlin (1855–1904), in his memory (plate 408); the bronze group *Mors Janua Vitae* not only commemorates Macloghlin but the benefactress too, and the casket the couple hold contains their ashes. For a time provision was envisaged for Gilbert's ashes, too, inside Mrs Macloghlin's head; this while the artist was himself emotionally entangled with his patroness; but they later fell out. Mrs Macloghlin gave the College in addition the white marble floor on which the monument stands, this in 1911; she died in 1928.[32] The Royal Academy turned patron at one stage:

341

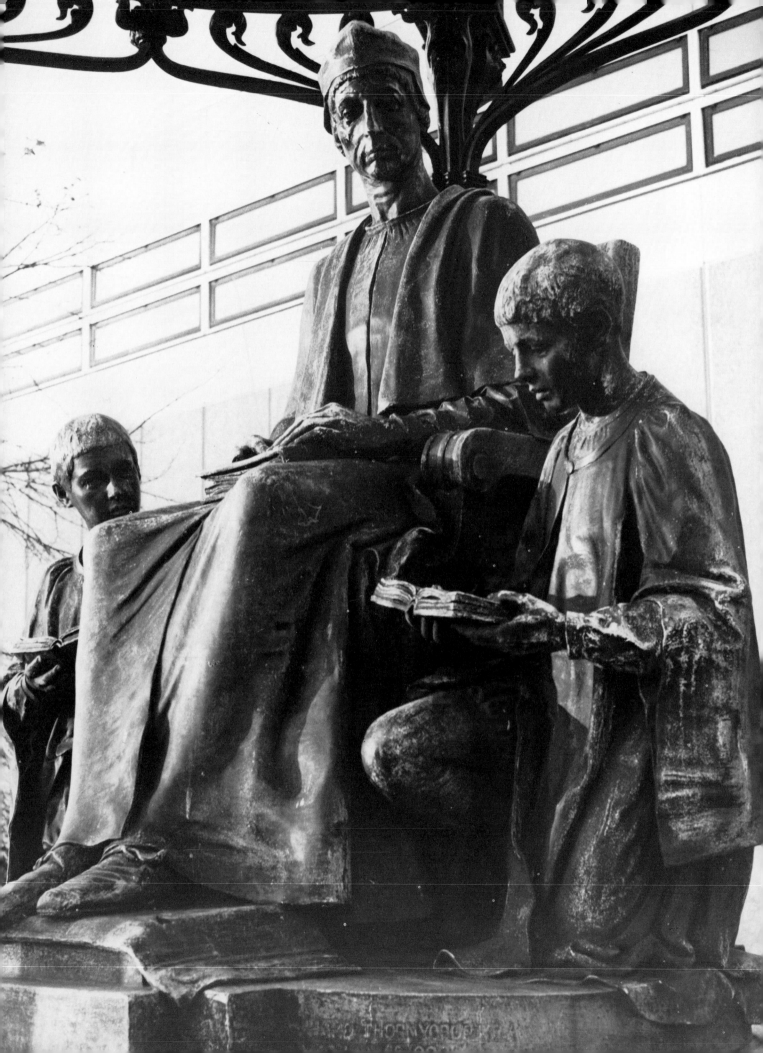

407 (facing page). Sir William
Hamo Thornycroft, Monument
to Dean Colet, 1900. London,
St Paul's School.

408. Sir Alfred Gilbert, *Mors
Janua Vitae*, 1908. London,
Royal College of Surgeons.

in 1916 the Council decided on conditions for a competition for the proposed statue of Reynolds for the forecourt of Burlington House. Money was to come from the Leighton Fund, and two sculptor members, selected by ballot, were to be invited to submit models. Drury and Derwent Wood headed the poll; Drury submitted one model, Derwent Wood two; the Council inspected the models in January 1917 and Drury got the job. His statue was not finished and installed until 1931.[33]

Other institutions awarded commissions to suit their various requirements. The Turner Memorial Home, Dingle Lane, Toxteth, in Liverpool contains a group of Charles Turner and his son by Hamo Thornycroft, dating from 1882 (plate 410); Trinity College, Dublin, erected a memorial to William Edward Hartpole Lecky, M.P., by Goscombe John, unveiled in 1906;[34] Trinity College, Cambridge, continued its series of life-size seated figures of famous old boys (see above, p. 128) with one of Tennyson by Thornycroft (1909); Clifton College in Bristol erected a Boer War Memorial which includes a massive figure in bronze of St George by Drury; and the Pearl Assurance Company in High Holborn, London, in addition to a series of marble busts by Frampton (*P. J. Foley*, 1904; *G. Shrubsoll*, 1915; *F. D. Bowles*, 1915; *Sir George Tilley*, 1927), erected a War Memorial to members of its staff killed in the Great War, consisting of a statue of St George, also by Frampton.

It was however in the field of public monuments, above all, that the New Sculptors continued, as had their professional predecessors, to acquire prestige and livelihood. In London, statues still continued to be put up. The Embankment along the Thames was opened only in 1868, and work completed in 1870; this provided a series of fine prospective sites, even if at first the area was apparently not much frequented.[35] Here were erected statues of Robert Raikes by Brock (1880),[36] and Bartle Frere, also by Brock (dated 1887, unveiled 1888) (plates 73, 409).[37] Here too came later Thornycroft's *General Gordon*, originally also set up in 1888, but in Trafalgar Square.[38] Bartle Frere (1815–84) had been High Commissioner of South Africa during the Zulu and Boer Wars of 1879–81; he is represented in Civil Service uniform, with the open robes of the Order of the Star of India; a certain formality of dress, but every detail handled with the truth and realism to be expected from Foley's successor. Gordon is portrayed (plate 411) in informal posture, neither dramatic nor conventional. As a soldier and (to some extent) adventurer, who met his end at the hands of the locals in the Sudan in 1885—to great excitement at home—Gordon is represented in patrol-jacket, trousers and long boots, standing in an attitude of meditation, left foot on a broken mortar, chin sunk in his right hand, left arm crossed, hand holding a Bible and supporting the right elbow, his famous 'whangee' cane tucked under his left arm: the whole ensemble is an amazing portrayal of Victorian values. Both statues have their supporting allegorical reliefs: Frere's a military figure with shield inscribed 'Pro Patria'; Gordon with two panels, one representing Fortitude and Faith, the other Charity and Justice (plate 412). All the reliefs display the New Sculpture's characteristic accomplishment of handling bronze in this form to good effect. To this choice Embankment site came later the Memorials to Sir Arthur Sullivan by Goscombe John (1903), and to Sir Walter Besant (1904), W. T. Stead (1912) and W. S. Gilbert (1913), all by Frampton, thus providing in close proximity examples over a whole generation of how four separate members of the new movement treated public monuments in bronze.

There were of course many others elsewhere. Gilbert's statue of John Howard, the eighteenth-century, Bedford-based prison reformer, dated 1890, was unveiled in Bedford in 1894. Thornycroft's statue of Oliver Cromwell is outside Westminster Hall, London, presented by Lord Rosebery and erected in 1899. Goscombe John executed two memorials in Eastbourne: one to the seventh Duke of Devonshire (bronze, signed and dated 1901), the other to soldiers of the Second Royal Sussex Regiment (bronze, 1905).

409. Sir Thomas Brock, *Bartle Frere*, 1887. London, Victoria Embankment.

345

410. Sir William Hamo Thornycroft, Monument to Charles Turner and his son, 1882. Liverpool, Turner Memorial Home.

411. Sir William Hamo Thornycroft, *General Gordon*, 1888. London, Victoria Embankment.

412. Sir William Hamo Thornycroft, detail from base of *General Gordon*, 1888. London, Victoria Embankment.

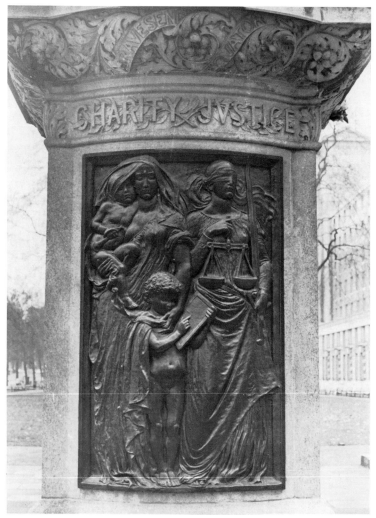

Members of the Regent Street Polytechnic set up a memorial to their founder, Quintin Hogg, which is in Portland Place, London, by Frampton (bronze, 1906); Sir Henry Irving was commemorated outside the National Portrait Gallery, London by Brock (1910). King Edward VII was commemorated by the citizens of Northampton with a monument outside the hospital that bears his name, erected in 1913 (plate 413). The sculptural parts comprise a bust of the king and a group of St George and the Dragon by Frampton. The monument to Bishop Gore outside the Cathedral in Birmingham (plate 414) is by Stirling Lee, 1914; Brock was responsible for a Titanic Memorial in Belfast. The First World War, like the Napoleonic Wars over a hundred years before, produced heroes to be commemorated: Nurse Edith Cavell, by Frampton, 1920, St Martin's Place, London, and the soldiers of the City and County of London, commemorated by a monument at Cornhill in the City of London, the architectural portions designed by Aston Webb, the sculpture by Drury; it was unveiled in 1920. Field Marshal Earl Roberts of Kandahar (and elsewhere) (1833–1914) is memorialised on Horse Guards Parade with a statue by Harry Bates unveiled in 1924. Bates had actually died in 1899, but the model for his *Roberts* in Calcutta (exhibited at the Royal Academy in 1896) was still in the possession of his widow. The committee involved originally considered awarding the London Roberts commission to Goscombe John, as the *Roberts* was envisaged as a pendant to the latter's *Viscount Wolseley* (erected 1920), but Roberts's daughter, a lady of determination, effected things otherwise.[39] The swansong perhaps of Victorian commemoration could be said to be the Memorial to Queen Alexandra, in Marlborough Road, off the Mall, London.[40] This is a very late work by Gilbert; with the Clarence Memorial still unfinished, Gilbert had gone bankrupt in 1901 and left the country, which

413. Sir George Frampton, *Edward VII*, erected 1913. Northampton, King Edward's Hospital.

414. Thomas Stirling Lee, *Bishop Gore*, 1914. Birmingham, Cathedral Yard.

415. Sir Alfred Gilbert, Memorial to Queen Alexandra, 1928–32. London, Marlborough Road.

416. Sir William Goscombe John, *The Reverend Lewis Edwards*. Bala, Theological College.

was considered rather poor form, with Royalty involved. In 1926, at the age of 72, he was persuaded to return to England and finish off the Clarence Memorial, which explains the radically different style of five of the saints on the screen. This done, he received the commission for the Alexandra Memorial (plate 415), which was completed in 1932. It illustrates a staggering mastery of bronze, used to high decorative effect, in the whorling lines of the drapery or the minute contortions and protruberances of the crowns; in the almost flat reliefs of the back of the throne or the wild linear motifs of the frieze along the back of the screen. This is but an extreme example of one of the basic features of the New Sculpture, a complete command by the sculptor of the material he is using.

The pattern of local patronage of national artists, involving the use of a local artist who has made good on a national scale was maintained. Havard Thomas, though of Welsh parentage, was born in Bristol and studied at the School of Art there; he executed the monument to Mary Carpenter (†1877) in Bristol Cathedral and later, for all that he went on to study in France and work in London and Italy, he was to do the public statues of Samuel Morley, M.P. for Bristol and of Edmund Burke, also M.P. for Bristol (from 1774 to 1780); these stand in Colston Avenue. Similarly Goscombe John, who was Welsh, built up a substantial practice parallel to his London-based career all over Wales: in the field of public statuary alone, there are examples not just in Cardiff—*Gwilym Williams of Miskin* (1839–1906), who was Chairman and Vice Chairman of Quarter sessions for the County of Glamorgan for nineteen years and Judge of the County Courts for twenty-two years, or *Viscount Tredegar,* commemorated in equestrian form to mark the fiftieth anniversary of the Charge of the Light Brigade in which he took part, and which is represented in reliefs below the statue[41]—but also, for instance, in Caernarvon (*Lloyd George*, erected 1921) and in Bala—*The Reverend Lewis Edwards* (plate 416) outside the Theological College.

348

It would however be a mistake to believe that between, say, 1880 and 1914, the New Sculptors were the only sculptors active. Certain senior figures were still in business, if fitfully. John Bell (who died in 1895) wrote to Edmund Gosse in 1883 that he had just finished in marble a life-size statue which his friends were telling him was the best female figure he had done.[42] The London monuments to Robert Burns by Sir John Steell (died 1891) date from 1884 (statue, Embankment) and 1885 (bust, Westminster Abbey), and Steell's medallion portrait of Sir Walter Scott in a corridor of Parliament House, Edinburgh (plate 417), is signed and dated 1886. John Lawlor (†1901), working only when he felt inclined or when necessity compelled him (he had not been able to make much provision for his old age), executed statues of Patrick Sarsfield for Limerick in 1889, and Dr Delaney for Cork in 1890.[43] The 1880s were a time of great activity still for Woolner, who was responsible for busts of Dr Percival (1880, Clifton College, Bristol), and Lord Lawrence (1881, Westminster Abbey) (plate 104); the Landseer Memorial (London, St Paul's Cathedral) and the Percival Cross (Oxford, Holywell Cemetery) of 1882; the Birmingham *Queen Victoria* (R.A. 1883) (plate 72); *The Water Lily* of 1884 (Aberdeen, City Art Gallery); recumbent effigies of Lord Frederick Cavendish (R.A. 1885) in Cartmel Priory Church, Lancashire, and of Bishop Jackson (1887) in St Paul's Cathedral, London; and not least *Bishop Fraser* (plate 418) in Manchester (1888) and *The Housemaid* (plate 275), already mentioned, on which he was working in the year of his death, 1892.

Henry Hugh Armstead, born three years after Woolner and who did not die till 1905, was active in his maturer years, as we have seen. His effigy of Bishop Ollivant for Llandaff was shown at the Royal Academy in 1887, his memorial to Mrs Craik (Tewkesbury) (plate 327) and statue of Lieutenant Waghorn (Chatham) were on show there in 1889, and the Winmarleigh effigy (Warrington) in 1894; and in 1903 his *Remorse*, shown at the Academy that year, was bought for the nation through the Chantrey Bequest; it is now in the Tate Gallery. In the last thirty years of his life, Adams-Acton (died 1910) executed such prestigious works as the statue of John Wesley, outside the City Road Chapel in London (unveiled 1891)[44] and the effigy of Cardinal Manning in the crypt of Westminster Cathedral, of 1908.[45] And for Charles Bell Birch[46] (1832–93), who had been for ten years pupil then studio assistant to Foley and who had built up a solid career during the 1860s and 1870s in portrait busts, statues and medallions, the 1880s opened with a flourish, with the exhibiting at the Royal Academy of 1880 of his most famous work, the portrait statue of Lieutenant Walter R. Pollock Hamilton, V.C. in action during the Afghan Wars (plate 419)—and a most spirited work it is, now in the collection of the Royal Dublin Society. His output continued to flourish until the year of his death (1893), with portrait busts for prominent institutions, such as *The late Earl Russell*, a bust in marble for the Guildhall (R.A. 1883) and public and institutional statues—for example, *The Earl of Dudley*, for Dudley, Staffordshire (1888), *The Earl of Beaconsfield* (that is, Disraeli) for the Junior Constitutional Club, London (1893), and others to be mentioned later.

Closer non-New-Sculptor contemporaries of, say, Thomas Brock (born 1847) were Albert Bruce Joy (1842–1924), Edwin Roscoe Mullins (1848–1907) and Henry Richard Hope Pinker (1849–1927). Bruce Joy[47] studied at South Kensington and the Royal Academy Schools, and then worked in Foley's studio. He was responsible for statues of Gladstone (Bow Road, London, signed and dated 1881) (plate 420), Lord Frederick Cavendish (Barrow-in-Furness) and several of John Bright, including that in marble in the Lower Waiting Hall of the Houses of Parliament; installed in 1902 and a replica of the statue in Birmingham, this replaced a statue by Gilbert, about whose artistic merits some doubts had been expressed.[48] Bruce Joy executed at least two examples of a bust of the first Earl Cairns (1819–85), Lord High Chancellor in 1868 and from 1874 to 1880; one of these

417. Sir John Steell, *Sir Walter Scott*, 1886. Edinburgh, Parliament House.

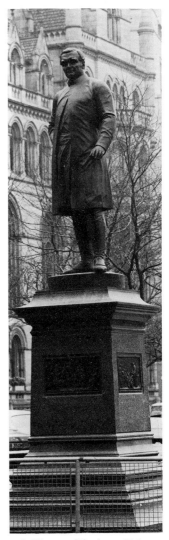

418. Thomas Woolner, *Bishop Fraser*, 1887. Manchester, Albert Square.

349

is in the Law Courts, London, the other at Lincoln's Inn. In the Houses of Parliament again is a further bust by Bruce Joy—of Thomas Erskine May, first Baron Farnborough, of 1890.[49] Bruce Joy also executed memorials and ideal works—in other words, the full range of conventional sculpture.

Roscoe Mullins[50] was a pupil of Lambeth and the Royal Academy Schools; he worked for Birnie Philip and then spent eight years (1866–74) with Professor Wagmüller of Munich. By him are, for instance, the statue of William Barnes, the poet, at Dorchester, Dorset (1888), two ideal works in the collection of the City Art Gallery, Glasgow—*Morn waked by the circling Hours*, exhibited in some form at the Grosvenor Gallery in 1883 (the Glasgow version in marble is signed and dated 1887), and *Isaac and Esau: Bless me, even me also, O my father*, shown first at the Royal Academy in 1884, then again there in 1904, this latter presumably being the Glasgow marble version which is signed and dated 1904. Although he executed bust memorials and statuettes as well, it was these ideal works that were considered Mullins's forte: these and architectural sculpture of which he executed a considerable amount in London and elsewhere, such as the pediment sculpture (plate 421) for the Harris Museum and Art Gallery at Preston in Lancashire (building of 1882–93), a highly classical performance boosting the building's dedication 'To Literature, Arts and Sciences' with an added message: 'The Dead But Sceptered Sovrans Who Still Rule Our Spirits From Their Urns.'

H. R. H. Pinker[51] executed the statue of Henry Fawcett in the Market Place, Salisbury, four statues in the University Museum, Oxford (Darwin, (plate 422) Roger Bacon, Sydenham and Hunter; the model for the latter was shown at the Royal Academy of 1886), and the statue in bronze of W. E. Forster (plate 423) on the Victoria Embankment, London.[52] Dated 1889, unveiled 1890, this commemorates 'Buckshot' Forster (1818–86) the Chief Secretary for Ireland under Gladstone, who had, we are told, the courage of his convictions, and kept his end up under extraordinarily difficult conditions. Pinker also executed busts; there is one by him of the fourth Viscount Gage at Firle Place, Sussex, shown at the Royal Academy in 1879.

Slightly younger than these, but still contemporary with other New Sculptors (for instance, Frampton and Goscombe John, both born in 1860, Pegram born 1862, Derwent Wood born 1871), were artists such as Charles John Allen (1862–1955), Albert

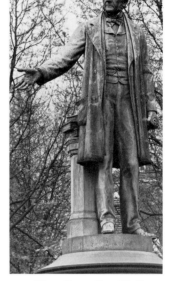

420. Albert Bruce Joy, *W. E. Gladstone*, 1881. London, Bow Road.

419 (facing page). Charles Bell Birch, *Lieutenant Walter R. Pollock Hamilton, V.C.*, 1880. Dublin, Royal Dublin Society.

421. Edwin Roscoe Mullins, Pediment group, *c.* 1882–93. Preston, Harris Museum and Art Gallery.

TO · LITERATURE · ARTS · AND · SCIENCES

422. Henry Richard Pinker, *Charles Darwin*. Oxford, University Museum.

423. Henry Richard Pinker, *W. E. Forster*, 1889. London, Victoria Embankment.

Toft (1862–1949) and John Tweed (1869–1933). Even the briefest summary of their careers demonstrates the equality of their status in the profession with that of the New Sculptors. Allen[53] trained at the Lambeth School under Frith, worked for ten years with Farmer and Brindley, attended the Royal Academy Schools, then worked as Hamo Thornycroft's assistant (for instance on the frieze for the Institute of Chartered Accountants). At the age of thirty-two he went to Liverpool as teacher of Sculpture at the University, and established there a career for himself with a strong local emphasis. The Walker Art Gallery acquired his *Love and the Mermaid* soon after his arrival in the city; he executed busts of local worthies (such as Alderman Philip Rathbone) and the substantial and elaborate monument to Queen Victoria in Derby Square, Liverpool; this was unveiled by Princess Louise in 1906.

Albert Toft[54] came from a family of Staffordshire artists in pottery and silverwork. He was apprenticed as a modeller at Wedgwood's, then after evening classes locally went on to the Royal College of Art in London where he studied under Lantéri. His earliest works exhibited at the Royal Academy were mainly portrait busts, such as *George Wallis* (London, Victoria and Albert Museum, R.A. 1890) but he also began to develop ideal works, some in bust form—*In the sere and yellow leaf* (R.A. 1892 and 1893)—others in the form of figure statues such as *Fate-led: Fate leading, she must needs go on and on* of 1890 and 1892, a full-length nude now in the Walker Art Gallery, Liverpool. In fact, Toft produced a series of statues of naked ladies with fancy titles, as did Onslow Ford; other Toft examples include *Spring* (Birmingham City Art Gallery, R.A. 1897) and *The Spirit of Contemplation* (Laing Art Gallery, Newcastle-upon-Tyne, R.A. 1901 and 1903) (plate 424). Spielmann wrote that this '. . . is the most complete of all Mr Toft's works. Life-size, it is a beautiful representation of the female form, original, almost daring, in its simple arrangement, decorative with praiseworthy self-restraint, dignified and refined.'[55] Toft was also responsible for South African War memorials in Cardiff and Birmingham.

John Tweed[56] established a practice in the conventional fields of public statues and memorials that extended well into the twentieth century. Born in Glasgow, he studied at the School of Art there, went on to the Lambeth School and then to the Royal Academy Schools while working for Hamo Thornycroft. In 1893 he went to Paris to work under Rodin; he also studied at the École des Beaux-Arts under Falguière. Back in England, he was responsible for the casting of Stevens's equestrian *Duke of Wellington* (plate 343), which was finally installed in 1912; Tweed also executed *Sir Joseph Cowan, M.P.*, for Newcastle-upon-Tyne, *Queen Victoria* for Aden, *Lord Clive* in bronze for London (erected 1912) and in marble for Calcutta; *Field Marshal Sir George White* in Portland Place, London (erected 1922) and *Lord Kitchener* in Horseguards Parade, London (unveiled 1926). Among memorials by Tweed are those to Joseph Chamberlain (marble bust) and Lord Clive (marble relief) in Westminster Abbey and that to Sir James Graham in Carlisle Cathedral (plate 425). Tweed also executed many busts.

These artists were as much part of the sculptural establishment as their more prominent New Sculpture coevals. From the consumer's point of view, there was also no necessary distinction. The Royal Family, who had favoured Glassby as well as Boehm (see pp. 77–8), were not exclusively committed to, say, Gilbert or Onslow Ford. Pinker's *Hunter* statue of 1886 was presented to the Oxford Museum by the Queen, while during the 1880s and 1890s the private sculptor to the Queen was Francis John Williamson[57] (1833–1920), one-time pupil of John Bell, and apprentice and then studio assistant to Foley for over twenty years. For the Royal Family he executed large numbers of portrait busts in marble—*Prince Alamaya of Abyssinia* (signed and dated 1880); *Prince Leopold, Duke of Albany* and *Prince Albert Victor, Duke of Clarence* (later commemorated by Gilbert) at Osborne; *Arthur, Duke of Connaught* (signed and dated 1885), and *Alfred, Lord Tennyson* (signed and dated 1893) (plate 426) at Windsor. It was from within this wide-ranging,

424. Albert Toft, *The Spirit of Contemplation*, R.A. 1901. Newcastle-upon-Tyne, Laing Art Gallery.

425 (above left). John Tweed,
Monument to Sir James
Graham. Carlisle, Cathedral.

426 (above right). Francis John
Williamson, *Alfred, Lord
Tennyson*, 1893. Royal
Collection, Windsor Castle.

427. H.R.H. Princess Louise,
Queen Victoria, erected 1893.
London, Kensington Gardens.

cosmopolitan, active interest in sculpture that the Royal Family nurtured two women sculptors of their own. One of Queen Victoria's daughters, Princess Louise[58] (1848–1939) studied under Boehm, and produced the statue of Queen Victoria in Kensington Gardens, London (plate 427), erected in 1893. Feodora Gleichen[59] (1861–1922) was the daughter of Admiral Prince Victor of Hohenlohe-Langenburg, himself a sculptor, and son of Queen Victoria's half-sister. Feodora studied at the Slade School with Legros, and exhibited at the Royal Academy from 1892. Her works were in the main decorative objects, figures and portrait busts—an example of the latter type being that of Emma Calvé (1896), at Osborne. But she was also responsible for the Diana Fountain in Hyde Park; originally in the woodland grounds of their seat at Frognal, Sunninghill, the fountain was presented to Hyde Park by Lady Palmer in 1906.[60]

A similar lack of distinction applied in the field of public monuments. We have already noted how the newly-opened Thames Embankment received a number of New Sculpture public monuments over some thirty years: but the pattern was established by a number of monuments by members of the previous generation. The first seems to have been Noble's *Sir James Outram* in 1871,[61] followed by Marochetti's *Brunel* in 1877,[62] an earlier work which had been hanging around in Government Cold Storage for some years. Then came Woolner's *John Stuart Mill* in 1878,[63] the same year as Cleopatra's Needle, a work of a previous civilisation; Sir John Steell's *Robert Burns*[64] and Boehm's *William Tyndale* (plate 359)[65] followed in 1884. By this time the New Sculpture had manifested itself in the area with Brock's *Raikes* (1880)[66] but for the remainder of the 1880s the 'aliens' (non-New-Sculptors) prevailed—the Memorial to Henry Fawcett (dated 1886), erected by 'his grateful countrywomen' incorporates a portrait medallion appropriately by a woman sculptor, Mary Grant.[67] Pinker's *W. E. Forster* of 1889 (plate 423) has already been mentioned;[68] from the same year dates the monument to Sir Joseph Bazalgette (plate 428)[69] who 'Flumini Vincula Posuit', 'put chains on the river'; as Chief Engineer to the Metropolitan Board of Works he was responsible for constructing the Embankment where all these Memorials are sited. The bust is by George Simonds[70] (?1847–1929) who

428. George Simonds, *Sir Joseph Bazalgette*, 1889. London, Victoria Embankment.

429. George Simonds, Monument to John Collingwood Bruce, 1896. Newcastle-upon-Tyne, Cathedral.

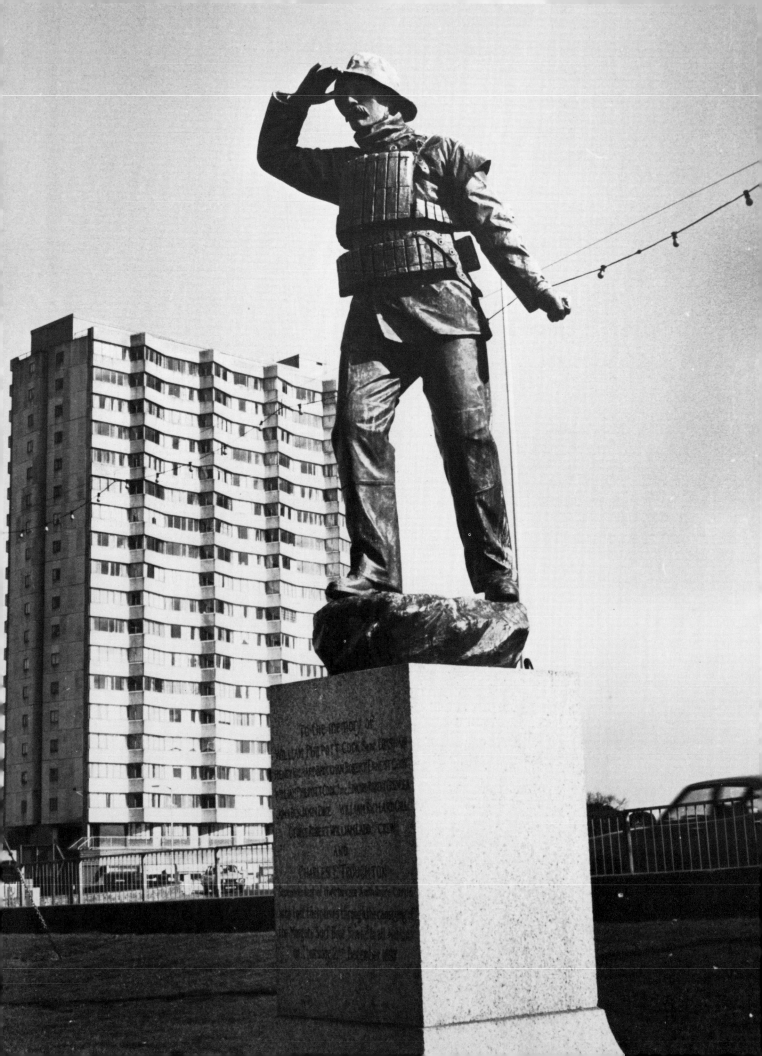

was quite definitely an Alien—he studied in Dresden from 1858 onwards, spent a year in Brussels under Jéhotte, then ten years in Rome (1866–76) before returning to London. While his masterpiece seems to have been *The Falconer* of 1871, of which versions were to be found in Central Park, New York, and the Society of Fine Arts in Trieste, his *Queen Victoria* is to be found in Reading, and his fine funerary monument of John Collingwood Bruce (signed and dated 1896) (plate 429) is in the Cathedral of St Nicholas at Newcastle-upon-Tyne. Simonds is clearly a figure of some eminence from outside the New Sculpture. He was, for instance, the first Master of the Art-Workers' Guild for two years in succession (1884 and 1885); among the subjects discussed in his term of office were no less than three dealing with sculpture, 'Processes of Modelling', 'Sculpture, from the different Craftsmen's points of view' and 'The Founding of Bronze Statues'. It is possible that Simonds could claim primacy among English artists in the revival of the lost-wax casting method; he certainly claimed that, whether working in bronze or marble, the artist ought himself to carry through all the stages of production and not be at the mercy of technical assistants.[70]

Outside London, memorials by non-New-Sculptors continued to be put up: Sir Hugh Owen is commemorated in Caernarvon with a bronze statue by Milo Griffith (who had worked in Llandaff Cathedral; see p. 261); the Margate Ambulance Men are commemorated by the sea-shore there (plate 430) with a statue by Frederick Callcott (signed and dated 1899). An unidentified sculptor executed the memorial at Colne, in Lancashire, to Wallace Hartley, Bandmaster of the R. M. S. Titanic (plate 431), who perished in the foundering of that vessel, on 15 April 1912. Consisting of a bronze bust on

431. Monument to Wallace Hartley (†1912). Colne.

432. Pittendrigh McGillivray, Monument to Peter Lowe. Glasgow, Cathedral.

430 (facing page). Frederick Callcott, Monument to the Margate Ambulance Men, 1899. Margate.

357

a pedestal, with two allegorical figures in support, this not undistinguished monument was erected by voluntary contributions to commemorate the heroism of a native of the town; under Hartley's leadership (one must assume) the band played on as the ship went down. In the Cathedral at Glasgow,[71] Dr Peter Lowe, founder of the Faculty of Physicians and Surgeons in the City, is commemorated by a fine relief monument (plate 432), allegorical of health, by James Pittendrigh McGillivray (1856–1938). This was set up by the Faculty because Lowe's original monument in the High Church Yard was now much decayed. Also by McGillivray in the Cathedral is the monument to James Hedderwick (1814–97), an alabaster gothic niche with a bronze portrait plaque, signed and dated 1901. It bears the gnomic inscription: 'Here fond remembrance rears the sculptured stone.' Meanwhile, over in Edinburgh,[72] architectural sculpture was keeping its hand in, with the series of figures in niches on the facades of the Scottish National Portrait Gallery, these by John (1830–92) and William Birnie (1853–1933) Rhind and others.

If we change our focus, and revert to examination by location, we shall get perhaps a truer picture of the variegated state of British Sculpture in the years up to 1914. In Manchester, commemoration still continued inside the Town Hall, with busts of Bishop Fraser by Warrington Wood (signed and dated 1881), Sir Charles Hallé by Onslow Ford (signed and dated 1897) (plate 433), and most magnificently the scientist J. P. Joule, in a marble statue by Gilbert, dated 1893 (plate 372). In this Gilbert showed the extent to which he was prepared to manipulate the material, even though it be the less malleable marble, deeply cutting in to portray Joule's coat hanging loosely (plate 434), tracing Art-Nouveau linear patterns in the chair in underside positions not normally visible (plate 435), and allowing Joule's slipper to dangle in what must be a conscious reminiscence of Roubiliac's *Handel*. Outside the Town Hall in Albert Square, Bishop Fraser gets a full-size bronze statue by Woolner, dated 1887 (plate 418), with three reliefs on the base of scenes from the Bishop's life. (His effigy in the Cathedral is by Forsyth; he died in 1885.) Further

434 & 435. Sir Alfred Gilbert, details from *Joule*, 1893. Manchester, Town Hall.

433 (facing page). Edward Onslow Ford, *Sir Charles Hallé*, 1897. Manchester, Town Hall.

359

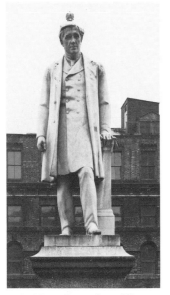

436. Albert Bruce Joy, *Oliver Heywood*, 1894. Manchester, Albert Square.

437.Edward Onslow Ford, *Queen Victoria*, 1901. Manchester, Piccadilly.

439. Mario Raggi, *W. E. Gladstone*. Manchester, Albert Square.

438. Edward Onslow Ford, detail from *Queen Victoria*, 1901. Manchester, Piccadilly.

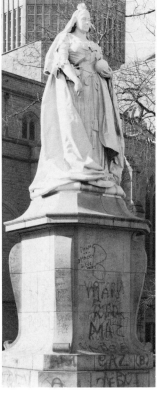

440. Bertram Mackennal, *Queen Victoria*, unveiled 1905. Blackburn, The Esplanade.

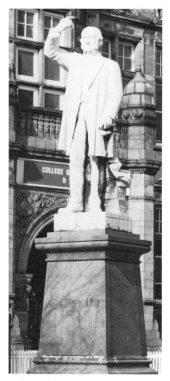

441. John Adams-Acton, *W. E. Gladstone*. Blackburn.

442 (right). Sir George Frampton, *Queen Victoria*, erected 1906. St Helen's, Victoria Square.

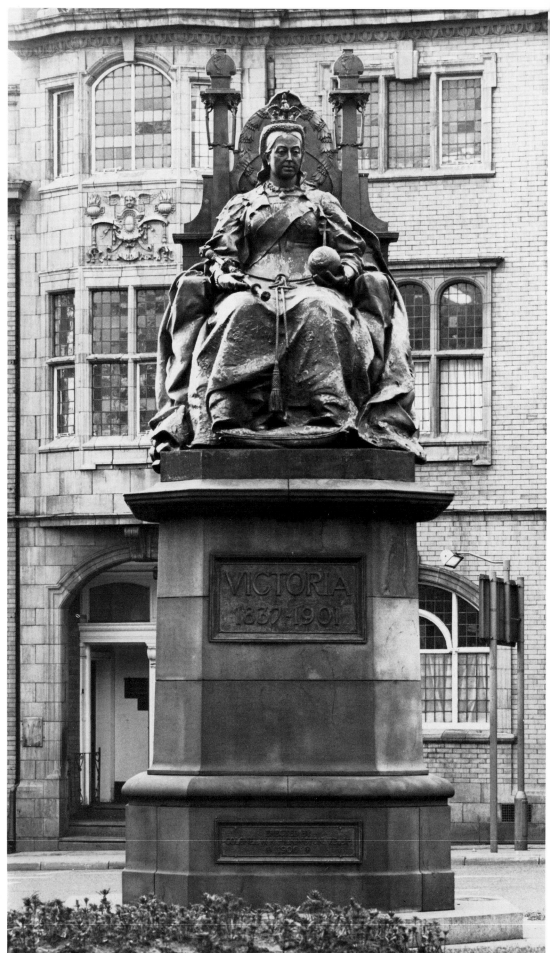

statues are of John Bright, by Bruce Joy (dated 1891); Alderman Oliver Heywood (1825–92) by Bruce Joy, dated 1894 (plate 436) (it was erected by the citizens of Manchester to commemorate a life devoted to the public good); and W. E. Gladstone, by M. Raggi (plate 439). In Piccadilly Gardens the citizens of Manchester set up a statue of Queen Victoria to commemorate her Diamond Jubilee in 1897; by Onslow Ford, this includes a massive, resplendent Queen in front (plate 437), Maternity behind (plate 438) and St George on top. In St Anne's Square a group by Hamo Thornycroft serves as a Boer War Memorial; it is signed and dated 1907. Thus in less than thirty years, Manchester gave work to New Sculptors (Gilbert, Thornycroft, Onslow Ford), old sculptors (Woolner) and the also-rans (Raggi, Bruce Joy etc.)).

Rochdale set up a statue of John Bright by Hamo Thornycroft (signed and dated 1891); an inscription reads 'This statue of Rochdale's Greatest Townsman . . . is erected as a mark of the love and veneration with which his memory is cherished by all classes of his countrymen.' St Helen's set up a statue of Queen Victoria by Frampton in 1906 (plate 442). Blackburn set up a colossal statue of Gladstone, by Adams-Acton (plate 441); its *Queen Victoria* by Bertram Mackennal (plate 440)[73] was erected by public subscription and unveiled by Her Royal Highness Princess Louise, Duchess of Argyll (and sculptress) in 1905. (The largest of its many graffiti reads 'ART'.) In 1912 a bronze statue was set up of William Henry Hornby (1805–84), first Mayor of Blackburn 1851 and M.P. for the borough from 1857 to 1869: sculptor, Bruce Joy. At Bolton, in Victoria Square in front of the Town Hall, Chadwick is commemorated with a statue by C. B. Birch (signed and dated 1871) with a bas-relief attached; and Sir B. Dobson, Mayor of Bolton, with a statue by Cassidy (1900); inside the Town Hall, Bishop Fraser features in a replica of the Manchester Town Hall bust by Warrington Wood; local worthies such as J. K. Cross in a bust by E. G. Papworth (signed and dated 1882), William Nicholson in a bust by Carl Albetill (signed and dated 1894); finally Edward VII, who opened the Town Hall as Prince of Wales in 1873, is commemorated in a bust by Frampton, erected by public subscription in 1912. In Victoria Park, Bolton, we find statues of Disraeli by J. Morris (plate 443) presented to the Borough of Bolton by the Bolton and District Working Men's

443. J. Morris, *Benjamin Disraeli*, erected 1887. Bolton, Victoria Park.

444. J. W. Bowden, *J. T. Fielding*, 1896. Bolton, Victoria Park.

445. John Cassidy, *James Dorrian*, 1898. Bolton, Victoria Park.

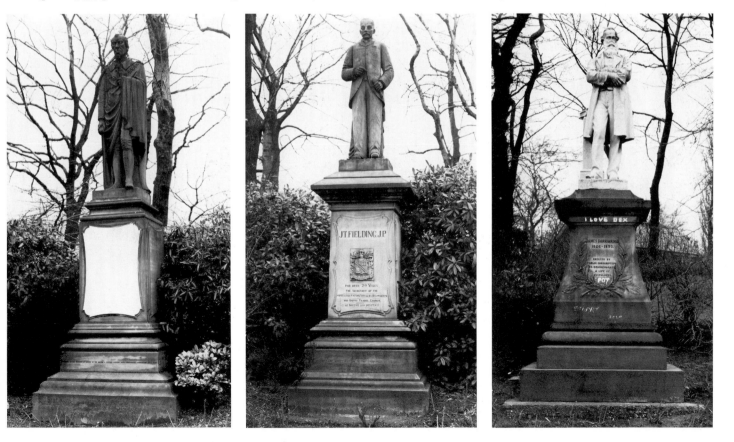

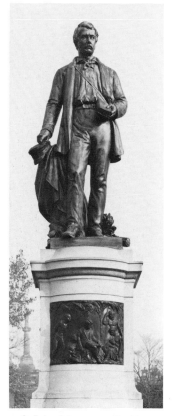

446. John Mossman, *David Livingstone*, 1877. Glasgow, Cathedral Square.

447. Sir Joseph Edgar Boehm, *John Elder*, erected 1888. Glasgow, Elder Park.

Conservative Association, April 1887; of J. T. Fielding, J. P. (plate 444) 'for over twenty years the Secretary of the Operative Cotton Spinners Association and United Trades Council of Bolton and District. Duty and Equity were the Guiding Principles of his Life'—this by J. W. Bowden (signed and dated 1896); and of James Dorrian, M.D. (1826–95) (plate 445), by John Cassidy (signed and dated 1898), this 'erected by Public Subscription to commemorate a life of usefulness'. These civic statues of a section of Lancashire provide a most telling cross-section: from the nobility of Thornycroft's *Bright* and the intricate decorative working of Frampton's *Queen Victoria*, through the less inspired competence of Birch, Bruce Joy and Cassidy, to the perhaps limited craftsmanship of Morris and Bowden (who are otherwise unknown), these Lancashire boroughs acted in their justifiable civic pride as catalysts for the sculptural life of a wide spread of the nation's art.

The city of Leeds, as already noted, had in Sam Wilson a notable private patron of Alfred Gilbert. In the arena of civic statuary the city was equally prominent, and in the sculpture of City Square, set up in 1903, Leeds must be almost without rival for an effective demonstration of contemporary work. The centrepiece is the massive equestrian statue of the Black Prince, donated by T. Walter Harding, Lord Mayor of Leeds 1898–9. This is by Brock and in the main figure in particular he demonstrates the application of New Sculptural qualities to a work of this scale, formulating striking detail work in bronze, not with the delicate intricacy of Gilbert or Frampton, which would be lost at that height, nor certainly with the flashy trickiness of, say, Marochetti's *Richard Cœur de Lion*, but with a studied firmness and power that is most effective. The pedestal has reliefs set in on either of the longer sides, with bronze ornamental decorative friezes above and below. On one side of the square, certain local celebrities line up in bronze: *Joseph Priestley*, by Drury (signed and dated 1899), the gift again of Harding in 1903. Next to him is *Dr. Hook*, Vicar of Leeds from 1837 to 1859, who found the city a stronghold of Dissent, and left it a stronghold of the Church;[74] the statue is by Pomeroy (signed and dated 1902), the gift yet again of Harding in 1903. The series is completed by two statues by Henry Fehr: *John Harrison* (1576–1656), the gift of Councillor Richard Boston, 1903 and *James Watt* (1736–1819), the gift of Richard Wainwright in 1898, erected in 1903. On the other side of the square are eight nearly naked ladies in bronze, holding up electric torches. Four of these, slumped and slumbering, represent Even, the other four, alert and carrying flowers are Morn; all the gift of Harding, again, in 1903, they are by Drury. As a statuesque ensemble, the whole collection is quite remarkable, even if its present arrangement is not as originally set out. But that was not all for Leeds. They also used to have, in Victoria Square, in front of the Town Hall, a substantial memorial to Queen Victoria by Frampton, unveiled in 1905. Rising in all over thirty feet, at the summit appeared the Queen, aged about fifty, enthroned and crowned, holding the Orb and Sceptre, wearing the richly brocaded and tasselled Coronation robes. Below, on the Portland Stone base, was an elaborately carved royal arms, with the inscription 'Victoria 1837–1901'; on the back of the base, facing the Town Hall entrance, was the inscription 'Raised by Volunteer Subscription of Citizens of Leeds in the year 1901', surmounted by the city's arms. The sides had luxuriant swags of the fruits of the Earth and Sea, symbolic of a plentiful reign and naval supremacy, and in large niches sat bronze figures of Peace, a woman holding the world in one hand and the palm branch of peace in the other, and Industry, an heroic, muscular male, stripped to the waist and surrounded by the implements of the industries of Leeds. Around the foot of the base was a bronze band, inscribed India, Canada, Africa and Australia, with their respective emblems, indicative of the great regions of British influence abroad.[75] The memorial still exists, though no longer on its original site; some time in the 1930s it was removed to Woodhouse Moor behind the University, a reminder that the New Sculpture as much as the old is liable to physical displacement.

In Liverpool, by contrast, one can observe within a relatively small area much of the panorama of the development of civic sculpture in the latter part of the nineteenth century. Starting only on St George's Plateau (north of St George's Hall) with Thomas Thornycroft's *Prince Albert* of 1866 and his *Queen Victoria* of 1869, one can progress in the same area to the men of the intermediate generation, with C. B. Birch's *Disraeli* and *Major-General Earle*, both of 1883. In St John's Gardens, below the Hall, is *Alexander Balfour* by Bruce Joy, signed and dated 1889. There too stand a series of public memorial statues by many of the most prominent New Sculptors—*Gladstone* by Brock; *William Rathbone* (signed and dated 1899), *Canon Lester* (†1903) and *Sir A. B. Forwood, M.P.*, all by Frampton; a group commemorating the King's Liverpool Regiment by Goscombe John (signed and dated 1905); *Mgr. James Nugent* by Pomeroy, unveiled in 1906. Elsewhere in the City are Allen's *Queen Victoria* (Derby Square, 1906), and at the Pier Head Frampton's statue *Sir A. J. Jones* (unveiled 1913), and Goscombe John's Memorials to the Engine Room Heroes (1916) and King Edward VII (model exhibited at the Royal Academy in 1916). In Sefton Park, in addition to Foley's statue of William Rathbone with its supporting base reliefs by Brock (one signed and dated 1876)—a most precise testimony of the succession from one generation to another in the mainstream development of Victorian Sculpture—here too are Liverpool's own versions of two of the New Sculpture's most famous works, *Eros* by Gilbert, a replica cast under the artist's supervision and erected in 1932, and a second *Peter Pan* by Frampton.[76]

A display of late-Victorian sculpture such as Liverpool's might seem hard to equal, yet Glasgow manages just this, maintaining until the end of the century and well beyond the standard that we have seen established earlier[77] (see above, p. 117). Cathedral Square can be seen as an extension of George Square, receiving monuments to the worthies of the last quarter of the century. David Livingstone (1818–73) was of course a figure of international renown; he was commemorated with a statue by the local John Mossman, of 1877 (plate 446). Around are set statues of Norman Macleod (1812–72) by Mossman (1881), James Arthur (1819–95) by George Lawson (1893), and James White of Overtoun (1812–84) by Frank Leslie (1890); nearby Provost James Lumsden (1778–1856) is by Mossman,[78] of undetermined date. At Elder Park, Govan, near his works, John Elder (1824–69), engineer and shipbuilder, is commemorated with a statue by Boehm (plate 447) erected by public subscription in 1888, his wife close by with a statue by Archibald Macfarlane Shannon (1850–1915) of 1905. At Govan Cross, the statue of Sir William Pearce, M.P. (1833–88) (plate 448) is by Onslow Ford (1894); at Springburn Park, that of James Reid (1823–94) of Auchterarder and the Hyde Park Locomotive Works is by Goscombe John (signed and dated 1903). In Park Terrance, nearer the centre of the city, a substantial memorial to Field Marshal Earl Roberts (plate 449) looks out over Kelvingrove Park; this is by Harry Bates, and in addition to the principal equestrian figure has relief scenes on all four sides and two large seated allegorical figures, representing *War* (plate 450) and *Peace*. The sheer technical virtuosity of bronze reflecting almost finicky modelling testifies here to what the New Sculpture represented and to what Bates, one of the movement's masters, could achieve. In the park below there is a memorial fountain to Robert Stewart by Mossman, erected 1872; statuary on the bridge by Paul Montford (1868–1938); and a memorial to Lord Kelvin, by Macfarlane Shannon, of 1913; all this demonstrating again the richness of Glasgow's public statuary, and the commendable range of artists represented, both from London and locally-based.

Glasgow is further enriched by architectural sculpture (some by New Sculptors) of high quality, no less indeed than the city's architecture deserves. This was of course continuing a tradition in which John Thomas had featured, for example on Gibson's National Bank of 1847, originally in Queen Street, re-erected in 1902–3 as Langside Public Hall.

448. Edward Onslow Ford, *Sir William Pearce*, erected 1894. Glasgow, Govan Cross.

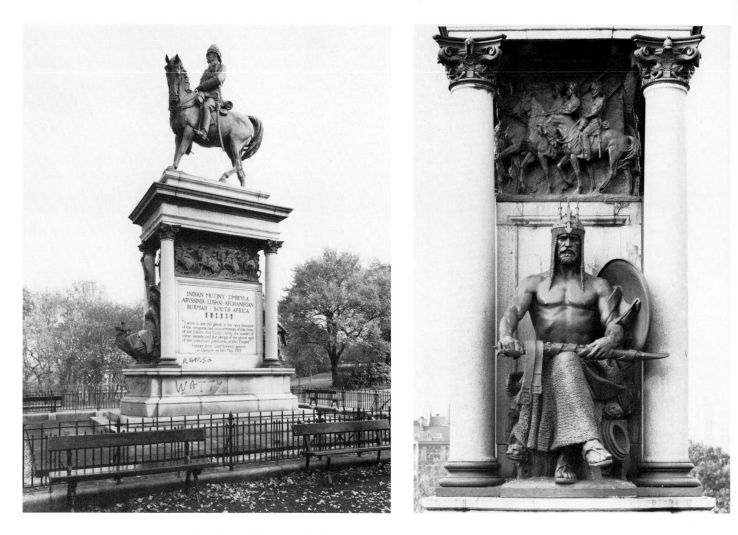

449. Harry Bates, *Field Marshal Earl Roberts*, Glasgow, Park Terrace.

450. Harry Bates, detail from *Field Marshal Earl Roberts*. Glasgow, Park Terrace.

Another Houses of Parliament-trained architectural sculptor, Andrew Handyside Ritchie, executed work on what is now the National Commercial Bank, 8 Gordon Street, dating from 1854–7. The name of Mossman is attached to work such as the Atlantes on the Bank of Scotland at the corner of George Square and St Vincent Place (the architect was J. T. Rochead, 1869), and further figures on the Clydeside Bank (1870–3) and the Scottish Amicable (1872–3) buildings, St Vincent Place, on Sellars's St Andrew's Halls (1873–7) and on Burnet's former Athenaeum, St George's Place of 1886.

The New Sculpture architectural work seems to have started at the Art Gallery, Kelvingrove, where Frampton, with others, executed work from 1893 onwards—such as St Mungo (plate 451), at the back entrance. Frampton was also responsible for the sculpture on J. J. Burnet's Savings Bank of Glasgow in Ingram Street (1896–1900), a fine example of a successful marriage between quality architecture and sculpture. Then in 1897, Derwent Wood was employed as modelling master at Glasgow School of Art, and in his four years in Glasgow, in addition to executing regular work for private and institutional patrons—such as the busts of John Campbell, Baron Overtoun (signed and dated 1898) (plate 452) and Margaret Somerville (signed and dated 1898) (plate 453) in the Christian Institute, Bothwell Street—he was responsible for sculptural decoration on Mercantile Chambers, Bothwell Street (1897–8) and the branch of the British Linen Bank, 816 Govan Road (plates 454, 455). The latter building, of 1899, is a fine, if restrained example of Glasgow architecture at the turn of the century; Derwent Wood's work is most spirited. However the peak (certainly quantitatively) of Glasgow's architectural sculpture had already been set on City Chambers (the building by William Young, 1883–8), with its lavish programme of reliefs around the entrance, spandrels about the first-floor windows,

366

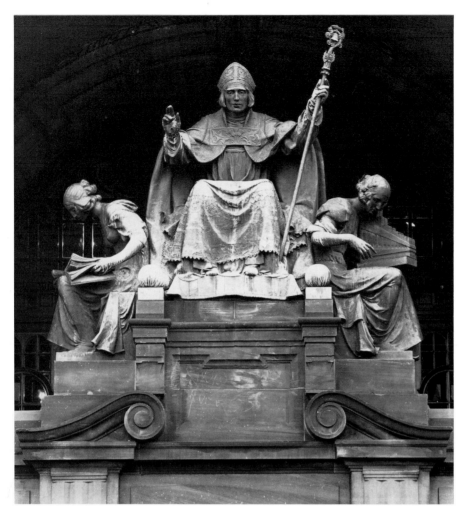

451. Sir George Frampton, *St Mungo*. Glasgow, Kelvingrove Art Gallery and Museum.

452. Francis Derwent Wood, *John Campbell, Baron Overtoun*, 1898. Glasgow, Christian Institute.

453. Francis Derwent Wood, *Margaret Somerville*, 1898. Glasgow, Christian Institute.

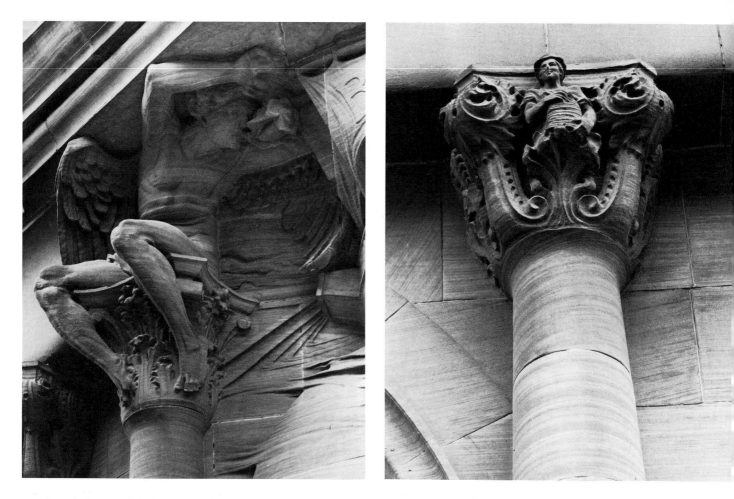

454. Francis Derwent Wood,
Atlas figure, *c.* 1899. Glasgow,
Govan Road.

455. Francis Derwent Wood,
capital, *c.* 1899. Glasgow,
Govan Road.

and groups and figures along the cornice of the main facade and on the central tower—
these all by George Lawson.

A nationalist dimension to sculptural display, over and above that detectable in, say,
Edinburgh or Dublin earlier in the century (as already noted), manifested itself at the end
of the nineteenth century in Cardiff. The creation there of a substantial national-cum-
civic centre, with Law Courts, Government Offices, a National Museum and the City
Hall brought with it the creation in Cathays Park of a series of statues of prominent
Welshmen, by Goscombe John and others. The buildings themselves were emphatically
adorned with sculpture, not only outside (for example, groups representing Poetry and
Music, Commerce and Industry on City Hall, other groups on the Law Courts) but also,
inside the City Hall, another series of statues of great figures of Welsh history—*St David* by
Goscombe John, *Boadicea* by Havard Thomas, *Hywel Dda* by F. W. Pomeroy, *Henry VII* by
E. G. Gillick, *Prince Llewellyn* by Henry Poole, *Dafydd ap Gwilym* by W. W. Wagstaff,
Giraldus Cambrensis by Henry Pollock, *Owen Glyndwr* by A. Turner, *General Picton* by T.
Mewburn Crook, *Bishop Morgan* by T. J. Clapperton and *Williams Pantycelyn* by L. S.
Merrifield.[79] The choice of sculptors (not all of them Welsh) involved the advice of
Goscombe John, Havard Thomas and the Royal Society of British Sculptors; not without
great ructions for the latter, but the project went ahead, and the collection was unveiled
by Lloyd George in 1916.[80]

This was also of course the period of maximum extension, in ideology and practice, of
the British Empire. Sculpture quite literally followed the flag, establishing over a global
dimension the concept we have observed developing within Britain during the Victorian
era, the commemoration of political and social forces in sculpture. In India in particular,
the jewel in the Imperial Crown, the tradition of British public statuary that had started
indeed by the time of Flaxman—see his statues of the Rajah of Tanjore (1803) for Tanjore

368

and the Marquess of Hastings (1826) for Calcutta[81]—and had subsequently drawn out works by Chantrey, Foley, Noble and Woolner, among others, continued until well beyond the turn of the century. Hamo Thornycroft's *Lord Mayo* (sketch model shown at the Royal Academy, 1874) went to Calcutta, Roscoe Mullins's *General Barrow* (1882) to the Senate House, Lucknow, Brock's *Sir Richard Temple* (1884) to Bombay Town Hall, Bates's *Lord Roberts* (R.A. 1896) to Calcutta, and Onslow Ford's Maharajah of Mysore (1898) to Mysore. Representations of the Queen-Empress herself were not lacking: Frampton's *Queen Victoria* for Calcutta, others by Hamo Thornycroft for Karachi (unveiled 1906), Lucknow (unveiled 1908) and Ajodhya, Oudh. Also by Hamo Thornycroft for India were statues of George V as Prince of Wales (R.A. 1911) and the Viceroy, Lord Curzon (erected 1912), both for Calcutta, and a statue of Edward VII, unveiled in 1916 in Karachi. India in this respect is simply an exemplar: other instances can be found all over the Empire, from Australia to British Guiana, for whom a colossal statue of Queen Victoria was executed by Pinker.[82]

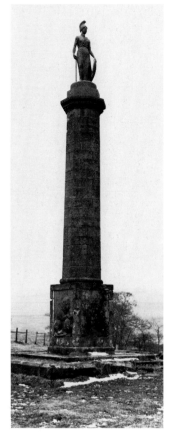

456. Thomas Bland, Monument to Queen Victoria, 1842. Shap Wells.

The late Victorian era's equivalent to the plethora of statues of Prince Albert that had been so marked a feature of mid-Victorian sculpture (culminating in the series of national Prince Consort Memorials) was the commemoration of Queen Victoria, whose death in 1901 was a major national event. There had been a fair number of memorials to the Queen before then as people had not wished (perhaps wisely, with hindsight) to wait until her demise. Indeed the first monument to her that I know of commemorates her accession in 1837 and is sited in a field by Shap Wells, in Westmorland (plate 456). It takes the form of a figure of Britannia on top of a column, the base of which has sculpted in relief a lion, a wreath and an act of libation. It is the work of a sculptor called Thomas Bland (1799?–1865) a local Westmorland lad quite determined not to make good: David Cox the younger, impressed by some of Bland's drawings, wished to introduce him to the world of art, but Bland was without ambition and the offer came to nothing. Instead he filled his own garden with pictures and statuary: a figure of Walter Scott with three bas-reliefs below representing characters from Scott's novels; statues of Addison, Burns, Hugh Miller the geologist, and Music holding a lyre; a figure symbolising the local river Lyvennet; and others. Each year, on the anniversary of her Majesty's accession, Bland opened his garden to the public; a band was engaged for the occasion, and the day's amusements were interspersed with lectures, addresses, music, dancing and other recreations.[83]

At a less individual level, we have already seen Queen Victoria commemorated at Glasgow (Marochetti, 1849) and Salford (Noble, 1857) (plate 108). Her Golden Jubilee in 1887 called forth one of the most outstanding commemorations of the Victorian period, that by Gilbert in the Great Hall of Winchester Castle (plate 457).[84] This was commissioned by a wealthy man named Whitaker who, after making a fortune in Malaga, retired to Winchester where he became High Sheriff of Hampshire and presented the city with Gilbert's statue in 1887. Originally erected opposite the Town Hall, it was later taken to the Abbey Grounds, and finally placed in the Castle. The way in which the bronze robes tumble about, the way in which the whole composition is studded with minutely wrought detailing, amounts to a total commitment to the decorative ideals of the New Sculpture, quite apart from the tribute it must pay to the bronze-caster's art.

Of the national memorials to Queen Victoria, that in Dublin (plate 43) was first adumbrated in 1897, in fact by the Royal Dublin Society as a private, institutional project. As time passed without anything definite being fixed, associations with Irish soldiers fighting in the Boer War (1899–1902) and the visit of the Queen to Dublin in 1900 altered the scope of the memorial; it became the Irish national monument, publicly subscribed, and was finally unveiled on the lawn outside Leinster House in 1908.[85] The sculptor chosen was John Hughes (1865–1941), Irish-born and trained in Dublin and

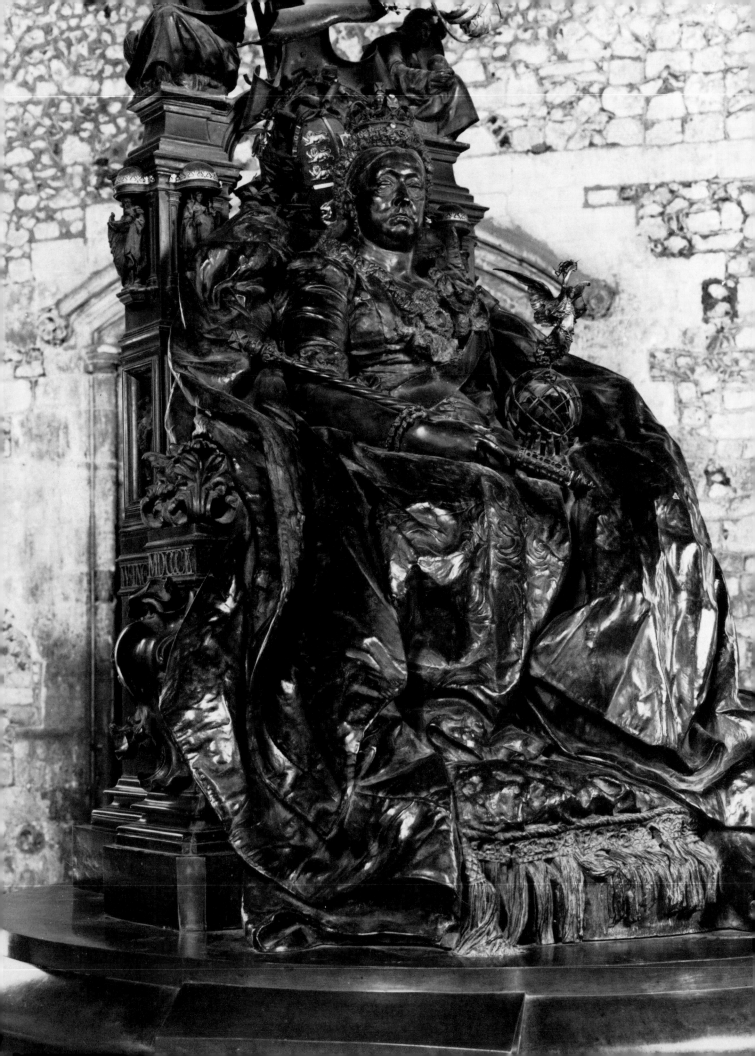

London (National Art Training School). A large seated figure of the Queen surmounted a triangular pedestal, with projecting spurs. In one angle of the pedestal was a group in bronze of a wounded Irish soldier, with Erin presenting him with a laurel crown; in the others were two bronze figures representing Peace and a bronze figure of Fame. There were in addition three small stone figures representing Science, Literature and Art. But with the change in the political complexion of Ireland, attempts were made to get rid of the statue, not so much because it was called the Hippopotamus, but because it was in front of the entrance to the Parliament of the new republican state. It was not in fact dismantled until 1948, since when it has been in the care of the Department of Works—exemplary care, since they have resisted all attempts to separate the component parts, melt down the bronze, etc., and the principal sculpture features remain in the courtyard of the former Royal Hospital, Kilmainham, while the rest is apparently stored elsewhere.

Scotland does not seem to have a national Victoria Memorial; the nearest Edinburgh comes to one is the statue at the wrong end of Leith Walk (plate 458), in fact Leith's own memorial. By a Scottish artist, John S. Rhind, it dates from 1907. It bears on its base two reliefs, 'Queen Victoria Entering Leith, Sept. 3, 1842' (this is signed and dated 1912) and '5th Volunteer Battalion "The Royal Scots". South Africa 1900–2. A Memorial to Patriotism and Loyalty' (this signed and dated). The work thus seems to be serving, most economically, several purposes at one and the same time.

But the major national memorial, as with Prince Albert, is that in London (plate 459). As soon as the Queen died a provisional committee was formed to consider a national memorial,[86] and by the end of March 1901 a public meeting had been held at the Mansion House, London (as had happened with Albert). A scheme to erect a memorial in front of Buckingham Palace had already been aired and had received the King's entire approval. Mr Balfour, the Prime Minister, next indicated that the kind of design that was contemplated would be something more than a mere monument in the ordinary sense—it would be some great architectural and scenic change in the quarter of London selected. In April, further decisions were announced: an executive committee had been formed which included Sir Edward Poynter, President of the Royal Academy, Emerson, President of the Royal Institute of British Architects, and Sidney Colvin, the critic.

The first and most vital decision they had made had been to ask the sculptor Thomas Brock to prepare a design for a group or groups of sculpture, including a statue of the Queen, to go opposite the entrance gate to Buckingham Palace. (The priority of sculpture should be noted.) Meanwhile, Adams-Acton, still active, had submitted to Lord Esher a design for the Memorial to the Queen: it showed her in her Coronation robes, while from the topmost jewel in her crown a great light was to radiate at night and lesser lights from her other jewels. The whole was to be mounted on a huge pedestal, the interior of which was to form a treasure-house for the mementoes of her reign, and a Valhalla for the names of the glorious dead of that period. It had, comments the sculptor's biographer, at least the merit of originality.[87]

The executive committee then invited five architects to prepare designs for the treatment of the west end—the Buckingham Palace end—of the Mall, where the sculpture group or groups were to be placed, and for a general scheme 'should funds allow' to include an architectural entrance at the Spring Gardens end of the Mall, and a general architectonic rearrangement of the Mall, with groups of sculpture, at intervals, the whole forming a processional road. The competition entry of Aston Webb (who won) differed from what eventually went up at the west end[88]—the principal sculpture feature was less emphatic, being set into the screen in front of the Palace without the outer groups and elements, while the semi-circular area in front of the screen, enclosed within a colonnade (not proceeded with), seems to have had envisaged for it large numbers of free-standing sculptures (of which the character is indeterminable in the small-scale

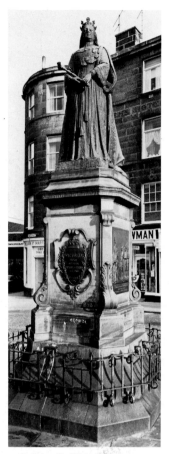

458. John S. Rhind, *Queen Victoria*, 1907–12. Leith.

457 (facing page). Sir Alfred Gilbert, *Queen Victoria*, 1887; 1910. Winchester Castle.

371

459. Sir Thomas Brock and Sir
Aston Webb, *Victoria Memorial*,
1901–24. London, The Mall.

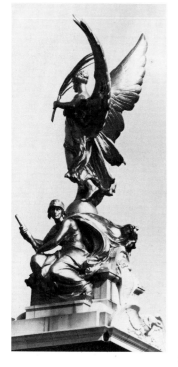

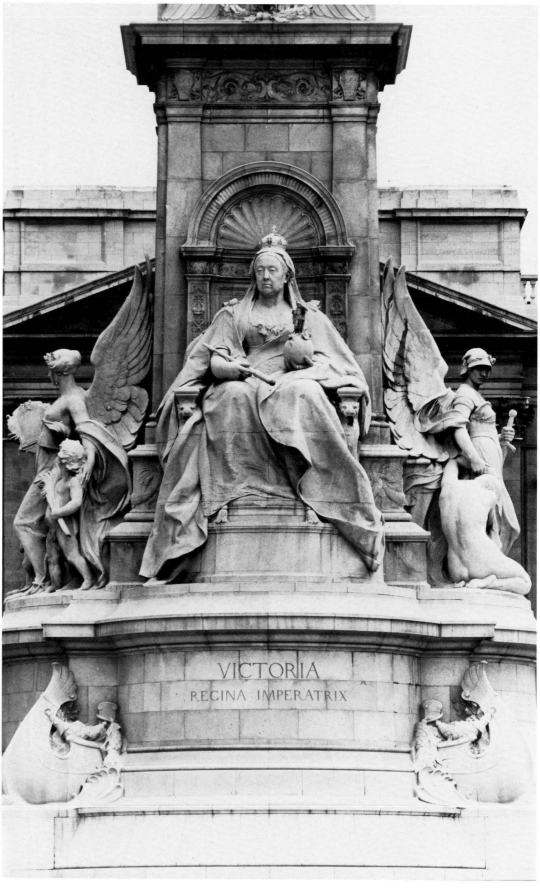

460, 461 & 462. Sir Thomas
Brock, details from the Victoria
Memorial, 1901–24. London,
The Mall.

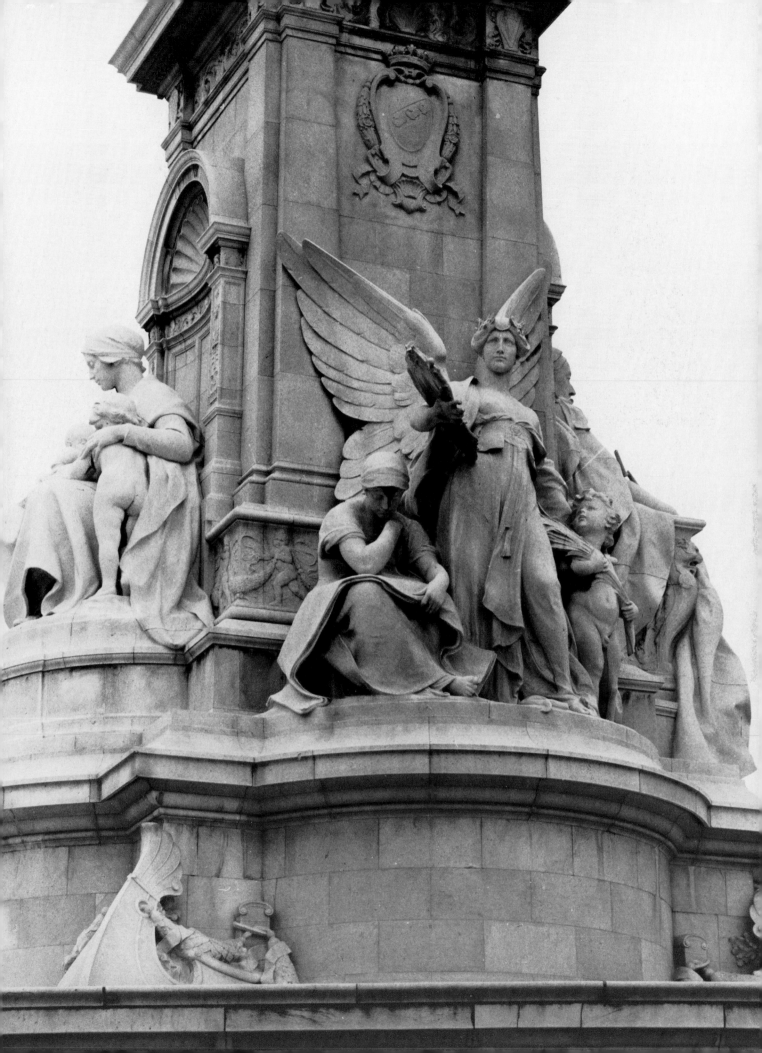

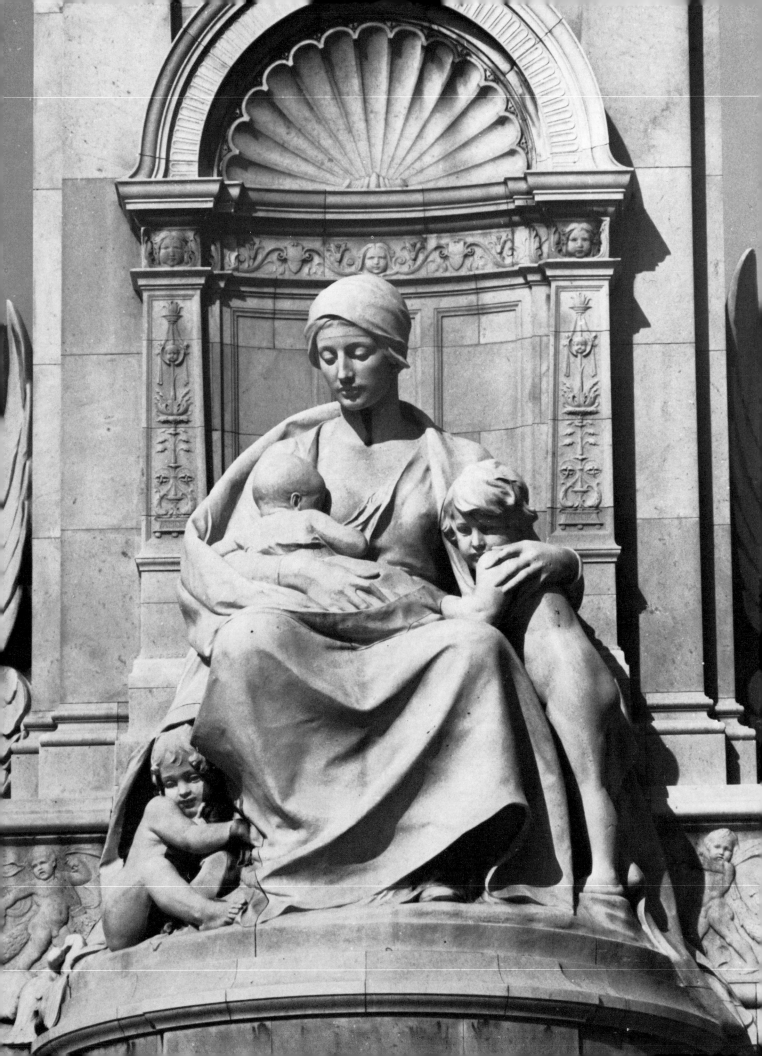

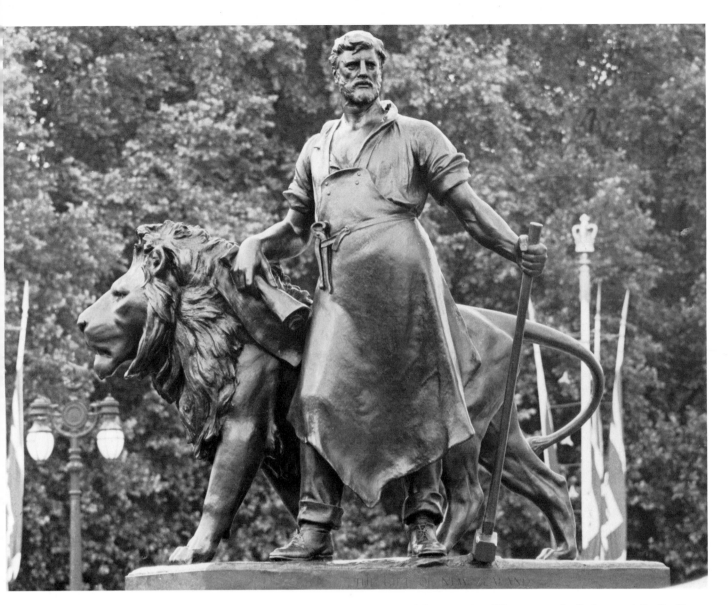

drawing at the R.I.B.A. Drawings Collection). The unsuccessful entry by Thomas Graham Jackson[89] included for his Spring Gardens architectural entrance element a traditional triumphal archway adorned with very conventional sculpture—Britannia Ruling the Waves on top, and reliefs of serried ranks of military below.

At this stage, some criticism began to be voiced. There had been no competition at all for the central feature, and only a limited one for the architectural setting. The arguments used in defence of the course of action taken seemed, it was thought, '. . . to involve a somewhat painfully, and perhaps unnecessarily, low estimate alike of artistic feeling and of artistic capacity in England at the close of the Victorian era.' Also, it was felt, the difference in the treatment of the professions of sculptor and architect was hard to account for on anything that could be called a principle. Be that as it may, Brock's model of his main feature was ready for the King's inspection in March 1904,[90] and construction began in 1906. The memorial was unveiled in May 1911 by George V; the Kaiser was there and family ties were stressed. Brock was presented to the King, who then called him back, asked for a sword, and knighted him. Largely completed by 1914, the last two of the groups on the surrounding pillars were placed in position in 1924.[91] The monument is in its way one of the supreme achievements of the New Sculpture, redolent throughout with features and reminiscences essential to its whole nature; or of the movement, at least, in its establishment format, lacking the extremes of finesse of Gilbert's decorative fantasy or

463 (facing page) & 464. Sir Thomas Brock, details from the Victoria Memorial, 1901–24. London, The Mall.

377

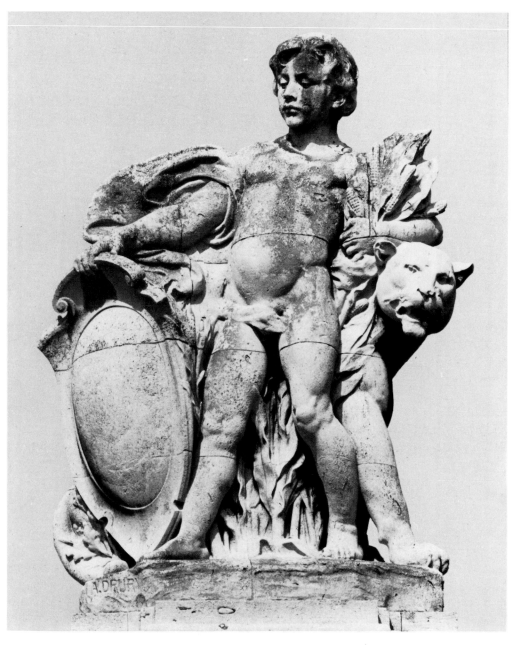

465. Alfred Drury, detail from
the Victoria Memorial,
1901–24. London, The Mall.

Frampton's craftiness. At the very top stands a (Gilbertian) figure of Victory, supported
on either side by Courage and Constancy (out of Stevens) (plate 460). Below, the seated
Queen (plate 461) looks up the Mall, with on either side of the main structure figures of
Truth (plate 462) and Justice (à la Gilbert). Facing Buckingham Palace is a figure of
Motherhood (plate 463); this is straight out of the series of Dalou Charity figures that he
had produced during his stay in England in the 1870s (plate 365). Round the rim are
placed groups of Painting and Architecture, War and Shipbuilding; below these are
bronze reliefs of mermaids, fountain-head figures and, in marble, reliefs of Nereids and
Tritons, these showing the subtlety of material handling and space gradation so
characteristic of the New Sculpture. At the outer corners of the main structure are bronze
figures accompanying lions—Peace, Progress, Agriculture and Manufacture (plate 464).
Hamo Thornycroft had treated such themes of labour in an ideal way twenty years
earlier, and we might remember too similar ideas on Dalou's Monument to the Third
Republic, set up in Paris in 1899.

378

The immediate architectural vicinity is established by a series of gateposts surrounding the main Memorial, forming part of the scheme. These are surmounted by youths or *Amorini*, displaying the shields of various Dominions and Colonies, with appropriate symbols behind them. By the Mall exit stand *West Africa* (with a leopard and an eagle behind) (plate 465) and *South Africa* (an ostrich and a monkey), by the gates into Green Park *Canada* (wheat and fruit on one pillar, a seal on the other); these were all by Drury. By the exit on to Birdcage Walk, stands *Australia* (kangaroo and ram) by Derwent Wood, and standing elsewhere are vases for the Malay States and Newfoundland. India is not represented, having set up its own memorial at Delhi to the Queen-Empress.

The whole scheme was finished off at either end by a new facade to Buckingham Palace and Admiralty Arch. On the latter Brock executed two large stone female figures representing Navigation (with a sextant) and Gunnery (with a gun). The whole scheme thus forms, from one end of the Mall to the other, a 'total environmental experience', the gift of a grateful Empire to their Queen, at a cost—met by public subscription—of nearly £325,000.[92]

Of all the other figures of Victorian England who received commemoration in sculpture, it is perhaps most fitting to draw to a close with Gladstone. First entering Parliament in 1832, a minister in 1843, his fourth term as Prime Minister ended only in 1894, over fifty years later; this was a political career extending through almost the entirety of the reign, and marked throughout by sterling Victorian principles and virtues. At his death in 1898, Parliament commissioned a memorial for Westminster Abbey, a full-length statue by Brock which was unveiled in 1903 (plate 466). Other memorials to him set up throughout the United Kingdom reflect the state of Victorian sculpture in its final phase. In the municipalities a wide range of sculptors attested that the New Sculpture was not an isolated phenomenon: we have already seen Manchester's Raggi (plate 439) and Blackburn's Adams-Acton (plate 441), and there were many others. Glasgow, though, chose Hamo Thornycroft; his work consisted of a standing figure of Gladstone (plate 467) with two reliefs on the base, one of Gladstone in the House of Commons, the other showing him chopping down a tree in the grounds of his home, Hawarden Castle (plate 468). The shallowness on the one hand, and the multiplicity of formal detailing on the other, in these bronze reliefs, are recognisable characteristic features of the New Sculpture.

In 1898 a Gladstone National Memorial Fund was set up; from the subscriptions received it eventually endowed St Deiniol's Library at Hawarden with £10,000 for a permanent building; in addition it commissioned three monuments for erection in London, Edinburgh and Dublin; each would incorporate a central figure of Gladstone.

There were problems with Dublin.[93] The City Corporation immediately refused to allow any site for such a monument; for although it was granted that Gladstone might have meant Ireland well, he had also, it was thought, done her some substantial wrong. The National Memorial Committee must nevertheless have persisted with the idea, since by 1910 they were in negotiation with John Hughes (once more) about a specific monument, and they had a site in mind in the People's Garden, Phoenix Park. In the ensuing years Hughes designed a monument to consist of a statue of Gladstone, with supporting figures of *Erin* and *Classical Learning*, *The Genius of Finance* and *Eloquence*, plus a pedestal with carved decorative work. Unfortunately by the time the five figure pieces were ready to be cast in bronze (Hughes was working on them in Paris), war had broken out and the whole project was postponed. Casting was only completed in 1921, the stonework finished only in 1923. Negotiations went on for the monument's erection in Dublin, but the political situation made this impossible. In 1924 the monument was offered to Hawarden, where it was set up, finally, in 1925.

The Edinburgh National Monument was assigned to Pittendrigh McGillivray, and

466. Sir Thomas Brock, *W. E. Gladstone*, unveiled 1903. London, Westminster Abbey.

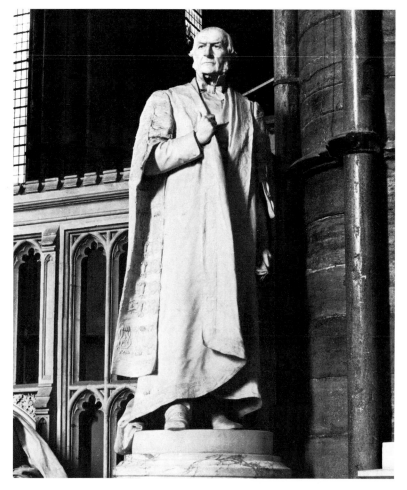

467 (below left). Sir William Hamo Thornycroft, *W. E. Gladstone*. Glasgow, George Square.

468 (below right). Sir William Hamo Thornycroft, detail from *W. E. Gladstone*. Glasgow, George Square.

469 (facing page). Pittendrigh McGillivray, Monument to W. E. Gladstone, unveiled 1917. Edinburgh, Coates Crescent.

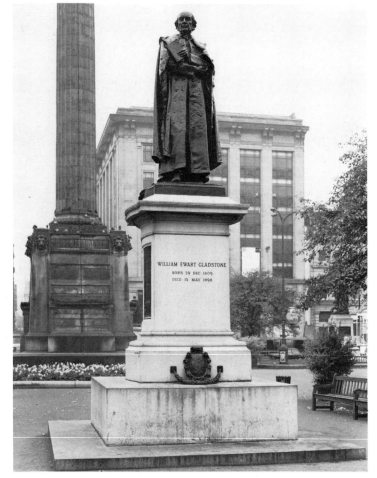

WILLIAM EWART GLADSTONE
BORN 29 DEC 1809
DIED 19 MAY 1898

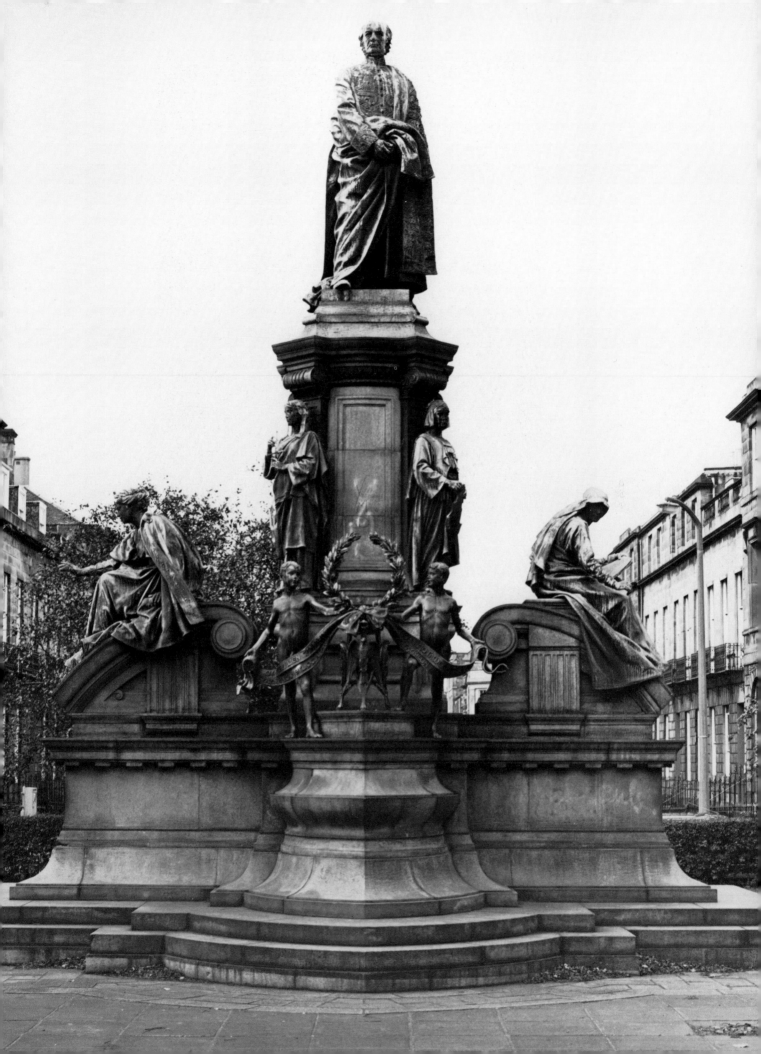

470 & 471. Pittendrigh McGillivray, details from Monument to W. E. Gladstone, 1917. Edinburgh, Coates Crescent.

though there were delays with this also, due it would seem to certain personality problems on the part of the artist, it was unveiled in 1917 in George Street, near where Gladstone had been staying when the result of his famous Midlothian Campaign of 1879 and 1880 was declared.[94] The Monument was later moved to Coates Crescent (plate 469). It takes the form of a statue of Gladstone at the top, in the robes of Chancellor of the Exchequer; immediately below (plate 470) are four supporting standing figures of *Faith*, *Measure*, *Fortitude* and *Vitality*, with more prominent seated figures of *Eloquence* and *History* (plate 471) forming the next stage down, these latter labelled in Latin, to go with the standing youths between them, who bear long ribands inscribed in Greek that radiate from laurel-crowned tripods—all forming an impressive enough tribute to the subject's principal attributes.

The English National Monument in London is by Hamo Thornycroft and seems to have been completed with a minimum of fuss; sited in the Strand, it was unveiled in 1905 (plate 472).[95] Gladstone stands in the robes of the Chancellor of the Exchequer, surrounded by four bronze groups representing Brotherhood, Aspiration, Education and Courage. On bronze panels between the groups are escutcheons of some of the counties and boroughs that Gladstone represented. The figure of Gladstone (plate 473) is a fine rendering, not only of character, but of modelled detailing in textured bronze, the New Sculpture hallmark. The allegorical groups, too, are representative of the movement and its aims: *Courage* (plate 474) with nonchalant strength attacking the serpent (itself a reference to Leighton?) harks back to Alfred Stevens's group of Truth plucking out the tongue of Falsehood, in the Wellington Memorial; *Brotherhood* (plate 475) exudes the domestic tenderness of Dalou, while *Education* (plate 476) directs a child to a beneficial future. These allusions are part of a fusion of a new sculptural language, in which a richness of formal values, released by modelling and translated into bronze, was given full-blooded artistic vitality.

472. Sir William Hamo Thornycroft, Gladstone Memorial, unveiled 1905. London, Strand.

382

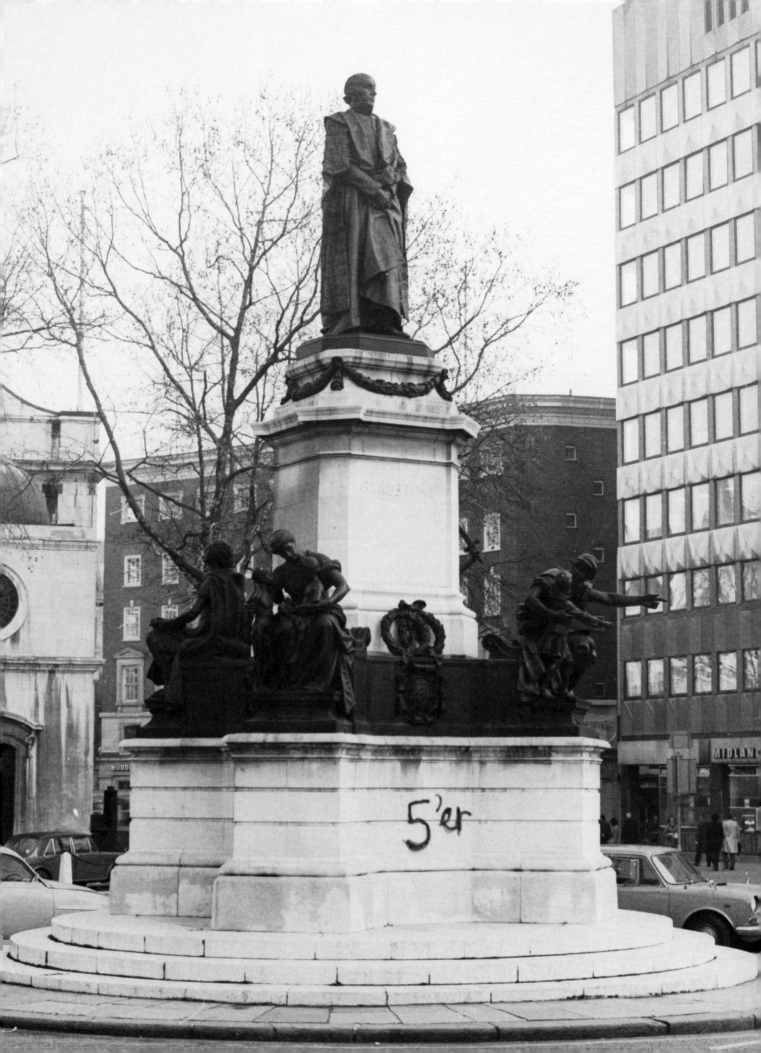

473. Sir William Hamo
Thornycroft, detail from
Gladstone Memorial, 1905.
London, Strand.

474 (facing page). Sir William
Hamo Thornycroft, detail,
Courage, from Gladstone
Memorial, 1905. London,
Strand.

475. Sir William Hamo Thornycroft, detail, *Brotherhood*, from Gladstone Memorial, 1905. London, Strand.

476. Sir William Hamo Thornycroft, detail, *Education*, from Gladstone Memorial, 1905. London, Strand.

A relatively short distance away stands the former headquarters of the British Medical Association; on this, in 1908, only three years after Thornycroft's work was unveiled, a series of figures by Jacob Epstein was offered to a public who, by their horrified reaction, indicated the arrival of the modern movement in sculpture in Britain. In the years that have since elapsed, British sculpture has achieved world-wide renown and prestige. Yet it is possible to see, in Thornycroft's Gladstone Memorial, a key to this achievement. For it represents a stage in the continuity of sculptural development in Britain that can be traced back at least to the middle of the seventeenth century, a vital stage at which artists were able to obtain a new freedom and independence of plastic language. This was in turn only a stage in a previous development: drawing on such figures as Leighton on the one hand and Brock on the other, with in turn his appreciative transfer of the efforts before him of Foley, the sculptor so often and so effectively of Prince Albert and his contemporaries—by such means later Victorian sculpture gave to the art of sculpture in this country an impetus that is still with us. This was essentially a consequence of the vigorous practice of the preceding generation; so that ultimately I hope to have demonstrated that the sculptural life of Britain achieved in the Victorian era not just a scale of dimension in the life of the country whose momentum is still with us, but also a reformulation of some of the fundamental aesthetic values of the plastic arts that still enrich our cultural heritage.

References

CHAPTER ONE

1. F. T. Palgrave *Introduction* p. 136
2. Willis and Clark iii pp. 222–4; Goodison pp. 117–18, no. 196
3. see for instance the contributions of Beattie, Dorment and L. Handley-Read cited in the General Bibliography
4. e.g. 'Sculpture 1850 and 1950', London County Council, Holland Park, 1957; 'British Sculpture 1850–1914', Fine Art Society, London, 1968
5. Ruskin xx p. 239
6. *ibid.* xii p. 155
7. I owe this information to Lady Mander.
8. *Art Journal* 1857 p. 129
9. *ibid.* 1857 p. 163
10. *ibid.* 1858 p. 191
11. *ibid.* 1857 p. 295
12. *ibid.* 1858 p. 232
13. *ibid.* 1859 p. 36
14. *ibid.* 1859 p. 259
15. see *Notes and Queries* 11th series vi 20 July 1912 p. 43 (Repose *v.* Movement); 11th series vi 10 August 1912 p. 105 (position of *Hardinge*). I am most grateful to Dr Nicholas Penny for these references.
16. *Art Journal* 1859 p. 259
17. *ibid.* 1862 p. 163
18. W. M. Rossetti *Fine Art* p. 360
19. F. T. Palgrave *Handbook* p. 108
20. *Art Journal* 1859 p. 36
21. W. M. Rossetti *Fine Art* p. 352
22. *Art Journal* 1857 p. 163
23. Gleichen p. 11
24. F. T. Palgrave *Handbook* p. 107
25. F. T. Palgrave *Introduction* p. 137
26. Waring i, commentary to plate 54
27. Browning i p. 599
28. A. Woolner *Life* p. 216
29. F. T. Palgrave *Essays* pp. 35–6
30. W. M. Rossetti *Fine Art* p. 343
31. *The Scotsman* October 1860
32. *London Review* 1 September 1860
33. *The Times* 15 January 1862
34. *Art Journal* 1862 p. 61
35. *ibid.* 1855 p. 318; 1856 p. 126; 1860 p. 377; 1861 p. 127; 1863 p. 147
36. *ibid.* 1864 p. 315
37. *ibid.* 1861 p. 223
38. for further examples see, e.g. *Art Journal* 1849 p. 49; 1865 p. 123
39. *ibid.* 1874 p. 306
40. *ibid.* 1862 p. 98
41. Stirling p. 127
42. *Illustrated London News* 15 October 1892 p. 475
43. *Birmingham . . . Statues* pp. 6, 7
44. Eastlake *Contributions*
45. Lady Eastlake 'Memoir' p. 160; Willis and Clark iii p. 210
46. Eastlake *Contributions* pp. 61–2
47. *ibid.* p. 61
48. *ibid.* pp. 66–9
49. *ibid.* p. 62
50. *ibid.* p. 61
51. *ibid.* pp. 72–6
52. *ibid.* p. 81
53. *ibid.* pp. 67, 70, 73–4, 107, 124
54. Lady Eastlake 'Memoir' p. 118
55. Gunnis *Dictionary* p. 428
56. Weekes pp. 78–9
57. *ibid.* p. 111
58. *ibid.* pp. 43, 66
59. *ibid.* pp. 134, 174
60. *ibid.* pp. 75, 108, 113, 137
61. *ibid.* p. 35
62. *ibid.* for instance Lecture VI *passim*
63. *ibid.* p. 139
64. *ibid.* p. 146
65. *ibid.* p. 61
66. *ibid.* p. 62
67. *ibid.* pp. 219ff
68. *ibid.* p. 134
69. A. Woolner *Life* pp. 306–7
70. T. Woolner p. 3
71. *ibid.* p. 105
72. *ibid.* pp. 13, 40
73. *ibid.* p. 57
74. *ibid.* p. 144
75. *ibid.* p. 145
76. A. Woolner *Life* p. 311
77. Listed variously in Thieme-Becker iii p. 227, *Dictionary of National Biography* xxii p. 166
78. W. M. Rossetti *Fine Art* pp. 335–62
79. *ibid.* pp. 340–2
80. *ibid.* pp. 345–6
81. *ibid.* pp. 338, 352
82. *ibid.* p. 338
83. *ibid.* pp. 352–4
84. *ibid.* pp. 356–8
85. *ibid.* p. 360
86. *ibid.* p. 361

87. *ibid.* p. 362
88. F. T. Palgrave *Introduction* p. 135
89. *ibid.* p. 136
90. *ibid.* p. 137
91. F. T. Palgrave *Handbook* pp. 85ff
92. *ibid.* p. 91
93. *ibid.* p. 98
94. *ibid.* pp. 99–100
95. *ibid.* p. 100
96. F. T. Palgrave *Essays* p. 87
97. *ibid.* pp. 218, 256
98. *ibid.* p. 36
99. *ibid.* p. 257—see also p. 120
100. *ibid.* pp. 256, 120
101. *ibid.* p. 36
102. *ibid.* p. 293—see also p. 223
103. *ibid.* p. 297
104. *ibid.* pp. 41–2
105. *ibid.* p. 85
106. *ibid.* p. 121
107. *ibid.* p. 296
108. *ibid.* pp. 225, 293–5. For Butler, see p. 83; for Foley see also (by implication) among the R.A. reviews pp. 2, 48, 83; for Woolner see pp. 28, 83
109. *ibid.* p. 119
110. *ibid.* p. 91
111. G. F. Palgrave p. 96
112. W. M. Rossetti *Fine Art* p. 341; F. T. Palgrave *Introduction* p. 135
113. A. Woolner *Life* p. 135
114. G. F. Palgrave p. 32
115. A. Woolner *Life* p. 334
116. F. T. Palgrave *Essays* p. 223
117. Letter, Woolner to Lady Trevelyan 23 December 1860, Trevelyan Papers, University of Newcastle-upon-Tyne, printed by courtesy of Maj.-Gen. C. G. Woolner and the University Librarian

Chapter Two

1. Matthews p. 230
2. *Athenaeum* no. 1997, 3 February 1866 p. 172
3. Matthews p. 230
4. Anstey pp. 34–5
5. *ibid.* pp. 73–4
6. *ibid.* pp. 179–83
7. see *The Times* 9 March 1962 p. 7
8. Maidstone p. 3, no. 12
9. Pevsner *Yorkshire: The West Riding* p. 534
10. see *Reports of the Commissioners on the Fine Arts...*, Second Report (1843) p. 68
11. *Literary Gazette* 1844 p. 466
12. see *Reports of the Commissioners on the Fine Arts...*, Third Report (1844) p. 11
13. see F. K. Hunt p. 138
14. *Art Union* 1844 p. 216
15. Physick p. 38 and pp. 132–71
16. *Illustrated London News* 29 August 1857 p. 225; 12 September 1857 pp. 277–8
17. see 'Immortal Fame: An Anthology of Drawings and Models for English Sculpture', Exhibition Catalogue Leeds 1973, cat. no. 33
18. Pevsner *Studies* ii pp. 66–7

19. *Great Exhibition...* ii p. 848
20. Tallis i pp. 125, 170
21. I am greatly indebted to Edna Everage for drawing my attention to this by standing in front of it during a television interview
22. *Art Journal* 1861 p. 223
23. *ibid.* 1869 p. 226
24. see Fletcher p. 195
25. for details of this Royal Commission see Gibbs-Smith p. 37
26. Lonsdale pp. 221–2
27. Whinney and Gunnis p. 1
28. Poole i pp. 207–19
29. Lady Eastlake *Life* p. 245
30. This can be inferred from accounts of the fortunes of the Stevens *Nachlass*; see Towndrow *Tate...* pp. ix–x; Beattie *RIBA* p. 5
31. see Robinson
32. Gunnis *Dictionary* p. 238
33. Gunnis *Dictionary* p. 395
34. Communication to the author from Torquay, kindly elicited by Judith Bronkhurst to whom I am most grateful.
35. Victoria and Albert Museum, *Checklist* pp. 3–6
36. Local, personal communication to the author. But see also Boase 'Lough' p. 288
37. Gunnis *Dictionary* p. 238
38. Sterne p. 1
39. Lady Eastlake *Life* p. 246
40. I am most grateful to the Society's Registrar for providing me with a copy of a list published at the time of the Bicentenary.
41. see copy of Bradford Town Council's resolution of acceptance: Glasgow University Library, Birnie Philip Collection, BP III 6/31
42. see (Woolner, A.) *Studios...*
43. Personal communication from Mrs E. Manning
44. Walker p. 96
45. Walker p. 96; PRO WORKs 11, 28/16, f.21
46. PRO WORKs II, 28/16, ff. 68–101 (catalogue of the casts sent to South Kensington); *An Inventory of Plaster Casts in Various Styles... acquired by the South Kensington Museum*, 1874 p. 10 (transfer to Edinburgh); letter to author from Royal Scottish Museum, 8 October 1971
47. Jameson p. 13
48. Personal information given to the author by the Dean of the time
49. For the history of Wyatt's *Wellington* see Physick pp. 2–19
50. see *Birmingham... Statues* p. 4
51. Clarke p. 958
52. Penny *Church Monuments* p. 203
53. Baudelaire ii p. 670

Chapter Three

1. Browning i pp. 599–600
2. Gunnis *Dictionary* p. 370
3. see *The Morning Post* 5 September 1856 p. 5
4. Gunnis *Dictionary* p. 318
5. Stirling pp. 223–7
6. Matthews p. 233

7. see 'Some Reminiscences of the Breconshire Sculptor', by his nephew G. T. Harley Thomas. Typescript 1936, Brecon Museum. I am most grateful to Fiona Pearson for communicating this to me.

8. Lonsdale p. 227

9. Lonsdale p. 112

10. Lonsdale p. 220

11. Lonsdale p. 217

12. Lonsdale pp. 161–2

13. A(tkinson) p. 34

14. Ruskin xxxvi p. 347. I am most grateful to Gerard Neill for this reference.

15. Gunnis *Dictionary* pp. 45–6, which includes a quotation from S. C. Hall *Retrospect of a Long Life* ii p. 238.

16. Gunnis *Dictionary* p. 71; S. Baring-Gould *Cornish Characters and Strange Events* p. 186

17. Gunnis *Dictionary* p. 389

18. *ibid.* p. 137

19. For a fuller account of Thomas's career, see later pp. 132–3, 143–6, 228–35 and note 30 p. 393

20. *Art Journal* 1849 p. 49

21. Mullins pp. 80–4

22. Weekes pp. 219–20

23. Lady Eastlake *Life* pp. 123–4

24. Leeds City Art Gallery no. 758/27

25. Mainly in the R.I.B.A. Drawings Collection

26. Mullins p. 21

27. Lady Eastlake *Life* p. 110

28. Fredeman p. 9

29. *ibid.* p. 42

30. *ibid.* p. 27

31. Mullins p. 79

32. *ibid.* p. 22

33. *ibid.* p. 22

34. *ibid.* p. 26

35. *ibid.* p. 23

36. Matthews pp. 45–6

37. Mullins pp. 26–32

38. Letter, Woolner to Lady Trevelyan, 18 October 1859, Trevelyan Papers

39. The following account of plaster casting is compiled from various sources. See for instance Tallis i p. 121; Mullins pp. 84–8; M. Saabye *Thorwaldsen* (Copenhagen 1972), unpaginated (pp. 19–20)

40. Letter, Woolner to Sir Walter Trevelyan, 10 November 1860, Trevelyan Papers

41. Letter, Woolner to Sir Walter Trevelyan, 25 August 1862, Trevelyan Papers

42. Stirling p. 126

43. Letter, Woolner to Lady Trevelyan, 8 March 1863, Trevelyan Papers

44. Gleichen p. 98

45. Letter, Woolner to Lady Trevelyan, 8 March 1863, Trevelyan Papers

46. *Art Journal* 1849 p. 261

47. *ibid.* 1867 p. 134

48. Gleichen p. 24

49. *ibid.* p. 37

50. LeFanu pp. 20, 4, 29

51. *Art Journal* 1865 p. 94

52. for sand casting, see Toft pp. 191–5

53. *ibid.* p. 194

54. Letter, Woolner to Sir Walter Trevelyan, 24 December 1860, Trevelyan Papers

55. Letter, Woolner to Sir Walter Trevelyan, 10 November 1860, Trevelyan Papers

56. Stirling pp. 259–60

57. *ibid.* p. 129

58. Gunnis *Dictionary* p. 290

59. Letter, Woolner to Sir Walter Trevelyan, 18 December 1860, Trevelyan Papers

60. Shinn plate 8. Other models are illustrated in the *Sculptors' Journal* pp. 18, 57

61. Letter, Woolner to Lady Trevelyan, 26 October 1863, Trevelyan Papers

62. see Osborne *Catalogue* p. 193; label on the reverse of the base

63. Letter, Woolner to Sir Walter Trevelyan, 18 December 1860, Trevelyan Papers

64. see IV Kings v, 3

65. A. Woolner *Life* p. 180; Ormond *Early Victorian Portraits* p. 450

66. Shinn pp. 13, 70

67. see *Great Exhibition . . . Official . . . Catalogue* ii p. 846 (Class 30, no. 85)

68. see Shinn *passim*

69. see their respective entries in Gunnis *Dictionary*

70. Shinn pp. 14, 107

Chapter Four

1. Stirling p. 143

2. Reynolds p. 408

3. Letter, Woolner to Lady Trevelyan, 23 December 1860, Trevelyan Papers

4. A. Woolner *Life* p. xi

5. see *The Times* Law Reports for (1882) 22, 23, 24, 29 June; 4, 7, 8, 9, 10, 11, 15, 16, 17, 18, 21, 22, 23, 24, 25, 28, 29, 30 November; 1, 6, 7, 8, 9, 12, 13, 14, 15, 16, 18, 19, 20, 21, 22, 23, 28, 29, 30 December; (1883) 12, 13 January; 16, 17, 21, 25, 26, 29, 30, 31 March; 1, 2, 5, 6, 8, 9, 11 June; 3, 4, 9, 10 July; 17, 22 December; (1884) 12, 14, 17 January; 4, 5, 6, 7, 8, 10, 11, 12, 18 March

6. *The Times* 23 June 1882 p. 4

7. Lonsdale pp. 228–9

8. F. T. Palgrave *Essays* p. 223

9. Lonsdale p. 85

10. F. T. Palgrave *Essays* pp. 223, 249

11. *Report . . . Royal Academy . . . 1863*, paragraphs 3915 (little accommodation), 3931 (Exhibition v. teaching), 3932 (suggestion)

12. *ibid.* paragraphs 2366–77

13. *ibid.* paragraphs 1964, 1993

14. *ibid.* paragraphs 1983–4

15. *ibid.* paragraphs 1964–6, 2033–7, 2045

16. *ibid.* paragraph 1875

17. *ibid.* paragraphs 1868–9

18. *ibid.* paragraphs 2368–9, 2373

19. *ibid.* paragraphs 1874, 1924–6

20. *ibid.* paragraph 1993

21. Weekes p. 174

22. *ibid.* p. 134

23. see these artists' individual entries in Gunnis *Dictionary*

24. F. T. Palgrave *Essays* pp. 224–5
25. information from Gunnis *Dictionary*; Spielmann *British Sculpture*
26. Stirling p. 148
27. Weekes p. 176
28. see *The Times* 22 June 1882 p. 10
29. Lonsdale p. 81
30. see Lonsdale, *passim*
31. Stirling p. 219
32. Matthews p. 179
33. Lonsdale pp. 87–8
34. for Thomas see below pp. 228–35
35. A(tkinson) p. 24
36. Weekes p. 194
37. *ibid.* pp. 181–98
38. *ibid.* pp. 221–2
39. Stirling p. 142
40. *Art Journal* 1877 p. 120
41. *ibid.* 1874 p. 20; 1877 p. 87
42. *ibid.* 1875 p. 319
43. *ibid.* 1877 p. 317; 1878 p. 62
44. Potterton pp. 9–10
45. *Art Journal* 1875 p. 95
46. *Birmingham . . . Statues etc.* p. 5
47. An example is in the Birnie Philip Collection, University of Glasgow, BP III 6/4 (2). I am very grateful to Mrs Margaret Macdonald for her assistance there.
48. Pevsner *Yorkshire: The West Riding* p. 240
49. Belonging to the Department of Fine Art, Glasgow University
50. Lonsdale p. 15
51. T. Woolner p. 144
52. Baldry p. 64
53. A. Woolner *Life* illustration facing p. 119
54. This information comes from notes in the Gunnis Files at the Courtauld Institute, compiled by the Chief Librarian, County Borough of Rotherham from *The Sheffield Miscellany* ed. W. J. J. Glassby part 6, June 1897
55. Mullins p. 70
56. see Gerdts (unpaginated)

Chapter Five

1. Letter, Woolner to Lady Trevelyan, 31 March 1862, Trevelyan Papers
2. A. Woolner *Life* p. 217
3. Letter, Woolner to Lady Trevelyan, undated
4. Letter in the Royal Institution of Cornwall, Truro. See also Pevsner *North Somerset and Bristol* pp. 383 (Elliott) and 306 (Hervey)
5. Letters, Woolner to Lady Trevelyan, 18 and 23 December 1860, Trevelyan Papers
6. Gunnis *Dictionary* p. 394; *Art Union* 1846 p. 264
7. *Report . . . Royal Academy . . . 1863* paragraphs 2026–30 (Foley), 3900, 3925 (Edwards)
8. *ibid.* paragraphs 2383–9
9. *ibid.* paragraphs 3919–21
10. *ibid.* paragraph 2025
11. Gunnis *Dictionary* p. 153
12. These details come from Cynthia A. Allen 'John Graham Lough and the Neo-Classic Tradition',

B.A. Dissertation, University of Newcastle-upon-Tyne/Durham, 1958 pp. 10, 12. This was communicated to me by Professor John Lough, to whom I am most grateful.
13. Gunnis *Dictionary* p. 155
14. *Reports of the Commissioners on the Fine Arts . . .* Second Report (1843) p. 68
15. *ibid.* Third Report (1844) p. 7
16. *ibid.* Third Report (1844) p. 11
17. *ibid.* Fourth Report (1845) p. 8
18. Walker p. 36
19. *ibid.* p. 25
20. *ibid.* p. 16.
21. *ibid.* p. 66
22. *ibid.* p. 48
23. *ibid.* p. 45
24. *ibid.* p. 28
25. *ibid.* p. 13
26. *ibid.* p. 56
27. *ibid.* p. 34
28. *ibid.* p. 68
29. *ibid.* p. 10
30. Hitchcock *Early Victorian Architecture* i p. 288
31. This account largely derives from Physick pp. 28–50.
32. *Report . . . Royal Academy . . . 1863* paragraphs 1946–9
33. F. T. Palgrave *Essays* pp. 257–9
34. Whinney *Sculpture in Britain* pp. 167, 198
35. Pevsner (and Cherry) *London Volume One* p. 135
36. Potterton p. 4
37. Patmore pp. 205–9
38. Arnold p. v
39. see *Birmingham . . . Statues etc., passim*
40. Patmore p. 207
41. *Daily Mirror* 27 June to 3 July, 1978
42. For Nelson's obsequies and the much more speedily erected memorials in Birmingham and Liverpool, see Penny 'Grand . . . Obsequies'. Accounts of the National Monument on which I have drawn are: Whinney *Sculpture in Britain* pp. 300–1; Physick pp. 19–21; M. H. Port in Crook and Port, pp. 492–4.
43. *Art Union* June 1839 p. 82
44. *ibid.* February 1840 p. 25
45. Hill pp. 41–2
46. Penny *Church Monuments* p. 190
47. The following account is once more greatly indebted to Physick.
48. see Whinney *Sculpture in Britain* p. 215; Gleichen p. 64
49. see in addition to Physick, Beattie *R.I.B.A.* pp. 38–9
50. Stewart pp. 83–4
51. For Albert memorials, particularly that in London, see *National Memorial; Survey of London* xxxviii pp. 148–76; C. Handley-Read (4); Ferriday (3)
52. Gleichen pp. 11–12
53. F. T. Palgrave *Essays* p. 35
54. Gunnis *Dictionary* p. 393
55. Gleichen p. 134
56. Swinburne ii pp. 157–8
57. *National Memorial* p. 12
58. Scott's manuscript draft features in one of his

notebooks in the R.I.B.A. Drawings Collection (New no. 23); my attention was drawn to it by Geoffrey Fisher, to whom I am most grateful. A published version exists in pamphlet form in the Cole papers at the Victoria and Albert Museum; I am very grateful to Elisabeth Darby for this information.

59. Scott *Recollections* p. 266
60. *Art Journal* 1864 p. 315
61. Boase 'Lough' p. 285; Pevsner *Cumberland and Westmorland* p. 115
62. Gunnis *Dictionary* p. 394
63. *ibid.* p. 33
64. I am very grateful to the Vicar of Preston for drawing attention to this.
65. F. T. Palgrave *Essays* p. 251
66. *Art Journal* 1853 p. 297
67. Stewart pp. 81–2
68. Axon p. 8
69. Robinson p. 64
70. *Illustrated London News* xxiv 7 January 1854 p. 11
71. For information on Edinburgh sculpture I am greatly indebted to the National Monuments Record for Scotland.
72. for whom see Gunnis *Dictionary* p. 370
73. see Gray; Wrinch
74. *Art Journal* 1874 p. 47
75. For information on Glasgow sculpture I am again indebted to the National Monuments Record for Scotland but also, more particularly, to Hugh Stevenson of the City Art Gallery, Kelvingrove.
76. For information on sculpture in Ireland see Strickland *Dictionary*. I am also greatly indebted for help in this area to Dr Anne Crookshank and Roger Stalley of Trinity College, Dublin and to Dr Homan Potterton of the National Gallery of Ireland, Dublin.
77. Potterton p. 4
78. for Summers, see Evans; Hutchison
79. for Sculpture (of various sorts) in the Houses of Parliament, general reference may be made to Boase *JWCI* 1954; Walker; Read 'Architectural Sculpture'.
80. Walker pp. 97–9
81. *ibid.* p. 102
82. *ibid.* pp. 74–5; see also Lady Eastlake *Life* pp. 205–8; Matthews pp. 175–8
83. see Walker pp. 100–1, 107; PRO WORKs 22/2, 49, 80, 101
84. LeFanu p. 20
85. *ibid.* p. 29
86. *ibid.* p. 4
87. *ibid.* p. 20
88. *ibid.* pp. 41–2
89. This information was provided for me by Mr Charles Parish, Librarian of the Literary and Philosophical Society, to whom I am most grateful.
90. see references later, note 39 p. 393
91. A. Woolner *Life* pp. 236–8; Poole i p. 125 (no. 316); *British Portraits* p. 219 (no. 731)
92. A. Woolner *Life* p. 177
93. see Strickland *Catalogue, passim*
94. Stirling p. 127
95. *ibid.* p. 254
96. *Art Journal* 1849 p. 49
97. Letter, Woolner to Sir Walter Trevelyan, 10

November 1860, Trevelyan Papers
98. This information is largely pieced together from the artists' entries in Gunnis *Dictionary*.
99. see Girouard plates 302, 304
100. Stirling pp. 152, 155
101. see Osborne *Catalogue*; Ames; and the lists compiled by the Photographic Survey Department of the Courtauld Institute to whom I am most grateful. Much assistance on the spot was given by Mr E. Sibbick, to whom again I am very grateful.
102. C. Handley-Read (3)
103. see Boase 'Lough' pp. 279, 282–4, 287–8
104. see Kenworthy-Browne
105. see *Dictionary of National Biography* xv pp. 972–4
106. for Thomas, see below pp. 228–35
107. for Somerleyton see Girouard pp. 101, 188
108. for other examples, see Gunnis *Dictionary* p. 389
109. see *Birmingham . . . Catalogue* p. 159
110. Gleichen p. 194
111. unpublished letter, private collection

CHAPTER SIX

1. *Art Journal* 1868 p. 162
2. reproduced *Illustrated London News* 29 August 1857 p. 225
3. This description comes largely from A(tkinson) p. 37 which is in turn based on that given in the *O'Connell Centenary Record*.
4. *Birmingham . . . Statues* p. 5
5. Stewart p. 82
6. see Woodward
7. Detailed confirmation of the various parts' signification is to be had from the *National Memorial* volume, *passim*
8. C. Handley-Read (4) p. 1516
9. *National Memorial* p. 58
10. Scott *Recollections* p. 263
11. *ibid.* pp. 264–5
12. N. Smith p. 235
13. Notebook 23, coll. R.I.B.A. Drawings, pp. 9 verso–10 verso
14. *Survey of London* xxxviii p. 154
15. e.g. Robert Branner in *St Louis and the Court Style in Gothic Architecture* 1965
16. Haskell p. 11
17. see Armstead Albums, Royal Academy Library
18. Birnie Philip Collection, Glasgow University Library
19. Scott *Recollections* p. 266
20. *ibid.* p. 266
21. Draft copy, Glasgow University Library, Birnie Philip Collection BP III 6/22
22. *Art Journal* 1874 p. 88
23. *Birmingham . . . Statues* p. 12
24. Stirling p. 155
25. C. Handley-Read (3)
26. *Art Journal* 1861 p. 62
27. Lonsdale p. 103
28. W. M. Rossetti *Fine Art* p. 357
29. Mullins p. 59
30. Sir C. Eastlake *Contributions* p. 72
31. Matthews p. 100; Lady Eastlake *Life* pp. 90–1
32. Lonsdale p. 133

33. *ibid*. p. 182
34. *ibid*. p. 182
35. Weekes p. 108
36. *ibid*. p. 180
37. Letter, Woolner to Lady Trevelyan, 8 March 1863, Trevelyan Papers
38. F. T. Palgrave *Essays* p. 220
39. Weekes p. 223
40. Mullins p. 59
41. Weekes pp. 219ff
42. Mullins pp. 45–6
43. *ibid*. pp. 45–6
44. *ibid*. p. 46
45. *Punch* 17 May 1879 lxxvi p. 226
46. Gleichen p. 62
47. Lady Eastlake *Life* p. 112
48. *ibid*. pp. 120–1
49. Stirling p. 125
50. Temple p. 43
51. Weekes p. 184
52. F. T. Palgrave *Essays* p. 123
53. *ibid*. pp. 41–2, 122
54. Weekes p. 165
55. *ibid*. pp. 221, 172–3
56. *Art Journal* 1866 p. 61
57. *Dictionary of National Biography* xx p. 1371
58. F. T. Palgrave *Essays* p. 87
59. Weekes pp. 221–2
60. Stirling p. 142
61. Mullins p. 44
62. *ibid*. p. 47
63. *Art Journal* 1850 p. 298. A biography of Hampden by Lord Nugent had been published in 1831 and an engraved portrait in it was described by Macaulay in his review of the book as '. . . undoubtedly an original, and probably the only original now in existence'.
64. A(tkinson) p. 35
65. W. M. Rossetti *Fine Art* p. 361
66. Letter, Woolner to Lady Trevelyan, 8 March 1857, Trevelyan Papers
67. Waring i plate 54, commentary
68. for Smith see Fredeman pp. 190–1
69. see Gere
70. W. M. Rossetti *Fine Art* p. 341
71. for references see n. 39 p. 393
72. D. G. Rossetti *Letters* i p. 295
73. *ibid*. i p. 369
74. Seddon p. 30
75. see Fredeman *passim*
76. W. H. Hunt i pp. 112, 128
77. Fredeman p. 88
78. *Spectator* xxiv 2 August 1851 p. 740
79. Woolner ms., private collection
80. W. M. Rossetti *Fine Art* p. 357
81. Letter, Woolner to Lady Trevelyan 26 October 1863, Trevelyan Papers
82. for Wallington in general see Trevelyan; more particularly Trevelyan *Apollo* 1977; *Apollo* 1978
83. Letter, Woolner to Lady Trevelyan 7 May 1864, Trevelyan Papers
84. Pevsner *South Lancashire* p. 126
85. Gunnis *Dictionary* p. 220
86. *Art Journal* 1865 p. 124
87. see Physick; Beattie
88. These drawings and the inferences to be drawn from them were certainly pointed out by, for instance, Lethaby, but I owe my first introduction to them to Rosalie Green of the Index of Christian Art, Princeton University, to whom I am most grateful.
89. Butler p. 70
90. Browne iv p. 50
91. *Art Journal* 1870 p. 221
92. Lonsdale p. 114
93. W. M. Rossetti *Fine Art* p. 347
94. Weekes pp. 75, 169
95. *ibid*. p. 169
96. Lady Eastlake *Life* pp. 103–4
97. Matthews p. 200
98. *ibid*. p. 231
99. *ibid*. p. 91
100. *ibid*. pp. 82–3
101. Weekes p. 75
102. Matthews p. 64
103. Lonsdale pp. 63–4
104. F. T. Palgrave *Handbook* p. 89
105. F. T. Palgrave *Introduction* p. 137
106. Gosse *Father and Son* pp. 177–8 (1970 ed.)
107. see Lonsdale p. 65. But see also Gunnis *Dictionary* p. 32 where it says the design was originally for a silver soup-tureen cover handle.
108. see Friedman and Stevens p. 33
109. illustrated in the *Art Journal* 1869 p. 326; see Boase 'Lough' p. 289
110. for details of this scheme see references in the *Art Journal* cited above n. 35 p. 387
111. see Boase 'Lough' pp. 284–5
112. according to the National Monuments Record for Scotland
113. Lonsdale pp. 91–5
114. *ibid*. p. 184
115. A. Woolner *Life* pp. 332–3

CHAPTER SEVEN

1. Linstrum p. 54
2. Gleichen pp. 119–20
3. I am very much indebted to Elisabeth Darby for information concerning the Royal Exchange sculpture. Basic details of the exterior statuary can be found in Gleichen pp. 119–20.
4. This date is documented in Penny 'Whig Cult' p. 105, though the *Art Journal* would seem to imply that final installation was not undertaken until 1851 (*Art Journal* 1851 pp. 97, 298–9).
5. Willis and Clark iii p. 210; Lady Eastlake 'Memoir' p. 160
6. Pevsner *North Somerset and Bristol* p. 418
7. see Gunnis *Dictionary* pp. 404–5
8. Lonsdale pp. 130–2
9. see Stannus p. 9; Towndrow (1951) pp. 16–19
10. for the Lincoln and Salisbury drawings, see Beattie *R.I.B.A.* pp. 21–2
11. Towndrow (1951) pp. 18–19
12. This date is given in '*Alfred Stevens of Blandford 1817–1875 Sculptor Painter Designer Centenary Exhibition*' Dorset County Museum Dorchester 1975. I am most grateful to Malcolm Warner for a copy of this.

13. Strickland *Dictionary* ii pp. 33–5

14. see *Art Journal* 1870 p. 43

15. This information was supplied to me by the Calderdale Public Library Service, to whom I am most grateful. See also *Builder* 3 April 1875 p. 300

16. see *Builder* 23 December 1865 p. 902

17. see Malden, *Henning* (unpaginated), Correspondence Section items 57–84, with further references to Manchester City Archives.

18. *Art Journal* 1869 pp. 286–7; *Survey of London* xxxii pp. 438 (University Headquarters statues), 420 (Royal Academy statues)

19. see Benson i p. xvii

20. This account is based on Crook 'Smirke' pp. 63–4; *Survey of London* xxxviii pp. 124–32

21. see *Survey of London* xxxviii p. 107 (Quadrangle), 104–6 (Courts), 111 (Refreshment Room)

22. quoted *ibid.* p. 90

23. Gunnis *Dictionary* p. 389

24. for Hardwick see Hobhouse p. 41; for Euston details see also *Survey of London* xxi p. 113

25. Pevsner *London except the Cities of London and Westminster* p. 304

26. Gunnis *Dictionary* p. 389; Young and Doak no. 34

27. Pevsner *North Somerset and Bristol* p. 424

28. Gunnis *Dictionary* p. 389; Pevsner *South Lancashire* p. 282

29. C. Handley-Read (3); Ames pp. 109–10

30. for John Thomas in general see *Art Journal* 1849 p. 340; obituary notices: *Art Journal* 1862 p. 144; *Builder* 1862 xx p. 275; *Illustrated London News* xli 30 August 1862 pp. 231–3; Gunnis *Dictionary* pp. 388–90

31. Pevsner and Wedgwood *Warwickshire* p. 131; Pevsner *Some Architectural Writers* p. 33, plate 17

32. *Illustrated London News* xli 30 August 1862 p. 231

33. For details of Thomas's career at Westminster, with further references, see Walker pp. 95–6; Read *Architectural Sculpture*

34. A. Barry pp. 92–3

35. *ibid.* pp. 91–2

36. see the accounts cited above, notes 30, 33, as well as H. T. Ryde, *Illustrations of the New Palace of Westminster, First Series (1849)*, plate VI, commentary

37. A. Barry p. 93

38. Pevsner *North Somerset and Bristol* p. 414

39. Eastlake *Gothic Revival* pp. 283–7 and Appendix p. 91, no. 122; Ferriday 'Oxford Museum'; McWilliam 40. see e.g. C. Handley-Read (6) p. 30

41. Hitchcock *Architecture Nineteenth and Twentieth Centuries* p. 176

42. C. Handley-Read (6) p. 30

43. *Builder* 3 October 1857 p. 563. This reference comes from Summerson p. 87.

44. A. Woolner *Life* p. 233

45. C. Handley-Read (6) p. 31

46. A. Woolner *Life* p. 233

47. Descriptions and attribution from *Sculptors Journal* i p. 27

48. Letter in Victoria and Albert Museum, London, cited by C. Handley-Read (6) p. 31

49. A. Woolner *Life* p. 213

50. The following account is based on Harbron pp. 28–9

51. There is no definitive source for them; information must be gleaned from the various sources for the buildings and architects they were associated with.

52. see *Survey of London* xxxviii pp. 200–16

53. see Stewart p. 76 and illustration p. 75

54. see *Survey of London* xxxviii p. 212 and plates 62c, 62d, 63a, 63b

55. S. A. Smith p. 120

56. *ibid.* p. 114

57. *ibid.* p. 119

58. see Victorian Society notes

59. see R.I.B.A. Drawings Catalogue 'S' p. 36, illustrated fig. 39

60. Brocklebank p. 47

61. Gunnis *Dictionary* p. 422

62. Verey 'Bodley' p. 86

63. Pevsner (and Cherry) *London I* (1973) p. 318

64. Brocklebank pp. 24–8 and *passim*

65. Cutts p. 295

66. Verey 'Highnam' pp. 1160–2

67. Pevsner *South Lancashire* p. 428

68. printed in *Good Words* for 1871 pp. 678–81

69. quoted in C. Handley-Read (6) p. 32

70. Cutts p. 293

71. According to the church guide book.

72. *ibid.*

73. Thompson p. 453

74. *Ecclesiologist* xxii (1861) p. 321

75. Thompson pp. 453–4

76. C. Handley-Read (6) p. 32

77. Pevsner *South Lancashire* p. 351

78. quoted in Brocklebank p. 50

79. C. Handley-Read (6) p. 33

80. Pevsner *North Lancashire* pp. 190–1

81. Gunnis *Dictionary* p. 285

82. Pugin p. 42

83. *ibid.* p. 44

84. Pevsner and Wedgwood *Warwickshire* p. 198

85. Stanton pp. 60–3

86. *ibid.* pp. 101–2

87. *ibid.* p. 170; ill. 112, p. 144

88. Pevsner *South Lancashire* pp. 74–5

89. Hobhouse p. 46 and footnote 62 p. 141; Gunnis *Dictionary* p. 389

90. for Llandaff see Seddon; Buttress; Read 'Work . . . Llandaff'

91. Howell *Victorian Churches* plate 29 and commentary

92. for probable examples see Surtees nos. 707, 707A, i p. 226

93. see drawings in the Armstead Albums, Royal Academy Library, London

94. see *Victorian Church Art* p. 133, cat. no. N 1

95. W. M. Rossetti *Fine Art* p. 341

96. Letter, Woolner to Lady Trevelyan, 6 April (?1857), Trevelyan Papers

97. Pearson p. 77

98. Pevsner and Wedgwood *Warwickshire* p. 289

99. dates from the Armstead Albums, Royal Academy Library, London

100. for Clarke authorship see Pevsner and Wedgwood *Warwickshire* p. 289

101. Scott *Recollections* p. 265

102. for 1863 date see Armstead Albums, Royal Academy Library, London
103. see Walker p. 104, with further references
104. see Port *Houses of Parliament* p. 178
105. see Graves i p. 62
106. C. Handley-Read (5) p. 200
107. *ibid.* pp. 205–6
108. C. Handley-Read (6) p. 33
109. dates from C. Handley-Read (5) p. 200
110. details of sculptural procedure from C. Handley-Read (6) p. 33
111. see Crook 'Patron Extraordinary' pp. 7–9
112. Pearson pp. 77–8
113. Crook 'Patron Extraordinary' pp. 10–11
114. quoted in *Survey of London* xxxviii p. 170
115. Scott *Recollections* p. 265
116. *Survey of London* xxxviii p. 153
117. Fisher and Stamp p. 59
118. *ibid.* p. 31
119. Lockett p. 14
120. Fisher and Stamp p. 32
121. Scott *Recollections* p. 216
122. This quotation comes from John Williams *Ancient and Modern Denbigh* (1856) and is cited in Howell 'Churches . . . Welsh Flavour' p. 1088. I am most grateful to Peter Howell for drawing my attention to this.
123. The following drawings are all in the R.I.B.A. Drawings Collection. They were exhibited in the 1978 Scott exhibition at the Victoria and Albert Museum, London and references are given to the catalogue of this exhibition
124. *Scott* catalogue no. 20c
125. *ibid.* no. 13g
126. *ibid.* no. 13i
127. *ibid.* no. 18c
128. A. Barry p. 89
129. Gunnis *Dictionary* pp. 300–1
130. see *Dictionary of National Biography* xvi pp. 819–20; *Art Journal* 1876 p. 276
131. Pevsner *Worcestershire* p. 310
132. Fisher and Stamp p. 28
133. *ibid.* p. 34
134. this date from the *Builder* 28 March 1857 p. 174
135. Pevsner *Staffordshire* pp. 183–4
136. Fawcett 'A Restoration Tragedy' pp. 103–4
137. Gleichen p. 38; Gunnis *Dictionary* p. 301
138. Scott *Recollections* p. 267
139. Gleichen pp. 133–4; Pevsner (and Cherry) *London I* p. 250
140. see L. Handley-Read 'Whitehall Sculpture'; Fisher and Stamp pp. 58–9
141. *The Artist* 15 January 1880
142. Spencer p. 61

CHAPTER EIGHT

1. Gleichen p. 167
2. Eastlake *Gothic Revival* p. 342
3. see Bennett *Holman Hunt* p. 57
4. Gutch p. 693 and illustrations 62 and 63, p. 695
5. Loshak p. 54
6. Fine Art Society *Catalogue* p. 35

7. Ormonds p. 163, cat. no. 237 (Daphnephoria figures); p. 180 (others)
8. *ibid.* p. 71, cat. no. 358
9. for Stevens see Stannus; Towndrow 1939, 1950, 1951; Beattie *Victoria and Albert* catalogue, *R.I.B.A.*
10. for Watts and sculpture, see in particular Gutch; references also occur in the general Watts literature e.g. Barrington *Watts*; Watts; Staley. Detailed references are cited where necessary.
11. see Gutch pp. 694, 697; Staley p. 73
12. Barrington *Watts* p. 36
13. for the Cholmondeley figure see Watts i pp. 85ff, 241; Pevsner *Shropshire* p. 112
14. see Gutch p. 697; Watts i p. 243
15. Staley p. 79
16. *ibid.* p. 79
17. Watts i p. 243
18. Barrington *Watts* illustration 14, facing p. 48
19. see Acropolis Museum Catalogue ii pp. 14, 155–9
20. Pevsner *Shropshire* p. 112
21. see a letter of 7 July (?) 1899 from Thornycroft to Gosse in the Brotherton Library, University of Leeds, referring to a point already discussed; this subsequently appears in print in E. Gosse *The Life and Letters of John Donne Dean of St Paul's* (2 vols.) London 1899, ii p. 288
22. Barrington *Watts* pp. 54–5; Gutch p. 693
23. Gutch p. 697
24. *ibid.* p. 697
25. *ibid.* pp. 697–8
26. *ibid.* p. 693
27. *ibid.* p. 698
28. Watts ii p. 265
29. Watts iii p. 271
30. Gutch p. 698

CHAPTER NINE

1. Ormonds pp. 93–4, 162–3 cat. nos. 229, 230
2. Barrington *Leighton* ii p. 387
3. Ormonds pp. 162–3
4. Gosse *New Sculpture* p. 140
5. Letter, Bell to Edmund Gosse, 20 March 1883, Brotherton Library, University of Leeds
6. Ormonds p. 93
7. for Brock see Spielmann *British Sculpture* pp. 24–33
8. Gosse 'New Sculpture' p. 201
9. *ibid.* p. 201
10. for Thornycroft see Spielmann *British Sculpture* pp. 36–45; *Tate Gallery Catalogue* ii pp. 721–5. For further insight and information concerning Thornycroft I am greatly indebted to his daughter, Mrs Elfrida Manning, who has allowed me to read her manuscript life of her father and to consult her lists and her collection of photographs.
11. Barrington *Leighton* i p. 6
12. Spielmann *British Sculpture* p. 34
13. These details come from the Alphabetical List of members from the foundation *Royal Academy Bicentenary* Catalogue pp. 8–17
14. Gosse 'New Sculpture' p. 310
15. see *Art Journal* 1881 p. 96; Gleichen p. 130
16. for Onslow Ford see Spielmann *British Sculpture* pp. 51–63; *Tate Gallery Catalogue* i pp. 183–4

17. Temple pp. 158–9
18. The Gilbert literature is relatively extensive—see McAllister; Bury; L. Handley-Read *Connoisseur*; and especially the Dorment contributions.
19. see Physick pp. 102–4
20. *Tate Gallery Catalogue* i p. 178
21. see *Chantrey Trust ... Report*, particularly Appendix C, pp. 209–18
22. Barrington *Leighton* i p. 6
23. see Gosse 'New Sculpture' pp. 308–10; Thieme-Becker iv pp. 194–5
24. F. T. Palgrave *Essays* pp. 42, 122
25. see Gutch p. 697
26. see Dorment *Victorian High Renaissance* p. 185
27. Gleichen p. 106
28. McAllister p. 104
29. Gosse 'New Sculpture' p. 310
30. Ormonds p. 93
31. for Dalou see Caillaux; Ciechanowiecki; Hunisak
32. Gleichen p. 118
33. Spielmann *British Sculpture* pp. 1, 125–7
34. *ibid.* pp. 1, 95–6
35. for which see *ibid.* p. 1
36. for Harvard Thomas see Spielmann *British Sculpture* p. 48; *Tate Gallery Catalogue* ii pp. 714–9
37. for Drury see Spielmann *British Sculpture* pp. 109–15; *Tate Gallery Catalogue* i p. 157
38. for Bates see *National Gallery, British Art ... Catalogue* pp. 7–8; *Tate Gallery Catalogue* i pp. 26–7
39. for Pomeroy see Spielmann *British Sculpture* pp. 115–8; *Tate Gallery Catalogue* ii p. 531
40. for Frampton see Spielmann *British Sculpture* pp. 88–95; *Tate Gallery Catalogue* i pp. 185–6
41. for Goscombe John see Pearson; Spielmann *British Sculpture* pp. 129–32; *Tate Gallery Catalogue* i pp. 341–2
42. for Tweed see *John Tweed ... A Memoir*; Spielmann *British Sculpture* pp. 152–3; *Tate Gallery Catalogue* ii pp. 740–1
43. for Stirling Lee see Spielmann *British Sculpture* p. 66; *Tate Gallery Catalogue* i pp. 381–2
44. Pearson pp. 10, 78
45. Baldry pp. 64–5
46. *Art Journal* 1856 p. 28
47. *ibid.* 1865 p. 29
48. Pevsner *Studies* ii pp. 68–9, 92–3
49. Fine Art Society *Catalogue* p. 25 no. 68
50. Bury p. 68
51. *ibid.* p. 66
52. *ibid.* p. 70
53. Pearson p. 35
54. *ibid.* pp. 45–6
55. *ibid.* pp. 47–8
56. see references cited above n. 40 p. 395
57. for medals see Spielmann *British Sculpture* p. 170; Stainton; Jones pp. 114–9, 138–41
58. Stainton p. 38
59. see Pearson pp. 44, 37
60. Mullins pp. 66–7
61. for Tinworth see the letters from Tinworth to Gosse, Brotherton Library, University of Leeds; Gosse *Critical Essay*; C. Handley-Read (1); *Victorian Church Art* pp. 165–6

62. C. Handley-Read (1) p. 561 and illustration 5
63. Gleichen p. 170
64. see Roskill; Dorment *Victorian High Renaissance* pp. 164–5, 192–7
65. *Art Journal* 1861 p. 367. I am very grateful to Elisabeth Darby for bringing this to my attention
66. L. Handley-Read *Connoisseur* p. 24; Dorment *Victorian High Renaissance* pp. 184–5
67. *Tate Gallery Catalogue* i pp. 31–2
68. Gleichen p. 69
69. *The Guardian* 7 October 1978 p. 7
70. see references cited above n. 38 p. 395
71. see references cited above n. 36 p. 395
72. see Fine Art Society *Catalogue* p. 23
73. *Tate Gallery Catalogue* ii p. 516
74. Gosse 'New Sculpture' p. 277
75. L. Handley-Read 'Introduction' p. 12
76. Gosse 'New Sculpture' p. 280
77. In the collection of Mrs Manning, to whom I am most grateful for this information.

Chapter Ten

1. LeFanu p. 50
2. For the symbolism of the candelabrum form and the relevance of the featured figures see Dorment *Victorian High Renaissance* pp. 189–91
3. Pevsner *Wiltshire* p. 271
4. see references cited above n. 43 p. 395
5. *Partnership in Style* pp. 37, 46
6. This information was most kindly supplied to me by Mrs Manning.
7. For a full description, with attributions, see Gleichen pp. 82–6
8. B. Clarke pp. 54–5
9. McAllister p. 85
10. Caillaux pp. 129–30; Ciechanowiecki p. 15
11. *Frogmore* p. 7
12. *ibid.* p. 6
13. *ibid.* p. 7
14. see the references cited above n. 64 p. 395
15. Dorment *Victorian High Renaissance* p. 197
16. see Spielmann *British Sculpture* p. 94
17. *British Portraits* p. 165 no. 532
18. see Pearson pp. 86, 89
19. Gleichen pp. 79–80
20. Dorment *Victorian High Renaissance* pp. 167, 175, 181
21. see Gosse 'The Place of Sculpture'; Spielmann 'Sculpture for the Home'
22. see Dorment *Victorian High Renaissance* pp. 174–5
23. Walker p. 33
24. *ibid.* pp. 29–30
25. *ibid.* p. 14
26. *ibid.* p. 2
27. *ibid.* p. 43
28. *ibid.* p. 32
29. LeFanu p. 76
30. *ibid.* p. 53
31. *ibid.* pp. 59–60
32. *ibid.* p. 52; Dorment *Victorian High Renaissance* pp. 42–52, 172–3
33. *Tate Gallery Catalogue* ii p. 784

34. Strickland *Catalogue* p. 61
35. Olsen p. 300
36. Gleichen p. 110
37. *ibid.* pp. 103–4
38. *ibid.* pp. 10–11
39. I am most grateful to Caroline Drummond for information on this monument.
40. see Dorment 'Queen Alexandra'
41. Pearson pp. 14, 63
42. Letter to Gosse, 12 March 1883, Brotherton Library, University of Leeds
43. Gunnis *Dictionary* p. 236
44. Stirling pp. 254–6
45. *ibid.* pp. 270–3
46. see Graves i pp. 197–8; Thieme-Becker iv pp. 46–7
47. Spielmann *British Sculpture* p. 24
48. Walker p. 7
49. *ibid.* p. 26
50. Spielmann *British Sculpture* pp. 48–50
51. *ibid.* pp. 63, 65–6
52. Gleichen p. 112
53. Spielmann *British Sculpture* pp. 148–9
54. *ibid.* pp. 118, 121–5
55. *ibid.* p. 122
56. see *John Tweed . . . A Memoir*
57. Spielmann *British Sculpture* pp. 18–9
58. *ibid.* pp. 160–1
59. *ibid.* p. 161
60. Gleichen p. 65
61. *ibid.* p. 104
62. *ibid.* pp. 111–2
63. *ibid.* p. 113
64. *ibid.* p. 107
65. *ibid.* p. 103
66. *ibid.* p. 110
67. *ibid.* p. 110
68. *ibid.* p. 112
69. *ibid.* pp. 104–5
70. Spielmann *British Sculpture* pp. 21–2; Massé pp. 99, 102

71. for Glasgow references see above n. 75 p. 391
72. for Edinburgh references see above n. 71 p. 391
73. I am most grateful to Susan Beattie for this attribution.
74. see Linstrum p. 41
75. Barnett p. 22
76. This information is derived largely from a photographic survey of monuments in Liverpool and its environs undertaken by the Walker Art Gallery, Liverpool.
77. for Glasgow information see above n. 75 p. 391
78. see Gunnis *Dictionary* p. 266
79. I am extremely grateful to Fiona Pearson for supplying me with these details.
80. Pearson pp. 15–16
81. Gunnis *Dictionary* p. 149
82. These details come from Spielmann *British Sculpture*, *passim*, except in the case of Hamo Thornycroft's work, where I am greatly indebted to Mrs Manning.
83. see Bates
84. see McAllister pp. 125–6; Dorment *Victorian High Renaissance* pp. 161–2
85. Denson pp. 200–44 and plates 96–113
86. The following account derives basically from *The Annual Register . . . for the year 1901* pp. 94–5
87. Stirling p. 260
88. illustrated in *Architectural Design* xlviii (1978) no. 5–6, p. 328
89. in the R.I.B.A. Drawings Collection; illustrated in *Architectural Design* xlviii (1978) no. 5–6, p. 399
90. see Royal Academy, London, Scrap Book SB80k, letter from Brock to Sir Isidore Spielmann
91. see *The Annual Register . . . for . . . 1911* pp. 107–8
92. Gleichen p. 54
93. *ibid.* pp. 50–4
94. see Denson pp. 245–375
95. *The Times* 19 January 1917, p. 31
96. Gleichen pp. 150–1

Bibliography

Contemporary accounts of Victorian sculpture are few, and none cover the entire period. William Bell Scott's *The British School of Sculpture* (London, n.d., *c.* 1871/2) contains an introductory essay followed by a selection of plates with critical commentary on the artists concerned, but these are only deceased ones, starting in the seventeenth century. S. C. Hall's *The Gallery of Modern Sculpture* (n.d., 1854) is a collection of plates with appreciative noises and is of limited value. A more detailed survey of contemporary printed source material appears in the main text, see pp. 10 ff.

Gunnis's *Dictionary* and Pevsner's *Buildings of England* series must be the foundations of any study. And invidious though it may be to name names, I would like to emphasise the value of the published work of Susan Beattie, Richard Dorment and John Physick listed below; Gleichen and Charles Handley-Read are also useful. *Archive 4 (Late 18th & 19th Century Sculpture in the British Isles)* in the series of Courtauld Institute Illustration Archives provides, so far as its coverage allows, a basic corpus of illustrations of public statues, architectural sculpture and church monuments in select areas.

MAIN PERIODICALS REFERRED TO

Architectural Review	*Burlington Magazine*	*Ecclesiologist*	*Punch*
Art-Journal	*Country Life*	*Literary Gazette*	*Sculptors' Journal*
Art-Union	*Daily Mirror*	*Manchester Guardian*	*The Times*
Builder			

WORKS REFERRED TO

Acropolis Museum (Athens), Catalogue, volume II: Sculpture and Architectural Fragments, by Stanley Casson. Cambridge 1921.

Ames, Winslow, *Prince Albert and Victorian Taste*. London 1967.

Anstey, F. (Guthrie, Thomas Anstey), *The Tinted Venus: A Farcical Romance*. London 1885. Another ed. Bristol and London 1912.

Arnold, Matthew (ed.), *Poems of Wordsworth*. London 1879.

A.(tkinson), S.(arah), *Arts and Industries in Ireland: I. John Henry Foley, R.A. A Sketch of the Life and Works of the Sculptor of the O'Connell Monument*. Dublin 1882.

Axon, W. E. A. (ed.), *An Architectural and General Description of the Town Hall, Manchester, to which is added a Report of the Inaugural Proceedings, September, 1877*. Manchester and London 1878.

Baldry, A. L., *Modern Mural Decoration*. London 1902.

Barnett, Rosalind, 'Frampton's Monument to Queen Victoria', *Leeds Art Calendar* no. 81 (1977), pp. 19–26.

Barrington, Mrs Russell, *G. F. Watts: Reminiscences*. London 1905.

Barrington, Mrs Russell, *The Life, Letters and Work of Frederic Leighton* (2 vols.). London 1906.

Barry, Alfred, *The Architect of the New Palace at Westminster. A Reply to a Pamphlet by E. W. Pugin Esq., entitled 'Who Was the Art-Architect of the Houses of Parliament?'* London 1868.

Bates, Rachel, 'A Westmorland Sculptor', *Manchester Guardian*, 2 May 1955.

Baudelaire, Charles, *Oeuvres complètes* (ed. Claude Pichois). Paris 1976.

Beattie, Susan, *Alfred Stevens*, vol. in *Catalogue of the Drawings Collection of the Royal Institute of British Architects*. Farnborough 1975.

Beattie, Susan, *Alfred Stevens 1817–75*. London (Victoria and Albert Museum) 1975.

Bennett, Mary, *William Holman Hunt* (Exhibition Catalogue). Liverpool and London 1969.

Benson, R. (ed.), *The Holford Collection, Dorchester House* (2 vols.). Oxford and London 1927.

Birmingham, City of, Museum and Art Gallery, *Illustrated Catalogue (with Descriptive Notes) of the Permanent Collection of Paintings and Sculpture, and the Pictures in Aston Hall and elsewhere*. Birmingham 1904.

Birmingham Public Library, *Statues, Public Memorials and Sculpture in the City of Birmingham: Publication No. 35*. Birmingham 1972.

Boase, T. S. R., 'The Decoration of the New Palace of Westminster, 1841–1863', *Journal of the Warburg and Courtauld Institutes* xvii (1954), pp. 319–58.

Boase, T. S. R., 'John Graham Lough A Transitional Sculptor', *Journal of the Warburg and Courtauld Institutes*, xxiii (1960), pp. 277–90.

British Portraits, Catalogue of the Winter Exhibition 1956–7, Royal Academy of Arts, London.

Brocklebank, Joan, *Victorian Stone Carvers in Dorset Churches 1856–1880*. Stanbridge, Dorset 1979.

Browning, Robert, *The Poetical Works* (2 vols.). London 1896.

Browne, Sir Thomas, *The Works* (ed. Geoffrey Keynes, 6 vols.). London 1928–31.

Bury, Adrian, *Shadow of Eros, A Biographical and Critical Study of the Life and Works of Sir Alfred Gilbert, R.A., M.V.O., D.C.L.* London 1954.

Butler, Samuel, *The Way of all Flesh*. London 1903; another ed. London, Everyman's Library 1933, reprinted 1949.

Buttress, D., 'Victorian Furnishings in Llandaff Cathedral', in *Victorian South Wales Architecture, Industry and Society*, The Victorian Society Seventh Conference Report, pp. 28–33. London n.d.

Caillaux, H., *Aimé-Jules Dalou (1838–1902)*. Paris 1935.

Chantrey Trust, *Report from the Select Committee of the House of Lords on the Chantrey Trust, together with the Proceedings of the Committee, Minutes of Evidence, and Appendix*. London 1904.

Ciechanowiecki, A. S., Introduction to catalogue of exhibition *Sculptures by Jules Dalou (1838–1902)*, pp. 5–12. London (Mallet at Bourdon House Ltd.), April/May 1964.

Clarke, Basil F. L., *Parish Churches of London*. London 1966.

Clarke, Michael, 'Victorian Sculpture at York; patronage and survival', *Preview* 107, City of York Art Gallery Quarterly, xxvii (July 1974), pp. 954–9.

Crook, J. Mordaunt, 'Patron Extraordinary: John, 3rd Marquess of Bute (1847–1900)', in *Victorian South Wales Architecture, Industry and Society*, The Victorian Society Seventh Conference Report, pp. 3–22. London n.d.

Crook, J. Mordaunt, 'Sydney Smirke: the architecture of compromise', in Jane Fawcett (ed.), *Seven Victorian Architects*, pp. 50–65. London 1976.

Crook, J. Mordaunt and Port, M. H., *The History of the King's Works*, vol. vi, 1782–1851. London 1973.

Cutts, Rev. Edward L., 'Ecclesiastical Art-Manufacturers. 1. Ecclesiastical Sculpture', *Art Journal*, New Series (1865), pp. 293–6.

Denson, Alan, *John Hughes, Sculptor, 1865–1941: A Documentary Biography*. Kendal 1969.

Dorment, Richard, 'The Loved One: Alfred Gilbert's Mors Janua Vitae', in *Victorian High Renaissance* (Exhibition Catalogue), pp. 42–52. Manchester and Minneapolis 1978.

Dorment, Richard, 'Alfred Gilbert 1854–1934', Biography and Catalogue Entries, in *Victorian High Renaissance* (Exhibition Catalogue), pp. 157–203. Manchester and Minneapolis 1978.

Dorment, Richard, 'Alfred Gilbert's Memorial to Queen Alexandra', *Burlington Magazine* cxxii no. 922 (January 1980), pp. 47–54.

Eastlake, Charles Lock, *Contributions to the Literature of the Fine Arts*. London 1848; 2nd ed. 1870.

Eastlake, Sir Charles Lock, *Contributions to the Literature of the Fine Arts, Second Series, with a Memoir Compiled by Lady Eastlake*. London 1870.

Eastlake, Charles L., *A History of the Gothic Revival*. London 1872; another edition (ed. J. Mordaunt Crook) Leicester 1970.

Eastlake, Lady, 'Memoir of Sir Charles Eastlake', in Sir Charles Lock Eastlake, *Contributions to the Literature of the Fine Arts, Second Series*. London 1870.

Eastlake, Lady (ed.), *Life of John Gibson, R.A. Sculptor*. London 1870.

Elswick Hall, Newcastle-upon-Tyne, *Descriptive Catalogue of the Lough and Noble Models etc*, see Robinson, John.

Evans, Jane, *Charles Summers 1825–1878* (Exhibition Catalogue, Woodspring Museum). Weston-super-Mare 1978.

Fawcett, Jane (ed.), *Seven Victorian Architects*. London 1976.

Fawcett, Jane, 'A restoration tragedy: cathedrals in the eighteenth and nineteenth centuries', in Jane Fawcett (ed.), *The Future of the Past: Attitudes to Conservation 1147–1974*, pp. 74–115. London 1976.

Ferriday, Peter, 'The Oxford Museum', *Architectural Review* cxxxii (December 1962), pp. 408–16.

Ferriday, Peter (ed.), *Victorian Architecture*. London 1963.

Ferriday, Peter, 'Syllabus in Stone', *Architectural Review* cxxxv (June 1964), pp. 396, 422–8.

Fine Art Society Limited, The, *British Sculpture 1850–1914* (Exhibition Catalogue). London 1968.

Fisher, G., Stamp, G. and others (ed. Joanna Symonds), *The Scott family*, vol. in *Catalogue of the Drawings Collection of the Royal Institute of British Architects*. Farnborough 1982.

Fletcher, H. R., *The Story of the Royal Horticultural Society 1804–1968*. London 1969.

Fredeman, W. E. (ed.), *The P.R.B. Journal*. Oxford 1975.

Friedman, Terry, and Stevens, Timothy, *Joseph Gott 1786–1860, Sculptor* (Exhibition Catalogue). Leeds (Temple Newsam House) and Liverpool (Walker Art Gallery) 1972.

Frogmore, The Royal Mausoleum at,. Windsor 1968 (2nd edition).

Gerdts, W. H., 'The White, Marmorean Flock', Introduction to Exhibition Catalogue, *The White, Marmorean Flock—Nineteenth Century American Women Neoclassical Sculptors*. Vassar College Art Gallery 1972.

Gere, J. A., 'Alexander Munro's "Paolo and Francesca"', *Burlington Magazine* cv, no. 728 (November 1963), pp. 509–10.

Gibbs-Smith, C. H., *The Great Exhibition of 1851*. London (HMSO/Victoria and Albert Museum) 1950; reprinted with amendments 1964.

Girouard, Mark, *The Victorian Country House*. Oxford 1971.

Glassby, William J. J., *The Sheffield Miscellany*, part 6, June 1897.

Gleichen, Lord Edward, *London's Open-Air Statuary*. London 1928.

Goodison, J. W., *Catalogue of Cambridge Portraits—I. The University Collection*. Cambridge 1955.

Gosse, Edmund, *A Critical Essay on the Life and Works of George Tinworth*. London 1883.

Gosse, Edmund, 'The New Sculpture 1879–1894', *Art Journal* 1894, pp. 138–42, 199–203, 277–82, 306–11.

Gosse, Edmund, 'The Place of Sculpture in Daily Life—Sculpture in the House', *Magazine of Art* 1894–5 pp. 368–72.

Gosse, Edmund, *Father and Son: A Study of Two Temperaments*. London 1907; another ed. Harmondsworth 1949, 1970.

Graves, Algernon, *The Royal Academy of Arts: A Complete Dictionary of Contributors and their work from its Foundation in 1769 to 1904* (8 vols.). London 1905–6; reprinted (4 vols.) 1970.

Gray, W. Forbes, 'The Scott Monument and its Architect', *Architectural Review*, xcvi (July 1944), pp. 26–7.

Great Exhibition of the Works of Industry of All Nations, 1851. Official Descriptive and Illustrated Catalogue. By Authority of the Royal Commission (3 vols.). London 1851.

Gunnis, Rupert, *Dictionary of British Sculptors 1660–1851*. London 1953; 'New Revised Edition' London n.d. (1964).

Gutch, R.E., 'G. F. Watts's Sculpture', *Burlington Magazine* cx, no. 789 (December 1968), pp. 693–8.

Handley-Read, Charles (1), 'Tinworth's Work for Doulton—I: Sermons in Terra-Cotta', *Country Life* cxxviii (1 September 1960), pp. 430–1; "II: Salt Cellars and Public Statues", *ibid* (15 September 1960), pp. 560–1.

Handley-Read, Charles (2), 'Sculpture and Modelling in Victorian Architecture', in *Royal Society of British Sculptors 1960 Annual Report*, pp. 36–42. London 1961.

Handley-Read, Charles (3), 'Prince Albert's Model Dairy', *Country Life* cxxix (29 June 1961), pp. 1524–6.

Handley-Read, Charles (4), 'The Albert Memorial Re-assessed', *Country Life* cxxx (14 December 1961), pp. 1514–16.

Handley-Read, Charles (5), 'William Burges' in Ferriday, Peter (ed.), *Victorian Architecture*, pp. 185–220. London 1963.

Handley-Read, Charles (6), 'Sculpture in High Victorian Architecture' in *The High Victorian Cultural Achievement*, Second Conference Report of The Victorian Society, Illustrated 2nd edition. London 1967.

Handley-Read, Lavinia, 'Alfred Gilbert: a new assessment', *Connoisseur* clix (1968), pp. 22–7, 85–91, 144–51.

Handley-Read, Lavinia, 'Introduction' to Fine Art Society Catalogue, *British Sculpture 1850–1914*, pp. 7–17. London 1968.

Handley-Read, Lavinia, 'Whitehall Sculpture', *Architectural Review* cxlviii (November 1970), pp. 276–9.

Harbron, Dudley, *The Conscious Stone: The Life of Edward William Godwin*. London 1949.

Haskell, Francis, *Rediscoveries in Art*. London 1976.

Henning, John, see Malden, John.

Hill, I. B., *Landseer*. Aylesbury 1973.

Hitchcock, Henry-Russell, *Early Victorian Architecture in Britain* (2 vols.), London and New Haven 1954.

Hitchcock, Henry-Russell, *Architecture: Nineteenth and Twentieth Centuries*. Harmondsworth 1958; 2nd edition, 1963.

Hobhouse, Hermione, 'Philip and Philip Charles Hardwick: an architectural dynasty', in Jane Fawcett (ed.), *Seven Victorian Architects*, pp. 32–49. London 1976.

Howell, Peter, *Victorian Churches*. Feltham 1968.

Howell, Peter, 'Churches with a Welsh Flavour—The Vale of Clwyd II', *Country Life* clxii (20 October 1977), pp. 1086–8.

Hunisak, John M., *The Sculptor Jules Dalou: Studies in His Style and Imagery*. New York and London 1977.

Hunt, F. Knight, *The Book of Art, Cartoons, Frescoes, Sculpture and Decorative Art as Applied to the New Houses of Parliament . . . with an Historical Notice of the Exhibitions in Westminster Hall and Directions for Painting in Fresco*. London 1846.

Hunt, W. Holman, *Pre-Raphaelitism and the Pre-Raphaelite Brotherhood* (2 vols.). London 1905–6.

Hutchison, N., 'Sculpture in Australia 1788–c. 1923' in *Early Australian Sculpture* (Exhibition Catalogue). Ballarat Fine Art Gallery, 1976–7.

Immortal Fame, An anthology of drawings and models for English sculpture (Exhibition Catalogue). Leeds 1973.

Instrumenta Ecclesiastica, edited by the Ecclesiological late Cambridge Camden Society, (1st series). London 1847.

Instrumenta Ecclesiastica, Second Series, edited by The Ecclesiological late Cambridge Camden Society. London 1856.

Jameson, Mrs, *A Hand-book to the Courts of Modern Sculpture*. London 1854.

Jones, Mark, *The Art of the Medal*. London 1979.

Kenworthy-Browne, John, 'Marbles from a Victorian Fantasy', *Country Life* cxc (22 September 1966), pp. 708, 710, 712.

LeFanu, William, *A Catalogue of the Portraits and Other Paintings, Drawings and Sculptures in the Royal College of Surgeons of England*. Edinburgh and London 1960.

Linstrum, D., *Historic Architecture of Leeds*. Newcastle-upon-Tyne 1969.

Lockett, R. B., 'George Gilbert Scott, the Joint Restoration Committee, and the Refurbishing of Worcester Cathedral', *Transactions of the Worcestershire Archaeological Society*, third series, vol. 6 (1978), pp. 7–42.

Loshak, David, *George Frederic Watts 1817–1904* (Catalogue of Exhibition held by the Arts Council). 1954–5.

London, Great Exhibition, 1851—see under Great . . .

Lonsdale, Henry, *The Life and Works of Musgrave Lewthwaite Watson, Sculptor*. London 1866.

Maidstone Museum and Art Gallery, *Handlist of Sculpture* by Susan Legouix, revised ed. 1975.

Malden, John, *John Henning 1771–1851 '. . . a very ingenious Modeller. . .'*. Paisley 1977.

Massé, H. J. L. J., *The Art-Workers' Guild 1884–1934*. London 1935.

Matthews, T., *The Biography of John Gibson, R.A., Sculptor, Rome*. London 1911.

McAllister, I., *Alfred Gilbert*. London 1929.

McWilliam, N., 'A Microcosm of the Universe: The Building of the University Museum', *Oxford Art Journal*, i (1978), pp. 23–7.

Mullins, E. Roscoe, *A Primer of Sculpture*. London, Paris and Melbourne 1890.

National Gallery, British Art, *Catalogue with Descriptions, Historical Notes and Lives of Deceased Artists*, 21st edition. London 1914.

National Memorial to His Royal Highness The Prince Consort, The. London 1873.

National Portrait Gallery, London, *Early Victorian Portraits*, catalogue by Richard Ormond. London 1973.

Olsen, Donald J., *The Growth of Victorian London*. London 1976.

Ormond, Leonée and Richard, *Lord Leighton*. New Haven and London 1975.

Ormond, Richard, *Early Victorian Portraits*. London, National Portrait Gallery/H.M.S.O. 1973.

Osborne, *Catalogue of the Paintings, Sculpture, and Other Works of Art at Osborne*. London 1876.

Palgrave, F. T., *Introduction to International Exhibition 1862: Official Catalogue of the Fine Art Department. Class 39 Sculpture, Models, Die-Sinking, and Intaglios*. London n.d.

Palgrave, F. T., *Handbook to the Fine Art Collections in the International Exhibition of 1862*. London and Cambridge 1862.

Palgrave, F. T., *Essays on Art*. London and Cambridge 1866.

Palgrave, G. F., *Francis Turner Palgrave, His Journals and Memories of His Life*. London 1898.

Partnership in Style: Edgar Wood and J. Henry Sellers (Catalogue of Exhibition at Manchester City Art Gallery). Manchester 1975.

Patmore, Coventry, *Principle in Art Etc*. London 1898; reprinted Farnborough 1969.

Pearson, Fiona, *Goscombe John at the National Museum of Wales*. Cardiff 1979.

Penny, Nicholas, 'The Whig Cult of Fox in Early Nineteenth-Century Sculpture', *Past and Present* 70 (February 1976), pp. 94–105.

Penny, Nicholas, 'Grand and National Obsequies', *Country Life* clx (26 August 1976), pp. 547–8.

Penny, Nicholas, *Church Monuments in Romantic England*. New Haven and London 1977.

Pevsner, Nikolaus, and others, *The Buildings of England*. Harmondsworth 1951–75.

Pevsner, Nikolaus, *Studies in Art, Architecture and Design* (2 vols.). London 1968.

Pevsner, Nikolaus, *Some Architectural Writers of the Nineteenth Century*. Oxford 1972.

Physick, John, *Victoria and Albert Museum Decorative Sculpture*. London 1978.

Physick, John, *The Wellington Monument*. London 1970.

Poole, Mrs R. L., *Catalogue of Portraits in the possession of the University, Colleges, City, and County of Oxford* (3 vols.) Oxford 1912–25.

Port, M. H. (ed.), *The Houses of Parliament*. New Haven and London 1976.

Port, M. H., see also Crook, J. M. and Port M. H.

Potterton, Homan, *The O'Connell Monument*. Dublin 1973.

Pugin, A. Welby, *An Apology for the Revival of Christian Architecture in England*. London 1843.

Read, Benedict, 'Architectural Sculpture' in M. H. Port (ed.), *The Houses of Parliament*. New Haven and London 1976.

Read, Benedict, 'The Work of Rossetti and the Pre-Raphaelites at Llandaff', in *43rd Annual Report (1975–76) of the Friends of Llandaff Cathedral*, pp. 6–15. Cardiff n.d.

Report of the Commissioners Appointed to Inquire Into the Present Position of the Royal Academy in relation to the Fine Arts; together with The Minutes of Evidence Presented to both Houses of Parliament by Command of Her Majesty. London 1863.

Reports of the Commissioners on the Fine Arts, presented to both Houses of Parliament by command of Her Majesty (9 vols.). London 1842–50.

Reynolds, Donald M., 'The "Unveiled Soul": Hiram Powers's Embodiment of the Ideal', *Art Bulletin* lix no. 3 (September 1977), pp. 394–414.

Robinson, John, *Descriptive Catalogue of the Lough and Noble Models of Statues, Bas-Reliefs and Busts in Elswick Hall, Newcastle-upon-Tyne* (6th edition). Newcastle-upon-Tyne 1914.

Roskill, M., 'Alfred Gilbert's Monument to the Duke of Clarence: A Study in the Sources of Later Victorian Sculpture', *Burlington Magazine* cx no. 789 (December 1968), pp. 699–704.

Rossetti, D. G., *Letters* (ed. O. Doughty and J. R. Wahl, 4 vols.). Oxford 1965–7.

Rossetti, W. M., *Fine Art, Chiefly Contemporary*. London and Cambridge 1867.

Rossetti, W. M., *The P.R.B. Journal*, see Fredeman, W. E.

Royal Academy of Arts Bicentenary Exhibition 1768–1968 (Exhibition Catalogue). London 1968.

Royal Academy Commission 1863, see *Report of the Commissioners . . .*

Royal Commission on the Fine Arts, see *Reports of the Commissioners . . .*

Royal Institute of British Architects, London: Catalogue of the Drawings Collection, 'The Scott Family' volume by G. Fisher, G. Stamp and others, ed. by Joanna Symonds. Farnborough 1982.

Royal Institute of British Architects, London: Catalogue of the Drawings Collection, 'S' volume, ed. Margaret Richardson. Farnborough 1976.

Royal Institute of British Architects, London: Catalogue of the Drawings Collection, 'Alfred Stevens' volume by Susan Beattie. Farnborough 1975.

Ruskin, John, *The Works* (ed. E. T. Cook and A. Wedderburn, 39 vols.). London and New York 1903–12.

Scott, G. G. (ed.), *Personal and Professional Recollections by the late Sir George Gilbert Scott, R.A.* London 1879.

Scott, Sir Gilbert (1811–1878): Architect of the Gothic Revival (Catalogue of Exhibition at the Victoria and Albert Museum). London 1978.

Seddon, J. P., 'The Works of the P.R.B. in Llandaff Cathedral', *The Public Library Journal: A Quarterly Magazine of the Cardiff and Penarth Free Public Libraries and the Welsh Museum* iv, 1903–4, pp. 28–30, 49–51, 66–70.

Shinn, Charles and Dorrie, *The Illustrated Guide to Victorian Parian China*. London 1971.

Smith, Nicola C., 'Imitation and invention in two Albert Memorials', *Burlington Magazine*, cxxiii no. 937 (April 1981), pp. 232–7.

Smith, S.A., 'Alfred Waterhouse: civic grandeur', in Jane Fawcett (ed.), *Seven Victorian Architects*. London 1976.

Spencer, R., *The Aesthetic Movement: theory and practice*. London and New York 1972.

Spielmann, M. H., *British Sculpture and Sculptors of To-Day*. London 1901.

Spielmann, M. H., 'Sculpture for the Home' in *First Exhibition of Statuettes by the Sculptors of To-Day, British and French* (Catalogue of Exhibition at the Fine Art Society), pp. 3–6. London 1902.

Stainton, Thomas, 'Introduction to Medals' in *British Sculpture 1850–1914* (Exhibition Catalogue), pp. 37–8. London 1968.

Staley, Allen, 'George Frederic Watts 1817–1904', Biography and Catalogue Entries, in *Victorian High Renaissance* (Exhibition Catalogue), pp. 53–93. Manchester and Minneapolis 1978.

Stanley, A. P., 'The Religious Aspect of Sculpture', in *Good Words*, 1871, pp. 678–81.

Stannus, Hugh, *Alfred Stevens and His Work*. London 1891.

Stanton, Phoebe, *Pugin*. London 1971.

Sterne, Laurence, *A Sentimental Journey through France and Italy by Mr. Yorick*. London, 1768; another ed. (ed. H. Read), London 1929.

Stevens, Timothy, *Joseph Gott*, see Friedman T. and Stevens, T.

Stewart, Cecil, *The Stones of Manchester*. London 1956.

Stirling, A. M. W., *Victorian Sidelights: From the papers of the late Mrs. Adams-Acton*. London 1954.

Strickland, W. G., *A Dictionary of Irish Artists* (2 vols.). Dublin and London 1913.

Strickland, W. G., *A Descriptive Catalogue of the Pictures, Busts, and Statues in Trinity College, Dublin, and in the Provost's House*. Dublin 1916.

Summers, Charles, see Evans, Jane.

Summerson, John, *Victorian Architecture: Four Studies in Evaluation*. New York and London 1970.

Surtees, Virginia, *The Paintings and Drawings of Dante Gabriel Rossetti (1828–1882): A Catalogue Raisonné* (2 vols.). Oxford 1971.

Survey of London: Volume XXI. Tottenham Court Road and Neighbourhood (The Parish of St. Pancras, Part III). London 1949.

Survey of London: Volume XXXII. Parish of St. James Westminster: Part II North of Piccadilly. London 1963.

Survey of London: Volume XXXVIII. The Museums Area of South Kensington and Westminster. London 1975.

Swinburne, A. C., *The Swinburne Letters*, (ed. C. Y. Lang, 6 vols.). New Haven and London 1959–62.

Tallis's History and Description of the Crystal Palace and the Exhibition of the World's Industry in 1851 (3 vols.). London and New York n.d.

Tate Gallery, Catalogue 1914, see National Gallery, British Art.

Tate Gallery Catalogues, *The Modern British Paintings, Drawings and Sculpture* (2 vols.). London 1964.

Temple, A. G., *Guildhall Memories*. London, 1918.

Thieme, U., and Becker, F., *Allgemeine Lexicon der bildenden Künstler* (37 vols.). Leipzig 1907–50.

Thompson, Paul, *William Butterfield*. London 1971.

Thornycroft, E., *Bronze and Steel: The Life of Thomas Thornycroft, Sculptor and Engineer*. Shipston-on-Stour 1932.

Toft, A., *Modelling and Sculpture: A Full Account of the Various Methods and Processes Employed in these Arts*. London 1924.

Towndrow, K. R., *Alfred Stevens: A Biography with New Material*. London 1939.

Towndrow, K. R., *The Works of Alfred Stevens in the Tate Gallery*. London 1950.

Towndrow, K. R., *Alfred Stevens* (Walker Art Gallery Monograph No. 1). Liverpool 1951.

Trevelyan, R., 'William Bell Scott and Wallington', *Apollo* cv (February 1977), pp. 117–20.

Trevelyan, R., *A Pre-Raphaelite Circle*. London 1978.

Trevelyan, R., 'Thomas Woolner, Pre-Raphaelite sculptor: The beginnings of success', *Apollo* cvii (March 1978), pp. 200–5.

Tweed, John, Sculptor, A Memoir. London 1936.

Verey, David, 'The Building of Highnam Church', *Country Life* cxlix (13 May 1971), pp. 1160–2.

Verey, David, 'George Frederick Bodley: climax of the Gothic Revival', in Jane Fawcett (ed.), *Seven Victorian Architects*, pp. 84–101. London 1976.

Victoria and Albert Museum, *List of English Nineteenth Century Sculpture in the Victoria and Albert Museum*. n.d.

Victorian Church Art (Catalogue of Exhibition at the Victoria and Albert Museum). London 1971.

Walker, R. J. B., *A Catalogue of Paintings, Drawings, Sculpture and Engravings in The Palace of Westminster: Part III, Sculpture*. London 1961.

Waring, J. B., *Masterpieces of Industrial Art and Sculpture at the International Exhibition, 1862* (3 vols.). London 1863.

Watts, M. S., *George Frederic Watts* (3 vols.). London 1912.

Weekes, Henry, *Lectures on Art with a short sketch of the author's life*. London 1880.

Whinney, Margaret, *Sculpture in Britain 1530–1830*. Harmondsworth 1964.

Whinney, Margaret and Gunnis, Rupert, *The Collection of Models by John Flaxman R.A. at University College, London, A Catalogue and Introduction*. London 1967.

Willis, R. and Clark, J. W., *The Architectural History of the University of Cambridge and of the Colleges of Cambridge and Eton* (4 vols.). Cambridge 1886.

Woodward, R., 'Scotland's Albert Memorial', *Country Life* clx (23 December 1976), pp. 1908–9.

[Woolner, Amy], *Studios of the late Thomas Woolner, R.A., 29 Welbeck Street, W. February 15th–February 28th, 1913*. Privately printed (London n.d., 1913).

Woolner, Amy, *Thomas Woolner, R.A. Sculptor and Poet His Life in Letters*. London 1917.

Woolner, Thomas, *Pygmalion*. London 1881.

Wrinch, A. M., 'George Kemp and the Scott Monument', *Country Life* cl (5 August 1971), pp. 322–4.

Young, Andrew McLaren, and Doak, A. M. (eds.), *Glasgow at a Glance*. Glasgow 1965.

Index

404

408

411

413